RETHINKING RECARVING

EDITED BY NAOMI NOBLE RICHARD

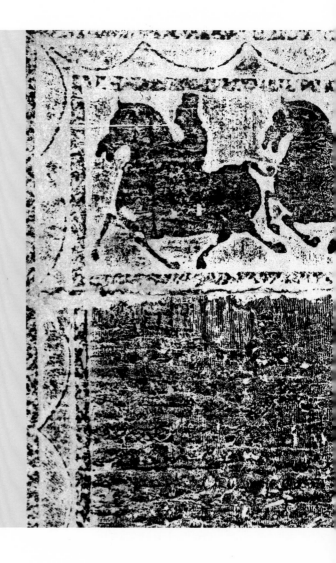

Cary Y. Liu
Michael Loewe
Lydia Thompson
Zheng Yan
Susan N. Erickson
Klaas Ruitenbeek
Jiang Yingju
Miranda Brown
Michael Nylan
Hsing I-tien
Eileen Hsiang-ling Hsu
Lillian Lan-ying Tseng
Qianshen Bai

RETHINKING RECARVING

IDEALS, PRACTICES, AND PROBLEMS OF THE "WU FAMILY SHRINES" AND HAN CHINA

PRINCETON UNIVERSITY ART MUSEUM
YALE UNIVERSITY PRESS, NEW HAVEN AND LONDON

Contents

Preface and Acknowledgements

CARY Y. LIU

Curator of Asian Art, Princeton University Art Museum

In dialogue with the *Recarving China's Past: Art, Archaeology, and Architecture of the "Wu Family Shrines"* exhibition publication and symposium, this collection of papers by archaeologists, art and architectural historians, curators, and historians develops, responds to, criticizes, and defends assertions or suppositions relating to ideals and practices apparently reflected by the Wu shrines and concerning Han-dynasty China. The Wu shrines' pictorial carvings are among the earliest works of Chinese art to have been examined in the international arena. Since the eleventh century these carvings have been identified by scholars as among the most valuable and authentic materials for the study of China's antiquity.

As such, the Wu shrines have become fundamental entities for the development of approaches to and methods of studying Han art, culture, and history. The traditional view of the shrines, however, as constructed by these approaches and methods, should be reexamined. Care must be taken to distinguish what is knowable from what is interpretation, the better to understand the story of both the Wu shrines and the world of Han. The traditional interpretive discourse — with its textual orientation — should be broadened to include a thorough examination of surviving physical and visual sources, and should approach such materials from new perspectives and by invoking new disciplines.

Essays in the book *Recarving China's Past* make the case for the need to study the actual carved pictorial stones of the Wu Family Shrines. At present access to the stones is restricted, in large part due to an abiding belief that rubbings and textual documentation are more than sufficient for the study of ancient carved stones and steles. This attitude is made evident by the jolting realization that, to date, there exists no published set of

photographs of the Wu shrines stones for scholarly study. Essays in *Recarving* question the utility of interpretations based solely on transmitted texts or rubbings. Limited access to the actual stones or to clear and accurate photographs of them raises questions about certain aspects of these older interpretations. Careful inspection reveals incontrovertible evidence of physical recarving in certain details (e.g., in this volume see Frontispiece and Part One, Liu, fig. 5), but a methodical study of the stones is still needed to determine the nature and extent of such recarving. The surviving monuments, rubbings, and photographs require further, and systematic, investigation, and such an investigation is likely to add significantly not only to an understanding of the complex cultural history informing the Wu shrines, but also to our recarving of China's past; that is, to our revised conception of the ideals, practices, and problems of the Han dynasty.

Contributions include essays on the Wu Family Shrines and on Han China by Cary Liu and Michael Loewe, respectively; on Han funerary art and architecture in Shandong and other regions by Lydia Thompson, Zheng Yan, Susan Erickson, and Klaas Ruitenbeek; on architectural functions and carved meanings by Jiang Yingju, Miranda Brown, Michael Nylan, and Hsing I-tien; and on Qing-dynasty reception of the Wu Family Shrines by Eileen Hsu and Lillian Tseng. The concluding section includes a critique of *Recarving China's Past* by Qianshen Bai followed by responses by Nylan and Liu.

My essay, "Perspectives on the 'Wu Family Shrines'," draws on research for the book and exhibition *Recarving China's Past*; it also introduces new research. My premise is that the traditional view of a "Han-dynasty Wu Family Shrines" needs careful reexamination. Most

studies have tended to build upon the received steles and the inscriptions associated with the Wu shrines, creating on that basis an impressive corpus of scholarship and interpretation. That discourse reflects the primacy of a "textual attitude" or bias, in which validity rests on the authenticity and accurate interpretation, or ideal reading, of the received texts. But correctly reading a Song scholar's perception of the Han is a different exercise from trying to reconstruct what Han practices may have actually been. The traditional identification of the Wu Family Shrines rests on the fit between the recovered stones and Song-to-present conjectural reconstructions of a Han shrine and a Han funerary site. In reconstructing a Han cemetery, however, the traditional models hypothesized in later periods must be compared with newly discovered materials and archaeologically excavated artifacts that may better demonstrate or shed light on the reality of Han cemeteries. The goal should not be to invent a single conclusive or ideal reconstruction, but to outline the range of possibilities evoked by systematic investigation of the surviving stones, rubbings, photographs, and texts.

Focusing on the organization of public life and social structure, religious practice, and intellectual activities, in "Ideals, Practices, and Problems of Han China" Michael Loewe attempts to distinguish between the ideals as imagined, the practices as achieved, and the deficiencies and defects of public life during the Han period. The essay animates our notions of Han life and society, providing a context within which to place monuments such as the Wu shrines. At the same time, it cautions us not to accept the ideal of the Han as monolithic or static. Practices, regulations, and enforcement varied over time and place, among social classes, and among individuals.

According to Loewe, "Should we seek a theo-retical formulation of an ideal social order…we would look to our sources in vain. Nor would we be necessarily justified in reading back anach-ronistically from the essays written in the later empires; for their authors may well have wished to portray the Han empire in terms that suited the intellectual ideas of Tang, Song, Ming, or Qing times." Scrutiny of recently discovered docu-ments and archaeological materials sheds light on the actual practices and problems particular to given moments and circumstances. Such particularities receive mention in our textual sources exceptionally rather than normally — exceptions which should warn us not to try to fit the Wu shrines into any idealized picture of the Han period.

The production of stone carvings as part of the ritual process of transforming the burial site into a sacred space is examined by Lydia Thompson in "Ritual, Art, and Agency: Consecrating the Burial Grounds in the Eastern Han Period." The burial time and place; the tomb's orientation and layout; the choice of material and pictorial imagery; and the auspicious time chosen for building the tomb all contributed to the ritual transformation of the tomb into a sacred space for the deceased, a medial zone whose structure and content was believed capable of affecting events in the realms of both the living and the dead. Moreover, the supernatural efficacy of mortuary pictorial carvings depended on several factors, including the quality of the carving and, possibly, on their activation by ritual. In these ways ritual and representation were parts of an interdependent system that aligned the burial site in time and place as a sacred intersection between heaven and earth and among the four directions.

In "Concerning the Viewers of Han Mortuary Art," Zheng Yan discusses how the funeral participants, on seeing that art's inscriptional content and pictorial iconography, apprehended the religious, ritual, and social functions of that art. The essay focuses on the types of viewers expected by the sponsors and makers of shrine and tomb carvings. The primary function of Han tombs and offering shrines as places where the spirits of the deceased dwelled and received sacrifices entailed, as viewers, on the one hand the spirit of the deceased and on the other the people who performed sacrifices and made offerings at the shrine and tomb sites. For this reason, Zheng theorizes that Han mortuary art was believed to be a point of intersection between viewers in this world and those in the world beyond. In addition, viewers yet unborn were anticipated, including not only casual visitors but also malicious vandals, whom inscriptions on the carvings warn or implore to keep away. Zheng Yan uses archaeological evidence in the form of shrine and tomb inscriptions to identify the various types of expected viewers. Inscriptions also reveal the changing function of mortuary art over time as construed by the sponsors, while consistency in pictorial imagery in shrine decoration, such as the recurring homage scene, may reflect workshop choice and practice among the makers.

In "Que Pillars at the Wu Family Cemetery and Related Structures in Shandong Province," Susan Erickson examines the structure and iconography of the Wu family que pillar-gate. She concludes that the iconographic program and the compositional designs for the gate drew upon stock imagery that already had been used on earlier pillar-gates and on stones in tomb chambers and shrine halls. This she demonstrates by comparison with pillar-gates in nearby Pingyi

County and with pictorial stones that were once part of a stone chamber in Jiaxiang. Legendary subjects like the progenitors Fuxi and Nüwa, and exemplary historical figures like the Duke of Zhou and Confucius, figured regularly on pictorial stones in the Shandong region during the early Eastern Han. Other motifs were used to protect the deceased or to embody family hopes for continued prosperity, and to reinforce the general concept of homage. Such similarities in the designs and themes indicate that the pictorial program of the Wu shrines pillar-gate was not specific to that family, but more likely continued preferred ideals and customary practices already in use for at least fifty years.

Klaas Ruitenbeek attempts to define the stylistic and iconographic characteristics of "The Northwestern Style of Eastern Han Pictorial Stone Carving," based on representative tombs in northern Shaanxi and western Shanxi. He examines several tombs from the vicinity of Lishi, Shipan, and Mamaozhuang in Shanxi, and focuses on the tomb of Zuo Biao: Mamaozhuang Tomb 1. These tombs are closely related in style and iconography, and several, including the tomb of Zuo Biao, may have belonged to members of one family. The Northwest style of pictorial stone carving during the Eastern Han dynasty is characterized by colorful painterly details, rendered on flat silhouettes slightly raised against a chiseled background. Typically, very few incised lines were used to show details within the raised silhouettes; instead, black ink lines and red paint completed the images. Although this style differs from carving found in Shandong, Henan, or Sichuan, artistic interaction between these regions is evident from particular iconographic and stylistic similarities, such as images of the legendary progenitors Fuxi and Nüwa and

their association with ox- and chicken-headed figures, respectively.

In the 1980s, Jiang Yingju and Wu Wenqi were in charge of excavating the tombs at the Wu cemetery. They were instrumental not only in refining the architectural reconstructions of the "Wu Family Shrines" pictorial stone chambers, but also in investigating the relationship of iconography to mortuary function in Han shrines. Jiang's perspective on more recent scholarship on the "homage scene" and its subsidiary components is thus especially welcome. In "The Iconography of the 'Homage Scene' in Han Pictorial Carving" Jiang proposes that the placement of the large tree, whether to left or right of the pavilion in the homage scene, was determined by the orientation of the shrine. Always the tree was east of the pavilion, the cardinal direction associated with birth and growth, symbols of family prosperity. Jiang also endorses Hsing I-tien's interpretation of the archery scene and unhitched horse and carriage image as rebuses for success in high office, and he asserts that these individual elements as well as the homage scene as a whole functioned as a symbolic representation of the shrine dedicatee receiving homage. But he argues strongly against Xin Lixiang's interpretation of the homage scene as representing the shrine dedicatee receiving offerings from his *living* descendants. Jiang considers the homage scene to be a "generic iconography serving the religious purpose of ancestor worship." Although he does not believe that the main male and female figures represent the deceased couple receiving homage from the living, he does argue that the "soul of the deceased was embodied in the homage scene, which…functioned as a pictorial ritual object central to the ceremony performed by family members who prayed for ancestral blessing."

In her essay "Han Steles: How to Elicit What They Have to Tell Us," Miranda Brown points to the ultimate indeterminacy of historical knowledge by assessing the reliability of stone inscriptions and rubbings that have been transmitted through the ages. She asks whether stone inscriptions of the Han dynasty are as incontrovertible as the hardness of the medium has led people commonly to believe. Or do they share some of the same problems of identification, authenticity, and the possibility of interpolation as recorded texts on less durable mediums such as paper or bamboo? Han stone inscriptions were often recopied and transmitted in various mediums, and in the process their contents were subject to textual accretion, deletion, interpolation, and alteration. After reflecting on such concerns, the essay discusses strategies for evaluating the authenticity and representativeness of "extant inscriptions" through the use of classical commentary, textual collation, and quantitative analysis. Brown concludes that the Han stele corpus can provide valuable access to the Han past—when used with such care. "Han Steles" draws out the larger implications of the historical validity of the Wu family steles, as examined in *Recarving China's Past*, by looking more broadly at Han steles as a whole.

Michael Nylan's essay "Constructing *Citang* in Han" is divided into three main sections: (1) an analysis of the vocabulary used in discussions of *citang*, (2) an analysis of the received literature pertaining to *citang*; and (3) an analysis of the archaeological evidence, which shows that the term *citang* often did not refer to an aboveground, permanent structure. Nylan affirms the abundant evidence for the existence of a variety of worship structures erected to commemorate extraordinary individuals, as well as cult sites constructed for members of the nobility. She notes a surprising lack of unambiguous literary and archaeological evidence for the erection of aboveground worship halls dedicated to the cult of the collective patriline in Han by the non-noble wealthy. Calling attention to (a) the discrepancies that existed between ritual prescriptions and actual ancestral practices, (b) the ambiguities in much of the literary and archaeological records; and (c) the twin tendencies making for distortion in scholarly writings: to extrapolate from imperial burial practices to those much further down the social scale, and to deduce earlier practices from those of late imperial China, Nylan raises the question: "How can we presume to estimate the prevalence of aboveground stone *citang* for ancestral worship erected by the merely wealthy during Eastern Han?" This question has important implications for our approach to understanding the Wu Family Shrines.

A framework for understanding the famous battle scenes depicting Han soldiers fighting female warriors across a bridge, found among the Wu shrine pictorial stones, is outlined in Hsing I-tien's (Hsing I-t'ien or Xing Yitian) abstract, "Composition, Typology, and Iconography of the 'Sino-Barbarian Battle Scene' in Han Pictorial Images" ("Handai huaxiang Hu Han zhanzhengtu de goucheng, leixing yu yiyi"). Regrettably, a full English translation of the paper could not be included in this volume; for the entire Chinese language article, see *Meishu shi yanjiu jikan* (*Journal for art historical research*), gen. no. 19 (2005), pp. 63–132. After reviewing past interpretations and adding new possible readings of battle scenes carved on many Han mortuary stones, Hsing cautions that there are multiple ways to understand these scenes. Not only may variations in composition or in typology signal different meanings, but people in different regions and at different times during the Han may also have understood the same scenes differently.

"Composition, Typology, and Iconography" builds on Hsing's *Recarving China's Past* symposium presentation, in which he connected the scenes of female warriors in the Wu shrines to the forgotten story of the Seven Ladies Seeking Revenge for Their Father (*Qinü wei fu baochou*). On the iconography of this story and its appearance on Han pictorial stones including the Wu shrines, the reader is referred to his "Stylistic Programs, Cartouches, Literary Records, and Pictorial Analysis: Case Study of the Lost Han Images of the 'Seven Ladies Seeking Revenge for Their Father' Story" ("Getao, bangti, wenxian yu huaxiang jieshi: yi yige shichuan de 'Qinü wei fu baochou' Hanhua gushi wei li").[1]

In Eileen Hsu's "Huang Yi's *Fangbei* Painting," the personal passion for antiquities displayed by Huang Yi (1744–1802), who rediscovered and identified the Wu shrines mortuary site in 1786, is viewed in the artistic, scholarly, and cultural milieu of the late eighteenth century. Although Huang Yi was not trained as a classical scholar, his study of stone inscriptions was nonetheless conditioned by the prevailing practice of *kaozheng* scholarship: the meticulous gathering of sources and careful analytic culling and recording of information. Huang compiled catalogues that included each rubbing and artifact he acquired, and he also created paintings to commemorate some of the events associated with his epigraphic study and collecting. Huang was perhaps the most active and successful practitioner of *fangbei* ("seeking steles") journeys, which are recorded in his *fangbei* paintings. Huang's impassioned pursuit of antiquities was so intense as to be almost obsessive, and is reflected both in his *fangbei* paintings and in his carving of seal inscriptions. In a cultural milieu that countenanced such a passion in such a degree, social contacts were made, personal

bonds formed, research goals articulated, research projects formulated, and sources of funding secured. These activities shed light on the circles of patronage and pedagogy that developed during this period.

In "Mediums and Messages: The Wu Family Shrines and Cultural Production in Qing China," Lillian Tseng analyzes various cultural products that proceed from or are inspired by archaeological discoveries, and which may bestow upon the latter an "afterlife" or "cultural biography." Focusing on the Wu Family Shrines, she discusses how their excavation stimulated Huang Yi to produce a group of paintings that depict his discovery and also embody his desire for documentation and remembrance. In addition, the preservation of the archaeological site led to the erection of a new commemorative stele, signaling a mood of celebration, scholarly acumen, and erudite camaraderie. Finally, she investigates the market that developed for reproductions of the shrines' pictorial carvings, the resulting mass reproduction of woodblock prints, and the problems of readability and authenticity engendered by competitive mass reproduction.

The concluding essay, "The Intellectual Legacy of Huang Yi and His Friends: Reflections on Some Issues Raised by *Recarving China's Past*," by Qianshen Bai, is in large part a critique of essays by Liu and Nylan in *Recarving China's Past*. Nylan and I welcome this essay in the spirit of scholarly dialogue, and at Bai's request the contents have not been changed or shortened. Bai's critique is followed by Nylan's "Response to Bai Qianshen," and the essay "Perspectives on the 'Wu Family Shrines'" doubles as my rejoinder.

Acknowledgements

Rethinking Recarving is cosponsored by the P.Y. and Kinmay W. Tang Center for East Asian Art at Princeton University, the Princeton University Art Museum, The Andrew W. Mellon Foundation, and the B.Y. Lam Foundation. Preliminary versions of many of the papers in this volume were first presented at the *Recarving China's Past* symposium (April 30–May 1, 2005) at Princeton University. The symposium was organized by the Princeton University Art Museum in memory of Frederick W. Mote. Cosponsors included the Chiang Ching-kuo Foundation for International Scholarly Exchange, the East Asian Studies Program, and the P.Y. and Kinmay W. Tang Center for East Asian Art; with the support of the Asian Studies Center at the University of Pittsburgh and the History Department and the East Asian Library at the University of California at Berkeley. Special thanks to all the participants, as well as the panel chairs: Wen C. Fong, Anthony Barbieri-Low, Michael Nylan, and Benjamin Elman.

The *Recarving China's Past* exhibition (Figs. 1–2) and publication were made possible by grants from the Getty, the E. Rhodes and Leona B. Carpenter Foundation, the Blakemore Foundation, The Andrew W. Mellon Foundation, the National Endowment for the Arts, the Princeton University Art Museum and Apparatus Fund, the Friends and the Partners of the Princeton University Art Museum, and the Department of Art and Archaeology, Princeton University. The project also was supported by gifts from Lillian Schloss and several anonymous donors.

Special thanks to Eileen Hsiang-ling Hsu, our research associate for *Recarving China's Past*, whose assistance in translating several essays in this volume is appreciated beyond words. My gratitude also to Susan L. Beningson, our project coordinator for the *Recarving* exhibition, catalogue, and symposium, as well as my cocurator for the companion exhibition and catalogue *Providing for the Afterlife*, organized by the China Institute in America.

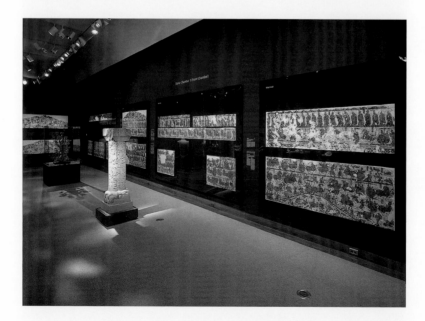

Fig. 1 View of the exhibition *Recarving China's Past: Art, Archaeology, and Architecture of the "Wu Family Shrines,"* March 5–June 25, 2005, Princeton University Art Museum. Photo by Bruce M. White.

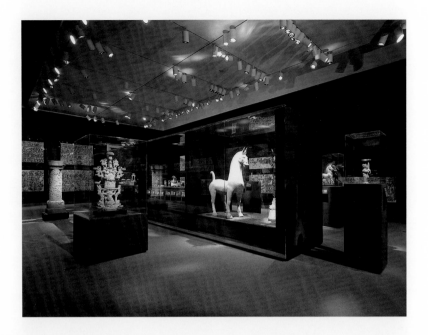

Fig. 2 View of the exhibition *Recarving China's Past*. Photo by Bruce M. White.

I also want to acknowledge the support of Susan M. Taylor, former director, and Rebecca Sender, acting director, at the Princeton University Art Museum, along with assistance from Sinead Kehoe, assistant curator of Asian Art, Michael Brew, business manager, Karen Richter, assistant registrar and photo services, and Jeffrey Evans, digital imaging specialist. This volume could also not have been completed without the strong support of the P.Y. and Kinmay W. Tang Center for East Asian Art; in particular I want to thank Jerome Silbergeld, director, and Dora C.Y. Ching, associate director.

Last but definitely not least, my deepest appreciation to all the authors and the entire publication team. Naomi Richard deployed her usual editorial ferocity, challenging all the authors to rethink and improve their essays. The design of this book rests with Joseph Cho and Stefanie Lew of the design firm Binocular, who also designed the *Recarving China's Past* exhibition and catalogue. Our thanks go also to David W. Goodrich of Birdtrack Press for the Chinese character typesetting, and to Robert J. Palmer, who prepared the index. At the museum, I am particularly indebted to Kim Wishart, project editor, who took over the responsibility of coordinating the production of the publication and worked closely with the individual authors and production team. We were also fortunate to have the wisdom of Jill Guthrie, managing editor, who made sure we stayed on course. Special appreciation goes also to Nicola Knipe, our project editor for *Recarving China's Past*, who contributed significantly to the early editorial process and on whom we depended for Swedish translations. ◑

Note

1 Xing Yitian, "Getao, bangti, wenxian yu hua-xiang jieshi yi yige shichuan de 'Qinü wei fu baochou' Hanhua gushi wei lie" in Xing Yitian gen. ed., *Zhongshiji yiqian de diyu* *wenhua, zongjiao yu yishu* (*Regional culture, religion, and arts before the seventh century*) (Taipei: Zhong-yang yanjiuyuan lishi yuyan yanjiusuo, 2002), pp. 183– 234.

Introduction

JEROME SILBERGELD

P.Y. and Kinmay W. Tang Professor of Chinese Art History
Director, Tang Center for East Asian Art, Princeton University

In August 1786 the astronomer Caroline Herschel discovered a new comet, the first to be identified by a woman. In November 1786 the Grand Duke of Tuscany abolished the death penalty, making his country the first to do so. In the spring of 1787 a convention in Philadelphia of states' representatives gathered to amend the Articles of Confederation, and as they wrote, instead, a new constitution, Wolfgang Amadeus Mozart, in Vienna and Prague, composed *Don Giovanni*. In the midst of these forward-looking and culturally defining events, the antiquarian Huang Yi (1744–1802) made a personal journey to Jiaxiang County in Shandong Province, where beside Wuzhai Hill he discovered the stones he identified as the "Wu shi ci," the Wu Family Shrines. He dated these monuments to the first year of the Jianhe era, 147 CE. Rubbings of these stones and catalogues recording their texts had been known and published, but the stones not actually seen by scholars since the time of Ouyang Xiu, in 1061. With their recovery by Huang Yi, a window onto the ancient practices of Chinese burial ritual was opened. The pictorial designs on these stones also opened a rare, if not unique, view of the distant past of China's pictorial arts, a view which remained canonical until the flowering of modern Chinese archaeology in the twentieth century. In Cary Liu's words, "The nearly one thousand years of cultural history and scholarship behind the monument known as the 'Wu Family Shrines' is itself a kind of monument."[1]

It might be thought that, unlike his Western contemporaries, Huang Yi represented the increasingly backward, or inward, turning of Chinese intellectual attitudes after the prime of the Qianlong emperor's long reign (1736–1796) had been reached and passed. In 1787 Huang Yi wrote, in a conservative vein, "We will erect a preservation hall to protect the carvings. People will find it easier

to make rubbings from these carvings, and the reproductions will spread far and wide. People will recognize the importance of taking good care of these objects, and the carvings will exist forever."[2] Wilma Fairbank, who provided the first credible reconstruction of these scattered stones into a solid architecture pattern, observed, "The original slabs — if they were considered at all — were in effect regarded as lithographic stones from which useful prints could endlessly be 'pulled.'"[3] Nevertheless, the extensive travels that Huang Yi organized in pursuit of antiquities previously known to scholars only through rubbings acquired from art dealers; his efforts to excavate, clean, identify, and preserve the inscribed steles and pictorial stones; the careful analysis and correlation of his data with information from other published scholarly reports; the commitment of this to notebooks and catalogues; and the paintings he made to visually record his finds, all serve as the marks of Chinese scholarship in an increasingly modern mode, contributing significantly to the *kaozheng* movement of the late Ming – Qing period.

"Have faith in antiquity, have doubts about antiquity, explain antiquity" is the form this scholarship has taken in modern times, with different scholars giving different weight to each of these three elements. The contributors to this volume have done just that with the complex outgrowth of this original material, an episodic and often dramatic history of alternating discovery, loss, and recovery of information from the eleventh century on. A love of antiquity and passion for truthful understanding drive the efforts here to reconsider this material in all of its many aspects: from construction to ceremonial use; from stones to rubbings made from stones to the reading, recording, and transmission of data from rubbings made from stones (material which is sometimes strangely inconsistent from one observer to another, and from one era to the next); from the nature of research scholarship in each successive historical era to the debate over reconstructive methodologies in our own time. Thus, the papers range widely. Broad aspects of Han funerary traditions and their pictorial programs, as they relate to Wu family shrines scholarship, are considered by Michael Loewe, Lydia Thompson, Zheng Yan, Jiang Yingju, and Hsing I-tien; more specific consideration of regional and local styles and iconographies are dealt with by Susan Erickson and Klaas Ruitenbeek. Huang Yi's antiquarian scholarship, and especially his on-site paintings, are the subject of Eileen Hsu's research; Lillian Lan-ying Tseng focuses on Huang Yi's paintings as well as on commemorative stele carving and printmaking generated by the rediscovery of the Jiaxiang stones. The matter of "having doubts" is most clearly embodied in three papers: methodological questions about the use of Han steles and the reliability of their inscribed texts are raised by Miranda Brown; the uncertain understanding of Han-period funerary "shrines" (*citang* or *shitang*) in later times is raised by Michael Nylan; the many problems of textual transcription and transmission (from the original carving of these stones to the later periods during which rubbings appeared and were recorded, in the eleventh century and beyond) are the topic of Nylan's and Cary Liu's essays.

Contra the postulate of "lithographic stones from which useful prints could *endlessly* be 'pulled'" (in Wilma Fairbank's words, with my emphasis here on the word "endlessly"), the troubling issue of stones subjected over time to both natural and man-made erosion (floods and too many rubbings) and possibly recarved so as to restore or reconstruct their legibility appears prominently in the work of Liu, Nylan, and Brown.

That controversial practice provided the title for the exhibition "Recarving China's Past," which this symposium accompanied. Whether these gathered stones all formed an original group, whether this "group" composed a funerary shrine, whether that "shrine" belonged to the Wu family, and whether these "Wu Family Shrines" date from the late Han dynasty have all been questioned, calling for a thorough, modern reexamination of the stones and inscriptions—carved, rubbed, and catalogued—on which this identification is based.

This symposium volume embellishes an exhibition whose elegant display of rubbings taken from Jiaxiang's incised stones, juxtaposed with excavated objects like those depicted on the stones, was an unquestioned success. But the symposium took "doubt" as its keynote, and so it should not be surprising that the thrust of the symposium might itself be doubted and challenged, even by some of the participating scholars. In many a symposium, outlying contributions, inconsistent with the others, are excluded from the final symposium volume; but that would be inconsistent here, where skeptical inquiry is the order of the day, and so this intellectual challenge is welcomed and included. At the core of this inquiry is the historiographic question of accuracy and the reliability of early Chinese scholarship, from the Song scholars Ouyang Xiu, Zhao Mingcheng (1081–1129), and Hong Gua (1117–1184) to Huang Yi and beyond. The recarving of badly worn stones carries with it the potential for guesswork, inaccuracy, projection, and even intentional misinformation, and inconsistencies between rubbings made from the same stone reveal this. Reading this situation in a contemporary, skeptical vein, Cary Liu, in his essay for this volume, quotes Edward Said as writing, "…texts can *create* not only knowledge but also the very reality they appear to describe. In time

such knowledge and reality produce a tradition, or what Michel Foucault calls a discourse, whose material presence or weight, not the originality of a given author, is really responsible for the texts produced out of it."[4] To the strong defense of the *kaozheng* movement and the integrity of early scholars in general comes Qianshen Bai's spirited essay, which challenges the readings and textual selections of Nylan and Liu. Bai's extended essay can stand for students as an exquisite, model lesson on the proper use of Chinese literature that has gone through various editions down through the ages. Whether or not it dispatches the questions raised by Liu and Nylan in their essays or answers their rejoinders to his objections is left up to our readers. Many readers (and I include myself) will not have the expertise to pass final judgment on this intellectual encounter, but the reading will nonetheless be intellectually exhilarating—academic debate at its best. ○

Notes

1 Cary Liu, "Perspectives on the 'Wu Family Shrines': Recarving the Past," in this volume, p. 20.

2 Huang Yi, translated by Wu Hung, *The Wu Liang Shrine: The Ideology of Early Chinese Pictorial Art* (Stanford: Stanford University Press, 1989), p. 4.

3 Wilma Fairbank, "Foreword" to Wu Hung, *The Wu Liang Shrine*, xviii.

4 Edward W. Said, *Orientalism* (New York: Vintage, 1979), p. 94, quoted in Liu, p. 22.

Chronology

Neolithic period	**ca. 8000–ca. 2000 BCE**
Xia period (protohistoric)	**ca. 2100–ca. 1600 BCE**
Shang dynasty	**ca. 1600–ca. 1100 BCE**
Zhou dynasty	**ca. 1100–256 BCE**
Western Zhou	ca. 1100–770 BCE
Eastern Zhou	770–256 BCE
Spring and Autumn period	770–ca. 470 BCE
Warring States period	ca. 470–221 BCE
Qin dynasty	**221–206 BCE**
Han dynasty	**206 BCE–220 CE**
Western (Former) Han	206 BCE–9 CE
Xin dynasty	9–24 CE
Eastern (Latter) Han	25–220
Three Kingdoms period	**220–265**
Wei	220–265
Shu Han	220–265
Wu	222–280
Western Jin dynasty	**265–317**
Northern Dynasties	**386–581**
Sixteen Kingdoms	304–438
Former Liang	314–376
Later Liang	386–403
Southern Liang	397–414
Western Liang	400–422
Northern Liang	398–439
Cheng Han	304–347
Former Zhao	304–329
Later Zhao	319–351
Western Qin	365–431
Former Qin	349–394
Later Qin	384–417
Xia	407–431
Former Yan	333–370
Later Yan	384–409
Southern Yan	398–410
Northern Yan	409–436
Northern Wei	386–535
Eastern Wei	534–550
Western Wei	535–557
Northern Qi	550–577
Northern Zhou	557–581

Southern Dynasties	**317–589**
Eastern Jin	317–420
Liu Song	420–479
Southern Qi	479–502
Liang	502–557
Chen	557–589
Six Dynasties period	**222–589**
Wu	222–280
Eastern Jin	317–420
Liu Song	420–479
Southern Qi	479–502
Liang	502–557
Chen	557–589
Sui dynasty	**589–618**
Tang dynasty	**618–907**
Liao dynasty	**907–1125**
Five Dynasties period	**907–960**
Later Liang	907–923
Later Tang	923–936
Later Jin	936–946
Later Han	946–950
Later Zhou	951–960
Dali kingdom	**937–1253**
Song dynasty	**960–1279**
Northern Song	960–1127
Southern Song	1127–1279
Xi Xia	**1038–1227**
Jin dynasty	**1115–1234**
Yuan dynasty	**1260–1368**
Ming dynasty	**1368–1644**
Qing dynasty	**1644–1912**
Republic	**1912–1949**
People's Republic	**1949–**

Period of Disunity 220–589

PART ONE IDEALS, PRACTICES, AND PROBLEMS:

THE "WU FAMILY SHRINES" AND HAN CHINA

Perspectives on the "Wu Family Shrines": Recarving the Past[1]

CARY Y. LIU

The act of recarving proceeds from a desire to preserve the past for the present and future. In any recarving, whether of history, literature, or the arts, a past model is recast or reenvisioned. More than just preserving the past, however, recarving renders the past new through repair, reform, and restoration. The Chinese term *xin* ("new"), in the sense of a "fresh start," also connotes "renovating," "reforming," or "repairing" the past (*xiu jiu*) through the recovery of exemplary conduct and correct behavior. It is in this sense that the recarving of China's past has often entailed identifying what is proper or vital in the past as prerequisite to preserving exemplars for the present and future. It is this "taste for antiquity" (*shigu*) or "addiction to antiquity" (*nigu*), the urge to recover and revitalize what is proper or ideal in the past (*fugu*), that underlies much of antiquarian scholarship and artistic revival in China.

Carved images of legendary rulers and paragons of filial piety and loyalty, historical and mythological stories, scenes of feasting, homage, processions, omens, and other figural and decorative designs are the subjects of an assemblage of pictorial stones known as the "Wu family shrines" (*Wu shi citang*).[2] Traditionally dated to the mid-second century during the Han dynasty, these carvings, and the rubbings made from them, have been recognized since the mid-eleventh century as some of the most valuable and authentic materials for the study of Chinese antiquity. For this reason the Wu shrines are fundamental to understanding historical approaches to, and methods of studying, Chinese art and history, and have also been central to the dating of archaeologically excavated Han tombs and artifacts. The nearly one thousand years of cultural history and scholarship behind the monument known as the Wu family shrines is itself a kind of monument.

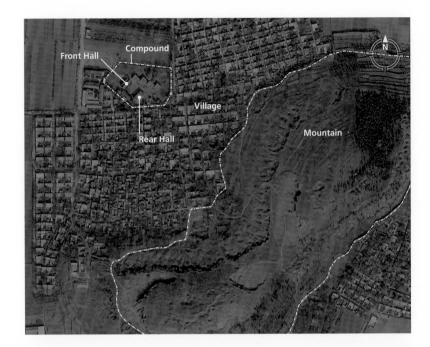

Fig. 1 *Wuzhai Shan site*, Jiaxiang County, Shandong. Courtesy of Google Earth.

What are the so-called Wu family shrines and what is their significance to the study of Chinese art, archaeology, and architecture? Many of the carved stones were recovered in the late eighteenth century at the ruins of a cemetery complex located in the northwest foothills of the Ziyun Shan (Purple Cloud Hills) mountain range in present-day Jiaxiang County, Shandong Province. Today the collected stones are stored inside a walled compound with a modern front gate built in imitation of a Han pillar-gate (*que*) composed of a pair of stone gate-pillars. Two exhibition halls and the remains of excavated tombs are located between the gate and the distant Wuzhai Shan, a peak of the Ziyun Shan range, to the southeast (fig. 1). Stored in the Front Exhibition Hall are a pair of gate-pillars, male and female feline sculptures, stele stones, as well as some architectural stones and commemorative plaques. The Back Exhibition Hall was renovated in 2004, with modern display cases to store the majority of the carved pictorial stones recovered

at the site, as well as a few miscellaneous stones from neighboring locations. The assembled stones in the Front and Back Halls are now collectively known as the "Wu family shrines." In addition, a small number of "Wu shrines" stones are presently stored elsewhere or are missing. Over the decades, many other pictorial stones found in the Jiaxiang area were also brought to the compound. Many are now stored in a side gallery between the Front and Back Halls, and many more are now in the collections of the Shandong Provincial Museum and Shandong Stone Inscriptions Art Museum, Jinan. Many of these stones are carved in a style similar to that of the Wu shrine stones.[3]

In this short essay a comprehensive review of studies on the "Wu shrines," starting from the eleventh century in the Song dynasty to the present, is not possible. In brief, during the Song period, when the initial accounts of the "Wu shrines" were written, they were based, not on the stones themselves, but on ink-on-paper rubbings.

Unfortunately, those rubbings no longer survive, so we cannot judge their condition or dependability, or use them to check the inscriptions and descriptions associated with the Wu shrines that have been transmitted through copying, compilation, and collation in later received editions of Song texts. Most later studies have tended to build upon the received inscriptions, creating on that basis an impressive corpus of scholarship and interpretation about the Wu shrines. This lineage of discourse reflects the primacy of a "textual attitude." The validity of the "textual attitude" rests on the authenticity and accurate interpretation, or ideal reading, of the received texts, at each stage in their transmission. But we must exert care to distinguish what is knowable from what is interpreted in order to better understand the ideals, practices, and problems behind the story of the Wu shrines. Moreover, care should be taken to refine any interpretive discourse based on a "textual attitude," which Edward Said has described thus:

A text purporting to contain knowledge about something actual…is not easily dismissed. Expertise is attributed to it. The authority of academics, institutions, and governments can accrue to it, surrounding it with still greater prestige than its practical successes warrant. Most important, such texts can *create* not only knowledge but also the very reality they appear to describe. In time such knowledge and reality produce a tradition, or what Michel Foucault calls a discourse, whose material presence or weight, not the originality of a given author, is really responsible for the texts produced out of it.[4]

The traditional or standard readings based on a "textual attitude" have led to ideal interpretations or understandings concerning the Wu shrines; such views, however, have not always been monolithic and have also varied over time. As will be pointed out, scholars in the Qing and modern periods have read the same texts in different ways, and even the received Song texts are not always in complete agreement and can sometimes be read differently depending on the context or perspective from which they are viewed. Often two scholars may approach the same problem from different perspectives, leading them to reach differing conclusions. For example, if a character taboo during the reign-period of Eastern Han emperor Mingdi (r. 58–75) is found in an inscription, one scholar may assign that inscription either to the pre-Mingdi or the post-Han period. On the other hand, another scholar may find Mingdi-reign taboo characters in post-Mingdi but still Han inscriptions, thereby concluding that prohibitions of taboo characters were generally not enforced. As generalities, neither interpretation is incorrect. Enforcement of taboos differed over time, region, and locality, and the use of a taboo character might reflect carelessness or deliberate insubordination. Either generality could be true, but when applied to a specific case—such as a taboo character found in a Wu shrine inscription—how can we know if the prohibition against taboo characters was observed or ignored?[5] Unless other determining characteristics of a given inscription can be found, it is best to recognize multiple interpretive views as general possibilities.

The traditional interpretive reading of the Wu shrines represents one methodological approach, focusing on the received textual sources originally recorded in the Song and transmitted by rubbings, manuscript copies, and print. This tradition should be integrated with a closer examination of other physical, visual, and textual sources, and such materials should be approached from new perspectives and disciplines. First, greater attention

should be paid to the actual surviving stones of the Wu shrines—not just the received inscriptions transcribed in texts or reproduced in rubbings and prints; a systematic scientific inspection[6] of the stones may prove revealing. Additionally, new stones are still being found and some missing stones have recently been relocated, so there are new materials to take into account. Secondly, the large number of Han-dynasty and Shandong-region archaeological materials excavated since the 1960s should also be reviewed with closer scrutiny. The perception of the Han formulated in the traditional discourse needs to be examined with these new materials in mind. Thirdly, variations among the many surviving versions of the Wu Shrine rubbings, as well as comparison of these with their reproductions in other media and with forgeries, should be documented and analyzed; and digital imaging is only beginning to make such a substantial undertaking reasonably possible. Lastly, formerly obscure texts and newly discovered Han texts need also to be taken into account.

Approaching the stones, the rubbings, and the textual Wu shrines materials from new perspectives and disciplines may also prove valuable. In *Recarving China's Past*, the traditional interpretation was not reviewed in any great detail, since it had already been well covered in the scholarship of others. Instead, new approaches to the Wu shrines were attempted from different perspectives: Michael Nylan offered the views of a Han historian; Anthony Barbieri-Low, those of an archaeologist-historian focusing on Han workshop practices; and myself, those of an architectural historian. Although our individual views about many aspects of the Wu shrines materials did not always concur, it was precisely at those points where we differed with one another and deviated from the traditional interpretive discourse, that further questioning or

research is required. Because many of these differences cannot be conclusively resolved, it is more productive not to argue for any single interpretation but instead to outline the range of general possibilities. Some possibilities lead us to alternatives to the standard readings of the received texts.

There is another reason to use new materials and perspectives to supplement and refine the traditional discourse. The traditional story of the Wu family shrine stones starts with a conspicuous absence. Until the eleventh century in the Song dynasty, there is no record of the stones, their inscriptions, or their pictorial images. The story of the Wu family shrines only begins in the eleventh century, with records of isolated, scattered stele rubbings. The earliest partial mention is in Ouyang Xiu's (1007–1072) *Jigu lu* (*Record of collected antiquities*), a received text which itself has had a complicated history of transmission. In the *Jigu lu* are records of two inscriptions, a Ban (or Wu Ban) stele and a Rong (or Wu Rong) stele, but Ouyang did not link them to each other, to a particular site, or necessarily to a Wu family.[7] Regarding the former stele, Ouyang Xiu noted in a 1064 entry that the family name, courtesy name, and office titles of the person named Ban are not legible and that eighty to ninety percent of the text was indecipherable. A 1069 supplementary entry adds that a second rubbing of the stele revealed the surname Wu, but notes no other major differences.[8]

In the next century an assemblage was formed that included these two stele inscriptions and additional inscriptions. In *Jinshi lu* (*Records of metal and stone*), Zhao Mingcheng (1081–1129) linked the Wu Ban inscription to the Wu Kaiming and Wu Liang stele inscriptions along with a gate-pillar inscription. He also mentioned the existence of pictorial stones belonging to a Wu family, but curiously omitted mention of the Wu Rong stele.

But it was only Hong Gua (1117–1184), in his *Lishi* (*Explications on clerical script*) and *Li xu* (*Supplement on clerical script*), who brought together the full assemblage that would become known as the Wu family shrines. The assemblage included the four stele inscriptions said to commemorate four males of the Wu family (Wu Ban, Wu Rong, Wu Liang, and Wu Kaiming), a gate-pillar inscription, and pictorial stones that Hong Gua associated with a Wu Liang Shrine (*Wu Liang ci*).

After the Song dynasty, between the thirteenth to eighteenth centuries, the Wu shrines site was reportedly flooded and the stones forgotten. Local gazetteer reports indicate that partly buried ruins of three stone offering halls (*xiangtang*) carved with good omens and figures of ancient loyal and filial persons and belonging to "a Han prince" were still visible aboveground during the sixteenth to eighteenth centuries.[9] It was also reported that a stone stele with an indistinct inscription was found among these remains. The gazetteers located the ruins to the west of the Ziyun Shan hills, and one such gazetteer led to the rediscovery of the Wu shrines stones in 1786 (see below). So it seems that, although flooding may have submerged the structures at various times, when the waters receded, the tops of the structures stood exposed. They may not have been lost, but their original identity had been forgotten. It remains uncertain whether these structures belonging to "a Han prince" were the Wu shrines, or whether these were two distinct sites.

While the stones remained forgotten, rubbings, copies, and textual descriptions of the Wu shrines continued to circulate from Southern Song to early Qing, and more information from this period is continuing to surface.[10] Zhang Xuan's *Zhida Jinling xin zhi* (*New Jinling gazetteer of the Zhida reign-period*, compiled 1344), lists the title "Slabs of the Wu Family Stone Chambers," which may refer to a set of rubbings in the Jinling area (present-day Nanjing) during the Yuan dynasty.[11] The 1573 edition of the *Yanzhou fu zhi* (*Gazetteer of Yanzhou Prefecture*) seems to indicate that both the Wu Rong and Wu Kaiming steles survived in Jining into the late Ming.[12] The so-called Tang Rubbings album — fourteen pictorial scenes of the Wu shrines — was examined by scholar and bibliophile Zhu Yizun (1629–1709) in 1704 and again in 1705.[13] In Yu Yizheng's (d. ca. 1635) *Tianxia jinshi zhi* (*Record of metal and stone inscriptions under heaven*) the Wu Ban, Wu Rong, and Wu Liang steles, along with the Wu Liang pictorial stones, are listed.[14] This may indicate that a rubbing of the Wu Liang stele still survived in the late Ming; but if so, we do not know if it was made from the original stele or if it was a copy. As for the pictorial stones, we do not know if the listing actually refers only to the inscribed cartouches, or labels (*bangti*), on the so-called Wu Liang Shrine slabs. Many records that mention collections of the pictorial stones refer only to rubbings of the inscribed cartouches, omitting the pictorial images.[15] Rubbings of the Wu Ban and Wu Rong steles were also recorded by Qian Daxin (1728–1804) as being in the Tianyi Ge private library.[16] Although such rubbings are recorded in catalogues and collections, one cannot assume that they all came from the same original stones or were free of modification or repair.[17] As a corollary, it is also hard to know exactly what individual scholars were looking at when writing about Wu shrine inscriptions or pictorial carvings. Were they relying on original or retouched rubbings, on rubbings from a recarved stone or woodblock, on manuscript or tracing copies, or on textual descriptions?

In 1786 during the Qing dynasty, actual stones were rediscovered to the west of the Ziyun

Shan hills by the official Huang Yi (1744–1802). Following a gazetteer report (discussed above), he located pictorial carved stones that had once composed three or four stone chambers, a pillar-gate composed of a pair of stone gate-pillars, a pair of stone sculptures of felines, one inscribed stone stele, and one blank stele to the northwest of the Ziyun Shan hills. Is it possible to assume that what Huang Yi found corresponds to the three shrines and the indistinct or illegible stele of a Han prince mentioned in the gazetteers? What was recovered does not fully match what is reported in the gazetteers, but if it did, wouldn't this site be that of a Han prince and not the Wu shrines? Perhaps there was another funerary site in the vicinity that has yet to be located or has already been obscured by village construction (fig. 1). At the site Huang Yi also found similarly carved miscellaneous stones that presumably came from nearby locations. Moreover, numerous similarly carved stones have later been recovered in the Jiaxiang environs.[18] All this seems to indicate that many funerary complexes were built in this locale during the second to third centuries (an observation also made by Hong Gua).

Huang Yi based his identification of the ruins as the Wu shrines on his discovery of the Wu Ban stele, the gate-pillar inscription, and Hong Gua's interpretation of the mention of pictorial stones in the Wu Liang stele inscription. Today the validity of this identification rests on the fit between the recovered stones and Song-to-present reconstructions of a Han shrine (ci or citang) and a Han funerary site. But since any reconstruction involves an act of interpretation, it becomes important to distinguish between what is actually known and what is an interpretation. In her essay "Constructing Citang in Han" in this volume, Michael Nylan reassesses the ideals, practices, and problems that would have determined what a

Han-period shrine (citang) may have been. Similarly, in reconstructing the architectural layout of a Han cemetery, the models or versions hypothesized in the Song through Qing periods should be compared with newly discovered materials and archaeologically excavated artifacts that may better demonstrate or shed light on Han practices. The goal should not be to invent a single conclusive or ideal reconstruction but to outline the general range of possible funerary structures and layouts. Let us start by examining how the recovered Wu shrines stones have been reconstructed.

Following discoveries in 1786 and 1789 by Huang Yi and his associates at the Wu shrine cemetery, the pictorial stones were divided into four main groups—labeled the Wu Liang Shrine, Front, Rear, and Left Groups—plus several miscellaneous stones, many of which had originated elsewhere. Subsequently, a substantial body of scholarship has focused on interpreting the pictorial images. This scholarship has been invaluable not only to elucidating the images associated with the Wu shrines, but also to the understanding of Han pictorial art in general.[19] This new focus on the pictorial images became feasible with the wide distribution of rubbings and printed reproductions (drawings, woodcuts, and photographs of rubbings) of the pictorial images. These rubbings and reproductions have, to the present, been the primary lens through which the carved images have been examined. This has also meant that until the mid-twentieth century, each image on the pictorial stones was often treated as an isolated unit divorced from any coherent architectural program.

The first attempt at architectural reconstruction occurred in 1941, when Wilma Fairbank used scale photographs of the rubbings to reconstruct three shrine structures, which allowed the "inter-relationships and positional significance" of the

individual scenes to be viewed in a pictorial and architectural program.[20] This study was immediately acclaimed as breakthrough scholarship, and Fairbank's reconstruction was remarkably accurate. In 1981 Jiang Yingju and Wu Wenqi used the actual stones to verify and refine Fairbank's architectural reconstruction with only minor adjustments.

The three structures Jiang and Wu reconstructed include a one-bay structure with pictorial carvings on every interior wall and ceiling surface, and with finished exterior walls carved with horizontal decorative bands continued from the interior. They identified this structure as the Wu Liang Shrine. Also reconstructed were two larger two-bay-wide structures, each with a center niche in the back wall, rough-hewn side and back exterior walls, protruding niche stones, and roof slabs. The decorated exterior of the one-bay hall tends to indicate that it was meant to be viewed as a freestanding structure. In contrast, the coarse, unfinished exteriors of the two two-bay halls may suggest that they were intended to be viewed from the front, with their three unfinished sides

Fig. 3 *Tomb 2, detail of traces of red paint wall decoration* (enhanced). Ca. second century CE, Wuzhai Shan site, Jiaxiang County, Shandong. Photo by author, 2004.

and protruding back niche embedded in a raised tomb mound.[21]

Among many possibilities, one interpretive reconstruction for the overall cemetery is proposed in the *Recarving China's Past* catalogue (fig. 2), and another variation is visualized in an interactive computer reconstruction.[22] The tentative proposed reconstruction superimposes several sets of information: (1) Huang Yi's 1787 *Xiu Wushi Citang ji lüe* (*Brief record on building the Wu Family Shrine [Preservation Hall]*), discovery report; (2) Sekino Tadashi's 1907 site survey map; (3) Jiang Yingju's and Wu Wenqi's 1981 survey of the site; and (4) locations of tombs excavated at the cemetery since 1981.[23] Ambiguity in these sources permits many alternative interpretations, but one possibility is that the cemetery was arranged sequentially from front (northwest) to back (southeast), with a spirit path, pair of feline stone sculptures, pillar-gate, steles, stone chambers, and finally the tomb mounds (fig. 2).[24] To date, three tombs have been located and excavated. Tombs 1 and 2 were uncovered and

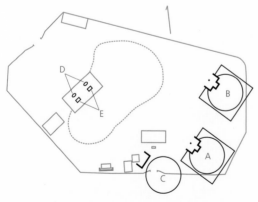

Fig. 2 *Site reconstruction map*. Drawing showing possible locations of Front, Left/Rear, and Wu Liang Groups as found by Huang Yi, and locations of Stone Chambers 1, 2, 3. (a) Front Group: Stone Chamber 1, Tomb 2; (b) Rear/Left Group: Stone Chamber 2, Tomb 1; (c) Wu Liang Group: Stone Chamber 3, possible tomb; (d) Stone Felines; (e) Gate-pillars.

surveyed in 1981. Tomb 3 was discovered between them in 2002, but documentation has yet to be published. Viewed from the pillar-gate in the front center, the three tombs form an arc across the back left side of the present cemetery grounds. A road and village now stand to the right of the arc; probably other tombs were originally located in that zone. From the location where groups of stones were found by Huang Yi, the tombs can be tentatively related to the stone structures as reconstructed in *Recarving China's Past*: the two-bay wide Stone Chamber 1 (former Front and Rear Group stones as found by Huang Yi) and Stone Chamber 2 (former Left and Rear Groups), and the one-bay Stone Chamber 3 (Wu Liang Shrine). If we assume that a freestanding Chamber 3 fronted a mound (possibly in the village area) to the southeast, on axis with the pillar-gate, then the position of Chamber 2 may correspond with the location of Tomb 1 or 3, and Chamber 1 with Tomb 2.[25]

At present the tombs languish exposed to the elements at the back of the walled cemetery compound. When I visited in June 2002, the topmost caisson roof stones on Tombs 1 and 3 were removed, revealing a glimpse into the interiors. The stone slab roofs covering Tomb 2, however, had been largely removed, exposing the burial chambers. Visible on the plastered walls of Tomb 2 were traces of decorative red-pigment lines that were not mentioned in prior reports (fig. 3). If original, these pigment traces may have implications for the original appearance of Chambers 1–3. On my revisiting the cemetery in June 2004, vegetal growth had forced the front lintel stone over the entry to collapse into Tomb 2, and the wall plaster had darkened, obscuring much of the red-pigment lines. Returning in October 2005, I found the area had suffered heavy rains and the tombs were completely submerged (fig. 4). Earlier in 2005 the red-stucco offices (built in 1989; still seen in fig. 1) occupying the northeast side of the compound had been demolished.

The assemblage of materials brought together for storage at this site has traditionally been known as the "Han-dynasty Wu family shrines," and has been accepted as such by many but not all scholars. Doubt about the identification was raised by the French sinologist Édouard Chavannes (1865–1918)

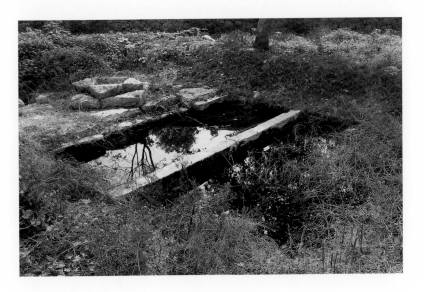

Fig. 4 *Tomb 2, submerged condition after heavy rains.* Ca. second century CE, Wuzhai Shan site, Jiaxiang County, Shandong. Photo by author, 2005.

in publications in 1893 and 1915, in which he consistently referred to the cemetery complex as the "pseudo-Wou Leang" shrines, but never explained why.[26] In the eighteenth century Gu Aiji in his *Li bian* (*Distinguishing clerical script*) and the editors of the *Siku quanshu zongmu tiyao* (*General catalogue with abstracts of the Comprehensive Library of the Four Treasuries*) had noted, respectively, that Zhao Mingcheng in his *Jinshi lu* and Qian Daxin in *Jinshi wen bawei* (*Postscripts to writings on metal and stone*) had referred to the assemblage of pictorial stones only as belonging to a Wu family "stone chamber" (*shishi*), without further specification. They then noted that Hong Gua in his *Lishi* was the first to say the pictorial stones belonged to a "shrine" (*citang*) dedicated to Wu Liang, basing his statement on a passage in the Wu Liang stele inscription mentioning a shrine with carved designs by the craftsman Wei Gai (cited below). Gu Aiji, however, noting that Wu Liang had died in 151, pointed out that the "Lu Zhuang gong" cartouche carved on the west-wall stone (Chamber 3-W.1), violated the taboo placed on the character *zhuang* beginning earlier in the reign of Mingdi. Gu concluded that the pictorial stones were those of a Wu family but "they are not [those of] Wu Liang." The *Siku tiyao* editors extended Gu's argument. They interpreted the failure to observe the taboo as meaning that the stones predated the Mingdi reign.[27] They did not mention that an argument could also be made for a post-Han date.

On the other hand, in his *Siku tiyao bianzheng* (*Critical inquiries on the Siku tiyao*), Yu Jiaxi (1883–1955) disagreed with the analysis of the *Siku tiyao* editors and Gu Aiji. Although Yu acknowledged the strict enforcement of the proscription against using taboo characters in government documents and public records during the Han, he argued that in other circumstances

enforcement was lax and observance of taboo was often evaded. As a result, regarding the *zhuang* character in the "Lu Zhuang gong" cartouche on the Wu shrine pictorial stone, Yu Jiaxi suggests that its presence in defiance of taboo in the Han was not uncommon.[28] By implication, he clearly concurs with Hong Gua: the pictorial stones correspond in date to the period of Wu Liang's death (151) and belong to a Wu Liang Shrine.[29]

Reviewing both sides of the argument, neither is entirely right or wrong. Cases of adherence to and evasion of Han taboos after the Mingdi reign are both recorded. Either conclusion as a general rule might be true, depending on differing levels of enforcement at various times and in different regions, as well as on differences between public and private practices, or on acts of carelessness or protest. We cannot know whether, at the time the "Lu Zhuang gong" cartouche was made, the proscription was circumvented or simply not in force. It is not even known whether the structures formed by the pictorial stones were intended for private worship or for public viewing. If the latter, then even Yu Jiaxi acknowledges the probability that taboos were strictly enforced. But following Yu Jiaxi's argument, if we can assume that the "Lu Zhuang gong" cartouche may represent an evasion of the taboo, then the cartouche could have been carved during the Mingdi reign, or after it during the Han, as well as any time before Mingdi or post-Han. Although Yu Jiaxi disagrees with the analysis of the *Siku tiyao* editors and Gu Aiji, he neither supplies any particular evidence to narrow the period when the "Lu Zhuang gong" cartouche was carved, nor adds any corroboration to Hong Gua's claim that the pictorial stones must be from the Wu Liang Shrine. And Hong Gua's assertion hinges only on his interpretation of a passage in the Wu Liang stele inscription (discussed below).

Other aspects of the traditional interpretive discourse on the Wu shrines have also been questioned. In the early twentieth century the historian and epigrapher Lao Gan expressed reservations about efforts to correlate the inscribed office titles and military events depicted on the Wu shrines pictorial slabs with the minimal biographies of Wu Rong and Wu Ban as recorded in their stele inscriptions.[30] This criticism has had significant bearing on efforts to interpret the pictorial details in the four groups (Front, Left, Rear, and Wu Liang Shrine) of pictorial stones as matching details in the scanty biographies recorded in the stele inscriptions commemorating each of the four males of the Wu family.[31] It also raises some questions about the connection between the received stele inscriptions and the pictorial stones found at the cemetery.

Questions about the connection between some of the stones found by Huang Yi and the cemetery were also raised by the scholar and official Wang Chang (1725–1806) in his *Jinshi cuibian* (*Collection of metal and stone carvings*) commentary on the so-called Wu Liang Shrine pictorial stones.[32] After discussing earlier records, rubbings, and reproductions of the scenes on the three main walls, Wang Chang remarked that, similar to Hong Gua's *Li xu* illustrations, his own supposedly more accurate woodcut illustrations in the *Jinshi cuibian* only reproduced those scenes with attached calligraphic cartouches or appraisals (*tizan*). According to Wang Chang, because the so-called Front, Rear, and Left Stone Chamber stones, Good Omen Picture stones, stone columns, and some other stones did not have cartouches or appraisals, they were not illustrated in his work. (This is some-what misleading, since many of the pictorial stones in these groups do have cartouches, although they are fewer in number, and many of the cartouches were damaged or remained blank.)[33] Wang Chang

then added his concerns about the pictorial stones Huang Yi had recovered, saying: "And according to what Mr. Hong [Gua] has reported, perhaps they are not all materials from the shrines of the Wu family" (*qie kong ru Hongshi suo cheng bu xie Wushici zhi wu*).[34] His reference to Hong Gua is made clear in subsequent lines noting that several dozen similarly carved pictorial stones were also discovered in the Jiaxiang area. This duplicates Hong Gua's observation in his commentary to the "Wu Liang Shrine Pictorial Images" ("Wu Liang citang huaxiang") section in *Lishi*. Before concluding that the pictorial stones must belong to a Wu Liang Shrine on the basis of the Wu Liang stele inscription, Hong Gua observed: "It must be that there were a thousand burial mounds in the Dongzhou area, and at that time [in the Han, they must] have vied to have this style [of pictorial stones]" (*bi shi Dongzhou qian long dangshi jing you ci zhi*).[35] If according to Hong Gua there were numerous similarly carved Han pictorial shrine stones in the Dongzhou (present-day Shandong) area, how then does he come to conclude that the Chamber 3 pictorial stones must belong to the Wu Liang Shrine? As Gu Aiji and the *Siku tiyao* editors pointed out, the passage in the Wu Liang stele inscription mentioning a shrine (*citang*) carved with designs by the craftsman Wei Gai seems to be the only link.

Before proceeding, we should carefully examine the Wei Gai passage in relation to Hong Gua's commentaries for the "Retainer Wu Liang Stele" ("Congshi Wu Liang bei") and the "Wu Liang Shrine Pictorial Images" entries in his *Lishi*. The passage reads:

His filial sons, Zhongzhang, Jizhang, and Jili, and the filial grandson, Ziqiao, personally cultivated what was proper to sons and spent everything the family had [to construct his shrine and altar]. They

chose excellent stones from the south side of the southern mountain; they chose those of perfect quality and color without any yellow blemishes. In front they established stone altars in a cleared space; behind they erected a shrine (*citang*). The skilled craftsman Wei Gai engraved the text and carved the designs; he arranged everything in its place. He gave free reign to his talent as expressed in the stunning ease and elegance [of his work].[36]

Hong Gua cited this passage in both his "Retainer Wu Liang Stele" and "Wu Liang Shrine Pictorial Images" commentaries. In the latter he assumed that because the Wu Liang Stele passage mentions the building of a "shrine" and that "Wei Gai…carved the designs," therefore the Chamber 3 pictorial images correspond with a stone chamber belonging to Wu Liang, and the structure is a "shrine" (*citang*). Despite Hong Gua's observation in this commentary that there must been many similarly carved funerary structures in the same area during the Han, he nevertheless concluded: "Apparently the [Wei Gai passage in the Wu Liang Stele] is talking about these pictures. For this reason I will use 'The Wu Liang Shrine Pictorial Images' to name them" (*si shi wei ci hua ye, gu yu yi Wu Liang citang huaxiang ming zhi*). This declaration is new with Hong Gua, and earlier in the commentary he proudly notes that Zhao Mingcheng had not been able to narrow down his identification beyond associating the pictorial stones with some stone chambers of a Wu family in Rencheng. Hong Gua's conjecture, however, solely hinged on the mention of "carved designs" and "shrines" in the stele's Wei Gai passage. The Chamber 3 stones do not include any mention of Wu Liang, or any other indication that they must correspond to a Wu Liang Shrine. Since the Chamber 1 and 2 and other pictorial stones were also found at the cemetery site, and there may

have been additional tombs and stone chambers as well, one of these structures might equally well have been the one dedicated to Wu Liang.

Moreover, it is unknown whether the Wu Liang Stele stone was originally located at the present cemetery site. It may have been erected at another location where there was an adjoining shrine with carved designs. In other words, we cannot be sure that the "carved designs" and "shrine" mentioned in the Wei Gai passage referred to a particular pictorial stone chamber at the cemetery. Zhao Mingcheng had reached the same cautious conclusion. Present-day archaeological evidence also corroborates this judgment. As already noted, in the Jiaxiang region are numerous pictorial stone chambers with very similar scenes, many carved in the same style. Anthony Barbieri-Low suggests, in his essay in *Recarving China's Past*, that a particular local workshop produced these anomalously styled pictorial carvings, and that model-book patterns were used. Both these factors imply the repetition of stock images and themes carved on many different stones. That implication has been borne out by the Songshan stone chambers, as well as by several Jiaxiang area pictorial stones uncovered nearby over the past several decades.[37]

In his "Wu Liang Shrine Pictorial Images" commentary, Hong Gua relies on the authenticity of the Wei Gai passage in the Wu Liang stele inscription. In his "Retainer Wu Liang Stele" commentary, however, he raised some incidental reservations about the Wei Gai passage.

If speaking about funerary and burial matters, it [i.e., the language in this passage] should not be as verbose as this. This stele is not quite half a *xun* unit long and only one *chi* foot wide. Since there are no skillful pictorial carvings and not everything

is arranged in its place, its words are absolutely not about the establishment of a stele. Having carefully mulled it over, it appears to me only to describe the pictorial images of a stone chamber.[38]

In the first sentence quoted above, Hong Gua notes that the language of the Wei Gai passage seems unlike a funerary inscription. If so, we need to consider whether that passage originally occurred on the Wu Liang funerary stele, particularly since the passage appears transcribed for the very first time as part of the stele text in Hong Gua's *Lishi*. It does not occur earlier, neither in Ouyang Xiu's *Jigu lu* nor in Zhao Mingcheng's *Jinshi lu*. Could it be that Hong Gua simply had a better rubbing of the Wu Liang stele? Or could the rubbing that Hong Gua examined have included comments or inscriptions added to the stele after the original carving?[39] Or might Hong Gua have interpolated the passage from some other Han inscription fragments that he believed to be from the stele? Because neither the actual stele stone nor any rubbing of its inscription survive, the answer to these questions may never be known. But by analyzing the appropriateness (or inappropriateness) of the term "shrine" (*citang*) in Hong Gua's "Wei Gai" passage, in relation to what we know of Han practice and to the stone chambers found at the Wu shrines cemetery, we may eventually approach some answers.

Apart from these questions, in Hong Gua's "Retainer Wu Liang Stele" commentary, the operative phrase is "Having carefully mulled it over…." Here, we have moved well beyond questions of accurate transcription, and are dealing with speculative interpretation. Because the Wei Gai passage mentions "shrines" and "carved designs," Hong Gua speculates that the Chamber 3 stones correspond to a Wu Liang Shrine. Hong Gua's interpretation, however, revolves around

a circular argument. In the "Wu Liang Shrine Pictorial Images" commentary, the identification of the Chamber 3 stones with the Wu Liang Shrine rests on the authenticity of the Wei Gai passage; in the "Retainer Wu Liang Stele" commentary, Hong Gua's acceptance of the Wei Gai passage as part of the Wu Liang stele inscription relies, after having "mulled it over," on the assumption that the Chamber 3 pictorial rubbings correspond to the Wu Liang Shrine.

Understanding the Wei Gai passage and related commentaries is more complex than simply reading their texts "correctly." In some later editions of the *Lishi*, sections of the Wu Liang stele inscription and Hong Gua's commentary were omitted and conflated with the Wu Ban Stele entry and commentary. The accurate reconstruction of this section of *Lishi* is not, however, the main point. We need to keep in perspective that Hong Gua's commentaries on the Wei Gai passage are Song interpretations of Han circumstances. Correctly reading what Hong Gua, a man of Song, thought of the Han, is a different exercise from trying to reconstruct what Han funerary practices may have actually been like.

It is also important to point out that, from the eleventh century to the 1980s, and still largely true today, few scholars have actually worked directly with the actual pictorial stones. Almost all have relied on textual descriptions and on the ink-on-paper rubbings and their reproductions. In part this results from the belief that early rubbings, which were collected as an art form, often embody the original engraved stone better than the centuries-old surviving stone can possibly do, because carved stone tends to become abraded or damaged over time. This neglect of the stones themselves is surprising in view of the importance of the Wu family shrines assemblage

as a monument among the arts of China. It was one of the only semi-excavated Han monuments of its time, and became a benchmark for dating other carved pictorial stones. It became one of the first Chinese pictorial monuments to be studied on an international stage, when Stephen Bushell (1844–1908) presented rubbings in Berlin in 1888. It is also one of the monuments that every student of Chinese pictorial arts begins with. Finally, in recognition of its artistic, cultural, and historical significance, the assemblage was among the first group of works to be awarded national landmark status by the Chinese government in 1961.

Since the early twentieth century, research on the assemblage has chiefly focused on the iconography of the pictorial scenes in the rubbings—essentially accepting the consensus view that these belong to a "Han-dynasty Wu family shrine," as based on standard readings of the transmitted texts. But some aspects of the traditional interpretive discourse on the Wu shrines have been questioned by later scholars; it is also worth noting that different Song recordings of the Wu shrines inscriptions do not always agree. When I began this project, I had expected to work on the pictorial program in Chambers 1 and 2. What I found during my research, however, shifted my attention in unexpected directions, including the complicated history of the received stele and gate-pillar inscriptions, the relationship between the four steles and the cemetery site, the absence of records concerning Chambers 1 and 2, the question of what was a "shrine" in the Han period, and the complicated problems of physical and historical recarving.

Traditionally the four inscribed stone steles dedicated to four males of the Wu family have been used to identify and date the site. But these four stones may not be from the site, and the

not unproblematic history of the transmission of their received inscriptions also requires considered interpretation.[40] Regarding the Wu Ban stele, for example, recall that Ouyang Xiu noted in the *Jigu lu* that the family name, courtesy name, and office titles were not legible and that eighty to ninety percent of the text was indecipherable. In a supplementary entry based on a second rubbing, the Wu family name was inserted, but no other changes were recorded, and there is no mention of a stele heading. Additional characters, including the courtesy name, office titles, and a stele heading, were supplied to the inscription in Zhao Mingcheng's *Jinshi lu*, and in later received editions of Hong Gua's *Lishi* eighty to ninety percent of the text was transcribed, which means that it must have been legible.

Why such a discrepancy between Ouyang Xiu's and Hong Gua's textual descriptions? One possible interpretation may be to assume that Hong Gua's later record reflects more sophisticated scholarship. For this scenario to be plausible, it is necessary to speculate that a better rubbing, preserving eighty to ninety percent of the text, was available to Hong Gua. It is impossible, however, to know the condition of the rubbing Hong Gua examined: whether it really was of better quality, or a reworked rubbing, or taken from a retouched or recut stone, or compiled from various rubbing fragments believed to be from the stele. Hypothesizing that Hong Gua's rubbing was better than Ouyang's also assumes that the eighty to ninety percent of the text was still inscribed on the stele when Ouyang Xiu's earlier two rubbings were made, but that those rubbings were so inferior as to obscure eighty to ninety percent of the text. This would also mean that after the Song period the condition of the stele deteriorated to such an extent that, after Huang Yi rediscovered the stone, Weng Fanggang

would write: "[Because the stele is] so severely damaged, only ten to twenty percent of the characters survive, compared with the text Hong Gua recorded [in the *Lishi*]."[41] In the end, the present condition of the Wu Ban stele seems to correspond to what Ouyang Xiu had recorded: eighty to ninety percent illegible.

A second possible interpretation may be that Ouyang Xiu's record of the condition of the Wu Ban stele stone was more accurate. It can be argued that, compared with Hong Gua, Ouyang Xiu was less committed to transcribing every clerical-script character of the inscription, but this argument collapses under Ouyang's specific record of what was not visible in the two rubbings he owned. He recorded that the courtesy name, office titles, and eighty to ninety percent of the stele text were lost or indecipherable. The text currently visible on the recovered stele corresponds remarkably well with Ouyang Xiu's description. In particular, Ouyang Xiu saw and transcribed eight characters and indicated one missing character of the inscription's opening line, and that transcription matches rubbings of the stele taken after its rediscovery in 1786 (discussed below). Given the correspondence between Ouyang's description and the surviving stone, we need to question the former Hong Gua scenario. Why presuppose the existence of a better rubbing, or of a stele that was better preserved in the twelfth century than in the eleventh, after which such a rubbing disappears and the stone becomes abraded over time until 1786, when the rediscovered stele coincidentally corresponds to the condition of the stele as had been recorded by Ouyang Xiu in the Song?

It is possible that these two interpretive scenarios represent different methodological approaches, one primarily concerned with textual interpretation as a means to understand material

objects, and the other emphasizing the primacy of the surviving object as a key to interpreting the texts. What should be evident is that these are only two of many possible approaches and interpretations, and that future physical and scientific inspection of the Wu Ban stele may help to narrow the possibilities. Personal inspection of the actual Wu Ban stele stone in 2002, 2004, and 2005, as well as of various Qing and modern rubbings, confirms that the carved text is heavily worn and largely illegible. The present-day Wu Ban stele also offers a clear-cut example of physical recarving. Ouyang Xiu in the *Jigu lu* had only transcribed eight characters plus one missing character of the inscription's opening line: "First year of the Jian[] reign-period when the Taisui asterism was in the position of *dinghai*" (*Jian*[] *yuan nian taisui zai dinghai*).[42] Ouyang extrapolated the inscribed date to be (Gregorian) 147, the first year·of the Eastern Han Jian[he] reign-period. In almost every subsequent transcription or description of this stele or its rubbed inscription, the extrapolated *he* character is recorded as missing. On the actual stone a damage forming a depressed pit occupies the location of the missing character. Yet today, not only are the eight characters recorded in the *Jigu lu* clearly visible, but the missing *he* character can also be seen carved at the bottom of the depression (fig. 5). The clarity of this nine-character opening stands out in contrast to the abraded and damaged surface of the remainder of the stele, and is evidently a modern recarving. X-ray fluorescence imaging technology should be used to examine this section of the stele, as well as the carved surfaces of all the Wu Shrine stele and pictorial stones.[43] During carving of the calligraphy and pictorial images on the stones, metallic traces of cutting tools are deposited in the incised lines and can sometimes be detected by X-ray fluorescence. Whereas it is

Fig. 5 *Wu Ban stele*, detail of recarved characters "Jianhe yuan nian...." Ca. second century CE. Wuzhai Shan site, Jiaxiang County, Shandong. Photo by author, 2004.

unlikely that traces of the original cutting tools can be detected today, recent retouching of any lines, or repairs such as the added *he* character, may well leave traces. Analysis of the trace metals and microscopic characteristics of the incised lines may also prove instructive.

The relationship of the four Wu shrines inscribed steles to the cemetery site and to each other also needs to be carefully considered. What was the original arrangement of the funerary structures in the cemetery? Was it Han practice to erect funerary steles inside or outside the cemetery pillar-gate? Or were they instead erected away from the cemetery at an ancestral hall? Or could they have been raised by family descendants at a later time and carved with an inscription in Han-style wording and calligraphy? It is difficult to investigate these questions because the majority of Han funerary stele inscriptions only survive as

recorded inscriptions or as rubbings, and those original stones that do survive usually have been moved from their original location. Moreover, in rare instances when funerary steles have been archaeologically excavated at a cemetery or found elsewhere, in no case with which I am familiar can the architectural relationship with the cemetery be established as representative of Han practice.[44] The Wu Ban and Wu Rong steles serve as examples.

Among the four Wu shrines inscribed steles, the Wu Ban stone was discovered by Huang Yi in 1786 to the north outside the pillar-gate, but Huang reported that decades earlier local people had found it in a pit by the side of a road.[45] This is the extent of what is known about the stele's recovery. Exactly where it was found by the Jiaxiang locals and its original spatial relationship to the cemetery can no longer be determined. It should be noted that several miscellaneous Han stones, probably from nearby sites, were also recovered at the cemetery by Huang Yi and his colleagues. It is not inconceivable that the Wu Ban stele was one of these relocated stones, although this does not mean that the stele inscription is not connected to the cemetery, just that the stone may have been erected elsewhere.

As for the Wu Rong stele stone, before 1786 it was already housed away from the cemetery at the Prefectural Academy in Jining city. There is no record of where or when this stele was originally found, and we should question how it came to be associated with the Wu family shrines. Can it simply be assumed that this stele was originally erected at the cemetery, or could it have been situated at some other ancestral or commemorative site? The remaining Wu Liang and Wu Kaiming steles no longer survive, but the former is sometimes identified with a blank stele that was reportedly found northwest outside the cemetery's pillar-gate.[46]

Similar to the Wu Ban and Wu Rong stones, this stele has a tall oblong body with a triangular peak and a circular hole about one third down from the top. When this blank stele was recovered, it no longer had, or never had, an inscription. Later a single character, "Wu," was carved on one side below the hole.[47] Could this blank stele have been the missing Wu Liang or Wu Kaiming stele? Could it have been dedicated to, or intended for, a fifth member of the Wu family, or someone else entirely? Was it even originally associated with the cemetery? One possible future avenue of investigation should be analysis of the crystalline structure of the surface layers of this stone. The limestone material of this stele, as well as of the Wu shrines stones, exhibits a degree of crystallization. If the stone had been carved, the force of cutting into the top surface would have impacted the crystalline substrate, and signs of the impact might still be detectible.

If none of the four inscribed steles can originally be connected with the site, what has linked them to each other and to this particular cemetery? The key seems to lie with an inscription, dated to 147 CE, once carved on the pillar-gate at the cemetery. This inscription, however, is presently illegible. On the north side of each gate-pillar, a blank panel can now be seen. On the northeast pillar, at mid level, is a vertical panel flanked by decorative bands. The panel appears empty, yet early rubbings reveal traces of partially effaced pictorial figures in the upper right (fig. 6; also see Frontispiece). Once this is noticed, traces of other figures, arranged in horizontal rows, can also be discerned. This indicates that the entire panel was originally carved with pictorial images that were only later obliterated, possibly in preparation for an inscription.[48] The gate-pillar inscription dated to 147 CE was formerly carved on a horizontal panel on the southwest pillar. This panel is curiously

located at the bottom of the gate-pillar body and is cradled between decorative bands on each side and across the bottom. In comparison with the northeast-pillar blank panel, one needs to consider whether this panel too was once decorated with pictorial carvings that were then effaced to make space for the dated inscription. Such an interpretation, however, does not mean that the

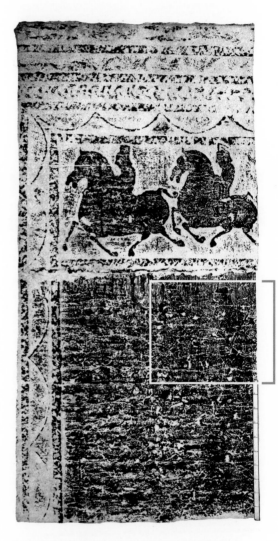

Fig. 6 *North side of northeast gate-pillar*. Detail; ink on paper rubbing. From Sekino Tadashi, *Shina Santōshō ni okeru Kandai Funbo no Hyōshoku* (Tokyo: Imperial University of Tokyo, 1916), pl. 26, fig. 41.

dated inscription was necessarily carved after the Han. Consistent with Han workshop practice, the pillar-gate stones may have been fabricated and decorated in advance. After the pre-carved stones had been purchased and erected at the cemetery, the need for an inscription may then have caused the two panel areas to be effaced for recarving. The possibility remains, however, that the panels were cleared at a later date and the inscription added by a descendant. A scientific analysis of the crystalline substrate should be conducted on both these panels.

The gate-pillar's dated inscription was first recorded in Zhao Mingcheng's *Jinshi lu*.[49] The inscription does not have a Hong Gua entry in received editions of the *Lishi*, but it is referred to in one of Hong's commentaries.[50] In the *Jinshi lu* transcription the pillar-gate was built by Wu Kaiming and three filial brothers without any mention of memorializing a member of an older generation. In addition, the last half of the inscription, oddly, focuses on Wu Ban, Kaiming's son and obviously of a younger generation. In Hong Gua's "Wu Ban Stele" commentary the pillar-gate is recorded to have been erected by Wu Kaiming "for" (*wei*) his elder brother(s) (*xiong*). Among the names of the three brothers listed on the gate-pillar inscription, only Suizong (courtesy name of Wu Liang) is known to be older. The full names of Kaiming's two other brothers, and the chronological relationship among the three, have never been known. If the designation *xiong* by Hong Gua refers only to Wu Liang, then, as Michael Nylan has pointed out, in Hong Gua's commentary the pillar-gate is recorded to have been erected by Wu Kaiming "for" (*wei*) his elder brother Wu Liang. This would contradict the *Jinshi lu* transcription, since Wu Kaiming died three years before his brother.[51] The *wei* character is transcribed in the two chief versions of the *Lishi*

circulating in print during the Qing: Wang Yunlu's edition of 1588 (basis for the *Siku quanshu* and *Sibu congkan* editions) and Wang Rixiu's Lousong shuwu edition of 1777–78 (basis for the 1871 Huimuzhai and 1985 Zhonghua shuju editions).

In response to Nylan's observation, in his essay in this volume, Qianshen Bai notes that in the commentary passage in question, the character "for" (*wei*) should have been written as "and" (*ji*), and the "error seems to rest on either a typographical error by Hong Gua" or by some later copyist or collator confusing the similar running-script configurations of the characters "for" (*wei*) and "and" (*ji*) in a manuscript copy. Though Bai's reading is entirely plausible, it relies on the assumption that Hong Gua did not have any other copy of the gate-pillar inscription at his disposal, and that he relied on Zhao Mingcheng's *Jinshi lu* transcription, as he copied it into the *Lishi*.

If the pillar-gate was indeed erected by Wu Kaiming "and" his elder brother(s), and not "for" him (or them), such a reading seems to negate the contradiction between Hong Gua's commentary passage and Zhao Mingcheng's transcription. It is important to note, however, that neither the characters *wei* nor *ji* appear in the gate-pillar inscription itself. They are confined to Hong Gua's interpretative commentary. Any confusion apparently stems from whether Hong Gua deliberately or mistakenly wrote (or the printers and later copyists correctly or erroneously copied) the character "for" or the character "and" in the *Lishi* commentary. On this point we have no evidence, but find ourselves *interpreting* the intention and accuracy of Hong Gua, or later copyists; we are multiple steps removed from the primary source: from carved gate-pillar inscription, to rubbings, to Zhao Mingcheng's transcription, to Hong Gua's commentary interpretation, to Song and Yuan

print and reprint editions of the *Lishi*, to manuscript copies, to later collated editions of the *Lishi*. It may be helpful to step back from such arguments about authorial intention, editorial transmission, and textual reading of Hong Gua's commentary, to examine the inscribed gate-pillar stone, or, by default, surviving rubbings.

As noted above, the gate-pillar panel with the inscription dated to 147 CE is now illegible. This in itself is a bit curious. Several Wu shrine stones (such as the "Confucius Meeting Laozi" slab) with similar or even finer carving, which have been rubbed as often, if not more often, than the pillar-gate inscription, have remained fairly legible. Why has the gate-pillar inscription become so illegible while the other stones remain relatively intact? One possible reason is that this panel was prepared and carved in a manner different from the other stones, which made the carved inscription more susceptible to abrasion. Alternatively, reports that the gate-pillars were repeatedly uncovered after periodic flooding and stood in pits that at times may have been used as lavatories, may also have seriously affected their condition. It is also worth noting that present-day visual inspection of the pictorial carvings on each gate-pillar reveals that they are among the most seriously abraded at the cemetery. The gate-pillars were exposed to the elements, and, in general, the upper layers of decoration are more weather-beaten. The contours and details of many of the carvings have become rounded and indistinct, and some of the original fine-line incised details on the figures have been deeply re-cut, resulting in exaggerated features such as the enlarged eyes.

If we examine early rubbings of the gate-pillar inscription, made after it was recovered by Huang Yi, they seem to match quite well with Zhao Mingcheng's *Jinshi lu* transcription. In most later transcriptions of the gate-pillar inscription,

one of the filial brothers is named Suizong, which corresponds with Wu Liang's courtesy name as recorded in the Wu Liang stele text. Farther along in the inscription a craftsman named Sunzong is usually credited with the two feline sculptures erected in front of the pillar-gate. In some transcriptions, however, this craftsman's name is written as Suizong. This is recorded by Gong Yanxing, who also reports that there are at least two recarved rubbing versions of the 147 pillar-gate inscription.[52] One of these versions may have substituted the name Suizong for Sunzong, or perhaps the character was switched during editorial compilation or scribal copying. Gong assumes that the two recut versions were produced after the actual gate-pillar panel had become illegible, but since relatively legible rubbings from the gate-pillar stone seem to have been made as late as the early 1980s, it is possible they were recarved at an earlier period. Without careful inspection and side-by-side comparison of the various rubbing versions, the surviving stone, and the textual transcriptions, however, we should reserve judgment. This is to say that, although thorough studies of the textual documents (*wenxian*) related to the Wu shrines have been conducted, there is still a need to systematically catalogue and verify the material objects (*shiwu*), including surviving monuments, rubbings, photographs, and paintings. For example, the variations between different surviving versions of the Wu Shrine rubbings, and the chronology when each rubbing was taken, have yet to be methodically documented. Once we realize the subtlety of rubbing as an art form — that almost every rubbing is unique, and that the clarity, sharpness, and completeness of a rubbing is insufficient to establish the condition of the carved stone or the date of the rubbing[53] — then it becomes imperative to establish what materials individual

scholars had access to and how this may have affected their scholarship. One should not assume that Qing or twentieth-century scholars had the opportunity to analyze and compare all surviving rubbings and other material objects connected with the Wu shrines in any comprehensive manner. It is only with the advent of digital imaging that it is becoming feasible to record the different sets of Wu shrine materials for comparison. It should be stressed, moreover, that this endeavor is only in its initial stages and is complicated by the fact that there are few if any complete rubbing sets. Most sets were not assembled as a single production, but compiled over time from diverse sources. Clearly, there is more work to be done on the material objects — the surviving stones and numerous rubbing versions — and their relationship with textual documentation.

Other questions that require further investigation include: why was there almost no mention of the majority of pictorial stones belonging to the reconstructed two-bay Stone Chambers 1 and 2 until after Huang Yi's recovery of the stones in 1786? Prior to that date there were only records of pictorial scenes associated with the one-bay Stone Chamber 3 (Wu Liang Shrine), as well as the "Confucius Meeting Laozi" and ceiling slabs that have been reconstructed as parts of Chambers 1 and 2. If all three stone chambers were together at the cemetery, why would the pictorial scenes and calligraphic cartouches in Chamber 3 be recorded, while those in the other two larger chambers were largely neglected?

Further consideration should also be given to the workshop construction of the tombs and chambers, the likelihood of using color or some other method to distinguish the carved designs or fine-line details from the limestone background, and the complex issues of later recarving, forgery, and the rubbing process. Preliminary forays into these questions have been raised in *Recarving China's Past*. As mentioned above, we also need to reconsider why the Wu family shrines are called "shrines" (*citang*), and in that connection, what a "shrine" was in the Han dynasty. Here I just want to highlight the architectural differences between the two-bay chambers with a central back niche and rough-hewn exteriors, and the one-bay chamber with finished exterior walls and different iconographic placement. If one type was indeed a "shrine," the other type may not have been. Similarly, the Han terms *citang*, *cimiao*, *shitang*, and *zhaici* or *shizhaici* are now all understood synonymously, as different words for "tomb shrines" (*mu shang citang*).[54] It is possible, however, that these terms, along with *zhaigong* or *shizhaici*,[55] both now translated as "purification halls," may then have designated disparate funerary structures that were differentiated by architectural type or by ritual function.

In sum, the consensus view of a "Han-dynasty Wu family shrines" should be carefully reexamined. We must take care to distinguish what is knowable from what is interpreted, in order to better understand the ideals, practices, and problems behind the story of the Wu shrines. The traditional interpretive discourse — with its textual orientation — should be broadened to include a thorough examination of physical and visual sources, and should approach such materials from new perspectives and by invoking new disciplines. Much still needs to be done to systematically investigate the surviving monuments, rubbings, and photographs, and such an investigation may add significantly not only to an understanding of the long cultural history behind the Wu shrines, but also to a knowledge of Han practices.

The 2005 exhibition *Recarving China's Past: Art, Archaeology, and Architecture of the "Wu*

Fig. 7 *Sleeve dancer*. Detail of Stone Chamber 1, Stone 1-E.2. "Wu family shrines" rubbings. Princeton University Art Museum, acc. no. 2002–307.2. Far Eastern Seminar Collection. Photo by Bruce M. White.

Fig. 8 *Sleeve dancer*. Western Han dynasty. Earthenware with pigments; h. approx. 40.6 cm. Private collection. Promised gift to the Princeton University Art Museum. Photo by Bruce M. White.

Family Shrines" at the Princeton University Art Museum presented the Wu Shrine rubbings as architecture through architectural reconstruction and computer modeling. Besides the rubbings, the exhibition included archaeological materials that were selected in order to bring to life various items and activities depicted in the rubbings (figs. 7, 8), or to show a conceptual relationship between burial objects in Han tombs and the tombs themselves. My hypothesis is that tombs, pictorial carvings, and tomb architecture were all conceived as "brilliant artifacts," "spirit objects," "vessels for the spirits," or "vessels symbolizing [their owners'] numinous virtue" (*mingqi*) that embodied the "bright spirits" or "spirit brilliance" (*shenming*) of the dead in the Han.[56]

The character *ming* is composed of two elements, the sun (*ri*) and moon (*yue*), and, according to Henri Maspero, although it originally meant "brightness" or "light," it was also substituted as a phonetic-loan (*jiajie*) for a character meaning "sacred." The latter is the meaning originally associated with *mingqi*, which Maspero translates as *objets sacrés*: spirit objects consecrated for the dead.[57] By the Han period,

however, the use of the loan character seems to have added another layer of meaning. The two elements of sun and moon came to symbolize a harmonious balance connected with proper burials. It is the attainment of such harmony through rites that is discussed in the *Writings of Xunzi*: "Through rites heaven and earth join in harmony, the sun and moon are brilliant (*ri yue yi ming*), the four seasons proceed in order, the stars and constellations march, the rivers flow, and all things flourish…."[58] Conversely, an imbalance between sun and moon was deemed detrimental. For example, in Liu Xi's (act. ca. 200) *Shiming* (*Explanation of names*) it states: "If the sun and moon are not complete [i.e., not balanced] then the burial is called parched; that is to say, [if one] wants to rush, then the burial is without blessings."[59] It is the symbolic balance between sun and moon that may also account for the customary appearance of paired images of the sun and moon in Han mortuary architecture, mirrors, shrouds, and banners and other items (fig. 9).[60] My translation of *mingqi* as "brilliant artifacts" is intended to encompass both meanings: as objects that embody the spirit brilliance or

intelligence (*shenming*) of the dead, and embody the harmonious balance between the light of the sun and glow of the moon.

The characteristics of *mingqi* are discussed in the "Tan Gong" chapter of the *Liji* (*Rites records*), where Confucius (551–479 BCE) is quoted as saying:

In dealing with the dead, if we treat them as if they were entirely dead, that would show a want of affection, and should not be done; or if we treat them as if they were entirely alive, that would show a want of wisdom, and should not be done. On this account bamboo artifacts (used in connection with the burial of the dead) are not fit for actual use; those of earthenware cannot be used to wash in; those of wood are incapable of being carved; the lutes and harps are strung, but not evenly; the reed pipes are complete, but not in tune; the bells and musical stones are there, but they have not stands. They are called brilliant artifacts (*mingqi*); that is, [the dead] are thus treated as if they were spirit brilliances (*shenming*).[61]

According to this passage the spirit brilliance of the deceased exists between the entirely dead and the entirely living in a medial zone of an afterlife.[62] In order to provide proper treatment for spirit brilliances in this afterlife realm, therefore, *mingqi* during the Han were conceived as simulacra, artifacts having the appearance and form of articles made for the living, but devoid of their use and function.

In probing the meaning of *mingqi* in the Han dynasty, it may be best not to conceive of any corresponding physical category or classification of objects. Instead, it may be better to examine *mingqi* in terms of its possible role in differentiating the realms of life and afterlife; that is, between articles and houses made for the living (exposed

Fig. 9 *Fuxi with the sun (right) and Nüwa with the moon (left).* Eastern Han dynasty. Carved pictorial tomb stones from Baizhuang, Linyi County, Shandong. Ink-on-paper rubbings (modern); image height approx. 117 cm. From *Linyi Han huaxiang shi*, ed. Feng Yi et al. (Jinan: Shandong meishu chubanshe, 2002), p. 23, figs. 32, 33.

to the light of the sun), and grave articles and funerary architecture for the afterliving (under the glow of the moon). In discussions of funerary rites contained in pre-Han and Han sources such as the *Liji*, the distinction between objects for the living and those for the afterliving hinges on the artifacts' ordinary use or lack of function. And it is the lack of mundane use that reveals a different, or afterlife, use.[63] This distinction between objects of use for the living and objects of use only for the afterliving was already controversial in the Han dynasty and even earlier. Confucius had argued for the burial of straw and wooden human figures and of unusable simulacra such as miniature models. He vehemently opposed burying lifelike human figures and

mundane articles, because to him that was all too reminiscent of the practice of human sacrifices,[64] a practice rare but not unknown by the Han.

Articles used by the living are inappropriate for the afterliving. In contrast, burial articles used by the afterliving have the form of their mundane counterparts but not their function. Similarly, houses are lived in by the living, whereas tombs are imitations of houses but shelter only the afterliving. It is this shared quality of simulacra that allow both burial items and tomb architecture, perhaps, to be conceived as "brilliant artifacts." This connection may be reflected in the placement of particular types of burial artifacts in particular tomb chambers to signify their function as reception halls, kitchens, stables, inner chambers, or other rooms.[65] Conversely, in some cases the placement of artifacts may have been determined by the pictorial images decorating the tomb walls of various tomb chambers. This allowed tomb chambers to simulate palace chambers while negating the living functions of the latter in order properly to accommodate and serve spirit brilliances in the afterlife. One may also ask if the ordinary articles and daily activities pictured on the walls of funerary structures—including pictorial carvings on the Wu shrines—were merely representations, or did they also fulfill a role as brilliant artifacts?

The connection between burial objects and tomb architecture as brilliant artifacts can also be seen by comparing the pictorial decoration on funerary structures and on the artifacts placed in them. Similar pictorial designs and decorative techniques can be observed on both. Many of the subjects and themes depicted in Han funerary pictorial stone carvings are also found in the decoration of burial objects. Shared images include historical and legendary figures, horse and chariot processions, buildings, food preparation

and banqueting, animals, supernatural beasts, and fabulous landscapes and cloudscapes. In some stone tombs and funerary structures, the walls are often decorated with pictorial carvings in fine incised lines, intaglio, relief, or openwork, sometimes enhanced with paint or other decorative techniques. All of these techniques are comparably utilized in ceramic, bronze, jade, stone, and lacquer artifacts buried in tombs.

An example is a Western Han chariot's canopy-shaft fitting (*bini*) (fig. 10), which is cast and incised with intricate relief designs in four horizontal registers.[66] Such tubular chariot fittings serve as a joint on the vertical shaft connecting the round canopy above and square chariot box below. As such, they have sometimes been likened

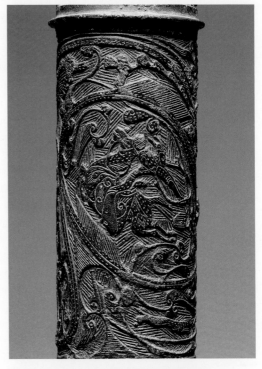

Fig. 10 *Chariot canopy shaft fitting*. Western Han dynasty. Detail; bronze; h. 25.0 cm, diam. 2.6 cm. Princeton University Art Museum, acc. no. 2002–384. Museum purchase, Fowler McCormick, Class of 1921, Fund. Photo by Bruce M. White.

to cosmic pillars linking the circular dome of heaven with the square shape of earth. Richly inlaid and bejeweled examples of such chariot fittings are well known, but it is this unique bronze example that caused me to notice a similarity to stone columns found in Shandong tombs and offering halls (some not far from the Wu shrines cemetery). Such columns were similarly carved with pictorial designs of cavorting or climbing figures often arranged in stacked horizontal registers (fig. 11).[67]

Examining such tomb columns, I realized that a certain square pictorial rubbing that had been reproduced with the Wu shrines assemblage in early twentieth-century publications (fig. 12) was actually a wrap-around impression taken from a circular column.[68] The actual stone corresponding to the square rubbing, however, had long been missing from the cemetery site. The rubbing showed a column with two horizontal registers divided by a plain band carved with the inscription "Made on the *gengchen* [] [] [] day in the fifth month of the first year (147) of the Jianhe reign-period" (*Jianhe yuan nian wu yue gengchen*

Fig. 11 *Stone column on west side of front chamber in the tomb at Mengzhuang*, Pingyin County, Shandong. Detail; wraparound ink-on-paper rubbing. From *Zhongguo huaxiang shi quanji*, vol. 3 (Jinan: Shandong meishu chubanshe, 2000), no. 191.

[] [] [] *ri zao*).[69] The 147 date also occurs in the Wu Ban stele and gate-pillar inscriptions; filling the two registers are cavorting and climbing figures and creatures. An early photograph of the actual column was reproduced by Adolf Fischer (1857–1914) in 1908 (fig. 13).[70] In the photograph the column has a square capital, a round shaft carved with pictorial figures, and a round torus in the shape of intertwined animals on a square base. The column was recorded as being 157 centimeters tall. Through correspondence with museums in Germany, this missing stone column was found in the Ethnological Museum in Berlin and came to the *Recarving China's Past* exhibition.[71] The photograph in the exhibition catalogue was taken before the column underwent conservation and the base stones were reattached.

When the Berlin column arrived for the Princeton exhibition, we were able to confirm its placement at the center of the open front face of one of the two-bay stone chambers. The recorded column height of 157 centimeters was almost precisely the calculated distance between the ground and the bottom of the front lintel and central-partition-gable beam in the architectural reconstructions of Chambers 1 and 2 by Jiang Yingju and Wu Wenqi.[72] Upon examining the top surface of the column capital, we found a rectangular notch on one side to receive the end of the central-partition-gable beam. A similar description of a notched capital stone associated with the Wu shrines is recorded for the "*Ci-Jin* Damaged Stone" (*Ci jin can shi*), a formerly missing stone that now is reportedly in the collection of the Tianjin Municipal Art Museum.[73] The notch permits us to determine that the Berlin column was oriented with the carved inscription facing outwards, which means that it was fully exposed to the elements; yet, the carving is surprisingly sharp and crisp, in contrast to

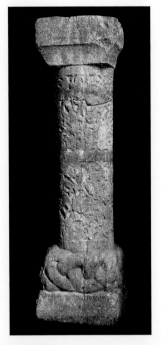

Fig. 12 *Circular pictorial stone column*, taken from the Wu cemetery in 1907 by Adolf Fischer. Wraparound ink-on-paper rubbing. From *Ōmura Seigai, Shina bijutsushi: Chōso hen* (Tokyo: Bussho kankōkai zuzōbu, 1915), pl. 72, fig. 177.

Fig. 13 *Circular pictorial stone column*, taken from the Wu cemetery in 1907 by Adolf Fischer. Limestone; h. 157 cm. Ethnological Museum, Berlin. From *T'oung Pao*, ser. 2, vol. 9 (1908), fig. 4 (p. 582).

the heavily abraded condition of the surrounding carved relief figures. This strongly suggests that the inscription was added to the stone, or recarved, sometime between when it was found and when the rubbings were made, before the column went to Germany in 1907.

Another missing pictorial stone associated with the Wu shrines assemblage has also recently been rediscovered, this one in the collection of the Museum of Far Eastern Antiquities in Stockholm (fig. 14). Recarved for use as part of a local bridge, the stone had been found and brought to the cemetery site for preservation. Due to its stylistic similarity to the nine Left Group stones found at the Wu cemetery in 1789, this stone was designated as Left Group Stone 1 (L.1). At about this time Huang Yi's associate Li Dongqi added an inscription at the

right end of the slab.[74] Feng Yunpeng (act. 19th century) visited the assembled stones in the twelfth month of 1820. In the *Jinshi suo* (*Index to metal and stone carvings*) (1821) by Feng and his brother Feng Yunyuan, notations were made regarding missing stones, such as Stone 10 of the Left Group. Since Stone L.1 was not reported missing, presumably it was still at the cemetery.[75] In 1880 Chen Jin (act. 19th century) noted in his *Chongxiu Wushi Citang ji* (*Record on the renovation of the Wu Family Shrine* [*Preservation Hall*]) that Stone L.1 and the newly found "Wang Ling mu" stone were adjoining fragments of a longer horizontal stone. According to Wu Hung, these two stones may be part of a "Fourth Chamber," along with the stylistically similar "He kui" and "You niao ru he" stones.[76] The stylistic similarity of these stones to

Fig. 14 *Left Group Stone 1* (L.1). Limestone. The Museum of Far Eastern Antiquities, Stockholm, acc. no. NMOK−66. Photograph by Karl Zetterström.

the pictorial stones recovered at the Wu cemetery suggests that the "Fourth Chamber" may originally have been located at the site. It is also possible that this "Fourth Chamber" may have been produced by the same stone workshop but built at a neighboring site. Numerous pictorial stones with similar stylistic carving, pictorial themes, and decorative patterns have been found elsewhere in Jiaxiang County, including several stones recovered at the village of Songshan.[77]

Édouard Chavannes visited the Wu shrines site on 27 January 1891 and published his observations in *Sculpture sur pierre en Chine* (1893). Included was the first relatively complete photographic documentation of the rubbings as well as drawings showing the location of the stone carvings inside the Preservation Hall housing the assembled stones.[78] Stone L.1 is diagrammed in Chavannes' drawing, indicating it was still present in 1891. In 1907 multiple expeditions visited the cemetery. Chavannes returned in early July and later

published his observations in *Mission archéologique dans la Chine septentrionale* (1913–1915). In the fall the Japanese archaeologist Sekino Tadashi arrived to survey, inventory, and photograph the site, which he published in 1909 and 1916.[79] Chavannes and Sekino both report that when they visited in 1907, Stone L.1 along with the "Wang Ling mu" and "He kui" stones were no longer there.

Earlier in 1907 the Jiaxiang District Magistrate Liu Xiaoyou had made unspecified repairs to the Preservation Hall.[80] That so-called repair work may have been the occasion when the embedded Stone L.1 and "Wang Ling mu" slab were removed. Both stones were then reportedly sold abroad in the early twentieth century, but their whereabouts has generally been unknown.[81] Mette Siggstedt, curator of the Museum of Far Eastern Antiquities, recently informed me that Stone L.1 was brought to Shanghai by a Swedish consortium in 1918. In 1920 the stone was acquired by the Friends of the National Museum in Stockholm from a collection

said to have belonged to the famed statesmen and diplomat Li Hongzhang (1823–1901).[82] The stone was later transferred to the Museum of Far Eastern Antiquities in 1945. In that same year, information about the stone was published by Osvald Sirén in *Kinesiska och Japanska Malningar och Skulpturer I Nationalmuseum Stockholm* (*Chinese and Japanese Paintings and Sculptures in the National Museum, Stockholm*), a little-known catalogue written in Swedish and without an illustration of Stone L.1.[83] In the catalogue entry Sirén described the stone and acknowledged Chavannes' contribution in *Mission Archéologique dans la Chine Septentrionale.* He then noted the illustrated scenes carved on the stone, translated Li Dongqi's inscription, and appended his own comments:

The execution, as with all the authentic stones from the Wu graves, is exceptionally precise. The figures protrude in very low, flat relief against a rough background, the contours are crisp and clearly defined, and details of dress and other accoutrements are illustrated by lines etched in the flat surface. Unfortunately, the stone has been subject to much careless treatment and possibly even used as construction material in later years; this would explain the large hole in the middle, and the partial destruction of the figures in the upper register. Even so the stone must be acknowledged as an object of unusual historical interest, as it is—along with another relief from the same funerary chamber that is now in the possession of Marquis Hosokawa in Tokyo—likely the only fully authentic relief from the Wu Shrines to have left China. Other, similar reliefs in Western collections are often said to originate from this site, but are later imitations."[84]

A photograph of this stone reveals that it matches early surviving rubbings of Stone L.1. The other "authentic" stone Sirén mentions as being in the "possession of Marquis Hosokawa in Tokyo," turns out to be the "Wang Ling mu" stone, and is presently located in the collection of the Eisei Bunko Museum in Tokyo (fig. 15).[85] Along with Stone L.1, the stone column in the Ethnological Museum in Berlin, and the column capital reportedly in the Tianjin Municipal Art Museum, four missing stones from the Wu shrines assemblage have now been relocated.

It should be noted that the Wu shrines assemblage of stones is a dynamic collection. Besides formerly missing stones that are now found, several architectural stones that were formerly neglected by reason of their dearth of inscriptions or pictorial carvings have recently been identified. Only with relatively recent efforts at architectural reconstruction have such stones begun to be reintegrated into the assemblage, and other such stones may continue to be discovered in years to come. It is also interesting to note that many damaged pictorial stones found at the cemetery formerly, were never integrated into the assemblage. For example, in their comments on Left Group Stone 10, the Feng

Fig. 15 *"Wang Ling mu" stone*. Limestone. Eisei Bunko Museum, Tokyo. Photo courtesy of Eisei Bunko Museum.

brothers noted that "by the side of the road and between the tombs, there are two stones that are both so damaged and splintered that they are not recorded."[86] One wonders how many other damaged stones were overlooked, and if their fragments will be located in the future.

In raising questions about the consensus interpretation of a "Han-dynasty Wu family shrines" assemblage, we must finally ask: What are these gathered stones? In my opinion most of the stones do indeed have a base origin in the mid-second to early third century, but they must be considered from the perspective of recarving China's past. The stones reflect "recarving" on several levels. First, the carved pictorial scenes of historical figures and exemplary deeds are stories that are retold or reenvisioned in stone; they indeed are recarvings of China's past. Secondly, the damage and wear on the stones caused by natural weathering, the rubbing process, or accident necessitates that finely incised designs be retouched, recut, or in some cases totally recarved. The surfaces of pictorial stones, therefore, may evidence a complex patchwork layering of original carving, accurate recarving, interpolated repair, or purposeful reinterpretation. Thirdly, over the course of a thousand years, the assembled stones as well as their rubbings and textual descriptions have generated a complicated cultural history and scholarly discourse. How the materials came to be gathered and identified as the Wu family shrines must also be considered a form of historical recarving of the past. ◉

Notes

1 This essay draws heavily from research in Cary Y. Liu, Michael Nylan, Anthony Barbieri-Low et al., *Recarving China's Past: Art, Archaeology, and Architecture of the "Wu Family Shrines"* (Princeton: Princeton University Art Museum; New Haven: Yale University Press, 2005). An effort has been made to introduce new research since 2005.

2 Following my essays in *Recarving China's Past*, I use "Wu family shrine," or "so-called Wu shrines," to designate the loose assemblage of stones associated with the cemetery site. In contrast, I use "Wu Family Shrines" for the so-titled Qing and modern-period preservation halls that were later built at the site.

3 For other Jiaxiang stones, see Zhu Xilu, *Jiaxiang Han huaxiang shi* (Jinan: Shandong meishu chubanshe, 1992);

Sun Qingsong and He Fushun, gen. eds., *Jiaxiang Han huaxiang shi xuan* (Hong Kong: Xianggang weimei chuban gongsi, 2005). For two Jiaxiang area stones, including one very similar in style to the "Wu shrine" stones, see Liu, *Recarving China's Past*, cat. nos. 10, 11, pp. 261–69.

4 Edward W. Said, *Orientalism* (1978) (New York: Vintage, 1979), p. 94.

5 Discussed below, with Gu Aiji and the *Siku quanshu tiyao* editors taking the former viewpoint, and Yu Jiaxi the latter.

6 One technology that should be tried is the application of X-ray fluorescence imaging, to recover worn inscriptions on ancient stones. See Franklin Crawford, "Scientists and Humanists Join Forces to Use X-ray Technology to Shed Light on Ancient Stone Inscriptions," Cornell

University Chronicle Online (2 August 2005) (http://www.news.cornell.edu /stories/Aug05/XRF.imaging.stones .fac.html).

7 The *Jigu lu* assembles selected colophons on about half the total works in Ouyang Xiu's rubbing collection. It is possible that other Wu shrine stele inscriptions were in the collection but did not receive a colophon. For a recent analysis of the aesthetic attitude that informed the *Jigu lu*, see Ronald Egan, "Rethinking 'Traces' from the Past: Ouyang Xiu on Stone Inscriptions," in his *The Problem of Beauty: Aesthetic Thought and Pursuits in Northern Song Dynasty China* (Cambridge, Mass.: Harvard University Asia Center, 2006), pp. 7–59.

8 Ouyang Xiu, *Jigu lu, Yingyin Wenyuange Siku quanshu* edition

(Taipei: Taiwan shangwu yinshuguan, 1983–1986), *juan* 3, pp. 1b–2a, 24b.

9 Huang Yi could have seen any one of several pre-1786 gazetteers that mentioned the offering halls, pillar-gate, and a stele reportedly for a Han prince located to the west of Ziyun Shan, including *Yanzhou fu zhi* (1573), *Tianyige cang Mingdai fangzhi xuankan xubian* edition, vols. 53–56 (Shanghai: Shanghai shudian, 1990), *juan* 49, p. 10b; *Jiaxiang xian zhi* (1652) (Princeton University Library, coll. no. mf c00540), *juan* 1, pp. 9b, 15a; *Jiaxiang xian zhi* (1778), *juan* 1, p. 16 (this edition not seen by author). There are probably many other early gazetteers that record these ruins. The various gazetteer descriptions are comparatively similar, but they also differ slightly from version to version. This suggests that they likely derive from a common source that was then transmitted from text to text. An in-depth study of Shandong gazetteers needs to be undertaken to determine what the earliest source for this description may have been, and to trace its transmission in later publications. This will then provide us with a range of possibilities of what Huang Yi may have read in some gazetteer.

10 For some examples, see Cary Y. Liu, "The 'Wu Family Shrines' as Recarving the Past," in Liu, *Recarving China's Past*, pp. 28, 39–41; Michael Nylan, "Addicted to Antiquity," in Liu, *Recarving China's Past*, pp. 530–37.

11 Zhang Xuan, *Zhida Jinling xin zhi*, *Yingyin Wenyuange Siku quanshu* edition, *juan* 12b, pp. 37b–38a.

12 *Yanzhou fu zhi*, *juan* 45, p. 17a.

13 See Zhu Yizun's 1705 colophon on the Tang Rubbing, recorded in Huang Yi, *Xiao Penglai Ge jinshi wenzi* (first published in 1785), unpaginated *Shimo Xuan* edition, 8 fascicles (n.p.: 1834) (East Asian Library, Princeton University, coll. no. B347–1264), "Wu Liang Ci xiang taben" sec., pp. 20b–21a. On the Tang Rubbing, also see Ma Ziyun, "Tan Wu Liang Ci huaxiang de Song ta yu Huang Yi taben," *Gugong bowuyuan yuankan* 1960.2, pp. 170–77; Liu, "The 'Wu Family Shrines'," p. 79 n. 14; and Nylan, "Addicted to Antiquity," pp. 534–37.

14 Yu Yizheng, *Tianxia jinshi zhi*, *Xu-xiu Siku quanshu* edition ([Shanghai]: Shanghai guji chubanshe, [1995]–2002), "Shandong" sec., pp. 142–43.

15 Rubbing sets of this sort are listed in *Fine Chinese Paintings, Calligraphy and Rubbings*, auction cat. (New York: Christie's, 19 September 1995), p. 40, lot 38; *Rubbings and Calligraphy*, auction cat. (Beijing: China Guardian, 3 June 2006), lot 2182; *Rare Books*, auction cat. (Beijing: China Guardian, 18 March 2007), lot 3326.

16 Qian Daxin, comp., *Tianyi Ge bei mu*, preface dated to 1787; reprinted in Fan family, comp., *Tianyi Ge cangshu zongmu* (Zhejiang: Wen-xuanlou, n.d.), fascicle 10, pp. 1b, 2a, 2b. In this catalogue the Wu Ban stele has two entries (pp. 2a, 2b), indicating that there may have been two copies.

17 On complexities in studying different rubbing versions, copies, and forgeries of some of the Wu cemetery stones, see Wu Huilin, comp., *Zengbu Jiaobei suibi* (Shanghai: Shanghai shuhua chubanshe, 1981), pp. 59–60, 84–86, 150–53.

18 See n. 3 above.

19 The poet Yuan Mei (1716–1798) considered the Wu shrine images to be the early foundation for Chinese portraiture. See Yuan Mei, *Suiyuan shihua* (Beijing: Renmin wenxue chubanshe, 1982), *juan* 7, p. 231; Ginger Cheng-chi Hsü, *A Bushel of Pearls: Painting for Sale in Eighteenth-Century Yangchow* (Stanford: Stanford University Press, 2001), p. 38. For iconographic studies in this volume, see Jiang Yingju's "The Iconography of the 'Homage Scene' in Han Pictorial Carving," and the abstract of Hsing I-tien's "Composition, Typology, and Iconography of the 'Sino-Barbarian Battle Scene' in Han Pictorial Images."

20 Wilma Fairbank, "The Offering Shrines of 'Wu Liang Tz'u,'" *Harvard Journal of Asiatic Studies*, vol. 6, no. 1 (1941), pp. 1–36; reprinted in her *Adventures in Retrieval: Han Murals and Shang Bronze Molds* (Cambridge, Mass.: Harvard University Press, 1972), pp. 43–86. Also see Fairbank, *Liang and Lin: Partners in Exploring China's Architectural Past* (Philadelphia: University of Pennsylvania Press, 1994), pp. 118–19.

21 Some excavated Han tomb mounds in the Shandong region have a perimeter wall with a stone chamber at front center, resembling the reconstructed Wu cemetery structures. Stone chambers attached to tomb-mound walls have been excavated at Tombs 1 and 2 (ca. 171 CE) at Chulan, Su Xian, Anhui. See Wang Buyi, "Chulan Han huaxiang shi ji you guan wuxiang de renshi," *Zhongyuan wenwu* 1991.3, pp. 60–66; Wang Buyi, "Anhui Su Xian Chulan Han huaxiang shi mu," *Kaogu xuebao*

1993.4, pp. 515–49. Also see Cary Y. Liu, "Reconfiguring the 'Wu Family Shrines': A Typological Study," in Liu, *Recarving China's Past*, pp. 572–74.

22 For detailed analysis of the reconstruction, see Liu, "Reconfiguring the 'Wu Family Shrines'," pp. 561–81. The associated computer reconstruction was designed by Anthony Barbieri-Low and is accessible online on the Princeton University Art Museum — Asian Art Website (http://etcweb.princeton.edu/asianart/). The computer-generated reconstruction allows viewers to move virtually through the cemetery and enter each stone chamber. Within each structure, each pictorial image is linked to narratives describing particular scenes. Original ideas for the computer reconstruction included different possible site configurations, as well as rendering the cemetery structures with colored wall decorations. The location of the stele stones at the cemetery, and even their original presence there, were also in question. Also see n. 24 below.

23 Huang Yi, *Xiu Wushi Citang ji lüe*, in Jiang Yingju and Wu Wenqi, *Handai Wushi muqun shike yanjiu* ([Jinan]: Shandong meishu chubanshe, 1995), pp. 132–33; translated in Liu, "The 'Wu Family Shrines'," pp. 75–77. Sekino Tadashi, *Shina Santōshō ni okeru Kandai Funbo no Hyōshoku* (Tokyo: Imperial University of Tokyo, 1916), text p. 26, and pl. 28. Jiang Yingju and Wu Wenqi, "Wushi Ci huaxiang shi jianzhu peizhi kao," *Kaogu xuebao* (hereafter *KGXB*) 1981.2, pp. 165–84.

24 Whether the steles were erected inside the pillar-gate, anywhere in the cemetery, or even during the Han dynasty, remains an open question.

25 In Anthony Barbieri-Low's computer-generated reconstruction, we actually plot an alternative layout, pairing Chamber 1 with Tomb 1 or 3 and Chamber 2 with Tomb 2.

26 Édouard Chavannes, *La sculpture sur pierre en Chine aux temps des deux dynasties Han* (Paris: Ernest Leroux, 1893), pp. xx, xxi; and Chavannes, *Mission archéologique dans la Chine septentrionale*, 2 vols. of text, 4 vols. of plates (Paris: Imprimerie Nationale, 1913 and 1915), text vol. 1, pp. 111–14 passim, 122.

27 Gu Aiji, *Li bian* (1718), *Yingyin Wenyuange Siku quanshu* edition, *juan* 2, pp. 38a–b, and *juan* 8, pp. 38b–40a. *Siku quanshu zongmu tiyao*, comp. Ji Yun et al. (1795), reprinted in *Heyin Siku quanshu zongmu tiyao ji Siku weishou shumu, Jinhui shumu*, gen. ed. Wang Yunwu, 5 vols. (Taipei: Shangwu yinshuguan, 1971), pp. 1791. Yu Jiaxi, *Siku tiyao bianzheng* (1937), 4 vols. (Beijing: Zhonghua shuju, 1980), *juan* 9, pp. 504–6.

28 Yu Jiaxi further notes that it was Han practice to replace taboo characters with substitute characters, and not to use the proscribed character written with a different number of strokes or a different script style. He argues that, in several Han examples cited by Gu Aiji, the character *zhuang* was only written with a change in script style (*bianti*) or a variation in clerical script (*lishu*); that is, no substitute character was used. In regard to the "Lu Zhuang gong" cartouche, however, because the proscribed character was not changed or substituted, this part of his argument has little relevancy.

29 Yu Jiaxi, *Siku tiyao bianzheng*, *juan* 7, pp. 504–6.

30 Lao Gan, "Lun Lu xi huaxiang san shi — Zhu Wei shishi, Xiaotang Shan, Wushi Ci," *Lishi yuyan yanjiusuo jikan*, vol. 8, no.1 (1939) (reprint, Beijing: Zhonghua shuju, 1987), pp. 101–2.

31 In addition to the Wu Liang Shrine, the Front Group stones came to be associated with Wu Rong, the Left Group with Wu Ban, and the Rear Group with Wu Kaiming. For a historical summary of how these associations were made, see Wu Hung, *The Wu Liang Shrine: The Ideology of Early Chinese Pictorial Art* (Stanford: Stanford University Press, 1989), pp. 27–28.

32 Wang Chang, *Jinshi cuibian*, facsimile reproduction of 1805 Jingxun Tang edition, *Shike shiliao xinbian* edition (Taipei: Xinwenfeng chuban gongsi, 1977), *juan* 20, pp. 51b–54b.

33 Although Wang Chang suggests that the blank or damaged cartouches explain why Hong Gua did not illustrate the stones in those groups, his hypothesis is not completely satisfactory. Another possibility is that Hong Gua never saw pictorial rubbings other than those of Chamber 3 and a few other slabs.

34 Wang Chang, *Jinshi cuibian*, *juan* 20, p. 54a.

35 Hong Gua, *Lishi*, *Yingyin Wenyuange Siku quanshu* edition, *juan* 16, p. 5a.

36 Hong Gua, *Lishi*, *Siku quanshu* edition, *juan* 16, pp. 5a–b, and *juan* 6, pp. 14b–15a. Also compare

this passage included as part of the Wu Liang stele entry and commentary in Hong Gua, *Lishi*, *Sibu congkan sanbian* edition (Taipei: Shangwu yinshuguan, 1975), supplement to *juan* 6, pp. 13a–b; and ibid., Wang Rixiu edition (reprint, Beijing: Zhonghua shuju, 1985), *juan* 6, pp. 14a, 14b–15a. On the different locations of the passage in *juan* 6 of various editions of the *Lishi*, see n. 38 below.

37 Anthony Barbieri-Low, "Carving Out a Living: Stone-Monument Artisans During the Eastern Han," in *Recarving China's Past*, pp. 485–511. On the Songshan stones and other pictorial stones found in the Jiaxiang area, see nn. 3, 77.

38 Hong Gua, *Lishi*, *Siku quanshu* edition, *juan* 6, pp. 14b–15a. This translation is modified from Liu, "Reconfiguring the 'Wu Family Shrines'," p. 572. The *Siku quanshu* and Wang Yunlu's 1588 editions of the *Lishi* conflate parts (including this passage) of the Wu Liang stele inscription and Hong Gua's commentary on the Wu Ban stele. This probably resulted from scribal omission in the Ming dynasty. A manuscript copy of two leaves from a Yuan-dynasty Taiding edition is appended to the end of *juan* 6 in the *Sibu congkan sanbian* edition, and apparently represents the entire missing section. Based on another Ming manuscript, Wang Rixiu reinserted the missing text in his 1777–78 edition. The lacuna (later incorporated into the *Siku quanshu* and Wang Yunlu editions) was already noted by Mei Dingzuo (1553–1619), Fu Shan (1607–1684), and other scholars before the eighteenth century.

39 Stanley Abe has shown post-Han examples in which inscriptions were added to steles in a kind of "creative reinscription," in which the added texts were sometimes borrowed from other steles. Such "creative reinscription" may also have been practiced on Han steles. See Stanley K. Abe, *Ordinary Images* (Chicago and London: The University of Chicago Press, 2002), pp. 296–97, 306–12, 345 n. 78.

40 See Liu, "The 'Wu Family Shrines'," pp. 36–38; Nylan, "Addicted to Antiquity," pp. 520–29. For alternative viewpoints, see Kuroda Akira, "Bushi shi gazo seki no kijun teki kenkyu—Michael Nylan 'Addicted to Antiquity' dokugo" ("Fundamental Research on the Wu Family Carved Pictorial Stones, In Response to Michael Nylan's 'Addicted to Antiquity'"), *Kyoto Gobun*, no. 12 (2005), pp. 155–204; Qianshen Bai's critique in this volume.

41 Weng Fanggang, *Liang Han jinshi ji*, *Shike shiliao xinbian* edition, *juan* 15, p. 51a; trans. Qianshen Bai.

42 Ouyang Xiu, *Jigu lu*, *Yingyin Wenyuange Siku quanshu* edition, *juan* 3, p. 1b.

43 On the X-ray fluorescence technique, see n. 6 above.

44 Admittedly I am not an expert in this area, and there may be, or there eventually will be, archaeological evidence that will help to resolve these questions.

45 Huang Yi, *Xiu Wushi Citang ji lüe*, p. 132; trans. in Liu, "The 'Wu Family Shrines'," p. 75.

46 See Liu, "The 'Wu Family Shrines'," pp. 30–31, fig. 2.

47 A square cutout under the circular

hole also indicates that the stone had been altered for later reuse, possibly as a well post. See Gong Yanxing, ed., *Jining quan Han bei* (Jinan: Qi-Lu shushe, 1990), pp. 104, 239, pl. 105 (right).

48 Anthony Barbieri-Low first brought this to my attention in a rubbing of the northeast gate-pillar in the collection of the Academia Sinica, Taipei.

49 Zhao Mingcheng, *Jinshi lu*, *Yingyin Wenyuange Siku quanshu* edition, *juan* 14, p. 10a–b. The inscription is translated in Liu, *Recarving China's Past*, p. 187, also see pp. 566–69.

50 In Hong Gua, *Lishi*, *Siku quanshu* edition, *juan* 6, p. 14a, this commentary appears as part of the Wu Liang stele entry. In the Wang Rixiu edition (*juan* 6, p. 13a), it appears as commentary in the Wu Ban stele entry. On this discrepancy, see n. 38 above.

51 Nylan, "Addicted to Antiquity," p. 526.

52 See Gong Yanxing, ed., *Jining quan Han bei* (Jinan: Qi-Lu shushe, 1990), p. 43. Two recut versions are also reported in Wu Huilin, *Zengbu Jiaobei suibi*, pp. 59–60. Wu also notes that rubbings of the gate-pillar inscription made after the Daoguang reign (1821–1850) were less clear than earlier rubbings, and that copy versions of the inscription were also printed.

53 Liu, *Recarving China's Past*, pp. 51, 123–24.

54 Xin Lixiang, *Handai huaxiang shi zonghe yanjiu* (Beijing: Wenwu chubanshe, 2000), p. 67.

55 Xin Lixiang, *Handai huaxiang shi zonghe yanjiu*, pp. 72–73.

56 See Cary Y. Liu, "The Concept of 'Brilliant Artifacts' in Han-Dynasty Burial Objects and Funerary Architecture: Embodying the Harmony of the Sun and Moon," in Liu, *Recarving China's Past*, pp. 205–21. For an earlier version of this essay, see Liu, "Embodying the Harmony of the Sun and the Moon: The Concept of 'Brilliant Artifacts' in Han Dynasty Burial Objects and Funerary Architecture," in Susan L. Beningson and Cary Y. Liu, et al., *Providing for the Afterlife: "Brilliant Artifacts" from Shandong* (New York: China Institute, 2005), pp. 17–29. Also see Lothar von Falkenhausen, *Chinese Society in the Age of Confucius (1000–250 BC): The Archaeological Evidence* (Los Angeles: Cotsen Institute of Archaeology, University of California, 2006), pp. 301–6.

57 Henri Maspero, "Le mot *ming*," *Journal Asiatique*, vol. 223, no. 2 (1933), pp. 249–52, 276, 283–84, 296. The character may have been a phonetic substitution for *ming** designating an unseen spiritual realm. By the Song dynasty the binome *ming*qi* was used for paper articles burnt as funerary offerings.

58 *Xunzi jinzhu jinyi*, annot. Xiong Gongzhe, rev. ed. (Taipei: Taiwan shangwu yinshuguan, 1984), p. 380; translation modified from Burton Watson, trans., *Basic Writings of Mo Tzu, Hsün Tzu, and Han Fei Tzu* (New York: Columbia University Press, 1963), p. 94.

59 Liu Xi, *Shiming*, *Yingyin Wenyuange Siku quanshu* edition, *juan* 8, p. 7a.

60 See Liu, "Concept of 'Brilliant Artifacts'," pp. 220–21, nn. 52, 53.

61 *Liji ji jie*, comp. Sun Xidan (Beijing: Zhonghua shuju, 1989), p. 216. Translation modified from James Legge, *The Li Ki*, in *The Sacred Books of the East*, ed. F. Max Müller, vol. 28 (Oxford: Clarendon Press, 1885), p. 148. Legge translates *mingqi* as "vessels to the eye of fancy" and *shenming* as "spiritual intelligences."

62 On early conceptions of the afterlife, see Ying-shih Yü, "'O Soul, Come Back!' A Study in the Changing Conceptions of the Soul and Afterlife in Pre-Buddhist China," *Harvard Journal of Asiatic Studies*, vol. 47, no. 2 (1987), pp. 363–95.

63 On the aesthetics of uselessness in later Chinese art, see Wai-yee Li, "The Collector, the Connoisseur, and Late-Ming Sensibility," *T'oung Pao*, vol. 81 (1995), pp. 269–302; Cary Y. Liu, "*Admonitions Scroll* in the Context of Ming Aesthetics and Collecting: Material Artefact, Cultural Biography, and Cultural Imagining," in *Gu Kaizi and the Admonitions Scroll*, ed. Shane McCausland (London: British Museum Press with the Percival David Foundation, 2003), pp. 258–59.

64 *Liji ji jie*, pp. 264–65; translated in Liu, "Concept of 'Brilliant Artifacts'," p. 215.

65 The functions of excavated tomb chambers have been identified based on the types of burial artifacts found within, as well as by comparison with Han tombs containing inscriptions naming various chambers. See Wu Zengde and Xiao Yuanda, "Jiu daxing Handai huaxiang shi mu de xingzhi lun 'Hanzhi'," *Zhongyuan wenwu* 1985.3, pp. 55–58.

66 See Haicheng Wang, "Chariot Canopy Shaft Fitting (*bini*)," and Susan L. Beningson, "Chariot Canopy Fitting: Potent Images and Spatial Configurations from Han Tombs to Buddhist Caves," in Liu, *Recarving China's Past*, pp. 341–46 and 347–53, respectively.

67 Also see Lydia Thompson's discussion of pillar tombs in the Eastern Han period in her essay "Ritual, Art and Agency: Consecrating the Burial Ground in the Eastern Han Period," in this volume.

68 Chavannes, *Mission archéologique*, text vol. 1, pp. 243–44; pl. vol., pl. XCII, fig. 172; Ōmura Seigai, *Shina bijutsushi: Chōso hen*, 2 vols. (Tokyo: Bussho kankōkai zuzōbu, 1915), p. 63, and pl. 72, fig. 177.

69 The inscription is transcribed in Chavannes, *Mission archéologique*, text vol. 1, p. 243; Ōmura Seigai, *Shina bijutsushi: Chōso hen*, p. 63; cited in Jiang and Wu, *Handai Wushi muqun shike yanjiu*, p. 32.

70 Adolf Fischer, "Vortag, Gehalten auf dem 15ten Internationalen Orientalisten-kongress in Kopenhagen: Über Vorbuddhist Steinreliefs und Romanische Löwenköpfe aus China," *T'oung Pao*, ser. 2, vol. 9 (1908), pp. 582–83.

71 Liu, *Recarving China's Past*, pp. 58, 59, 198–201. Conservation of the column was funded in large part by the Princeton University Art Museum.

72 Calculated height extrapolated from the scaled reconstruction drawings and the dimensions of the stones for the two-bay chambers in Jiang and Wu, *Handai Wushi muqun shike yanjiu*, pp. 29–31, 39, 44.

73 Huang Yi, *Qian hou shishi huaxiang ba* (1796), in Fang Shuo, *Zhenjingtang jinshi tiba* (1862), *Shike*

shiliao xinbian di er ji edition, facsimile reproduction of 1864 edition (Taipei: Xinwenfeng chuban gongsi, 1979), *juan* 2, p. 35a; Rong Geng, *Han Wu Liang Ci huaxiang lu*, 2 fascicles (Beijing: Yanjing daxue kaogu xueshe, 1936), text vol., p. 37a; Liu, "The 'Wu Family Shrines'," pp. 57–58.

74 For Li Dongqi's biography, see Yu Jianhua, gen. ed., *Zhongguo meishu jia renming cidian* (Shanghai: Renmin meishu chubanshe, 1981), p. 367. The inscription is transcribed in Jiang and Wu, *Handai Wushi muqun shike yanjiu*, p. 50, n. 4.

75 Feng Yunpeng and Feng Yunyuan, eds., *Jinshi suo* (N.p.: Ziyang xian shu cang ban, 1821), vol. *Shi suo si*, "Han Wushi shishi xiangrui tu yi" section.

76 Chen Jin, *Chongxiu Wushi Citang ji* (1880), cited in Jiang and Wu, *Handai Wushi muqun shike*, pp. 134–36. Wu Hung, *Wu Liang Shrine*, pp. 20–24.

77 The Songshan stones were found as reused building materials in three post-Han tombs located about 24 km southwest of the Wu shrines cemetery. See Jiaxiang Xian Wushi Ci wenguan-suo, "Shandong Jiaxiang Songshan faxian Han huaxiang shi," *Wenwu* 1979.9, pp. 1–6; Jining diqu wen-wuzu and Jiaxiang xian wenguan-suo, "Shandong Jiaxiang Songshan 1980 nian chutu de Han huaxiang shi," *Wenwu* 1982.5, pp. 60–70; Li Falin, "Jiaxiang Songshan chutu Yongshou sannian shike tiji jianshi," in his *Shandong Han huaxiang shi yanjiu* (Jinan: Qi-Lu shushe, 1982), pp. 101–8; and Jiang Yingju, "Han-dai de xiao citang," *Kaogu* 1983.8, pp. 741–51. Also see n. 3 above.

78 For a description of his travels

and arrival at the site, see Chavannes, *La sculpture sur pierre en Chine aux temps des deux dynasties Han* (Paris: Ernest Leroux, 1893), pp. ii–iv. For the interior plan and elevation drawings, see ibid., p. xxxviii.

79 Sekino Tadashi (Sekino Tei), "Stone Mortuary Shrines with Engraved Tablets of Ancient China under the Latter Han Dynasty," part II, *Kokka*, vol. 19, no. 227 (1909), pp. 302–15; Sekino Tadashi, *Shina Santōshō ni okeru Kandai Funbo no Hyōshoku* (Tokyo: Imperial University of Tokyo, 1916), text vol., pp. 23–76, 157–58, figs. 1, 6, 9, 12–16, 27, and plates vol., pls. 27–100, 238, 242, 244.

80 For Liu Xiaoyou's 1907 stele inscription, see Jiang and Wu, *Handai Wushi muqun shike yanjiu*, p. 136.

81 Jiang and Wu, *KGXB* 1981.2, p. 167. Rong Geng, *Han Wu Liang Ci huaxiang lu*, text vol., p. 4b. The *Shandong tongzhi*, comp. Sun Baotian (1840–1911), cited in *Jining zhilizhou xu zhi* (1925; reprint, Taipei: Xuesheng shuju, 1968), *juan* 19, p. 58a, records that in the early twentieth century the "Wang Ling mu" stone entered the collection of the Manchu official and collector Duanfang (1861–1911) in Changbai, Shandong.

82 On the sale of this likely bogus collection and on the Swedish market for Chinese art in the 1920s, see Karl Asplund, *Konst, Kännare, Köpmän* (Stockholm: Bonniers, 1962), pp. 125–30. Although Asplund does not mention Stone L.1, he records that Professor Erik Nyström had recom-mended the collection, which had been catalogued by an expert named Croft, an Englishman. The "collection was purchased for about one million

crowns by a consortium of about twenty interested parties, who signed for lots of 5,000 crowns each and who then divided the collection once the National Museum had selected ten percent for its own holdings" (translated by Nicola Knipe).

83 Osvald Sirén, *Kinesiska och Japanska Malningar och Skulpturer I Nationalmuseum Stockholm* (Stockholm: Royal Academy of Letters, History, and Antiquity, 1945), pp. 19–21. A photograph of two pictorial stones with inverted trap-ezoidal profiles shown in an early twentieth-century photograph attrib-uted to Sirén, indicates that he visited the cemetery site. See Osvald Sirén, *Histoire des arts anciens de la Chine*, vol. 4: *L'architecture* (Paris and Brus-sels: G. Van Oest, 1930), pl. 104–b. These stones have been misidentified as missing column capitals in some modern studies, but both stones still survive at the site; see Liu, "The 'Wu Family Shrines'," p. 59, fig. 19.

84 Sirén, *Kinesiska och Japanska*, pp. 20–21 (translated by Nicola Knipe).

85 Confirmed through correspon-dence with the museum in summer 2006. The works of art from the Hosokawa Clan are preserved in the Eisei Bunko Museum.

86 Feng Yunpeng and Feng Yunyuan, *Jinshi suo*, vol. *Shi suo si*.

Ideals, Practices, and Problems of Han China

MICHAEL LOEWE

Throughout the centuries of imperial dynasties, to many of China's officials, men of letters, and princes, Han stood out as the ideal; it was a regime that had unified China successfully; it formed an example of empire that successors who were worthy of the name would emulate; its years of government had been marked by social stability; the population had been happy to accept its authority. Such a view can hardly be sustained if due attention is paid to the repeated moments of strife, discord, and crisis; nevertheless Han's reputation survived for long without question; by 551 CE several regimes had adopted the title of Han as a means of enhancing their right to wield power.[1]

We have no statement by a writer of Han times of the concepts that lay behind those ideals; and we lack a Thucydides who contrived to formulate them as they might have been expressed by leading men of the day. Nonetheless, it is possible to draw together some of the principles and motives that appear to have been in the minds of some of the major actors in public life and that may have affected the decisions that they took. Such principles may have been recognized consciously or they may have been latent; they may have been advocated openly or left unexpressed. In attempting to define them it is necessary to avoid a gullible acceptance of the force of a cliché; of a message spelt out in propagandist fashion in an imperial decree; or of a protestation of sincerity or humility in an official's report. The following pages attempt to distinguish between the ideals as imagined, the practices as achieved, and the deficiencies of public life during the four centuries of the Han dynasties. They will concentrate on the organization of public life and social structure, and refer briefly to religious practice and intellectual activities.

Ideals and Achievements

Han officials and writers saw themselves as upholding a type of government that was infinitely superior to that of their predecessors. A united rule over all that lay beneath the skies was preferable to division of the lands among several regimes that disputed power with one another; and Han's beneficent rule formed a sharp contrast with the cruel dispensation of Qin. In particular it was claimed that, even before the Han empire had been formed, Liu Bang had taken steps to mitigate the cruelties of the Qin regime by reducing the legal system to three clauses.[2] Careful provisions regulated the marital relations of the emperor and ensured the transmission of his authority to his rightful heir, without intrigue. An emperor was not himself vexed by long and weary attention to affairs of state; he devolved his authority to his officials who delegated responsibilities to their subordinates. In the absence of oppression or corruption, with a fair system of laws that were known to all and with a prosperity that was generally enjoyed, there would be little cause for protest or crime. The empire with its extended *pax serica* would be attractive enough to secure the cooperation, loyalty, or alliance of peoples whose habitat lay beyond the lands where imperial officials operated. With the passage of time an ideal dispensation such as this was seen as an integral and essential element of the whole scheme of the universe, thus enjoying to the full both nature's gifts and the benefits of unseen but all-controlling powers.

Such may well have been the ideals, and in some ways and at some times they were achieved in practice. No official is known to have challenged the view that supreme authority lay with the emperor, or that all persons, men, women, and children, were obliged to obey the commands conveyed in his decrees. Officials who were parts of a structure of major and minor offices of state implemented these orders at the levels of central, provincial, and local administration. A system of postal communications conveyed documents from one level to another; the central government distributed copies of decrees and calendars to the senior officials of the provinces. In their turn these latter submitted the annual accounts of how successfully their area was being governed; of an increase or decrease in the numbers of the population—or rather that part of the population whom they had succeeded in registering; and of the extent to which the land was actually being worked. The central government circulated copies of the Statutes and Ordinances throughout the empire, with detailed regulations for punishing crimes that persisted despite the hopes of all idealists. Provincial officials submitted detailed documentation over legal questions whose solution lay beyond their jurisdiction or their knowledge.

Officials and the Tasks of Government

The administration of an empire required officials who were capable of performing a variety of tasks. They must be able to draw up routine reports, to formulate other types of documents, to control subordinates, try criminal cases, collect taxes, and call up those due to render service in the armed forces or the labor gangs; and they could be called upon to take a force of conscripts to pursue and apprehend criminals, or to lead troops in battle. The means of attracting young men to serve in this way, to provide training, and to test their abilities appear in some of the early prescriptions for governing the empire (186 BCE) and in reports on the proficiency and service of officials circa 100 BCE. A system of grades and corresponding salaries set a scale along which an official could advance, perhaps eventually to reach the most senior administrative

or consultative positions of the empire.[3] Training included attention to literacy and acquaintance with some approved texts of literature. A few men who were not born of Han stock rose to become distinguished servants of state.[4]

Sixteen grades distinguished the officials and clerks who conducted imperial government, each one with his recognized degree of status and its corresponding salary. Some of those who carried the highest responsibilities had advanced to that point of eminence by starting from a humble position in a village or country town. Others may have owed their appointment to favoritism, or to membership of a prominent family. In the capital city some nine senior officials at the head of the central government attended to the major aspects of administration, such as finance, security, judicial matters, and defense, with subordinates who supervised specialized tasks, as calendar regulators, reciters of prayers, translators from non-Chinese languages, and advisory counselors.

It may be estimated that at the close of Western Han there were some 30,000 officials working in offices at Chang'an and some 100,000 posted to the cities, villages, and settlements of the countryside, bringing the writ of government to bear on those who lived in the counties and commanderies.[5] Provincial and local officials could call on conscript servicemen to assist in the work of maintaining security and arresting criminals, or in the upkeep of waterways or delivery of tax, which was partly collected in grain, from fields to designated stores. Commanderies (*jun*), the largest of the provincial units, were under the control of Governors (*shou* or *taishou*), whose high rank was comparable with that of senior posts in the central government. The areas of the commanderies varied widely, with registered populations ranging from 200,000 or less to over two million persons.

They comprised counties (*xian*), which were under the control of magistrates (*ling* if the county was large, *zhang* if small); counties were themselves divided into districts (*xiang*). At each level a special official reported on the achievements and services rendered by his colleagues, assessing the merits that would entitle them to promotion or the defects that could warrant demotion or dismissal.

Although there was no acknowledged theory of a "state economy," provincial officials were charged to control the working efforts of the population and to extend the area under cultivation, thereby increasing the revenue that would fall to the government. At times effective regulations kept the minting of coins under the government's control; attempts were made to establish a government monopoly over the salt and iron mines and industries. In a more positive way, imperial bounties could on occasion come to the aid of those suffering distress thanks to natural disasters such as flood or drought; caravans whose camels were laden with bales of silk set out with government support along the hazardous routes to Central Asia whence their precious cargoes were transported farther afield. They brought back luxuries rather than staple goods.

Individuals carried documents of identification showing their name, place of origin, social status, and age. When traveling, they were required to present these for inspection by officials stationed at points of control, at mountain passes or the waterways. In addition to checking the identity of individuals and ensuring that they were not deserters or fugitives from the law, these officials checked whether animals and goods should be allowed transit from one commandery to another, or outside the defense lines at the perimeter of the empire in the northwest (present-day Gansu).[6]

From a comparatively confined area in the northwest (present-day Shaanxi) that was partly

protected by mountains, the central government of the Han empire surely but slowly expanded its sphere of influence in all directions, posting officials in present day Hainan and Liaoxi, in Yunnan and Dunhuang. Governors assigned to remote situations might well live in isolation from their home government, deprived of the comforts of life to which they and their families had been accustomed. Governors and their officials would need to become familiar with the ways of life, sometimes rather strange, that were practiced around them; they might need to learn how to negotiate with leaders of peoples who had little in common with the inhabitants of the metropolitan area. On occasion a skilled military leader, familiar with the terrain where he was fighting, might be able to draw on Han ideas of strategy or tactics to throw back forces that threatened the security of the empire, or to bring the force of Han arms to bear on communities in Central Asia. Other officials who served in far-flung regions might seek to promote a type of colonial expansion rather than one of military occupation, setting up sponsored farming establishments for the purpose.[7] Assignment of an imperial princess to wed the leader of one of the non-Han peoples could serve to strengthen peaceful relations and secure the succession of a half-Chinese person to be their leader.

Despite these endeavors and achievements, there was no shortage of problems and controversies in the operation of Han imperial government. Han had accepted many of the institutions and methods of administration of its predecessor, including some of its stringent rules and severe punishments for crime. As was well known, Qin had nonetheless failed to stem insurgency, and had been brought to a close all too soon; some, perhaps not many, officials of Han were well aware of the dangers that might beset them and were anxious to avoid the repetition of such a fate. Inherited as the laws of Qin had been, their complexities and cruelties had not been eliminated as Han would claim.[8] They survived, with all their minutiae, as expedients to sustain the will of government, rather than as a code or set of ordered principles upon which imperial government could rest and which could provide an intellectual basis for a stable structure of society. Such rules and prescriptions could perhaps derive from problems that a particular official might encounter in the course of his administration. Problems could easily arise in the absence of a comprehensive attempt to avoid duplication and remove inconsistencies in documents that had been drawn up over the years.

Problems in Imperial Rule

Effective government depended on cooperation on the part of the emperor, as the fount of all authority; of his immediate kinsmen, nominated to be kings with some measure of authority, and perhaps including his successor; and his appointed officials, who were charged both to proffer advice and to implement his will, and also to advise against an ill-thought-out scheme. An emperor might perhaps be too forceful for the comfort of his kinsmen and inferiors; high-ranking officials might be more concerned with realizing their ambitions than with advancing the interests of the empire.

Matrimonial complications and the influence exerted by members of an imperial consort's family might upset the balance of interests that was needed for a stable regime; and they might affect the imperial succession, particularly when, as happened not infrequently, that had fallen to an infant. In such circumstances the strength of his position was no more than nominal; the boy simply filled a formal role and was subject to manipulation. By contrast, a few emperors, such as the two Han

founders (Gaozu, r. 202–195 BCE, and Guangwudi, r. 25–57 CE) were fully capable of personal initiative, leadership, and action. Wudi (r. 141–87 BCE) has long enjoyed a fine reputation for presiding over a flourishing empire with strength, but as early as the end of Western Han, it was being questioned whether he personally deserved the high degree of acclaim that he enjoyed.

Ideally the heritage of empire would pass in direct and peaceful manner from father to son in accordance with the declared nomination of an heir. That heir must be the son of an emperor's established empress, not of one of his many secondary consorts; the mere fact that these latter were graded in ranks of status and privilege showed the inferiority of their position. Trouble could occur when one such consort intrigued to supersede the established empress and secure the imperial succession for her son. Such difficulties could be engendered or intensified if the male relatives of such a consort held important positions at court or in the government. There is not much direct evidence to suggest that intellectual issues or controversies played a part in any of the disputes regarding the imperial succession. It is reported that the future Yuandi (acceded 48 BCE) had criticized the style of government practiced under his father (Xuandi) as being too dependent on the exercise of punishments; and that as a result Xuandi had pondered altering the succession. How far this difference was a personal matter between father and son or how far it reflected different attitudes to government remains uncertain.[9] The line of succession remained unchanged.

The imperial matrimonial system was intended to ensure that sons would be born to accede to the throne. But so far from bringing about dynastic stability and a smooth transfer at the time of a sovereign's demise, the system could all too easily lead to dispute, violence, or bloodshed. In such circumstances a woman, such as the Empress Lü in 188 BCE, could take personal control of the powers of the throne; the throne came under dispute again in 180 and 122; the rivalries of consorts' families gave rise to bitter fighting in Chang'an city in 90; further disputes took place in 74 and 66. In 9 CE Wang Mang, nephew of Yuandi's empress, founded his own dynasty, named Xin, to take the place of Han; Liu Xiu (2), one of several contenders for power, restored the house of Liu in 25 CE after considerable fighting; Eastern Han witnessed factional disputes between families such as Ma, Dou, Deng, Yan, and Liang.[10] On a number of occasions a young or infant emperor lay under the immediate influence of his mother or grandmother, whose strength derived from her position as the empress or secondary consort of an earlier emperor.

The unity of the empire could lie open to threats from the kings, as was seen on several occasions, when one of them wished to lay a claim to the imperial throne and could command sufficient local resources to mount a challenge. Even more serious was the concerted revolt staged by seven kings in 154 BCE. As members of the imperial family, the kings deserved respect, and some may well have shown that they had earned it. There were also those whose behavior was pernicious and whose activities could only be described as grossly cruel, e.g., Liu Jian (3), king of Jiangdu 127–21.[11]

Officials and Their Difficulties

All credit is due to some of the high-ranking officials on whose advice and counsel the empire was founded and its institutions operated; some, notwithstanding their services, suffered dismissal, disgrace, or a wretched death thanks to the animosities and intrigues of their rivals.[12] To ensure

the safety of the imperial heritage, it was necessary to find and employ officials of a somewhat rare type; they must combine marked ability and administrative skill with an unquestioned loyalty; they must be able to override personal quarrels and rivalries and ignore the force of family connections.

Senior officials for their part might be faced with a problem that could be recurrent at all times, whether in Asia or Europe, in a kingdom or a republic, in Han times or in the twenty-first century; and being a question of conscience, the problem also involved personal survival. The problem did not arise for those who had no doubts regarding the integrity and motives of the emperor or king whom they served, after receiving training and while enjoying a salary that was appropriate to their post. Likewise those who were subordinated to an official who commanded general respect need not worry where their duty lay. But the situation could change suddenly if an emperor or his court came under the domination of ruthless oppressors or men of evil intent; or if on a king's death his successor turned out to be a profligate wastrel with a taste for cruelty; or if the senior official for whom one worked was known to be engaged in practicing corruption. Retention of a position in such circumstances could be repugnant on moral grounds; open protests against all too obvious abuses could lead to one's death. Or else, at a time of dynastic change an official might face a difficult choice between two courses of action; either he could agree to serve a newly arisen master so as to maintain law and order and protect those who were being governed; or he could deliberately refuse to support an upstart who had seized power and was exercising it illegitimately in place of the imperial house to whom his loyalty was due.[13]

In a number of edicts an emperor requested or even ordered his ministers not to refrain from criticizing him if it was necessary; but the sincerity of such requests may well have been a matter of doubt,[14] and should a high-ranking official voice a protest against a contemporary state of affairs, or a decision taken in an emperor's name, he might incur resentment, wrath, or even ruin. Criticism could not be seen to be directed at a reigning emperor; it could perhaps be veiled in allusion to incidents of the past rather than related overtly to contemporary practice. Certain documents fasten on the theme of contrasting the moderate and disciplined ways of the golden past with the decadent and depraved days of the present.[15] Somewhat exceptionally, Gu Yong and Du Qin stand out as fearless critics of the way of life of Chengdi (r. 33–7 BCE),[16] and Chen Fan against certain aspects of favoritism practiced during Huandi's reign (147–168 CE).[17] Sometimes an exceptional natural event or disaster could enable a high-ranking official to voice a protest, as was possible for Li Gu and Zhang Heng, following an earthquake of 133 CE;[18] or for Cui Shi, after the earthquake of 151, a year that was already marked by plague and famine; and for Liu Tao after a solar eclipse and plague of locusts in 156–157.[19]

Protest against proposals put forward by a rival who was in power could lead to dismissal or death. Sometimes a man of letters who was not especially concerned with advancement in public life could express himself in an unofficial piece of writing such as a "rhapsody" (fu), whose allegories could do duty for direct protest. As a final step it was possible to retire from public life. Exceptionally, open protests against the government's policies may have been expressed in a staged debate, such as one that was held in 81 BCE and for which we possess a record that was drawn up subsequently.[20]

As elsewhere, so in China's early empires it is impossible to estimate how far the men and women who toiled in China's farms or suffered as

convicts condemned to hard labor, or, alternatively, those who lived in the luxury and affluence of city life or country manor consciously identified themselves as members of the imperial order or valued the type of government that controlled much of their lives. Nor can it be known how far they accepted the orders and demands of officials as a normal part of existence, or with the silent reluctance and resentment of most taxpayers. We may perhaps assume that the intensity with which officials implemented their orders varied widely, depending on the means at their disposal or their personal inclination. Senior officials were not posted to serve in their home areas and perforce had to rely on their subordinates to supply a knowledge of local conditions, and even, in some localities, to interpret from a strange dialect on their behalf. A man from the north who rose to be a provincial governor in the south or the west might well at first find himself unfamiliar with the way of life of the farmers, the natural dangers that beset the area, or the strange and crude habits of some of the inhabitants.

Some senior officials who were known for their highly efficient administration in the provinces might advance to the highest offices of the central government. But dangers could attend such a *cursus honorum*, as it could easily involve a quarrel with their contemporaries. Some officials were known for the fair way in which they handled criminal cases; others, such as Zhang Tang,[21] for the rigor and severity with which they applied the laws. Some were magnanimous, others were charged with oppression, some were men of integrity, others were open to bribery; some were highly respected for the beneficial results of their administration.

From at least 186 BCE regulated ways of testing the abilities of young men who wished to serve as astrologers, diviners, or prayer reciters were included in the Statutes. Little is known about the form or methods of those tests except that they required familiarity with passages of assigned writings and with different styles of script; would-be diviners needed to prove, from earlier trials, that their predictions were likely to be valid. At later periods the tests directed attention to approved interpretations of certain texts. What was lacking was training in the methods of government or in ways to solve administrative problems. As a man advanced along the stages of his career he would acquire knowledge and experience at first hand, perhaps in trying criminal cases or suppressing banditry. As the decades passed, proposals that involved major political decisions could draw on precedent; they did not necessarily derive from purposely thought-out arguments that had been committed to writing.

The Imposition of Imperial Rule

Copies of the Statutes and Ordinances were distributed regularly to officials who served in the provinces, but implementation in an equable manner might produce problems. The claim that a benign Han government had simplified and modified the harsh laws of its cruel predecessor can hardly stand up to scrutiny in the light of recently discovered documents with their detailed regulations.[22] Shortly after the formal close of the Han dynasty (220 CE) officials were able to write about the large volume of documentation that existed; some of this consisted of case histories upon which decisions were based; other, lengthy, documents were devoted to interpreting the intentions of the Statutes. Clearly, over the centuries a great deal of inconsistency and duplication had arisen, and the absence of a comprehensive clarification had given rise to difficulties in applying the regulations.

These regulations included lists of particular rules of action and sanctions needed in case of particular crimes; but there were very few attempts at definition of a principle. As a result, legal cases could easily arise for which an official had no guidance; and should he later be charged with improper practices in the conduct of a case, he would find himself facing a trial. Possibly he might have been able to find help in copies either of hypothetical or of actual cases that were sometimes written up and circulated; or he might have been able to consult sets of questions and answers regarding the meaning or interpretation of the laws.

Documentation of a case, as was required, could be complex and lengthy, recording how evidence had been acquired and referring it for corroboration. It was also necessary to determine which of the given laws applied to a case, and how they did so, before a decision could be reached. The range of punishments for crime ran from execution with exposure of the corpse to banishment. Mutilating punishments inherited from Qin were mitigated, but only after some fifty years, and severe cruelties persisted in the form of sentences to castration, execution at the waist, terms of five years' hard labor (for both sexes), or the forced removal of family members to work in government offices. Recently discovered documents include detailed examples of trial and punishment for acts of violence, robbery, or murder; dereliction of duty; forgery; sexual irregularities, or counterfeit coining; all these and many other actions constituted grave offences. Ideally the emperor's commands and the ways of government should be seen to be trustworthy, with rewards for those who deserved them and due punishments awaiting criminals. In practice, however, it is highly unlikely that the administration of the many laws operated in equable ways throughout the empire.

Emperors and their governments required considerable labor forces to accomplish the tasks on which they were set, and which included care and repair of communications, the prevention of crime, the collection and transport of staple goods, control of mines and industrial work, flood control, and irrigation, and effective security from bandits or incursions. But provision of such forces could entail difficulties. In response to the rules of statutory conscription able-bodied men served as state laborers for set periods to accomplish these tasks; during such periods they perforce had no opportunity to work in their own farms and fields. Commanderies of the north lay at risk if there were not enough men to man the defense lines; but the conscription or recruitment of men to staff the armed forces and stand to arms in the permanent garrisons could remove much needed labor from the countryside. An ensuing shortage of agricultural produce could breed distress and give rise to insurrections. So too could an increase in tax or in demands for service. Yet the payment of salaries to officials depended on sufficient tax revenues, as did the construction of palaces and tombs, whether for the emperor and his immediate kin or for the kings.

Tax was raised on the produce of the land and as a per capita poll tax; stringent measures enforced the upkeep of registers of the land and the population, to ensure that the required dues were being collected; detailed accounts demonstrated that this work was being done. Punishment followed the detection of fraudulent returns as well as cases of desertion or flight that were designed to evade an individual's statutory obligations. Provincial officials were in duty bound to round up such vagrant persons, and they gained credit if they could show that they had been successful in so doing. They were likewise bidden to increase the

rate of production in their areas by reclaiming land for cultivation.

The exchange of goods depended on the cash, or copper coin, which was normally issued in a single denomination. Fines and payments for certain other transactions were reckoned in units of gold, but may well have been settled in cash, at a nominal rate of 10,000 cash to one *jin* (244 gm) of gold; rare experiments in introducing a multi-denominational currency were not successful. For most of the Han period the government assumed responsibility for minting coin and banned private minting. As references to the purchasing power of money are anything but regular or consistent, it is not possible to reconstruct how the value of the cash coin varied from time to time or to set up a scale of comparable prices.

The transport and distribution of staple goods presented a perennial problem, which was particularly noticeable in times of natural disaster, when communications between neighboring communities could easily be cut. In addition to the general use of conscript manpower for the purpose, rewards were sometimes offered to merchants to complete this work, particularly over long distances such as those from the grain-producing areas of the east to the frontiers of the far west. In a few instances the government set up sponsored farms that were worked by conscripts and their families to produce the supplies that the garrison forces needed.

Ideological controversy entered into the mining of iron and salt and the manufacture and sale of those commodities. Private owners could grow rich by working the mines at their disposal, perhaps imposing an extortionate price on their products. To ease such difficulties, some officials introduced a scheme to take over these industries and work them under government-controlled agencies. Such methods were decried by others as

a means of transforming the officials of government into merchants and of restricting the freedom of individuals to pursue the occupations that they chose. It was also alleged that the iron goods turned out by the agencies of state were of poor quality.[23]

Expansion and Its Needs

Ideally, participation in the empire came spontaneously from those who wished to benefit from its blessings, and there was no call to use force so as to compel adherence to the emperor's rule. Such a doctrine, however, may not have been conspicuously noticeable in the ways in which imperial governments encountered and treated leaders and groups from beyond the pale. In practical terms security might well depend on a military presence; Chinese expeditions could drive into distant areas that lay beyond Han control for short periods, and would be briefly successful in deterring a potential enemy from taking unpleasant actions. At home the regular system provided sources of conscript soldiers, and it was possible to man the defense lines of the north, sporadically rather than continuously, between circa 100 BCE and 100 CE. On occasion a Chinese commander was able to call on the support of forces, particularly cavalry, from some of the neighboring communities.

Disciplined as some of the Chinese forces were in the maintenance of their defense lines, and skilled as some commanders were when leading a campaign, they could hardly rely on a traditional ideal of noble heroism or call on the results of a training whose value was proven over long decades or even centuries. A few leading officers could appreciate the value of a strategic approach to a problem or take tactical advantage of a particular moment or a particular type of terrain; but there was no trained class of professional soldiers who had been taught the basic principles of

campaigning or defense. There were also problems in the conduct of a campaign. Governments were reluctant to entrust the overall command of a force to one general officer; cooperation between two or more generals could be fraught with rivalry. Problems of supply over long distances could seriously prejudice the possibility of maintaining an expedition for a lengthy period of time.

When built to their full extent, by circa 100 BCE, the defense lines reached as far as Dunhuang. Watchtowers and command posts, equipped with devices for signaling, enabled officers of the garrison to maintain contact with each other and give warning of intrusion. They sent out patrols to search for traces of potentially hostile activity and to take the necessary defensive steps. The lines that they manned could act as a protected causeway along which troops could be marched to take up their stations and to control ingress by unwanted foreigners and egress by deserters and fugitives. The lines also served to separate peoples of the north, such as the Xiongnu, from entering into a collaborative compact with those farther south, such as the Qiang.

In addition the lines and their garrisons provided safe passage for the caravans of traders that set out from Chang'an to sell silks that might eventually reach the Mediterranean world and the city of Rome. Some officials may have supported such activities; others raised objections on the grounds that they brought China nothing but luxuries and baubles at the cost of considerable labor and expense. There was no consensus of opinion that territorial expansion would necessarily be beneficial.[24]

Once beyond the protection of Han authorities and servicemen at Dunhuang, the westward roads took the caravans out along a series of oases that skirted the northern side of the Taklamakan Desert, and back along the southern side. Without a friendly reception at those asylums a Chinese caravan with its many camels might easily perish; and should those small settlements come under the coercion of powerful leaders to the north they could be persuaded to bar the road to Chinese merchantmen. To the Han government, then, amicable relations with the leaders of those small communities were of considerable importance. At best, a friendly relationship might be sealed by diplomatic or matrimonial arrangements. The post of Protector General, which was established in 59 BCE, was intended to coordinate Han colonial activities in these parts of Central Asia and to confirm friendships where these existed. The Protector General would report back to Chang'an with information regarding the size and strength of those communities, the stability of their rulers, their natural resources, and their attitude towards Han officials, traders, and servicemen. On occasion Chinese relations with these communities could involve deceit or violence, as happened in Loulan in 77 BCE.[25]

Meanwhile a Han government was conscious of the threat that the Xiongnu or other groups could impose on the security of farm, settlement, or city in the commanderies of the north. Appeasement in the form of material gifts of Chinese products could perhaps buy a respite from hostile activity; exceptionally, a Xiongnu leader would visit Chang'an to be received in all honor and with promises of friendship (e.g., 51 BCE). Such accommodation, however, might not outlast the death of the visiting dignitary, which could open the way to factional or family strife at home and a new attitude that suited the taste of a newly arisen leader. On at least one occasion two forceful Han officers displayed their initiative by engaging one of the Xiongnu leaders in battle and putting him to death (36 BCE). But since the home government

had not authorized such a foray, the two men (Gan Yanshou and Chen Tang) faced legal proceedings after their success. The incident illustrates a major problem in determining effective policy, as seen in the difficulties and delays in communication between the center and officials at the periphery, coupled with the central government's distrust of officers who could control and lead Chinese armed forces effectively.

Social Stability and Hierarchies

Should we seek a theoretical formulation of an ideal social order that emperors and their officials were striving to establish, we would look to our sources in vain. Nor would we be necessarily justified in reading back anachronistically from the essays written in the later empires; for their authors may well have wished to portray the Han empire in terms that suited the intellectual ideas of Tang, Song, Ming, or Qing times. Two fundamental ideas, however, obtrude in Chinese writing; that of *social stability*, upon which the security of the realm rests; and that of respected *hierarchies*, which provide a framework within which men, women, and children may best order their lives and serve their emperor. These ideals or aspirations lay at the root of family relationships and drew strength from systems that a government could impose.

Degrees of kinship were of vital importance in determining modes of correct interpersonal behavior and ensuring the solidarity and continuity of a family from one generation to another. Differences of seniority within a family were marked by special terms that denoted one's position in a generation, and the expressions adopted for a man's style (*zi*) name could immediately signify such a position. Distinctions were also signified in the rights that seniors could exercise over their juniors, by the entitlement to own property, and

by one's appropriate part in mourning rites for a given kinsman. Such relationships were reciprocal; parents and grandparents nurtured their children and grandchildren; at the death of a father a son was obliged to look to the well-being of a surviving grandparent.[26] Attainment of a high age in itself brought respect; the privilege of carrying a special type of staff, crowned with a dove's head, signified to all that the holder deserved deference. An imperial decree granted possession of such an emblem.

Stability required the maintenance of law and order, if necessary by force; hierarchies excluded ideas or ideals of equality. Stability rested on a preponderance of law-abiding members of the population who were willing to accept the orders of officials without demur and to render tax and service as these were demanded. It also rested on a recognition of the status that one occupied in the social order and of one's appropriate behavior toward superiors and inferiors.

The series of orders of honor (*jue*) or social ranks that the government imposed, together with designation of some persons as commoners, slaves, or convicts of various types, classified all members of the community. Inherited from Qin and other kingdoms were twenty ranked orders of honor, which could be granted to individuals, thereby conferring valuable legal privileges and allocations of land, and setting up a social scale. Such marks of distinction were intended to recognize services rendered to the empire; or else they could in effect be acts of bounty whereby an emperor sought to enhance his reputation for generosity; it was possible to advance up the scale, as and when these acts of bounty were repeated. Below those who had received the lowest of these honors, that of *gong shi*, there followed those without honors or those who had forfeited them as a penalty for a crime. Documents such as passports, whereby an

individual was identified, included a note of the order of honor that he held, thereby informing officials of the treatment that was his due.

The highest of these twenty orders was that of noble (*che hou*, *lie hou*, or *tong hou*), sometimes rendered as "marquis"; it carried with it not only a title but rights to administer estates whose extent was specified and to enjoy part of the dues that they raised. In that capacity the nobles, whose titles were held on a hereditary basis, in effect contributed to the administration of the empire without holding a post as an official (see pp. 65–66). Allocations of land to others varied in extent according to the degree of the order that was held.

Some of the orders of honor and their degrees of status could be transmitted on a hereditary basis, as with the highest, that of noble. For holders of the lower orders a son might acquire a lower degree than that actually held by his father, if the latter had died while carrying out his prescribed duties; without a son, a man's orders could pass to his parents, wife, half-brothers, or even his grandparents. A son born posthumously could be declared successor to his father's order or to his position in a household. If there was no son to succeed to the household on the death of the leader, this would pass in order to the deceased person's father or mother, widow, daughter, grandson, great-grandson, grandfather, or grandmother.[27]

Higher than the nobles and inferior only to the emperor, certain members of the imperial family were nominated as kings or inherited kingship and a kingdom from their fathers. Sons themselves of an emperor, they transmitted their titles to their own descendants; they held powers to govern large areas of land with the assistance of their own officials, while paying dues to the center. This hereditary system was intended both to secure the loyalties of such persons and to provide them with opportunities for leading their own, separate, lives with some powers and measure of independence, while denying them the opportunity of interference in the imperial palace or central government. As it would be in their own interests to maintain law and order and to promote a high degree of economic production within their kingdoms, it could be expected that the kings would in effect contribute to the main purposes of government—the retention of a stable society, the suppression of crime, and an increase in the revenue due to the central government. As members of the highest-ranking social class in the land, they would provide an example of cohesive and coherent kinship that others would be proud to emulate.

Emperors and officials may well have seen a system of hierarchies as the natural way in which to establish the organs of government and maintain controls from one level to another. Such a principle entailed a *cursus honorum* along which an official would advance in his career, rendering service, meriting promotion, or incurring demotion at each level. Such a means would check the rise of unruly ambition but provide incentives to serve the empire. The resulting series of ranks and corresponding salaries of officials comprised sixteen degrees, ranging from that of the humblest of clerks, graded at a notional salary of 100 bushels (*shi*) of grain, to that of the most senior of officials who guided the emperor and took decisions, at the grade of 2,000 bushels.[28] The secondary consorts of the emperor were classed in similar hierarchies, of as many as fourteen grades.[29]

Households and Responsibility Groups, Commoners, and Slaves

Two basic units, that of the household and that of the "responsibility group," divided the main part of the population into units whereby the purposes

of government could be achieved. Tenure of land with dwellings, together with responsibility for reporting its extent, produce, and liability for tax, was vested in the household (*hu*), which probably consisted of four or five members. At the death of the holder the household's assets, including land, dwellings, and slaves, might be divided among several kinsmen, who would each set up his own household; possibly such allocations had been determined previously by means of a will (*xian ling*). In certain cases leadership of a household devolved on its most senior female member. There was no legal unit of the "family" (*jia*).

The households had come into being as the smallest units under administrative control, and may have existed in several of the kingdoms of the Warring States period. Possibly no such unit, consisting of a mere four or five members, was evolved in the institutions of early empires other than China, and its adoption and operation may serve to indicate the efficiency of Qin and Han government. The system may well have been maintained with reasonable regularity, at least in areas that were given over to agriculture. Here the system could induce the population to work the land to its fullest potential and to render tax and service as demanded in a socially cohesive manner; it could also serve to reduce the extent of vagrancy. Reasonably consistent figures survive for the numbers and sizes of the households in 1–2 and 140 CE, and officials who falsified the returns might well be subject to penalties. What remains unclear is the relationship between the *hu*, with its members, and the *jia*, the nuclear or extended family with its several genera- tions and members and its religious ties. We do not know how far members of a family (*jia*) could rely on the *hu* to supply their daily needs of subsistence.

The responsibility group (*wu*) had existed in Qin and perhaps elsewhere in pre-imperial times. Men of the status of *Wu Dafu* (i.e., ninth in the series of orders of honor as just described), and below, who were settled in adjoining lands, formed a communal unit whose members shared responsibility for reporting crimes committed by any one of them, or for any activity that gave rise to suspicion.[30] Such units may have held no more than five members, whether counted by the person or the family, and they were possibly paralleled by the *lian*, of ten members. On receipt of a report of a crime committed by a member of the group, officials locked the gates of the residential wards of the towns, carefully controlling ingress and egress. Failure to report a crime could cost other members of the group severe punishment.

Recently found documents show a few instances wherein the members of the *wu* were required to provide information or take action,[31] but we have nothing to show how generally these groups were consulted and were able to help in the deterrence or detection of crime. Nor do we know how the *wu* was formed, and what steps, if any, were taken to prevent its domination by a particularly powerful individual or family.

Li min, "officials and persons," was a general term that denoted all persons other than convicts or slaves.[32] The term *shu ren*, "commoner," seems to apply to persons who had never received any of the orders. Ranked below those who held the lowest of the twenty orders of honor, that of *gong shi*, were the *shi wu*, either persons who had never received an order or those who had been deprived of them by reason of crime. Lower grades included those of criminals sentenced to hard labor for two years (*si kou*) and those persons "concealed in government offices" (*yin guan*). These latter may have been family members of a criminal, whose punishment included the taking over, or confiscation (*shou*) of such members to work as ordered by officials.

Various terms denoted criminals sentenced to longer terms of hard labor. Sentences of five years were known as "wall building from dawn" (*cheng dan*) for men, and "grain pounding" (*chong*) for women; those of three years as "fuel collection needed for sacrifices" (*gui xin*) for men, and "rice sorting" (*bo can*) for women. In all probability the actual work to which these men and women were assigned varied according to need.

In certain circumstances slaves, male or female, could be manumitted and become commoners, as at the death of the owner without an heir. Female slaves who bore their masters a child became free at his death. Children born to a slave and a free woman were given over to the slave's owner; those born to a master and one of his female slaves, or those born to the master of a slave and the wife of a slave of another family, were made over to the master of the female slave, all such children becoming slaves. In some cases, however, children born to a slave and a commoner became commoners.[33]

Administrative documents of 186 BCE refer to some aspects of the position of women; a wife's duties lay in service to her husband. If a husband died leaving no son, first place in matters such as inheritance and the conduct of mourning devolved on the deceased person's parents, then on his widow, and then on his daughter.

The Hereditary Principle

In both the Qin and the Han empires the position of the emperor followed the hereditary principle; in both empires this was at times subject to manipulation, as brought about by senior officials or by the devices of an imperial consort. In Qin times the hereditary principle may have applied to some of the technical positions, such as that of diviner, but senior offices did not pass from father to son. From the very start of the Han dynasty emperors were nominating men to be kings or nobles, whose titles were inherited by the eldest son, often for several generations. Difficulties could arise, with no guarantee that those who acquired high powers and responsibilities thanks to their parentage would possess the qualities and virtues that their positions demanded. As against this danger, other weaknesses persisted in a system in which offices and their responsibilities fell by appointment to those who showed merit; for there could be no guarantee that such accomplished men would maintain their loyalty to the throne if this conflicted with their own interests.

Han emperors soon found that their links with the kings grew tenuous with the passage of the generations, as degrees of kinship grew more remote. And many examples showed that there could be no implicit trust that the kings would necessarily be loyal to the throne. The events of 154 BCE, when seven kings banded together to contest Jingdi's rule of the world, may well have remained in memory as a warning of what might occur; such thoughts may have led to some of the institutional steps taken to reduce the powers of the kings, and the sharp measures designed to eliminate any threats that they might pose. Only a few of the kingdoms lasted a long course in Western Han; by Eastern Han they had probably lost their effective powers and importance.

A somewhat strange conflict of interest arose in 117 BCE, when an emperor's wish to create some of his sons to be nobles was thwarted; his ministers insisted that they should be given the higher rank of kings. Nobilities fulfilled a variety of functions. They acted as an administrative device to govern parts of the land in the days before a government could call on a sufficient number of trained officials to shoulder the whole task. They

formed rewards whereby an emperor could hope to retain the services of those who had supported him in a struggle for power; and if conferred on leaders of non-Han peoples they could induce them to feel a sense of identity as recognized members of the empire. Exceptionally, some of the nobilities could last for as many as eleven generations; many were ended with the accusation of the first and only incumbent for crime. At times there were considerable disparities in the size of the estates over which nobles enjoyed rights of taxation, and such differences may well have given rise to jealousies. Nomination of certain persons as nobles could arouse resentment, particularly if their merits lay in no more than relationship to a consort, or if their nobilities simply resulted from favoritism.

There remain a variety of questions regarding social distinctions and official practice. At administrative levels the dividing lines between efficiency and benign rule, and between justice and oppression, could perhaps be difficult to maintain. Harsh application of the laws could perhaps earn an official high praise; it could perhaps lead to a perversion of justice, as we think of that term today. The system of official grades and of promotion or demotion may well have been intended to ensure the smooth devolution of authority from the highest to the lowest levels; possibly its constraints prevented the effective and speedy operation of government. As a result of repeated grants of orders of honor or their inheritance from a father, these marks of distinction may well have lost much of their character, though the legal privileges that they carried may have still made them worthy of acquisition.

The Growth of an Ordered Way of Life

One might perhaps speculate how far Plato, with his distinction between governors and governed,

might have understood and appreciated the principles involved in these arrangements, those of hierarchies that affected both the officials who ordered Chinese society and those who were obedient to their commands. Or it may be asked whether Aristotle might have seen in the Chinese way of life a compromise between the natural force of those who govern and the freedom of will of those who are governed. Alternatively, would Li Si (?280–208 BCE), Xiao He (d. 193 BCE), or Ban Gu (32–92 CE) have comprehended an idea of citizens who saw themselves as active members of a *politeia*, let alone of a *demokrateia* such as Athens boasted? Would they rather have understood and respected the disciplined system of Sparta, while denying that it owed anything to divine gifts such as those of Lycurgus?

It is difficult to discern how ideas known in the West, such as those of liberty, equality, or fraternity, could find a place within the social structure of early imperial China, which rested on agreement to abide by a prescribed set of practices and an acceptance of the conditions imposed by authority. Both Western and Eastern cultures included to varying extents a respect for the force of ordered conventions as against an unrestricted license, and both would claim a sense of duty towards members of one's family.

Much of the regulation of China's society and government placed a particular emphasis on the key terms *li* ("correct behavior according to social distinctions") and *xiao* ("respect due in families, mainly from children to parents"). Both of these concepts reflect what may almost be called an obsession with age and degrees of kinship. Anachronistically they were traced to the heritage left by the revered teachers of old and were honored as voluntarily accepted precepts; but adoption in practice might well have required sterner measures.

Laws that are cited in documents of 217 and 186 BCE refer to cases when a lack of *xiao* was punishable, even by execution in public.[34]

In all probability many of the officials and teachers who played a prominent role in public life would have claimed that their work in administering the land and its inhabitants derived from these two ideals; that of *li*, whereby human relations were maintained in regular harmony; and that of *xiao*, whereby responsibility for kinsfolk ensured the solidarity of the family. Both of these concepts contributed to a framework whereby law and order prevailed; but despite such claims conditions varied widely over time and place and neither a unity of achievement nor a uniformity of practice can be assumed. Harsh legal sanctions were necessary to supplement the principles of *li* and *xiao*; implementation could be severe or light, perhaps according to the whim of an official.

Neither the persuasions of ethical ideals nor the brute force of the laws could succeed in imposing a standard of civilized living universally. Customs such as human sacrifice designed to appease a god or bring a blessing could continue in remote areas such as present-day Yunnan;[35] but the annual propitiation of the Count of the Yellow River by offering him a bride, floated downstream to meet her death, had probably been stamped out.[36] Where officials had been long established and could bring their orders to bear, they could treat the population strictly in accordance with the rules: depending on age, status, and sex, men, women, and children were required to respond to different obligations and entitled to receive different benefits.[37] Women could sometimes become leaders of a household; exceptionally, they could receive the rank of a nobility.[38] By the end of the Han dynasty officials were reporting how in the southern regions men and women went naked and knew no arrangements for marriage until Chinese settlers introduced these norms of a cultured way of life.[39]

Intellectual Change in Western and Eastern Han

An anecdote recalls that, almost immediately after the establishment of the Han empire, a senior adviser delivered a warning to Liu Bang: if the new empire was to be governed suitably and safely, he must needs call on qualities other than those of military valor.[40] In those early days, when the new regime was adopting many of the institutions of its predecessor, there seems to have been no conscious attempt to shake free of the ideas on which Qin had been based; but a slow and gradual process soon began whereby intellectual authority and the full force of scholarly argument was invoked to support the continued exercise of authority by an emperor and his officials. Such arguments rested on principles other than those expressed in support of the First Emperor's rule. As the decades passed, scholars, litterateurs, and scientists were developing their ideas and producing a not insubstantial literature in which they set them forth.

For indeed a change was coming upon the world that would mark a major divergence between the attitudes of men and women in Western and in Eastern Han times. Shortly before the close of Western Han the imperial cults of state were being addressed to a different focus than hitherto; imperial might was seen to prosper thanks to the blessing of Heaven rather than the power of the sword. The establishment of the imperial library during Chengdi's reign (33–7 BCE) lent a new form to literature and brought with it a classification of thought; it distinguished between classical works, historical writings, teachings of the masters, and technical treatises; it set patterns

corresponding partly to a distinction between the precepts of a moralist, musings of a mystic, and determination of a realist. Transfer of the capital city early in Eastern Han from Chang'an to Luoyang signified a move from the realistic lookout of Qin to the traditional teachings of Zhou; for Qin had sought safety by establishing its base in the west; Luoyang retained its association with the traditions of Zhou. The theory of the Five Phases (*wuxing*) had found a place in the minds of some officials and men of letters; the calculations of astronomers and others led to adjustments in the calendar, whose circulation symbolized the will and purpose of government. Artists and writers were showing that those who sought a way to paradise might do well to turn their thoughts to a mysterious realm in the west rather than the east. From perhaps 150 CE communities were arising under Zhang Lu, a figurehead whose promises of material blessings attracted a following of those who were dissatisfied with the harsh demands of a civil authority; a new faith came from foreign parts to inspire those who were bound by daily suffering with a new message of hope. Among scholars the Five Approved Texts were calling for different approaches and giving rise to major inspiring scholarly studies; and if their precepts were receiving wide acceptance, their wording was perhaps subject to differing modes of treatment.

In ideal terms intellectual support would provide the context in which an emperor and his officials would impose their authority and the organs of government would rest on approved and respected principles. It would show how the rule of an emperor was an integral and essential element in the whole scheme of being, inalienable from the systems whereby the activities of the heavens and the earth operated. Ideas formulated by thinkers of the past and perhaps modified for the present would show how the social and political orders of the day rested on ethical and other principles that would benefit all mankind; possibly such principles could be traced back some centuries to teachers such as Kongzi (Confucius; 551–479 BCE); possibly texts written before the emergence of Qin and Han could show how the institutions of empire derived from the sayings and records of monarchs of the dim past, whether of mythology or history.

If possible it needed to be shown how the organization of an empire and the day-to-day actions involved in its government were in harmony with the ways in which the major cycles of existence pervaded the world. Family solidarity, the ideal of *xiao*, and religious rites rested on a deep respect for earlier ancestors, their ways of life, and their teachings; the authority of the past must be found, or if necessary created, to support the hierarchical view of society and the orderly treatment of the population, and to display the importance of ritual performances of the court to a wider public.

Two writers, Lu Jia (ca. 228–ca. 140 BCE) and Jia Yi (201–169 BCE), were the earliest persons known to express some of these ideas in Han times, but time had to pass before they could be formalized in such a way that they would gain acceptance at a high level. After nearly a century Dong Zhongshu (ca. 179–ca. 104 BCE), who never reached a senior position in government, submitted three well-constructed memorials, perhaps in an attempt to reach a synthesis of ethical ideals whereby imperial government could look to inspiration from the past. Steps to fasten on certain ancient writings and to propagate their lessons followed; and Wang Mang (emperor of the Xin dynasty, 9–23 CE) made determined efforts to link imperial authority with the ideas and deeds

ascribed to the long since deceased kings and heroes of Western Zhou. In doing so he could call on the changes made recently in the state religious cults whereby Heaven, god of Zhou, was accorded prime place, and on the growing attention and deference paid to Kongzi. Heaven was now to be seen as the final arbiter of human affairs, Kongzi as the master of ethical and ritual matters.[41]

From the time of Dong Zhongshu the way lay open for the growth of scholarly attention to the interpretation of such precepts and ancient writings. Since perhaps 130 BCE the government had included official posts for scholars who specialized in these early texts. By 146 CE, as we are told, the number of students who attended a major institute of learning of these texts had risen to 30,000. This was the *Taixue*, sometimes termed the Academy, which had been set up as early as 124 BCE. At Chengdi's imperial orders, in 26 BCE a few named scholars collected copies of different types of writings from all parts of the empire, collating these when necessary so as to produce a complete and standard version. In this way the imperial library came to house works of philosophers, historians, and litterateurs, and technical guides needed for the conduct of daily life and the solution of mundane difficulties. The two centuries of Western Han had seen the emergence of history writing proper, in the form of annals and biographies; the newly emerged genre of *fu* had given scope for the expression of protest; and technical treatises gave practical guidance in matters such as divination, medicine, and the conduct of warfare. Some of these texts reflected the study of astronomy and mathematics.

It would be too simplistic to claim that these achievements resulted without argument from an unquestioned recognition of an accepted "Confucian ethic"; or from a general belief in the pervasive influence of the Five Phases in ordering the movements and activities of the world; or from the existence of discrete mutually exclusive schools of thought. In fact, considerable controversy obtruded. There were several versions, not vitally different, of the texts that had been chosen as authoritative for the teachings of the masters and the lessons of history with which those who wished to hold office must become familiar. Both the textual variations and the different interpretations that arose gave rise to a choice that had to be made in the instruction that the Academy would provide. Further difficulties arose in applying such texts and their precepts, some of ancient origin, to the political, social, and intellectual circumstances of the imperial age. For it may well have become meaningless to apply statements that had been expressed in one of the kingdoms of the sixth or fifth centuries BCE to an empire that claimed from 221 BCE onward to govern mankind with a single authority. Similarly, theories formulated from perhaps the third century BCE to explain the position of man in the cosmos and its workings could hardly be invoked to explain the meaning of esoteric texts such as the *Changes of Zhou* (*Zhouyi*), the oldest parts of the *Book of Changes* (*Yijing*), completed perhaps by 800 BCE.

The scheme of empire rested on the devolution of governing authority through successive stages and into ever smaller areas and the acceptance by human beings that they occupied a defined position in the corpus of society with its many layers. Such a system required a sacrifice of individual initiative and a recognition that the values advanced by governing officials were unique and irrefutable. Such intellectual constraints could by no means have been agreeable to all, and some of those who were not prepared to accept the limitations may well have retired from public life, to leave no name behind them. There were, however,

some who were prepared to express views based on entirely different premises, seeing the order of nature as the ruling principle of the cosmos and the regulated disciplining of mankind as something that was pernicious. Such views are seen in writings preserved to us in a collection known as the *Huainanzi* (presented to the throne in 139 BCE).

The ordered hierarchies of society, conduct of government by a recognized authority, reliance on the teachings of old masters, and adherence to family links and their responsibilities are features of what has been known generally and loosely as "Confucianism." In the harsh terms of a precarious life marked by outbreaks of human quarrels, such ideals could hardly survive intact. By perhaps the third century CE a call to those ideals was ringing hollow and drawing criticism. The system of public life was not attracting persons of merit and loyalty to serve the empire in a disinterested way; some were calling for the imposition of harsh disciplinary rules so as to control an aberrant population and its criminals.[42]

Meticulous observance of all the detailed prescriptions of *li* could not necessarily satisfy a mind that was searching for permanent values. Neither those who reiterated ethical precepts that were traced to Kongzi nor those who sought a mystical understanding of truth in the *Dao* were necessarily bent on a path to acquire self-knowledge. Poets may have composed their poems as an expression of emotion recollected in tranquility; but there is nothing to show that the masters of thought of the early empires saw any value in a deliberate and disciplined practice of meditation. Buddhist visitors who reached China with their scriptures from perhaps 150 CE brought with them a foreigner's view of the world and its problems and a means of facing up to one's own weaknesses.

Religious Belief and Practice

It is hardly possible to draw up a descriptive or an analytical account of the beliefs in supernatural powers that were prevalent in early imperial times; nor would it be right to think in terms of a single religious system comprising a set of beliefs and practices and exercising a compulsion among its devotees. The information that we possess regarding rites, worship, prayer, or sacrifice refers mainly to the activities of the highest in the land, and it is from such practices that the major part of our archaeological evidence derives. Practices at village level, such as the unregulated services to appease a local deity, deserved and received mention in our sources exceptionally rather than normally; as some of those references concern the suppression of observances that lacked official approval, we have no direct, positive description of the spirits or deities whose presence and powers could only be assumed and not witnessed. Nor have we any direct knowledge of what inspired the majority of China's varied population to serve them.

A search for survival in a world replete with hazards and perils perhaps lay beneath many of the practices of which we know. The retention of links with ancestors would, it might be hoped, lead to a survival of the family and kin, while the blessing or curse of one's forebears could affect the lives of their descendants. Elaborate funeral and mourning rites, by providing for the happiness of deceased persons, would perhaps secure their blessings, and prevent their anger. A hope of securing the continuity of kin may perhaps account for practices conducted at imperial levels as well as at the lowest reaches of society.

Some religious practices were addressed directly to the unseen lords and masters of the world of nature. These might inhabit a prominent feature of the landscape, be it mountain or river; or

they might preside over the soil and its output, or even over the crops themselves, which could supply or withhold sustenance. Some religious rites sought to prevent drought or, alternatively, excessive rain and inundation. Prayer, offering, and dance took their place in these rites; dragons were seen as powerful agents who could precipitate rain, and a mimetic drama was enacted to persuade them to mount the clouds and bring this about.[43] Some spirits could take the form of hybrid creatures who lurked in their lairs in the hills and could extend happiness or inflict injury, and whose goodwill could be acquired by wearing pieces of their fur upon one's own body.[44] As has been noted, a powerful deity such as the Count of the Yellow River had formally required annual appeasement in the form of human sacrifice.

There were various ways of ascertaining the will of other unknown forces and thus planning for a successful outcome for one's own activities. These included divination, which was practiced in a variety of ways, such as the interpretation of heat-induced cracks on a turtle's plastron, or of the linear patterns formed by casting milfoil stalks.[45] Movements of the stars and planets, the appearance of a comet, the occasion of an eclipse could all signify to an initiate the dangers that attended mankind.

Government did not ignore these matters. Officials were responsible for carrying out the necessary mantic procedures and for observing and recording the movements of the heavenly bodies. They were required to interpret the phenomena that they saw and the results of the rites that they conducted; and they trained and tested young men to become astrologers, diviners, or prayer reciters. At festivals that the court recognized, the exorcist performed acts of mimesis to expel evil influences or to bring about a purification. One other type of activity can hardly have received

official support to this extent; this was the trance and journey of the shaman or shamaness experienced in efforts to form a bridge between the seen and the unseen worlds.

Officials could not stand aloof from the practices or needs of popular religion. By standing order of the government, provincial officials conducted services to the local gods of soil and grain in the spring and autumn, in the hope of securing a fine harvest.[46] Some popular movements and activities, however, drew frowns from officials or men of letters, who could not always control them. The term yin si may well have denoted crude or cruel practices that shocked those who had been nurtured on approved ethical or moral principles, and officials who were able to suppress such goings-on may well have merited rewards. Emperor and court would perform highly regulated rites that claimed to be based on ancient tradition. Mythology could give rise to activities that were no less conspicuous, as when a large-scale popular movement swept through the land, devotees beseeching a goddess, the Queen Mother of the West, for the gifts of salvation and immortality.[47]

As noted above, written records tell us much more about the religious practices of the highest in the land than about those of the great majority. Drawing on earlier precedents, the Qin and more particularly the Han imperial house formalized some of the existing cults of worship that were addressed to supreme powers. These were conceived as deities who controlled the destinies of a kingdom or an empire and its ruler, and who could vouchsafe to him personal safety and the survival of his realm. But with no implication of, or requirement for, a monotheism, emperors paid their respects at a variety of altars or shrines. Some of these were first dedicated to four spiritual agents or forces that were seen to direct and control activities

severally in each of the four quarters of the earth, and in each of the four seasons.

In Han times the four agents or powers were extended to five. It came about that one of these five was believed to possess the particular power of blessing or cursing a reigning dynasty, and ideally the emperor regularly attended at sites dedicated to his worship. In addition, ideally he worshiped regularly at other sites, the altars addressed to Taiyi and Houtu; Taiyi, "Grand Unity," was perhaps a stellar deity portrayed in anthropomorphic guise; Houtu was Sovereign of the Earth. There were also the very few occasions (219 and 112 BCE and 56 CE) when an emperor embarked on an arduous pilgrimage by ascending Mount Tai in the east (present-day Shandong); here he was to report on the manner in which he was conducting his charge and his stewardship of mankind. Secrecy surrounded the manner in which this was done and even the identity of the god who was thus addressed, but we may surmise that at least in 56 CE this was Heaven. Four other mountains drew particular attention as sites where a contact might be made with superior powers: Huashan, in the west (Shaanxi), Songshan in the center (Henan), Huoshan or Hengshan in the south (Henan), and one other in the north.

In the absence of a fixed and inviolate monotheistic creed, questions and conflicts might arise in identifying the supreme deities to whom services were due. Several stages of change and change-about occurred, with the issues being seen to involve the continuity of the dynasty and the stability of the throne. The major change in the state cults, from that of worshipping the Five Powers to that of addressing prayers to Heaven, was first introduced circa 30 BCE. Some protagonists favored the Five Powers in the belief that each one of these took its turn in controlling the universe

in a manner that was both comprehensible and perceptible in the heavens and on earth. Others wished to worship Heaven as a godhead known from China's tradition of the dim past. Sometimes a change from one set of services to the other was motivated by practical needs, such as that of bringing about the birth of an imperial heir; and if the change failed to bring about such a blessing, it could be reversed.[48]

Other authors in this volume and elsewhere consider the views that were held regarding the nature of human beings, be it corporeal or spiritual, and the beliefs in an afterlife.[49] They discuss how treatment of the dead and arrangements for mourning reflected an attention to rites, the constraints of the social hierarchies, an insistence on family duties, and a yearning to sustain continuities.

Controversy arose over the number of generations for which an emperor was entitled to maintain memorial shrines for his deceased ancestors; some cited traditional writings in support of seven, others in support of five. Aside from questions of propriety and the value of ancient learning, material and even political questions affected this issue; for with the passage of the generations maintenance of the shrines had become expensive, while memories of distant forebears had grown thin.

Divination could likewise present problems. Different methods applied to the same question might produce inconsistent or contradictory answers. Interpretation of the signs revealed by these practices could also be variable and could become subject to false or anachronistic intellectual suppositions. An ancient text, the *Changes of Zhou*, purported to reveal the meaning of the patterns that resulted from the cast of the milfoil stalks, but by imperial times the precise meaning of its formulae had long been forgotten; a number of varying expositions of the text were arising to

point the way to correct interpretations. In this way a process that had originally depended on the insight of a seer and a faith in his powers was being transformed into a matter of intellectual discussion and argument. In the same way, the meaning of signs such as the appearance of a comet, which had been the subject of a visionary's pronouncement, now depended on a choice among those given in lists of strange phenomena and their significance. A catalogue was taking the place of revelation. Similarly, reports that we have of complex prayers and rites designed to bring about a fall of rain correspond with a view of the universe and its operation by Five Phases; such intellectual theories are shown as taking pride of place over practices that had originated, long, long previously, in mythology or folklore.

Religious beliefs and practices that were native to China had their limitations. Only with the advent of Buddhism from the second century CE do we find Chinese taught to draw a sharp distinction between the body and its needs, and the spirit and its yearnings, and to recognize that care for the soul should take priority over that for the flesh. ○

Notes

The following abbreviations are used in the notes: HHS (*Hou Han shu*); HS (*Han shu*); SGZ (*Sanguo zhi*); SJ (*Shiji*); references are to the punctuated editions of Zhonghua shuju. The titles of Chinese books are given in characters in the glossary. Numerals that follow personal names in parentheses distinguish between individuals who bore the same family name and given name, as noted in Loewe, *A Biographical Dictionary of the Qin, Former Han and Xin Periods (221 BC–AD 24)* (Leiden, Boston, Cologne: Brill, 2000).

1 See B.J. Mansvelt Beck, in *Cambridge History of China*, vol. I, ed. Denis Twitchett and Michael Loewe (Cambridge: Cambridge University Press, 1986), pp. 369–73.
2 In 206 BCE; HS 1A.23, 23.1096; A.F.P. Hulsewé, *Remnants of Han Law* (Leiden: E.J. Brill, 1955), pp. 368–73.
3 See the statutes from Zhangjiashan entitled *Zhi lü* and *Shi lü* in *Zhang-jiashan Han mu zhu jian* [*ersiqi hao mu*] (Beijing: Wenwu chubanshe, 2001), transcriptions pp. 192–203, 203–5; documents YM6D3 and YM6D4 from Yinwan (Michael Loewe, *The Men Who Governed Han China* [Leiden and Boston: Brill, 2004], pp. 71–74); Michael Loewe, *Records of Han Administration* (Cambridge: Cambridge University Press, 1967), vol. II, documents MD 6, UD 1, UD 2; Hans Bielenstein, *The Bureaucracy of Han Times* (Cambridge: Cambridge University Press, 1980); *The Men Who Governed Han China*, p. 117.
4 E.g., Jin Midi, a Xiongnu, who rose to be one of the controlling officials of state at the death of Wudi; see *Biographical Dictionary*, pp. 196–97.
5 For this estimate, see *The Men Who Governed Han China*, p. 113.
6 See Zhangjiashan, *Jin guan ling*, and *Records of Han Administration*, vol. II, documents MD 13, UD 5, TD 8.

7 For proposals for these ventures by Chao Cuo (ca. 160 BCE) and Sang Hongyang (ca. 90 BCE), see *Biographical Dictionary*, pp. 28–29, 463. Zheng Ji was appointed Protector General in 59, possibly with a view to overseeing these projects; see A.F.P. Hulsewé, *China in Central Asia: The Early Stage: 125 BC–AD 23* (Leiden: E.J. Brill, 1979), pp. 62–65. For the establishment of agricultural colonies in the northwest, see *Records of Han Administration*, vol. I, pp. 56–57.
8 See p. 59 in this volume.
9 See *The Men Who Governed Han China*, pp. 617, 620.
10 For these disputes and their consequences, which may be summarized as follows, see H. Bielenstein, in *Cambridge History of China*, vol. I, pp. 278–87. Powerful in Mingdi's reign, the Ma family lost out to the Dou family in 82 CE; the Dou family's strength lasted, with some interruption, until 92. Empress Dowager Deng

dominated the government during Andi's reign until 121; the family of Andi's Empress Yan held a powerful position from 115 to 125; the Liang family from 128 to 159.

11 For the kings, see pp. 63, 65 in this volume.

12 E.g., see the rivalries between Chao Cuo (executed 154 BCE) and Yuan Ang, or between Xiao Wangzhi (suicide 47) and the two eunuchs Hong Gong and Shi Xian.

13 E.g., see the entry for Si Hao in *Biographical Dictionary*, p. 483. At a later stage several officials (such as Chen Xian [2] and his sons) took a deliberate and conscious decision to refuse to serve under Wang Mang; see *Biographical Dictionary*, p. 390, *s.v.* Chen Can.

14 For examples of decrees in which Wendi, Xuandi, and Yuandi requested their ministers to name their faults, in 178, 67, and 47 BCE, see *SJ* 10, p. 422; *HS* 4, p. 116; *HS* 8, p. 249; *HS* 9.82–83.

15 See *Yantie lun* 6 (29 "San bu zu") and *Qianfu lun* 3 (12 "Fu chi").

16 *HS* 60.2671, 85.3443–49.

17 For Chen Fan, see *Cambridge History of China*, vol. I, p. 319.

18 *HHS* 6.262, 63.2073–77, and 59.1910–12.

19 For Cui Shi, see *HHS* 7.297, and 52.1725–29; for Liu Tao, *HHS* 7.302–3, 57.1843–44.

20 I.e., the *Yantie lun*; for criticism voiced in a private capacity by Wang Fu (ca. 90–165) in the *Qianfu lun*, see Etienne Balazs, *Chinese Civilization and Bureaucracy: Variations on a Theme* (New Haven and London: Yale University Press, 1964), pp. 198–205.

21 Zhang Tang was Superintendent of Trials in 126 BCE and Imperial Counselor in 120 BCE; see *Biographical Dictionary*, pp. 692–94.

22 See fragments of the Statutes of Qin (217 BCE) and Han (186 BCE); also see Wang Liqi, *Yantie lun jiaozhu* (rev. ed., Beijing: Zhonghua shuju, 1992), 10 (58 "Zhao sheng"), p. 594 for recognition by a spokesman for the government (allegedly in 81 BCE) that a simplified code such as was claimed on behalf of Gaozu would not suffice to govern an empire. Also see A.F.P. Hulsewé, *Remnants of Han Law* (Leiden: E.J. Brill, 1995), p. 372.

23 See Michael Loewe, *Crisis and Conflict in Han China 104 BC to AD 9* (London: George Allen and Unwin Ltd, 1974; reprint, London: Routledge, 2005), pp. 100–101, for a summary of the exchange of views on this subject as recorded in the *Yantie lun*.

24 See *Crisis and Conflict*, pp. 96–98.

25 See *Cambridge History of China*, vol. I, p. 409; *China in Central Asia*, pp. 89–91.

26 See, e.g., Zhangjiashan Statutes, strips 337–39.

27 Zhangjiashan Statutes, strip 379.

28 See *Bureaucracy of Han Times*, pp. 4–5.

29 See *The Men Who Governed Han China*, p. 579.

30 See Zhangjiashan Statutes, strips 305–6, and *Yantie lun* 10 (57 "Zhou Qin"), p. 584, which gives the *wu* as affecting those of the order of *Guannei hou* (nineteenth order of honor) and below.

31 See Zhangjiashan Statutes, strips 201, 260, for responsibility for reporting illegal minting of coin or tax evasion; for enquiries to be put to

members of a *wu* in judicial proceedings, see Shuihudi "Feng zhen shi," strips 10, 82.

32 The term *bai xing* is not used in the Zhangjiashan material, but does appear in that of Shuihudi, as does *wan xing*; see *Shuihudi Qin mu zhu jian* (Beijing: Wenwu chubanshe, 1990; reprint, 2001), "Wei li zhi dao," 51(2).

33 Zhangjiashan Statutes, strip 189.

34 E.g., *Shuihudi*, "Feng zhen shi," strip 50; Zhangjiashan Statutes, strips 35–38; "Zou yan shu," strip 186; *Shuihudi*, "Questions and answers," strip 102.

35 For representation of a scene of human sacrifice, see *Yunnan Jinning Shizhai Shan gu mu qun fajue baogao* (Beijing: Wenwu chubanshe, 1959), pls. 52–55; *The Chinese Bronzes of Yunnan* (forward by Jessica Rawson; London: Sidgwick and Jackson, with Beijing: Cultural Relics Publishing House, 1983), pls. 1–12.

36 See Loewe, "He Bo Count of the River, Feng Yi and Li Bing," in *A Birthday Book for Brother Stone*, ed. Rachel May and John Minford (Hong Kong: The Chinese University Press, 2003).

37 Age divisions were set out as 6 years and below (*wei shi nan* and *wei shi nü*); 7 to 14 (*shi nan and shi nü*); 15 and above (*da nan and da nü*); special provisions granted degrees of status and privileges to the aged. For the distinctions of age and sex in the rations given to servicemen and their families who were serving on the frontier, see *Records of Han Administration*, vol. 2, pp. 67–70.

38 For leadership of a household, see Zhangjiashan Statutes, strip 338; for

conferment of nobilities on women, see *The Men who Governed Han China*, pp. 292–93.

39 See *HHS* 76.2462 for the undeveloped way of life of Jiuzhen Commandery (Vietnam) at the start of Eastern Han; *SGZ* 53.1251 for reports on conditions in Jiaozhou (Guangxi); and *Jin shu* 57.1560; Loewe, "Guangzhou: the Evidence of the Standard Histories from the *Shiji* to the *Chen shu*: a preliminary survey," in *Guangdong: Archaeology and Early Texts/Archäologie und frühe Texte* (*Zhou-Tang*), ed. Shing Müller, Thomas O. Höllmann, Putao Gui (Wiesbaden: Harrassowitz Verlag, 2004), pp. 51–80.

40 See *HS* 43.2113 for Lu Jia and the *Xin yu*.

41 For the adoption of Heaven, see p. 72 in this volume.

42 See *Chinese Civilization and Bureaucracy*, pp. 205–13.

43 See Michael Loewe, *Divination, Mythology and Monarchy in Han China* (Cambridge: Cambridge University Press, 1994), pp. 142–60.

44 See ibid., pp. 40–41.

45 See ibid., chaps. 8, 9, 10.

46 See Li Junming, *Zhongguo zhenxi falü dianji jicheng* (Beijing: Kexue chubanshe, 1994) p. 131, citing EPT 20.4A,B; EPF 22.153–61 from *Juyan xin jian* (Beijing: Wenwu chubanshe, 1990), pp. 69, 486–87.

47 See Michael Loewe, *Ways to Paradise: The Chinese Quest for Immortality* (London: George Allen and Unwin, 1979), pp. 98–100.

48 Most of these changes occurred during the somewhat troubled and insecure reign of Chengdi (33–7 BCE); see *Crisis and Conflict*, chap. 5.

49 See "Funerary practice in Han times," in Cary Y. Liu, Michael Nylan, and Anthony Barbieri-Low, *Recarving China's Past: Art, Archaeology, and Architecture of the "Wu Family Shrines"* (Princeton: Princeton University Art Museum; New Haven and London: Yale University Press, 2005), pp. 99–118.

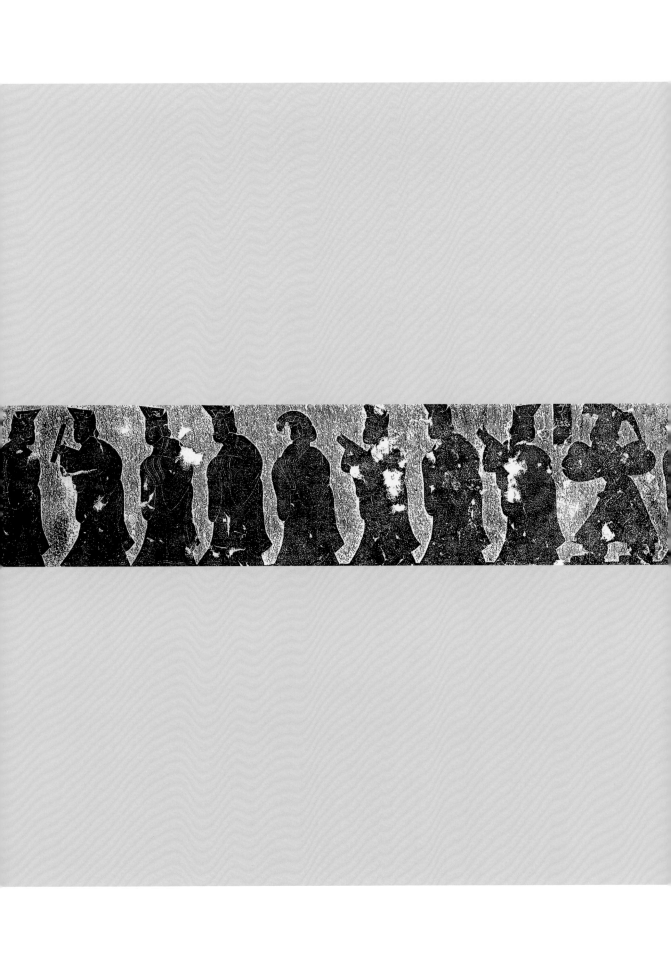

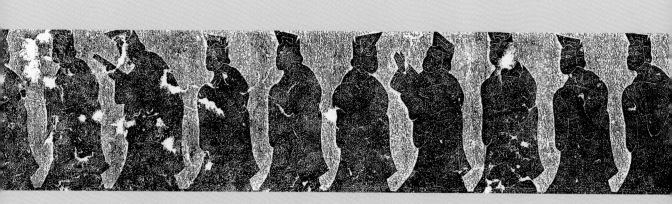

PART TWO HAN FUNERARY ART AND ARCHITECTURE
IN SHANDONG AND BEYOND

Ritual, Art, and Agency: Consecrating the Burial Ground in the Eastern Han Period

LYDIA THOMPSON

Introduction

In his catalogue essay "Carving Out a Living: Stone-Monument Artisans during the Eastern Han Dynasty," Anthony Barbieri-Low has shown us how the production of stone funerary monuments in the Han period was streamlined and standardized through efficient modes of production.[1] This made it possible for provincial families of moderate means to emulate the lavish shrines and tombs of the nobility and make a show of filial piety, important social currency of the time. In this paper I too shall examine the production of stone carvings, but from a different perspective; as part of the ritual process of transforming the burial site into a sacred space for the deceased.

In the Han period the cosmos was conceived of as a holistic system of resonant relationships between Heaven and earth. Representations and objects used in ritual were regarded as "agents" capable of generating a response from Heaven, thereby altering environments and events in the earthly domain. In the context of Han epistemology, ritual art, in the words of anthropologist Arthur Gell, is more about "doing" than "communicating."[2] He argues that this kind of art "should be viewed as a system of action intended to change the world rather than to encode symbolic propositions about it." The anthropologist Christopher Gosden has argued that human relations are mediated by objects; that material culture is at the heart of social relations.[3] Therefore you could argue that Han funerary art functions, in Gosden's words, as "social agents" playing a mediating role between the living and the dead. Carved in stone, arranged according to the cosmic order, and consecrated by ritual, Eastern Han tombs and their images were intended as artifactual embodiments of ritual performance, and were thought to forge a mutually beneficial relationship between the living and the dead.

In the following I shall outline the process of making the burial site sacred, from site selection, to tomb layout, to placement and execution of the carvings. I shall also consider the role of craftsmen in making the tomb a ritually efficacious site.

Selection and Orientation of the Burial Site

The selection of an auspicious place and time for burial were standard practices in the Han period. Mention of specialists commissioned to divine an auspicious place for burial are found in Han ritual texts and in stele inscriptions.[4] Of these texts, "The Mourning Rites of the Gentleman" section of the *Yili* (*Ceremonials*) contains the most detailed description of the process of selecting a burial site. According to this passage, the persons involved included divination specialists, cemetery keepers, and mourners. It tells us that the "grieving son" consulted with diviners who manipulated yarrow stalks and drew diagrams to determine the right orientation of the burial site. The symbols were then interpreted by the diviner and communicated to the family of the deceased.[5]

The divination of auspicious days for significant ritual and life events is also well documented in Han period texts.[6] In the *Lunheng* (*Doctrines evaluated*), an entire chapter, the "Calendar of Burials," is devoted to divination of burial days and times. Michael Loewe has argued that Ganyu, one of the best-documented schools of divination, was concerned with the selection of propitious times. He argues that the term *ganyu* refers to the instruments used to forecast the results that could follow from actions undertaken at a particular time. One of the instruments thought to be used was the *shipan*, a diviner's board often found in Han-period tombs.[7] The *shipan* consisted of a square board and a round disk, which were diagrams of earth and Heaven, respectively. At the center of the disk

was the Northern Dipper, which was rotated to determine whether the proposed actions would have a favorable result. The presence of *shipan* in some Han-period tombs indicates that they might have been used to determine the right time for burial.

Pillar Tombs in the Eastern Han Period

I have argued elsewhere that Yinan M1, by its orientation, layout, structural components, and imagery, acted to guide the deceased to the sacred center. Functioning as a kind of cosmic diagram, the organizing principles underlying the tomb's structure were the four cardinal directions and the center (fig. 1). The two main chambers are square, with doors marking north, south, east, and west. In the center of each chamber are eight-sided carved pillars. A burial document dating from 179 CE indicates that tombs were conceptualized as embodying the central axis. In the burial document the Lord of the Soil is asked to establish the tomb's boundaries, not only on a horizontal plane according to the four directions, but also vertically, from the underworld below to Heaven above. Another burial document, dating from 161, also describes the tomb's boundaries as being demarcated on both horizontal and vertical axes. Only here the center is described as a *mingtang* (fig. 2). Conceived of as an architectural representation of Mount Kunlun, the *mingtang*, or Brilliant Hall, constituted a building set in the center of a square, walled enclosure with gates leading in the four directions. Just as the *mingtang* functioned as a sacred center where the Son of Heaven would commune with the Supreme Deity, so the pillars located at the heart of the tomb functioned as a sacred center, which gave the deceased access to supernatural and divine realms.[8] The tomb in general and

the pillars in particular occupy, as Cary Liu has observed of *mingqi*, a medial zone between the living and the dead.[9]

The pillar in the front chamber is carved in high relief with imagery of the underworld, the Lord of the Soil (Houtu), demon-quellers, guardian animals, etc. (fig. 3). The pillar in the central chamber is engraved with imagery relating to Mount Kunlun, including the Queen Mother of the West (the winged, canopied figure at the top of the central panel) and King Father of the East (on the opposite side of the pillar, and not visible in this drawing) (fig. 4). The supporting brackets are carved in the shape of dragons, which appear to swoop down from Heaven above (fig. 5). All together, the pillars function as an *axis mundi*, establishing the tomb as the zone of the sacred, linking Heaven, earth, and the underworld.

Four other Shandong area tombs feature pillars as important structural and symbolic components. They include: a tomb excavated at the Changli Reservoir in northern Jiangsu Province, and tombs discovered at Dawenkou, Mengzhuang, and Anqiu in central Shandong.[10] The basic layouts of these tombs are similar. Although some are more elaborate than others, with middle and side chambers, all are positioned on a north-south axis, and have front chambers and partitioned rear chambers where the bodies of the deceased couple were laid. Although the imagery varies from one pillar to the next, all of it relates to underworld and divine realms, evoking the central axis.

The carving style of the pillar and brackets of the Changli tomb most closely resembles the pillar in the central chamber at Yinan. Lightly incised onto the eight-sided pillar in the front chamber are frontally facing figures, presumably the deceased, ascending guardian animals, and traces of a crowned figure at the top, likely the Queen Mother

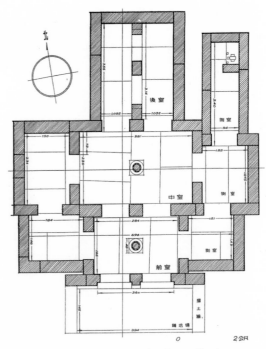

Fig. 1 *Plan of Tomb M1 at Beicun, Yinan County, Shandong.* From Zeng Zhaoyu et al., *Yinan gu huaxiang shi mu fajue baogao* (Shanghai: Wenhua guanli ju, 1956), fig. 2.

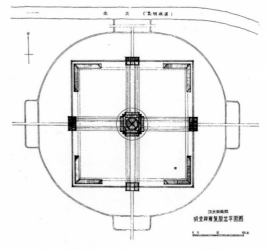

Fig. 2 *Plan of* mingtang *excavated in Chang'an area.* Yang Hongxun, "Cong yizhi kan Xi Han Chang'an mingtang (biyong) xingzhi," in *Jianzhu kaoguxue lunwen ji* (Beijing: Wenwu chubanshe, 1987), fig. 34.

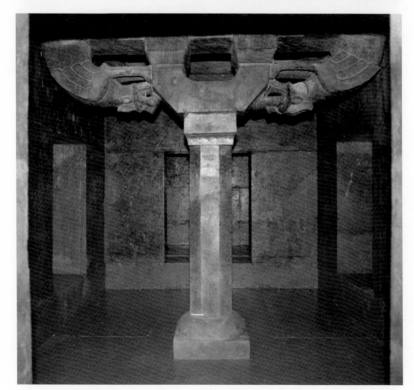

Fig. 3 *Pillar in front chamber of Tomb 1 at Beicun, Yinan County, Shandong* (details). Photos by author, 1997.

Fig. 4 *Drawing of engraving on pillar in central chamber of Tomb 1 at Beicun, Yinan County, Shandong.* From Zeng Zhaoyu et al., *Yinan gu huaxiang shi mu fajue baogao* (Shanghai: Wenhua guanli ju, 1956), pl. 66.

Fig. 5 *Dragon brackets in central chamber in Tomb 1 at Beicun, Yinan County, Shandong.* Photo by Zheng Yan, 1997.

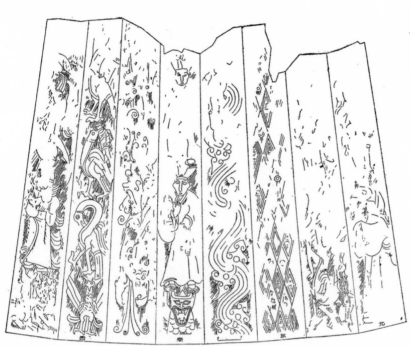

Fig. 6 *Drawing of engraving on pillar in front chamber of tomb at Changli Reservoir, Jiangsu.* Nanjing bowuyuan, "Changli shuiku Han mu fajue jianbao," *Wenwu* 1957.12, p. 38.

Fig. 7 *Diagram of side view of tomb at Changli Reservoir, Jiangsu.* Nanjing bowuyuan, "Changli shuiku Han mu fajue jianbao," *Wenwu* 1957.12, p. 36.

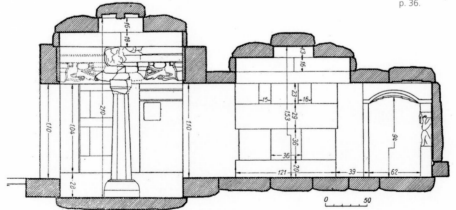

Fig. 8 *Rubbing of central pillar in front chamber of tomb at Dawenkou village, Taian City, Shandong*. From *Zhongguo huaxiang shi quanji*, vol. 1: *Shandong Han stone engravings* (Jinan: Shandong meishu chubanshe, 2000), p. 180, no. 234.

of the West (fig. 6). The pillar's supporting brackets are carved into the shape of dragon heads, which are seen in figure 7.

As at Changli, a tomb excavated at Dawenkou has a relatively simple layout, with a front chamber flanked by two side chambers and a partitioned rear chamber. The pillar located in the center of the front chamber is carved with human figures which chase and grapple with bears, birds, dragons, and other guardian animals (fig. 8). Although this could be interpreted as a battle, it has a stylized quality, more like a ritualized enactment or dance than a violent engagement. The deep-cut style of carving and the figures with upraised arms resemble imagery found on the pillar in the front chamber at Yinan.

The Mengzhuang tomb, with multiple rooms and ten columns/pillars, is more complex. The imagery resembles that of Dawenkou but is overtly sexual in nature (fig. 9). The columns are densely carved with animal and human figures battling, dancing, playing, embracing, and engaging in sexual intercourse. The genitals of several of the figures are depicted. I have argued elsewhere that this imagery pertains to agricultural and fertility rites that took place during festivals at the end of the harvest. On the upper and lower registers of the round pillar in the front chamber, two figures, one wearing breeches and a cap, the other, flowing garments, are supported and protected by what appear to be Han soldiers and guardian animals. The frontal posture suggests that they are the deceased couple. To the right of the female figure, a couple is having sex. The presence of the deceased couple being protected on their journey to the afterlife provides a context for these images of fertility: that the successful journey of the deceased to the afterlife will lead to prosperity and progeny for the living. Inscriptions on Eastern Han mirrors often link the two: "…the Yi barbarians of the four directions have submitted. Much congratulation to the country. The people can rest. The Hu

Fig. 9 *Rubbing of pillar on west side of front chamber from tomb at Mengzhuang, Pingyin County, Shandong* (detail). From *Zhongguo huaxiang shi quanjji*, vol. 3: *Shandong Han stone engravings* (Jinan: Shandong meishu chubanshe, 2000), pp. 170–71, no. 191.

Fig. 10 *Pillar in central chamber of tomb at Dongjiazhuang, Anqiu City, Shandong.* Photo by author, 1997.

prisoners have been exterminated or destroyed. All-under-Heaven is restored. The wind and rain are timely. The five grains ripen. Eternal protection for our parents.... Transmit limitless happiness to the descendants."[11]

Imagery related to fertility is also found on the three pillars in the tomb at Anqiu (fig. 10). Human figures stick out their tongues, embrace, and dance with each other. A kneeling figure touches the belly of a pregnant woman. On another pillar a figure touches the belly of a pregnant bear, a woman nurses her child, and intertwined human figures evoke the fecundity of life.

At Changli and Yinan, the deceased's successful journey to Mount Kunlun is implied by the presence of the Queen Mother of the West at the top of the pillar. In the Anqiu tomb and elsewhere, imagery of Mount Kunlun and heavenly phenomena located on the ceiling signify the heavenly domain, the hoped-for destination for the deceased (fig. 11).[12] Images of heavenly bodies

and constellations commonly found on ceilings of tombs may have functioned as divination diagrams, intended to permanently locate the dead in an ideal time for conveying him to paradise.[13]

In all of the above examples, the tomb's structure, imagery, and space are integrated, establishing the tomb as a sacred center. Done correctly, art created for ritual could generate sympathetic resonance between heavenly and earthly phenomena, leading to positive outcomes for the living. Even Wang Chong (27–97 CE), a skeptic who ridiculed the popular belief in ghosts and demons, adhered to the prevailing view that the cosmos was a holistic system of resonant relationships between Heaven and earth. By way of example, Wang Chong argued that fashioning clay dragons was effective in producing rain and that peachwood statues of demon quellers had the power to protect the living from malicious spirits. " … District magistrates have peach trees cut down and carved into human statues, which they place by the gate, or they paint the shapes of tigers on the door screens. Now, peachwood statues are

not Shen Shu and Yu Lu, and painted tigers are not ghost-eating tigers. Nonetheless, these carvings and paintings ward off evil influences."[14]

That peachwood statues were assigned the power of warding off evil suggests that the process of fashioning a ritual object, mortuary sculpture, painting, or relief carving may not have been viewed simply as manufacture but as transformation. Yet what was the process by which materials such as stone, wood, clay, and pigment were thought to be transformed from mundane elements to numinous objects? Archaeological and textual evidence tell us that artifacts and representations were thought to be rendered efficacious in a number of ways; by carefully selecting the source of the materials and the day of manufacture, by the skill of the craftsman and, possibly, by ritual consecration.

Materials

The materials used to fashion burial objects and construct the tomb, such as jade, bronze, and stone, were associated with the land of the Immortals. In

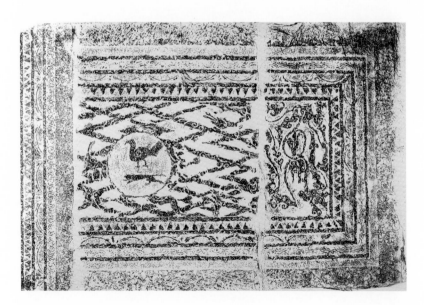

Fig. 11 *Rubbing of relief on ceiling of tomb at Dongjiazhuang, Anqiu City, Shandong.* From *Zhongguo huaxiang shi quanji*, vol. 1: *Shandong Han stone engravings* (Jinan: Shandong meishu chubanshe, 2000), no. 153 (p. 112).

Han mirror inscriptions and steles, jade and stone were regularly invoked as metaphors for longevity and immortality, as exemplified by such phrases as "longevity like stone and metal."[15] Stone tombs and coffins are commonly referred to as "longevity vaults," ("longevity pavilions," or, for an imperial occupant, "longevity palace"). According to the *Shanhaijing* (*Classic of mountains and waterways*) and the *Hanshu* (*History of the Western Han*), the Queen Mother of the West resided in a stone chamber.[16]

The pigment found on some engraved stones in Eastern Han tombs was probably viewed as having a transformational function. In Shandong Province traces of red have been found in some tombs and polychromy in others. In Yinan M1, red, black, green/blue, and yellow pigments remain on the ceiling in the rear chamber and red pigment is still visible in the mouths of the dragon brackets (figs. 12, 13). Wang Chong tells us that ritual sculptures such as clay dragons were painted green and yellow, then clothed in red silk, while their handlers, the invocators, were dressed in black.[17] These colors obviously connoted, and were held to resonate with, the Five Phases. The use of these colors in the tomb was likely also intended to assure its proper alignment with cosmic forces.

Time and Place

As discussed earlier, divining the right place for burial was the foundation for site selection. Inscriptions on mirrors and steles tell us that the source of the material was also important to creating a numinous object. In some mirror inscriptions a specific place is mentioned, as in: ''Han has good copper which comes from Danyang.'' In others the source is identified in generally auspicious terms, such as *ming shan*, or "famed mountains." Commemorative inscriptions on tombs and shrines routinely

Fig. 12 *Ceiling of rear chamber of Tomb 1 at Beicun, Yinan County, Shandong.* Photo by author, 1997.

Fig. 13 *Dragon bracket in central chamber of Tomb 1 at Beicun, Yinan County, Shandong.* Photo by Zheng Yan, 1997.

state that the stones used to construct them were quarried from areas in the south, vaguely described as the "southern hills" or "south of the southern hill."[18] The south, of course, correlates with the *yang* force, rebirth, and immortality.

The selection of an auspicious time for production also played a role. A number of late Eastern Han mirror inscriptions list the cyclical day *bingwu* of the first or fifth month as the date of their production; that day does not exist in the cyclical calendar. The term *bingwu*, however, is highly resonant with *yang* forces, *bing* corresponding to fire and *wu* to the sun at its height:

a "*bingwu* day" would have been considered efficacious for casting bronze.[19] The same day is mentioned in two stele inscriptions as the completion date of the shrines. Both inscriptions state that the shrines were completed when Taisui, the imaginary asterism associated with averting evil, was in the position of *bingwu* or *wu*.[20] In the same vein, the *Chunqiu fanlu* (*Luxuriant dew of the spring and autumn annals*), ascribed to Dong Zhongshu (ca. 179–ca. 104 BCE) tells us that the manufacture of clay dragons used in rituals seeking rain "should take place on a water day." In all of these examples, the date of manufacture is selected to resonate with the cosmic force corresponding to the desired outcome.

Craftsmen

Han texts and inscriptions tie the efficacy of the object to the skill of the craftsman. One mirror inscription tells us that the source of the material and the skill of the craftsmen were key to producing an object powerful enough to confer longevity and blessings on the deceased and his descendants:

As for the mirror's nature of ancientness,
 it is characterized by its solid durability.
Residing in the famed mountains, it awaited
 the laborer.
Smelting (refining) extracted its essential
 efflorescence, causing its radiance
 to be bright.
It elevates lofty uprightness and advances
 family closeness.[21]

Here the metal's potential power is portrayed as lying dormant in the famed mountains, and it is the artisan's skill that brings out the metal's *yang* potential, its efflorescence and radiance. Here the mirror acts as an agent, advancing family closeness,

and engendering a positive relationship between the living and the dead. The inscription goes on to say that extraction of these qualities helps smooth the transition of the deceased to the land of the Immortals.

Suzanne Cahill has shown how the language used to describe mirror casting resembles fourth-century texts on Daoist alchemy.[22] One Eastern Han mirror inscription reads: "In seclusion I have refined the *gong* ("earth") element and the three *shang* ("metal") elements." The phrase "in seclusion" refers to the Daoist alchemist's practice of secluding himself to "refine" (again a Daoist term) ingredients used in elixirs of immortality.[23] Such language suggests that artisans were regarded as potentially having supernatural abilities, capable of manipulating earth's elements to produce objects with talismanic and transformational properties.

Although the stone worker's craft is not described in such explicitly Daoist terms of transformation, nonetheless, the language used is auspicious and evocative of ritual perfection. Like the mountains that were the source of the material, master artisans are referred to as *ming*, meaning "brilliant" or "well-known."[24] In one inscription the craftsman is referred to as brilliant (*ming*), a term that, as Cary Liu has proposed, is associated with cosmic equilibrium and reserved for ritual and burial objects.[25]

One of the characteristics of the Jiaxiang school of carving is the geometric perfection of the figures. Compasses were used to render the perfect arcs that denoted carriage wheels, horses' rumps, and outlines of people, while try-squares were used to render short line segments.[26] In an inscription dating from 157 CE, the phrase "[zhuoli mozhi] guiju shizhang" is used to describe the process of cutting, polishing, and laying out the quarried stones.[27] Literally the phrase can be

translated as "a compass and square were used to lay out the stones." Figuratively, it can be translated as "they were measured," or, as Ruitenbeek has translated it, "laid out according to the rules."[28] Either way, it is clear that precision was deemed important.

In Han and pre-Han texts and imagery the compass and the square are not only tools of precise measurement for the stone carver, draftsman, and carpenter, but also signifiers of the creation and accoutrements of the creators of Heaven and earth. In several Han reliefs the creation deities Fuxi and Nüwa are shown clutching try-square and compass, respectively, their intertwined serpentine tails representing the union of Heaven and earth, as seen in this carving from the Wu family shrines (fig. 14). In the *Mengzi*, the skill of the artisan is related both to his clairvoyance and to his tools, the compass and the square. Here standards and precision make for ritual perfection rather than simply a more efficient mode of production. To paraphrase Suzanne Cahill: "By creating a product that is as standard and as permanent as he can make it….[the artisan makes it] immortal."[29]

In both received literature and inscriptions the character *qiao* is used to describe the craftsman's capabilities. It is a term that has both material and magical connotations. Klaas Ruitenbeek has observed that the carpenter has "'…personified the ideal of *qiao*, technical skill'…since the days of Mencius and Mozi…. The word has a strong connotation of artfulness, and correspondingly the carpenter may figure both as a diligent and honest craftsman and as an evil sorcerer whose way it is better to keep out of."[30] When the artisan's skill is put to artful ends, the manipulation of the material could lead to miraculous results. Wang Chong cites Lu Ban, the patron divinity of carpenters, who was

able to produce kites that could fly for three days. He then concludes that clay dragons were capable of generating rain, attributing this to their makers' skill or *qiao*.

…If those who make clay dragons are as skilled (*qiao*) as Lu Ban and Mozi, then what they produce will belong to the same category as the wooden kites that fly for three days. Now the *qi* ("essence") of kites is the same as the *qi* ("essence") of clouds and rain. This *qi* allows the kites to fly. Why should the clay dragon be the only thing that *qi* can not follow?[31]

In this passage skill has crossed over into magical efficacy. The artisan is able to imbue his representation with the same essence as clouds and rain, thereby stimulating rain.

Accordingly, in Han commemorative steles, the master masons, designers, and draftsmen receive a measure of respect, their names found together alongside those of their patrons.[32] Some Han inscriptions reveal a palpable anxiety that, if the artisans were not treated generously and with respect, their skill could be turned to bad ends. An inscription dating from 154 CE states: "We served these master workmen carefully morning and night, fearing to lose their favor and thus become unable to express our thanks to Heaven and our gratitude to our parents."[33] Contained in this inscription is an explicit caution, that if workmen are not treated well, the monument will be poorly executed, causing the message of gratitude to be lost, with disastrous consequences for the descendants. Anthony Barbieri-Low has argued that the inscriptions found on this stele and others are formulaic and likely written by the artisans themselves. Consequently, praise of the artisans and the claims of magical efficacy of their work

Fig. 14 *Fuxi and Nüwa.* "Wu Family shrines" rubbing. Detail. Princeton University Art Museum, acc. no. 2002.307.17.

is evidence more of their self-aggrandizement than of their customers' esteem. Nonetheless, that their employers allowed such messages to be included on their monuments is a tacit acceptance of the artisans' claims of the magical efficacy of their craft.

This association between craftsmanship and sorcery is found in much later texts, such as the *Lu Ban jing* (*Classic of carpentry*), published in the fifteenth century, and the *Jiabao quanji* (*Complete collection of household treasures*), a seventeenth-century encyclopedia. The former is addressed to artisans and offers tips on how to practice sorcery should their customers turn out to be stingy or difficult. The latter takes the side of the customer/ patron, advising how to avoid becoming a victim of artisan's sorcery: Again, stinginess is the primary offense cited:

In general, sorcery is suggested to the carpenters by the clients' exaggerated stinginess and preoccu-pation with trivialities. In my opinion it is absolutely necessary to serve meat once every four or five days. If in addition to that you put on a friendly face and speak kind words, if you treat them leniently when you know that they are suffering

from hunger and cold, then the carpenters will no doubt produce their best efforts for you.[34]

Finally, I suggest that ritual consecration may have played a part in activating the imagery. Again turning to Wang Chong, he tells us that the spirit (*jingshen*) of the clay dragons was activated at the time of the rain ritual. He writes: "If the spirit of Zhi Du (a deified Xiongnu military hero) is in the figurine then the heavenly dragon's spirit is in the clay dragon. If the spirit of the Xiongnu is in the wooden figure, then the spirit of those performing the rain ritual is also in the clay dragon."[35]

According to Wang Chong, the clay dragon's spirit (*jingshen*) comprises the union of the spirits of both the heavenly dragon and those performing the rain ritual. Extrapolating from this, it is possible that activation of the imagery in tombs and shrines took place during funeral rites when ritual special-ists and mourners entered the tomb to inter the remains of the deceased. Pausing in each chamber, conducting rites while contemplating the imagery, the funeral-goers may have invested the imagery with *jingshen*.

In this paper I have suggested that ritual and representation were parts of an interdependent

system. The burial time and place; the tomb's orientation and layout; the selection of material, subject matter, and placement of the imagery; and date of the monument's completion all contributed to the transformation of the site selected for burial into a sacred space for the deceased. Moreover, the efficacy of relief carvings was contingent on several conditions, including the skill of the artisan and possibly activation during ritual. Placed within this ideal time and place, the deceased was aligned with positive cosmic influences and could be expected to confer blessings on the living. ◉

Notes

1 Anthony Barbieri-Low, "Carving Out a Living: Stone-Monument Artisans during the Eastern Han Dynasty," in *Recarving China's Past: Art, Archaeology, and Architecture of the "Wu Family Shrines"* (Princeton: Princeton University Art Museum; New Haven and London: Yale University Press, 2005), pp. 485–511.
2 Arthur Gell, *Art and Agency: An Anthropological Theory* (Oxford: Clarendon Press, 1998), pp. 6–12.
3 Christopher Gosden, *Anthropology and Archaeology: A Changing Relationship* (London and New York: Routledge Press, 1999).
4 Yang Shuda, *Han dai husang lisu kao* (Shanghai: Shanghai wenyi chubanshe, 1933), p. 146; Michael Loewe, *Divination, Mythology and Monarchy in Han China* (Cambridge: Cambridge University Press, 1994), pp. 177–78.
5 *Yili*, Ruan Yuan et al., eds. *Shisanjing zhushu* (Beijing: Zhonghua shuju, 1979), *juan* 37, pp. 1142–43.
6 For a discussion of this, see Lydia Thompson, "The Yinan Tomb: Narrative and Ritual in Pictorial Art of the Eastern Han (25–220 CE)," (PhD diss., New York University, Institute of Fine Arts, 1998), pp. 309–10.
7 For a summary, see Lan-ying Tseng, "Picturing Heaven: Image and Knowledge in Han China" (PhD diss., Harvard University, 2001), pp. 36–39.
8 Thompson, "The Yinan Tomb," pp. 152–84.
9 Cary Liu, "The Concept of 'Brilliant Artifacts' in Han-Dynasty Burial Objects and Funerary Architecture: Embodying the Harmony of the Sun and the Moon," in *Recarving China's Past*, p. 211.
10 Though none of these tombs have inscriptions, it is likely that this group of pillar tombs dates to the late Eastern Han. For a discussion of all of these tombs except Mengzhuang, see Thompson, "Yinan Tomb," pp. 49–62. Moreover, an inscribed stone *que* dating from 178 CE, found in neighboring Ju County, includes an image of a figure seated under a tree that is very like the image of Cang Jie in the middle chamber at Yinan. For a transcription of the inscription, see Wang Sili, ed., *Ju Xian wenwu zhi* (Jinan: Qi-Lu shushe, 1993), p. 130; for an image, see Zhongguo hua-xiangshi quanji bianji weiyuanhui, ed., *Zhongguo huaxiangshi quanji 3, Shandong Han huaxiang shi* (Jinan: Shandong meishu chubanshe, 2000), pl. 140.
11 Lydia Thompson, "Demon Devourers and Hybrid Creatures: Traces of Chu Visual Culture in the Eastern Han Period," *Yishu shi yanjiu*, vol. 3 (2001), pp. 280–82.
12 Susan Beningson observes that, as at the Yinan tomb, the pillars in the Anqiu tomb may have outlined a path toward the afterlife for the soul of the deceased. Susan Beningson, "Chariot Canopy Shaft Fitting: Potent Images and Spatial Configurations from Han Tombs to Buddhist Caves," *Recarving China's Past*, p. 348.
13 For a discussion of star maps used for prognostication as a source for constellation images in tombs, see Tseng, "Picturing Heaven," pp. 183–91.
14 Huang Hui, annot., *Lunheng jiaoshi* (1938; reprint, Beijing: Zhongshu chubanshe, 1990), vol. 3,

juan 16, p. 699. Translations based on Alfred Forke, *Lun-heng* (New York: Paragon Book Gallery, 1962), vol. 2, pp. 352–53.

15 For a detailed discussion of the implications of this term as it appears in mirror and stele inscriptions, see K.E. Brashier, "Longevity like Metal and Stone: The Role of the Mirror in Han Burials," *T'oung Pao*, vol. LXXXI (1995), p. 223.

16 Wu Hung, *Monumentality in Early Chinese Art and Architecture* (Stanford: Stanford University Press, 1995), pp. 129–35.

17 Loewe, *Divination*, pp. 145–46.

18 See Xiang Tajun inscription in Luo Fuyi, "Xiang Tajun shi citang tizi jieshe," *Gugong bowuyuan yuankan*, vol. 2 (1960), pp. 178–80. Also see Wu Hung, *Monumentality*, p. 239.

19 Michael Loewe, "Dated Inscriptions on Certain Mirrors (AD 6–105): Genuine or Fabricated?" *Early China*,

vol. 26–27 (2001–2002), pp. 227, 250.

20 Wu Hung, *Monumentality*, p. 239.

21 Inscription found in Brashier, "Like Metal and Stone," p. 224.

22 Suzanne Cahill, "The Word Made Bronze: Inscriptions on Medieval Chinese Bronze Mirrors," *Archives of Asian Art*, vol. 36 (1986), p. 64.

23 Ibid.

24 See Wu Hung, *Monumentality*, p. 239.

25 Ibid. Also Liu, "The Concept of 'Brilliant Artifacts'," pp. 212–13.

26 Ibid. Also Barbieri-Low, "Carving Out a Living," p. 488.

27 For a transcription, see Li Falin, *Shandong Han huaxiang shi* (Jinan: Qi-Lu shushe, 1982), p. 105.

28 Klaas Ruitenbeek, *Carpentry and Building in Late Imperial China: A Study of the Fifteenth-century Carpenter's Manual "Lu Ban Jing"* (2nd ed.; Leiden: E.J. Brill, 1996), p. 24.

29 Cahill, "The Word Made Bronze," p. 67.

30 Ruitenbeek, *Carpentry and Building*, p. 24.

31 *Lunheng jiaoshi*, vol. 3, *juan* 16, pp. 699–700; Forke, *Lun-heng*, vol. 2, p. 253.

32 A stele dating from 183 includes the name of the stonemason alongside of prominent members of the local community, including the governing chancellor and district prefect. See K.E. Brashier, "The Spirit Lord of Baishi Mountain: Feeding the Deities or Heeding the Yinyang?" *Early China*, vols. 26–27 (2001–2002), pp. 230–31.

33 Trans. Wu Hung, *Monumentality*, p. 239.

34 Trans. Klaas Ruitenbeek, *Carpentry and Building*, p. 111.

35 *Lunheng jiaoshi*, 16, pp. 700–1; Forke, *Lun-heng*, vol. 2, p. 354.

Concerning the Viewers
of Han Mortuary Art

ZHENG YAN

A distinctive art-historical feature of the Han dynasty, when compared with the Bronze Age, is the flourishing development of pictorial carvings on flat surfaces, as recorded in epigraphic and archaeological literature. Studies of mortuary stone and brick carvings, as well as polychrome wall paintings in tombs, focus on interpretation of inscriptions, architectural reconstruction, and iconographic analysis, both historically and symbolically. As many scholars have pointed out, investigations into the cultural significance of tomb iconographies must include an understanding of the various social behaviors connected with image making. For example, Wu Hung considers the functions of Han mortuary architecture from the perspectives of four social groups: families, friends and colleagues, the deceased, and the builders.[1] In developing my argument for this study, I follow Wu's general line of inquiry, which centers on the connection between those social groups and the mortuary structures and their pictorial decorations. My discussion will include the viewers (*guanzhe*) as well, who had no role in determining mortuary decoration, but whose opinions may well have been considered by the aforementioned four groups.

Documentation of early pictorial art, such as the wall paintings in temples and shrines in the Chu kingdom, described in the *Tianwen* (*Heavenly questions*), attributed to Qu Yuan (ca. 343–ca. 227 BCE),[2] or the *Rhyme-prose on the Lingguang Hall of the Lu Kingdom* (*Lu Lingguang dian fu*), composed by Wang Yanshou (132–192 CE),[3] are records transmitted by viewers. Our writings and lectures about Han pictorial carvings are all results of "viewing." Generally speaking, there are two types of viewing audiences, the first being those expected by the sponsors and makers of the carvings.[4] They were the principal viewers

for whom the carvings were made and through whose participation the religious, ritual, and social functions were fulfilled. The second type of viewers encompasses those of whom the donors and makers presumably took no account—often those whose lives postdated the making of the carvings. Their engagement with the carved images existed essentially outside the ritual function of the original carvings, and their understandings of the images may sometimes have been different from those intended. Since the complex and dynamic relationship between the later viewers and the images merits a separate study,[5] this paper focuses on the first group—those expected by the sponsors and makers.

Viewers of Pictorial Carvings in Offering Shrines

Extant Han stone shrines preserve richly carved images whose meanings can only be realized and communicated through the participation of viewers. The primary function of offering shrines is related to sacrifices on burial sites, since, according to Wang Chong's *Lunheng* (*Doctrines evaluated*), "The tomb [i.e., the cemetery site including the tomb and shrine] is where the ghosts and spirits dwell, and the site for making sacrifice."[6] This primary function thus dictates two types of expected viewers:

1. The shrine dedicatees.
The shrine dedicatees, believed to still possess consciousness and the ability to see after death, are the owners of the entire iconographic contents of the shrine and tomb (see below). They can see and own the kitchens and enjoy the entertainments depicted in the carvings in the same way as they receive the food placed on the offering tables. The vast material wealth and spiritual virtue offered in visual form by the patrons were actual to the dedicatees, but to the living these pictorial objects were

"things that were prepared but could not be used."[7] The carvings substituted for what they depicted, analogous to the Chinese saying: "Drawing a cake to ease hunger" (*huabing chongji*). For the deceased, on the other hand, the carved images and the *mingqi* (funerary goods) were all real.

2. People who perform sacrifices and make offerings at tomb sites.
These include both the filial sons and brothers of the deceased, who hired craftsmen to build the shrines, and their offspring. The Wu Liang stele inscription, for example, after relating the background and context of the construction and decoration of the Wu Liang Shrine in the Eastern Han Wu cemetery in Jiaxiang, Shandong, includes a wish that the images carved on the walls be "transmitted to posterity, [so that they will] not be forgotten for ten thousand generations."[8] This expression is reminiscent of similar hopeful inscriptions cast in many Shang and Zhou bronze vessels, such as: "[It is hoped this vessel can] be forever treasured by generations of offspring." The patron's desire for the durability of the offering shrine is also demonstrated by the choice of stone as the building material, as stone's imperishability is aptly suggested by the congratulatory phrase: *shou ru jin shi* ("life lasting as long as metal and stone"). The most important pictorial theme for this group of viewers is the homage scene, occupying the center of the shrine's main wall, because it is through visual engagement with the deceased portrayed in this scene that the descendants come to communicate with the spirits of their ancestors.[9] Viewing the images, their descendants not only pay tribute to their departed loved ones, but also pray for ancestral blessings.

The existence of mindless vandals is attested by cartouche inscriptions carved adjacent to the

Fig. 1 *Yongyuan Stone Fragment inscription dated to 91 CE.* From an offering shrine in Tengxian, Shandong Province. From *Zhongyang yanjiuyuan lishi yuyan yanjiusuo cang Handai shike huaxiang taben jingxuan ji*, p. 62.

Fig. 2 *Inscription dated to 154 CE.* From Xiang Tajun offering shrine, Dong'e, Shandong Province. From *Gugong bowuyuan yuankan*, vol. 2 (1960), p. 180.

pictorial images, as exemplified by the inscription on the Yongyuan Stone Fragment (Han Yongyuan canshi) believed originally to have been part of an offering shrine, found in Tengxian, Shandong:

[The shrine]…completed on the fourth month of the third year of the Yongyuan reign-period (91 CE); we wish that it will be transmitted to later generations. Respectfully we ask all gentlemen: Please do not destroy or damage it. Please do not destroy or damage it (fig. 1).[10]

Viewers are explicitly mentioned also in the inscription in the putative offering shrine dedicated to Xiang Tajun and his wife by their sons Xiang Wuhuan and Xiang Fengzong. It is carved on a

column of the shrine, excavated in 1934:

You, the esteemed visitors: Please do not climb the walls and incur damages. May you live for ten thousand years, and your family enjoy wealth and prosperity" (fig. 2).[11]

The inscription in the An Guo shrine, discovered in 1980 in Songshan, Jiaxiang, is a long text of 461 characters. Written in the twelfth month of the third year of the Yongshou reign-period (158 CE), the message to the viewers is delivered like a sincere plea from the patron:

You, observers: Please offer your pity and sympathy. Then may your longevity be as gold and stone, and

may your descendants extend your line for ten thousand years. You boys who herd horses and tend sheep and cows are all from good families. If you enter this hall, please just look and do not scribble or scratch [on the walls]. Then you will enjoy a long life. Please do not destroy the hall or make any trouble; this will cause disaster to your offspring. We are stating this clearly to people of virtue and kindheartedness within the four seas. Please regard these words and do not ignore them" (fig. 3).[12]

In the Yongyuan Stone Fragment and the Xiang Tajun shrine the literary style and contents of the inscriptions that address anticipated audiences are quite similar. The pictorial carvings in the An Guo shrine are stylistically very close to those on the Xiang Tajun and the famed Wu Family Shrines; the discovery of the securely dated An Guo shrine thus serves to confirm the authenticity and reliability of the latter two, which were found earlier.

In another offering shrine, dated to the sixth year of the Yonghe reign-period (141 CE) and excavated in 2000 in Jiaxiang, the inscription also mentions the viewers:

To you the visitors: When you descend to…, please do not cause any damage. You can then live for a thousand years, and enjoy long-lasting happiness."[13]

Wu Hung has suggested that the narrator of the An Guo inscription is the patron of the shrine,[14] so presumably these other inscriptions are also the words of the shrines' patrons. These inscriptions therefore may be taken as primary sources for our knowledge of the production and function of Han mortuary shrines, providing direct information about donors' intentions and wishes. Both the repeated adjuration "Please do not…damage it. Please do not…damage it" and the flattering "You boys who herd horses and tend sheep and

Fig. 3 *Inscription dated to 158 CE*. From An Guo offering shrine, Jiaxiang, Shandong Province. From Zhu Xilu, *Jiaxiang Han huaxiang shi* (Jinan: Shandong meishu chubanshe, 1992), pl. 75 (p. 59).

Fig. 4 *Pictorial stone carvings dated to 83 CE*. From Feicheng, Shandong Province. From *Shandong Han huaxiang shi xuanji* (Jinan: Qi-Lu shushe, 1982), pl. 472.

the shrine's completion.[16] Contrariwise, the inscription of 129 CE at the Xiaotang Shan shrine might also prove the existence of later visitors who habitually incised shrine walls, something anticipated and worried about by the patrons, as I have discussed earlier. Examples of such earnest appeals as "please do not damage or destroy" and "please do not cut or draw" can be found in even earlier times, as seen in an offering shrine inscription in Feicheng:

[This shrine] was completed on the eighth month of the eighth year of the Jianchu reign-period (83 CE). Filial son Zhang Wensi wept and paid respect to his father. The stone [shrine] was built by Wang Ci, and it cost three thousand [in cash]. Please do not ruin [] (fig. 4).[17]

Although there is no specific mention of any expected future visitors, the final request, "please do not ruin []," is obviously addressed to them. The visitors in all of the earnest appeals mentioned above appear to include people of such different social backgrounds as "those with virtue and kindheartedness within the four seas," "scholarly gentlemen," or even "herd boys." The inclusiveness of the potential addressees suggests that the patrons clearly realized that although the offering halls were primarily used by family members for ancestor worship, they were nevertheless located in open fields, where they were unprotected against all sorts of intrusions. It is also very likely that the sponsors were not just begging visitors to respect the architecture and the carvings; they must also have intended to convey other messages to the visitors through the latter's visual engagement with the images.

cows are all from good families" reflect passionate concern for the preservation of the shrines and their carved decorations. The sponsors of these Han mortuary structures and carvings wished fervently that visitors would treasure the monuments built with such enormous cost and hard labor.

Many visitors' inscriptions are found on the walls of the Xiaotang Shan shrine, in Changqing, Shandong, including the one written on the west side of a triangular gable:

On the 24th day of the fourth month in the fourth year of the Yongjian reign-period (129 CE), Shao Shanjun, from Shiyin Commandery, Pingyuan District, came to visit this hall. Bowing my head in reverence, I thanked the wise sage-spirit.[15]

Based on the word "thanked," Xin Lixiang believes that this might have been inscribed by a disciple or peer of the deceased not too long after

In his careful examination of the inscriptions in Eastern Han offering shrines, Wu Hung has noted the changes in their narrative focuses, from

remarks on the shrine's function and biographical descriptions of the deceased in earlier times, to the increasingly detailed reports on the construction processes in later times. Wu interprets these changes as indicative of a kind of conspicuous display of filial virtue in second-century China.[18] This enthusiasm can be deduced from the critical writings of the educated elite at the time, most notable being those of Wang Fu (ca. 76–ca. 157 CE), an uncompromising recluse with a reputation for "standing above vulgarity." In a passage from the *Qianfu lun* (*Criticisms of a hidden man*), he denounced the rampant wasteful practices of the time:

People these days spend little to take care of their aging parents, disregarding the latter's desires, and just wait for the old to die. After their parents pass away, they then squander the money thus saved on sumptuous funerals, inviting guests to big feasts to ostentatiously show off their filial piety. While this kind of despicable behavior is imitated by many opportunistic hypocrites, it in fact is a violation of the true value of filial virtue, and can only harm later generations.[19]

The excessive spending on funerals and constructions of elaborate mortuary architecture in later Eastern Han times were in part motivated by the system of *xiaolian* recommendation. Those who wished to attain office had to first demonstrate the much-revered virtues of filial piety and incorruptibility, creating a serious social anomaly described in Wang Fu's acute criticism: *sheng bu ji yang, si nai chong sang* ("Although [the wealthy aristocracy and great landowners] scarcely trouble to look after their parents during their lifetime, they honor them with a sumptuous funeral when they die").[20] By "stacking up large burial mounds, planting pine and

juniper trees around entire cemeteries, and building rush huts and offering shrines," Wang observed, the common folk "are indulging in a degree of extravagance that exceeds the levels enjoyed by people of higher social status."[21]

The changes in the function of offering shrines in the later Han can be understood as reflecting the changes in responses and expectations of viewers. Because of their public location, family shrines originally intended for private sacrificial performances had become vehicles whereby patrons showcased their filial piety. The detailed descriptions of selecting luxurious materials and fine craftsmen, as well as emphasis on the time required for the entire production, became, for the most part, an advertisement of filial virtue. The language of a patron's self-promotion is most evident in the Xiang Tajun inscription of 154 CE:

The two brothers Wuhuan and Fengzong, remembering their parents' kindness and affection, and feeling deep sorrow and longing, camped outdoors near the grave. Day and night, they transported soil on their backs to build the tomb, planted pine and junipers in rows, and constructed this stone shrine, in the hope that the spirits of their parents would find a dwelling, and that their children and grandchildren will enjoy each New Year's festival celebration. Though small, the hall still took a long time to build. We used the stones quarried from the mountain on the south, and it is now finally complete after two years of construction. We hired more than ten people, including the master craftsmen Caoyi and Rongbao from Xiaqiu of Shanyang, and the painters from Gaoping, Daisheng and Shao Qiangsheng, at a total cost of 25,000 cash.[22]

The inscription in the An Guo shrine also states that the project took "months to complete,

and the very hard work cost about 27,000 cash."[23] By comparing the cost of the shrine construction with the cost of living at the time, Katō Naoko has shown that the numbers reported in the inscriptions were mostly exaggerated.[24] Lengthy or exaggerated construction times could also be a means to show off the patron's filial piety.[25] Conspicuous effort and expense would surely generate, it was thought, fame and consequent social and/or career advancement. What, then, would visitors be expected to see in the iconography of these shrines? Were the decorated images intended solely to express filial affection?

One of the most difficult obstacles to answering these questions is that the abovementioned shrines—those with the Yongyuan Stone Fragment, Xiang Tajun, and An Guo inscriptions—have not survived intact, impeding a thorough investigation of their pictorial content. A passage in the An Guo shrine, however, describes the carvings:

The bodies of interlocking dragons wind and turn in sweeping beauty; fierce tigers stretch their heads forward, gazing into the distance; black apes ascend heights; lions and bears roar, strewn everywhere like clouds. There are towers and pavilions of various heights; great processions of chariots set forth. Above, clouds and Immortals; below, figures of filial piety, excellent virtue, and benevolence. Superiors are dignified, their attendants respectful. Inferiors are obedient and look agitated as well as joyous.[26]

Most likely the flowery language employed to describe the carvings was meant to draw attention to their general artistry; it lends no particularity or individuality to the images, nor does it in any way express their symbolism. A comparison between the An Guo inscription and the far more vividly detailed *Rhyme-prose of the Lingguang Hall*,

mentioned above, sheds light on the real purpose of the An Guo inscription:

Flying birds and running beasts,
Are given form by the wood.
Prowling tigers, clawing and clasping in
 vicious clenches,
Raise their heads in a furious frenzy, manes bristling.
Curly dragons leap and soar, twist and twine,
Their jowls seeming to move as they limp and
 lumber along.
The Vermilion Bird, with outspread wings,
 perches on the crossbeams;
The Leaping Serpent, coiling and curling,
 winds round the rafters,
The White Deer heaves its head among the brackets,
A coiling wivern, writhing and wriggling,
 clings to the lintels,
The wily hare creeps and crouches beside
 the cap blocks,
Gibbons and monkeys climb and clamber
 in mutual pursuit.
Black bears, tongues protruding, fangs bared,
Draw back, hunching and hunkering from
 their heavy loads.
With leveled heads they gaze and glance,
Gaping and goggling, glaring and glowering.

Hunnish figures huddle far away on the
 upper columns,
Solemn and serious they kneel face to face;
Brave, horrid-headed, gaping like eagles,
With hollow skulls, beetled brows, bulging eyes;
Their visage as if saddened by this perilous place
Are painfully wrinkled, laden with grief.
Divine Immortals stand straight amongst the purlins,
The Jade Girl, peeping from a window, looks down.
Suddenly all is a bleary blur, vaguely visualized,
As the shadowy likeness of ghosts and spirits.[27]

Fig. 5 *Tracing copy of an inscription.* Xiaotang Shan, Changqing, Shandong Province. From Nanyang Handai huaxiang shi xueshu taolunhui bangongshi, ed., *Handai huaxiang shi yanjiu* (Beijing: Wenwu chubanshe, 1987), pl. 2 (p. 206).

The author of the An Guo inscription, using the rhymed, ornamented style of paired stanzas commonly employed in a popular Eastern Han literary genre, appears to have been more interested in writing in the style of elite scholar-officials than in faithfully describing the images.[28] The conventional, superficial, and embellished literary style was aimed at flaunting the lavish wall decorations before prospective visitors, rather than guiding them in interpreting the images. Additionally, the authors wanted to draw attention to their composition: "We are stating clearly to people of virtue and kindheartedness within the four seas: Please regard these words and do not ignore them." Carvings were produced by artisans,[29] but the patrons' intentions were conveyed through inscriptions, which recorded not only such concrete results as the pictorial carvings and the architectural structures, but also the long, difficult process of negotiating the financial arrangements and recruiting labor. The visitors were asked to "see" (*guan*) the carvings and architecture, as well as to "reflect" (*xing*) on the admirable behaviors revealed in the inscriptions. The patrons' ultimate goal was to present themselves as men of "utmost filial piety, exemplary conduct, and righteousness,"[30] and the carvings and architecture were meant to reflect their high morality.

That later viewers accepted this proclaimed intent is demonstrated by an inscription dated to the second year of a Yongkang reign-period (either 301 or 397 CE), in which a visitor to the Xiaotang Shan site, Shen Shanglong, expressed his admiration: "[I am] moved by the deep filial piety [of the man who built this shrine]"[31] (fig. 5). Some two or three centuries after the composition of the Xiaotang Shan dedication, the author of this "graffito" not only shared the patron's moral values, but fully and uncritically accepted the patron's self-presentation. Later inscriptions (in 479 and in 501) found on the site simply name the building *xiao tang* ("filial hall"), or *xiaozi tang* ("hall of a filial son").[32] In the sixth-century work *Shuijing zhu* (*Commentary on the Classic of Waterways*), the structure is also called a *xiaozi tang*.[33] Jiang Yingju considers it quite appropriate to assign a generic name—"hall of a filial son"—to the shrines dedicated by, or used for sacrifices by, children to their parents, since he believes that name had already been in use during Han to Wei times (3rd–5th centuries CE). The mistaken identification of the Xiaotang Shan "hall of a filial son" as a memorial shrine to Guo Ju, a famous filial son of Han dynasty, occurred later.[34]

It would, however, be simplistic to argue that the Han offering shrines are merely "advertisements for myself," because, unlike inscriptions, pictorial carvings have their own workshop traditions. As can be exemplified by Eastern Han pictorial carvings, from Feicheng (83 CE) to An Guo and other Songshan shrines (fig. 6), notwithstanding an increase in compositional details over time, in all of them the homage scene consistently dominates the main walls of the shrines and forms their iconographic theme. This theme retained its predominance in the second century, when the narrative focus of the inscriptions shifted. Xin

Lixiang calls this consistent presence of the central homage scene an "invariable theme,"[35] and Yang Aiguo also notes that despite changes in contents and designs, "the picture representing the shrine dedicatee and his consort receiving homage always occupies the dominant position in the overall iconographic program. This consistency indicates the unchanging function of Han mortuary shrines."[36]

Various conditions may have contributed to this iconographic consistency. First, as the

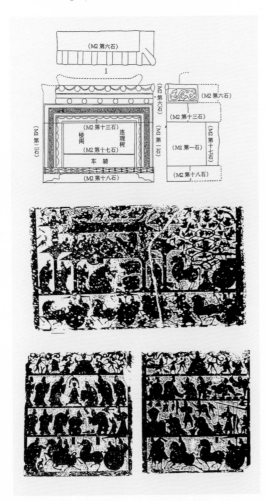

Fig. 6 *Songshan shrine 1*. Jiaxiang, Shandong Province. Reconstruction: plans and rubbings of pictorial carvings. From Xin Lixiang, *Handai Huaxiang shi zonghe yanjiu* (Beijing: Wenwu chubanshe, 2000), p. 77.

production of pictorial stone carvings became professionalized, experienced and skillful master masons and carvers may have developed a certain autonomy in choice of subject, and may have chosen to depict the same pictorial themes over and over again. More importantly, when the immediate purpose of performing sacrifices "where the ghosts and spirits dwell," became obsolete, the same structure on the tomb site then ceased to function as an offering shrine. This is perhaps the reason why Xiang Wuhuan and Xiang Fengzong, in the Xiang Tajun dedication said they built the shrine "in the hope that the spirits of their parents would find a dwelling."

Different types of viewers and different angles of viewing do not imply that the carved images are fragmented into disparate parts. On the contrary, most pictorial designs remain complete and unified, as visual elements carrying various iconographic meanings are woven into a seamless whole. Although the practice of sumptuous burials and the luxurious production of mortuary carvings were partly encouraged by the *xiaolian* recommendation system, the opportunistic abuse of the recruitment policy and the resultant functional changes of the pictorial carvings were only temporary by-products of a steady development of traditional thought and customs.

Viewers of Pictorial Carvings and Murals in Tombs

It is prerequisite to understand that Han views of death and the postmortem state varied enormously over time and space, and also that inconsistent views might be held by one and the same person.

In contrast with aboveground offering shrines, underground tombs exist in an enclosed space, but even in tombs a relationship exists between the images carved on tomb walls and viewers. An

Fig. 7 *Inscription in an Eastern Han tomb*. Suide, Shaanxi Province. From Li Guilong and Wang Jianqin, eds., *Suide Handai huaxiang shi* (Xi'an: Renmin meishu chubanshe, 2001), p. 154.

inscription found in the tomb recently excavated in Suide, Shaanxi Province, has this passage:

Viewing the images of Fan Ji and other virtuous women, people can be inspired to behave humbly and respectfully and to honor noble virtues.... Their children will then be blessed with prosperity and happiness (fig. 7).

The two verbs *lan* and *guan*, both denoting the act of viewing images, suggest that the carvings were expected to be seen, by the deceased and by visitors.[37]

People of the Han conceived the tomb not only as a burial site for the corpse, but also as a space for the deceased's spirit, believed to continue to exist indefinitely. Family members stocked the tomb with funeral objects—real or simulacra—such as nourishing foods and delicious drinks, as well as expansive courtyards, mansions, chariots, and servants, plus entertainers performing for the delectation of the deceased. In other words, the family provided the deceased's spirit with what it had possessed or desired during life. Moreover, it was believed that the spirit of the dead would take off from the tomb on its ascent to the realm of immortality, a journey often represented by burial objects or by paintings and carvings on the tomb walls. This underground world, however well furnished, was at the same time considered a horrifying place, full of monstrous creatures such as those described in the "Zhaohun" ("Summoning the soul") chapter of the *Chuci* (*The songs of the south*):

O soul, come back! Go not down to the Land
 of Darkness,
Where the Earth God lies, nine-coiled,
 with dreadful horns on his forehead,
And a great humped back and bloody thumbs,
 pursuing men, swift-footed:
Three eyes he has in his tiger's head, and his
 body is like a bull's.
O soul, come back! Lest you bring on yourself
 disaster.[38]

As the realm of the dead was thought to be dangerous, measures were taken to protect the spirits of the dead. Ritual texts inform us that families of the nobility would employ *fangxiangshi*, an exorcist with "a bear's skin, four eyes emitting golden rays, red clothes, daggers and shields in hand," to attack or kill all sorts of demons in the underworld.[39] Commoners would place the ferocious- and grotesque-looking *zhenmushou* ("tomb-protecting monsters") in burial grounds to guard the deceased against demonic attacks.

Since peace and joy could not be proved to exist in the imaginary afterworld, the fear of death was real. Equally real was the fear of the dead. In the eyes of the early Chinese, even loved ones became members of another world after death. Notwithstanding Wang Chong's sophisticated argument in the chapter "Dinggui" ("Settling the issue of ghosts") in the *Lunheng*: "The ghosts that are [thought to exist] in the world are not the spirits of the dead; rather, they are evoked by intense thinking and contemplation,"[40] common folk (who could not read *Lunheng*) generally believed that after death people were transformed into ghosts who could menace the living. This perceived threat probably led to the creation of grave-quelling inscriptions (*zhenmu wen*) on ceramic jars, placed in tombs between the third and fifth centuries. With their Daoist connotations, these inscriptions were obviously aimed at ameliorating such fear.[41] The fear of postmortem anger also motivated the Cangshan (in southeastern Shandong) tomb inscription, dated to 151 CE: "[To the dead soul:] you are going to the deep and dark [underground] for good, and [we will] never open the tomb again after it is closed."[42]

Since precious gold or silver burial objects invited looting, some tombs were sealed tight and secured with antitheft devices.[43] There is insufficient evidence to suggest that sacrifices were performed in tomb chambers after burials; more-over, the sets of ritual vessels found in tombs may have been used only once, for sacrifices at funerals before the tombs were sealed. Any contacts with things associated with burials was taboo, and this psychology may have been associated with traditional Chinese folk literature about the unusu-ally mischievous and repugnant conduct of model burial figurines. Because physical and conceptual barriers separated the world of the dead from that

of the living, burial sites were not considered public places. Rather, they were private domains owned by and belonging to the deceased. Decorating the tombs with paintings was also part of the mortuary tradition, offered and dedicated by the living and to be seen only by the dead.

To repeat, the question is: Did the early Chinese truly believe that dead people are able to "see" (*guan*)? The celebrated poet Tao Yuanming (365–427), wrote this elegy:

There was no wine to drink in the past,
And the wine cup is empty now.
With the spring-brew foams and bubbles,
When will I ever be able to taste my wine again?
Displayed before me is the table holding
 delicious food;
Relatives and friends old and new are weeping
 by my side.
I desire to speak but no sound can be uttered,
I desire to see but my eyes receive no reflections.
I used to sleep in a high-floor room;
But now I rest in a weedy wild field.[44]

Tao, a member of the educated elite, no doubt profoundly understood the reality of death, because his regret — "I desire to speak but no sound can be uttered; I desire to see but my eyes receive no reflections," is poignant. The voices in the poem, however, are contradictory; since the eyes of a dead person "receive no reflections," the "desire to see" is that of a living person. Tao was attempting to speak with the voice of a dead man.

Images of the dedicatee, often painted on the tomb walls, in no way resemble the corpse that has a desire to see but whose "eyes receive no reflec-tions." The picture of the dedicatee often seems a colorful living portrait. The person represented was thought to be able to truly enjoy the food left

in the tomb, as well as the dancing and musical entertainments depicted on the walls and the real objects and simulacra deposited there; he was believed to continue to enjoy, by virtue of these things, a good life in another world. The pictorial carvings were not mere images; the eyes of the deceased could see them.

In an interesting experiment, Lydia Thompson used a computer program to reconstruct a three-dimensional model of the Eastern Han tomb in Yinan. Assuming the standpoint of the deceased from the rear chambers (where the coffins of the husband and wife are placed), and "gazing" onto the paintings on the crossbeams of the front chamber, she discovered that the directional, compositional, and thematic arrangements of the paintings all correspond with this hypothetical "point of view."[45] A positive answer to the question whether the deceased could see may be found in another elegy, written by the Eastern Jin man of letters Lu Ji (261–303):

How precarious are these layered mounds,
With the deep dark dwelling enclosed inside.
So immense that they reach up to all four extremes,
With the arched dome extending into the sky.
Listening to the flowing sound in the covered
 drainage ditch,
I lie here looking at the lattice ceiling hanging above.
Oh! This graveyard is indeed remote and desolate![46]

Here the subject, dead and buried, can both "hear" and "see," affirming that the early Chinese perceived the dead as conscious, sensible to sound and sight.

As said before, however, ancient China encompassed different opinions on the afterlife. Cao Pi (187–226), who was Emperor Wen of Wei, wrote that "[after death] bones are not aware of pain or itch, and graves are not the residences of the spirits," and "even beautiful coffins are just for perished bones, and fine clothes are just for perished flesh,"[47] an opinion that became the rationale for his social policy of frugal burials. His view may prove, by negation, that the practice of lavish burials during the Han was indeed closely connected with the belief that consciousness persisted after death.

Lu Ji's description of the tomb structure and decorations, such as domed chamber, hanging lattice ceiling, and drainage ditch, can all be confirmed by excavated Six Dynasties burial sites.[48] We can, then, reasonably assume that Lu Ji, a literatus, must have had opportunities to visit underground tomb chambers. Zhao Qi (ca. 108–201), a Han official, is recorded in the *Hou Hanshu* (*History of the Latter Han*) to have left detailed instructions on the paintings to be executed in his own *shoucang* ("spirit hideout," i.e., burial chambers): "[Qi] had his own burial chambers prepared beforehand. He put (or possibly "He painted") pictures of Ji Zha, Zi Chan, Yan Ying, and Shu Xiang next to his own portrait, all accompanied by eulogistic inscriptions."[49]

This is the only mention of mortuary painting in the texts of dynastic histories. One wonders, then: if Zhao Qi's design of his own burial chambers was a personal matter, how would the details of the story have come to be known two centuries or more later? Possibly Zhao himself recorded his intentions, but it is far likelier that others visited the chambers before the tomb was sealed and saw the paintings. And if visitors saw the interior of Zhao's tomb, we can assume that other tomb paintings and pictorial carvings were seen by other visitors. Two inscriptions in an Eastern Han brick tomb, discovered in Baizi Village, Xunyi District, Shaanxi Province, confirm this hypothesis. They are written in red, each adjacent to one of the two guardian

figures painted on opposite sides of the tunnel leading to the tomb chambers:

"All viewers must take off shoes before entering" (fig. 8).

"Those who wish to view [the pictures] must take off shoes before entering."[50]

During the pre-Qin, Han, and Wei periods, it was proper etiquette to remove shoes before entering a room to meet senior or high-ranking officials. Ritual texts contain such specific instructions on proper social protocol as: "Shoes cannot be worn in reception halls when sitting next to seniors."[51] Underground tomb chambers were considered the homes of the dead, and removing shoes before entering was an expression of respect for the deceased. These two inscriptions, although appearing next to the painted guardian figures, do not pertain to them, since the guardians have their own captions, placed even closer to them: *Bin wang lishi* ("Guardians of the King of Bin").[52] The addressees — "all viewers," or "those who wish to view" — are written in a plural form, thus referring explicitly to more people than the dedicatee alone. It is likely that, at least during the Eastern Han, a tomb was not a private place; after the paintings were completed and before the interment, it was open for public viewing.

The practice of letting the public tour burial chambers to view the pictorial images painted or carved on their walls may also be connected with the *xiaolian* recommendation system. Yang Shuda has argued that constructing tombs during the deceased's lifetime was not a special privilege of the emperors; officials and aristocratic scholars also made burial preparations during their lifetimes. Moreover, it was not unusual for burials to take place from seven to four hundred days

Fig. 8 *Inscription in an Eastern Han tomb.* Baizi Village, Xunyi District, Shaanxi Province. From Shaanxi sheng wenwuju and Shanghai bowuguan, eds., *Zhou Qin Han Tang wenming* (Shanghai: Shanghai shuhua chubanshe, 2004), p. 99.

after death,[53] a more or less adequate interval for relatives and guests to visit the chambers and see the artworks. The major venue for viewing the tomb art was the funeral ceremony, a prime social event, at which friends, colleagues, disciples, and relatives gathered, not only to pay final tribute to the deceased, but also to assess the moral virtue of the tomb sponsors.[54] In the *xiaolian* system, in which filial piety was a prerequisite for career advancement, furnishing the tombs of one's elders and decorating them with artworks that would be seen by peers and superiors was essential. Zhao Xuan, who was said to have delayed sealing off his father's tomb for twenty years in order to carry out his mourning rite in the burial tunnel,[55] may have been motivated by the desire for public acknowledgment of his virtue. This practice, whatever its motivation, won him a reputation for being exceptionally filial.

Notably, in many tombs in northern Shaanxi, the mural decorations are mostly located on the gates, door jambs, and lintels, which face outward and therefore could not be seen by the deceased. Apparently, therefore, they were designed to be seen by visitors entering the burial chambers. The evidence introduced above seems to suggest that the patrons intended the tomb paintings not only for the gaze of the dead, but also for that of the living. In contrast to offering shrines, inscriptions are relatively scarce in tombs, which may indicate a difference in the public function and the degree of public accessibility of shrines and tombs. As the brevity of the Baizi Village inscriptions offers us no clues to the social status of the viewers or the length of time in which the tomb was open for public visits, we must wait for further archaeological work, which may answer these questions.

Recent archaeological findings in Yongcheng, Henan Province, however, have revealed an intriguing mortuary design that may shed some light on our inquiry. Between 1987 and 1991, a mausoleum dedicated to a king of Liang (Western Han appanage) was excavated, and on the ceiling of its main burial chamber is a large, well-preserved mural, datable from coins found in the tomb to between 136 and 118 BCE.[56] Traces of ash inside a ring of

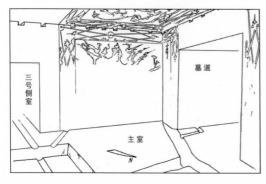

Fig. 9 *Mural paintings in the mausoleum of a king of Liang, datable between 136 and 118 BCE.* Yongcheng, Henan Province. Drawing by author.

notches along the upper edges of the four walls of the chamber suggest that a secondary timber ceiling once fitted into these notches and covered the mural painting above it. This wooden ceiling may have been installed precisely to prevent the painting's being seen (fig. 9).[57] It is possible that the guests at the funeral, even if invited into the chamber, were not able actually to see the mural. Thus concealed from living eyes, the painting may have been meant only to be "sensed" by the spirit of the king. One implication of this hypothesis is that a dead person was thought to perceive paintings quite differently from the "seeing" of a living person.

A more plausible explanation for the existence of the notches can be indirectly corroborated by a contemporaneous practice in the court of Han Wudi (r. 141–87 BCE). On the advice of his *fangshi* sorcerers, Wudi enthusiastically used pictorial images to woo the Lord on High (Tianshen) to assist his quest for immortality. Believing that "the heavenly spirits would not arrive if the palace is not properly furnished and decorated in a way that resembles [the dwellings of] the spirits," the emperor "painted chariots supported by scrolling clouds" to insure that the spirits would come to assist his journey to immortality. He would also "ride on the chariots to ward off evil ghosts on unharmonious days." In addition, he "built the Palace of Sweet Spring (Ganquan Gong), in the center of which is a room painted with the images of Heaven, Earth, and the Grand Unity (Taiyi), and furnished with a ritual terrace, on which offerings are placed to summon heavenly spirits."[58]

The paintings in the Palace of Sweet Spring functioned as visual interfaces between this world and the world beyond, and as "guides" to the Immortals on their way to welcome the souls of the dead. Just as the properly decorated imperial palace could assure the arrival of heavenly spirits, tombs

painted with fabulous images of the Immortals must also have been meant to facilitate their descent. Mortuary paintings thus transformed a tomb into a structure with double functions—it was not only a burial pit holding the corpse and a setting for the dead and his burial objects, but also a virtual replica of an Immortal land. The tomb is both a mirror image of the real world and a bridge to the realm of immortality.[59]

Epilogue

Study of the viewers of mortuary art requires a basic understanding of its function, contents, and the iconography of those contents. Images and viewers participate in the same ritual process in a complementary relationship. Some images were meant to serve a didactic function, as the inscription in the Suide tomb suggests, but viewers' perception of the images could also contribute to their formal and thematic changes. Li Daoyuan, author of *Shuijing zhu*, for example, remarked that the paintings in the tomb of Zhao Qi served as "a way to state his aspirations."[60] If the paintings in Zhao's tomb functioned as objects of seeing, then his decision to surround his own portrait with four exemplary figures of ancient times was a declaration to viewers known and unknown of his self-image or aspirations. Pictorial carvings in offering shrines occasionally depict events in the life of the deceased; one well-known example, on the east wall of the Wu Liang Shrine, is the ox-cart rider being invited by a district clerk, accompanied by the two cartouches "district official in the Bureau of Merit" (*xian gongcao*) and "retired gentleman" (*chushi*). This reading is corroborated by the inscriptions on the Wu Liang stele: "Invited by officials of the commandery [to serve in office], he declined by reason of poor health." Cartouche inscriptions next to the scenes of chariot processions, found

on the walls, supporting beams, and both sides of the triangle gables of the Wu Family Front Shrine, all correspond with the records in the Wu Rong stele.[61] Based on this biographical nature of the cartouche inscriptions at the Wu Family Shrines, Xin Lixiang believes that the chariot processions in the Xiaotang Shan shrine, with the cartouche inscription *dawang* ("great lord"), showing him as a retainer in the parade of a princely lord, represent the achievements in which the dedicatee gloried during his lifetime. Xin further argues that the scenes of chariot processions, which signify the proudest moment of the deceased's career, may not be iconographically related to the central homage theme, usually appearing on the main wall of the shrine. It is a "variable content" in the pictorial carvings of Han offering shrines.[62] The meanings of this and other pictorial subjects may ultimately be discernable only from the perspectives of the viewers.

The iconographic meanings of the mortuary art made for tombs and offering shrines during the Han dynasty have to be studied within the context of social structures and burial practices, and especially of the role of visitors. The motivation behind the creation of Han pictorial art, as well as its iconographic significance from the viewer's perspective, need to be further emphasized, but it is beyond the purpose of this essay to explore how the visitors viewed mortuary art. It is an irony that some Han patrons' pious and sincere efforts in constructing offerings shrines for their loved ones should have only incurred Wang Fu's negative criticism; it is equally ironic that for over a thousand years the Xiaotang Shan shrine had been misconstrued as the memorial hall of Guo Ju.[63] How could any patrons have foreseen these consequences? ◐

Translated by Eileen Hsiang-ling Hsu

Acknowledgements

In writing this essay, I have received the assistance and advice of the following teachers and colleagues: Yang Hong, Xing Yitian, Lukas Nickel, Yang Aiguo, Shi Jie, Qiu Zhongming, and Liu Jie. Parts of this paper, and related material, were delivered at the Annual Conference of the Association of Chinese Han Pictorial Carvings and Paintings, Yulin, Shaanxi, October 2002; the International Symposium of Han Archaeology and Culture, Zhangqiu, Shandong, August 2004; and at the international symposium, *Recarving China's Past: Art, Archaeology, and Architecture of the "Wu Family Shrines,"* Princeton University, March 2005. I wish to thank the participants of these meetings for their valuable suggestions and comments.

Notes

1 Wu Hung, *Monumentality in Early Chinese Art and Architecture* (Stanford: Stanford University Press, 1995), pp. 189–250.

2 Hong Xingzu, *Chuci buzhu* (Beijing: Zhonghua shuju, 2002), pp. 85–119.

3 Fei Zhengang et al., *Quan Han fu* (Beijing: Beijing daxue chubanshe, 1993), pp. 527–33.

4 The makers could include designers and craftsmen, as their work was sometimes separate. The donors could select the themes of the images, and the craftsmen executed the carvings. Sometimes donors would only demand certain types of images, leaving the design and pictorial details to the masons, who often followed workshop conventions in producing their art works.

5 Eugene Y. Wang and I have discussed the various forms of discourse deriving from the viewers' opinions and comments on a Qing-dynasty stone archway in "Romancing the Stone: An Archway in Shandong," *Orientations*, vol. 35, no. 2 (March 2004), pp. 90–97.

6 In this passage in Wang Chong's *Lunheng*, the "tomb" (*mu*) designates the entire cemetery compound as the mortuary setting for ancestor worship, which includes not only the burial mound but also the offering shrine; see *Zhuzi jicheng* (Shanghai: Shanghai shudian, 1986), vol. 7: *Lunheng*, p. 228. As a result, this passage has often been cited as demonstrating the sacrificial function of shrines. For discussions of the mortuary function of Han offering shrines, see Xin Lixiang, *Lun Handai de mushang citang ji qi huaxiang* (Beijing: Wenwu chubanshe, 2000), p.185, and Jiang Yingju and Wu Wenqi, *Handai Wushi muqun shike yanjiu* (Jinan: Shandong meishu chubanshe, 1995), p. 97.

7 See the "Tangong" chapter of the *Liji* in *Shisanjing zhu shu* (Beijing: Zhonghua shuju, 1980), p. 1303. The "San buzu" chapter of the *Yantie lun* contains this similar passage: "The burial goods in ancient times had only forms but lacked any substantial features; they were intended to show people that they were not for practical use"; see *Zhuzi jicheng*, vol. 8, p. 34.

8 Hong Gua, *Lishi, Li xu* (reprint, Beijing: Zhonghua shuju,1985), pp. 168–69.

9 [Translator's note: for a recent iconographic study of the "homage scene" in Han mortuary pictorial carvings, see Jiang Yingju's essay in this volume.]

10 Sheng Kezhao, *Tengxian jinshi zhi* (Beijing: Fayuansi kanben, 1944), p. 29. For rubbings of this inscription, see Wenwu tuxiang yanjiushi Handai tapian zhengli xiaozu, *Zhongyang yanjiuyuan lishi yuyan yanjiusuo cang Handai shike huaxiang taben jingxuan ji* (Taipei: Zhongyang yanjiuyuan lishi yuyan yanjiusuo, 2004), pp. 62–63, 168.

11 Luo Fuyi, "Xiang Tajun shi citang tizi jieshi," *Gugong bowuyuan yuankan*, vol. 2 (1960), p. 180.

12 Li Falin, *Shandong Han huaxiang shi yanjiu* (Jinan: Qi-Lu shushe, 1982), p. 102. [Translator's note: English translation from Wu Hung, *Monumentality*, p. 194.]

13 Jiang Jishen, "Hanhua tibang yishu," in *Zhongguo Hanhua xuehui dijiujie nianhui lunwen ji*, ed. Zhu Qingsheng (Beijing: Zhongguo shehui

chubanshe, 2004), p. 535. The archaeological report of the excavation has not been published, and this author has not seen either the stone or its rubbings.

14 Wu Hung, *Monumentality*, p. 195.

15 Jiang Yingju, "Xiaotang Shan shici guanjian," in *Handai huaxiang shi yanjiu*, ed. Nanyang Handai huaxiang shi xueshu taolunhui bangongshi (Beijing: Wenwu chubanshe, 1987), p. 213.

16 Xin Lixiang, *Handai huaxiang shi zonghe yanjiu* (Beijing: Wenwu chubanshe, 2000), p. 82.

17 Shandong sheng bowuguan, Shandong sheng wenwu kaogu yanjiusuo, *Shandong Han huaxiang shi xuanji* (Jinan: Qi-Lu shushe, 1982), pl. 472.

18 Wu, *Monumentality*, pp. 193–200.

19 See *Zhuzi jicheng*, vol. 8: *Qianfu lun*, p. 9.

20 [Translator's note: translation from Etienne Balazs, "Political Philosophy and Social Crisis at the End of the Han Dynasty," in his *Chinese Civilization and Bureaucracy: Variations on a Theme* (New Haven: Yale University Press, 1964), p. 203.]

21 *Zhuzi jicheng*, vol. 8: *Qianfu lun*, p. 57.

22 Luo Fuyi, "Xiang Tajun," p. 180.

23 Li Falin, *Shandong Han huaxiang shi*, p. 102.

24 Katō Naoko, "Hirakareta Kanbo—kōren to 'kōshi' tachi no senryaku," *Bijutsushi kenkyū*, vol. 35 (1997), pp. 67–86.

25 In an e-mail correspondence (29 September 2002) Professor Hsing I-tien elucidated the social implications of this family activity: "We can imagine a Han rural community, whose members lived, plowed, and buried their loved ones within a small circle of geographical areas. News about passed fellow villagers and tomb buildings would be spreading around quickly. Preparing materials and hiring stone masons, craftsmen, and painters to work on the construction and decoration would also have to take place near the tomb sites, attracting the attention of other villagers. The entire process, lasting months, even years, was the best opportunity for a 'show.' The intended 'viewers' were both the living and the dead."

26 Li Falin, *Shandong Han huaxiang shi*, pp. 101–2. [Translator's note: translation from Wu, *Monumentality*, p. 194, with minor modifications.]

27 Fei Zhengang, *Quan Han fu*, pp. 528–29. [Translator's note: translation from David Knechtges, *Wenxuan, or Selections of Refined Literature* (Princeton: Princeton University Press, 1987), vol. 2, pp. 271–73, with minor modifications.]

28 As literary accomplishment was also considered a necessary aspect of scholarly cultivation for a typical Han official, the author of the An Guo inscription may indeed have intended to display his literary talent; see Hsing I-tien, "Yunwen yunwu: Handai guanli de dianxing—'junxian shidai de fengjian yuyun' kaolun zhi yi," *Zhongyang yanjiuyuan lishi yuyan yanjiusuo jikan*, vol. 75.1 (2004), pp. 223–82.

29 The carving style and contents of the An Guo shrine are close to those displayed in the four small reconstructed offering shrines in Songshan, suggesting that the images were created by the same workshop using the same blueprints. For the reconstruction of the Songshan shrines, see Jiang Yingju, "Handai de xiao citang—Jiaxiang Songshan Han huaxiang shi de jianzhu fuyuan," *Kaogu* 1983.8, pp. 741–51.

30 This passage is also from the An Guo inscription.

31 Jiang Yingju, "Xiaotang Shan shici," p. 205.

32 Ibid.

33 Wang Guowei, *Shuijing zhu jiao* (Shanghai: Shanghai renmin meishu chubanshe, 1984), p. 275.

34 Based on the King of Longdong's (Hu Changren's) *Eulogy Inspired by Filial Virtue and Written by the King of Longdong* (*Longdong wang gan xiao song*) carved in 570 CE of the Northern Qi dynasty on the west wall of the Xiaotang Shan shrine, Jiang Yingju believes that Hu was likely the first to identify the Xiaotang Shan site as a memorial shrine for Guo Ju; see his "Xiaotang Shan shici," p. 206. Lin Shengzhi, however, argues that in the Northern and Southern Dynasties period the Han practice of building shrines had become a symbol of filial behavior, and that Hu Changren had only recorded earlier local legends, as corroborated in a passage in Hu's *Eulogy*: "[I] visited and interviewed the senior people"; see Lin Shengzhi, "Bei Wei Ning Mao shishi de tuxiang yu gongneng," *Meishushi yanjiu jikan*, vol. 18 (2005), pp. 48–49.

35 Xin Lixiang, *Handai huaxiang shi*, p. 118.

36 Yang Aiguo, *Dong Han shici huaxiang buju fanying de wenti*. Unpublished manuscript.

37 Unfortunately, the subject is

omitted in the inscription, making it difficult to interpret its full meaning; see Wu Lan et al., "Suide Xindian faxian de liangzuo huaxiang shi mu," *Kaogu yu wenwu* 1993.1, pp. 17–22.

38 Lu Kanru et al., *Chuci xuan* (Shanghai: Shanghai gudian wenxue chubanshe, 1956), p. 108. [Translator's note: translation from David Hawkes, *The Songs of the South: An Anthology of Ancient Chinese Poems by Qu Yuan and Other Poets* (Harmondsworth, England: Penguin Books Ltd., 1985), p. 225.]

39 See *Zhouli*, in *Shisanjing zhu shu*, vol. 1, p. 213.a.

40 See *Zhuzi jicheng*, vol. 7, p. 219. [Translator's note: translation from Alfred Forke, trans. and annot., *Lun-heng* (New York: Paragon Book Gallery, 1962), vol. 2, p. 239.]

41 See Zhuo Zhenxi, "Shaanxi Huxian de liangzuo Han mu," *Kaogu yu wenwu* 1980.1, pp. 46–47; Wang Zeqing "Dong Han Yanxi jiunian zhushu hunping," *Zhongguo wenwu bao*, 7 November 1993, sec. 3.

42 See the inscription in Shandong sheng bowuguan, *Shandong Han huaxiang shi xuanji*, p. 42.

43 Yang Aiguo, "Xian Qin Liang Han shiqi lingmu fangdao sheshi luelun," *Kaogu* 1995.5, pp. 436–44.

44 Lu Qinli, ed., *Xian Qin Han Wei Jin Nanbeichao shi* (Beijing: Zhonghua shuju, 1983), vol. 2, p. 1013.

45 Lydia Thompson, "The Yi'nan Tomb: Narrative and Ritual in Pictorial Art of the Eastern Han (25–220 CE)," (PhD diss., Institute of Fine Arts of New York University, 1998), pp. 207–11.

46 Lu Qinli, *Xian Qin han Wei Nanbei chao shi*, vol. 1, p. 654.

47 *Sanguo zhi* (Beijing: Zhonghua shuju, 1959), p. 81.

48 For Eastern Jin and Southern Dynasties burial sites, see Zhongguo shehui kexueyuan kaogu yanjiusuo, ed., *Xin Zhongguo de kaogu faxian he yanjiu* (Beijing: Wenwu chubanshe, 1984), pp. 527–36; Luo Zongzhen, *Liuchao kaogu* (Nanjing: Nanjing daxue chubanshe, 1994), pp. 54–98, 106–239.

49 *Hou Hanshu* (Beijing: Zhonghua shuju, 1965), p. 2124.

50 For the archaeological report on the tomb, see Shaanxi sheng kaogu yanjiusuo, "Shaanxi Xunyi faxian Dong Han bihua mu," *Kaogu yu wenwu* 2002.3, p. 76. The author saw the inscription in October of 2001 when visiting the site. For published illustrations of the paintings in the Xunyi tomb, see Susanne Greiff and Yin Shenping: *Das Grab des Bin Wang: Wandmalereien der Östlichen Han-zeit in China* (Mainz: Verlag des Römisch-Germanischen Zentralmuseum; Wiesbaden: Harrassowitz in Kommission, 2002). For Zheng Yan's review of this book, see *Yishu shi yanjiu*, vol. 5 (2003), pp. 510–18.

51 *Liji zhengyi* in *Shisanjing zhu shu*, vol. 1, p. 12.

52 Bin was a historical site ruled by Gongliu, an ancestral leader of the Zhou people; see *Hou Hanshu*, p. 3406.

53 Yang Shuda, *Handai hun zang lisu kao* (Shanghai: Shanghai guji chubanshe, 2000), pp. 87–99.

54 More than a thousand guests gathered at the funeral of the erudite Han scholar-official Zheng Xuan (127–200); see *Hou Hanshu*, p. 1211. For a description of these grand social

gatherings at funerals, see *Zhuzi jicheng*, vol. 8: *Qianfu lun*, p. 57.

55 *Hou Hanshu*, pp. 2159–60.

56 Yan Genqi, ed., *Mangdang Shan Xi Han Liang wang mudi* (Beijing: Wenwu chubanshe, 2001), pp. 81–247.

57 The original function of this wooden ceiling is unknown. Another similar structure is the timber house built inside the middle chamber of the Han rock-cut tomb in Mancheng, Hebei, seemingly creating an above-ground residential house in the chamber.

58 *Shiji* (Beijing: Zhonghua shuju, 1959), pp. 1387–88.

59 For an iconographic study of the tomb paintings in Yongcheng, see Zheng Yan, "Guanyu muzang bihua qiyuan wenti de sikao—Yi Henan Yongcheng Shiyuan Hanmu wei zhongxin," *Gugong bowuyuan yuankan* 2005.3, pp. 56–74.

60 Shi Zhecun, *Shuijing zhu beilu* (Tianjin: Tianjin guji chubanshe, 1987), p. 405.

61 Jiang Yingju and Wu Wenqi, *Handai Wushi muqun*, pp. 107–8.

62 Xin Lixiang, *Handai huaxiang shi*, pp. 107–18.

63 Jin Wenming, *Jinshi lu jiaozheng* (Shanghai: Shanghai shuhua chubanshe, 1985), p. 44.

The best-known *que* pillars in Shandong Province are those at the entrance of the Wu family cemetery in Jiaxiang County (fig. 1).[1] In structure these stone towers most likely imitate features of wooden architecture of the period, but the surfaces of the pillars are covered with imagery that would not have been added to functioning gates. First I shall discuss the pillars' structure and iconography, and then compare these *que* with examples of an earlier date: *que* pillars in Pingyi County located 120 kilometers to the east and pictorial stones that were once part of a stone chamber in Jiaxiang County. Similarities in the organization of decor and more importantly, in the selection of themes, indicate that the program of the Wu family cemetery pillars was not specific to that family, but that more likely it was a continuation of preferences and practices already in use for about fifty years.

Que Pillars at the Wu Family Cemetery and Related Structures in Shandong Province

SUSAN N. ERICKSON

The *Que* Pillars at the Wu Family Cemetery

Details about the erection of the *que* and the date of construction are recorded in the inscription on the north face of the west pillar (fig. 14, lower section):

On the fourth day of the third month of the first year of the Jianhe reign (147 CE), that is the year of Dinghai, dutiful son Wu Shigong, and his brothers Suizong, Jingxing, and Kaiming, ordered stone-masons Meng Fu and Li Dimao to build these *que* that cost 150,000 cash. Sun Zong carved the stone lions that were worth 40,000. Xuanzhang (Wu Ban), a son of Kaiming, obtained an official position at Jiyin. When he was twenty-five years old, he was selected by the Assessing Officer Cao for his filial piety, honesty, and fairness to be promoted to Chief Clerk of Dunhuang Prefecture. He became ill and died at an early age without any heir. Alas! Every gentleman and lady was deeply grieved.[2]

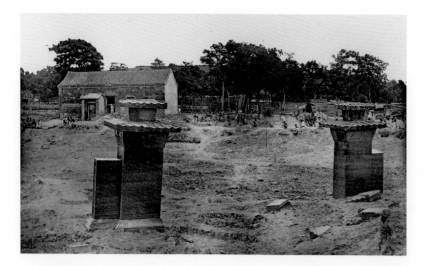

Fig. 1 *Photo of the Wu family* que *pillars, Jiaxiang County, Shandong.* From Édouard Chavannes, *Mission archéologique dans la Chine septentrionale.* Paris: E. Leroux, 1909–, Series Publications de l'École française d'Éxtrême-Orient, vol. 13, pt. one, pl. 32.

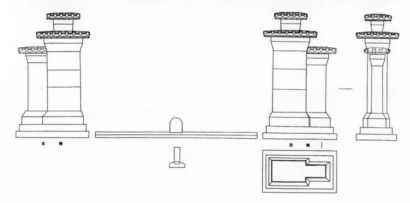

Fig. 2 *Line drawing of the* que. From Jiang Yingju and Wu Wenqi, *Handai Wu shi muqun shike yanjiu* ([Jinan]: Shandong meishu chubanshe, 1995), fig. 3.

Reading the *que* inscription by itself, it suggests that the death of the young Xuanzhang must have helped prompt the commission of the pillars and the stone felines still preserved at the site.

Standing 3.4 meters high, the *que* create an impressive initial view of the site. They are constructed as a main pillar joined to a shorter side pillar, a structure called *erchu que* (fig. 2).[3] The pillar shafts stand upon a separate stone base, below which is a stepped platform composed of two stones. A single piece of stone forms the shaft of the side pillar; three compose the shaft of the main pillar. Above the shafts a "capital" zone flares gently upward to create a transition

to the roof. Pseudo rafters are evident under the roof, and end tiles wrap around its edges. Its four vertical sides slope gently. Above this, supported on a straight-sided block, the main pillar has a second roof, and rafters and end tiles are carved in relief at this upper level too. The transition zone or "capital" of the side pillars features forms at the center and the sides of each face that should be read as simplified brackets (fig. 4). This detail refers to bracket sets (*dougong*) that supported the heavy tile roofs of wooden structures of the day. Almost all of the remaining surfaces of the *que* are covered with relief carvings of decorative forms and pictorial images (fig. 3).

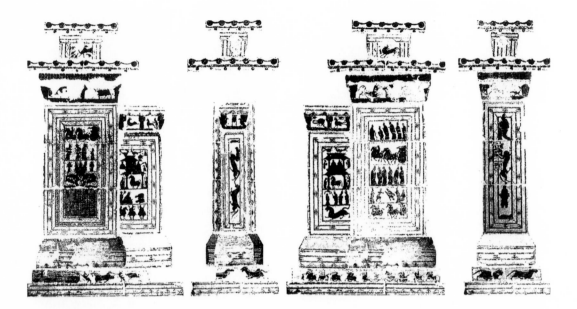

Fig. 3A *Rubbings of west* que. After *Handai Wu shi muqun shike yanjiu*, pls. 11–14.

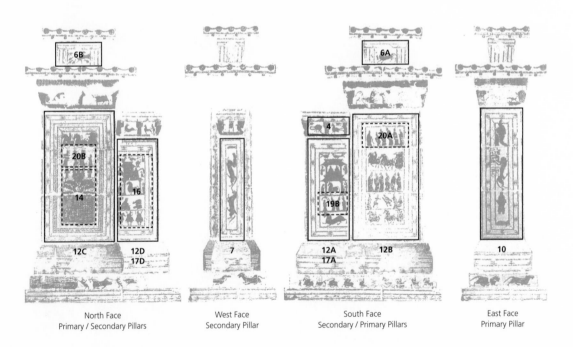

North Face
Primary / Secondary Pillars

West Face
Secondary Pillar

South Face
Secondary / Primary Pillars

East Face
Primary Pillar

WEST *QUE*

Diagram showing locations of the detail illustrations in this chapter overlaid onto the rubbings of west *que*. Diagram by Binocular.

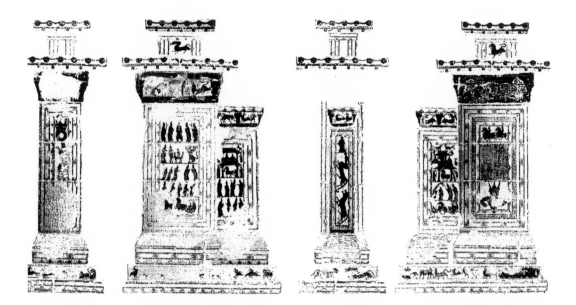

Fig. 3B *Rubbings of east* que. After *Handai Wu shi muqun shike yanjiu*, pls. 15–18.

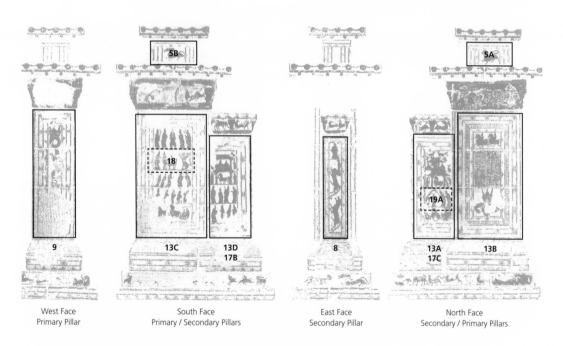

EAST *QUE*

Diagram showing locations of the detail illustrations in this chapter overlaid onto the rubbings of east *que*. Diagram by Binocular.

Carved into the faces of the pillar shafts
are frames composed of geometric patterns, a
decor repeated on the bases of the shafts, on the
lower step of the platform, and also on the block
under the uppermost roof. The upper step of the
platform is decorated with a row of pictorial motifs,
including figures and animals. Images of real and
fantastic creatures appear in the transitional "capital"
zone above the shafts of the pillars, including those
associated with the cardinal directions, like the Dark
Warrior of the North (Xuanwu) and the Red Bird of
the South (Zhuque) (fig. 4). On the front and back
sides only of the block, below the uppermost roof
of the main pillar, single animals occupy each frame.

Fig. 4 *Rubbings of Xuanwu and Zhuque, south face of west que.*
From *Zhongguo huaxiang shi quanji: Shandong Han huaxiang shi* 1
(Jinan: Shandong meishu chubanshe, 2000), pl. 25.

On the east pillar a dragon occupies the south face
and a tiger the north face, while the west pillar has
a bird with chicks on the north and what appears
to be part of a dragon and small fish on the south
side (figs. 5, 6). All of these images are auspicious
creatures. The Dragon and Tiger are the guardian
deities of the east and west, respectively, and they
complete the group that also includes the Red Bird
and the Dark Warrior. The character for fish, *yu*, is
a homophone for a different character meaning
"abundance," and likewise *ji* that means "fowl" is
a homophone for the *ji* that means "prosperity."
These motifs symbolize the hope for continued
good fortune for the Wu family.[4]

Fig. 5 *Rubbings of tiger and dragon, north (a) and south (b) faces
respectively under upper roof, east que.* From *Zhongguo huaxiang
shi quanji: Shandong Han huaxiang shi* 1, pls. 39–40.

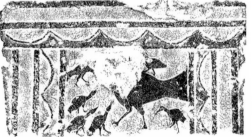

Fig. 6 *Rubbings of dragon with fish, and bird with chicks, south (a)
and north (b) faces respectively under upper roof, west que.* From
Zhongguo huaxiang shi quanji: Shandong Han huaxiang shi 1,
pls. 26–27.

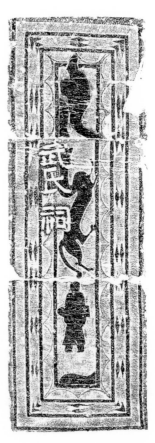

Fig. 7 *West face of secondary pillar, west* que. From *Zhongguo huaxiang shi quanji: Shandong Han huaxiang shi* 1, pl. 21.

Fig. 8 *East face of secondary pillar, east* que. From *Zhongguo huaxiang shi quanji: Shandong Han huaxiang shi* 1, pl. 34.

Fig. 9 *West face of main pillar, east* que. From *Zhongguo huaxiang shi quanji: Shandong Han huaxiang shi* 1, pl. 33.

Fig. 10 *East face of main pillar, west* que. From *Zhongguo huaxiang shi quanji: Shandong Han huaxiang shi* 1, pl. 20.

Far more easily seen from ground level are the shafts of the pillars. On the much narrower east and west sides of the pillar shafts the area enclosed by the frame is so limited that the images are stacked vertically (figs. 7–10). Some of the motifs squeezed into these fields are the same, and have the same symbolism as motifs in the "capital" zones of the pillars: auspicious dragons, tigers, and fish are depicted several times. Other images make reference to these structures as gates: guards and also *pushou*, a type of door or gate pull consisting

of a beast's face holding a ring in its mouth, an example of which is located on the west (inner) face of the east pillar (fig. 9, upper section). Below this *pushou* and also opposite it on the east face of the west pillar are images of composite creatures that appear human above the waist but have dragon tails (figs. 9, 10). Although the figure on the east pillar is partly obscured by an inscription added after the imagery was carved, it is clear that he is holding a carpenter's square, the primary attribute of Fuxi (fig. 9, center section). The other

Fig. 11 *Rubbing of Fuxi and Nüwa from "portraits of the eleven ancient sovereigns" section, west wall of Stone Chamber 3, Jiaxiang County.* From An Chunyang, ed. *Han Dynasty Stone Reliefs — The Wu Family Shrines in Shandong Province* (Beijing: Foreign Languages Press, 1991), p. 17.

figure with a tail might be Nüwa, who often is paired with Fuxi (fig. 10, upper section). A later representation of Fuxi is found on the west wall of Stone Chamber 3 in the section known as "portraits of the eleven ancient sovereigns," and there his scaled tail is intertwined with that of Nüwa (fig. 11).[5] As on the pillars, Fuxi holds a carpenter's square, and Nüwa is empty-handed. The inscription to the side of the chamber illustration refers only to Fuxi and reads: "Fuxi, the Black Spirit:/He initiated leadership;/He drew the Trigrams and made knotted cords,/To administer the land within the seas."[6] Fuxi used the knotted cord to keep records, and in addition, he invented the carpenter's square to regulate space. The inscription also notes his creation of the Eight Trigrams, thus linking him to the *Book of Changes* (*Yijing*) and to writing. During the Han dynasty Fuxi was regarded as an important culture bearer — the first of the sage-kings who brought order out of chaos. As Wu Hung has explained: "Standing at the beginning of history, Fuxi was thought to be an interjacent figure

between the divine and the human spheres; his greatness lay in his transmission of divine patterns to human society."[7] The images of both Fuxi and Nüwa are given prominence on the inner faces of the pillars, and the viewer would pass by them as she moved from the space outside to that within the cemetery grounds.

On their north and south sides the framed panels of both the primary and secondary pillars afford more room to develop imagery that focuses on figures (figs. 12, 13). Nevertheless, large blocks of space are given over to the inscription noted above and to a large *pushou* depicted on the north face of each of the main pillars.[8] As explained above, *pushou*, being gate pulls, imply that these *que* are gates marking the entrance to the grounds of the cemetery. But since the early Han period *pushou* were depicted on the sides of coffins, closely associating them also with the tomb context.[9] These *pushou* on the north faces are more elaborate than the one on the west face of the east pillar. Flanking the ring, two tigers stand back to back, with heads reversed so that each tiger holds the tail of the other in its mouth, thereby creating a "sideways-eight" design, referring to continuity. On the north face of the west pillar, fish, which are associated with abundance, are placed below the tigers, and on a ground line above the tigers stand two trees (fig. 14). These trees are evergreens and thus represent everlasting life; they also refer to the practice of planting trees on tomb mounds, as documented in Han-dynasty texts.[10] Such images were popular within the general context of tomb decor, but it is nonetheless noteworthy that a relief unearthed to the north, in Qingzhou City, features not only motifs but compositions resembling several sections of the west *que* (fig. 15A).[11] Like the Wu family pillar, the upper register of the Qingzhou relief shows a man

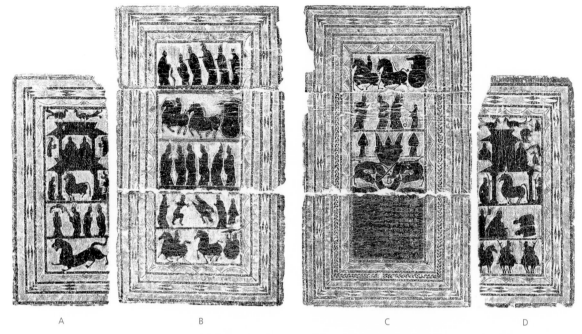

Fig. 12 *Rubbings of north and south faces of primary and secondary pillars, west que.*
After *Zhongguo huaxiang shi quanji: Shandong Han huaxiang shi* 1, pls. 16–19.

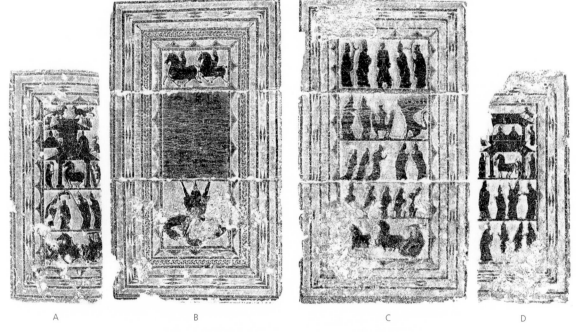

Fig. 13 *Rubbings of north and south faces of primary and secondary pillars, east que.*
After *Zhongguo huaxiang shi quanji: Shandong Han huaxiang shi* 1, pls. 29–32.

Fig. 14 *Rubbing of detail on main pillar, west* que. After *Zhongguo huaxiang shi quanji: Shandong Han huaxiang shi* 1, pl. 16.

B A

Fig. 15 *Rubbing of stone relief unearthed in Qingzhou City, Shandong.* From Qingzhou bowuguan, "Shandong Qingzhou Shi faxian Han huaxiang shi," *Kaogu* 1989.2, p. 184: (a) *Mounted rider and carriage, paired figures, and tigers and fish.* Qingzhou relief obverse; (b) Pushou *mask and ring.* Qingzhou relief reverse.

on horseback preceding a horse-drawn carriage. In the Qingzhou relief's middle register, the same pairs of figures are depicted with their positions reversed. In the Qingzhou lower register the trees and the *pushou* mask and ring are absent, but the unusual motifs of tigers above and fish below imitate the images in the same position on the Wu family west pillar's north face. When this Qingzhou stone was found, it was no longer in its original context, but excavators believe it once was a tomb door. The stone's reverse also bears carved designs, including the *pushou* mask and ring (fig. 15B). In style the *pushou* image varies from the one on the Wu family pillar, so another model must have been used. On the whole, however, this replication of motifs stylistically resembling those on the Wu family pillars suggests reuse of compositions by the workshop or copying by another workshop.[12]

The remaining registers on the main faces of the pillars emphasize compositions of figures and creatures that can be considered within broad groups. One of the major motifs is either a procession of horseback riders (depicted twice), or horseback riders accompanying a carriage (repeated five times) (see figs. 12, 13). These images consistently show the horses in profile, the better to convey that they are in mid-gallop. One exception is the striking frontal view of horses on the north face of the secondary shaft of the west pillar (fig. 16).[13] These horses appear to stand still, and thus the riders may be sentries rather than part of a procession.

A second major motif comprises figures placed in an architectural setting. All representations of buildings on the side pillars, both north and south faces, are located on the upper registers (fig. 17). The structures are two-storied, with a horse in profile view positioned in the lower story; probably the horse should be read as standing

in front of the structure. On the north faces (figs. 17C,D) the buildings are virtually identical, perhaps indicating use of a pattern or template. The upper story is not aligned with the lower part, and people are depicted under the eaves of the roof. On the south faces (figs. 17A,B) the scenes and architecture also vary little between the two pillars, except for the size of the images. Two figures are seated within the room in the upper story, and two others stand under the eaves. Birds, fish, and other creatures placed along the rooflines suggest an auspicious setting.[14] A clue to the nature of the activities in the structures may be detected in the depiction of the horses. They stand motionless and unbridled, and the profile view reveals their long tails hanging freely, unlike the tied and docked ones of the galloping horses. Patricia Berger has suggested that illustrations of unbridled horses like these refer to the practice of offering a horse as a funerary gift after the death of a lord, as described in the *Comprehensive Discussions in the White Tiger Hall* (*Baihu tong*).[15] She also notes that in the *Lunheng* (*Doctrines evaluated*), Wang Chong states that Confucius ordered his own horse be unharnessed to present as an expression of his grief when a former landlord died.[16] The prominent position of these horses and also their depiction on the faces of these pillars support this interpretation.

The third major motif comprises groups of figures and a few creatures, all without any setting whatsoever. In the second register on the south face of the east pillar, a pair of human figures stands beside two fantastic creatures (fig. 18). Nearest the two humans is a beast with human heads at both ends of its body and a small person on its back. In the *Shanhaijing* (*Classic of mountains and waterways*), a creature like this is identified as a *bingfeng*, which lives in the west near the territory of Shaman Xian (Wu Xian). At the far right of the

register a beast with eight human heads and a feline body may represent Tianwu from the east, near the valley of the rising sun, also described in the *Shanhaijing*.[17] These two creatures are associated with regions to the extreme east and west, and their appearance would be auspicious. All of the other figural scenes involve humans only, like the scene of homage on the north face of the west side pillar where two figures bow before a seated man (fig. 16, middle register).[18] Who this large, seated figure represents is not known, but in

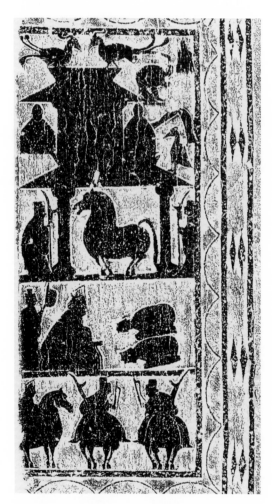

Fig. 16 *Rubbing of north face of secondary shaft, west* que. From *Zhongguo huaxiang shi quanji: Shandong Han huaxiang shi* 1, pl. 18.

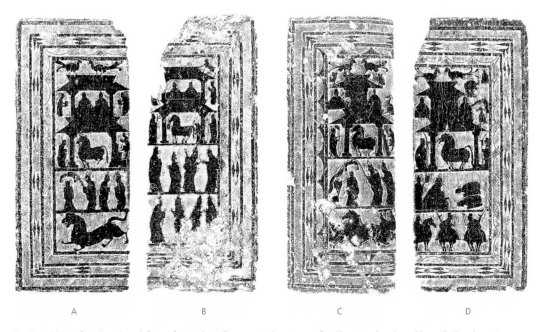

A B C D

Fig. 17 *Rubbing of north and south faces of secondary pillars, east and west* que. After *Zhongguo huaxiang shi quanji: Shandong Han huaxiang shi* 1, pls. 18, 19, 31, 32.

other representations, figures can be identified by telling gestures, by their size, and with the benefit of labeled reliefs from other sites.

One such scene appears on both side pillars (east *que*, north face of the side pillar; west *que*, south face of the side pillar): an adult male stands before a boy whose superior status is indicated by the parasol held above his head and his triple-peaked crown (fig. 19). This is a depiction of historical personages, the Duke of Zhou (Zhou Gong) and King Cheng (Cheng Wang). The reputation of the Duke of Zhou as an instructor and exemplary minister to the boy is highlighted in this scene. The duke also was important because of his connections to the founding of the State of Lu, and he resembled the deity Fuxi in bringing order out of chaos at the beginning of the Zhou dynasty. Mark Lewis has written about other links between Fuxi and the Duke of Zhou, most especially the Duke's association with the authority of writing

and texts, one of which was the *Yijing*.[19] Lewis also discusses connections between the Duke of Zhou and Confucius, another important figure of Lu and an exemplary minister.

Confucius is represented twice on the pillars (fig. 20). The biography of Confucius in the *Shiji* (*Records of the Grand Historian*) notes the meeting at which Laozi gave instruction to Confucius, and this scene is represented on the south face of the west pillar. Laozi is identified by his crooked staff, and Confucius kneels in front of him (fig. 20A).[20] In back of Confucius stand his disciples, who are distinguished from Confucius by the object each holds under an arm.[21] On the north face of the same pillar, there is a depiction of Confucius receiving instruction from Xiang Tuo, a seven-year-old child whose youth is indicated by the wheeled toy he holds (fig. 20B).[22] In a study of perceptions of Confucius and the Duke of Zhou during the Han dynasty, Michael Loewe points

Fig. 18 *Rubbing of south face of main pillar, east* que. *After* Zhongguo huaxiang shi quanji: Shandong Han huaxiang shi 1, *pl. 30.*

Fig. 19 *Rubbings of the north face of east* que (a) *and the south face of west* que (b). *After* Zhongguo huaxiang shi quanji: Shandong Han huaxiang shi 1, *pls. 19, 31.*

Fig. 20 *Rubbings of the south face of west* que (a) *and the north face of west* que (b). *After* Zhongguo huaxiang shi quanji: Shandong Han huaxiang shi 1, *pls. 17, 16.*

out that Eastern Han emperors rendered services in person to Confucius and his disciples in 72 CE (Mingdi, r. 58–75); 85 (Zhangdi, r. 75–88); and 124 (Andi, r. 106–125), and that sacrifices in honor of the Duke of Zhou were established in 1 CE.[23] He also notes that in 59 CE, services were established to the Duke of Zhou and to Confucius in the commanderies and counties.[24] The Duke of Zhou and Confucius, both with close ties to Lu, appear to have been particularly popular images in this area, and by the mid-second century when the decor on the pillars was designed, the images already are conventionalized and recognizable. Unfortunately other registers on the surfaces of the pillars feature groups of standing men without sufficient clues to allow identification, but most likely, they too were meaningful to Han viewers. Precedent for the themes discussed above and preference for them on *que* can be found on pillars in Pingyi County.[25]

The *Que* Pillars of Pingyi County

The Huang Shengqing gateway in Pingyi County retains both east and west pillars, and although part of the inscription no longer is clear, the date of construction and its function are recorded on the south face of the west pillar as follows (fig. 21):

The gate of the Huang Shengqing graveyard is at Pingyi, South Wuyang. Qing died on the twenty-[] day, *jimao* day, of the twelfth month of the first year of the Yuanhe reign [84 CE]…the eighth month of the third year of Yuanhe reign [86 CE].[26]

In the same area the west pillar of a pair known as the Gongcao *que* is preserved (fig. 22).[27] Even though a number of characters in its inscription have been lost, its date of 87 CE is recorded on the south face:

The *que* of the late Director of General Affairs of South Wuyang, Judge, Tax Collector and Secretary of Township, and gentleman of Pingyi [] [] [] [] qing. Qing [] [] [] [] [] [] [] [] had suffered hard times in the country, and felt [] [] thousand [] [] [] [] three [] observed imperial court [] [] wise emperor [] appointed the positions directly [] [] two [] came [] as the Thrice Venerable of the country [] [] [] [] []. On the sixteenth day of the second month of the first year of Zhanghe reign (87 CE), [] son [] Secretary [] [] (ordered) stonemasons [] [] [] [] Judge, Tax Collector, and Secretary of Township [11 characters missing] *bo* [] was [] [] [] 45,000.[28]

Both sets of *que* in Pingyi County appear to commemorate an individual, possibly like the pair at the entrance to the Wu family cemetery, but these pillars differ in size and form. The Pingyi County pillars seem massive, but they are much shorter than the pillars of the Wu family—approximately 2.5 meters. All of these pillars from Pingyi have similar construction, being made up of separate pieces of stone, conforming to the method that would have been employed in building a structure of wood. In each, the monolithic pillar shaft is placed on a flat, slightly wider base. Above the vertical shaft, there is a horizontal stone functioning like a capital. The upper part of this block has high-relief pseudo bracket sets positioned at the corners, seeming to support the overhanging roof (fig. 23). The sloped roof has a flat top, and its roof tiles and end tiles are carved in high relief (fig. 24). The only deviation comes in the area under the roof, where the Huang Shengqing *que* have pseudo rafters, but the Gongcao pillar is left plain.

Pictorial decor is limited to the faces of the pillar shafts.[29] The faces are divided into four (Gongcao) or five (Huang Shengqing) registers, and within each register, motifs are carved in very

Fig. 21 *Photo of the Huang Shengqing* que, *Pingyi County, Shandong*. Photo by author.

Fig. 22 *Photo of the Gongcao* que, *Pingyi County, Shandong*. Photo by author.

Fig. 23 *Detail of architectural elements, Pingyi* que. Photos by author.

Fig. 24 *Detail of roof elements, Pingyi* que. Photos by author.

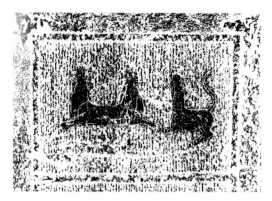

Fig. 25 *Rubbing of west face of Huang Shengqing west que.* After *Zhongguo huaxiang shi quanji: Shandong Han huaxiang shi* 1, pl. 5.

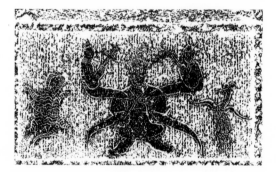

Fig. 26 *Rubbing of south face of Huang Shengqing east que.* After *Zhongguo huaxiang shi quanji: Shandong Han huaxiang shi* 1, pl. 8.

low relief. The figures are relatively small, and they float with no indication of setting. These pillars have sustained considerable damage because until recently they were subjected to the natural elements.[30] Some of the registers no longer retain enough detail to reveal more than the mere presence of figures; in other areas the decor remains distinguishable.[31] Compared with the Wu family pillars, the range of imagery on these pillars is more extensive. In addition to horseback riders and carriages, a procession of a camel and an elephant, and performances of music, dance, and acrobatics also are depicted. Scenes of an animal hunt, a battle with "barbarians," and the discovery of a *ding* tripod are represented.[32] These subjects are

beyond the scope of this study, but it should be noted that the tripod scene is one of the themes in the reliefs from the Wu family stone chambers.

As on the Wu family pillars, fantastic creatures with auspicious associations are included in the program. In the uppermost register of the west face of the west Huang Shengqing pillar, on the right side is an animal with a human head, and on the left side an animal human-headed at both ends of its body (fig. 25), like the *bingfeng* on the Wu family *que*. Also as on the Wu family *que*, on the south face of the east Huang Shengqing pillar are Fuxi and Nüwa, easily identified by their attributes, a carpenter's square and a compass. Here, though, they are part of a triad: a large figure in the center holds their tails (fig. 26).[33] Images of the Dark Warrior and the Red Bird, symbols of the north and south, respectively, flank the triad. Unfortunately, the center figure holding the tails of Fuxi and Nüwa is not labeled, but several suggestions have been made. Martin Powers believes it is Taiyi, Ultimate Unity, the progenitor of Fuxi and Nüwa.[34] In a Chinese source the figure is identified as Gao Mei, the Supreme Intermediary, who is associated with fertility.[35] During the reign of Wudi (r. 141–87) of the Western Han, the cult of the Supreme Intermediary was inaugurated after the birth of the emperor's son, and fertility rituals involving Gao Mei continued to be performed during the Eastern Han. Irrespective of the specific identify of the central figure, inclusion of the image of Fuxi and Nüwa on the Huang Shengqing pillar may suggest that the related images on the Wu family pillars are connected to fertility too.

Even more cogent links with the imagery on the Wu family *que* are the figural scenes representing paragons of virtuous ministers. For example, the theme of the Duke of Zhou as minister to the youthful King Cheng is depicted in the first register

of the east face of the west Huang Shengqing pillar (fig. 27). In this case, the figures are seated, but the parasol over the head of King Cheng identifies the subject. Confucius also appears on the pillars at Pingyi. On the north face of the Gongcao pillar (first register) and less clearly on the north face of the east Huang Shengqing pillar (second register), the meeting of Confucius and Laozi is represented, but on both of these the meeting is conflated with the representation of Confucius taking instruction from the boy Xiang Tuo (fig. 28).[36] The diminutive Xiang Tuo is placed between Laozi on the right and Confucius on the left, who is followed by four disciples. Unlike later images of Xiang Tuo, for example at Jiaxiang, here he is depicted en face

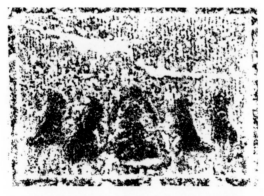

Fig. 27 *Rubbing of east face of Huang Shengqing west que. After Zhongguo huaxiang shi quanji: Shandong Han huaxiang shi 1, pl. 7.*

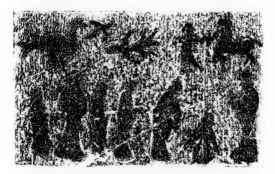

Fig. 28 *Rubbing of north face of Gongcao que, Pingyi County. After Zhongguo huaxiang shi quanji: Shandong Han huaxiang shi 1, pl. 14.*

rather than standing in profile looking at Confucius. Despite these minor variations in pose, it becomes clear that a number of motifs on the pillars at the entrance of the Wu family cemetery probably were not specific to the Wu family but were selections long current in Pingyi County.

Other Stone Reliefs in Jiaxiang County
Another group of stones from Jiaxiang County provides evidence that these motifs were part of iconographic programs for other types of funerary structures at about the same time as the Pingyi pillars were constructed. These pictorial stones were excavated in Jiaxiang County, Zhifang Town, at Jinglaoyuan.[37] When found, the reliefs were part of a tomb constructed during the post-Han period (Wei-Jin), but originally they had been walls in a stone shrine that Chinese scholars have dated to the early Eastern Han period (25–88 CE). The pictorial compositions are arranged in registers stacked vertically, just as in the *que* from Pingyi and in those from the entrance to the Wu family cemetery (figs. 29–32).

In the upper register of one of the reliefs a beast with the body of a feline and nine human heads most likely is the creature known as *kaiming*, as described in the *Shanhaijing* (fig. 29).[38] According to the text, one of these creatures stood on the summit of Mount Kunlun, and others guarded the nine gates located at each face of the mountain. Other composite creatures are found in the top register of a second relief (fig. 30). As seen on the south face of the east Huang Shengqing *que*, a triad consisting of a large center figure holding the serpentine tails of Fuxi and Nüwa is illustrated. Here two phoenixes (*fenghuang*) hover over them. The Jinglaoyuan reliefs also depict historical personages. The theme of the Duke of Zhou and King Cheng is depicted twice, and

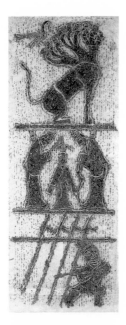 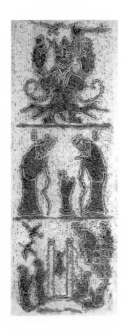 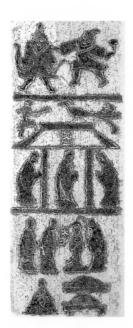 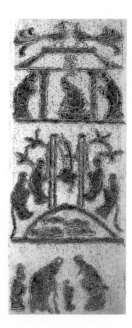

Fig. 29 *Rubbing of pictorial stone from Jinglaoyuan, Zhifang Zhen, Jiaxiang County, Shandong.* From *Zhongguo huaxiang shi quanji: Shandong Han huaxiang shi 2* (Jinan: Shandong meishu chubanshe, 2000), pl. 114.

Fig. 30 *Rubbing of pictorial stone from Jinglaoyuan, Zhifang Zhen, Jiaxiang County, Shandong.* From *Zhongguo huaxiang shi quanji: Shandong Han huaxiang shi 2* (Jinan: Shandong meishu chubanshe, 2000), pl. 115.

Fig. 31 *Rubbing of pictorial stone from Jinglaoyuan, Zhifang Zhen, Jiaxiang County, Shandong.* From *Zhongguo huaxiang shi quanji: Shandong Han huaxiang shi 2* (Jinan: Shandong meishu chubanshe, 2000), pl. 112.

Fig. 32 *Rubbing of pictorial stone from Jinglaoyuan, Zhifang Zhen, Jiaxiang County, Shandong.* From *Zhongguo huaxiang shi quanji: Shandong Han huaxiang shi 2* (Jinan: Shandong meishu chubanshe, 2000), pl. 113.

fortunately here the figures are labeled. In one of the illustrations not only are the main characters identified, but also a figure on the right side is labeled "Shao Gong," or "Duke of Shao" (fig. 29, middle register). In the *Shiji*, the Duke of Shao was called the guardian of King Cheng, and the Duke of Zhou his tutor.[39] In the second illustration of this scene, only King Cheng is labeled, as *taizi*, or heir apparent (fig. 31, lower register).[40] The other important theme noted at all the monuments under consideration, Confucius meeting Laozi and Xiang Tuo, is depicted twice, in both labeled and unlabeled versions (figs. 30, middle register; 32, lower register). The theme of the recovery of the *ding* tripod appears twice too (figs. 30, lower register; 32, middle register).

In contrast to the Pingyi pillars but like those of the Wu family, scenes with figures in an architectural setting also are included. Although these buildings are very simple structures, the illustrations are particularly significant because labels are carved above the heads of figures. In one scene "Chu Wang" ("the King of Chu") appears above a seated figure who bows his head slightly in acknowledgement as a figure under the eaves bends his head forward in homage (fig. 32, upper register). Two phoenixes are perched on the roof. In the second representation the characters "Wu Wang" ("the King of Wu") are carved above a standing figure who faces another figure in a posture of homage (fig. 31, middle register). On the roof of this building, a phoenix and an Immortal appear. All of the

figures on the roofs are auspicious. Nagahiro Toshio, among others, has suggested that illustrations appearing to be general homage scenes probably were meant to be viewed as depictions of specific historical figures. In an essay from the 1960s his primary example for this interpretation was a pictorial stone unearthed in Jiaxiang County at Jicheng Village (fig. 33).[41] On the post to the side of the homage scene on this stone, an inscription reads: "Ci Qi Wang ye" ("the King of Qi"). The composition, consisting of a large figure being fanned by an attendant behind him and offered homage by a figure who bows in front of him, is very similar to that of the homage scene on the north face of the west *que* of the Wu family cemetery site (fig. 16, middle register). Although Nagahiro is not sure which Qi king is represented, and it is not certain which kings of Chu and Wu are depicted in the Jinglaoyuan reliefs, at least in these cases particular personages of the past were selected for illustration.

One other relief from the stone chamber at Jinglaoyuan has imagery that compares with representations on the pillars from the Wu family site (fig. 34). This damaged stone is dominated by a two-story structure with *que* pillars located to each side. In the interior of the upper story are

seated figures, and under the eaves of the roof are standing figures, much like the arrangement on the south faces of the Wu family side pillars (see figs. 16). In the lower story, the scene of two figures bowing in front of a seated figure seems to be almost a reversed template of the homage scene from the north side of the west pillar of the Wu family (see figs. 17A,B). And finally, in the bottom register of the Jinglaoyuan stone, the sentries depicted in frontal view and also the unharnessed horse in profile view are related to the motifs that later appear on the main faces of the Wu family pillars (see fig. 16).[42]

In conclusion, salient elements of the iconographic program and of the compositional designs for the Wu family pillars, possibly built to honor a deceased individual, drew upon stock imagery that already had been used on the *que* at Pingyi and on stones once part of chambers in Jiaxiang before the end of the first century CE. In all of the monuments discussed above, subjects like Fuxi and Nüwa, the Duke of Zhou and Confucius, were included to advance an overarching message of cultural continuity and also an enduring reverence for the contributions of these figures. Other motifs were employed to safeguard the locale or

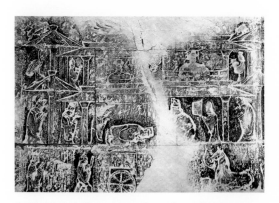

Fig. 33 *Rubbing of homage scene from Jicheng Village, Jiaxiang County, Shandong.* From Édouard Chavannes, *Mission archéologique dans la Chine septentrionale*, pl. 79, no. 152.

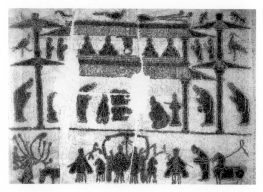

Fig. 34 *Rubbing of pictorial stone, Jinglaoyuan, Zhifang Zhen, Jiaxiang County.* From *Zhongguo huaxiang shi quanji: Shandong Han huaxiang shi* 2, pl. 120.

to signify the hopes for continuing prosperity, and finally to reinforce the general concept of homage. It does not diminish the importance of the Wu family pillars to see their imagery as motif blocks that were selected from a repertoire of pillar and chamber decorations that had certainly been in place for over fifty years. By comparison with the earlier examples, the designers of the Wu pillars created a much more compelling arrangement of images. The geometric borders and orderly baselines facilitated a measured perusal of the larger-scale figures that were part of the rich iconography.[43] All of these features, combined with the towering height of the pillars, resulted in visually striking structures that marked the entrance to the Wu family cemetery site. ○

Notes

1 Photographed by Édouard Chavannes (1865–1918), *Mission archéologique dans la Chine septentrionale* (Paris: E. Leroux, 1909–), Series Publications de l'École française d'Éxtrême-Orient, vol. 13, pt. one, pls. 32–43, 76. For documentation of the Wu family *que* after the Han period, see Cary Y. Liu's essay, "The 'Wu Family Shrines' as a Recarving of the Past," in *Recarving China's Past: Art, Archaeology, and Architecture of the "Wu Family Shrines"* (Princeton: Princeton University Art Museum; New Haven and London: Yale University Press, 2005), pp. 23–97.

2 Trans. Fan Bangjin. For discussions of the authenticity of the inscription, see essays by Cary Y. Liu and Michael Nylan in *Recarving China's Past*, pp. 59–60; 526–29.

3 *Que* might also have two secondary side pillars (*sanchu que*), but this type was reserved for imperial use. See Han Zhao, Li Ku, Zhang Lei, and Jia Qiang, "Gu dai quemen ji xiangguan wenti," *Kaogu yu wenwu* 2004.5, pp. 58–64. The authors report the discovery of *sanchu que* at the

mausoleum of the First Emperor of Qin and at Yangling, the mausoleum of Jingdi of the Western Han dynasty. See Shaanxi sheng kaogu yanjiusuo and Qin Shihuang bing ma yong bowuguan, "Qin Shihuang lingyuan 2000 niandu kantan jianbao," *Kaogu yu wenwu* 2002.2, pp. 3–15; and Shaanxi sheng kaogu yanjiusuo and Yangling kaogu dui, "Han Jingdi Yangling kaogu xin faxian 1996–1998," *Wenbo* 1999.6, pp. 3–11.

4 In the *Shijing*, fish often are associated with abundance. For example see Mao 190/Waley 160: "…Your herdsman dreams,/Dreams of locust and fish,/Of banners and flags./ A wise man explains the dreams: 'Locusts and fishes/Mean fat years./ Flags and banners/Mean a teeming house and home'," trans. Arthur Waley, *The Book of Songs* (New York: Grove Press, Inc., 1960), p. 168. Also see Mao 24/Waley 84; Mao 104/ Waley 85; Mao 57/Waley 86; Mao 221/Waley 193; Mao 170/Waley 168; and Mao 171/Waley 169.

5 See *Recarving China's Past*, p. 170 (1.35).

6 Trans. Wu Hung, *The Wu Liang Shrine: The Ideology of Early Chinese Pictorial Art* (Stanford: Stanford University Press, 1989), p. 160.

7 Wu Hung, *The Wu Liang Shrine*, p. 161. For an extended discussion of Fuxi's roles, see Mark Edward Lewis, *Writing and Authority in Early China* (Albany, NY: State University of New York Press, 1999), pp. 197ff.

8 The block above the *pushou* on the north side of the east *que*, which appears to be blank, is damaged. Traces of figures can be seen, especially in a rubbing published by Sekino Tadashi, *Shina Santōshō ni okeru Kandai funbo no hyōshoku* (Tokyo: Tōkyō teikoku daigaku, 1916), pl. 26 (no. 41 *Shina Santōshō ni*).

9 For a late Western Han coffin from Wohushan, Zoucheng County, Shandong, see Zhu Zhengchang, gen. ed., *Shandong wenwu congshu: Han huaxiang shi* (Jinan: Shandong youyi chubanshe, 2002), p. 77.

10 Tjan Tjoe Som, *Po Hu T'ung: The Comprehensive Discussions in the White Tiger Hall* (Leiden: E.J. Brill, 1952), vol. 2, p. 651: "The Grave

Mound: A tumulus is made and trees are planted [on the grave] that it may be recognized [as such].… The *Han wen chia* says: 'The grave-mound of the Son of Heaven is thirty feet high with a pine-tree planted on it; that of a Feudal Lord is half that height with a cypress planted on it…'" In addition, Klaas Ruitenbeek has translated an inscription relating to this practice on a stone slab from a funerary shrine at Songshan, Shandong: "We planted tall cypresses, and made sacrifices every morning and evening, offering a variety of sweet and rare dishes." See *Chinese Shadows: Stone Reliefs, Rubbings, and Related Works of Art from the Han Dynasty (206 BC–AD 220) in the Royal Ontario Museum* (Toronto: Royal Ontario Museum, 2002), pp. 16–17.

11 Qingzhou bowuguan, "Shandong Qingzhou Shi faxian Han huaxiang," *Kaogu* 1989.2, p. 184 (h. 130 cm, w. 57 cm, thickness 12 cm).

12 For more about workshop practice, see Anthony Barbieri-Low's essay, "Carving Out a Living: Stone-Monument Artisans During the Eastern Han Dynasty," in *Recarving China's Past,* pp. 485–511.

13 Related views are utilized on several of the reliefs from the shrines. See the variations in *Recarving China's Past*: p. 139, Stone Chamber 1, niche wall (1.8, third register); p. 150, Stone Chamber 2, west wall (1.20); p. 159, Stone Chamber 2, niche wall (1.25, fourth register); and p. 161, Stone Chamber 2, east wall (1.28, second register).

14 A pair of owls appears on the roof of the building on the north face of the east pillar. This motif probably refers to filial piety. Huan Tan reported during the reign of Emperor Xuan, the chancellor said, "'The owl gives birth to young which devour their mother when they grow up, and thereupon they become able to fly.' A wise man responded, 'I have only heard that the young of the owl [grow up] to feed their mother'." See Timoteus Pokora, *Hsin-lun (New Treatise) and Other Writings by Huan T'an (43 BC–28 AD)*, (Ann Arbor: Center for Chinese Studies, University of Michigan, 1975), p. 52.

15 Patricia Ann Berger, "Rites and Festivities in the Art of Eastern Han China: Shantung and Kiangsu Provinces" (PhD diss., University of California, Berkeley, 1980), pp. 87–88. Tjan Tjoe Som, *Po Hu T'ung: The Comprehensive Discussions in the White Tiger Hall*, vol. 2, pp. 643–44.

16 Alfred Forke, trans., *Lun-heng: Philosophical Essays of Wang Ch'ung* (New York: Paragon Book Gallery, 1962), vol. 1, p. 411 (*juan* 7: "Wen Kong").

17 *Shanhaijing* 7 ("Hai wai xi jing"), see Rémi Mathieu, trans., *Étude sur la mythologie et l'ethnologie de la Chine ancienne: Traduction annotée du Shanhaijing* (Paris: Institut des Hautes Études Chinoises, 1983), vol. 1, p. 402: "Les bingfeng se trouvent à du territoire du sorcier Xian, ils ressemblent à des truies, par devant et par derrière ils ont une tête noire." Also see *Shanhaijing* 9 ("Hai wai dong jing"); see Mathieu, trans., *Étude sur la mythologie et l'ethnologie de la Chine ancienne*, vol. 1, pp. 433–34: "L'esprit de la Vallée du Soleil levant, Zhaoyang, se nomme Tianwu, c'est le comte de l'eau, Shuibo; il se situe au nord du territoire des Honghong, entre deux cours d'eau. C'est un quadrupède qui a huit têtes à faces humaines, huit pattes et huit queues, toutes vertes et jaunes."

18 A similar grouping appears on one of the stones from the Wu Family Shrines, although the hand gestures of the large figure differ. See *Recarving China's Past*, Stone Chamber 2, south wall, p. 159 (1.26).

19 Mark Edward Lewis, *Writing and Authority in Early China*, pp. 209–18.

20 Derk Bodde discussed care of the aged by providing canes and stools in *Festivals in Classical China: New Year and Other Annual Observances during the Han Dynasty 206 BC–AD 220* (Princeton: Princeton University Press, 1975), pp. 342 ff.

21 Michael Loewe suggests this kind of object may be the "calling cards" (*ci* or *mingci*) officials presented at an audience. He cites examples excavated at Yinwan, Donghai County, Jiangsu Province. See Loewe, *The Men Who Governed Han China: Companion to A Biographical Dictionary of the Qin, Former Han and Xin Periods* (Leiden and Boston: Brill, 2004), pp. 52 and 38ff. Also see Lianyungang Shi bowuguan, "Jiangsu Donghai Xian Yinwan Han muqun fajue jianbao," *Wenwu* 1996.8, pp. 4–25; and Teng Zhaozong, "Yinwan Han mu jian du gaishu," *Wenwu* 1996.8, pp. 32–36.

22 See Michael Nylan's discussion of these scenes involving Confucius in *Recarving China's Past*, pp. 261–63. Also see Michel Soymié, "L'Entrevue de Confucius et de Hiang T'o," *Journal Asiatique*, vol. 242 (1954), pp. 311–91. Thanks to Julia K. Murray for this reference.

23 Michael Loewe, *The Men Who Governed Han China*, pp. 339, 347. In this study of the role of the Duke of Zhou during the Han dynasty, Loewe explains that the Duke of Zhou was cited by "many of the prominent officials and writers of Han times, and they called on his name for a variety of purposes." See p. 355.

24 Ibid., p. 339.

25 This paper is limited to extant visual evidence, but another possible source for the imagery on the Wu family *que* could have been decor on structures for the living. This has long since disappeared, but was described in prose poems like the *Rhapsody on the Hall of Numinous Brilliance* (*Lingguang Dian fu*), by Wang Yanshou (act. 163). The palace, located near Qufu, was built during the Western Han dynasty but continued to be used during the Eastern Han. Wang's *Rhapsody* describes the building's pictorial decoration, which does parallel the images described above: creatures of the cardinal directions, a variety of real and composite animals; Immortals; deities (Fuxi and Nüwa); loyal statesmen, filial sons, and also examples of good and tyrannical rulers. For a translation, see David R. Knechtges, *Wen xuan or Selections of Refined Literature* (Princeton: Princeton University Press, 1987), vol. 2, pp. 273 ff.

26 Trans. Fan Bangjin of transcription in *Zhongguo huaxiang shi quanji: Shandong Han huaxiang shi* 1 (Jinan: Shandong meishu chubanshe, 2000), pl. 4 (see entry text).

27 *Gongcao* is one of the titles of the deceased.

28 Trans. Fan Bangjin of transcription in *Zhongguo huaxiang shi quanji: Shandong Han huaxiang shi* 1, pl. 12 (see entry text).

29 The main fields of each shaft are comparable in size: Huang Shengqing 153 × 57–70 cm; and Gongcao 153 × 59–70 cm.

30 At present both the Huang Shengqing *que* and the Gongcao *que* are housed in one room in the Pingyi County Museum.

31 For the most part I am relying on identifications provided by scholars at the Pingyi County Museum in their recently published article; see Wang Xiangchen and Tang Shiying, "Shandong Pingyi Xian Huangshengqing que, Gongcao que," *Huaxia kaogu* 2003.3, pp. 15–19, 24. All of these features are much clearer in early twentieth-century rubbings published by Édouard Chavannes than in others recently published in China. See Chavannes, *Mission archéologique dans la Chine septentrionale*, vol. 13, pt. one, pls. 80–84; and *Zhongguo huaxiang shi quanji: Shandong Han huaxiang shi* 1, pls. 2–15.

32 Scenes of the discovery of the *ding* tripod are found on the west face of the Gongcao pillar and the north face of the east Huang Shengqing pillar. In the Pingyi representations, the discovery of the tripod is probably an auspicious reference to the success of good rulers in recovering it, (rather than an inauspicious reference to the inability of the First Emperor of Qin to recover the tripods of the Zhou). Sima Qian recorded the discovery of a large *ding* during the reign of Wudi [*Shiji* (Beijing: Zhonghua shuju, 1959) 12 ("Xiao Wu benji"); see William H. Nienhauser, *The Grand Scribe's Records*. vol. 2: *The Basic Annals of Han China* (Bloomington and Indianapolis: Indiana University Press, 2002), pp. 234 ff]. For the discovery of the tripod during the Qin dynasty, see *Shiji* 6 ("Qinshihuang benji"), p. 248. For an extended discussion of this theme, see Martin J. Powers, *Art and Political Expression in Early China* (New Haven: Yale University Press, 1991), pp. 200–202. This subject, as well as the others depicted on the faces of the Pingyi pillars, also was utilized on stone coffins made during the late Western Han and early Eastern Han dynasty. For more on images of barbarians, see Zheng Yan, "Barbarian Images in Han Period Art," *Orientations*, vol. 29, no. 6 (June 1998), pp. 50–59. For a discussion of carriage processions in later Eastern Han dynasty art, see Wu Hung, "Where Are They Going? Where Did They Come From? — Hearse and 'Soul-carriage' in Han Dynasty Tomb Art," *Orientations*, vol. 29, no. 6 (June 1998), pp. 22–31.

33 A virtually identical representation of the triad was discovered on a stone from Hualin Village in Jiaxiang County. To the left of the triad, a creature with nine human heads, a beast with human heads at each end of its body, and two other human-headed quadrupeds are represented. The nine-headed beast may be a *kaiming*, as described in *Shanhaijing* 11 ("Hai nei xi jing"), see Mathieu, *Étude sur la mythologie et l'ethnologie de la Chine ancienne*, vol. 1, pp. 470–80. For the Hualin Village relief, see Shandong sheng bowuguan and Shandong sheng wenwu kaogu yanjiusuo, *Shandong Han huaxiang shi xuanji*

(Jinan: Qi-Lu shushe chuban faxing, 1982), pl. 192 (74 × 80 cm).

34 Martin Powers, "An Archaic Bas-relief and the Chinese Moral Cosmos in the First Century AD," *Ars Orientalis*, vol. 12 (1981), pp. 25–40.

35 The authors of the entry for pl. 115 in *Zhongguo huaxiang shi quanji: Shandong Han huaxiang shi* 2 (Jinan: Shandong meishu chubanshe, 2000), identify the central figure as Gao Mei. For a discussion of the Supreme Intermediary, see Derk Bodde, *Festivals in Ancient China*, pp. 243–61. The center figure also has been identi- fied as the King Father of the West (Dongwanggong) in *Weishan Han huaxiang shi xuanji*, ed. Ma Hanguo (Beijing: Wenwu chubanshe, 2003), pl. 24. Also see *Zhongguo huaxiang shi quanji: Shandong* 2, pl. 153 for an image of the triad from the late Eastern Han period, unearthed in Tengzhou City, Longyangdian Zhen (92 × 130 cm). In Henan this triad is not common, but an example was found in Nanyang City in 1933; see *Zhongguo huaxiang shi quanji: Henan Han huaxiang shi*, pl. 207.

36 Martin Powers discussed the conflation of these scenes of Con- fucius meeting Laozi and Confucius meeting Xiang Tuo. See Powers, *Art and Political Expression in Early China*, pp. 203–5. Powers cites sources for the imagery: Meeting of Confucius and Laozi: *Shiji* 47 ("Kongzi shi jia"), p. 1909; Confucius and Xiang Tuo: *Shiji* 71 ("Chu li zi gan mao liezhuan"), p. 2319; *Huainan jizheng*, comp. Liu Jiali (Shanghai: Zhonghua shuju, 1934) 19 ("Xiuwu xun"), p. 24a; Evan Morgan, *Tao: The Great Luminant:*

Essays from Huai Nan Tzu (London: Kegan Paul, 1935), p. 238.

37 Jiaxiang Xian wenguansuo, "Shandong Jiaxiang Zhifang hua- xiang shi mu," *Wenwu* 1986.5, pp. 31–41. Also see the rubbings of the stones in *Zhongguo huaxiang shi quanji: Shandong Han huaxiang shi* 2, pls. 111–20. Editors of this volume have dated this group of stones to the early Eastern Han period. Another grouping of stones from Shandong that features decor related to that on the *que* of Pingyi and the stones from Jinglaoyuan is from Wulaowa, in Jiaxiang County. The major themes discussed above — the Duke of Zhou and King Cheng; Laozi, Confucius and Xiang Tuo; the discovery of a *ding* in a river; and processions of carriages — are represented but are not labeled. See Jiaxiang Xian wenguansuo and Zhu Xilu, "Jiaxiang Wulaowa faxian yi pi Han huaxiang shi," *Wenwu* 1982.5, pp. 71–78. The stones also are reproduced in *Zhongguo huaxiang shi quanji: Shandong Han huaxiang shi* 2, pls. 135–40. Also see Jean M. James, "The Eastern Han Offering Shrine: A Functional Study," *Archives of Asian Art*, vol. 51 (1998–1999), pp. 16–29, where she discusses these stones as part of a Han shrine that were reused in a post-Han tomb. Martin J. Powers believes these stones date to 67 CE; see "The Dialectic of Clas- sicism in Early Imperial China," *Art Journal*, vol. 47, no. 1 (Spring 1988), pp. 20–25.

38 *Shanhaijing* 11 ("Hai nei xi jing"); see Mathieu, *Étude sur la mythologie et l'ethnologie de la Chine ancienne*, vol. 1, pp. 470–80.

39 *Shiji* 4 ("Zhou benji"); Nienhauser, *The Grand Scribe's Records*, vol. 1, p. 45.

40 The style and placement of this inscription suggest it may have been carved in the post-Han period.

41 Nagahiro Toshio, "A Study on the Central Pavilion Scenes of the Wu Family Shrines," trans. Money Hickman, *Acta Asiatica,* vol. 2 (1961), pp. 40–58.

42 Two other stones of similar size (87 × 61–65 cm) from the tomb feature another grouping of themes. Like the Pingyi pillars, these stones have images of performances of music, dance, and acrobatics, a procession of horseback riders and a horse-drawn carriage, and a hunt scene. A connection to imagery from the Wu Family Shrines is seen in the inclusion of a register where an homage scene centered on the Queen Mother of the West (Xiwangmu) is included. In this rather unimposing depiction she is positioned at the center of a nearly symmetrical com- position. The nine-tailed fox and the three-legged bird appear to the right side to indicate that this is indeed the court of Xiwangmu and to balance the figures to the left. See *Zhongguo huaxiang shi quanji: Shandong Han huaxiang shi* 2, pls. 118, 119.

43 It should be noted that the ico- nography of the pillars contains some of the same themes seen in the more elaborately carved reliefs from the Wu family stone chambers, but the compositions of the *que* are less complicated, and the style is more reserved, reflecting an earlier date.

The Northwestern Style of Eastern Han Pictorial Stone Carving: The Tomb of Zuo Biao and Other Eastern Han Tombs Near Lishi, Shanxi Province

KLAAS RUITENBEEK

Note to the reader: Throughout this article, "right" and "left" refer to the viewers' right and left.

In northern Shaanxi and western Shanxi during the Eastern Han dynasty, a distinctive style developed of carving and painting stones for use in tombs, a style quite different from those found in Shandong, Henan, or Sichuan. In general terms, the Shaanxi-Shanxi style, also called the Northwestern style, is characterized by very free and painterly designs, rendered as perfectly flat, smoothly polished silhouettes slightly raised against a background of faint, shallow chisel marks. Typically, there are no, or very few, incised lines in the raised designs to indicate details; instead, there is a generous use of black ink lines and red paint. Artistically, the Northwestern style is far removed from the more rigid, hieratic designs of the Shandong "Wu Family Shrines," and technically, from the bold reliefs against an often rough, grooved background common to Henan and Sichuan.[1] This essay is a first attempt to define the characteristics, both stylistic and iconographic, of the Northwestern style, based on a number of representative tombs excavated in western Shanxi.

The region in which these Northwestern tombs were found belonged to the Upper and Western River Commanderies (Shang Jun and Xihe Jun), a frontier area in which Han Chinese lived in the midst of a population of nomadic or semi-nomadic Southern Xiongnu tribes (fig. 1). Large numbers of Chinese had been forced to move into Xiongnu territory since the Qin dynasty, when General Meng Tian started his war on the Xiongnu and evicted them from their pastures near the Yellow River. In 48 CE the Southern Xiongnu had split off from the Xiongnu confederation that had existed since 209 BCE, and from 50 CE they entered into a tributary relation with the Eastern Han dynasty. From that year the Chinese had a "Leader of Court Gentlemen and Envoy to the Xiongnu" (*Shi Xiongnu zhonglangjiang*) residing

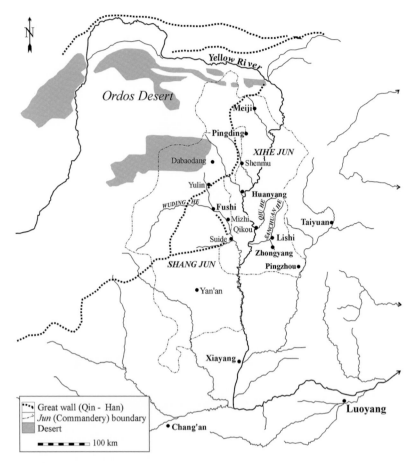

Fig. 1 *Shanxi–Shaanxi border area in the Eastern Han dynasty.* Map by Robert Mason, ROM, based on Tan Qixiang, *Zhongguo lishi ditu ji* (Shanghai: Ditu chubanshe, 1982), vol. 2, pp. 59–60.

in Pingding, the capital of Xihe, with a staff of administrators and secretaries and about 2,500 locally recruited Chinese troops. Fifty of these were even stationed permanently at the residence of the Southern Xiongnu *shanyu* leader in Meiji, to act as his guard. One of the tasks of the envoy was to oversee the yearly dispatch of a son of the *shanyu* as a hostage to the Han court in Luoyang. In spite of these measures, the mingling of Xiongnu and Chinese remained uneasy, and the Chinese could not prevent major Southern Xiongnu uprisings in 94 and 140 CE.[2]

Most of the Northwestern tomb sites are in Shaanxi, west of the Yellow River. They were built between circa 90 and 140 CE, primarily in the valley of the Wudinghe River near Suide and Mizhi. A few sites are more to the west, near Yulin, and Dabaodang in Shenmu District, close to the Great Wall.[3] The number of individual stone slabs, including scattered finds, is over one thousand pieces. The smaller number of tombs and scattered stones found east of the Yellow River (more than 300 individual stone slabs) all come from around Lishi, and date from after 140 CE. The year 140 is pivotal: in that year, confronted with mounting pressure from the Southern Xiongnu, the Han decided to move the administrative center of Xihe Jun from Pingding outside the Great Wall one hundred and seventy-five kilometers south to Lishi, and of Shang Jun from Fushi three hundred kilometers south to

Xiayang.[4] A number of stonemasons and tomb decorators from western Xihe must have crossed the river then also, following their patrons, and set up shop in Lishi, as the tombs found there are closely related to those of Suide and Mizhi. West of the Yellow River, the latest dated tomb is from 139 CE, and it is likely that the construction there of tombs with carved and painted stones decreased considerably after 140 CE.[5] In Lishi, the new administrative center, the earliest dated tombs are from 150 CE, the latest from 175 CE. The following pages will concentrate on a number of these later tombs from the vicinity of Lishi. These comprise six tombs excavated near Mamaozhuang, 2 kilometers west of Lishi, in 1990 and 1993; the tomb of Zuo Biao, laid open in 1924 near the same site; and a tomb excavated in 1997 near Shipan, 2 kilometers west of Mamaozhuang. The tomb of Zuo Biao, part of which was brought to the Royal Ontario Museum in 1925, was the starting point for my research and is the focus of this paper. These tombs are closely related, and several, including the tomb of Zuo Biao, may have belonged to members of one family.

The Mamaozhuang Tombs: Types, Layouts, Inscriptions, and Iconographic Features

The six tombs excavated near Mamaozhuang were located on a part of Tiger Hill (Hu Shan), which was cut through when the Sanchuan River was canalized in 1993 (fig. 2). Tombs 2, 3, and 4 (all undated) were excavated in 1990; tombs 14 and 19 (both dated to 175 CE), and 44 (undated) in 1993. By their description and numbering, the excavators of 1990 implicitly labeled the tomb of Zuo Biao (dated to 150 CE; and found in 1924) as Tomb 1.[6] Apart from these more or less completely preserved tombs, a considerable number of scattered, carved tomb stones have been found nearby; also, several other Han tombs remain unexcavated on Tiger Hill.[7]

The seven Mamaozhuang tombs (as well as the nearby Shipan tomb, the discovery of which has allowed an accurate reconstruction of the tomb of Zuo Biao) all have a square chamber at the center, with walls approximately 3 meters long and 1.7 meters high, constructed of gray bricks and topped by a brick dome. The chamber is accessed through a stone gate and following entrance corridor (*yongdao*), all underground. Part or all of the walls of the central chamber may be faced with carved stone panels, with stone tie-beams at the top. Tomb 14 consists of just the main chamber; Tombs 4 and 44 (only partially preserved) have a rear chamber; Tombs 3 and 19 have a rear and one lateral chamber; Tomb 2 and the Zuo Biao and Shipan tombs have a rear and two lateral chambers (meaning that all four walls of the main chamber have central openings, some with a supporting column at the middle of the opening). Entrance corridors, central, rear, and side chambers are topped with vaults. Peculiarly, Tombs 14 and 19 have a small side chamber in front of the tomb gate, *outside* the tomb proper (fig. 3). Tombs 14, 19, and the Zuo Biao and Shipan tombs contain inscriptions.

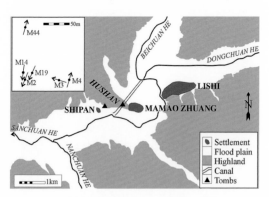

Fig. 2 *Vicinity of Lishi with approximate positions of Mamaozhuang and Shipan tombs.* Map by Robert Mason, ROM, based on Archaeological Institute of Shanxi Province, Cultural Relics Station of Lüliang Region, and Cultural Relics Office of Lishi District, "Shanxi Lishi Mamaozhuang Dong Han huaxiang shi mu," *Wenwu* 1992.4, p. 14; Wang Jinyuan, "Shanxi Lishi Shipan Handai huaxiang shi mu," *Wenwu* 2005.2, p. 42; Google Earth.

That of Tomb 14, engraved on the left door post, reads: "Everlasting tomb of the late honorable Niu Chan of Pingzhou, District Magistrate of Huanyang in Xihe, of the Han dynasty" (*Han gu Xihe Huanyang shouling Pingzhou Niu gong Chan wansui zhi zhaizhao*); moreover, the date "sixth month of the fourth year of the Xiping period (175 CE)" is written in ink on the left door panel of the gate. Pingzhou and Huanyang are both districts in Xihe. Pingzhou is east of the Yellow River, 75 kilometers southeast of Lishi, and Huanyang is west of the river, 100 kilometers northwest of Lishi. Inside Tomb 14 a bronze seal was found with the text "Seal of Niu Chuan" (*Niu Chuan yinxin*). *Chuan* could be a variant for the near-homophone *Chan*, or else for the character *chuan* meaning "assistant official." Several Northwestern tomb inscriptions contain this character, and it is clear that many of the tombs with carved stones belonged to lower- and middle-rank officials. Tomb 19 has an incomplete date engraved on a stone column: "Positioned here on the 27th day, with the cyclical signs *gengshen*, of the 12th month of … "[8] (…*shi'er yue nianqi ri gengshen ancuo yu si*; this combination of date and cyclical signs occurs in 149 CE and 175 CE, but here most likely refers to 175). The tomb of Zuo Biao has inscriptions incised on both of its stone columns (fig. 4). The first reads: "In the first year of the Heping reign-period (150 CE), Zuo Yuanyi of Guang Village in Zhongyang District, within Xihe Commandery, built this Dwelling of Ten Thousand Years" (*Heping yuannian Xihe Zhongyang Guangli Zuo Yuanyi zaozuo wannian lushe*), and shows that the tomb occupant had started to build his tomb during his lifetime. The second reads: "The tomb of Zuo Biao from Xihe, courtesy name Yuanyi, Scribe in the Memorials Section at the Military Headquarters of the Leader of Court Gentlemen and Envoy Holding the Tasseled Staff" (*Shizhe chijie*

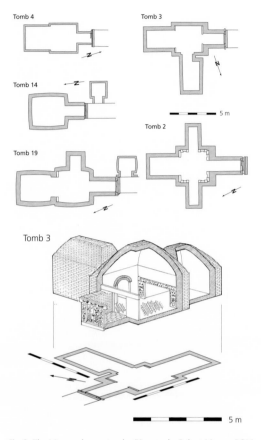

Fig. 3 *The Mamaozhuang tombs.* Diagram by Robert Mason, ROM, based on "Shanxi Lishi Mamaozhuang Dong Han huaxiang shi mu," pp. 15, 29, 38; Archaeological Institute of Shanxi Province, Cultural Relics Station of Lüliang Region, and Cultural Relics Office of Lishi District, "Shanxi Lishi zaici faxian Dong Han huaxiang shi mu," *Wenwu* 1996.4, pp. 14, 19; *Shaanxi, Shanxi Han huaxiang shi*, vol. 5 of *Zhongguo huaxiang shi quanji*, ed. Zhongguo huaxiang shi quanji bianji weiyuanhui (Jinan: Shandong meishu chubanshe, 2000), p. 7.

zhonglangjiang mufu zoucao shi Xihe Zuo Biao zi Yuanyi zhi mu). The "Leader of Court Gentlemen and Envoy Holding the Tasseled Staff" is none other than the "Leader of Court Gentlemen and Envoy to the Xiongnu," whom we have met above, and this tomb of one of his scribes is a valuable material confirmation of what is written in the historical sources.[9] Of the long inscription written in ink on a column of the Shipan tomb, finally, only the

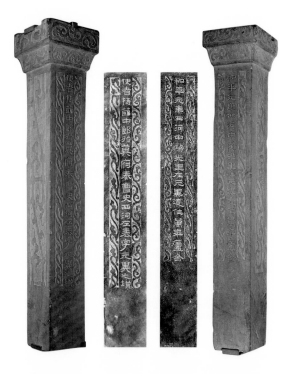

Fig. 4 *The two inscribed columns of Zuo Biao's tomb, with rubbings.* Sandstone with traces of black and red paint. ROM 925.25.22.O, P. The George Crofts Collection. Left column (P): 135.5 (total height) × 17.5 (inscribed side) × 20 cm; capital: 16 × 25 × 28 cm. Right column (O): 136.5 (total height) × 18.5 (inscribed side) × 19 cm; capital: 18 × 27.5 × 28.5 cm. Courtesy of the Royal Ontario Museum © ROM.

In all the tombs carved and painted decoration shares a similar iconographic program and certain formal characteristics. On each of the two panels of the gate is a large *pushou* monster mask and a phoenix; on the doorposts are guardians and images of the Queen Mother of the West (Xiwangmu) and the King Father of the East (Dongwanggong); and on the lintel a procession of carriages and mounted attendants. Similar processions, as well as hunting scenes, are found on the tie-beams atop the stone panels inside the tomb chamber; the panels themselves are carved and painted with paradise imagery. Wide ornamental borders filled with various scroll patterns are a characteristic element in all tombs. Without exception, the upper third of all horizontal beams bears such scroll patterns, which also border the central scenes of the vertical panels.

Notwithstanding this overall similarity, there are important differences among the tombs, both in artistic style and quality. Tomb 3 stands out for the richness and liveliness of its imagery, the quality of its execution, and its flamboyant style. It is, in fact, a prime example of this flamboyant style, which represents the highest achievement of the art of the stone carvers and painters of the northwest. The flamboyant style is characterized by overall restless movement combined with superior technical execution, manifested in thin, precisely drawn straight lines and scrolls, and delicately rendered animal and human figures. The style may have developed from the more stereotyped, schematic rendering of decorative and iconographic motives found in the majority of northwestern tombs. Alternatively, and perhaps more likely, it could directly reflect a metropolitan or palace style, from which more pedestrian styles were subsequently derived. (The contrast is patent between figs. 9 and 32A). Other examples of this flamboyant style are the Yanjiacha tomb of Suide, excavated

words "[Of the] Governor of Xihe…" have been deciphered[10] (*Xihe taishou*…; several inscriptions in Northwestern tombs belonging to minor officials in Xihe Commandery start with these words). All Mamaozhuang tombs and the Shipan tomb had been looted, with only a very few tomb gifts left, mainly ceramic vessels and objects such as ceramic stove models (Tombs 14, 19); a bronze mirror, seal, and tripod vessel with spout and handle (*jiaohu*; all in Tomb 14); an iron hoe, a bronze chariot-canopy part, and a pair of lead cheek-pieces of a horse bit (all in Tomb 2). What makes these tombs important is the abundance of carved and painted stones they have yielded.

Fig. 5 *Gate of Mamaozhuang Tomb 3* (rubbings). Lintel: 31 × 217 × 12 cm; posts: 125 × 32 × 11 cm; door panels: 115 × 50 × 5 cm. From *Shaanxi, Shanxi Han huaxiang shi*, p. 5.

in 1975; the two panels with birds and fantastic animals found in Suide in 1957, now kept in the Beilin Museum in Xi'an; and the two panels found in Mizhi in 1981, one showing a deer and the other a ram.[11] A somewhat more detailed description of Tomb 3 will be given first; the other tombs can then be discussed in comparison with it. In this way differences and similarities will appear clearly.

Mamaozhuang Tomb 3

Tomb 3 is of medium size, with a gate at the west, a main chamber, one lateral chamber at the north, and a rear chamber at the east. Carved and painted stones make up the gate and the west and east walls of the main chamber, where they frame the opening leading to the *yongdao* and the rear chamber.[12]

The gate consists of five stones: two door panels, a lintel, and two doorposts (figs. 5, 6). The door panels, 115 centimeters high, 50 centimeters wide, and 5 centimeters thick, are decorated with

Fig. 6 *Doorposts of Tomb 3* (drawings). From "Shanxi Lishi Mamaozhuang Dong Han huaxiangshi mu," p. 31.

Fig. 7 *Branches of money trees.* Eastern Han dynasty, second century CE. Sichuan. Bronze; 10.5 × 21.5 × 0.3 cm (ROM 2000.106.1739); and 18 × 13.5 × 0.4 cm (ROM 2000.106.1697). Gift of Joey and Toby Tanenbaum. Courtesy of the Royal Ontario Museum © ROM.

Fig. 8 *Frieze of west wall, Tomb 3* (rubbing). 31 × 274 × 12 cm. From *Shaanxi, Shanxi Han huaxiang shi*, no. 260.

facing phoenixes, each surmounting a large *pushou* monster mask with ring carved into the stone and painted. Below the *pushou* are two facing long-tailed felines, each with a unicorn-like long single tusk and carrying a bird on its back. Apart from the large carved and painted door rings, real iron door rings, 11 centimeters in diameter, were once fitted to the outside of the doors. As in all stones in this tomb (and the other tombs discussed in this article), the details in the raised designs are not carved, but painted in black and red.[13] Rubbings only reproduce the carved outlines, and thus give a much less complete image of the designs than, for example, rubbings of the Wu Family Shrines stones, on which the details were incised in fine lines. On each doorpost (125 × 32 × 11 cm), in the upper register, is a kneeling figure under a large canopy, wearing a long robe and three-pointed crown; these two figures face each other across the door panels. They

sit on platforms lush with vegetation, supported by bent columns. The two kneeling figures must be the Queen Mother of the West and the King Father of the East, although their iconography is not very specific here apart from the Mount Kunlun-type platforms on bent columns. Under the platform, on each post, a bird perches on a three-peaked mountain. At the bottom of the posts are guards, the left-hand one heavily moustached and bearded, carrying a shield with both hands; the right-hand one with only a fine moustache, armed with a kind of halberd or rake with a long shaft. The lintel (31 × 217 × 12 cm) shows in the lower register a procession: one canopied carriage in the middle, preceded by three open carriages and followed by a horseman and two more open carriages (fig. 5). The passenger in the canopied carriage may represent the tomb occupant. Four trees stand among the carriages, one with two birds hovering under it.

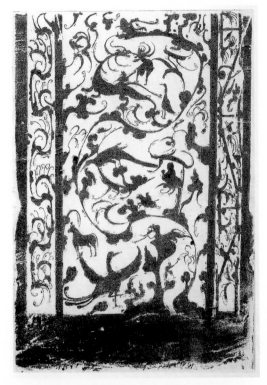

Fig. 9 *Left panel of west wall, Tomb 3* (rubbing). 130 × 88 × 12 cm. From *Shaanxi, Shanxi Han huaxiang shi*, no. 265.

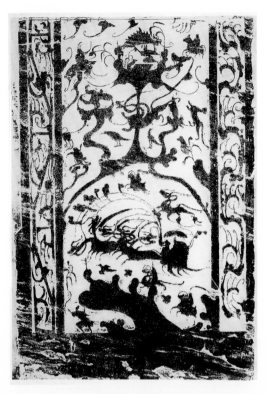

Fig. 10 *Right panel of west wall, Tomb 3* (rubbing). 140 × 86 × 12 cm. From *Shaanxi, Shanxi Han huaxiang shi*, no. 266.

These trees are characteristic of the Northwestern style; they are never found in carriage processions in Shandong. The top register of the lintel shows an angular, lattice-type scroll pattern enlivened with stylized and abstracted Immortal-, animal-, and plant-like designs. These scrolls with abstracted (and, in other Northwestern tombs, sometimes realistic) animals and Immortals are part of the paradise imagery associated with the Queen Mother of the West and the King Father of the East. They remind us of the branches of bronze money trees from Sichuan, in which all kinds of animals and Immortals also frolic (fig. 7), and there may well be a connection in the symbolism.[14]

The lintel on the west wall of the main chamber (31 × 274 × 12 cm) also shows a procession

of carriages and horsemen, all speeding toward the left (fig. 8). In the middle is a building with an open gallery at the left side. To its right, a standing figure welcomes three canopied carriages coming from the right, all with a driver and one passenger. The middle one, escorted by four horsemen, is the largest. Its passenger may represent the tomb occupant. More horsemen and canopied carriages, and flying birds, fill the left half of the lintel, with a scroll pattern above the whole picture.

The two large panels under this lintel are the most extraordinary works of art among the Mamaozhuang stones (figs. 9, 10). The right panel (fig. 10) (140 × 86 × 12 cm) shows in a powerful composition full of restless movement the ascension of a cloud carriage drawn by five

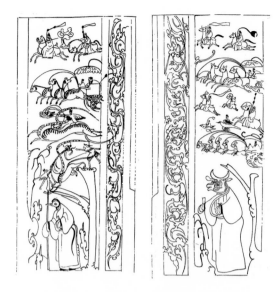

Fig. 11 *Left and right panels of east wall, Tomb 3* (drawings). 120 × 52 × 12 and 120 × 53 × 12 cm, respectively. From "Shanxi Lishi Mamaozhuang Dong Han huaxiang shi mu," pp. 36, 37.

dragons, guided by long reins swung by the driver in wide arcs over their backs. The passenger wears a three-pointed crown, indicating that he is in or approaching the state of immortality. Under the carriage is a cloud-like mountain, crested like a wave, surrounded by birds, a horseman, a dragon, and a bent figure holding up a long stalk of a vine. Over the dragon carriage is an arch, possibly a rainbow, spanning the entire width of the scene. A slender column rises from its middle, supporting a garden with rich vegetation. Centered in the

garden is a square table, with a canopy held over it by a female Immortal. A large dragon, birds, a tiger, a toad, Immortals or feathered men, and a horseman surround the paradise garden. The left panel (fig. 9) (130 × 88 × 12 cm) shows the paradise world with its vegetation and denizens. The undulating body of a dragon stretches from bottom to top like a giant *S*, dividing the scene into three sections. Birds, dragons, and winged Immortals can be seen in the upper section, and two Immortals seated close together on Kunlun-type thrones (probably the Queen Mother of the West and the King Father of the East) and a large bird occupy the middle part. At the bottom, a dancing bird with outspread wings, a unicorn, a tiger, and an Immortal picking a fruit from a paradise herb populate the scene. There is not a single straight line in these two panels; everything is whirling movement and dance-like rhythm, striving upward in a joyful rush. Wide vertical borders filled with eddying scroll patterns reinforce the sense of upward movement. The artistic effect is extraordinary.

The carved stones on the east wall of the main chamber form the entrance to the rear chamber, and show a pair of standing figures guarding it: an ox-headed figure holding a ceremonial tablet at the right side, and a chicken-headed figure holding a halberd at the left (fig. 11). These figures are commonly paired with the Queen

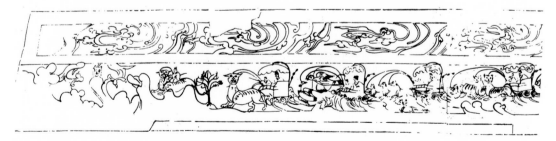

Fig. 12 *Frieze of east wall, Tomb 3* (drawing). 31 × 284 × 13 cm. From "Shanxi Lishi Mamaozhuang Dong Han huaxiang shi mu," pp. 34–35.

Mother of the West and the King Father of the East, and, as we shall see, the two divinities are sometimes themselves depicted with chicken and ox heads. Over the ox-headed guard are carved two wheelless cloud carriages ascending to the heavenly paradise depicted on the lintel, the lower drawn by five, the upper by four deer-like animals. They are escorted by men riding horses, deer, and birds, all holding banners and other insignia. On the other panel, only one canopied cloud carriage appears, drawn by three winged horses. It is escorted by a winged Immortal riding a dragon, and two horsemen holding banners. The passenger in this carriage could be interpreted as the male tomb occupant, and those in the two deer-drawn carriages on the other panel may perhaps represent his wives.

On the lintel over the doorway a procession of seven cloud carriages through a landscape of cloud-like mountains is depicted (fig. 12). A vanguard riding a tiger is entering the mountains at the left, followed by a tiger-drawn carriage, a carriage drawn by three large birds, a carriage drawn by three deer or foxes, another drawn by three leopard-like felines, a carriage drawn by three fishes escorted by figures riding on fishes, a carriage drawn by four deer- or dog-like animals, and finally, a carriage drawn by four dragons. Another dragon and three riders on horseback

follow in the mountains at the right. Whereas on the other two lintels in this tomb all the carriages have wheels, and may show excursions of the tomb occupant, or possibly relatives coming to visit his tomb shrine, the carriages here rest on clouds instead of on wheeled axles. This lintel, and the four vertical carved panels in the tomb chamber, together represent one of the most elaborate renderings of paradise in Han-dynasty art. Only the carved stones of the Yanjiacha tomb come close.

Seen as a whole, the iconographic program of the tomb consists of three parts: a gate with auspicious birds, monster masks, and guardian figures; carriage processions and hunting scenes; and cloud carriages with paradise imagery. The gate wards off intruders (hence the monster masks and guards) and, at the same time, announces the blissful world of paradise (hence the birds, Queen Mother of the West, and King Father of the East). The carriage processions represent the tomb occupant traveling to the offering shrine aboveground near the tomb (depicted in all four tombs described in this article), to meet with his living relatives and enjoy their offerings. The wheelless cloud carriages and paradise imagery illustrate the ascension of the tomb occupant to the paradise world of Mount Kunlun.[15] This same program is also found in the other Lishi tombs. The gates of all eight tombs considered here are nearly

identical, and will not be described individually. In the horizontal friezes with carriage processions and hunting scenes there is more variety. Some include architecture and quite prominent landscape elements, such as hills and trees. Also, some friezes are subdivided into smaller sections or panels by vertical lines. The paradise imagery is largely absent from the more simply decorated Tombs 4 and 14 (only the gates and entrances to the rear chambers are decorated) and Tombs 19 and 44 (only the gates are decorated). But in the tombs that have central chambers covered with stone slabs on two or all four sides (Nos. 2, 3, and the Shipan and Zuo Biao tombs), paradise imagery occupies most of the surface of the carved decorations, and shows the largest variety.

Mamaozhuang Tomb 2

The main chamber of Tomb 2 has a very clear program of paired and facing paradise scenes.[16] On the south wall, flanking the tomb chamber entrance, are two panels, each of which shows the Queen Mother of the West and the King Father of the East sitting side by side on individual column-shaped Mount Kunlun platforms under individual canopies (fig. 13). Under them on either panel is a vertical scene of a cloud carriage with two passengers, drawn by mythical animals, deer, or horses, and escorted by several Immortals riding on identical animals. Clearly, these scenes were originally meant to be horizontal, and were simply turned ninety degrees in order to fit the space on the narrow panels. These narrative scenes are each bordered on both sides of the wall by very wide and elaborate scrolls. Over the south entrance there is a semicircular supraporte or lunette (fig. 14), resting on the horizontal frieze with a carriage procession. On its outside face the supraporte is carved with a winged tiger, with a large tongue

hanging from its mouth. The inside face of the carving shows a crouched, winged leopard. Both animals have large bulging eyes and look rather humorous. This is the only example of a lunette, not only among the eight tombs studied here, but among all known northwestern tombs.

The Queen Mother and King Father side by side on one stone slab bear witness to an interesting phenomenon: the rapprochement of two figures that originally belonged to two opposite ends of the world. In the Wu Family Shrines, they are still on facing gables, and on the entrance gates of all eight Lishi tombs they are on different doorposts, separated by the door panels. Here they seem to be joint rulers of one and the same paradise, a king and queen living together.

On the southern part of the east and west walls of Tomb 2 are three narrow vertical slabs

Fig. 13 *Three left panels of south wall, Mamaozhuang Tomb 2* (rubbing). 137 × 87 × 25 cm. From *Shaanxi, Shanxi Han huaxiang shi*, no. 238–40.

each: a central pictorial panel flanked by panels with elaborate scroll designs. The central slabs show an inventory of paradise wildlife, vertically arranged in four small panels each (fig. 15). On the west are birds: from top to bottom, a peacock-like bird picking a berry from a bush; a one-legged bird holding a jade plaque pendant from a string in its beak; a three-legged bird facing shrubs; and a two-legged, two-headed bird with outstretched wings. On the east, quadrupeds: a unicorn winged horse facing shrubs; a winged horse with two sheep heads; a winged horse facing a shrub; and a turtle with a leopard head.

The northern ends of those two walls hold similar arrangements. The central one of three narrow vertical slabs on the west wall shows the King Father of the East [sic], with under him a chicken-headed guardian in a long robe with "water sleeves," holding a spear. On the east wall, under the Queen Mother of the West, is an ox-headed guardian in similar attire (fig. 16). In the Lishi tombs, the King Father and Queen Mother are not always clearly distinguishable, but here they are: there is no question that the winged figure with a moustache and a three-pointed crown on the west wall is the King Father of the East.[17] The facing Queen has no crown, but wears her hair in a large chignon. The King Father is seated cross-legged, the queen Mother kneels; both have their clasped hands covered by long sleeves and each sits on a dais supported by a column curving upward from a mountain chain below. Scroll-shaped pendants dangle from each dais, and from the canopy over the King Father coin- or *bi*-shaped discs are suspended. Pendants and discs recall money-tree branches, and the appearance of the King and Queen seems to be influenced by Sichuan examples as well.

Finally, the north wall has two similar single slabs at the left and right of the open entranceway

Fig. 14 *Front and back sides of supraporte, Mamaozhuang Tomb 2* (drawings). 44 × 94 × 6 cm. From "Shanxi Lishi Mamaozhuang Dong Han huaxiang shi mu," p. 19.

Fig. 15 *Central panels at south side of west* (left) *and east* (right) *wall, Tomb 2* (rubbings). 140 × 39 × 12 cm. From *Shaanxi, Shanxi Han huaxiang shi*, nos. 254, 251.

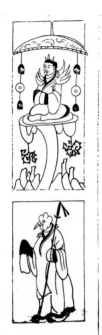
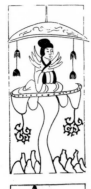

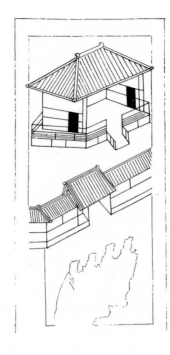

Fig. 16 *Central panels at north side of east and west wall,* Tomb 2 *(drawings).* 135 × 37 × 112 cm. From "Shanxi Lishi Mamaozhuang Dong Han huaxiang shi mu," p. 26.

Fig. 17 *West panel of north wall,* Tomb 2 *(drawing).* 137 × 50 × 23 cm. From "Shanxi Lishi Mamaozhuang Dong Han huaxiang shi mu," p. 27.

to the rear chamber. These show architecture: a building with an open front on a platform, with a surrounding gallery and a gate incorporated into the front of the gallery (fig. 17). The building is empty, but in front of the gate stand four capped attendants holding ceremonial tablets, seeming to be about to welcome visitors. The architectural designs on the north wall are matched by an architectural design on the frieze above them (which is supported by a column in the center of the open entryway). The design shows a hall surrounded by a gallery, with a gate and a pair of *que* pillars at both front and rear. Trees are planted around the complex, and at both front and back are a pair of guards, one holding a shield and the other a halberd, to receive and see off visitors. It should be mentioned that the friezes on the west, south, and east walls comprise a single carriage procession, running counter-clockwise.

The Shipan Tomb

The tomb found at Shipan is similar to Tomb 2 of Mamaozhuang, in having a fully decorated central chamber with a central opening in all four walls. A central column divides the openings in the eastern and western walls (fig. 18).[18] The two tombs are also very similar in their iconographic content and in the style of their scrolls and pictorial designs. Each wall consists, however, of only two large slabs, instead of the numerous narrow slabs in Tomb 2. Apart from the south wall, the pictorial designs seem to be distributed over the slabs in a haphazard manner, not paired meaningfully as in Tomb 2. The two south-wall slabs show large lattice panels, suggesting windows or doors.[19] Both have a narrow bottom register. The western one shows a central tree with two horses tied to it, facing each other at a manger (fig. 19). At the top right of this register is a small kneeling figure. The eastern register shows an ox, a carriage, and

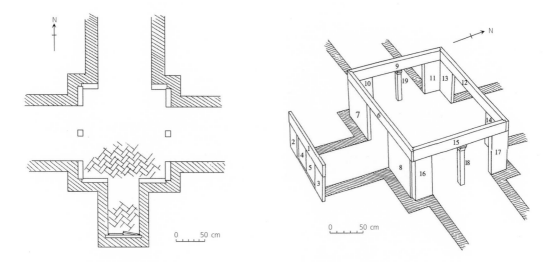

Fig. 18 *Plan and elevation of the Shipan tomb.* From Wang Jinyuan, "Shanxi Lishi Shipan Handai huaxiang shi mu," p. 43.

a flying bird. On the west wall, the southern slab shows an ox-headed figure, standing on a platform supported by two columns. Its usual companion, the chicken-headed figure, is not standing next to it or facing it, but is carved on the western panel of the north wall. Making up the northern slab of the west wall are three registers showing horsemen and horse-drawn carriages. A more-or-less matching panel, showing horse-drawn carriages in the upper three registers and two standing figures at the bottom, is, again, neither facing nor adjacent to the horsemen and carriages, but positioned at the east side of the north wall. The east wall, finally, shows on its northern slab the Queen Mother of the West, sitting on her column-borne platform, with below her a two-storied watchtower; on the southern slab are two heavenly horses, one above the other, the top one facing a tall bush. To the left of the bottom one is an inscription in ink: "Those with a horse head and ox hooves are called *Fu*...(character illegible)." As for the frieze, it is carried on beams under the ceiling along all four

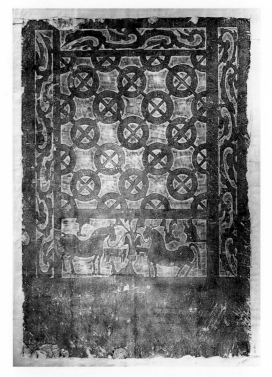

Fig. 19 *West panel of south wall, Shipan tomb.* 130 × 88 × 20 cm. Original rubbing in ROM collection, gift of the Museum of Han Pictorial Stones, Lüliang, Lishi, Shanxi. Courtesy of the Royal Ontario Museum © ROM.

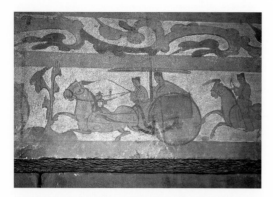

Fig. 20 *Detail of south frieze, Shipan tomb.* 32 × 300 × 24 cm (frieze in its entirety). Photo by author.

walls. Subdivided into panels by vertical lines, it shows a counter-clockwise procession of carriages and horsemen (fig. 20), and on the west half of the north-wall frieze, a three-bays-wide building with double eaves. As in the other Lishi tombs, the top register of the frieze and the borders of the vertical slabs are decorated with scroll patterns. In the Shipan tomb the painted designs in red and black have been preserved exceptionally well.

The Tomb of Zuo Biao

The excavation of the tombs at Mamaozhuang and Shipan in the 1990s has made it possible to reconstruct the original arrangement of a group of stone columns, frieze-decorated beams, and wall slabs that had belonged to the tomb of Zuo Biao and were found at Mamaozhuang in 1924. Shortly after their discovery some of the stones were taken away to Beijing, whence they were shipped to Toronto. The remaining stones stayed in China, and are now kept in Taiyuan and Lishi: eight large vertical slabs (approx. 135 × 90 cm), one frieze beam (l. 287 cm), and one doorpost (136 × 33 cm). During subsequent decades, the stones in China and Canada were published and researched independently of one another. Only in

2003 did the curators of the three museums where the stones are kept meet and exchange rubbings.[20]

The ROM stones arrived in Toronto from Beijing in 1925: two stone columns with incised inscriptions (h. 136 cm) and fourteen fragments of a pictorial stone frieze in shallow relief (total length 16 m, including two complete beams measuring 300 and 307 cm). They had been acquired by George Crofts, the Irish fur merchant and Chinese art wholesaler established in Tianjin who had sent more than four thousand Chinese antiquities and works of art to the ROM in the years 1918–1925. As part of his last shipment before his sudden death later in 1925, he sent the Zuo Biao stones. In his account, dated to 25 February 1925, he gives a rough translation of the commemorative inscriptions for the tomb occupant, and states that the stones came "from a tomb at Yung Ning Chow — Shansi — (near the Tsio Ho River) which still contains the memorial to the General's wife, and also the entrance gates to the tomb. […] The tomb is about 35 feet long, 20 feet wide and high."[21] This is the earliest information available about Zuo Biao's tomb. Before Crofts acquired the stones, rubbings had been made of the inscriptions on the two columns. Transcriptions were published in 1926, reproductions in 1928.[22] A brief account of the discovery of the stones was published in 1939. It mentions that they were found in 1924 by shepherds, between the villages of Mamaozhuang and Wangjiapo near Lishi, after a flood of the nearby river. They were part of a square tomb chamber with brick walls, covered with a pointed dome. On their interior faces, the walls were lined with carved stones. Some earthenware vessels and dishes, and a shallow bowl containing human bones were found inside. Two stone columns and carved stones found next to the tomb chamber, and four or five carved stones from inside were

bought by the Beiping antiques dealer Li Zhongxian. After the local authorities learned of this, thirteen remaining carved stones were brought into the city and deposited in the Confucius Temple of Lishi.[23] Rubbings of some of the stones in China were published in 1958, and in 1962 Hsio-yen Shih, then curator at the ROM, published and discussed all the stones in Toronto. She noted the relation with the stones from Suide, but with the limited material available at the time it was not yet possible to sketch a broader picture, let alone attempt a reconstruction of Zuo Biao's tomb. Shih's article was hardly noticed in China, and when Xie Guozhen wrote his article about the inscriptions of the tomb in 1979, he merely mentioned that Xia Nai had told him that the stones were now in a Canadian museum.[24]

The eight large slabs, two columns, and frieze beams found in 1924 make it next to certain that the plan of Zuo Biao's tomb was the same as that of the Shipan tomb: a square central tomb chamber with central openings in all four walls (see fig. 18). Columns were centered in the openings leading into the two side chambers. Of the eight slabs (some have rabbets, but their original position in the tomb chamber is not known), four have paradise imagery (fig. 21A–H). The first slab has at the top a wheelless cloud carriage drawn by four winged tigers or leopards, with a driver and passenger under its canopy, both rendered as Immortals. Under the carriage are two Immortals, one riding on a winged tiger and the other on a winged horse. At the bottom are a large toad and a human figure with a long snake tail, possibly Fuxi (fig. 21A).[25] At the top of the second slab is a canopied cloud carriage drawn by four deer, with Immortals as the driver and passenger. In the middle is a large trefoil composed of three fish joined at the head, surrounded by a winged

horse with a dragon head, a unicorn deer, and a double fish joined at the eye (*bimu yu*). At the bottom are hills, with a tiger pursuing a fox, and an owl (fig. 21B). At the top of the third slab a cloud carriage without canopy is drawn by four fish, with a winged Immortal driver at the back, and a passenger at the front; their escorts, just below, are two winged Immortals riding on fishes. In the middle an Immortal rides an unidentifiable animal, and two figures with tails, probably Fuxi and Nüwa, hold hands. The scene at the bottom is damaged, but shows hills, part of a bird, and what seems to be a building (fig. 21C). As we saw earlier, cloud carriages drawn by tigers, deer, and fish also occur in Tomb 3 of Mamaozhuang. The paradise scene of the fourth slab is different: it shows a long-eared, winged Immortal standing on a cliff, feeding twigs of (presumably) the herb of immortality to a winged horse hovering in front of him.[26] Under the horse are a large quatrefoil and two birds (fig. 21D).

The other four wall slabs also show some mythical animals, but primarily depict scenes from the world of the living. The first shows a large buffalo tied to a tree trunk in front of a manger. The scene recalls the horses tied to a tree and eating from adjacent mangers on the south wall of the Shipan tomb. Under the large buffalo are an oxcart with a guide and a horseman followed by four figures walking. At the bottom are a tiger, two intertwined dragons, and a scroll that may be an abstracted dragon (fig. 21E). The second slab shows a hooded cart with a driver, drawn by two horses, preceded by a rider on a horse whose forequarters disappear beyond the scene's border. The cart is escorted by two other galloping horsemen, the rear mount having only his forequarters visible, his hindquarters cut off by the border of the scene. The cut-off figures, uncommon in Chinese art, convey a strong impression of speed. At the bottom

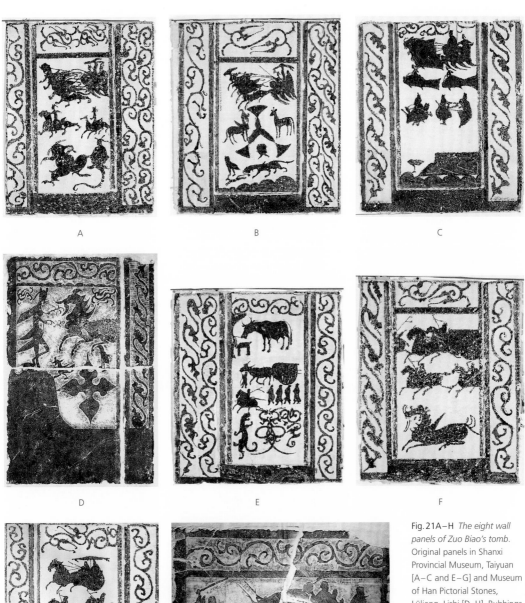

Fig. 21A–H *The eight wall panels of Zuo Biao's tomb.* Original panels in Shanxi Provincial Museum, Taiyuan [A–C and E–G] and Museum of Han Pictorial Stones, Lüliang, Lishi [D, H]. Rubbings in ROM, gifts of the Taiyuan and Lishi museums; 109 × 85 cm, 110 × 93 cm, 110 × 95 cm, 133 × 90 cm, 110 × 94 cm, 109 × 87 cm, 110 × 85 cm, and 77 × 93 cm, respectively. Height of all original stone panels except the last is about 135 cm. Courtesy of the Royal Ontario Museum © ROM.

Fig. 21I *Bullfight, wall panel of Zuo Biao's tomb* (detail of stone carving from which rubbing of fig. 21H was made). Photo by author.

of the slab is a winged horse in fast gallop. It wears a bit with two large, S-shaped cheek pieces, similar to the two lead cheek pieces that were found in Tomb 2 (fig. 21F). The third slab shows a canopied carriage with a driver and passenger, drawn by one horse. The vehicle is escorted by two horsemen carrying long spears. The bottom of this slab is empty (fig. 21G). The last slab is badly broken, with the entire bottom half missing. The top part shows a bullfight: a bearded man running while brandishing a long sword, looking over his shoulder at a bull with daggers tied to its horns that is pursuing him to attack. The first of two figures to the right, wearing a sword and holding a long stick crowned by a disc (possibly a drum or clapper) seems to be part of the scene: the bull, the swordsman and the drum beater appear to run in circles. The man

with the drum, whose right sleeve shows a bag-like protrusion, reminds one strongly of the figure of an elephant driver depicted in Tomb 24 of Dabaodang. This figure, clearly a foreigner, likewise holds a circular object in one hand and has a bag-like protrusion at his other side (fig. 22).[27] Under the bullfight are a fish, a tree, a rectangle (possibly a cartouche), a unicorn horse, and a dragon. At the broken edge part of a horse's head is still visible (figs. 21H,I).

As for the horizontal frieze beams that reportedly come from Zuo Biao's tomb, there is some uncertainty about their placement and provenance. The fourteen fragments in the ROM can be combined into two complete and five partial beams; another complete beam is in Taiyuan. The lengths of the complete beams are 307 (326 including rabbets), 300, and 287 centimeters, respectively. The longest beam has rabbets at both ends, the two shorter beams do not. If we assume these three beams were placed at three sides of Zuo Biao's central tomb chamber, then the fourth beam should likewise have been rabbeted. Two of the five incomplete beams (l. 241 and 212 cm) are rabbeted, so either might have formed part of that fourth beam. One may object that the scroll pattern that fills the upper third of the ROM's shorter beam (figs. 25, 26) is quite different from the scrolls on the other beams. Both types, however, occur in

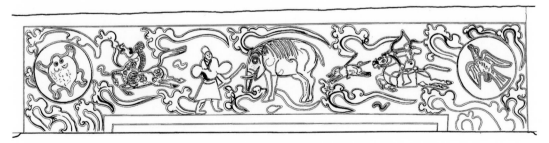

Fig. 22 *Elephant and driver, Dabaodang Tomb 24* (drawing). 36 × 196 × 9.5 cm (entire lintel). From *Shenmu Dabaodang: Handai chengzhi yu muzang kaogu baogao*, ed. Shaanxi sheng kaogu yanjiusuo and Yulin shi wenwu guanli weiyuanhui (Beijing: Kexue chubanshe, 2001), p. 72.

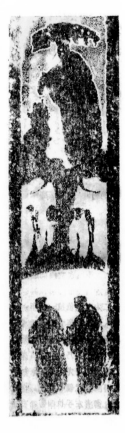

Fig. 23 *Right-side doorpost of Zuo Biao's tomb* (rubbing). 136 × 33 cm. From Gao Weide, "Zuo Yuanyi mu Han huaxiang shi qianxi," in *Handai huaxiang shi yanjiu,* ed. Nanyang Handai huaxiang shi xueshu taolunhui bangongshi (Beijing: Wenwu chubanshe, 1987), p. 276.

may be chicken-headed. Below are two standing attendants. The lintels in six of the seven excavated tombs described here (the lintel of Tomb 44 has not been preserved) vary in length from 217 to 164 centimeters. Of the Zuo Biao fragments, that carved with architecture at the left would be too long, as it is 220 centimeters and has part of a foreleg of a horse at the right edge, which means that it must have been at least 30 to 40 centimeters longer. Either of two other fragments would fit. The three left-over fragments must come from another tomb, unless one of the ancillary chambers of Zuo Biao's tomb had decorated stones. This is unlikely, however, since no other examples are known of northwestern tombs with decorated stones anywhere but in the gate and the main chamber.

The two complete frieze beams in the ROM both show hunts. The one with rabbets is exceptional for showing what is most likely a bridge, marked by two poles at either end with fourfold crosspieces drawn in ink at the top (fig. 24). This would be the only representation of a bridge in the northwest. It is, however, completely unrelated to the classical bridge scenes from eastern China, which have been interpreted (perhaps overinterpreted) as a crossing to the underworld, the rescue of a drowning person, or a battle between Chinese and Barbarians.[28] One of the horsemen is holding a falcon. He is preceded by two dog handlers afoot, one holding a dog on a leash. Each is holding a lance and something that may be a sling with a stone. At the left is a large mountainous area that originally, doubtless, had painted details. The rendering of landscape is particular to the Northwest; it is totally absent in Shandong and other centers. But even in the Northwest landscape scenes are rare, with just a few examples from Dabaodang and Suide.[29] The ones on the Zuo Biao stones are among the better-done landscapes

combination on the borders of the vertical wall slabs and on the two columns. On the column with the dated inscription the scroll to the left of the inscription even "morphs" from the first type into the second (see fig. 4), so different scrolls may well have been used in the friezes too.

The hypothetical arrangement described above leaves four fragments unaccounted for. Three are right ends of beams, one with and two without a rabbet. The fourth is a left end, without rabbet. One of the three fragments without rabbet probably served as the lintel of the gate. The door panels and viewer's left-hand doorpost of the gate of Zuo Biao's tomb have not survived, but the right-side doorpost has (fig. 23). The upper part shows a figure standing under a canopy on a Kunlun-shaped mountain platform; the figure is abraded, but

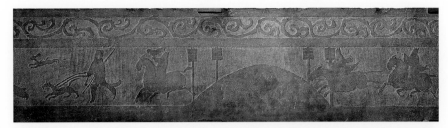

Fig. 24 *Bridge. Detail of frieze, Zuo Biao's tomb.* Sandstone with traces of black ink; 36.5 × 307 × 17 cm (complete beam). ROM 925.25.22.A. The George Crofts Collection. Courtesy of the Royal Ontario Museum © ROM.

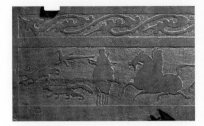

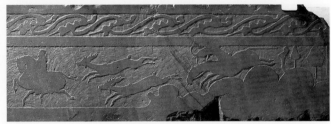

Fig. 26 *Frontally rendered rider. Detail of frieze, Zuo Biao's tomb.* Sandstone with traces of black ink; 36 × 118 × 18 cm (entire fragment). ROM 925.25.22.N. The George Crofts Collection. Courtesy of the Royal Ontario Museum © ROM.

Fig. 25 *Hunt. Detail of frieze, Zuo Biao's tomb.* Sandstone with traces of black ink; 36.5 × 290 × 15 cm (entire beam). ROM 925.25.22.M, The George Crofts Collection. Courtesy of the Royal Ontario Museum © ROM.

found in the northwest. This is especially true for the landscape at the right end of the ROM's other complete beam: mountains with trees whose proportions and shapes seem to anticipate the Gu Kaizhi style of the fourth century CE (fig. 25). A mounted archer at full gallop is aiming at two large fleeing deer. At the left end of this beam is a rare frontal representation of a mounted archer with some of his game: a bird, a hare, and a fox (fig. 26). The third complete beam from Zuo Biao's tomb, kept in Taiyuan, shows a procession of fifteen horsemen at full gallop, with, oddly, one camel plodding along in the last but one position, tied to a horse (fig. 27). The camel motif appears in a number of Shandong reliefs, but also in Dabaodang and other Northwestern tombs.[30] The remaining fragments at the ROM all show standard processions of mounted men and carriages. Six are one-horse canopied carriages with a seated driver holding the reins in front and one passenger in the

back. The seventh carriage is a hooded one, with the driver and passenger invisible inside. Three of the carriages (possibly representing the tomb occupant's carriage) are preceded by four foot-soldiers armed with lances and long swords (fig. 28). One of the processions (all counter-clockwise) arrives at a large dwelling, consisting of a lower building and a storied building with stairs (fig. 29). The lower part

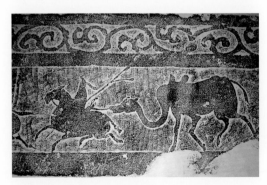

Fig. 27 *Camel. Detail of frieze, Zuo Biao's tomb.* Original rubbing in ROM collection, gift of Shanxi Provincial Museum; 36.5 × 287 cm (entire beam). Courtesy of the Royal Ontario Museum © ROM.

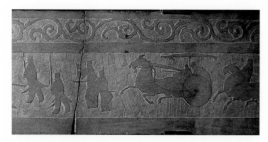

Fig. 28 *Escorted carriage. Detail of frieze, Zuo Biao's tomb.* Sandstone with traces of black ink; 36 × 220 × 17.5 cm (entire fragment). ROM 925.25.22.F, E, The George Crofts Collection. Courtesy of the Royal Ontario Museum © ROM.

Fig. 29 *Building. Detail of frieze, Zuo Biao's tomb.* Sandstone with traces of black ink; 36 × 220 × 17.5 cm (entire fragment). ROM 925.25.22.G, The George Crofts Collection. Courtesy of the Royal Ontario Museum © ROM.

of two *que* towers seems to be visible behind the lower building; their tops may have been painted on the flat band that separates the procession scene from the scroll carved at the top of the beam. A hare-like creature (without long ears, but they may have been painted) holding a long, curved stick or pestle is standing under a tree in front of the lower buildings. The trees here are another motif commonly found in northwestern stone engravings, whereas, like landscapes, they are virtually absent in other regions.

Characteristics of the Northwestern Style in Eastern Han Stone Engraving

The stone engravings of the eight Lishi tombs largely reflect the artistic styles and iconographic content that developed first on the west bank of the Yellow River. Both the "regular" free painterly

style and the more extreme flamboyant style that are typical for the Northwest are represented, as are the highly developed paradise imagery, landscapes with hunts, and daily-life scenes. The latter, always stressed in literature from the People's Republic of China, are actually not very prominent in any northwestern tomb, and are limited to small scenes of plowing, harvesting, and other farmwork. Most are found west of the Yellow River; in Lishi they are rare.[31] In our tombs the ox and the horses in front of mangers in Zuo Biao's tomb and the Shipan tomb can be said to reflect the theme. Depictions of hunts, rare in Shandong, are very common in the Northwest, and may reflect the life of the Xiongnu. The eight tombs discussed here are very pure examples of the Northwestern style, in that they do not show elements borrowed from more easterly traditions, particularly Shandong. Common Shandong themes such as the meeting between Confucius and Laozi, tales of filial sons, exemplary wives, and loyal servants, and also kitchen and banquet scenes are rare in the northwest, and where they do occur, their drawing style strongly suggests that models from Shandong were followed. Cartoons, or models, executed on fabric, wooden boards, or sheets of paper or leather, must have circulated widely among the sometimes highly peripatetic artisans who carved stone tombs and shrines. The simultaneous occurrence of the regular and the flamboyant style in Tombs 2 and 3, which likely belonged to the same family graveyard, can be easiest explained if one assumes that the stonemasons used different sets of model drawings, which probably had been brought to Lishi when the administrative center of Xihe Commandery moved there in 140 CE. The vertical positioning of designs that were clearly meant to be horizontal in Tomb 2 makes it virtually certain that the artisan simply copied an existing design. Very clear cases

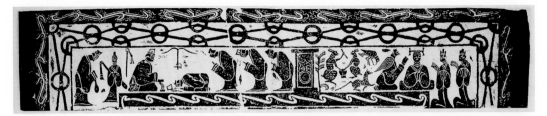

Fig. 30A *Homage scene on lintel of Sishilipu tomb* (Shandong influence) (rubbing). Ca. 100 CE. 30 × 159 cm (entire lintel); height of seated figure 12 cm. From *Shaanxi, Shanxi Han huaxiang shi,* no. 177.

of Shandong designs traveling to Shaanxi can be seen in tombs excavated in 1975 at Sishilipu near Suide, and in 1992 near Hengshan. Both tombs show a scene of a kneeling man with his arms on an armrest being greeted by a man kowtowing in front of him, with a crossbow hanging between the two figures. The scene is virtually identical to three similar scenes found on the back wall of Xiaotangshan Shrine in Shandong (fig. 30A, B). In the Sishilipu tomb, the rendering of the Queen Mother of the West, shown frontally with a large *sheng* headdress, flanked by attendants holding *bian* fans and branches of a shrub, one of the attendants being a winged figure with a chicken head, is likewise closely related to the Xiaotangshan Shrine and several other related stone carvings.[32]

In the Northwest, the Queen Mother of the West and her companion, the King Father of the East, are typically shown in side or three-quarter view, whereas in Shandong or Sichuan, they are without exception depicted frontally, in what Wu Hung has called the "iconic representation." In fact, there are other local elements in the rendering of these two deities in the northwest. The characteristic *sheng* headdress of the Queen Mother in Shandong and Sichuan does occur, but equally often, and in the tombs found at Lishi discussed here without exception, she lacks this attribute and has her hair in a chignon, or sometimes, adorned with a three-pointed crown. In one case

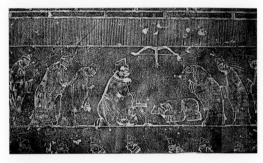

Fig. 30B *Homage scene, rear wall of Xiaotangshan Shrine* (Shandong influence), first century CE. Height of seated figure 13.5 cm. Original rubbing in ROM. Courtesy of the Royal Ontario Museum © ROM.

(Dabaodang Tomb 24) she even wears an emperor's *mian* headdress with veil (fig. 31). The Queen and King are sometimes shown sitting side by side, as we have already seen, and are intriguingly associated with the ox and chicken.[33] In Shandong, Sichuan, and Henan the ox and chicken do not occur together with the Queen and King. In Shandong a chicken-headed human figure *alone* is quite common as an attendant of the Queen Mother (or the King Father; it is not always possible to tell the two apart); it occurs in the Wu Family Shrines and on many other carved stones.[34] Often there are horse-headed and dog-headed figures, too, but never an ox-headed figure. The only example I could find outside the Shaanxi-Shanxi area of the ox- and chicken-headed figures as distinctive attendants of, respectively, the King Father of the East and the Queen Mother of the West, is in Anhui, on

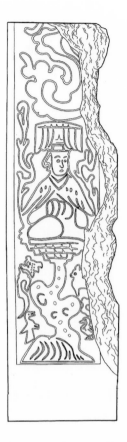

Fig. 31 *Queen Mother of the West wearing a* mian *headdress* (drawing). From *Shenmu Dabaodang: Handai chengzhi yu muzang kaogu baogao*, p. 73.

zodiacal animals the chicken represents the West, but the ox does not represent the East; it represents a point close to north (NNE 3/4 E). True east would be represented by the hare, so it seems unlikely that chicken and ox represent compass points.

Sometimes chicken- and ox-headed guardians occupy paired doorposts, with no other company;[36] sometimes they are positioned under human-faced images of the Queen Mother and King Father;[37] and sometimes the Queen Mother and King Father themselves have chicken- and ox-heads.[38] The last-named forms are winged, and they sit on the same Kunlun-type platforms, in the same positions (the upper part of doorposts or the ends of the lintel), as the regular human-headed Queen and King, so I

the east and west walls of a tomb in Chulanzhen in Suxian, dated to 174 CE.[35] The lower parts of the two stones show the standard Shandong repertoire of kitchen, banquet, fishing under a bridge, rows of standing figures, etc., but to the left of the King Father in the east gable is an ox-headed figure, and to the left of the Queen Mother on the facing gable a chicken-headed figure. The bodies of the King and Queen are shown frontally, but their faces, interestingly, are in three-quarter view, as is typical for the Northwest.

In the Northwest, too, the ox is usually associated with the King Father and the chicken with the Queen Mother. There are exceptions, but these may have just been mistakes by artisans not paying attention. Nothing is known about the rationale of this association. It is true that among the twelve

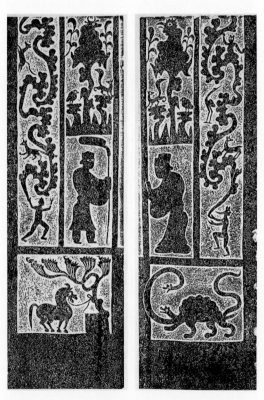

Fig. 32A *Chicken- and ox-headed Xiwangmu and Dongwanggong: Two doorposts from Suide* (rubbings). Found 1976. Left stone 132 × 36 cm; right stone 135 × 36 cm (complete post). From *Shaanxi, Shanxi Han huaxiang shi*, nos. 131–32.

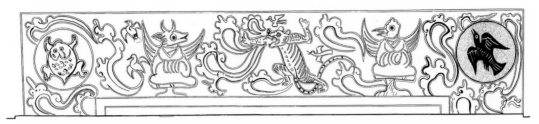

Fig. 32B *Chicken- and ox-headed Xiwangmu and Dongwanggong: Lintel from Dabaodang Tomb 18* (drawing). Excavated 1996. 34 × 193 cm. From *Shenmu Dabaodang*, p. 68.

think there can be no question that they are indeed the Queen Mother of the West and the King Father of the East (fig. 32). It is tempting to assume an evolution from chicken- or ox-headed guardian into chicken- or ox-headed Queen and King, but there are not enough dated examples to allow that. In fact, the representations of the animal-headed Queen and King have all been found in the older tombs west of the Yellow River, in Suide, Mizhi, Yulin, and Dabaodang, and the animal-headed guardians in the later tombs near Lishi, east of the river, so the development might also have been the other way round. In one early tomb, that of the Prefect of Liaodong in Suide, dated to 90 CE, an actual chicken and ox are carved on the south and north doorposts, respectively, of the entrance into a western side chamber.[39] The animals, rendered quite prominently, climb upward along a sinuous stalk, amid small birds and mythological creatures. No Queen Mother or King Father are included in the design, but it seems likely that the naturalistically rendered chicken and ox refer to them.

The seven tombs (including Zuo Biao's) discovered at Mamaozhuang and the one from nearby Shipan together embody all characteristic elements found in Eastern Han tombs in the Shaanxi-Shanxi border area, with the exception of imported designs from Shandong. The simultaneous appearance, between 150 and 175 CE, in this small area east of the River, of different indigenous substyles

that had developed on the west bank of the Yellow River from the second half of the first century CE to about 140, makes it clear that many of these designs, just like designs from farther away, were copied from models on fabric or some other easily transportable medium. Other designs, for example, several of the bold scenes on the eight large slabs of Zuo Biao's tomb, seem to be new creations. Just as in the other major centers of stone carving — Shandong, Henan, and Sichuan — the painters and carvers of the Northwest freely copied and adapted existing designs as they saw fit and combined them with new creations of their own. This is precisely what makes the study of Han-dynasty stone carvings so compelling. Until the 1950s the stones from the tomb of Zuo Biao, discovered in 1924, were the only examples of Eastern Han carved stones from the Northwest that were known in China or the West. As isolated pieces, however, half of which, moreover, were brought to the Royal Ontario Museum in 1925, they were difficult to fit into the overall picture of Han-dynasty stone carving. Only with the discovery of larger numbers of carved stones in Suide and Mizhi did it become evident that the Northwest had been home to a distinctive style of carved and painted stone tomb decorations, and the immediate context of the Zuo Biao stones only became clear with the excavation of the Lishi tombs in the 1990s. Although the Zuo Biao stones are no longer unique, they still are the

type specimens of the Northwestern style in Eastern Han stone carving. Both in China and the West they served as the starting point for its study and identification. So perhaps it is justified that, in his turn, a curator of the museum where half of them are kept has taken them as the starting point for an overview of the stone-carving tradition of which they are a prime example. ◉

Notes

1 This article expands further on the subject of my catalogue essay "Carved and Painted Frieze from the Tomb of Zuo Biao," pp. 270–74 in *Recarving China's Past: Art, Archaeology, and Architecture of the "Wu Family Shrines,"* Cary Y. Liu, Michael Nylan, Anthony Barbieri-Low, et al. (Princeton: Princeton University Art Museum; New Haven and London: Yale University Press, 2005). The most complete overview of Eastern Han pictorial stone engravings from north-western China is: *Zhongguo huaxiang shi quanji,* vol. 5: *Shaanxi, Shanxi Han huaxiang shi,* ed. Zhongguo huaxiang shi quanji bianji weiyuanhui (Jinan: Shandong meishu chubanshe, 2000), with introductory essay "Shaanxi, Shanxi Han huaxiang shi zongshu," pp. 1–16, by Xin Lixiang and Jiang Yingju.

2 Derk Bodde, "The State and Empire of Ch'in," pp. 20–102 in *The Cambridge History of China,* vol. 1: *The Ch'in and Han Empires, 221 BC–AD 220,* ed. Denis Twitchett and Michael Loewe (Cambridge: Cambridge University Press, 1986), pp. 64–66; Rafe de Crespigny, *Northern Frontier: The Policies and Strategies of the Later Han Empire,* Faculty of Asian Studies Monographs, NS 4 (Canberra: Faculty of Asian

Studies, Australian National University, 1984), pp. 238–40, 306–17 ("The Chinese Withdrawals"); see pp. 238–39: DeCrespigny, "Like a British Resident in a princely state in the time of the Indian empire," the Leader of Court Gentlemen and Envoy to the Xiongnu "had ultimate authority over the Government of the Southern Xiongnu." See also Xie Guozhen, "Ba Han Zuo Yuanyi mu shi tao pian taben," *Wenwu* 1979.11, pp. 43–45, esp. p. 44, and Xin Lixiang and Jiang Yingju, "Shaanxi, Shanxi Han huaxiang shi zongshu," p. 3 (migration in Western and Eastern Han). The large tamped-earth mound of Meng Tian's tomb can still be seen in Suide, as well as the one of Fusu, the First Emperor's eldest son and heir, who was staying with Meng Tian. Both were forced to commit suicide in 210 BCE.

3 Shaanxi Provincial Museum, Shaanxi Cultural Relics Administrative Committee, eds., *Shaanbei Dong Han huaxiang shike xuanji* (Beijing: Wenwu chubanshe, 1959); Li Guilong and Wang Jianqin, eds., *Suide Handai huaxiang shi* (Xi'an: Shaanxi renmin meishu chubanshe, 2001); Li Lin, Kang Lanying, and Zhao Liguang, eds., *Shaanbei Handai huaxiang shi* (Xi'an: Shaanxi renmin chubanshe, 1995);

Shaanxi sheng kaogu yanjiusuo, Yulin shi wenwu guanli weiyuanhui, eds., *Shenmu Dabaodang: Handai chengzhi yu muzang kaogu baogao* (Beijing: Kexue chubanshe, 2001).

4 Xin Lixiang and Jiang Yingju, "Shaanxi, Shanxi Han huaxiang shi zongshu," pp. 1–3.

5 Ibid., p. 5. Based on dated tombs, which, however, represent only a small proportion of the total number. A list may be found in Li Guilong and Wang Jianqin, eds., *Suide Handai huaxiang shi,* p. 6.

6 Archaeological Institute of Shanxi Province, Cultural Relics Station of Lüliang Region, and Cultural Relics Office of Lishi District, "Shanxi Lishi Mamaozhuang Dong Han huaxiang-shi mu," *Wenwu* 1992.4, pp. 14–40; Archaeological Institute of Shanxi Province, Cultural Relics Station of Lüliang Region, and Cultural Relics Office of Lishi District, "Shanxi Lishi zaici faxian Dong Han huaxiangshi mu," *Wenwu* 1996.4, pp. 13–27.

7 *Zhongguo huaxiang shi quanji,* vol. 5 nos. 289–98. Personal communication, Mr. Wang Jinyuan, Cultural Relics Office of Lishi District, Lishi, 2003.

8 "Shanxi Lishi zaici faxian Dong Han huaxiang shi mu," *Wenwu* 1996.4, pp. 15–17, 19, 20.

9 Xie Guozhen, "Ba Han Zuo Yuanyi mu shi tao pian taben," p. 44. The *jie* is an eight-foot long bamboo staff with three cow hair tassels near the top, used as a sign of authority by imperial envoys, cf. Sun Ji, *Handai wuzhi wenhua ziliao tushuo* (Beijing: Wenwu chubanshe, 1991), pp. 151–52, fig. 38-2.

10 Wang Jinyuan, "Shanxi Lishi Shipan Handai huaxiang shi mu," *Wenwu* 2005.2, pp. 42–51: esp. p. 48, fig. 19, p. 50.

11 Dai Yingxin and Li Zhongxuan, "Shaanxi Suide Xian Yanjiacha Dong Han huaxiang shi mu," *Kaogu* 1983.3, pp. 233–37. Better illustrations in *Zhongguo huaxiang shi quanji*, vol. 5, nos. 93–106. Ibid., nos. 137, 138 (Beilin panels), nos. 57, 58 (Mizhi panels).

12 "Shanxi Lishi Mamaozhuang Dong Han huaxiang shi mu," *Wenwu* 1992.4, pp. 29–35 (note that figs. 7 and 45 in this article have been switched by mistake). Better illustrations in *Zhongguo huaxiang shi quanji*, vol. 5, nos. 258–66.

13 These pigments, especially the red, are extremely vulnerable, and visible clearly only shortly after excavation. Possibly this is due to the porous nature of the stone or to the method of application, as the pigments themselves are mineral and long-lasting. Most stones in the museums of Suide, Mizhi, and the Beilin (Forest of Steles) in Xi'an only show faint traces of ink lines, with almost nothing of the red left. The same is true for the stones in the Royal Ontario Museum. In the recently excavated tombs of Shipan and Dabaodang the colors are better preserved. A scientific analysis of the pigments used in the Dabaodang tombs is contained in *Shenmu Dabaodang: Handai chengzhi yu muzang kaogu baogao*, pp. 162–66 and color plate 24. The black samples contained iron, no carbon, so the black lines seem not to be regular soot-based ink. The reds were mixtures of vermilion and iron red. It is likely that the pigments used in the Lishi and other Northwestern tombs were similar.

14 See Susan N. Erickson, "Money Trees of the Eastern Han Dynasty," *Bulletin of the Museum of Far Eastern Antiquities Stockholm*, vol. 66 (1994), pp. 5–115; Klaas Ruitenbeek, *Chinese Shadows: Stone Reliefs, Rubbings, and Related Works of Art from the Han Dynasty (206 BC–AD 220) in the Royal Ontario Museum* (Toronto: Royal Ontario Museum, 2002), pp. 21–24, 52–56.

15 This interpretation follows Xin Lixiang and Jiang Yingju, "Shaanxi, Shanxi Han huaxiang shi zongshu," pp. 8–11.

16 "Shanxi Lishi Mamaozhuang Dong Han huaxiang shi mu," *Wenwu* 1992.4, pp. 14–29. Better illustrations in *Zhongguo huaxiang shi quanji*, vol. 5, nos. 234–57.

17 It is possible that the stones have been switched by accident. Six of the eighteen vertical stone slabs of this tomb chamber have clerical-script (*lishu*) ink inscriptions on the back that indicate their position. The stones showing the King and Queen are not inscribed, but some of the adjacent stones with ornamental borders are. The inscriptions on the stones south and north (left and right) of the King on the west wall read *xibi hubei zhu* and *xibi beitou zhu* ("column north of the door opening, west wall" and "north end column, west wall"), respectively, which fits their actual positions. But, the stone south (right) of the Queen on the east wall is inscribed *dongbi hunan zhu* ("column south of the door opening, east wall"), which is wrong. It should be *hubei* ("north of the door opening"), suggesting that the stones south and north of the eastern door opening have been switched. As they are similar in size and decoration, this could easily have happened. A stone inscribed *dongbi beizhu* ("north column, east wall") is actually located south of the door opening in the west wall, likewise a mistake. See "Shanxi Lishi Mamaozhuang Dong Han huaxiangshi mu," *Wenwu* 1992.4, pp. 24, 27–28.

18 Wang Jinyuan, "Shanxi Lishi Shipan Handai huaxiang shi mu," pp. 42–51.

19 Similar but more beautifully executed lattice panels are found in the Yanjiacha tomb; see Dai Yingxin and Li Zhongxuan, "Shaanxi Suide Xian Yanjiacha Dong Han huaxiang shi mu," p. 234, fig. 4.

20 Except for two vertical slabs kept in the Museum of Han Pictorial Stones in Lüliang (Lishi), the stones are in the Shanxi Provincial Museum, Taiyuan. I wish to thank Zhang Shaokun, vice director of the Shanxi Provincial Museum, and Dong Louping, director of the museum in Lüliang, for providing the Royal Ontario Museum with rubbings of the stones in their institutions, as well as Jason Sun, associate curator, The Metropolitan Museum of Art, for making the initial introduction.

21 Yongning is present-day Lishi in western Shanxi; the Qiuhe flows into the Yellow River at Qikou, an ancient trading town and important ferry crossing 30 kilometers northwest of Lishi.

22 *Xigulou jinshi cuibian*, comp. Luo Zhenyu on behalf of Liu Chenggan (1926), *juan* 1. In his *Shijiao lu* of 1939, Luo relates that he saw the stones at a dealer's in Beijing (and mentions that they were painted in colors; see Ruitenbeek, *Chinese Shadows*, p. 19). Reproductions of the rubbings were first published in *Yilin xunkan*, nos. 7, 8 (1928).

23 Wei Juxian, "Han Zuo Biao mu shihua shuoming shu," *Shuowen yuekan*, vol. 1, no. 1 (1939), p. 456. All People's Republic of China publications give 1919 as the discovery year of the Zuo Biao stones. They are based on Liang Zonghe, "Shanxi Lishi Xian de Handai huaxiang shi," *Wenwu cankao ziliao* 1958.4, pp. 40, 75, the first to publish reproductions of rubbings of the Zuo Biao stones still in Shanxi. Liang's information seems less reliable than Wei's, which is based on an investigation by a former school-mate who was chief of police of Lishi at the time. Xie Guozhen, "Ba Han Zuo Yuanyi mu shi tao pian taben," p. 44, names the Beijing dealer who held the stones as Huang Baichuan of the firm Zunguzhai—of course, it is possible that the stones went through the hands of several dealers.

24 Liang Zonghe, "Shanxi Lishi Xian de Handai huaxiang shi," pp. 40, 75; Hsio-yen Shih, "Some Fragments from a Han Tomb in the Northwestern Relief Style," *Artibus Asiae*, vol. 25 (1962), pp. 149–62; Xie Guozhen,

"Ba Han Zuo Yuanyi mu shi tao pian taben," p. 43. Also see Yang Shao-shun, "Shanxi Lishi Mamaozhuang Han huaxiang shi you you xin faxian," *Wenwu* 1984.10, pp. 93–94; Gao Weide, "Zuo Yuanyi mu Han huaxiang shi qianxi," in *Handai huaxiang shi yanjiu*, ed. Nanyang Handai huaxiang shi xueshu taolunhui bangongshi (Beijing: Wenwu chubanshe, 1987), pp. 270–79. The latter illustrates and describes all stones said to come from Zuo Biao's tomb that are preserved in China.

25 In *Zhongguo huaxiang shi quanji*, vol. 5, no. 284 (p. 77), the figure with a tail is interpreted as the sun god Xihe, no doubt to correspond with the toad symbolizing the moon. But in fact, Xihe is nowhere else reported to have a tail; see Yuan Ke, *Zhongguo shenhua chuanshuo cidian* (Shanghai: Shanghai cishu chubanshe, 1985), p. 441. The figure with snake tail in combination with the lunar toad also occurs in the T-shaped *feiyi* paintings of Mawangdui of the early Western Han, and has been interpreted either as Zhulong, a sun god mentioned in works such as the *Chuci* and *Shan-haijing*, or as Fuxi; see An Zhimin, "Changsha xin faxian de Xi Han bohua shitan," *Kaogu* 1973.1, pp. 43–53, esp. p. 45 [suggesting Zhulong]; Sun Zuoyun, "Changsha Mawangdui yihao Han mu chutu huafan kaoshi," *Kaogu* 1973.1, pp. 54–61, esp. p. 55 [suggesting Fuxi]. The classical combi-nation of Fuxi and Nüwa is depicted in Zuo Biao's tomb on the slab with the fish carriage.

26 The fish joined at the eye is also found on one of the good-omen slabs that form the ceiling of Stone

Chamber 3 of the Wu Family Shrines; see Wu Hung, *The Wu Liang Shrine: The Ideology of Early Chinese Pictorial Art* (Stanford: Stanford University Press, 1989), pp. 75, 104, 241. Examples of the triple fish design in Shandong (*que* tower of 85 CE) and Sichuan (Eastern Han stone coffin) are illustrated in *Zhongguo huaxiang shi quanji*, vol. 1: *Shandong Han huaxiang shi*, no. 2, and vol. 7: *Sichuan Han huaxiang shi*, no. 179, respectively. Cloud carriages drawn by animals and mythological creatures also are common in other regions; compare, for example, the cloud carriages drawn by felines (?), winged Immortals, bird-headed quadrupeds, dragons, and fish in the Wu Family Shrines engravings (*Recarving China's Past*, cat. nos. 1.17, 1.18, 1.32, 1.33, 1.34 (pp. 146, 147, 166, 176). Both the flying horse and feathered, winged Immortal are also common motives in money trees from Sichuan; see n. 14 and Klaas Ruitenbeek, "Images of Paradise," *Rotunda* (maga-zine of the Royal Ontario Museum), vol. 34, no. 3 (2002), pp. 7–8.

27 See *Shenmu Dabaodang: Handai chengzhi yu muzang kaogu baogao*, pp. 71–72, color plate 23.

28 See Jean M. James, "Bridges and Cavalcades in Eastern Han Funerary Art," *Oriental Art*, vol. 28, no. 2 (1982), pp. 165–71; Xin Lixiang, *Handai huaxiang shi zonghe yanjiu* (Beijing: Wenwu chubanshe, 2000), pp. 328–34. Poles with similar cross-pieces, however, are depicted at a bridge on an Eastern Han pictorial stone found in Lanling, Cangshan, Shandong; see *Zhongguo huaxiang shi quanji*, vol. 3, no. 115.

29 For an example from Dabaodang in Shenmu, somewhat more primitive in execution, see *Shenmu Dabaodang: Handai chengzhi yu muzang kaogu baogao*, color plates 4–5, pp. 43–44. Some painted details in the hills are still visible here.

30 For camels in Shandong, see the Xiaotangshan Shrine, east wall; in the Northwest, Dabaodang Tomb 3, the Yanjiacha tomb, and a tomb excavated in 1992 at Duanjiawan near Yulin (*Zhongguo huaxiang shi quanji*, vol. 5, nos. 213, 97, 24). Frontally rendered horses also occur in Shandong, for example in the Wu Family Shrines, Stone Chamber 2, west wall of niche (*Recarving China's Past*, p. 159).

31 Xin Lixiang and Jiang Yingju, "Shaanxi, Shanxi Han huaxiang shi zongshu," pp. 8, 11–13.

32 *Zhongguo huaxiang shi quanji*, vol. 5, nos. 177 and 230 (kneeling man). For corresponding Xiaotangshan scene, see Ruitenbeek, *Chinese Shadows*, p. 70. For Queen Mother, see *Zhongguo huaxiang shi quanji*, vol. 5, no. 177 and Li Guilong and Wang Jianqin, *Suide Handai huaxiang shi*, p. 18. Shandong parallels in Zhu Xilu, *Jiaxiang Han huaxiang shi* (Jinan: Shandong meishu chubanshe, 1992), figs. 9–11, 107, 134.

33 For the *mian* headdress, see *Shenmu Dabaodang: Handai chengzhi yu muzang kaogu baogao*, color plate 22, p. 73. In the few early texts about the Queen Mother and King Father, the ox and chicken are not mentioned. See Zong Li and Liu Qun, *Zhongguo minjian zhushen* (Shijiazhuang: Hebei renmin chubanshe, 1986), pp. 47–53, 429–40. Nor is the subject addressed in recent literature on Han-dynasty religion, e.g., Wu Hung, *The Wu Liang Shrine*, pp. 108–41. Xin Lixiang, in his *Handai huaxiang shi zonghe yanjiu*, p. 269, just mentions in passing that the ox- and chicken-headed figures in Mamaozhuang Tomb 3 must be guardian deities of Mount Kunlun. Also see *Shenmu Dabaodang: Handai chengzhi yu muzang kaogu baogao*, p. 117: "But why she [the Queen Mother] is depicted with an ox head [sic] is unknown as yet."

34 For the Queen with chicken-headed attendants, see n. 32 above. For horse and chicken together in the Nanwushan Shrine, see Zhu Xilu, *Jiaxiang Han huaxiang shi*, fig. 80. In the Wu Family Shrines, the chicken- and horse-headed figures are found together with the King Father of the East (Stone Chamber 2; east wall; see *Recarving China's Past*, pp. 160–61).

35 *Zhongguo huaxiang shi quanji*, vol. 4: *Jiangsu, Anhui, Zhejiang Han huaxiang shi*, nos. 170, 171.

36 Tomb 3 at Mamaozhuang and Shipan tomb.

37 Tomb 2 at Mamaozhuang.

38 *Zhongguo huaxiang shi quanji*, vol. 5, nos. 1, 4, 5 (doorposts at Tancun, Yulin); nos. 49, 50 (doorposts at Dangjiagou, Mizhi); nos. 131, 132, 133, 135 (doorposts at Suide); no. 218 (lintel at Dabaodang, Shenmu); nos. 218, 219–220 (bodies on doorposts, heads on lintel).

39 Li Guilong and Wang Jianqin, *Suide Handai huaxiang shi*, no. 15.

PART THREE ARCHITECTURAL FUNCTIONS AND CARVED MEANINGS

The Iconography of the "Homage Scene" in Han Pictorial Carving

JIANG YINGJU

Among pictorial carvings found in Han stone mortuary shrines, a distinctive group of images, generally placed on the rear walls, has become commonly known as Paying Homage in a Pavilion (*louge baiye tu*; hereafter the "homage scene") (fig. 1). The type comprises a two-story building flanked by a pair of *que* towers, inside which sits the lord, his consort, and servants. Many and various interpretations have been applied to the homage scene. In the early 1940s Wilma Fairbank challenged Stephen W. Bushell's thesis that the homage scene in the Wu Family Shrines, in Jiaxiang, Shandong Province, represents the visit of King Mu to the Queen Mother of the West (Xiwangmu). Basing her argument on research by the eminent Chinese scholar Rong Geng (1894–1983), Fairbank asserted that the Wu Family Shrines were "offering shrines in honor of a deceased family member and this focal scene can logically only represent homage to him."[1] In other words, the homage scene symbolizes the paying of respect and the offering of sacrifice to the deceased (the shrine dedicatee). In our detailed examination of the Wu Family Shrines and their architectural reconstructions, conducted in the early 1980s, Wu Wenqi and I adopted Fairbank's interpretation.[2] Given the mortuary function of an offering shrine, the homage scene can hardly be symbolic of anything other than the shrine dedicatee receiving a sacrifice from his living descendants. Xin Lixiang has provided further evidence to substantiate Fairbank's reading, but he goes too far with his assertion that her reading is the only correct explanation of the pavilion scene and that it is an actual "Picture of the Shrine Dedicatee Receiving Sacrifices" (*cizhu shouji tu*).[3] This paper analyzes the various elements that are regularly included as part of the homage scene, such as the large tree next to the pavilion, the birds or a monkey in the

Fig. 1A *Homage scene.* Rubbing of niche in rear wall in Front Shrine. Wu family cemetery site. Jiaxiang, Shandong. Wu Family Shrines rubbings, Princeton University Art Museum, acc. no. 2002.307.9. Photo by Bruce M. White.

Fig. 1B *Homage scene.* Rubbing of niche in rear wall in Left Shrine. Wu family cemetery site. Jiaxiang, Shandong. Wu Family Shrines rubbings, Princeton University Art Museum, acc. no. 2002.307.24. Photo by Bruce M. White.

tree, the archer standing below or beside the tree, the unhitched horse and carriage, as well as the procession of infantry, horsemen, and carriages running below the pavilion. Differing interpretations of the symbolic or actual content and meaning of these pictorial elements in the homage scene and their connection to the theme of the shrine dedicatee receiving sacrifices also will be examined. By carefully probing these questions, we can better understand the nature and original meaning of the homage scene in Han mortuary art.

The Tree and Its Component Motifs

An important motif in the homage scene is a large tree next to the pavilion; these two together form the key components of the scene in many later

Eastern Han pictorial carvings in offering shrines. In the Wu Family Shrines (fig. 1) and the Songshan small shrines (*xiao citang*) (fig. 2), also in Shandong, a more complex assemblage of images and motifs, including birds and/or a monkey in the tree, an archer, and an unhitched horse and carriage, greatly enrich the pictorial content of the homage scene. One noticeable variation is that the tree is depicted sometimes to the left of the pavilion (with respect to the viewer), as in the Wu shrines, and sometimes to the right, as in some of the Songshan shrines.[4] Some scholars have wondered whether this variation in the position of the tree has iconographical significance.

In the context of shrine architecture, however, the position of the tree in the pictorial assemblage

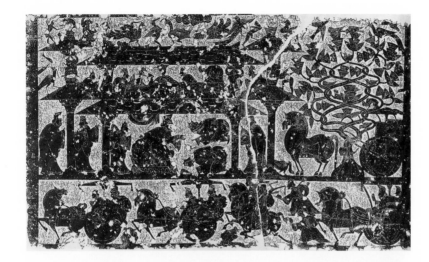

Fig. 2A *Homage scene.*
Rubbing of rear wall
of Shrine 1. Songshan,
Shandong. From *Zhongguo
huaxiang shi quanji* (Jinan:
Shandong meishu chubanshe,
2000), vol. 1, pl. 92 (p. 67).

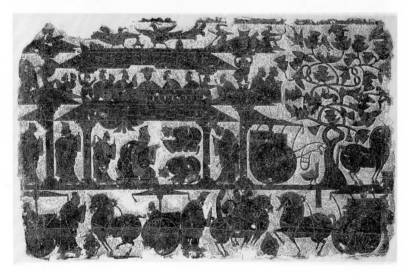

Fig. 2B *Homage scene.*
Rubbing of rear wall
of Shrine 2. Songshan,
Shandong. From *Zhongguo
huaxiang shi quanji*, vol. 2,
pl. 103 (p. 96).

is consistent, i.e., it is always east of the pavilion. As Xin Lixiang notes, the Wu Family Left Shrine (see fig. 1B) faced north, putting the east end of the rear wall at the viewer's left; Songshan Shrine 2 faced south (see fig. 2B), putting east at the viewer's right. In both, therefore, the tree stands east of the pavilion. As is well known, the three reconstructed Wu Family Shrines all faced north, an orientation in accord with the aboveground *que* pillars and underground burial

chambers.[5] In all of them the tree stands to the viewer's left, that is, east of the pavilion. The reconstructed small shrines on the Songshan site, on the other hand, did not all face the same direction; Shrines 1, 2, and 3 (without tree) faced south and Shrine 4 faced north.[6] Even as seen in rubbings, the tree in the first two is at viewer's right (figs. 2A, B), and that in the fourth is at the viewer's left (fig. 3). This consistency of placement is corroborated by the location of the images of the King Father of the

East and the Queen Mother of the West on the decorated side-wall stones as reconstructed for the north-facing or south-facing shrines: the King Father is always on the east wall and the Queen Mother is on the west wall.

The iconographic significance of the eastern orientation of the tree is related to the concepts of *yinyang* and Five Elements or Agents (*wuxing*), a cultic system of thought popular during the Han dynasty. As described in the "Wuxing" section of the *Baihu tong* (*Comprehensive discussions in the White Tiger Hall*): "Wood [has its position] in the eastern quarter. The east is [the place] where the [energy] of *yin* and *yang* begins to move, and myriad things begin to be born…. The east belongs to the element of wood and is where myriad new things grow from the earth."[7] In other words, the east is the direction of the awakening of all life, harmonized by the forces of *yin* and *yang*. In the homage scene, which always occupies the central position on the shrine's rear wall (facing the entrance), the pavilion and the figures inside it represent the shrine dedicatee receiving offerings. East of the pavilion grows the verdant tree, symbolizing prosperity, and by its position reflecting a wish for the continuous growth and prosperity of the family. Consistency in the cardinal positions of the images also applied to other motifs, such as the

King Father of the East and Queen Mother of the West, on the east and west walls respectively, the battle and hunting scenes on the west wall, and the kitchen scene on the east wall.

Pictorial carvings in Han offering shrines serve the religious function of ancestor worship and follow the representational conventions born out of traditional thought and practices. In life the trees in the courtyard of a Han residence may not always have grown on the east side, but popular association of the eastern direction with growth and prosperity dictated that placement of the tree in mortuary pictorial carvings. This directional convention of imagery can also be demonstrated in literature, as exemplified by one of the most cited stanzas in the poem "Drinking Wine" ("Yin jiu"), composed by Tao Yuanming (365–427) of the Jin dynasty: "Picking chrysanthemums by the eastern hedge/I catch sight of the distant southern hills."[8] It is because the east is associated with birth and growth in all living things that the chrysanthemums at hermit Tao's eastern fence are beautiful and thriving. A tree planted on the east side of a two-story pavilion in the homage scene reveals the Han Chinese concept of a law of universal harmony based in part on proper placement of all things on earth, as well as their belief that by adhering to such a universal law they could elicit blessings from

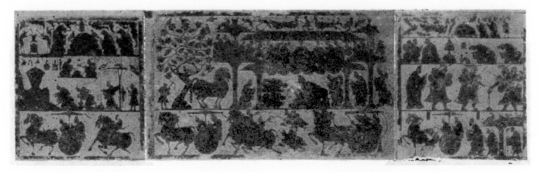

Fig. 3 *Homage scene*. Rubbings of east, rear, and west walls of Shrine 4. Songshan, Shandong. From *Kaogu* 1983.8, ill. 4 (p. 748).

Fig. 4 Que *pillars and cassia trees*. Wall painting of a Han tomb in Helingor, Inner Mongolia. From *Helinge'er Han mu bihua* (Beijing: Wenwu chubanshe, 1978), p. 144.

ancestors for continuous prosperity and abundant offspring. Only an eastern tree could embody and demonstrate the wealth and glory of the dedicatee, because that orientation automatically implies solid rooting, strong footing, and potential growth.

This large tree is often accompanied by other motifs, the most common being birds and sometimes a monkey in its branches, an archer, and a horse and carriage. Scholars have incorrectly called this pictorial assemblage the *Image of Shooting the Birds in the Tree* (*shumu sheniao tu*; hereafter "archery scene") and the tree the mythical *fusang* tree, *jianmu* tree, or *tongtian* ("sky-reaching") tree. In discussing the iconography of the homage

scene, Xin Lixiang argues that the tree is an ordinary earthly tree, and the archer is also a mundane figure, not an immortalized mythical being such as Houyi. His interpretation, however, that "shooting at birds" represents the descendants of the shrine dedicatee preparing for live animal sacrifice, and that the unhitched horse and carriage under the tree signify the journey of the deceased's spirit from the grave to the shrine to receive offerings,[9] cannot be supported by archaeological evidence.

A different reading of the "archery scene" theme is provided by Hsing I-tien, who believes that the pavilion, the carriage, and the archer are not necessarily parts of a unified iconography; they may be isolated motifs. Assessing the homage scene on the basis of cartouche inscriptions, Hsing finds, flanking the pavilion, three major iconographic components: (1) a big tree; (2) birds or a monkey in the tree; and (3) an archer near the tree. Though these have no appertaining inscriptions, Hsing interprets them as rebuses by analogy with the cartouche in a late Eastern Han tomb painting in Helingor (fig. 4).[10] That cartouche, adjacent to a tree, reads *li guan guishu*, "to establish an official career [by planting] a cassia (cinnamon) tree." Since the characters *gui*, "cassia," and *gui*, "honorable, prestigious, or aristocratic" are homonyms, the cartouche could well be a rebus for "planting a noble tree to attain high office (*li guan guishu*). The birds and the monkey should likewise be understood as rebuses. In the context of universal aspirations for a prestigious official career, the archer aiming at the birds (*she que*) or the monkey (*she hou*) is a rebus for attaining high office: *que* ("birds") is a homonym for *jue* and *hou* ("monkey") for *hou*; both these latter terms signify noble ranks.[11]

In the Wu Family and Songshan shrines, the tree in the homage scene, though lacking a cartouche, is correctly understood to be a cassia.

The auspiciousness of the cassia tree is exemplified in Han literature in the lyric poem "Xiang feng xing" ("Encounter on the Road"), in which a local official's residence is described as follows:

Gold is for the lord's gate, and white jade for
 his halls.
Wines are served in the main hall, and beautiful
 entertainers sent from Handan.
Cassia trees grow in the middle court, and
 lanterns shine brightly.
The family has three sons, and the middle one
 is an Attendant Gentleman.
When he journeys back for his five-day leave,
 pride and glory fill the roads.[12]

The image of cassia trees—in this poem "growing in the middle court" and thereby symbolizing the affluence, prestige, and power of a local family with a member in high office—became a conventional visual metaphor in Han and later times. As shown in a seventeenth-century architectural plan of Neixiang District compound in Henan Province (fig. 5), cassia trees are seen growing in the inner courts of the Public Office (gongshu) and the Third Hall (santang), an indication that the traditional association of the cassia tree with a successful official career, the ultimate goal of all aspiring educated men in imperial China, endured long and well.

The archery scene, as it conventionally appears in Han pictorial carvings, whether alone or combined with other motifs and images to enhance its meaning, functions as a metaphor of career success. If the archer represents the offspring of the deceased, then the archery scene symbolizes the high office that the heirs wish for themselves and the deceased wishes for them. As for the horse and carriage: since horse-drawn carriages were the prerogative solely of official rank,

their depiction under a tree could likely suggest aspiration to public service. On the other hand, if they represent the horse and carriage of the deceased, they symbolized the wealth and prestige of the family. The biography of Xue Guangde in the *Hanshu* (*History of the Western Han*) records: "Guangde was dismissed from office ten months after being appointed censor-in-chief. When he returned to his hometown of Pei, the magistrate (*taishou*) greeted him at the district border. Proud of Guangde's achievement, the [people] of Pei hung up

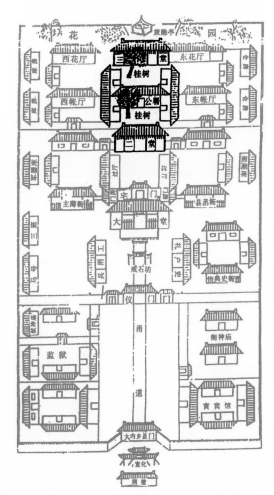

Fig. 5 *Cassia trees in courtyards*. Architectural plan of Neixiang District Compound, Henan. From Wu Si, *Xuechou dinglü* (Beijing: Zhongguo gongren chubanshe, 2003), p. 109.

[the reins] of his carriage to celebrate." The famous literatteur Yan Shigu (581–645) commented on the significance of hanging up the carriage reins as follows: "Hanging up the reins is an expression of the [locals'] pride [in Xue]. Retiring from office and hanging up the reins (*zhishi xuanche*) is an old custom."[13] Therefore, the horse and carriage, unhitched under the tree in the homage scene, may also be a rebus, a visual metaphor for the glad return to one's hometown after the completion of a distinguished career. It was a conventional image in Han offering shrines, seen also in an early Eastern Han shrine at Wulaowa, Jiaxiang, in Shandong Province (fig. 6).[14]

The Wulaowa carving is divided into sections, showing at the top a two-story building inside which the shrine dedicatee, seated, is receiving offerings and greetings. On the dedicatee are carved three characters, *gu taishou* ("the late governor"), denoting his official title. The bottom register depicts a groom tending a carriage, its shaft angled up and supported by a post, and two horses, both feeding and the one on the right being curried by another groom. This is a picture

of restful retirement following the dedicatee's successful official career, intended to be viewed by his descendants and also by the public.[15] The symbolism of an unhitched horse and empty carriage is illuminated in the "Zhishi" ("Retiring from Office") chapter of the *Baihu tong*: "I, the humble subject, am seventy years old, ready to retire from office and hang up the [reins] of my carriage," and its commentary: "To hang up the reins of a carriage [*xuanche*] indicates that it no longer needs to be used, and to retire from office [*zhishi*] is to resign from serving the lord."[16] The horse and carriage could also be understood as part of the awards and pension granted to descendants of the honored retirees, symbolizing their hope and preparation for similarly successful careers.

The assemblage of images and motifs in the homage scene, including the *zhishi xuanche* rebus and the archer, together form a unified iconography, reflecting the prevalence and intensity of ancestor worship during the Han dynasty. By making offerings to the deceased, one hoped to receive blessings from the ancestor's spirit for the continuing success and prosperity of oneself and

Fig. 6 *Homage scene.* Rubbing of rear wall of offering shrine, Wulaowa, Jiaxiang, Shandong. From Zhu Xilu, ed., *Jiaxiang Han huaxiang shi* (Jinan: Shandong meishu chubanshe, 1992), pl. 87 (p. 67).

one's descendants. These pictorial carvings figured in mortuary rituals; they are conventionalized representations in offering shrines, desired by the living and believed to be accepted by the dead, in a relationship sealed by the conviction that the living's "intention to be filial sons and loving siblings can be communicated to the [ancestor] spirits."[17] Performing ritual sacrifices to ancestor spirits was an essential form of religious expression in ancient China, and the visual metaphors and rebuses concealed in the carvings had obviously become a popular practice in mortuary art during the Han dynasty.

The archery scene, as mentioned above, is sometimes presented separately from the homage scene, as a simple representation of a common activity. Its appearance with the homage scene does not imply that it performs a similar ritual function; rather, it was the visual rebus that it contains, i.e., aiming at the *jue* or *hou* noble rank, that connected it with the more elaborate iconographic program of the homage scene.

The Homage Scene as a Symbolic, Not an Actual, Representation of Ancestor Worship

According to Xin Lixiang, the homage scene actually depicts ancestor worship: a "Picture of the Shrine Dedicatee Receiving Sacrifices" (*cizhu shou ji tu*). Xin argues that the image connects the living world and the netherworld of ghosts and spirits,[18] and that "the two-story pavilion is a form of aboveground sacrificial shrine; the figures on the ground floor of the building are the shrine dedicatee and his living offspring, and the women seated frontally on the second floor are his consort and concubines. The horse and carriage under the tree are the vehicles transporting the shrine dedicatee between grave and shrine, and the archer represents the offspring hunting to prepare

animal sacrifice."[19] Xin also argues that the carriage procession under the pavilion "is the journey of the deceased couple from grave to shrine to receive offerings."[20] Furthermore, Xin asserts a temporal sequence for the images, from the couple's journey to the two-story pavilion-shrine to their arrival at the destination (thus the unhitched horse and carriage), and finally to sitting in the pavilion receiving offerings.[21] In other words, according to Xin, the homage scene depicts sequential vignettes of a narrative: proceeding from the deceased's departure from the underworld with a cavalcade of horses and soldiers, to arrival at the offering shrine, and finally to ascending the pavilion to receive sacrifice.

This scenario, though intriguing, does not exactly fit the depicted scene. How, for example, do we explain the dwindling of the journey from a cavalcade to a single carriage under the tree? Where is the rest of the procession? How can the ghosts or spirits (from the realm of the dead) sit in the offering shrine (which belongs to the living) to receive offerings? And since both the grave and the shrine are in the same cemetery, the latter usually located directly in front of the former, why the need for a cavalcade? In fact, how do ghosts and spirits even travel? I offer a different interpretation.

First of all, the two-story building in the homage scene does not represent an offering shrine in a Han cemetery, because the offering shrines reconstructed from archaeological materials are all single-story structures (fig. 7).[22] Granted, these are all stone structures, since no wooden buildings of Han date have survived. Even the two examples of shrines cited by Xin, one a square enclosed structure (fig. 8A), and the other a double courtyard divided and enclosed by corridor-like houses (fig. 8B), are both one-story buildings. Since archaeologically reconstructed shrines carved with

Fig. 7 *Types of stone offering shrines of the Han dynasty.* Line drawing. From Jiang Yingju and Yang Aiguo, *Handai huaxiang shi yu huaxiang zhuan* (Beijing: Wenwu chubanshe, 2001), ill. 23 (p. 86).

the homage scene on their rear walls are all single-story buildings, there is no evidence to support the argument that the pavilion in the homage scenes represents a shrine. Mortuary shines, temples, or ancestor shrines were usually single-storied; even as late as the Ming and Qing dynasties such structures at imperial mausolea, or at the Confucius and Mencius temples in Shandong, were all one-level buildings. As seen in many Han pictorial carvings and architectural models, the two-story building was a form of residential architecture. In Xin's interpretation, the consort of the dedicatee would have had to descend the carriage and climb to the second floor to receive offerings, which is hard to imagine. I believe that the woman and her servants on the second floor of the pavilion represent a scene of daily life in the Han dynasty.

Xin's assertion that the activities inside the pavilion represent the descendants sacrificing to their deceased parents also contradicts his statement elsewhere that during the Han dynasty sacrificial rituals at burial sites were conducted outdoors.[23] Compared with the outdoor scenes of sacrifice to the ancestors, carved on the lintels of the front and middle chambers in the Yinan

tomb,[24] the essential elements suggesting such a religious activity are conspicuously lacking in the homage scenes. Instead of portraying a solemn ritual procession, the latter depict common gestures and interactions suggesting activities and events of daily life. In the homage scenes we see no common sacrificial animals such as cows, pigs, chickens, and fish. Birds and monkeys (the two animals in the tree next to the pavilion, which Xin believes to be the targets of the archer preparing for the sacrifice) were depicted as part of visual rebuses or as evocations of an idealized afterlife realm (see below), but not as items for sacrifice. More troubling is the simultaneous appearance of the deceased and the living in the same purported shrine. As shown in the Songshan and Wu shrines carvings, the large figure, which represents the lord of the family, sits close to the visitors humbly bowing or kneeling in front of him; in many carvings he extends his hand toward them and appears to return their greetings warmly. If these were the deceased parent and his offspring, the latter would likely be more terrified than respectful. The belief in early China that life and death do not and must not trespass on each other's territory is best reflected

in a grave-quelling inscription (*zhenmu wen*) on a pottery mortuary jar, which reads: "The living have their residences, and the dead have their coffins. Life and death exist in separate realms, so, [dead soul,] please do not come taking things from the living!"[25] In light of such feelings of apprehension, it is unlikely that the homage scene would portray the living and the dead in the same space. I would argue that the scene is a pictorial representation of the *life* of the deceased; it proclaims the high social status and prestige he enjoyed during his lifetime, complete with frequent visits of honored guests and bountiful and prosperous offspring paying their due respects.

As for the carriage procession below the pavilion, it is almost beyond imagination to interpret it as the deceased couple's travel from the netherworld to the living world of the aboveground shrine, where they can be worshiped by their descendants. Xin Lixiang, to substantiate his argument, further suggests that the cavalcade is a journey between the realms of death and life, symbolized by the decorative band that runs around the midsections of the walls of some shrines. He elaborates: "Whereas those carriage processions depicted above this dividing band are parades taking place in this life, the homage scene and those carriage processions below the band are activities belonging to or bordering the underworld." In other words, that decorative band has, in Xin's interpretation, become a "cosmic demarcation line."[26]

Let us look at the carvings in a typical example of Han offering shrines — the Wu Liang

Fig. 8A *Offerings before a shrine*. Line drawing of rear wall of offering shrine excavated near Xiaotangshan Shrine, Changqing, Shandong. From Xin Lixiang, *Handai huaxiang shi zonghe yanjiu* (Beijing: Wenwu chubanshe, 2000), pl. 43 (p. 82).

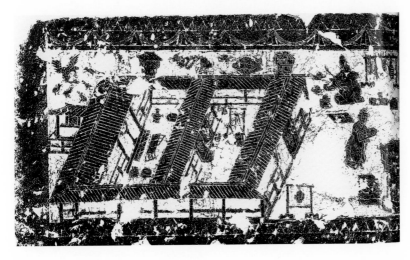

Fig. 8B *Offerings before a shrine*. Rubbing (detail) of west section of south wall lintel in central chamber. Tomb 1, Yinan, Beizhai, Shandong. From *Zhongguo huaxiang shi quanji*, vol. 1, pl. 205 (p. 154–55).

Shrine (fig. 9). Carved under the midlevel decorative band of geometric signs and running across the east, rear, and west walls, are historical figures such as the heroic assassins Nie Zheng, Yu Rang, Yao Li, Jing Ke, as well as the virtuous woman Zhongli Chun, and the exemplary statesmen Fan Sui and Lin Xiangru.[27] If the space below the decorative band is allocated to the depiction of the underworld, according to Xin, then how do we explain the presence of these historical figures, representatives of the living world, being portrayed in the realm of ghosts and spirits? Moreover, in the lowest register of the east wall at viewer's far left, is a carriage, its rider kneeling before it facing an ox-drawn cart to his right. A cartouche inscription above the carriage reads *xian gongcao* ("District Official in the Bureau of Merit"), and another, above the ox, is inscribed *chushi* ("retired gentleman"). These carvings are biographical depictions of Wu Liang, whose eremitic inclination and determination to shun public service are clearly recorded in his stele inscription: "Having been called upon by commandery authorities to official posts, [Wu Liang] declined by reason of illness. Content with a simple life of humility, he took delight in learning

as a free man."[28] This is a pictorial narrative of Wu Liang's life, just as, in the Front Shrine (i.e., the Wu Rong Shrine), such cartouches as *wei duyou* [*shi*] ("at the time of [serving as] a local inspector") and *jun wei shiyuan shi* ("when the lord served as a market clerk") (fig. 10), label the pictorial depictions of Wu Rong's official titles and ranks. Like the cartouches and the images they label in the Wu Liang Shrine, those for Wu Rong are also located below the decorative band, which Xin suggests is a pictorial zone allocated for the representation of the underworld.

The artistic excellence of the Wu Liang Shrine carvings is reflected in the statement that they were created by "the fine craftsman Wei Gai, who carved the images in orderly registers, fully displaying his dexterous skills in the undulating and beautiful patterns."[29] As can be seen from the rubbings (see fig. 9), the continuous decorative bands at about the midsections of the three walls, and the images, are distributed evenly within clearly defined registers in a systematic and well-proportioned design program, which corresponds with ancient Chinese cosmology. For the most part, celestial beings and deities are shown on the ceilings, Immortals

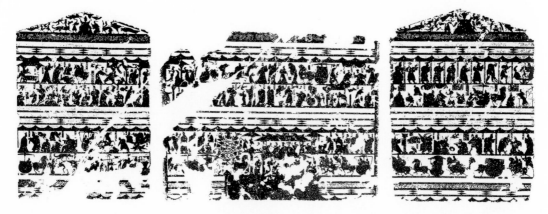

Fig. 9 *Rubbings of west, rear, and east walls of Wu Liang Shrine.* Jiaxiang, Shandong. From *Zhongguo huaxiang shi quanji*, vol. 1, ill. 7 (p. 39).

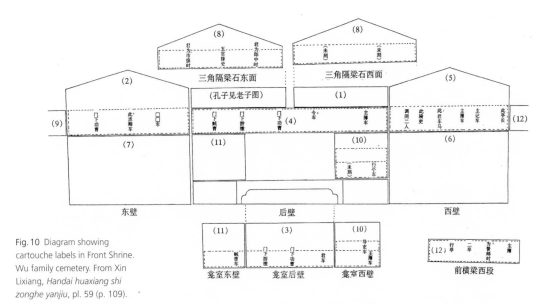

Fig. 10 Diagram showing cartouche labels in Front Shrine. Wu family cemetery. From Xin Lixiang, *Handai huaxiang shi zonghe yanjiu*, pl. 59 (p. 109).

on the triangular gables, and stories and events of human history on the three walls. In harmony with the Chinese cosmological perspective, images pertaining to a higher realm are placed higher (Heaven/the ceilings) on the shrine, those of a lower level, lower (this world/the walls); images of beings conceived as far-off are placed higher (heavenly beings/ceilings), and those closer to the mundane world lower (historical figures/the walls); things of the past are placed higher, and present events are shown lower. Although this is a general observation, it matches our habitual visual perception of the universe. There is so far no evidence to suggest that the decorative band around the midsection symbolizes the division between life and death. Xin has argued that the realm of the underworld is represented by the "dragon, tiger, and monsters" in the silk painting discovered in the Han tomb at Jinque Shan, or by the "beast standing on a giant fish holding the mighty earth,"[30] in the Mawangdui silk painting; we see no traces of such imagery in the Wu shrines pictorial carvings.

Unquestionably the carriage procession below the homage scene is associated with the official career of the deceased, but it by no means illustrates the journey of his postmortem spirit or ghost to the shrine. Parades of infantry, horsemen, and carriages are also found above the central homage scene, and, as I have suggested above, their positions relative to this central scene generally coincide with their temporal, spatial, or narrative relationship with that scene. The procession above the homage scene, which may pertain to the past or to the far distance, is sometimes omitted, but the procession below the homage scene is omitted rarely. Although archaeological evidence has sometimes indicated the absence of a carriage procession from the overall iconographic scheme of the homage scene (see below), it is mostly present for another major reason: it greatly refines and enriches the pictorial contents of the carvings. Nevertheless, Xin Lixiang characterizes the carriage procession as an "invariable element" in the pictorial carvings of Han mortuary shrines, citing a pictorial stone from a

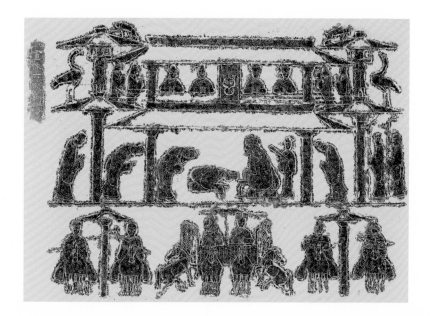

Fig. 11 *Homage scene.* Rubbing of rear wall of offering shrine excavated in Wujiazhuang, Jiaxiang, Shandong. From *Zhongguo huaxiang shi quanji*, vol. 2, pl. 129 (p. 120).

shrine at Wujiazhuang, Jiaxiang, Shandong (fig. 11), as an early Eastern Han example for his assertion.[31]

The carriage procession in Wujiazhuang, showing six horses in frontal view with foreshortened perspective and two others with bodies angled and heads reversed, may reveal early Chinese craftsmen's naïve and crude techniques, but it unquestionably shows a cavalcade of the living, not the shrine dedicatee's postmortem travel from the grave to the shrine. The direct message conveyed by the Wujiazhuang homage scene is that the lord enjoyed an affluent and prestigious life—greeting his guests in a multistoried house, traveling with an escort befitting a man of power and wealth—both demonstrated by the carriages in front of the luxurious mansion marked by a pair of *que* pillars. In contrast with the frontal foreshortening of the Wujiazhuang carriage scene, the carriage processions in many later Han carvings, such as those at the Wu site and at Songshan, are rendered in profile and fill their entire register in a display of awe-inspiring majesty. This type of portrayal is seen not only on the rear wall below the homage scene, it also appears in other areas, such as the lower registers of all three walls of the Wu Liang Shrine. In the Front (Wu Rong) Shrine the procession starts on the east wall of the inset niche, runs along the niche's rear and west walls, then continues onto the west side of the shrine's rear wall, thus integrating the three surfaces of the niche and the west side of the rear wall. In the Songshan shrines the chariot processions appear only below the homage scenes. In the Wu Family Shrines the cavalcades below the homage scenes are the longest, indicating the greater significance of this spectacular visual display of pride and glory compared with those procession scenes shown on the upper portions of the shrine walls.

Careful examination of the relationship between the carriage procession and the homage scene above it reveals that the cavalcade is either leaving from or arriving at the front of the luxurious two-level residence marked by the *que* pillars. It likely depicts the shrine dedicatee's travel, during his lifetime, to the family cemetery to perform an ancestor ritual, an interpretation

that can be supported by Han literature on the popular custom of ancestor worship at cemetery sites. Termed *musi* ("offering at the grave site"), or *shangzhong* ("attending to the tomb mound"), it was a convenient social occasion often used by family members to publicly demonstrate their filial virtue and to solidify clan relationships. Officials were sometimes granted special leave in order to perform these funeral rituals in their hometowns. Lou Hu, a Western Han grand master of remonstrance, for example, requested permission to "pay respect to his ancestor's tomb first when traveling through Qi [his home town]," and after permission was granted, he used that opportunity to "meet clansmen, relatives, and former peers, offering gifts of textiles, squandering one hundred gold cash in one day."[32]

As political power increasingly devolved to prominent local clans during the Eastern Han dynasty, ancestor worship performed in hometown family cemeteries became even more popular. Then too officials whose accomplishments or performances in office were extraordinary, were by imperial favor allowed to detour in their official travels to make offerings at ancestral grave sites. For example, when Wang Chang was returning to Luoyang (capital of the Eastern Han) from his military duty in the year 30 CE, Emperor Guangwu (r. 25–57) ordered Wang's wife to receive Wang in Wuyang (his hometown), so that Wang could "go home and pay homage to his ancestors at his family cemetery." In 37 the emperor issued an edict allowing Wu Han, then traveling along the Yangzi River and arriving at Wan (his hometown) after defeating Gongsun Shu the previous year, to return home to perform ancestor worship at the family cemetery site. Also by imperial edict Feng Yi returned home to visit his family cemetery; "local officials and relatives posted or residing within

two hundred *li* were ordered to join the social gathering."[33]

From these records we deduce that the popularity of grave-site ancestor worship, made possible by the imperial reward of "home leave" for this religious purpose, created an opportunity for powerful families to promote their social standing and showcase their filial virtue. Returning home in a parade of carriages, infantry, and horsemen was a major opportunity for self-aggrandizement. As the popular saying *yi jin huan xiang* ("returning home clothed in brocade") implies, no other form of display better demonstrated a man's success in his government career (in imperial China the traditional path to social status, wealth, and family security) than returning home in a procession. This cultural practice is the background against which to understand the meaning of the homage scene and carriage procession in Han mortuary carvings. Instead of depicting the deceased shrine dedicatee's journey to the cemetery site from the front gate of his residence, the cavalcade is a symbolic representation of the greatest achievement to which any man in Han China could aspire during his lifetime. The glory and pride thus on display were believed to extend backward to ancestors, through whose blessings they would extend forward to posterity.

Although additional motifs and themes, such as the birds and monkey in the cassia tree, the unhitched horse and carriage under the tree, and even the carriage procession, are sometimes added to the core image of the deceased couple (depicted as living and symbolic of the shrine dedicatee) seated in a two-story pavilion receiving greetings, the core function of the homage scene remains the same. The subsidiary motifs, in varying combinations, consistently enrich the pictorial celebration of an ideal Han family life, with its members enjoying the most prestigious and

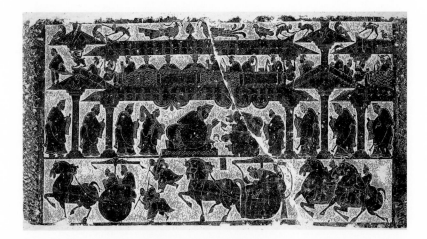

Fig. 12 *Homage scene.*
Rubbing of rear wall
of Shrine 3. Songshan,
Shandong. From *Zhongguo
huaxiang shi quanji*, vol. 2,
pl. 105 (p. 97).

comfortable housing, transportation, and other
commodities. The homage scene in a small offering
shrine unearthed in Songshan (fig. 12), for example,
depicts neither the tree nor the unhitched horse
and carriage. Another example that highlights
the symbolic function of the homage scene is a
small shrine in Weishan, Shandong. A couple is
shown seated in a canopied hall with four visitors
and two female attendants (fig. 13), and the
adjoining inscription records that two brothers
built the offering shrine (*shitang*) in 141 CE for their
deceased elder brother and his son.[34] This simpli-
fied picture, symbolic of paying homage to the
shrine dedicatee (elder brother) and to his consort,
shared the same function and purpose as the more
elaborate presentations of the homage scene in the
Wu Family Shrines, despite the Weishan shrine's
lack of such subsidiary themes as the large tree, the
archer aiming at birds, or the unhitched horse and
carriage.

The homage scene, therefore, was a generic
iconography serving the religious purpose of
ancestor worship. It could be placed in a family
offering shrine in a cemetery, or in a temple; it
could also be created as a painting to be hung in
a house as an object of veneration and worship.

The images, though in figural form, should not
be understood as true portraits of the deceased,
since true portraits were unlikely to be placed in
mortuary structures in traditional China. The soul
of the deceased was embodied in the homage
scene, which in its position on the main wall of a
shrine functioned as a pictorial ritual object central
to the ceremony performed by family members
who prayed for ancestral blessings. The homage
scene is a link between the living world and the
netherworld, the single element whereby the entire
visual program in a tomb or shrine connects the
living with the dead. It represents the deceased
in life, while also serving as an image whereby
descendants venerated the deceased in death. The
worldly dignities of the deceased that it depicts
are also the desiderata of their descendants; the
blessings incurred by reverencing it bonded family
members past, present, and future. Han pictorial
carvings are the best art-historical documents
for the well-known social and religious concept
expressed in the phrase: *shi si ru shi sheng* ("[One
should] serve the dead as if serving the living").

The source materials for the homage scene
are the real lives of Han aristocrats, nobility, and the
landed rich, whose material comfort and wealth

are vividly described in Han literature, such as the Han poem "Encounter on the Road," discussed above. The skillfully executed images on the walls of the Wu Family Shrines and the Songshan shrines—the magnificent pavilion, the service and displays of deference that the lord and his wife enjoy in the pavilion, the symbolic cassia tree and the gallant procession, all fully reflect the sumptuous lives of the privileged families. Since housing and transportation are two primary standards by which one's social status is measured, the pavilion and cavalcade therefore constitute the main elements in these carvings. On the other hand, Han pictorial carvings were products made by artisans whose work followed certain workshop conventions. The carvings were created with imaginative exaggerations in order to serve both the religious function and aesthetic considerations of mortuary art. For example, the figures and activities inside the pavilion are rendered in cross section, enabling a full viewing of the scenes. The fantastic birds perching on the roofs and the many winged Immortals are not of this world; rather, they are pictorial designs inspired by an idealized

world enlivened with such unusual creatures. Since the offering shrine was believed to be "where the ancestor's spirit dwells," as well as "where sacrifice takes place,"[35] the imagined world where Immortals, fantastic birds, and animals abound was created for the gratification of the spirit and also to induce the ancestor spirit to bless his progeny and their descendants.

The relationship between the homage scene and the shrine dedicatee is symbolic and general; the pavilion image neither represents a specific family, nor is it a realistic portrayal of any individual's life. This is evident from the formulaic compositions and pictorial details of the scene in shrines of different scales and sizes. As an idealized visual symbol fulfilling the wish of the living for their departed parents or relatives, the homage scene was a popular iconography desired by both the makers and the users. Produced as ready-made stock, Han pictorial stones could be purchased by any family and installed in any shrine, the way modern folk-print images of the Stove God (Zaowang ye) are worshiped in every kitchen. The only difference is that prints are identical, whereas

Fig. 13 *Homage scene.* Rubbing of wall of an offering shrine (141 CE). Weishan, Shandong. From *Shandong Han huaxiang shi xuanji* (Jinan: Qi-Lu shushe, 1982), vol. 1, pl. 1.

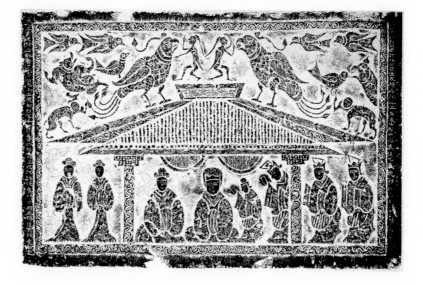

stone slabs in Han mortuary art were individually carved and therefore subject to differences in technique, style, and compositional scheme.

Epilogue

Han pictorial carvings can be studied from many different angles. A close understanding of their original meanings is the primary concern of archaeological and art-historical inquiries, which need to consider both the function of the entire visual program in relation to the overall architectural structure and the symbolism of specific images or themes. We must try to avoid the pitfall of overinterpreting particular sections of the program and thus removing them from their context, and we should not indulge in conjuring up elaborate and systematized interpretations. Iconographic and iconological research is a difficult and complicated discipline, because the images reflect thoughts and ideology. In discussing the role of imagery in the study of the history of thought, Ge Zhaoguang cautions against "overinterpretation and underinterpretation," and emphasizes "careful examination of all evidence with prudence."[36] The same caution pertains to the iconographic interpretation of Han art. Although I too am not certain how to avoid "overinterpretation and underinterpretation," I hope that this essay will invite further discussion and encourage better understanding of Han mortuary stone carvings. ◉

Translated by Eileen Hsiang-ling Hsu

Notes

1 Wilma Fairbank, "The Offering Shrines of 'Wu Liang Tz'u'," *Harvard Journal of Asiatic Studies*, vol. 6, no. 1 (1941); reprinted in her *Adventures in Retrieval: Han Murals and Shang Bronze Molds* (Cambridge, Mass.: Harvard University Press, 1972), p. 85. Also see its Chinese translation, Fei Weimei [Wilma Fairbank] "Han 'Wu Liang Ci' jianzhu yuanxing kao," *Zhongguo yingzao xueshe huikan*, vol. 7, no. 2 (1945), pp. 1–60.

2 Jiang Yingju and Wu Wenqi, "Wushi Ci huaxiang shi jianzhu pei-zhi kao," *Kaogu xuebao* 1981.2, pp. 165–84; see also Jiang Yingju and Wu Wenqi, *Handai Wushi muqun shike yanjiu* (Jinan: Shandong meishu chubanshe, 1995), p. 97.

3 Xin Lixiang, *Handai huaxiang shi zonghe yanjiu* (Beijing: Wenwu chubanshe, 2000), pp. 83–102.

4 Ibid., p. 94.

5 The exact orientation of the *que* pillars on the Wu site is 323 degrees, that of Tomb 1 excavated in 1981 is 305, and Tomb 2 is 307 degrees, all facing north and slightly west. The reconstruction of the Wu Shrines is based on this northern orientation; see n. 2 above.

6 Jiang Yingju, "Handai de xiao citang—Jiaxiang Songshan Han hua-xiang shi de jianzhu fuyuan," *Kaogu* 1983.8, pp. 741–51.

7 Cheng Rong, ed., *Han Wei congshu* (Changchun: Jilin daxue chubanshe, 1992), pp. 158–59. [Translator's note: For a study and English translation of the *Baihu tong*, see Tjan Tjoe Som, *Po Hu T'ung: The Comprehensive Discussions in the White Tiger Hall* (Westport, Conn.: Hyperion Press, 1973). My translation differs slightly from Som's.]

8 [Translator's note: English translation by James Robert Hightower, in *The Columbia Anthology of Traditional Chinese Literature*, ed. Victor H. Mair (New York: Columbia University Press, 1994), p. 180.]

9 Xin Lixiang, *Handai huaxiang shi zonghe yanjiu*, pp. 93–102.

10 Hsing I-tien, "Handai hua-xiang zhong de 'shejue shehou tu'," *Zhongyang yanjiuyuan lishi yuyan yanjiusuo jikan*, vol. 71, pt. 1 (March 2000), pp. 1–66.

11 For the inscription *li guan guishu*, see Nei Menggu Zizhiqu bowuguan

wenwu gongzuo dui, ed., *Helinge'er Han mu bihua* (Beijing: Wenwu chubanshe, 1978), p. 144 and cpl. on pp. 100, 101. Of the four characters in this inscription, the first three are clearly readable, but only the *"mu"* radical remains for the last character, *shu* ("tree"). Hsing also points out that although the archery scene may be understood primarily as a rebus for Han people's wish for official career, it may have other meanings. For example, Han painted bricks excavated in Chengdu, Sichuan, depict such common daily activities as archery, fishing, hunting, and agricultural activities.

12 Lu Qinli, ed., *Xian Qin Han Wei Jin Nanbeichao shi* (Beijing: Zhonghua shuju, 1983), p. 265.

13 *Hanshu* (Beijing: Zhonghua shuju, 1962), p. 3048.

14 See the excavation report in Jiaxiang wenguansuo, "Jiaxiang Wulaowa faxian yipi Han huaxiang shi," *Wenwu* 1982.5, pp. 71–78. The unhitched horse and carriage image is on Stone 13, which can be architecturally reconstructed with Stones 14 and 15 to form a small shrine; see Jiang Yingju, *Handai xiao citang*, p. 750.

15 [Translator's note: for a study of the intended viewers of the pictorial carvings in Han tombs and shrines, see the article by Zheng Yan in this volume.]

16 Cheng Rong, *Han Wei congshu*, p. 163.

17 This is part of the long inscription engraved on the Han tomb marker of Lord Qin, an assistant copier in Youzhou, discovered in suburban Beijing in 1964. For the reading of the inscription, see Guo Moruo, "'Wu huan bu mu' shike de buchong kaoshi," *Wenwu* 1965.4, pp. 2–4.

18 Xin Lixiang, *Handai huaxiang shi zhonghe*, p. 62.

19 Ibid., pp. 101–2.

20 Ibid., p. 118.

21 Ibid., p. 115.

22 For reconstructed Han offering shrines, see Jiang Yingju and Yang Aiguo, *Handai huaxiang shi yu huaxiang zhuan* (Beijing: Wenwu chubanshe, 2001), pp. 86–94.

23 See Xin Lixiang, *Handai huaxiang shi zonghe yanjiu*, p. 81.

24 Zeng Zhaoyu, Jiang Baogeng, and Li Zhongyi, eds., *Yinan gu huaxiang shi mu fajue baogao* (Shanghai: Wenhuabu wenwu guanliju, 1956), pls. 28, 29. For Xin's discussion of these two carvings of sacrifice rituals, see Xin Lixiang, *Handai huaxiang shi zonghe yanjiu*, pp. 249–51, fig. 129.

25 This spirit jar was excavated in Linqi County, Shaanxi Province; see Wang Zeqing "Dong Han Yanxi jiunian zhushu hunping," *Zhongguo wenwu bao*, 7 November 1993, sec. 3. Another similar inscription

is found on a jar unearthed in Hu County, Shaanxi, in 1972; see Zhuo Zhenxi, "Shaanxi Hu Xian de liangzuo Han mu," *Kaogu yu wenwu* 1980.1, pp. 44–48.

26 Xin Lixiang, *Handai huaxiang shi zonghe yanjiu*, p. 118.

27 Jiang and Wu, *Han Wushi Ci*, pp. 52–61.

28 See the stele inscription of Wu Liang in Hong Gua, *Li xu* (reprint, Beijing: Zhonghua shuju,1985), pp. 168–69.

29 Ibid.

30 See Xin Lixiang, *Handai huaxiang shi zonghe yanjiu*, p. 144, fig. 79, and pp. 190–93, fig. 101.

31 Ibid., pp. 113–15.

32 See Lou Hu's biography in *Hanshu*, p. 3706–7.

33 For biographies of Wang Chang, Wu Han, and Feng Yi, see *Hou Hanshu* (Beijing: Zhonghua shuju, 1965), pp. 581, 682, 645 respectively.

34 Shandong sheng bowuguan, Shandong sheng wenwu kaogu yanjiusuo, eds., *Shandong Han huaxiang shi xuanji* (Jinan: Qi-Lu shushe, 1982), pl. 1.

35 Wang Chong, *Lunheng*, in *Zhuzi jicheng* (Shanghai: Shijie shuju, 1935), vol. 7, p. 228.

36 Ge Zhaoguang, "*Sixiang shi yanjiu shiye zhong de tuxiang*," *Zhongguo shehui kexue* 2002.4, pp. 74–83.

Han Steles: How to Elicit
What They Have to Tell Us

MIRANDA BROWN

For historians of China's early period, questions about the reliability of our sources give us pause. Standing between the historian and the data are nagging doubts about the nature and provenance of sources, the majority of which have been transmitted through the ages. When was this text written—and who wrote it? By what routes has it come down to us? To what extent do sources represent the views of their authors—or the biases of later compilers, presumptuous editors, or clever forgers? Questions such as these are neither fashionable, nor do they make for compelling grant applications or interesting dialogues with other historians. In addition, such questions jeopardize our ability—or better still, they dispel our illusions about our ability—to extract data from our sources, and they serve no less as uncomfortable reminders of the ultimate indeterminacy of historical knowledge. It is no surprise then that historians of the early period tend to banish messy textual problems to the margins of our discussion—to footnotes or appendices placed discretely out of the sight of our broader readership—rather than foreground these matters or make them part of the central narrative.

To be sure, none of these anxieties are new or unique to modern or Western practitioners of the craft; such questions about the reliability of transmitted sources have prompted Chinese scholars since the Song dynasty to study bronze and stone inscriptions (*jinshi xue*).[1] Indeed, as comments made by the eminent antiquarian Wu Yujin (1699–1774) suggest, stone inscriptions have long been regarded as "harder," i.e., more trustworthy, than other kinds of sources, especially those written on literally softer mediums, such as paper. "Generally speaking," Wu observed, "writing in print medium is inferior to stone inscriptions in terms of truthfulness. For this reason, earlier

men often used the texts of [stele] inscriptions to correct the errors of books."[2] Wu's characterization of the way his predecessors used stone inscriptions finds support in two authoritative figures. As Zhao Mingcheng (1081–1129) put it in his monumental collection of stone inscriptions, *Record of Stone and Bronze* (*Jinshi lu*), "The histories and annals are by the hands of later men, and so they cannot be without error. But carved words were erected at the time and so they can be believed without doubt."[3] Zhao's views were seconded by Zhu Yun (1729–1781), a leading Textual Authentication (*kaozheng*) figure during the Qing dynasty. In this connection Zhu remarked, "Stone inscriptions are the oldest historical sources, and they can be relied upon in examining the past, as they never lose their truth."[4]

In the pages below we shall ask again whether stone inscriptions of the Han dynasty are as incontrovertible as all that. Can they be regarded as pristine sources of Han history? Or are there problems inherent in the use of these sources, problems not very different in kind from those found in other mediums? This paper will represent a first attempt in English to answer these questions. And as it is part of a larger collection of papers given on the occasion of the exhibit on the "Wu Family Shrines," it is appropriate to take as our point of departure the findings of members of the Princeton University Art Museum team, particularly those of Cary Liu and Michael Nylan. Both Liu and Nylan have raised questions about the authenticity, integrity, and the very identity of the so-called Wu family steles.[5] This essay will draw out the larger implications of their specific arguments about the Wu family steles by looking more broadly at the Han stele genre as a whole. It will begin by showing that Han steles and rubbings share some of the problems of texts transmitted through the ages,

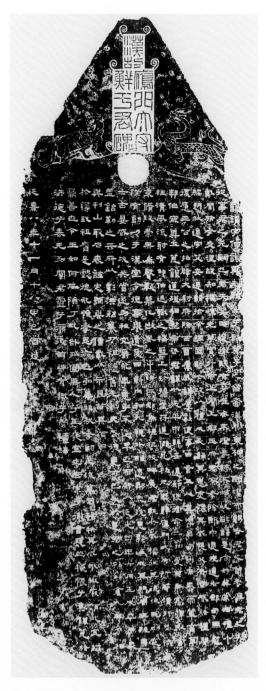

Fig. 1 *Rubbing of Xianyu Huang inscription.* Ca. 165 CE. From Beijing tushuguan, *Beijing tushuguan cang Zhongguo lidai shike taben huibian*: *Zhanguo Qin Han bufen* (Zhengzhou: Zhongzhou guji chubanshe, 1989), vol. 1, p. 144. The stele, which was excavated in 1973, is now in the Tianjin Historical Museum.

that is, problems of identification, interpolation, and authenticity. After examining in depth the uncertainties attending stele texts, this essay will discuss strategies for evaluating their authenticity and representativeness, specifically the use of classical commentary, textual collation, and quantitative analysis. Finally, it will conclude that, though steles fail to provide unmediated access to the distant past, when used with care they hold considerable value as sources of Han history.

Identification

The identity of a stele dedicatee would seem to be straightforward. And indeed, in many cases, it is; the stele dedicated to Xianyu Huang (165 CE) provides one such example. As the stele reveals (fig. 1), the surname and title of the dedicatee is clearly carved in the header. The main text of the carving provides the dedicatee's name, place of origin, and the date of Xianyu's death.

Yet, as divergent remarks made by two Song commentators on a Han-dynasty inscription suggest, the identity of some stele dedicatees may be less than airtight. To begin, let us consider the Kong Biao (d. 171 CE) inscription. In the *Record of Collecting Antiquities* (*Jigu lu*), Ouyang Xiu (1007–1072) refused even to guess at the name of the dedicatee, of whom only a Kong surname, a position in the genealogical sequence, and a few governmental posts could be known. "The graphs for his name have been effaced and cannot be seen," Ouyang asserted. Not surprisingly, the stele entered his record merely as "the stele of a Kong gentleman of the Eastern Han" ("Hou Han Kong jun bei").[6] In contrast, Zhao Mingcheng was confident in his identification of the stele. "Nowadays, although the inscription is fragmentary," Zhao wrote, "the graphs are nevertheless

completely intelligible. It says that the gentleman's tabooed name was Biao and that he was self-styled Yuanshang."[7]

The differences between these two accounts, made perhaps a century apart, raise a number of questions. Did Zhao, who never saw the actual stone, come across a better (that is, an older or more pristine) rubbing?[8] Several possibilities come to mind. First, a neutral but plausible scenario: perhaps, as Qianshen Bai has suggested in conversation, Zhao Mingcheng simply found a better rubbing than did Ouyang. Or, a somewhat more disquieting scenario: Zhao Mingcheng got hold of a rubbing made from a new stele, one that had been cut following Ouyang's account. By many reports, recutting stones according to earlier rubbings or even according to printed texts was common in late imperial China.[9] Finally, the worst case scenario: the possibility that some clever forger or wishful scholar recut a stone not only with Ouyang's description in mind, but with a few embellishments to "fill in the blanks" (*buque*). Regardless of which, if any, of these scenarios are correct, one needs to consider the possibility that the identity of the Kong stele is not a foregone conclusion.

Lest we imagine that the Kong Biao stele was unique in this regard, it is important to keep in mind that early Song commentators, particularly Ouyang Xiu, were also tentative in their identification of other steles. In some cases the identity of the stele dedicatee appears to have been the product of ingenuous guesswork. Let us thus consider entries by Ouyang, Zhao, and Hong Gua (1117–1184) about the "Kong Qian" stele (figs. 2, 3). Ouyang reported that he found a stele dedicated to a Kong male, self-styled Derang, in the Kong family grave complex. Noting that the inscription mentioned that the young man had

8	7	6	5	4	3	2	1
不祿	卅四，永興二年七月，遭疾	弱冠而仕，歷郡諸曹史，年	秋經，升堂讓誦，深究聖指，	孝友之行，褆述家業，脩春	蘭石自然之姿，長齠清少	世孫，都尉君之子也，幼體	孔謙，字德讓者，宣尼公廿

Fig. 2 *Rubbing of the Kong Qian stele.* Ca. 154 CE. Kyōto Daigaku Jinbun Kagaku Kenkyūjo shozo takuhon collection. From Nagata Hidemasa, *Kandai sekkoku shūsei* 2.152. The original stele is housed in the Kong Temple in Qufu. The name of the dedicatee is as unintelligible today as it was in Ouyang Xiu's time.

Fig. 3 *Nagata Hidemasa's transcription of the Kong Qian stele.* In *Kandai sekkoku shūsei* 2.152. The transcription shows no hint that the identification of the dedicatee might be uncertain.

been the twentieth-generation descendant of Confucius and that he died during the Yongxing reign-period (153–155 CE), Ouyang concluded that the young man must have lived during the reign of Emperor Huan (147–168 CE). Zhao Mingcheng was similarly tentative in his identification.[10] Like Ouyang, he noted that the tabooed name (*hui*) of Kong Derang was missing.[11] Hong, however, appears to have been somewhat more sure of the identity of the dedicatee — or at least more creative than his predecessors in his efforts to identify who the person had been. In his entry to the *Explications of Clerical Script* (*Lishi*), Hong began by declaring it to be "the stone tablet of Kong Qian." He then proceeded to give his reasons for that identification: "The graph for his name cannot be discerned, but studying the Kong genealogy, I obtained it … The *Unofficial History of Kong Rong* (153–208) says that Kong Zhou (d. 164) [i.e., Kong Rong's father] had had seven sons. Kong Rong had been the sixth in the sequence, and among those recorded in the genealogy, there were only three: Qian, Bao (d. 168?), and Rong." Since Hong already knew of

another stele for Kong Bao and the details found in the inscription did not match Kong Rong's biography, Hong concluded that the stele in question must have belonged to Kong Qian.[12]

Not only could the identity of the stele dedicatee be uncertain, but the relationship between parts of stele (i.e., the rubbings made from a stele obverse and reverse) could also be shaky. As Wu Hung aptly points out, antiquarians rarely visited steles in situ.[13] Mostly, their knowledge of stone inscriptions came from rubbings found on the market. Sometimes, the rubbings made from the obverse and reverse of steles were obtained separately, leading some antiquarians to worry that rubbings presented as belonging to the same stele were actually procured from more than one stone. This possibility bothered Ouyang with respect to the reverse of a stele (*beiyin*) now identified as belonging to Yang Tong. Ouyang was certain that he had the obverse of the stele: "Generations of the Yangs were buried at Wenxiang. At the side of each tomb was a stele. What remains at present are four. For the *Jigu lu,* I have been able to obtain

[rubbings of] all of them, [including] the inscriptions of the Grand Commandant [Yang Zhen (d. 124 CE)], the chancellor of Pei [Yang Tong (d. 162 CE)], the magistrate of Fanyang [another Yang male whose name is unknown], and the magistrate of Gaoyang [Yang Zhu (116–168)]." The rubbing purporting to be the reverse, however, was a different matter. "With respect to this stele reverse," he wrote, "I do not know whose stele it belonged to." Ouyang did, however, hazard a guess: that is, the reverse belonged to the stele of Yang Tong.[14]

In contrast to Ouyang who was unsure about the identity of the dedicatee, Zhao Mingcheng claimed outright that the reverse belonged together with the obverse of the Yang Tong stele. Zhao's comments do, however, reveal that he was aware of Ouyang's views:

Master Ouyang had said that, for *Jigu lu*, they were able to obtain [the rubbings] of the four steles from the area of the Yang Zhen grave, including those for [Yang] Zhen, for the chancellor of Pei [i.e., Yang Tong], for the magistrate of Fanyang, and for the magistrate of Gaoyang [i.e., Yang Zhu]. He was also able to obtain [separately] [rubbings of] the stele reverses and headers. This being the case, what he was able to obtain at the time was in a mess, and he did not know whose stele reverse was whose. I have been able to obtain all [the Yang rubbings] that appear in the *Jigu lu*, and each of them has [text of the] reverse attached to the back [of the obverse].[15]

All doubts vanish in Hong Gua's presentation. Unlike Zhao, who at least felt compelled to explain why his distinguished predecessor stopped short of identifying the stele reverse, Hong's entry simply notes: "[On the right is the text of] the stele reverse of Yang Tong."[16]

In order to better understand the significance of the discrepancy between accounts of the dedicatee's identity, it is necessary to introduce the concept of the "factoid" as elaborated by archaeologist Norman Yoffee. In a recent book (2005), *Myths of the Archaic State: Evolution of the Earliest Cities, States, and Civilizations*, Yoffee explains a factoid thus: "A factoid is a speculation or guess that has been repeated so often it is eventually taken for hard fact. Factoids have a particularly insidious quality—and one that is spectacularly unbiological—in that they tend to get stronger the longer they live. Unlike "facts," factoids are difficult to evaluate because, although they often begin as well-intended hypotheses and tentative clarifications, they become received wisdom by dint of repetition by authorities."[17]

Yoffee's description of a factoid pertains to our discussion in several ways. We see that Ouyang made a reasonable hypothesis based on what he knew about the location of the Yang burials and the information presented on the Yang Zhen stele. Moreover, Ouyang was honest about what he knew and did not know (hence, his well-deserved reputation among Chinese scholars). And we see that factoids tend to get stronger the longer they live: Ouyang's doubts vanish from our consciousness as subsequent commentators gloss over or utterly ignore questionable points about the inscriptions; the identification of the stele and the reverse become accepted fact. For evidence of this, one scarcely needs to go beyond modern indices by Zhang Yansheng (1943–) or Yang Dianxun—or, to cite a still more flagrant example, the critical edition of Han stone inscriptions by Nagata Hidemasa.[18]

The power of the factoid is perhaps best illustrated by the later history of the Yang Zhu stele. Certain of the identity of the Yang steles, officials

in the Ming dynasty repaired the local cemetery in 1573 and outfitted the grave complex, comprising seven large, unmarked tombs, with a new memorial hall (*xiangtang*).[19] Another critical example of the power of the factoid can be seen in the role that the "Yang" steles have played in establishing new "facts," particularly in documenting important social changes. According to Candace Lewis, when archaeologists discovered what they took to be a lineage graveyard in 1963 near the Yang homeland, they also discovered two steles, including one from the Ming dynasty that documented repairs made to the complex. Relying upon the Ming steles, as well as Hong Gua's entries in *Lishi*, archaeologists such as Wang Zhongshu and Han Guohe identified the unmarked graves as belonging to seven male members of the Yang clan. The significance derived from this discovery should not be underestimated.[20] In the view of Wang Zhongshu and others, the rediscovery of the "Yang cemetery," a "representative example" of the Han practice of joint burial, attests to the rise of lineage consciousness in the Eastern Han period.[21]

Errors of Omission and Commission

Having discussed the problem of identifying steles, let us turn to another question: are stone inscriptions necessarily very different from or more reliable than texts written on wood, paper, or bamboo? As will be shown presently, the differences may be less than one might expect. Despite the "hard" nature of their medium, the contents of stone inscriptions were far from fixed or permanent. Prized for their calligraphy, Han inscriptions were often recopied. In the process of recopying, their contents were subject to changes of various kinds—including textual accretion, deletion of information, interpolation, and graphic changes.

In making a rubbing of the contents of a stele, new text could be incorporated in often very obvious ways. The stele dedicated to Xia Cheng (d. 170 CE) serves as a prime example of this phenomenon (fig. 4). Xia Cheng had presumably been the magistrate of Chunyu County (present-day Shandong). The 'presumably' is warranted, as questions about this stele's authenticity were raised by Zhao Han (act. 1573–1620) and Li Guangying (18th century).[22] Putting aside the question whether the inscription actually dates from the Han dynasty (as what concerns us is not its origin but its post-Song fate), let us look at the transcription provided by Hong Gua. As can be seen in figure 4, the transcription ends with a hymn. Sometime after Hong transcribed its contents during the Song dynasty, however, the text of the stele changed. According to Wu Yujin, 110 characters were inscribed on the reverse of what might have been a Ming copy of the original stele.[23] As a Qing-dynasty rubbing (ca. 1796–1821) reveals, this was not the only text

Fig. 4 *Rubbing of the Xia Cheng stele* (detail). From *Beijing tushuguan cang zhongguo lidai shike taben huibian* 1.138–39. Attribution of the inscription to Cai Yong is on the farthest line to the left.

added. Worth noting in the photograph are the two lines to the far left on the obverse, written in small characters in what is perhaps Song calligraphy: "Chunyu zhang Xia Cheng bei" ("Stele of the magistrate of Chunyu, Xia Cheng").[24] More surprising still is the additional text written farthest to the left: "Jianning sannian Cai Bojie shu" ("The third year of the Jianning reign-period [i.e., 171 CE] written by Cai Bojie [i.e., Cai Yong, 132/33–192 CE]").[25]

Besides such obviously later additions, Han stele inscriptions could be recut with less conspicuous interpolations or changes. The stele dedicated to Liu Min (erected ca. 170 CE, found in Zhongzhou or near present-day Chongqing, Sichuan) serves as a case in point. Changes in it were first identified by Qing antiquarian Wu Yujin in his *Record of Extant Bronzes and Stones* (*Jinshi cun*). After meticulously comparing the extant stele in Sichuan with the transcription found in Hong Gua's *Lishi*, Wu concluded that the inscription on the stele was not the original one, but a later recutting based on an earlier text (*jiuwen*). In support of this view Wu pointed to five discrepancies between the extant stele and the text in *Lishi*. In the *Lishi* an additional space was inserted or accidentally interpolated following the negation marker, *bu*.

The *Lishi* reads:
厲風子孫 固窮守陋 不[][][] 堂無文麗

The stone inscription that he saw,
Wu Yujin stated, read:
厲風子孫 固窮守陋 不[][] 堂無文麗

As Wu correctly reasoned, this was most likely an error on the part of the stone carver, as most of the inscription is made up of four-character lines. This is, however, not the only sign that someone,

post-Song, had recut the stone and in the process introduced errors. Wu also noted four textual variations, which are listed below in the order in which they appear in the inscription.

1. *Lishi* 因勤銘之
 Extant stele 因勤歎之

2. *Lishi* 天憒鯁[]
 Extant stele 天鐕鯁[]

3. *Lishi* 舊威外梱
 Extant stele 舊威外困

4. *Lishi* 嗚呼俒哉嗚呼俒哉
 Extant stele 嗚呼哀哉嗚呼哀哉

To be sure, Wu understood that the discrepancies between the Song transcription and the text on the extant stele could mean that Hong Gua's transcription was unfaithful, rather than that the stele had been incorrectly recut. In support of the latter interpretation, Wu reminded his readers that Hong had been fastidious about noting graphic variants or irregularities in inscriptions; hence, Hong was unlikely to have introduced changes in the process of transcription without mentioning that he had done so.[26]

In addition to graphic changes and interpolations, the process of recutting a stele could result in significant omissions. One sort of omission that has not failed to draw comment is the recutting of the obverse but not the reverse of the stele. Consider, for example, the stele dedicated to the recluse Lou Shou, who died circa 174 CE. According to the *Lishi*, the reverse of Lou's stele once contained the names of 58 donors: 30 minor officials and 28 "reclusive gentlemen" (*chushi*).[27] Sometime after Hong transcribed the contents of the stele, the original was lost. During the Ming dynasty, however, the inscription was recut (*chongke*) on a new stele, and rubbings were made from this.[28] Judging

from surviving rubbings and comments by Wu Yujin, the Ming recutting appears to have lacked an inscription on the reverse.[29] The fate of Lou's stele reverse was not an isolated phenomenon. As Nagata Hidemasa notes, the reverse of the Tang Gongfang stele also has not been seen since the Qing dynasty.[30] Similarly, a later recutting of the Yang Zhen inscription also failed to reproduce the donor list on the stele reverse, which had likewise been transcribed by Hong Gua.[31]

Is Seeing Believing? Or, How We May Not Be Able to Tell an (Altered) Copy from the Original

Given the vagaries of textual transmission, one might expect that the most prudent course of action would be to limit oneself to extant steles. Yet a surviving stele is only as reliable as the ways of determining whether it is the original or a copy. In some cases, it is reasonably clear whether a stele is original. Some steles (including the one dedicated to the aforementioned Xianyu Huang) have been scientifically excavated—this one from a site in Tianjin in 1973. Even more remarkable than the inscription's excellent condition and completeness is the fact that this stele was previously undocumented. Thus, unless one is inclined to assume that the stele is a forgery, it seems unlikely to have been reconstructed from earlier rubbings or prior records.[32] It is also true that the histories of some inscriptions are well documented through the textual record and through rubbings made at various times. For example, for the Xiyue Huashan stele (ca. 165 CE) there are several surviving rubbings of the original stele, as well as of various recut versions of the stone.[33] Thus, it can be proven that the extant Xiyue stele is not the original one.

Limited information about origins makes one difficulty in determining whether a stele is original or was recut following a transcription or rubbing. Indeed, only a relatively small number of extant steles are considered by scholars to be original. By my count, 57 out of the 277 surviving stele inscriptions conventionally dated to Eastern Han actually date from that period. Of these, only about 36, or thirteen percent, are of known origin, and still fewer (9) have been "scientifically excavated," that is, excavated after 1949.[34] The remaining steles appear suddenly in records of the Song dynasty—and many were never seen by the antiquarians who recorded their contents. Relatively few steles have histories that can be traced continuously through surviving records. Some steles have been lost and found not once, but several times. The Yin Zhou stele (177 CE) provides one such example; according to Nagata Hidemasa, this stele was discovered twice in Weichuan County (Henan), once in the fourteenth century and then during the Wanli reign-period (1573–1620).[35] Similarly, the Heng Fang stele (168 CE), first recorded in Ouyang's *Jigu lu*, then transcribed by Hong Gua, was rediscovered in 1799 in Wenshan County (Shandong).[36] Still other steles were lost to history for millennia before resurfacing. For example, the *Commentary on the Classic of Waterways* (*Shuijing zhu*, ca. 265–527 CE) records an inscription erected for Li Gu (d. 147 CE) in Nanzheng County (present-day Shaanxi).[37] No further record of the stele appears until the stone itself resurfaced in a museum in Shanyang, Shaanxi, at some unknown time.[38]

In fact, even for steles with known provenances, it is difficult to ascertain whether they are in fact original. Let us discuss at length an extant stone whose professed identity with an ancient stele is unclear and in dispute. The Yuan An stele is first mentioned in the *Commentary on the Classic of Waterways*. The stele then dropped out of the written record for centuries. Notably, it does not appear in the records of the great Song

antiquarians or, according to Yang Dianxun, in any catalogue from the Song to Qing dynasties. But sometime during the Ming dynasty the stele reemerged from an unknown location and was moved to Yanshi County (Henan) — long enough for an inscription to be engraved on its side.[39] As mysteriously as it had resurfaced, the stele then vanished. According to Gao Wen, in 1929 an elementary school student noticed a stele with writing in Yanshi, prompting a local person to make a rubbing.[40] The stele was subsequently lost once again, presumably while being moved in 1934, then rediscovered in 1961.[41] Given its history, questions about the authenticity of the stele linger and the opinions of experts diverge. Not unreasonably, Ma Heng (1880–1955) and Zhang Yansheng insist upon the authenticity of the stele, based on its similarity in content and style to the Yuan Chang stele (ca. 117 CE), which was discovered in the same place a few years before. But Ouyang Fu (act. 1923), author of *Collecting Antiquities for Seeking the Truth* (*Jigu qiuzhen*), has emphatically declared it to be a forgery.[42]

Toward a Solution

As argued above, inscriptions on purportedly "Han" steles should not be regarded as what some scholars would call "hard" sources. They are not free of the uncertainties that plague sources transmitted through the ages. On the contrary, as the work of eminent classical scholars, including Wu Yujin, Wang Zhuanghong, and Yuan Weichun, has clearly shown, Han stele inscriptions exhibit the same kinds of problems as other textual mediums, that is, problems of identification, interpolation, and authenticity.

This is not to say that the Han stele corpus should not be used. On the contrary, the Han stele corpus can provide rare and sustained glimpses of the values and perspectives of the local Eastern Han elite — when used with care. In addition, as will be shown presently, textual problems associated with Han steles are far from insoluble.

Allow me to suggest several ways to manage the risks of the stele corpus. Certainly, one way is to consult the extensive Chinese tradition of scholarship on Han steles. Whereas the study of stone inscriptions is relatively new to the world of North American and European sinology, Chinese scholars have long studied the genre as valuable objects of art as well as historical sources. Han steles have been closely scrutinized by men such as Wu Yujin, who were deeply familiar not only with the steles themselves, but also with the ways in which stones and rubbings evolved over time. Not only is it important to consult this scholarly tradition, it is also now relatively convenient to do so. The most important studies to 1957 have been compiled by Yang Dianxun in his index of stone inscriptions. Many of them, furthermore, have been digested and summarized by Wang Zhuanghong, Yuan Weichun, and Gao Wen. More significantly, studies incorporated as part of the *Complete Library of the Four Treasures* (*Siku quanshu*, comp. 1783) are now available through a searchable database. Most recently, studies that postdate the *Complete Library* have become available in a digital format, as a CD-ROM version of the *New Compilation of the Historical Material in Stone Inscriptions* (*Shike shiliao xinbian*) has been released.

Another way to manage risk is to compare the information found in the stele corpus with other texts, particularly with the standard histories. To be sure, there are inherent limitations to what we can know through collation. For one, this approach cannot definitively determine authenticity. This is because standard histories (including the *History of the Eastern Han,* or *Hou Hanshu*) are synthetic

texts by men who lived centuries after the Han. Nevertheless, by collating standard histories with steles — in other words, by seeing where these sources converge — we can arrive, not at incontrovertible facts, but at hypotheses with high degrees of probability.[43]

Allow me to provide a concrete example of how one would collate with soft sources by returning to a problem discussed by Michael Nylan. In her discussion of the Wu Ban stele she notes that half of the Han inscriptions found in the *Lishi* date from a single eighteen-year period: the Proscription, or Danggu (166–184 CE), a bloody factional conflict between the inner and outer court. This in itself would not be so remarkable, were it not that this was also the period that Ouyang Xiu identified as richest in forged steles.[44] Aside from forgery, there is another potential reason to suspect that the time distribution of steles found in the *Lishi* is distorted rather than representative. As two of my colleagues, David Rolston and David Porter, have suggested in conversation, one potential reason why so many of the inscriptions date to the period of the Proscription is that the Proscription had special significance for Song antiquarians. In this scenario antiquarians were more interested in preserving or transmitting inscriptions that date from the period of the Proscription than inscriptions from other periods during the Han dynasty.

Whereas both of these considerations suggest that it is not necessarily true that half of all Han steles dated from the Proscription, neither is it unquestionably false. It retains credibility because we know something about the ways in which some Song antiquarians collected steles. Both Ouyang Xiu and Hong Gua, our two most important sources, claimed that their collections of Han inscriptions were comprehensive. In the preface to the *Jigu lu*, Ouyang even claimed to have included all Han

inscriptions extant in his age. Hong noted that he had spent thirty years seeking out all extant inscriptions, including those not found in the *Jigu lu*.[45]

Another reason *not* to dismiss the view that the Proscription was the heyday of erecting steles is that noninscriptional sources, particularly, the *History of the Eastern Han*, corroborate the picture found in the Hong collection. Biographies in the *History* report the literary activities of a figure by listing not only titles of his works, but also the genres the individual composed. To take an example, we know that, besides composing inscriptions on steles, eulogist Cai Yong also wrote *fu* ("rhapsodies") and *zhen* ("admonitions"), as well as eulogies for mediums other than stone.[46] By searching through the *History of the Eastern Han*, it is possible to create a list not only of all known authors of stele inscriptions (*bei*), but also of all authors of related genres. Certainly one might object that the biographies may have been largely based on information found on steles. But there are reasons to believe that this was not necessarily the case. For one thing, Fan Ye (398–445 CE), author of the *History of the Eastern Han*, relied heavily on fourteen earlier dynastic histories, including a handful written during the Eastern Han, as well as on surviving steles and funerary inscriptions.[47] For another, it is unlikely that Fan relied upon steles for information about who wrote steles because extant inscriptions most often did not mention their author (or even tell us whether the dedicatee was in the habit of writing inscriptions him- or herself).[48]

Having mentioned some potential objections, let us now see what information can be culled from a list of Eastern Han eulogists. As I have shown elsewhere, about seventy percent (19 of 27) of all known authors of stone inscriptions (*bei*, or steles; *ming*, or markers) were active between 140 and 190 CE.[49] In addition, almost all of the known

authors (14 of 15) of stele inscriptions (*bei*) were active during the same fifty-year period. These facts suggest that, although members of the Han elite were clearly in the habit of writing eulogies of one kind or the other before the Proscription, the practice of carving them into stone does not appear to have been in vogue before the middle of the second century.

A third strategy for managing risk makes use of quantitative analysis, analysis that allows us to gauge the representativeness of individual stele collections by contextualizing them. In order to show how quantitative analysis could be fruitfully employed in examining our sources, let us return to the question whether the Proscription was the heyday of erecting steles. To begin, let us start with the collection Nylan mentioned—the *Lishi*. She notes that fifty-three percent of steles dedicated to Han individuals date from a single eighteen-year period (166–184 CE). This pattern is consistent with the Hong corpus as a whole (which also includes the *Supplement of Clerical Script*, or *Li xu*). If we include steles commemorating meritorious acts, special events, deities, and historical figures, as well as those dedicated to Han individuals, we have 135 (out of 173) stele inscriptions that can be dated. Of these, 75, or fifty-six percent, date from the period of the Proscription. If we plot out the distribution of these steles over time, we see, as figure 5 indicates, the following pattern: few inscriptions were carved onto steles before 150 CE. After 160 the number of inscriptions rises sharply, leveling off about 170, before falling circa the 180s and then precipitously after 190. It is worth mentioning that we find a consistent pattern with the 211 extant Eastern Han stele inscriptions having dates ("extant inscription" refers to cases where the text of the stele, rather than the stone itself, survives): 107, or fifty-one percent, date from the period of the Proscription.

Plotting the time distribution (see fig. 5), we see a similar pattern in the Hong collection: few steles before 150, a dramatic rise after 160, a modest increase during the 170s, a significant drop after the 180s, and a precipitous decline after 190.

I certainly do not want to lend the impression that by comparing the Hong collection with the body of extant inscriptions we can prove that the Proscription was the heyday of erecting steles. On the contrary, questions may be raised about the utility of comparing the Hong collection with the extant stele corpus. After all, the Hong collection comprises much of the current corpus that can be assigned dates: 137 of 211, or sixty-five percent. Thus, there is little wonder that the time distributions resemble each other. Equally problematic, there may be questions about the way that dates are usually assigned to Han steles. Scholars such as Nagata Hidemasa, Yang Dianxun, and Gao Wen have assigned dates to steles in two ways: first, according to the date on the stele itself, telling when it was erected. Second, where that date was not available, scholars have assigned a rough date according to the year in which the dedicatee died, the assumption being that the stele was erected within a couple years of the dedicatee's death. But some steles were erected several decades after the dedicatee's death: Yang Zhen (d. 124/erected ca. 168 CE), Xianyu Huang (d. 125/erected 165 CE), Yuan Liang (d. 132/erected ca. 170s), Zhang Heng (d. 139/erected ca. 177–178 CE).[50] Confounding confusion, for some dedicatees who had lived and died during the Eastern Han, the stele was erected after the end of the dynasty: Liu Biao (d. 208/erected 228 CE) and Fan Shi (2nd century CE?/erected 235 CE).[51] These cases prompt doubts as to whether the time distribution found in the Hong collection or in our extant corpus reflects Han practice, or rather a later craze

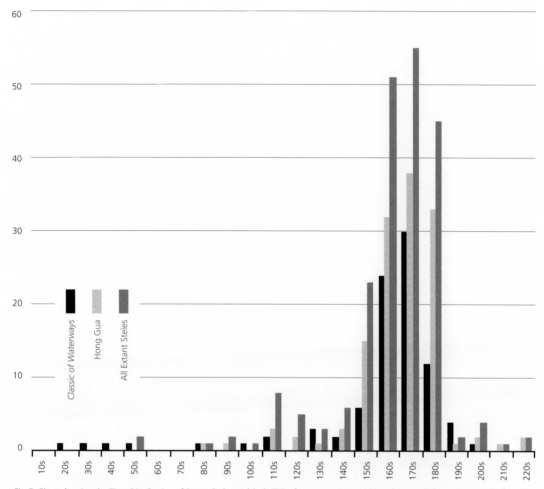

Fig. 5 Chart showing the Time Distribution of Extant Steles and Stele Titles from Hong Gua's *Lishi*; and Extant Steles and Stele Titles from the *Commentary on the Classic of Waterways*

for erecting inscriptions to Han individuals. In other words, the specter remains that we might confuse inscriptions erected during the Han with those erected much later for Han individuals.

An arguably better way to assess the representativeness of the Hong collection or the extant corpus is to compare them to the titles found in the *Commentary on the Classic of Waterways*, our earliest collection of inscriptional titles (composed ca. 265–527 CE).[52] One virtue of comparing the *Commentary* with the Hong and

extant stele collections is that there is only a small amount of overlap: *Commentary* titles make up at most twelve percent of all extant stele inscriptions. Before plunging into the details of what we find in the *Commentary*, a caveat is in order. The lack of overlap is in some sense advantageous, but it also means that relatively few texts of the 116 presumed Han stele titles in the *Commentary* are extant, somewhere between twenty-eight and twenty-nine percent.[53] This makes it difficult to assign precise dates to many steles. At best, the dates attached in

the *Commentary* to two-thirds of its titles represent the *earliest possible date* that a given stele could have been erected. Caveats aside, let us now look at the *Commentary*. Fifty-two percent of the titles can be roughly assigned dates that fall between 166 and 184. Turning to a graphic representation of the time distribution found in figure 5, we find a pattern similar to that found in the Hong and extant stele collections: few steles appear before the end of the first century, an increase around 150, a dramatic increase in the decade of the 160s, the same number or perhaps a few more in the 170s, a significant drop in the 180s, and a precipitous decline after 190.

To summarize the preceding discussion, I would tentatively conclude that the time distribution in the Hong collection is representative and that the period of the Proscription was indeed the heyday of erecting steles. I have two reasons for this conclusion: first, the *History of the Eastern Han* and other noninscriptional sources also suggest that the Proscription was the heyday of erecting steles; and second, the high degree of consistency between the *Commentary* and other stele collections.

Conclusion

Let us return to the question posed at the beginning of this essay, that is, whether Han steles (and other stone inscriptions) are reliable. The answer depends on what one means by reliable. If, by reliability, we mean sources that provide pristine or unmediated access to the past, then the stele corpus certainly falls short. As the foregoing discussion should make clear, Han steles are not very different from texts composed in other mediums. As with texts written on paper and bamboo, steles were often copied with graphic errors, interpolations, marginalia, and sometimes

significant omissions. Moreover, as with other kinds of texts, questions of identity inevitably arise (who wrote it? when was it written? for whom was it written?). Authenticity — is this the original artifact? — is also elusive, whether of a stone or of a rubbing produced from a stone. Yet my hunch is that the Han stele corpus is reliable, in the sense that, taken as a whole, it provides accurate, though perhaps not unmediated, information about the period in question. Of course, deciding that the Han stele corpus is reliable and using it merely shifts the burden of responsibility from the sources to the historian. Such a stance requires historians to acknowledge what one of our number has termed the "fragility of our grip on the classical world."[54]

Let us revisit the question whether textual uncertainties limit the subjects available to historians of early China. Do they get in the way of our efforts to address broader themes — or better still, to partake in broader conversations, conversations that ideally would include scholars working outside the early China field? It goes without saying that problems of textual transmission are of little interest to modern and Western historians (with the possible exception of classicists, who also find themselves confronting the mediated nature of their sources). But this is not to say that such problems were not of interest to many other people. Indeed, textual problems have preoccupied the best classical minds, including the often anonymous scholars who edited, copied, altered, and creatively reconstructed texts, as well as men such as Ouyang Xiu and Wu Yujin, who scrutinized these texts for signs of tampering. To be sure, classical minds did not merely concern themselves with the authenticity or spuriousness of particular texts. Such questions prompted them to think more broadly about the nature of their own analytic categories, to contemplate the ways in which

changes in medium or technology filtered their access to the textual record, to devise ingenuous ways of investigating and deducing distant events, and to ponder how they might best perform an empathetic reconstruction of the past. To study the Han with an awareness of how its sources have been mediated and filtered is thus *not* to constrain oneself to subjects of limited interest. On the contrary, this mode of inquiry requires scholars to broaden their field of vision to consider the opinions and interpretative maneuvers of the long-dead scholars responsible for transmitting our sources. It requires, finally, a willingness to engage in dialogue with and to treat as equal partners the Chinese scholars who have shared our preoccupation with the Han past. ⊙

Notes

The author would like to thank Rafe de Crespigny, Kevin Carr, Lai Guolong, Michael Nylan, Nick Tackett, Naomi Richard, David Rolston, and Yang Suh-jen for their comments and suggestions on this paper.

1 Zhu Jianxin, *Jinshi xue* (Hong Kong: Shangwu yinshuguan, 1964), pp. 4–5. For a seminal article on stone inscriptions, see Patricia Ebrey, "Later Han Stone Inscriptions," *Harvard Journal of Asiatic Studies* 40.2 (1980): 325–353.

2 Wu Yujin, *Jinshi cun*, ed. *Congshu jicheng* (Shanghai: Shangwu yinshuguan, 1937), vol. 1534–1537: 7.278.

3 Zhao Mingcheng, *Jinshi lu* (Beijing: Zhonghua shuju, 1983), *xu*, 1/2.

4 Cited in Michael Nylan, "Addicted to Antiquity (*nigu*): A Brief History of the Wu Family Shrines, 150–1961 CE," in *Recarving China's Past: Art, Archaeology, and Architecture of the "Wu Family Shrines*," Cary Y. Liu, Michael Nylan, Anthony Barbieri-Low et al. (Princeton: Princeton University Art Museum; New Haven and London: Yale University Press, 2005), n. 12, pp. 542–53.

5 Cary Y. Liu, "The 'Wu Family Shrines' as a Recarving of the Past," in *Recarving the Past*, pp. 36–38; Nylan, "Addicted to Antiquity," pp. 515–18; 521–23.

6 Ouyang Xiu, *Ouyang Xiu quanji* (Beijing: Zhonghua shuju, 2001), v. 5/136.2122.

7 Zhao Mingcheng, *Jinshi lu* 16.6b. Hong Gua appears to have been confident in his identification of the stele; see *Lishi*, edition *Sibu congkan sanbian*, vol. 30: 8.14b.

8 Wu Hung, "On Rubbings: Their Materiality and Historicity," in *Writing and Materiality in China: Essays in Honor of Patrick Hanan*, ed. Judith T. Zeitlin and Lydia H. Liu (Cambridge, Mass.: Harvard University Asia Center, 2003), p. 37.

9 Wu, "On Rubbings," pp. 41–45. This phenomenon has also been pointed out by a number of Chinese scholars. For instance, see Wu Yujin, *Jinshi cun* 7.276–79; 8.310–11; Zhao Jun (1591–1640), *Hanshantang jinshilin shidi kao*, edition *Congshu jicheng chubian*, vol. 1608: 1.6–7; Wang Sili and Lai Fei, "Shandong Liang Han beike zhenwei kao sanli," in *Han bei yanjiu*, ed. Zhongguo shufajia xiehui Shandong fenhui (Jinan: Qi-Lu shushe, 1990), pp. 332–39; Wang Zhuanghong, *Beitie jianbie changshi* (Shanghai: Shanghai shuhua, 1985), pp. 17–20, 54; Yuan Weichun, *Qin Han beishu* (Beijing: Beijing gongyi meishu, 1990), pp. 342–43, 351.

10 Ouyang Xiu, *Ouyang Xiu quanji* 5/135.2108.

11 Zhao Mingcheng, *Jinshi lu* 15.3a.

12 Hong Gua, *Lishi* 6.16b.

13 Wu Hung, "On Rubbings," p. 37.

14 Ouyang Xiu, *Ouyang Xiu quanji* 5/136.2127.

15 Zhao Mingcheng, *Jinshi lu* 18.9b.

16 Hong Gua, *Lishi* 7.18a.

17 Norman Yoffee, *Myths of the Archaic State: Evolution of the Earliest Cities, States, and Civilizations* (Cambridge: Cambridge University Press, 2005), pp. 7–8.

18 Zhang Yansheng, *Shanben beitielu* (Beijing: Zhonghua, 1984), p. 38; Yang Dianxun, *Shike tiba suoyin* (Shanghai: Shanghai shangwu, 1957), p. 9; Nagata Hidemasa, *Kandai*

sekkoku shūsei (Kyoto: Dōhōsha, 1994) 2.172.

19 Candace Jenks Lewis, "Pottery Towers of Han Dynasty China" (PhD diss., New York University, 1999), pp. 236–37.

20 Han Guohe, "Lun Qin Han Wei Jin shiqi de jiazu mudi zhidu," *Kaogu yu wenwu* 1999.2, p. 61.

21 Wang Zhongshu, "Han Tongting Hongnong Yangshi zhongying kaolüe," *Kaogu* 1963.1, pp. 58–64, 74.

22 *Jinshi wenkaolüe*, edition *Siku quanshu zhenben wuji* (Taipei: Taiwan Shangwu yinshuguan, 1974), vols. 113–15: 2.15a; *Shimo juanhua*, edition *Congshu jicheng*, vol. 1607: 1.6.

23 Wu Yujin, *Jinshi cun* 8/285–86.

24 I am grateful to Lu Huiwen for suggesting that the calligraphy attributing the inscription to Cai Yong dates probably from the Song.

25 Yuan Weichun, *Qin Han beishu*, p. 344.

26 Wu Yujin, *Jinshi cun* 7/275–79.

27 Hong Gua, *Lishi* 9.10b–12a

28 Zhang Yansheng, *Shanben beitielu*, p. 37. This observation squares with Wu Yujin's comment (*Jinshi cun* 8/310) that the stone stele had not been seen for more than six hundred years when he wrote his notes.

29 Wu Yujin, *Jinshi cun* 8/309–11.

30 Nagata Hidemasa, *Kandai sekkoku shūsei* 1.277. Nagata assumes that this is the original stone, yet the disappearance of the stele reverse suggests the contrary.

31 Nagata Hidemasa, *Kandai sekkoku shūsei* 1.157.

32 Gao Wen, *Han bei jishi* (Kaifeng: Henan daxue, 1993), p. 284. For a scientifically excavated stele that may be a forgery, see Wang Jiakui, "Han

Fei Zhi bei kaoyi," *Zongjiaoxue yanjiu* 2001.2, pp. 47–51. In support of his view that the stele is a forgery, Wang notes three characteristics. The first is the irregularities in the content of the inscription. The second is the unusual positioning of the stele, which was found inside rather than outside of the tomb. Third, the stele was found in good condition in a tomb that had been robbed. This is suspect largely because grave robbers would have been likely to steal the inscription, which was relatively small and easy to transport.

33 As Wu Hung shows ("On Rubbings," pp. 41–45), a number of rubbings were made of the stele before it was destroyed by an earthquake in 1555. In 1802 Ruan Yuan (1764–1849) erected a new stele, based on a mid-Ming rubbing of the original stele, a rubbing that captured the damage to the stele. Some time later another version of the same stele was erected on the initiative of Ruan Yuan's students, Lu Kun and Qian Baofu, but unlike Ruan Yuan's version, this version reconstructed the stele to its original second-century form, omitting signs of later damage.

34 To date, I have collected and catalogued the contents of some 469 inscriptions or fragments with the assistance of Zhang Zhongwei and Zhang Tianhong (Tsinghua University). This catalogue has been incorporated as part of a database of Han officials that I have created in collaboration with Yu Xie and James Lee (available on the research pages of www.yuxie.com).

For "scientifically excavated" steles, see Nagata Hidemasa, *Kandai sekkoku shūsei*, "Wang Xiaoyuan

bei," 2.70; "Zhang Jing bei," 2.136; "Bo Xingqi mubei," 2.212; "Wang Sheren canbei," 2.234; "Caoshi mucanbei," 2.306; "Bushu canbei," 2.286. In addition to these, three more steles have been excavated since the publication of *Kandai sekkoku shūsei*. They can be found in (1) Henan sheng Yanshixian wenwu guanli weiyuanhui, "Yanshixian Nancaizhuangxiang Han Fei Zhi mu fajue jianbao," *Wenwu* 1992.9, pp. 37–45; (2) Li Chusen, Zhang Xiaoguang, Sun Jianhua, "Shandong faxian Dong Han mu zhi yi fang," *Wenwu* 1998.6, pp. 73–89; (3) Zhao Yi stele (ca. 208 CE), recorded in Sichuan sheng Wenwu kaogu yanjiusuo deng, *Ya'an xin chutu Hanbei erzhong* (Chengdu: Bashu chubanshe, 2005). For help tracking down these last two references, I am indebted to Zhang Zhongwei, a doctoral student in history at People's University, Beijing. For questions about the Fei Zhi inscription, see n. 32 above.

35 Nagata Hidemasa, *Kandai sekkoku shūsei*, 1.221.

36 Gao Wen, *Han bei jishi*, p. 307.

37 Shi Zhecun, *Shuijing zhu beilu* (Tianjin: Tianjin guji, 1987), 7.298. The *Shuijing zhu* comprises two parts, an earlier geographical work called the *Shuijing* or *Book of Waterways*, which was written by an unknown author circa 265 CE; the later part is Li Daoyuan's commentary, which probably dates no later than 527 CE.

38 Beijing tushuguan jinshizu, ed., *Beijing tushuguan cang Zhongguo lidai shike taben huibian* (Zhengzhou: Zhonghua shuju, 1989), vol. 1, p. 100. Five of the stones regarded as being authentically Han appear

in the *Shuijing zhu* — that is, those belonging to Yuan An, Yang Shugong (171 CE), Lu Jun (173), Tang Gong-fang, and Li Gu. Besides the Li Gu inscription, the history of the Yuan An and Yang Shugong steles are unaccounted for.

39 See Yang Dianxun, *Shike tiba*, p. 2.

40 Gao Wen, *Hanbei jishi*, p. 25. Unlike the Yuan An inscription, Yuan Chang's stele (see below) is not attested in the *Shuijing zhu* or any earlier catalogue. Nonetheless, the inscription bears a striking resemblance to the Yuan An inscription: both appear, as Gao Wen remarks, to have been written in the same hand, and both are written not in clerical but in seal script.

41 Beijing tushuguan jinshizu, ed., *Beijing tushuguan cang Zhongguo lidai shike tuoben huibian*, vol. 1, p. 30.

42 Yuan Weichun, *Qin Hanbei shu*, p. 90.

43 For a similar conclusion about sources from Europe's early modern period, see David Goodman, "Intellectual Life under the Spanish Inquisition: A Continuing Historical Controversy," *History*, vol. 90 (2005), pp. 353–58, esp. p. 386.

44 Nylan, "Addicted to Antiquity," p. 519; cf. *Ouyang Xiu quanji* 5/134.2079.

45 *Ouyang Xiu quanji* 5/134.2061–62; *Lishi*, *xu*, 1a–1b.

46 Fan Ye, *Hou Hanshu*, 12 vols. (Beijing: Zhonghua shuju, 1984), 60B.2007.

47 For more information about the relationship between the *Hou Hanshu* and the stele corpus, see Brown, *Politics of Mourning in Early China* (Albany: State University of New York Press, 2007), esp. chap. 2.

48 For inscriptions written for women, see Brown, "Sons and Mothers in Warring States and Han China, 453 BCE–220 CE," *Nan nü: Men, Women, and Gender in Early Imperial China*, vol. 5.2 (2003): 137–69, 154–59; *Politics of Mourning*, chap. 3. To the best of my knowledge, only three extant inscriptions mention their authors. One such inscription is dedicated to the hermit Hun Dian; see Cai Yong, *Cai Zhonglang ji*, edition *Sibu beiyao*, pt. 203, 6 vols, 2.17b. The other two are dedicated to Bi Feng, which mention the author; see Hong Gua, *Lishi*, "Tangyi ling Bi Feng bei," 9.18a, and "Bi Feng bie bei," 9.20b. For the last two references, I am grateful to Yang Suh-jen (University of Washington).

49 Brown, *Politics of Mourning*, pp. 248–49.

50 For Yang Zhen, see *Lishi* 12.2b–3a; for Xianyu Huang, see Nagata Hidemasa, *Kandai sekkoku shūsei* 2.156 and *Han bei jishi*, p. 284; for Yuan Liang, see *Lishi* 6.7b; for Zhang Pingzi, see *Lishi* 19.21b.

51 For Liu Biao, see *Cai Zhonglang ji* 3.17b–18a. Fan Shi was an Eastern Han figure; see *Hou Hanshu*, 81.2676–77; cf. Wang Wentai (1796–1844), *Qijia Hou Hanshu*

(1882, reprint, Taipei: Wenhai chuban-she, 1972); *Xie Cheng Hou Hanshu* 5.12a/159. For the dates of the steles, see Hong Gua, *Lishi* 19.16b–18b.

52 As Hu Shi [Hu Shih] (1891–1962) noted, the text of the *Shuijing zhu* is not without its problems, two of which were identified by *kaozheng* scholars: the current version of the text lacks five chapters and it was transmitted for millennia with Li's commentary intermingled with the original *Shuijing* — a situation only identified and partially remedied by the *kaozheng* scholars. For further details, see Hu Shi, "A Note on Ch'üan Tsu-Wang, Chao I-Ch'ing and Tai Chen: A Study of Independent Convergence in Research as Illustrated in their Works on the *Shui-ching chu*," in Arthur Hummel, *Eminent Chinese of the Ch'ing Period* (Washington: U.S. Govt. Printing Office, 1943–44), p. 970.

53 That is, 32–34 out of 116 Han steles. (For a catalogue of Han titles in the *Shuijing zhu* that I have compiled, see the research pages of www.yuxie .com.) The higher figure comes about if one identifies the Zhou Bao stele with the *Lishi*'s Zhou Fu stele and if one counts as extant the Yuan An and Li Gu steles, whose authenticity was discussed above. The possibility that the Zhou Fu stele might be the same as the Zhou Bao stele was pointed out to me by Rafe de Crespigny (private correspondence, 18 May 2005).

54 Nylan, "Addicted to Antiquity," p. 519.

Constructing *Citang* in Han

MICHAEL NYLAN

Good historians never try to prove a ubiquity or an absence, lest they commit grave errors in framing their hypotheses.[1] Unquestionably, *citang* ("worship halls") were erected in Han for members of the nobility, a class restricted, at that time, to the two highest ranks of the twenty or twenty-one rank system of orders of honor, below which were commoners.[2] Unquestionably too, the system of ancestral temples had classical precedents in the *Rites* canons, at least at the imperial level, which may be yet confirmed by archaeology.[3] This essay affirms the abundant evidence for the existence of a range of worship sites, structures, and steles erected to commemorate extraordinary individuals by members of communities defined by locale, occupation, rank, or patronage networks, as well as the cult sites routinely constructed for members of the nobility. It does note a surprising lack of unambiguous literary and archaeological evidence for the routine erection of aboveground, non-noble worship halls dedicated to the cult of the collective patriline in Han by the wealthy. In arguing that uncritical and anachronistic uses of texts and termi-nology have impeded our understanding of many religious beliefs and institutions of distant eras, this essay follows the main thread of path-breaking research by three Chinese scholars working in Taiwan and the People's Republic—Feng Erkang, Li Qing, and Zhao Pei—whose works track major changes in the practice of ancestor worship through history, while applying Bourdieu's insight that traditions are very hard to maintain in unchanging forms.[4]

Art historians, historians, and archaeologists today, when writing about the classical era, here defined as the late 4th century BCE through the early 4th century CE, presume that large, perma-nent stone *citang* were routinely commissioned for collective ancestor worship by "wealthy" but

non-noble families who patronized famous local artists.[5] For example, a recent catalogue devoted to Han artifacts states,

The tombs *of the wealthy* in the Han dynasty were lavish. *Typically* [both italics mine], they consisted of two parts: an earthen mound with a tomb chamber under it, in which the coffin and the tomb gifts were kept, and a shrine [*citang*] aboveground in the front of the mound, where the relatives of the deceased came to make offerings at regular times.[6]

Embedded in such seemingly straightforward assertions, which have become standard in the field, are at least ten interlocking assumptions relating to memorial structures and practices: that (1) mourning practices throughout the four centuries of the Han dynasty did not change, despite dramatic changes in tomb architecture over four hundred years and three dynasties (Western Han; Xin; and Eastern Han); and (2) large, aboveground, permanent *citang* were regularly, even typically, built (3) by the family for (4) worship of the patriline, (5) soon after the death of one or more of its male members, (6) at the grave mound, the principal locus of sacrifices offered (ideally, in perpetuity) to the family dead, since (7) the patriline in Han was the sole or principal object of worship. (8) The grave site *citang* was the chief memorial structure used by lineage members to construct social memory and so bring honor to the family line. (9) Thus, it was normal for non-noble families, especially the merely wealthy, to ignore Han sumptuary regulations whenever they chose, because (10) worship halls, as a form of extravagant display akin to lavish funeral processions, brought the family line so much prestige as to outweigh the risks of criminal action. A single prevailing theory, in an apparent twist of Occam's Razor, assumes as

settled the relative location, size, permanence, and function of the *citang*, as well as the customary recipients and offerers of cult.[7]

For traditions to be upheld, let alone expanded into new populations, complex phenomena must be handed down in exceedingly complex ways, requiring time and effort; thus change and discontinuity is usually more the norm in history than the uninterrupted transmission of cultural forms.[8] Nonetheless, scholars who see "China as the oldest continuous culture" believe that in Han "there were a lot of *citang*," in the sense of "architectural forms where offerings were made."[9] What physical realities are we talking about, however? Of what size, material, and location? Sufficient evidence now exists to query the wisdom of extrapolating, from the realities of late imperial China, a Han landscape featuring the near-ubiquity of permanent, aboveground worship halls dedicated to non-noble patrilines.

In the Song period, historians noted that during the Han, family sacrifices for hereditary ministers (i.e., those of noble rank) were often but not invariably placed at the grave site (see below). Though non-noble family members may also have offered sacrifices to their dead at the grave, the distinct possibility exists that the primary site for the construction of long-term lineage memory for the non-noble ancestral dead in non-noble families lay elsewhere, and that the typical form of commemoration accorded the non-noble dead was not aboveground grave-site *citang*. Many steles and worship halls were erected to individuals, male and female—not to families, let alone to patrilines—by those outside the family: by bureaucratic peers, by subordinates, and by local communities to admired administrators.[10] The preponderance of the extant literary evidence at this time suggests not only that aboveground,

permanent stone *citang* were not routinely built
to worship males in non-noble patrilines, but also
that such worship halls were constructed to honor
specific individuals outside the ranks of the nobility,
generally those who had attained high office
or made extraordinary contributions to the local
community, rather than the *collective ancestral*
dead. If the primary reason in Han to erect worship
halls or complexes was *not* the desire to celebrate
non-noble patrilines, then the few non-noble
citang mentioned in the extant Han records cannot
be construed as precise equivalents of the great
lineage *citang* structures known from late imperial
China.[11]

This essay has three main sections: (1) an
analysis of the vocabulary used in discussions of
citang, (2) an analysis of the received literature
pertaining to *citang*, including passages not often
cited in the secondary literature that serve to
illustrate the types of people for whom *citang*
were built; and (3) an analysis of the archaeological
evidence to date, which shows that the words
citang and *shitang* did not invariably refer to an
aboveground, permanent structure. The Siku
editors chided Hong Gua for his tentative reassign-
ment of the pictorial rubbings from a Wu Family
"Stone Chamber" (*shishi*) to a Wu Liang *citang*,[12]
but what spurred such criticism? What lies in a
name? The belief that the Wuzhai Shan stones
together represent a single and unique example of
large, freestanding stone *citang* dedicated at grave
site to ancestor worship of the male patriline by the
relatively low-ranking members of the Wu family[13]
has relied on a concomitant belief in the continuous
and consistent use of certain terminology over
millennia, regardless of changing historical contexts.
As demonstrated below, the word *citang* (usually,
"shrine" but here, "worship hall") rarely appears in
the received Han and post-Han literature, making

scrupulous interpretation of the term exceedingly
difficult. The archaeological record offers little help
in the form of unambiguous material evidence,
though it suggests an intriguing alternative to the
standard view: to wit, that the tomb itself may have
been considered the primary *citang* for non-noble
commoners.[14]

It is hardly likely that indisputable evidence
of aboveground worship halls would have survived
into the present day, even in the most remote
areas of the old Han empire, though several tens
of thousands of Han graves have been excavated.[15]
Wars and erosion, not to mention the intentional
destruction of memorial sites to clear a space
for later structures or to obliterate all traces of
an enemy—these in combination demolished
all but a few remnants of structures dating from
previous dynasties.[16] Aside from several sets of
stones associated with Huang Yi and his circle in
the late eighteenth century, no part of the present
material record definitively confirms or refutes the
existence of aboveground *citang* routinely erected
by non-noble patrilines for their collective males.
Every historian recognizes the weakness of the
argumentum ex silencio, however, and the paucity
of physical evidence for such a supposedly wide-
spread phenomenon is now routinely explained by
theories alleging that most worship halls in Han
were built of perishable wood, rather than of more
permanent stone.[17] In consequence, archaeological
interpretations to date have relied mainly upon
literary evidence.

The topic of *citang* is worth pursuing—and
not only because the earliest references to the
Wu family pictorial images describe it as a "stone
chamber" (*shishi*) either "within the grave mound"
(*mu zhong*) or "before the grave mound" (*mu qian*;
zhong qian).[18] More importantly, the topic neces-
sitates a thorough reexamination of the host of

assumptions that we tend to bring to the study of religious practices in early China. Before proceeding further, however, the usual caveats must be duly registered: enormous gaps and not a few ambiguities mark the extant literary and archaeological records, so we cannot know how faithfully these represent the full range of Han realities. We must therefore patiently compile more evidence before proceeding to make generalizations. At the same time, the subjects of death and burial are so vast and overwhelming that the experiential worlds evoked by Han writers tend to commingle instinctive ideas, community religious beliefs, and poetic fictions. Pious citations of the ritual canons complicate matters more, for ritual canons "banish from consideration" the ad hoc character of decisions undertaken in matters of life and death. Simply put, prescriptions differ from descriptions.[19]

Basic Vocabulary

To begin, a review of the basic meanings of the terms *ci* and *citang* is in order. The word *ci* means to offer cult to a deity, thing, person, or groups, in order to repay an obligation and in the pious hope of securing an extension of blessings, material or spiritual.[20] In modern Chinese the binome *citang* is often applied to quite different structures: (1) specially fine *citang*, presumably made of stone, which were erected (*qi*) in the Han and later periods, as one of the marks of extraordinary imperial favor granted select members of the nobility who were deemed "famous ministers or subjects" (*mingchen*) after death;[21] (2) cults "established"—the verb is often *li* or *jian*—by "officers and the people" to honor especially meritorious local officials, typically regional inspectors, provincial governors, or county prefects, believed to have rendered exceptional service to the community in the form of such activities as pacifying enemies;

insuring the safety of the local population in times of unrest; supervising major irrigation, canal, and dike projects, and founding local academies;[22] (3) *citang* set up *outside* the family residence—at grave sites or in cities—by pious descendants wishing to demonstrate particular devotion to a particular ancestor; (4) *citang* situated *inside* the family residence for the purposes of reverently communing with the entire ancestral line via commemorative images or wooden tablets,[23] as promoted by Zhu Xi (1130–1200) in his *Jia li* (*Family rites*);[24] and (5) freestanding lineage halls erected from Song on, but especially during Ming and Qing (first mostly in the south and later in the north), by large clans of up to a thousand people to enhance their standing in their localities.[25] The foregoing examples may not exhaust the entire range of types of memorial sites known to modern Chinese-speakers as *citang*, but they suffice to make clear the variety of structures encompassed by the single term. Structures of types 4 and 5, in contrast to types 1 and 2, were erected to the corporate patriline, not to specific individuals, regardless of location (and neither, as it happens, at the grave site). Originally, structures of type 4 were reserved for *shi* families, whose birth and education qualified them for government office, but during late imperial China even peasants with no pretensions to office-holding were building large lineage halls. A detailed understanding of the type 3 structure is well worth achieving, but none of the types 1 through 3 was erected at the grave in honor of the non-noble collective dead of the patriline. The mental conflation of these five types of structures makes it harder to assess the significance not only of the Wuzhai Shan materials, but also of the entire literature on ancestor worship in early China.

It should be noted at the outset that, whereas the term *ci* is exceedingly common in Han texts,

the term *citang* — quite surprisingly — is not. The binome does not occur, for example, in any of the three ritual texts, the *Yili* (*Ceremonials*), the *Liji* (*Rites records*), or the *Zhouli* (*Rites of Zhou*). As readers will recall, the term used in the "Three Rites" canons for the graded ritual sacrifices reserved for the noble and *shi* (lower-ranking descendants of noble clans in service) families is *miao* ("temple"), as it is in Cai Yong's (133–192) authoritative *Du duan* (*Singular judgments*).[26] The *Simin yueling* (*Monthly ordinances of the four classes*), the famous second-century manual on estate management, does not use either *citang* or *miao* when outlining the yearly calendar's four or five lineage sacrifices (presumably offered within the household) and separate grave-site offerings. One Eastern Han text, in reconstructing the past, distinguishes the "temples" (*miao*) erected for members of the Chu royal family from the *citang* awarded deceased members of the hereditary ministerial families (i.e., those of noble rank), but it is unclear whether this distinction reflects a real distinction in practice that prevailed in all times and places during the Han.[27]

On the term *citang*, the early gazetteers and stele compendia offer mainly silence. The binome *citang* is not to be found in the first extant local gazetteer, Chang Qu's (act. 265–316) *Huayang guozhi* (*Record of the Huayang Mountains*).[28] It appears only a few times in the later and far more famous gazetteer, the *Shuijing zhu* (*Commentary on the Classic of Waterways*) (524?) by Li Daoyuan (d. 527 CE), the most systematic pre-Tang account of memorial structures.[29] Aside from multiple entries devoted to the "Wu Liang pictorial figures" in *Lishi* (*Explications on clerical script*), that Southern Song compendium of memorial sites includes a total of two other mentions of *citang*: the first in an entry on the Eastern Han cavalry general Feng Gun, a man of noble rank, who, in the manner of Zhang Pu (see below), forbade his survivors to build a *citang* for him, and the second in an entry dedicated to Li Gang, an influential local officer.[30] (Later men raised a stele — not a *citang* — in Feng Gun's honor.)

Reasons can always be adduced for the paucity of references in the records we have. Extant writings constitute but the merest fraction of the written texts produced in those centuries, and the surviving writings are drawn almost always from the works of a very small elite either working at or preoccupied with the court. Still, it seems safe to hazard the statement that the term *miao* was mostly preferred to *citang*. It seems unlikely, too, that the term *citang* during Han denoted the entire range of cult sites and memorial structures listed above, since the privilege of building ancestral cult sites was extended to new population groups over the course of centuries in late imperial China.

Even in Tang times, a *zong* temple — a separate building where the collective spirits of the ancestors were worshipped — was the "exclusive prerogative of the imperial official"; high officials could erect "family temples" or "private temples," but their descendants could worship in them only so long as they continued themselves to hold comparably high office, and ancestors many generations back could not be worshiped in them at all.[31] A lively debate persisted in Northern Song about the propriety of worship halls dedicated to the family dead, a debate that was part and parcel of larger debates about ritual, which eventually prompted the compilation of ritual manuals by a number of Song authorities, including Sima Guang (1019–1086) and the Cheng brothers. Song edicts — chiefly those of 1041 and 1050–1051 — spoke about extending the right to build family temples (*jiamiao*) to the "great officers"

(*da chen*), but in wording sufficiently vague that most of the families who stood potentially to benefit from such spectacular displays of piety and status hesitated to proceed with construction.[32] Only in 1056 did Wen Yanbo take the step of constructing a family temple, after carefully justifying his decision by impeccable Tang precedents.[33] Would high-ranking officers in mid-Song have hesitated to build *jiamiao* to ancestors in the patriline if *citang*—as synonym for *jiamiao*—had been routinely built for centuries to honor the patriline, not only by the highest-ranking officers of the court, but also by the merely wealthy? Not likely. One suspects that Zhu Xi, by slightly later terming the in-house location for ancestor worship *citang*, gave the word so much greater currency among elites of late imperial times that the term *citang*, conflated with *jiamiao*, became an umbrella term for many types of memorial structures, permanent and temporary, including those erected at academies to honor teachers and other worthies.[34] In Yuan, Ming, and Qing many commoner families with no pretensions to rank dedicated temples (called *jiamiao* or *citang*) for worship of their forebears in the patriline. But that hardly should preclude the query, Is it anachronistic to extend this custom back to Han times?

To cite but one example germane to the problem of semantic extension: during Han the archetypal *miao* ("temple") indicated the cult sites of the emperor, of members of the imperial Liu clan, and of the highest deities worshiped by the Liu.[35] Those of noble rank, by analogy to and extension from the imperial model, were permitted to set up *miao*, but the number (and presumably the size and decoration, as well) was correlated with rank. The lower the rank, the fewer temples allowed. As citations from the *Liji* demonstrate (see below), in theory at least, office-holders of relatively low rank,

"along with the commoners," had no *miao*; they were [only] to offer seasonal sacrifices at the grave site, at the *qin* ("retiring chambers" or "resting place"). (We know that special chambers within the precincts of the imperial mausolea were designated as *qin*, but precisely what a *qin* was in commoners' cemeteries is far from certain, though it may have been part or all of the tomb itself.)[36]

Of course, one can easily imagine infractions of the sumptuary regulations. But there can be no doubt that sumptuary rules existed in Han,[37] even if scholars are not of one mind on how far sumptuary regulations prevailed at that time.[38] One would expect obedience in rough proportion to the strength of the enforcer and the proximity to the local seats of government. Rencheng and environs in late Eastern Han were under the direct jurisdiction of princes of the Liu clan.[39] Wherever the local Han representatives had the power to enforce the sumptuary regulations, conscientious officers would have done so, for the Han ruling family took seriously the vision of Xunzi (d. ca. 238 BCE) and his followers, who advocated strict enforcement of sumptuary regulations as the single most important prop for just and stable rule. In preserving the prerogatives of those expressly favored by the ruling house, sumptuary regulations had the capacity to distinguish for celebrity and emulation the conduct of a select few deemed to be true moral exemplars.[40]

The gulf between noble and non-noble was very wide; for most it would have been unbridgeable. Members of the Han bureaucracy, judging from an excavated Han strip, were divided into two distinct categories: men-in-service below the rank of 600 bushels, and the "court dignitaries" at the rank of 600 bushels and above, who are known as *daifu* ("counselors in service").[41] Those illustrious persons who commanded an annual

salary of 2,000 bushels or more, all or nearly all of whom were automatically awarded noble rank, represented the top two percent of the imperial bureaucracy. Historians will recall that, in theory at least, rank eight in the hierarchy of twenty or twenty-one Han orders of honor marked an absolute bar above which Han subjects could not rise without extraordinary commendations from the throne in return for specified acts of service. The distinction not only motivated the powerful families outside the capital to forge close personal ties with nobles whenever possible; it also led the Eastern Han court—not to mention later historians—to measure the health of the dynasty by the degree to which it managed to control such alliances.[42]

Let us turn now to consider two entries in Cai Yong's collected eulogies that reveal a bit more than most Han texts about the reasons for erecting *citang*: The first recounts the tale of one Zhang Xuan, from Yanshi City in Henan. One among his forebears had, as chancellor under Western Han, received noble rank. Much later, when Xuan's grandson, Fan, rose to be commandery governor, a position of considerable power and influence, "he searched for the origin of his great good fortune." Ascribing it to the merit accumulated by his grandfather, he built a *citang* to express his gratitude to him, and, presumably, his hope that his illustrious forefather would continue to shower down blessings on the family from on high. The second entry tells of a *citang* erected for another governor, one Zhu Mu, who after dying in the capital was buried north of Wan City. Mu in his final instructions had urged his son Ye not to follow the usual custom of building a high mound over his burial place. Ye dutifully complied, but then built a *citang* in Wan to house cast bronzes recounting his father's glorious deeds, conscious of the analogy with nobles of the Shang and Zhou eras.[43] Anecdotal evidence

tells us only so much, but these entries from Cai Yong alert us to three facts corroborated by other passages in Han writings: first, that respect for a single family member might lead an exemplary person of sufficient standing to erect a *citang* for that individual in the patriline, but not necessarily for the entire patriline or even for his own father; second, that justifications for such actions often made reference, as in some Cai Yong stories, to the canonical precepts relating to ranks equivalent to that of counselor (*daifu*), since that rank qualified a man to erect a single ancestral temple for one ancestor;[44] and third, that memorial sites were often located at some distance from the grave site, in public places, where they were more likely to be visited. Meanwhile, we may imagine that permanent buildings, presumably of stone, were also being erected in the mausoleum precincts of the nobility, to better serve the long-term interests of the family lines.

The Received Literature on *Citang*, from Han and Other Pre-Song Sources

Readers may find it useful to consider some of the passages from the received tradition that are routinely adduced as hard evidence that non-noble patrilines routinely erected aboveground worship halls at grave sites for their deceased male members. Such a review allows nonspecialists to see the specific historical contexts in which assertions were made, so that they can appreciate the stakes involved in presuming the motives and identity of persons who erected *citang* in Han. A total of thirteen excerpts are cited below, followed at the end by a brief analysis of the significance (and limitations) of the passages, before the essay proceeds to an examination of the evidence from archaeology. We begin with nine passages from Han and later dynasties:

(1) from the *Liji* (*Rites record*), compiled first century BCE, on the basis of earlier traditions influenced by Xunzi:

In sacrifices, one does not want lots of repetition. If [the person offering the sacrifice] repeats, then he makes trouble, and when one makes trouble, then he is not considered to be reverent (*bu jing*).... Within the ancestral temple [in ideal antiquity], reverence prevailed. The ruler himself led the victim forward, while the counselors followed, bearing offerings of silk. The ruler himself cut out the liver for the preliminary offering, while his wife bore the dish in which it was presented. The ruler himself cut up the victim, while his wife presented the wines. The ministers and counselors following the ruler ordered their wives to follow his wife. How grave and still was their reverence! ...When the sacrifice was set forth in the hall, it was repeated next beside the gate of the temple....

Thus the king had seven ancestral temples made for himself ... and for each feudal prince, five, ... and for each counselor, three, ... and for each officer of the highest grade, two (for his father and grandfather).... An officer in charge of merely one department of government had one ancestral temple (namely, that of his father). The *shi* and the commoners had no ancestral temple (*wu miao*).[45]

(2) from the newly excavated Zhangjiashan legal strips (*terminus ad quem* 186 BCE):

"Let us suppose that the father has died, and his son does not [as chief mourner lead] the cult [to him] in the family [home?] for three days. What sentence does the son deserve?" "He ought not to be sentenced."[46]

(3) *Simin yueling* (*Monthly ordinances for the four classes*), by Cui Shi (ca. 110–170 CE)

The first day of the first month is called New Year's Day. The family head [*jia zhang*] personally leads his wife and children to make pure offerings to his ancestors and parents. From three days prior to the appointed time, the family head and those playing roles in the ceremony undergo purification. On the day of the offering, they present wine to cause the spirits to descend. Then all members of the household, both noble and base, without exception for young or old, are arrayed before the ancestors in order of age. Sons, their wives, grandchildren, and great grandchildren each present pepper blossom wine to the family head, happily offering toasts to wish the head long life.[47]

The text then stipulates that grave-site offerings take place the day after offerings in the house. These grave-site offerings "atop the grave mound" are made to the ultimate ancestor and other important connections in the afterlife, including several categories of the dead that are explicitly non-kin.[48] This text shows that many offerings to the dead in early China were carried out in the open air or in makeshift structures near the tomb.

(4) from the *Hanshu* (*History of Han*) biography of Sima Qian, comes the famous passage in which Sima Qian describes his miserable state:

On account of what I had said, I, a miserable wretch, met this calamity [castration]. I feel doubly misfortunate to have become the butt of cruel jokes by my peers and compatriots. I have brought dishonor to my forebears, so how would I ever have the face to ascend the grave mounds of my parents [to offer them cult]? Even though a

hundred generations pass, the sense of corruption will still have greater and greater force — that's just the way it is. This is the gut-wrenching truth that I confront all day long. At home, I am so preoccupied and distracted that I seem to be lost, and when I venture out, I seem not to know where I am going....[49]

(5) from the *Hou Hanshu* (*History of Later Han*) biography of Zhang Pu, an Eastern Han minister:

...Several months later, Zhang replaced Lu Gong as Minister of Works. A month later he died [*hong*, used only of nobles].... He was awarded [the right to have built for him] a funeral mound.... The funeral gifts and marks of favor [from the emperor] were different from [i.e., better than] those of other ministers. When Zhang Pu was sick and near the crisis point, he commanded his sons: "At Xianjie Mound [the funeral mound of Han Mingdi], they sweep the ground and offer sacrifices in the open air, in order to lead the empire in frugal practices. I, who hold one of the three highest offices in the land, that of the Three Dukes, was unable to propagate the kingly Way of moral transformation, so that the officers and common people obeyed the edicts. Would it be right for me not to devote my energies to frugality and moderation? Let you not raise a *citang* [after my death]. It will suffice to build a makeshift covered room in which the sacrifices will be carried out — that and no more."[50]

(6) from *Sanguo zhi* (*Record of the Three Kingdoms*), compiled 285–297, on who merits a *citang*:

Later Wang Shang established cults (*li ci*) to Yan Junping and Li Hong [two Chengdu figures who lived centuries before]. Qin Mi sent him a letter saying:

"... I have learned that you have established cults for Yan and Li. This is something that favors and commemorates men of the right sort, I would say. I have perused the writings of Yan Junping, and they were first in the empire. Yan had the reclusive principles of a Xu You or a Bo Yi; he refused to budge from the mountain peaks. But he caused Yang Xiong not to sigh [with regret]; he certainly made himself illustrious. Had Li Hong not happened to be mentioned in the *Fayan* (*Model sayings*) [Yang Xiong's neo-classical masterwork], his fine name would certainly have perished. Though he exhibited no marks of the tiger or leopard [meaning, he did not join the ranks of high officials], he could be said to have scaled the heights with dragons and to have flown with phoenixes....

"As such men were your compatriots — men who showed their brilliant lights to the farthest reaches of the realm — we would have blamed you who followed them had you not raised a *citang* for them. Shu [Sichuan] originally had no men of learning; Wen Weng sent Sima Xiangru east to receive the Seven Classics; he returned and taught them to the officers and common people. Thus it was that Shu learning became comparable to that of Qi and Lu [the homelands of Confucius and the Gongyang masters].... I for my part commend the transformation led by Sima Xiangru. There ought to be a *citang* raised for him, too, so that we quickly define his merit, once and for all."[51]

(7) from the *Shuijing zhu*, entries 160–62:

In Suiyang, two *li* south of the city, there is the grave of the Aide to the Senior Tutor, Qiao Cai.... A hundred paces east of the city, there is a stone chamber that bears the legend: "Cult [site] of Qiao Ren, Superintendent of State Visits for the Han."[52] North of the city by five *li* there are stone tiger

[sculptures] and stone pillars, but no stele inscription. When those were erected is unknown.[53]

(8) *Hou Hanshu* biography of Li Shan,[54] a man famous for singular conduct (*du xing*):

When Li Shan…was appointed governor of Rinan, he passed by the offices at the capital…and by the funeral mound of Li Yuan. Before he had gone a full *li*, he took off his court robes, and took up a hoe to remove the weeds. Then he bowed in prayer at the grave site, weeping and bawling in the most piteous tones. He personally prepared the food offerings, and he set out tripods and platters in preparation for the sacrifices. With tears falling, he said, "Sir, it is I, Li Shan, who is here." He left only after he had finished mourning, after several days.[55]

(9) from two observations by Sima Guang, the most famous being "Wenlu Gong jia miao bei" ("Stele of the Family Temple of Wenlu Gong"):

It was the regulation of the former kings that from the Son of Heaven on down to the officers and tutors, each has a temple. The Qin honored the ruler and devalued the minister. Therefore, aside from the Son of Heaven, no one dared to build ancestral temples. In the Han period many of the dukes and ministers and people of high rank built *citang* at their grave sites….[56]

The rite of offering cult to the departed arose in Han. In some cases, the provincial and commandery governors (*mushou*) who had compassionately governed the people were offered cult while still alive (*sheng ci*). Although this [offering cult] was not an institution of the former kings, it nevertheless arose from the fond memories of people, and thus it should not be abrogated.[57]

Let us discuss these nine passages, as they serve to establish some of the parameters of the problem. Text 1, an excerpt from one of the Three Rites canons compiled in late Western Han, probably on the basis of earlier authoritative works, tells us quite plainly that no temple (*miao*)—and presumably no *citang*—is to be erected by the mass of ordinary officers (*shi*) and the common people on behalf of their ancestors. Why was this? The Five Classics posit a direct correlation not merely between rank and sumptuary laws or rank and ritual proprieties, but also between rank and magical efficacy. The emperor epitomizes magical efficacy whenever he participates in the culture of public display, with the result that those connected with him by birth and state service, to the degree that they are connected, also have special access to the gods and the efficacy they endow. This explains why, in Han, *miao* (or *citang*) were built for nobles and sometimes also for local shamans. Temples and worship halls are religious institutions, not secular marks of prestige, and both were erected to superior beings with special access to the divine.

Text 2, drawn from the recently published Zhangjiashan bamboo strips, offers inadvertent corroboration of the principle outlined in Text 1, insofar as it presumes the standard location for cult worship of the deceased parents to be in the home, not at the grave site. (Similarly, one popular tale from Han has the filial paragon Ding Lan worshiping a wooden statue of his mother *at home*). In Text 4 Sima Qian, who held a mid-ranking position in the Han court, that of *taishi ling* ("Court Archivist," ranked at 600 bushels),[58] mentions offering cult to both his parents atop their grave mounds—not in a specially erected temple located either in the home or at the grave site. Text 3, an excerpt from the *Simin yueling*, a manual for estate management, stipulates that

cult offerings be made to the ancestors on New Year's day by the entire household, great and small, apparently within the household, since additional offerings are to be made at the grave site to various honored dead on the second day of the holiday.[59] (Modern archaeology confirms that ritual offerings to the dead were made at the grave site and within the tomb itself.)[60] Certainly, neither Text 3 nor the other texts above specify that non-noble householders were to offer cult to their honored dead outside the home, in a special temple or worship hall.

Text 5 tells us that Zhang Pu, one of the three highest-ranking ministers at the Han court, ordered his son(s) not to build a *citang* for him, despite imperial favor and the expectation of his heir(s), who knew that his ministerial rank automatically conferred a noble title. (Another passage, not cited here, shows that even imperial consorts did not have *citang* built for them as a matter of course after their deaths.)[61] Note that imperial edicts seem to have been necessary if a *citang* was to be built by non-noble locals.[62] Zhang Pu may have been motivated by modesty, by a wish to present a strict model of selfless state service, by sheer prudence (lest his son(s)' propensity to extravagance endanger the long-term security of his family line), or by a combination of all of these. No doubt, the close family members of the deceased at the very highest levels of government would have been very pleased to erect temples or worship halls in their honor, as such memorial sites redounded to the credit of the entire family line. Men like Zhang Pu nonetheless chose to understate their accomplishments by asking that grave-site sacrifices be offered in the more usual way, in the temporary covered lean-tos erected by the grave for the new mourners.[63] Finally, Text 6, the *Sanguo zhi* passage, takes it for granted that *citang* could be

raised to honor individuals of extraordinary merit who had died many centuries earlier.[64] The main question with regard to such public memorials was who did or did not merit a *citang*.[65] It was quite the vogue in Song times — not to mention Ming and Qing — to erect worship halls for the exemplary dead of the Han period, almost all of whom were high-ranking officials.[66] Ouyang Xiu, the statesman credited with starting the stele craze, explains why, in his view, this was so: "These men were absolutely preeminent, so that even children in diapers and rustic women can speak of them [their extraordinary accomplishments]. It is not that there were no great men from the Wei and Jin periods; it is just that their glorious fame does not measure up to that of those who came before."[67]

Text 7 shows us that not all family members, even in important patrilines, were buried in a single family cemetery, where memorials were erected to them. (Memorial sites could be erected for a worthy individual at the location where he held office.)[68] Text 8 shows us something equally interesting: that important men (and women) tended to be remembered for the way that they sought, through elaborate mourning practices lovingly detailed in prose (and elsewhere in poetry), to establish their emotional affinity with exemplars of the past. Men and women were apt to be commemorated, in other words, for their acts of commemorating others. Hence, the propensity of texts like the *Shuijing zhu* to allot, in an entry nominally devoted to a given worthy, as much or even more space to elucidating the motives and specifying the rank of the noteworthy person(s) who set up steles or memorial sites for that exemplary figure.[69] Even stele inscriptions legible enough to supply biographical information sometimes give relatively short shrift to the lives of the commemorated dead,

so intent were their authors upon relating their own acts of piety. Early eulogists were ignorant of the frustrations that modern historians would experience as a result.

Text 9 is perhaps the most eye-catching of the passages cited here, for in its summary it states, "In the Han period many of the dukes and ministers and people of high rank built *citang* at their grave sites." Sima Guang, one of the most highly respected historians ever to live in China, surveyed the Han from a time a full millennium closer than we, before the full impact of printing was felt, when presumably many more Han texts were available in manuscript; he certainly was well versed also in the antiquarian pursuits of his day.[70] In the Han many of the dukes and ministers and people of high rank built *citang* at their grave site, he reports.[71] He also states, "The rite of offering cult to the departed arose in Han." Who offered cult to whom, then? Sima Guang is talking of "dukes and ministers and people of high rank" erecting cult sites for themselves, possibly while living or via deathbed instructions.

Talk of Sima Guang prompts the citation of two additional passages, coupled in the minds of historians of Han, which many consider the best proof for the existence of numerous *citang* erected at grave sites by commoners on behalf of the patriline. I have saved them for last, because they present the most complex problems in interpretation. The first of these two passages comes from the *Yantie lun* (*Debates on the salt and iron monopolies*), ascribed to Huan Kuan, but written long after the original debates in 81 BCE, perhaps as a rhetorician's tour de force;[72] the second from Wang Fu's (ca. 90–165) *Qianfu lun* (*Treatises by a recluse*), which repeats many of the arguments found in the earlier *Yantie lun*. The relevant *Yantie lun* polemic, quoted here at some length in order

to establish the proper context for key phrases, says:

In the good old days commoners offered fish and beans in sacrifice; in spring and autumn they offered cult to their ancestors. The *shi* [typically from the ranks of the governing elites] had one temple (*miao*) [where this was done]; the counselor, three. And when they carried out the seasonal activities with respect to the five Household Deities, they apparently never went out of doors to offer sacrifice. Nowadays, the rich pray to the famous mountain peaks. They offer the *wang* sacrifice to the [famous] streams and mountains.[73] They "bludgeon the bull" and beat the drums; there are entertainers and models of dancers. Those of middling wealth [offer cult] to the Lord of the South and the Lord of the Road. At water's edge they build towers that ascend to the very clouds. They slaughter sheep and kill dogs; they play on flutes and blow on panpipes. The poor kill chickens and pigs and use the five fragrances [in sacrifices]....

In the good old days, those of virtuous conduct who sought blessings offered cult liberally. The benevolent and dutiful (*renyi*) who sought good fortune cast divinations, [though] they were sparing. Nowadays, the custom of the age is thus: liberal in its practices and in what it seeks from the spirits; lax with respect to ritual but earnest as to sacrifices; disdainful of close relations but honoring powerful connections....

In the good old days they had tombs lined with clay just big enough to contain the corpse. Wooden boards were fired so that the fused clay surrounded [the corpse], and this sufficed to hold the skeleton and to store the hair and teeth and nothing more.... Nowadays, those who are rich have the walls of their tombs hung with silk

embroideries and their tombs built "barricade style" [with wood].[74] Those of middling rank have catalpa coffin chambers and hardwood outer coffins. The poor have patterned covers and sets of robes, silken bags and sacks of reddish silk.

In the good old days, the grave goods (*mingqi*) were in the shape [of items used above-ground] but they were not the real things. This made it plain that they were not to be used by the living…. Nowadays, there are luxury goods and many treasures [buried in tombs]; the [grave] goods are just like those of the living. For the functionaries and officers employed in the commanderies and kingdoms, there are decorated axles of mulberry wood and model carriages, shields, and wheels. The commoners have nothing to cover their faces or necks, while the tomb figurines wear the finest gauzes or heavy weaves.

In the good old days, they did not build a mound nor did they plant trees [at the burial mound]. On the contrary, they offered prayers for the repose of the dead at the bedside [or resting place of the corpse?]. [The grave] had no dwelling with an altar or roof; there was no ranking in the temple. And when it came to later times, when they erected mounds for them [the ancestors], the grave mounds of commoners were [only] two feet or so,[75] so that their height was not conspicuous. Nowadays, the rich pile up earth to make mountains. They have trees set in rows to make forests. There are terraces, kiosks, and one pavilion after another. They build lookout towers in clusters and pile on towers. Those of middling wealth [build] *citang*, screened entrances [to tombs], side doors, and enclosing walls with regularly spaced pillar-gates" (*zhong zhe citang ping ge, yuan que fu si*).[76]

This long *Yantie lun* passage by a late Western Han author generally contrasts the good

old days of frugality with contemporary license and extravagance. The text, which seems upon first reading to be a verbatim transcription of part of a series of famous court debates on economic policies, is viewed by no less a Han expert than Michael Loewe as a "contrived piece of play-acting"[77] compiled decades after the event, perhaps as an exercise in rhetoric or a policy piece. In any case, it is obviously crafted to incite outrage in readers, urging them to clamp down on a variety of activities alleged to contravene the most conservative post-facto constructions of the halcyon past. Of course, the text's description of the past is patently absurd, judging from its confident attribution of more egalitarian burial practices to the "good old days." Archaeologists can point to no time in Chinese history from the Neolithic era (e.g., Liangzhu) onward when extraordinary luxuries were not unequally divided among some few of the honored dead. Sharp and increasing status stratification occurred long before the historical period. Nor have archaeologists up to now found a single "barricade style" construction of a tomb of someone below noble rank. It is an interesting question why the *Yantie lun*, which is manifestly wrong in its descriptions of the "good old days," is believed to offer absolutely reliable testimony for practices in late Western Han, the probable time of its compilation.[78]

It moreover beggars belief that ordinary people (i.e., the non-nobles) — no matter how wealthy — were routinely out conducting the *wang* sacrifices to the deities of the most famous mountains and rivers. According to the ritual logic specified in the Han canons, such sacrifices were strictly reserved for local princes, because they conferred political legitimacy on those who carried them out. As many Han classics intone, "To sacrifice to objects of cult at a higher rank [than

the officiant] is to arrogate powers to oneself."[79] Illicit sacrifices would have conflated the ranks of non-noble with noble, and thereby worked against every conscious effort by the Han ruling house. And when did the really poor ever sport silk purses or have draft animals to spare for blood sacrifices? The phrases "those of middling wealth" and "poor" must refer to those well-off but relatively deprived vis-à-vis the very highest-status group (as is stipulated in another passage of the *Yantie lun*).[80]

Still, the original allegations recorded in the *Yantie lun* are weighty ones delineating a climate of great fear and acrimony in members of a court faction who contrived to topple the most powerful man in Zhaodi's (r. 87–74 BCE) government. Before coming to any firm conclusions about the accuracy of assertions in the *Yantie lun*, let us tarry awhile over its allegations of egregious abuses of the "measures under regulation" (*zhidu*). The text alleges that the powerful families, in their avid search for blessings (*qiu fu*) in this life and the next, no longer trust that virtue alone will sustain their lines. Instead, they engage in all manner of self-aggrandizing acts designed to increase their power and security—acts that, in wasting the empire's limited resources, severely diminish the scope of imperial power and authority. When the text charges that "the rich pile up earth to make mountains [for grave mounds].... Those of middling wealth [build] *citang*, screened entrances [to tombs], side-doors, and enclosing walls with regularly spaced pillar-gates," it describes abuses against the law and imperial authority, rather than court-sanctioned, regular expressions of filial piety.

Since the *Yantie lun* describes the erection of *citang* by inappropriate groups ("those of middling wealth") as conduct so outrageous that it must be quelled immediately by the emperor and his representatives, the key to the foregoing

citations undoubtedly lies in the identity of these great families—the wealthy and middling wealthy—against which the *Yantie lun* diatribes inveigh. Those wishing to arrive at a reasonable answer to their identity would do well to consult Yang Lien-sheng's classic article on "The Great Families in Han";[81] also, to try reading the rest of the *Yantie lun*, in order to figure out which groups and persons are targeted in the text. Yang makes it abundantly clear that the so-called "great families" (*haojia*) of Eastern Han are swaggerers with their fingers in every pot, including manufacturing, estate-owning, high office, and intermarriage with the court nobility. Under the rubric of *haojia*, then, fall mainly members of the national elite, though the term would be stretched upon occasion to include the merely locally eminent, especially when such people colluded with law-breakers. The tenor of Yang's remarks tallies well with the entire contents of the *Yantie lun*, where quite specific charges leveled against members of a court faction are almost always veiled as general complaints lodged against unnamed perpetrators of a range of abuses. Thus it seems likely that we must add to the expression "of middling wealth" the qualifying phrase "among those commanding such high rank and connections that they dare to usurp imperial or noble prerogatives."

Significantly, over a century after the *Yantie lun*, in a diatribe against lavish burials, Wang Fu, in his *Qianfu lun*, takes aim at the "imperial relatives in the capital and the powerful families in the provinces and counties" (*jingshi guiqi junxian haojia*); these groups, Wang complains, have usurped imperial prerogatives in unseemly displays of conspicuous consumption.[82] Wang accuses such people of using jade suits to bury their dead, of planting evergreens, and of erecting mourning sheds and *citang* (shades of the *Yantie lun*). Wang Fu's critique is more

explicit about the identity of the groups whom he criticizes: the imperial distaff relatives (*waiqi*), the hereditary ministerial families (*shijia*), a small group of eunuchs whose adopted sons had been allowed to inherit noble rank, and their closest allies and dependents. That Wang Fu was not lodging a broad complaint about the routine activities of commoners with pretensions and surplus cash was evidently the opinion of the eminent historian Sima Guang, whose name has been repeatedly invoked in this essay. In reconstructing the Eastern Han context by reference to Wang Fu, Sima Guang writes of the "hereditary ministers [i.e., those families holding the highest offices in the land for generation after generation, all of whom had been ennobled] and nobles [or those of high rank] (*shi gong qing gui ren*), many of whom built *citang* at grave sites, and fewer, in the cities."[83]

Interestingly enough, upon close reading, these two famous polemics, the *Yantie lun* and the *Qianfu lun*, seem to contradict themselves and each other. The *Yantie lun* denounces extravagant display by the poor, who in mourning go so far as to dress their dead in silk, only in the next breath to fulminate against the rich for extravagance so gross that it leaves the poor with nothing to their names. Nor do the *Yantie lun* and *Qianfu lun* charge precisely the same class of offenders with the crime of arrogating noble privileges to themselves in building *citang*. The *Yantie lun* alone accuses those "of middling wealth," while the *Qianfu lun*, a text dating to the time period in Eastern Han when the Wu Family Shrines were purportedly built, was preoccupied with the arroga-tion of powers by those noble families called the "hereditary ministers." Historians usually ask readers to ascertain whom a document was designed to persuade, whether it is credible, and whether literal readings are appropriate.[84] The literary sources,

received or excavated, reveal few details about the local variations or the processes of change. They fail also—except for the *Yantie lun*, a text of dubious accuracy given its dating and polemical tone—to offer support for the notion that wealthy families of low rank were routinely erecting *citang* to their ancestors, collectively or individually.

To reiterate: there is no doubt that *citang* existed in Han. The problem under consideration is the quality of the evidence that those outside the nobility routinely erected *citang* for their male dead in the patriline. The literary evidence is weak not only because there is so little of it, but also because what little exists is either ambiguous or slanted. We can but surmise that passages on temples or worship halls must be understood in the context of Han and post-Han assertions about behavior, good or ill, of high-ranking officials or other members of the court; occasionally texts also specify the court's intervention or express sanction in such matters. We would expect no less, perhaps, in the court-centered standard histories, but it is interesting that we find much the same in works composed in unofficial circles. If the foregoing represents the best evidence we have for late Western Han and Eastern Han, then it does not allow us to assume that permanent, aboveground stone *citang* were typically dedicated by the merely wealthy in non-noble families to collective worship of the patrilineal ancestors. But we have yet to turn to evidence from the archaeological record.

The Material Record to the Present

At this date, four types of evidence that may relate to *citang* should draw our attention immediately: (1) epigraphic evidence employing in formulaic language three words: *ci* ("worship"), *tang* ("halls"), or *shitang* ("offering halls");[85] (2) sets of pictorial stones (often three in number) that lie within the

Fig. 1 *Rubbing of Xiang Tajun stele.* From Nagata Hidemasa, *Kandai sekkoku shūsei* (Tokyo: Dōhōsha shuppan, 1994), vol. 2, fig. 72 (p. 119).

entrance to the tomb or crypt; (3) large stone coffins similar in size, shape, and design to the structures now dubbed "shrines";[86] and (4) "stone chambers" put to various uses.

The inscriptions, most nonspecialists assume, afford a slowly but surely growing body of evidence attesting the existence of many aboveground *citang* during Han. Would that it were so simple. As early as 1983 Jiang Yingju, the distinguished Chinese archaeologist, noted with regard to the Songshan inscription (dated to 157 CE) that the phrases recording the "building of this hall" (*zao li ci tang*) for cult offerings (*ci*) almost certainly referred not to an aboveground structure, but rather to underground chambers within the burial site.[87] That is equally true, says Jiang, of another inscription found on the wall of a burial chamber in Qufu, Shandong, and dated to 158 CE.[88] The majority of excavated Han inscriptions cited as "proof" of aboveground *citang* actually use the phrase *shitang* ("offering hall"), a euphemism for the tomb.[89] One exception is a famous but unprovenanced Xiang Tajun inscription (fig. 1), whose unusual features and lack of secure provenance in combination have generated questions about its authenticity since its publication.[90]

Given the scantiness of the epigraphical evidence, it is curious that the prevailing theories about the Han ancestral landscape do not take into account the possible significance of many newly excavated stones slabs, usually found in sets of three stones within the entryways to burial sites. When the Recarving China's Past research team traveled to Shandong in 2002, it met with Hu Xinli, Director of the Zoucheng Municipal Museum, which boasts a great many beautifully carved stone slabs. Hu stated unequivocally that whenever two or more pictorial slabs of the same size are found in conjunction with a third depicting a tower-gate,

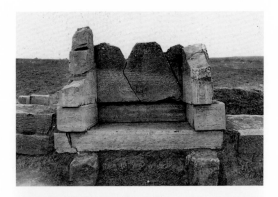

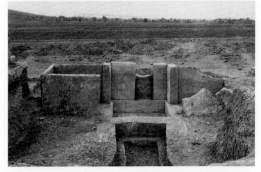

Fig. 2 *Reconstructed aboveground* citang *of Hu Yuanren*. From Wang Buyi, "Anhui Suxian Chulan Han huaxiang shi mu," *Kaogu xuebao* 1993.4, pp. 515–49; pl. 20.

either in the tomb proper or within the ramp, the set of finished stones should constitute a *citang*, whether or not inscriptions identify it as this at the site.[91] (Other scholars in China and Japan have put forward other ideas, for example, that the presence of *citang* is best identified by the depiction of a male figure formally receiving guests, though the different theories disagree as to whether the male represents the head of household, chief mourner, or tomb occupant, and whether the reception takes place in this life or in the next.)[92] If any of the foregoing theories are correct, there arises a host of fundamental issues that await resolution: did these pictorial stones left near the entryway once form temporary aboveground structures for offerings that were then dismantled and placed within tombs or crypts just before they were closed? If

so, on what occasions, to whom, and why were such temporary offering sites established? How long did they remain aboveground, and why were they finally deposited in the tomb? If these once constituted temporary *citang*, what percentage of these structures remained aboveground near the burial site for an appreciable length of time? Were they stowed away in the entryways to "joint burial" tomb chambers so that they would be available as successive family members were ritually interred, one after another, in tombs expressly designed to admit not only the coffins of deceased family members but also bands of mourners, both family members and clients?[93] Or were these structures dismantled because of restrictions against non-noble families building permanent worship halls for their family members aboveground? Were mourners in non-noble families afraid, in other words, of officious neighbors and zealous officials prosecuting commoners for infringing sumptuary regulations? We simply do not know.

One working hypothesis that is consistent with current evidence is that large, permanent, aboveground *citang* could not be lawfully erected at the grave site by the non-nobility. After all, the standard histories record numerous proscriptions of steles and *citang*, each aimed at sharply restricting memorial displays patronized by locally powerful families (*haozhe*) whose self-aggrandizement threatened imperial supremacy in the area.[94] If even the stone steles set up to commemorate high-ranking Han and Six Dynasties officials were enough to provoke repeated proscriptions by ruling houses jealous of their prerogatives,[95] it makes sense that many magnificent Han tombs come equipped only with either a small offering site composed of small carved stones lining a niche within the tomb chamber or with a small offering site atop the tomb mound. Examples of these small structures — less

offensive to the authorities, surely, than impressive aboveground *citang*—include the decorated niches reconstructed at Songshan,[96] as well as the small stone offering site—also reconstructed—above Hu Yuanren's grave. The latter, which includes a short inscription naming the deceased[97] (fig. 2), could hardly present a starker contrast in size, munificence, and cost to the complex reconstructed from the Wuzhai Shan carved stones. In Han parlance were these smaller offering sites called *xiaotang* ("small hall") or *citang*, as they are today, or was the term *citang* generally reserved for larger and more impressive structures meant to be viewed by many outside the family circle?

A third and fourth body of archaeological evidence may prove relevant here: the large stone containers for coffins, sometimes dubbed "stone chambers" or "outer coffins," replete with decorated panels and roofs. A tomb origin is posited for some structures once confidently labeled as "sacrificial houses" or "shrines" and assumed to be aboveground, freestanding memorials erected for ancestral worship at the grave site. For instance, both Albert Dien and Wu Hung have recently proposed that the Boston Museum's Ning Mao assemblage of carved stones was a sarcophagus, not an aboveground shrine.[98] Wu Hung's essay on

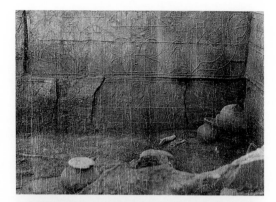

Fig. 4 *Tomb lined with pictorial tiles.* Jinxiang County, Shandong. From *Kaogu* 1989.12, pp. 1103–09, pl. 7.

Fig. 3 *Stone sarcophagus from Leshan with decorations similar to those found at Wuzhai Shan.* From Gao Wen, *Sichuan Handai shiguan huaxiang ji* (Beijing: Renmin chubanshe, 1998), fig. 65.

stone sarcophagi theorizes that non-Han peoples connected with Five Pecks of Rice Daoism brought the idea of these immense stone sarcophagi from Sichuan across the northern frontier in the post-Han period.[99] But with some twenty-odd stone sarcophagi at present, one can only remark on the similarities in size, shape, and decoration between these magnificent stone outer coffins (fig. 3) and the reconstructed Han shrines (*citang*) and wonder whether in earlier ages the two were ever confused later by those who came upon ruins.[100] The grainy image in a journal is not altogether clear, but still closer to the Wuzhai Shan stones are the pictorial hollow tiles lining the walls of a small Shandong tomb excavated in Jinxiang County, in the vicinity of Wuzhai Shan (fig. 4).[101] This is especially interesting,

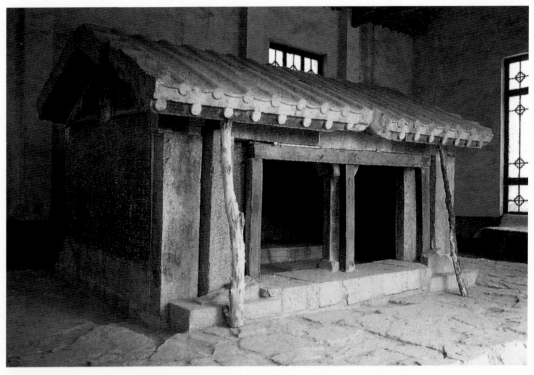

Fig. 5 *Xiaotangshan Shrine*. From *Zhongguo huaxiang shi quanji* (Jinan: Shandong meishu chubanshe, 2000), vol. 1, fig. 5 (p. 36).

as one early source (compiled 1213 CE), which was less frequently reedited than many others, refers to the Wu Liang images as coming from *within* a tomb mound (*muzhong*).[102]

It is in light of such open questions—who erected *citang* in Han times and for whom? were *citang* located inside the tomb, at the graveside, or some distance away? were they intended most commonly as temporary or permanent stone memorial structures? and have stone coffins ever been conflated with stone shrines?—that we should assess the new evidence discovered by members of the Recarving China's Past team: Anthony Barbieri-Low has found that sunlight seldom flooded some portions of the walls reconstructed for the Wu Liang Shrine, illuminating the decorative carvings on the upright stones.[103] Jiang

Yingju and other Shandong archaeologists are sure that the Wuzhai Shan stones, upon close examination, bear no traces of painting. That means that most of the delicate traceries that have made the Wuzhai Shan stone carvings—the walls and ceilings, but not the *que* stones—world famous would have been largely invisible to all but the denizens of the spirit world, until such time as their delicate traceries were revealed, centuries later, via rubbings that picked up the fine patterns of the stone pictorial carvings and their cartouches.[104] How likely is it that works of such consummate skill and artistry as the Wuzhai Shan stones, whose stated purpose was to convince viewers of the illustrious virtues of the Wu family, would have been made in such a way as to be hard to view, since everything that we know about late Eastern Han memorial

sites suggests the fashion to advertise filial activities through public and semi-public display, as with pillar-gates?[105] Perhaps later pious persons erected the complex in the Han style favored during Northern Wei and later, to commemorate ancestors or worthy locals, in the hopes of bringing honor to themselves—especially as the *Shuijing zhu* (compiled 624?), the earliest account of memorial cults in the received tradition, lists commemorative sites in the vicinity but says nothing about a major site dedicated to the Wus.

Any comprehensive review of the material evidence relating to the Wu Family Shrines must include consideration of the two structures presumed to be most like it: the reconstructed single-structure "shrines," one at Xiaotang Shan and one for Zhu Wei.[106] The original function and dedicatees of Xiaotang Shan (fig. 5) are unknown. Its earliest inscription is dated to Eastern Han (129 CE), and current theories generally suppose that it was first established as a cult site for a high-ranking member of the nobility or even the imperial family, and that only after centuries, sometime before 570 CE, did its function gradually change to a cult site in honor of the Western Han filial exemplar Guo Ju, who was not a noble, so far as we know.[107] But, as it happens, Huang Yi played a singularly important role in the Qing reconstructions of the Han religious world, for it was Huang himself, in the summer of 1784, who first noticed, on rubbings made after he specifically requested that the Xiaotang Shan stones be cleaned, the very visitor's graffito that established the earliest date for the cult site.[108]

At present, the existence of a second reconstructed shrine—that assigned to Zhu Wei—is routinely adduced as a second piece of evidence for Han "family shrines." A grave mound attributed to Zhu Wei, one of the leaders of the revolt against Wang Mang in 22 CE, was indeed opened in Song, as we learn from a report by Shen Gua (1031–1095):

In Jizhou, Jinxiang Prefecture, they have opened up an ancient mound belonging to the Han *dasitu* Zhu Wei. The stone walls were all carved with human figures, ritual vessels, and racks for carillons of bells and stone chimes. The clothing and caps worn by the figures are of many kinds, some of which look like turbans squared at the top. These all look like the contemporary version without the flaps. The women, for their part, have the 'falling shoulders' cap, like the *jiaoguan in fashion in recent years....*" [italics added].[109]

Obviously, this Song report describes the tomb chamber itself, not a *citang* erected aboveground at the grave site, and it is the tomb walls that were carved. No *citang* was found at that time on site. One can only wonder, then, at this remove, whether and how the tomb carvings reported to Shen relate to the shrine assigned now to Zhu. Nonetheless, this eleventh-century passage reminds us of two important points often overlooked: (a) that Han tombs were repeatedly opened in Song, as in later times; and (b) that Song (not to mention later) antiquarians already had, in consequence, a good sense of the standard Han pictorial program, which included several motifs found at Wuzhai Shan and nearby.[110] Still, the main thrust of Shen's comments is not entirely self-evident, if only because Shen was one of the most subtle writers of the period. Is Shen curious about what he has heard, since fashions in caps and clothes (which had certainly changed since the Tang, let alone since Eastern Han) were the object of close study by Song connoisseurs and philosophers alike, or is he merely registering his excitement about the connections

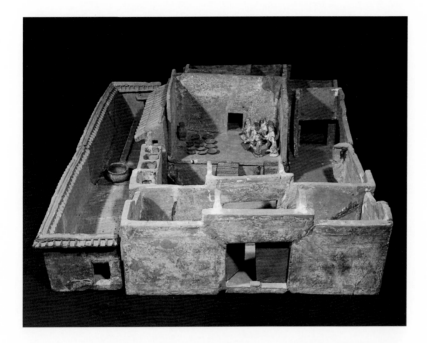

Fig. 6 *Han earthenware model*, 89 × 114 × 130 cm. From Jessica Rawson, *Mysteries of Ancient China* (New York: Braziller, 1996), cpl. 106, p. 204.

he perceives between old and new?[111] Was Shen surprised that Zhu Wei's tomb was found in Shandong, rather than in Chenliu (Henan)?[112] If the stones in the present reconstructed shrine linked to Zhu Wei *do* belong to a Han mortuary structure erected in Zhu Wei's honor, they cannot provide any clues concerning the precise significance that Shen placed on this particular find, since early experts deemed them to be heavily recarved.[113]

By this point, the relative paucity of firm evidence upon which major hypotheses have been built should be obvious. In contrast to classical Greece and Rome, for which there remain abundant aboveground traces, China lacks sufficient material evidence for aboveground sites to allow scholars to work up the necessary "thick description" of cult sites in the classical era. Scholars have tended to bridge yawning gaps in the early record using materials drawn from much later periods, on the assumption that "China is the oldest *continuous* culture." Unfortunately, the visual record, where

not absolutely silent, is often highly ambiguous. A case in point: a Han earthenware house model (fig. 6) has been described by two specialists in startlingly different ways; according to one, the model shows preparations for a feast replete with musicians and food platters, but according to the other, the model depicts figures grouped for ceremonies of family worship within the household.[114] Disputes over the meaning—and sometimes even the veracity—of parts of the early visual record will inevitably arise, as each part of that record is liable to overinterpretation, especially in the case of mass-produced items. The archaeologist Xin Lixiang, for instance, believes that he has found a stone carving that illustrates a "Han-dynasty *citang*" erected for ancestral sacrifices (fig. 7).[115] Let us suppose for the moment that Xin is correct. Is a depiction of a worship hall on the walls of a tomb proof that such halls were routinely built aboveground by the merely wealthy? As is usual with Han stones, no background situates the presumed worship hall in

a realistic setting. That is likewise the case with an Yinan stone carving (fig. 8), said to depict a temple or worship hall whose doors are closed to the person making offerings outside the door.[116] Why does the Yinan carving of a freestanding structure match none of the reconstructed *citang* at Wuzhai Shan, Xiaotang Shan, and Songshan, all of which are open at the front? (figs. 5, 9)

Given (a) the discrepancies that existed between ritual prescriptions and actual ancestral practices, (b) the ambiguities in much of the literary and archaeological records; and (c) the twin tendencies in scholarly writings to extrapolate from imperial burial practices to those much further down the social scale and to deduce earlier

practices from those of late imperial China, how can we presume to estimate the prevalence of aboveground stone *citang* for ancestral worship erected by the merely wealthy during Eastern Han?[117]

No Conclusions but Further Queries

Gideon Shelach, an expert on Chinese archaeology, states, "The 'ancestors cult' is perhaps the best example for [sic] a gender-biased concept that scholars project back and use in their interpretations."[118] In the premodern era, scholars took the terminology of ritual seriously. Let us try to do the same. As late as the Song, there was talk of "building *citang* according to the law" (*xiu zao*

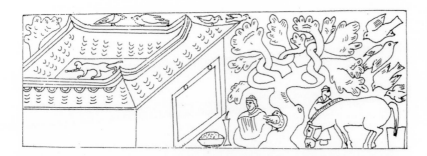

Fig. 7 *Depiction of a* citang, *after a rubbing of a carved stone.* Tokyo University Museum. No dimensions given. From Xin Lixiang, *Handai huaxiang shi zonghe yanjiu* (Beijing: Wenwu, 2000), fig. 43, p. 82.

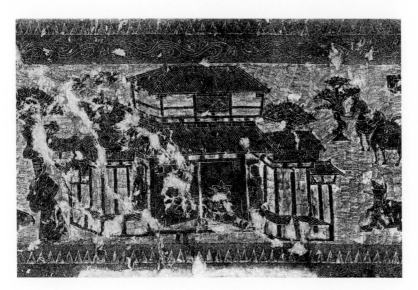

Fig. 8 *Rubbing of a pictorial stone widely believed to depict a stone* citang *or* miao. From Shandong sheng Yinan Han mu bowuguan, *Shandong Yinan Han mu huaxiang shi* (Jinan: Qi-Lu shushe, 2001), p. 18.

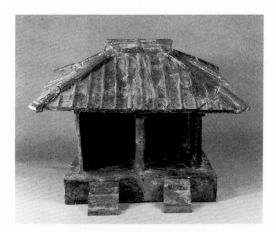
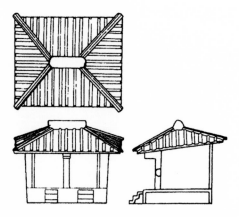

Fig. 9 *Earthenware model of structure identified as a* citang. Shandong Zibo Museum. No dimensions given. From Huang Xiaofen, *Han mu de kaogu xue yanjiu* (Changsha: Yuelu shushe, 2003), pl. 61; fig. 118, p. 273.

citang ru fa).[119] Since Huang Yi, centuries later, in the Qing, used stones he had discovered to create a *citang* dedicated to the Wu patriline, complete with ancestral spirit tablets (see Cary Liu's essay in *Recarving China's Past*), we still need to clarify what connotations the erecting of *citang* might have carried in Huang Yi's time, as well as in Eastern Han (the date to which Huang Yi assigned the stones).[120] Do we imagine a stone *citang* erected for Wu Liang, to take a prime example, as an extraordinary mark of imperial favor or as a cult site established to a local dignitary? If as a mark of imperial favor, did the rank and deeds of Wu Liang—or any of his brothers, for that matter—qualify for an imperial award, since the surviving evidence suggests that office and rank far higher than those of Wu Liang were the usual minimum qualifications for imperial conferrals of such permanent stone halls? The vast majority of *citang* were built not for assistants to local officials, but for those with the ranks of governor, inspector, or better. If as a cult to a local dignitary, would three or four separate memorial structures have been built at public expense for particularly worthy males in two generations in the same household? Not at all likely, judging either

from the extant records of Han through Song or from the Wu family inscriptions themselves. For example, the west pillar-gate inscription specifically uses the formula, when speaking of Wu Ban, that he died before he had time to "flower" (i.e., to exhibit his potential for true greatness). Equally importantly, how many families were capable of building such a site and maintaining it over centuries, at enormous expense, for sacrifice to their own deceased male ancestors?

One Chinese scholar, noting the inherent unlikelihood of the scenario whereby mid- to low-ranking officials erected stone *citang* for ancestor worship, argues that the Wu at Wuzhai Shan must represent a lateral branch of one or more noble lines based elsewhere.[121] His essay acknowledges a problem generally ignored since Huang Yi: that it is "really to be wondered at" (*liang ke guai ye*) that the Eastern Han or post-Han histories fail to mention these Wu, given the scale, artistic fineness, and permanency of the structures associated with the family name. In Li Daoyuan's *Shuijing zhu*, we find only two fairly detailed descriptions of Eastern Han stone memorials with pictorial images; each is dedicated to a single prominent person, the

Inspector Li Gang and the Han Colonel Lu Jun.[122] (Neither, in other words, was built to honor a family or patriline.) Since both structures are located in the same vicinity as the Wuzhai Shan pictorial stones, it is puzzling that the *Shuijing zhu* makes no mention of what would have been a much more impressive complex composed of four stone memorial structures dedicated to members of the Wu family.[123] At the same time, it is conceivable that memorials built "in the Han style" might be raised at a later time to those credited with improving the fortunes of a family or a locale, since such shrines had long been built and rebuilt. Qianlong's call to compile local gazetteers and restore old shrines lent added weight to the impetus. The Qianlong emperor announced in 1793 that supplements be prepared for the earlier catalogues produced under his direction that

would include the texts of stone engravings.[124] This announcement, combined with his warm endorsement of local worthies and of local gazetteers, encouraged local elites to revive local cults.[125]

It need hardly be said that the foregoing remarks may have to be revised in the future in light of new archaeological discoveries. Two final observations: There is intriguing (if hardly conclusive) evidence that depictions of exemplary figures as types (e.g., sages and filial sons), rather than as individuals, may date to the post-Han period.[126] Meanwhile, the Mawangdui mourning diagram, as well as the Zhangjiashan statutes, suggest that far more importance was attached in Han to female family ties than hitherto thought.[127] Large generalizations must await more archaeological finds of relevance, however. ◉

Notes

1 David Hackett Fischer, *Historians' Fallacies: Toward a Logic of Historical Thought* (New York: Harper Perennial, 1970), chap. 1. I thank Michael Loewe, Christian de Pee, Miranda Brown, Naomi Richard, and all the members of the Princeton working group for help in preparing this essay. It need hardly be said that the author is responsible for all errors.

2 See Michael Loewe, "The Orders of Aristocratic Rank of Han China," *T'oung Pao*, ser. 2, vol. 48 (1960), pp. 97–174, which mentions twenty ranks. The Zhangjiashan strips mention a possible twenty-first rank of *gongzu*, but this is not yet certain. Neither can we be certain of the

precise forms that worship halls took in different regions and times during the four centuries of Han.

3 The discovery, in 2003–4, of Western Zhou finds, consisting of oracle bones (with three out of more than 760 bones mentioning the Duke of Zhou) and what looks to be a royal cemetery, near the premises of a Tang-dynasty Zhougong Miao (Temple of the Duke of Zhou), is widely regarded as one of the most potentially exciting finds to be made in recent years. For further information, see *Zhongguo zhongyao kaogu faxian*, 2005 (Beijing: Wenwu chubanshe, 2006), pp. 63–69.

4 Feng Erkang, *Zhongguo gudai*

zongzu yu citang (Taipei: Commercial Press, 1998), p. 71. Feng discusses the differences between Han and later conceptions of ancestor worship in his first two chapters, pp. 8–66, 67–92. By Feng's argument, a real shift occurred in Song and Yuan (p. 43), in part spurred by True Way Learning advocates Cheng Yi and Zhu Xi. Feng, while noting exceptions, stresses the enormous gap in practices between early and late imperial China. To Feng's data, one might add Chang Qu, *Huayang guozhi*, *Yingyin Wenyuange Siku quanshu* edition [hereafter *Siku* edition] (Taipei: Taiwan shangwu yinshuguan, 1983–86), 3/5b, on the great names in Shu for

whom cult was offered. Two PRC scholars who have learned from Feng but object to parts of his analysis are Li Qing, *Qin Han Wei Jin Nanbei chao shiqi jiazu zongzu guanxi yanjiu* (Shanghai: Renmin chubanshe, 2005), esp. pp. 214–35; and Zhao Pei, *Liang Han zongjiao yanjiu* (Jinan: Shandong daxue chubanshe, 2002). Li Qing writes that "in the whole society [in the area of China], clan consciousness, in general, was not deep" (*zhengge shehui zhong zongzu guannian yiban bu nonghou*), contrary to most scholars' assumptions (p. 211). She also writes that the Song-style family *citang* "was not yet seen" (*wei jian*), and that the *citang* which receive frequent mention in Han sources tend not to be family *citang* (pp. 214–16). Of six types of *citang*, four were erected for those without any blood connections, and no instance of a *citang* erected for clan members, rather than for one or more dead parents, is recorded (p. 216). Grave-site worship at a cult-site structure was not common (p. 217), and it seems to have been for individuals who were one's immediate ancestors (p. 218). Li believes that the *jiamiao* sacrifices were uncommon prior to "Tang and later" (pp. 221–22).

5 The classical era may be said to have begun in 323 BCE, when the rulers of all the major Central States had declared themselves kings, and to have ended with the fall of Chang'an and Luoyang, in 316.

6 Klaas Ruitenbeek, *Chinese Shadows: Stone Reliefs, Rubbings, and Related Works of Art from the Han Dynasty (206 BC–AD 220) in the Royal Ontario Museum* (Toronto:

Royal Ontario Museum, 2002), p. 8. The author of this essay would have written something very like this before conducting her research; needless to say, this citation is not meant as criticism of Ruitenbeek's excellent scholarship.

7 By "permanence," I mean that the structures were meant to be permanent.

8 All of Pierre Bourdieu's works on cultural reproduction are relevant here, especially, perhaps, *The Rules of Art: Genesis and Structure of the Literary Field*, trans. Susan Emanuel (Stanford: Stanford University Press, 1996).

9 Hsing I-tien (personal communication by Email, 22 February 2004), which adopts the broadest possible definition for *citang*. (As we see below, the tomb itself may be a *citang*.) Cf. Yang Kuan, *Zhongguo gudai lingqin zhidu shi yanjiu* (reprint, Shanghai: Shanghai guji chubanshe, 1985).

10 See Kenneth E. Brashier, "Han Thanatology and the Division of 'Souls'," *Early China*, vol. 21 (1996), pp. 125–58, esp. pp. 152–53; Miranda D. Brown, *The Politics of Mourning in Early China* (Albany: State University of New York Press, 2007). Brashier distinguishes the memories of the individual dead from the social memories followed by a "selective amnesia" accorded the collective lineage dead.

11 Cf. Feng Erkang, *Zhongguo gudai zongzu yu citang*, p. 71. Many funerary monuments were erected by clients and subordinates for patrons and bureaucratic superiors. For example, Liu Kuan's stele lists 300 clients from across north-central China, and Kong

Zhou mentions forty-two clients (*mensheng*) and eleven disciples (*dizi*). The Liu Kuan stele is transcribed in Hong Gua, *Lishi*, *Siku* edition, 11/1a; the donor list is found starting on *Lishi*, 11/4a and Hong Gua, *Li xu*, *Siku* edition, 12/5b. The stele is discussed in Brown, *Politics of Mourning*, p. 93, where she talks of the donors as "clients and peers." The total number of stele donors is given by Patricia Ebrey, "Later Han Stone Inscriptions," *Harvard Journal of Asiatic Studies* 40.2 (1980), pp. 325–53, esp. pp. 335–36. (However, the full names of only 162 appear in Hong Gua; see Miranda Brown and Yu Xia, "Between Heaven and Earth: Dual Accountability in Han China," unpublished paper, July 2007, Table 1.) For the Kong Zhou stele donor list, see Nagata Hidemasa, *Kandai sekkoku shūsei* (Tokyo: Dōhōsha shuppan, 1994), vol. 2, p. 150; Hong Gua, *Lishi*, 6/5b.

12 Prior to Hong's time, as readers will recall, the rubbings had been related to a "Wu Family Stone Chamber." For "in the tomb," see Liu Changshi (*jinshi* 1205; d. after 1215), *Lupu biji* (comp. 1213), *Siku* edition, 2/8b. *Qingshi gao* (Beijing: Zhonghua shuju, 1977), p. 13420, relates Huang Yi's building a "Wu family *citang*." The *Siku quanshu* manuscript version of Hong Gu, *Lixu*, 6/1a, calls the rubbings for Wu Liang a "Wu Liang *Dian*" (hall).

13 See Hong Gua, *Lishi*, 16/4a–5a.

14 New archaeological data may eventually clarify the record, though at present the archaeological data for Warring States and Han has served mainly to fill in or refine—not

controvert — our understanding of the old records. (The same, of course, cannot be said of the Neolithic or Bronze Ages.)

15 Liu Qingzhu, "Qin Han kaoguxue wushi nian," *Kaogu* 1999.9, p. 807, speaks of more than 30,000 Han graves excavated since 1949. That a large number of items has been acquired through salvage archaeology or illicit sales frustrates systematic attempts at sorting.

16 For the destruction of monuments erected to one's enemies, see Ouyang Xiu, *Xin Wudaishi* (Beijing: Zhonghua shuju, 1974), 45.491.

17 See, e.g., Xin Lixiang, *Handai huaxiang shi zonghe yanjiu* (Beijing: Wenwu chubanshe, 2000), pp. 74–75. Cf. Hsing I-tien (personal communication, Email dated 20 February 2004): "*Citang* could be made of stone, earth, brick, or wood. Only the stone ones could survive the ravages of time."

18 One of the earliest extant accounts comes from Liu Changshi, *Lupu biji*, 2/8b, which puts the stones "within the grave mound" (see below); according to Yves Hervouet, ed., *A Sung Bibliography* (Hong Kong: The Chinese University of Hong Kong Press, 1978), p. 312, Liu's book "deals with the errors and omissions found in old and new books and enquiries into such errors." [NB: Liu lived after Hong Gua (d. 1184).] *Shishi* ("stone chambers") itself is the word used to name, as one scholar puts it, one of the "most enigmatic structures in East Asia," for it refers in the early sources to rock caverns as the homes of deities, Immortals, and the noble dead; to stone chambers or libraries for the

safe-keeping of state documents, steles, and ancestral tablets; to stone sarcophagi; and to boxes. One Han stone chamber for the safe-keeping of state documents still survives in Qinghai Province. See Nancy Shatzman Steinhardt, "*Shishi* (Stone Rooms)," forthcoming in a *festschrift* for Victor Mair. Dr. Steinhardt and I were working in parallel tracks on this question in 2003–4, as I discovered in June 2004. The debates on the significance of stone chambers continue, as can be seen from Lin Shimin, "Zhejiang yanhai tudun yicun tansuo," *Nanfang wenwu*, 1998.2, pp. 68–71.

19 See John Bowker, *The Meanings of Death* (Cambridge: Cambridge University Press, 1991), p. 209; Emily Vermeule, *Aspects of Death in Early Greek Art and Poetry* (Berkeley: University of California Press, 1979), p. 29. Bowker comments on the "frequently irreconcilable opposites [that] are maintained … in the same tradition"; Vermeule, on scholars' failures to read their texts sensitively. Sally F. Moore and Barbara G. Meyerhoff, eds., *Secular Ritual* (Assen: Van Gorcum, 1977), pp. 3–24, esp. 16–19, speak of "questions [driven] by the made-upness of culture."

20 It would be impossible to check every instance of *ci* to see if it ever functions as a noun (i.e., as a synonym for *citang*, as the electronic *Siku quanshu* turns up 116,761 instances of the word, and the *Song huiyao jigao* (see n. 22 below) lists thousands more. But in the many pre-Tang sources that I consulted when preparing this article, *ci* seems to be used verbally, aside from the names of sites found in sources like the *Shuijing zhu*,

which may represent later editorial insertions. My essay sets aside the cults to deities, to deified things, and to magicians claiming to be in regular contact with deities. Sima Qian, *Shi ji* (Beijing: Zhonghua shuju, 1959), 28.1379 has *wu* ("magus") offering cult below a hall. *Sanguo hui yao*, ed. Qian Yiji (Shanghai: Shanghai guji chubanshe, 1991), p. 241, is but one of many texts to record the worship of divinized or semi-divine persons who were "feared and loved" because of their achievements. Cf. *Huayang guozhi*, 3/2b, which speaks of the Shu people establishing cult (*li ci*) to a local Immortal.

21 Michael Loewe (personal communication) notes that in an "appreciable number of cases construction of a [stone] *citang* is described as *qi*, … clearly indicating an aboveground structure." See, e.g., Ban Gu, *Han shu* (Beijing: Zhonghua shuju, 1962) [hereafter *HS*], 59.2653, 68.2948, where the *citang* is awarded along with other marks of favor, such as seals and sashes, to nobles who had been ministers or regents. Cf. Fan Ye, *Hou Han shu* (Beijing: Zhonghua shuju, 1965) [hereafter *HHS*], 55.1801.

22 *HS*, 89.3643 refers to an imperial edict of 4 CE issued by the regent Wang Mang, which sanctioned the offering of sacrifices to "ministers and *shi* [whose meritorious service] had been of benefit to the people." This phrase is repeated in many later texts. Cf. Ying Shao, *Fengsu tongyi*, *Siku* edition, 2/6a, on "offering cult to those of merit" (*ci gong*); and Xu Song, *Song huiyao jigao* (Taipei: Xinwenfeng chuban gongsi, 1976),

p. 0767 (*Li*, 20.34a). Hsing I-tien, in a personal communication 20 February 2004, mentioned "people setting up *citang* for a magician"; Hsing refers, I believe, to *HHS*, 82B.2742.

23 Sima Guang, however, called his own ancestral shrine a *yingtang* ("image hall"?).

24 During Song, efforts to revive antique rituals spurred intense debates about their proper forms, which in turn spawned numerous ritual manuals, including the famous *Jiali* (*Family rites*) by Zhu Xi, who advocated a hall located within the family compound in which to honor the ancestors (especially members of the patriline) as represented by ancestral tablets. See Patricia Ebrey, *Chu Hsi's "Family Rituals": A Twelfth-Century Chinese Manual for the Performance of Cappings, Weddings, Funerals, and Ancestral Rites* (Princeton: Princeton University Press, 1991); and Ebrey, *Confucianism and Family Rituals in Imperial China: A Social History of Writing About Rites* (Princeton: Princeton University Press, 1991), pp. 53–56. Following Zhu Xi, in 1530 the emperor issued an edict to replace all portraits or statues of worthies in the "Confucian Temple" (*wenmiao*) with wooden tablets (*ci muzhu*). On Zhu Xi's attitude, see Kojima Tsuyoshi, "Jukyō no gūjōkan," *Chūgoku shakai to bunka*, vol. 7 (1992), p. 70. Linda Walton, *Academies and Society in Southern Song China* (Honolulu: University of Hawai'i Press, 1999), pp. 50–86, demonstrates that True Way Learning advocates sponsored the erection of many shrines to eminent figures; cf. Ellen Neskar, *Politics and Prayers: Shrines to Local Former Worthies in Sung China* (forthcoming, from Harvard East Asian monographs).

25 The Jiaqing emperor (r. 1796–1820) allowed commoners to worship up to four ancestors (not the *shizu*, or "beginning ancestor") but not to erect *citang*; but, this accommodation to current practice seems only to have set off a wave of further construction, as noted by Feng Erkang, *Zhongguo gudai zongzu yu citang*, p. 51. The institution of *jiamiao* for commoners burgeoned particularly in two areas where clans were especially strong: western Shandong (i.e., the very location under scrutiny) and south of the Yangzi River. For the Qianlong emperor, see "Xiangshe lun" in Qianlong, *Qing Gaozong* (*Qianlong*) *yuzhi shi wen quanji* (Beijing: Zhongguo renmin daxue, 1993), vol. 10, pp. 900–901. Mark Elvin in his "Female Virtue and the State in China," *Past and Present*, vol. 104 (1984), pp. 111–52, discusses the "democratization" of virtue (i.e., the extension of demands upon the working poor to exemplify hitherto elite virtues) in the eighteenth century, and the growth of commoner ancestral halls may be related to this phenomenon.

26 Cai Yong, *Du duan*, *Siku* edition, *shang* (A)/10a–11a.

27 See Wang Yi, *Chuci zhangju*, *Siku* edition, 3/1a, ascribing such customs to the pre-Qin Chu court.

28 One *citang* is mentioned in connection with a scholar's study in the Song topographical work Zhu Mu, *Fangyu shenglan*, *Siku* edition, 19/7a; and none in the other great Song work of the same type, Wang Xiangzhi, *Yudi jisheng*.

29 For the *Shuijing zhu* as a record detailing the loss of memorial sites, rather than a record of major monuments on the ground, see Michael Nylan, "Wandering in the Land of Ruins: The *Shuijing zhu* Reconsidered," in *Ethics, Religion, and the World of Thought in Early Medieval China*, ed. Alan K. Chan (Albany: State University of New York Press, 2008). The text of the *Shuijing zhu* has been greatly modified over the years, both to reinforce a sense of continuity from past to present and to make the text consistent with modern geographical notions.

30 Hong Gua, *Lishi*, 7/15b; 20/5a. Li Gang held the rank of *cishi* ("inspector"). Feng Gun acted like Zhu Mu (see below). Zhang Pu, a student of Huan Rong, became palace tutor for the *Documents Classic*; he later taught the heir, Liu Da (the future Emperor Zhang), and rose to become a duke, the highest position in the civil service. See also *HHS*, 2.113, for mention of an imperial cult.

31 See David Johnson, "Chinese Kinship Reconsidered," *The China Quarterly* (June 1983), pp. 362–65. Johnson notes the significance of innovations by Fan Zhongyan (of the charitable estate jointly owned by a corporate group of kin) and by Cheng Yi, who proposed that even commoners should worship the founding ancestors of their families in ancestral temples, which "took root rapidly … by Southern Song."

32 For Song Renzong's (r. 1022–1063) decrees, issued in connection with the suburban sacrifice, see, e.g., Ye Mengde, *Shilin yanyu*, *Siku* edition,

1/10b–11a; Wang Yong's (act. 1227) *Yanyi yimou lu*, *Siku* edition, 4/4b. For further information on Song practices, see Wang Shanjun, "Songdai de zongzu jisi he zuxian chongbai," *Shijie zongjiao yanjiu* 1999.3, pp. 114–24, esp. 116–17.

33 See also the prescriptions of Emperor Huizong (r. 1101–1126) concerning family temples that diverged from certain practices advocated by Cheng Yi and his successors in the True Way Learning movement. In Tang, however, it was still considered a signal honor for the emperor to confer upon an official family the right to construct a *citang* to honor a dead family member. See, e.g, Ouyang Xiu, *Xin Tangshu* (Beijing: Zhonghua shuju, 1975), 197.5630. For references to family shrines in Southern Song, see Bettine Birge, *Women, Property and Confucian Reaction in Sung and Yuan China* (Cambridge: Cambridge University Press, 2001), p. 78, citing the Vice Chancellor of the Directorate of Education Gao Kang (*jinshi*, 1131 CE).

34 The record becomes, not surprisingly, much clearer in Song. Linda Walton has written about shrines to sages and worthies (generally called *ci* or *shengci*, if dedicated to a living person) built in Song academies, as has Ellen Neskar in her thesis and forthcoming book.

35 For emperors, see n. 36 below. One can cite many instances of *citang* built for deities, for example in Sima Qian, *Shi ji* 28.1379 and *HS*, 25A.1210–11. Two classic works on the subject are still of great use: Yang Shuda, *Handai hunsang li su kao* (Shanghai: Shanghai yinshuguan, 1933), passim; and Yang Kuan,

Zhongguo gudai lingqin zhidu shi yanjiu, esp. pp. 30–39. (Where Yang lacks sources, however, he tends to conflate practices pertaining to quite different levels of society.) See also Ding Hongwei, "Zhongguo gudai de citang jianzhu," *Wenshi zhishi*, vol. 77 (November 1987), pp. 50–52.

36 For emperors, of course, a *miao* ("temple") and a *qin* ("resting place") were provided. For ancestor worship at the imperial level, see Michael Loewe, "State Funerals of the Han Empire," *Bulletin of the Museum of the Far Eastern Antiquities Stockholm* 71 (1999), pp. 5–72; also Loewe, *Divination, Mythology, and Monarchy in Han China* (Cambridge: Cambridge University Press, 1994), pp. 280–82. For temples erected to Marchmount deities whose worship was reserved to the ruling house, see, e.g., Shi Zhecun, annot., *Shuijing zhu beilu* (Tianjin: Tianjin guji chubanshe, 2000) [hereafter *SZC*], no. 65, pp. 99–100; no. 78, pp. 116–17; no. 148, pp. 211–12. For the *Shuijing zhu*, I have consulted various editions, of which I consider the best to be *SZC*.

37 See Shao Mingsheng, "Han You Zhou shuzuo Qin Jun shi que shiwen," *Wenwu* 1964.11, pp. 22–24, on the Qin Jun *que* pillar found near Shijing Shan, carved with a long inscription that ends, according to Xin Lixiang, *Handai huaxiang shi zonghe yanjiu*, p. 67, "Alas, it is not that I begrudge the effort and expense, but that I am constrained by the regulations" (not to build a *citang*). Shao Mingsheng transcribes the passage differently, however.

38 For "offering sacrifices according to the law" (*jisi rufa*), see *HS*,

72.3085; for the sumptuary regulations, see *Liji zhushu*, *Siku* edition, 5/24a. Whether and for how long sumptuary regulations were upheld in Eastern Han is still debated. Yu Weichao, *Xian Qin Liang Han kaoguxue lunji* (Beijing: Wenwu chubanshe, 1985) contends that tomb structures in both Eastern and Western Han were subject to imperial regulations; so does Huang Zhanyue, "Handai zhuhouwang mu lunshu," *Kaogu xuebao* 1998.1, pp. 11–34, esp. 11–12, 13, 27. Similarly, Li Falin and Xia Chaoxiong argue that grand mortuary structures could only have belonged to members of the imperial clan. See Li Falin, *Shandong Han huaxiang shi yanjiu* (Jinan: Qi-Lu shushe, 1982), pp. 86–92; and Xia Chaoxiong, "Xiaotangshan shi ci huaxiang niandai ji zhuren shitan," *Wenwu* 1984.8, pp. 34–39. Li Falin and Xin Lixiang disagree (and Jiang Yingju later joined the dispute), however, in Xin, *Handai huaxiang shi zonghe yanjiu*, pp. 107–13, largely on the basis of the Wu Family Shrines. See also Tang Changshou, "Minjiang liuyu Han huaxiang yamu fenxi ji qita," *Zhongyuan wenwu* 1993.2, pp. 49–54; and Lydia duPont Thompson, "The Yinan Tomb: Narrative and Ritual in the Pictorial Art of the Eastern Han (25–220 CE)," (PhD diss., New York University, 1998), pp. 118–19; 127–37. One possible new piece of evidence comes from a newly excavated site in Chang'an County (excavated 2005; reported March 2006), where a huge tomb has been found with no burial mound atop. Archaeologists in Xi'an (personal communication) speculate that

it belonged to a *waiqi* relative in disgrace, or to someone wealthy enough to construct such a tomb, but denied the right to build a mound over it.

39 A king of Rencheng was installed in the years 146–188 under Eastern Han.

40 See the "Li lun" chapter of the *Xunzi*, especially the opening passage, for the importance of sumptuary regulations enforced by law and the imperial will.

41 For further information, see A.F.P. Hulsewé, *Remnants of Ch'in Law: An Annotated Translation of the Ch'in Legal and Administrative Rules of the 3rd Century B.C. Discovered in Yünmeng Prefecture, Hu-pei Province, in 1975* (Leiden: Brill, 1985), p. 43, translating strip 44 from Shuihudi; p. 176, translating D140 regarding the distinction for those above and below 600 bushel rank, which text of the statute is then repeated in an edict of Huidi in 195 BCE, as Hulesewé notes.

42 Cf. the analysis of early Greek society as one where the noble *genē* monopolized cults; fought in wars and competed in games; laid down the laws; and "displayed their wealth at funerals and weddings." See Louis Gernet, "Notes de lexicologie juridique," in *Mélanges Boisacq I, Annuaire de l'Institute de philologie et d'histoire orientales et slaves*, vol. 5 (Bruxelles, 1937), pp. 391–98.

43 Both stories appear in Cai Yong, *Cai Zhonglang wenji*, *Siku* edition, 6/7a–8b, 6/34a–35a.

44 See, for example, the anecdote recorded in ibid., 6/30b.

45 *Liji*, "Liqi"; James Legge, *Li Chi: Book of Rites*, 2 vols. (New Hyde Park, NY: University Books, 1967),

vol. 1, pp. 411–12, with the last paragraph from "Jifa"; Legge, *Li Chi*, vol. 2, pp. 204–6. A similar hierarchy of ancestral temples appears in "Wangzhi"; Legge, *Li Chi*, vol. 1, pp. 223–24. For frank talk about the ruinous expenses of luxury burials, see *HHS*, 43.1481. For the refusal of a great officer to participate in sacrifices as a crime, see *HHS*, 43.1487.

46 *Zhangjiashan Hanmu zhujian (er shi qi hao mu)* (Beijing: Wenwu chubanshe, 2001) [hereafter *ZJS*)], strip 190 ("Zouyan shu"). For further information, see Michael Loewe, "The Laws of 186 CE" in *China's Early Empires: Supplement to The Cambridge History of China*, vol. 1, ed. Michael Nylan and Michael Loewe (forthcoming).

47 Translation modified from Mark Edward Lewis, *The Construction of Space in Early China* (Albany: State University of New York Press, 2006), p. 127, which adds his interpretation: "The hierarchical array of the extended households in front of all the ancestors could only take place *in an ancestral temple*, where all the relevant tablets were present" (italics mine). Lewis draws from Cui Shi, *Simin yueling jishi*, annot. Miao Qiyu and Wan Guoding (Beijing: Nongye chubanshe, 1981), p. 1. For other observances, see pp. 1, 25, 53, 84, 109.

48 Lewis, *Construction of Space*, p. 127, adds, "suggesting the ritual priority of the latter [i.e., offerings in the temple]." Lewis continues, citing cases in the imperial cult. This essay will not use evidence from imperial—or indeed, noble—cults, since it may be hard to extrapolate

practices from one sociopolitical sphere to another. But it does note, with Lewis, that in the *Simin yueling*, cult at the grave site is offered to a variety of recipients who are not close kin, including local officials, teachers, distant kin (*jiu zu*), and friends. Presumably it is to these grave site offerings that the standard Han phrase *qi zhong li ci, sui shi ci ji* refers.

49 *HS*, 62.2736.

50 *HHS*, 45.1533–34.

51 Chen Shou, *Sanguo zhi* (Beijing: Zhonghua shuju, 1959), 38.973.

52 *SZC*, p. 227. For further information, see Michael Loewe, *A Biographical Dictionary of the Qin, Former Han, and Xin Periods* (Leiden: Brill, 2000), pp. 454, 635–36.

53 *SZC*, pp. 227–28, entries 160–61. There are numerous examples of stones erected in honor of living officials, often for their work in irrigation. See, e.g., *HHS*, 43.1487.

54 *HHS*, 81.2679–80.

55 *HHS*, 81.2680.

56 Sima Guang, *Wenguo Wenzheng Sima gong ji*, *Sibu congkan chubian* edition (Taipei: Shangwu yinshuguan, 1929–34), 79/9a–13a. Cf. Gu Yanwu (1613–1682), *Rizhi lu*, *Siku* edition, 15/6b–7a, which says, "The men of Han moved the ritual of the *zongmiao* [ancestral temple] to the grave site. There were officials who reported matters to the grave mound…; there were cases of people who ascended the mound to meet with all their relatives in the lineage and clients; there were cases of people who ascended the grave mound as imperial offers who intended to supply grave goods for the dead;…there were cases of rulers who visited their officials' grave

sites...and of commoners who sacrificed at the grave sites of the worthy men of the past (*you shumin er ji gu xianren zhi muzhe*)." For examples where the Son of Heaven personally visited or sent envoys to visit the grave sites of members of the royal family (in the male or female lines) and the great officers (*wang gong, gui qi, gong chen*), see Li Rusen, *Handai sangzang li su* (Shenyang: Shenyang chubanshe, 2003), pp. 61–62. Li also mentions several sites, including Tomb 1 at Mancheng, where broken bricks and tiles may represent the remains of Han *cimiao* erected to honor nobles (ibid., pp. 62–63).

57 Sima Guang, *Chuanjia ji, Siku* edition, 71.2a; cf. Wei Liaoweng, *Heshan ji, Siku* edition, 48.1b–2a, which also speaks of offering cult to "former sages, former teachers, former worthies, and former elders." I am indebted to Miranda Brown for the latter citation. For senior officials in an area offering cult at the graves of former worthies, see *HHS*, 57.1852, where an inspector passing by the grave site of Li Yun offers cult and erects a stone to Li's memory.

58 Hans Bielenstein, *The Bureaucracy of Han Times* (Cambridge: Cambridge University Press, 1980), p. 19, based on *HHS, zhi* 25.3572.

59 In other words, it is likely that the New Year's day offerings were made in the home, not in a temple or worship hall, since no special site is mentioned for the assembly of relatives on the first day of the New Year's, in contrast to the explicit mention of grave site offerings.

60 At Tomb 1 at Mancheng (mid-Western Han) there are bricks on

which were inscribed the characters *simiao* ("cult temple"), but this, of course, was a tomb built for a member of the nobility, Liu Sheng. In Jiangsu, at Shiqiao, Xuzhou, there seems to have been found the remnants of a stone wall and also some Han-era patterned bricks, which have been tentatively identified as evidence for a temple (*you keneng yuan shi ci miao*); again, nobles lived in this area. See Xuzhou bowuguan, "Xuzhou shiqiao Han mu qingli baogao," *Wenwu* 1984.11, p. 38. At the same time, there is abundant evidence of open-air sacrifices (often libations) at grave sites and of libations performed within the coffin chambers, as we might expect. E.g., for the small brick coffin chamber and its lacquer cups for libation, see *Luoyang Shaogou Han mu* (Beijing: Kexue chubanshe, 1959); cf. Huanghe shuiku kaogu gongzuodui, "Henan Shan Xian Liujiaqu Han mu," *Kaogu xuebao* 1965.1, pp. 107–68. At Gansu Mozuizi the eared cups used for libations were on the coffin itself. See *Kaogu* 1960.9, pp. 15–30.

61 Yuan Hong (328–376), *Hou Han ji, Siku* edition, 15/10b. *HHS*, 86.2846 speaks of "an edict ordering that there be raised a *citang*, at which the people of the commandery raised a temple to sacrifice to the deceased," (*zhao wei qi citang, junren li miao ji zhi*) suggesting that *miao* and *citang* were used interchangeably by some. For later examples, see, e.g., Wei Zheng, *Suishu* (Beijing: Zhonghua shuju, 1973), 3.66, where the term is *ciyu*. In searching for these and related terms, including *ciwu, zongci,* and *cishi*, a pattern emerges: in many

cases such memorial structures were erected to those who have performed great services for the ruling house, as in *HHS*, 55.1803. So far as I can ascertain from the *Siku quanshu*, the term *zongci* was not used of commoner family worship before late imperial China. Modern usage is fairly sloppy. *Shandong Yinan Hanmu huaxiang shi* (Jinan: Qi-Lu shushe, 2001), p. 113, calls a structure a *miaoyu*, whereas *Zhongguo huaxiang shi quanji: Shandong Han huaxiang shi* 1 (Jinan: Shandong meishu chubanshe, 2000), no. 187, p. 61 (text), calls the same structure a *cimiao*.

62 *HHS*, 86.2846 (said of early Eastern Han, after the time of Wang Mang), 2853. For information about the erection of a *citang* in honor of Confucius, see *HHS, zhi* 20.3430, n. 3.

63 For the opposition between *citang* and straw-covered huts, see *HHS*, 45.1533.

64 See n. 51 above. Cf. *HS*, 89.3627, for devotions to Wen Weng.

65 Chen Shou, *Sanguo zhi*, 38.973.

66 See, for example, Xu Song, *Song huiyao jigao*, p. 0762. Also see ibid., p. 0765, for an example of a Song emperor mandating "discussions" about cults to worthy men of "proven efficacy" who were without rank or title; p. 0788, a Song emperor donating a plaque for a Han cult; p. 0789, a Song emperor giving a posthumous title for a pre-Han cult figure.

67 See Ouyang Xiu, *Jigulu* (comp. 1063), *Siku* edition, 9/2a. This belief that the men of Han were peerless continued for the rest of imperial China. Yao Nai (1732–1815) writes in his *Guwenci leizhuan, Siku* edition, "Xumu," 14a–b, for example: "Today

when I compile the rhythmic prose and the rhapsodies, I exclusively adopt the Han exemplars as standard. The [very notion of] *guwen* ("ancient prose") refuses to accept authors of the Six Dynasties, detesting their decadence…"

68 *SZC*, entry 232, for Jia Biao, whose commemorative site is located at the place where he served as prefect, rather than at his grave.

69 See Michael Nylan, "Wandering."

70 Shen Gua, *Mengxi bitan*, *Siku* edition, 19/3b–4a, reports the opening of a tomb mound (near Wuzhai Shan) attributed to the Eastern Han *dasitu* Zhu Wei (see below).

71 Sima Guang, *Wen guo Wenzheng Sima gong ji*, 79/9a–13a. Cf. Gu Yanwu, *Rizhi lu*, 15/6b (see n. 56 above).

72 The text is obviously much later. See Michael Loewe, ed., *Early Chinese Texts: A Bibliographical Guide* (Berkeley: Society for the Study of Early China, 1993) [hereafter *ECT*], pp. 477–82.

73 The *Rites* canons reserve for the local princes in an area the right and duty to offer this sort of sacrifice. See *Liji*, "Wang zhi"; Legge, *Li Chi*, vol. 1, p. 225.

74 For *huangchang ticou* or "barricade" construction, see Michael Loewe, "State Funerals of the Han Empire," *Bulletin of the Museum of Far Eastern Antiquities Stockholm* 71 (1999), pp. 38–42. According to sumptuary regulations, this sort of coffin chamber was reserved for the nobility.

75 Literally, half a *ren* (i.e., about four feet).

76 I have consulted several editions of the *Yantie lun*, and cite here Huan

Kuan, *Yantie lun jiaozhu*, annot. Wang Liqi based on Wang Xianqian version (1958; revised, Tianjin Shi: Tianjin guji chubanshe, 1983), *juan* 6, *pian* 29 ("San bu zu"), pp. 353–55. For dating, see n 72 above.

77 Loewe, personal communication (March 2006).

78 One might contrast this presumption with an assertion from Liu Zhen et al., *Dongguan ji* (cited in *HHS*, 8.684, n. 4). As Endymion Wilkinson notes in *Chinese History: A Manual* (revised, Cambridge: Harvard University Asia Center for the Harvard-Yenching Institute, 2000), p. 788: "Until the Tang this was regarded as the standard work on the Later Han. It was used as a main source by Fan Ye for the *Hou Hanshu*. Sixty percent of it was retrieved from the *Yongle dadian* by the *Siku* editors."

79 *Analects*, bk. 2, chap. 24 (James Legge, *The Chinese Classics* [reprint, Taipei: Southern Materials Center, Inc., 1985], vol. 1, p. 154) condemns the offering of cult to those above one's own family's rank. This statement is repeated in a great many Han texts, including the *Liji* and the *Fengsu tongyi*. In the *Zhouli*, male *wu* shamans are deputed by the court to undertake such sacrifices on its behalf.

80 The identification of the "rich" as dukes and ministers (*gong qing*), both of which were nobles, is made in the complaint registered in *Yantie lun*, *juan* 4, *pian* 18 ("Hui xue") that "the wealth and high ranked are laughing at *Ru*."

81 Yang Lien-sheng, in *Chinese Social History*, ed. E-tu Zen Sun and John De Francis (Washington, D.C.: American Council of Learned Societies, 1956),

esp. p. 121. (This essay is based on a 1936 *Qinghua xuebao* article in Chinese [11:4]). Cf. pp. 110–11, which speak of families "powerful enough to ask the princes to intercede for them with the emperor"; a descendant of a general given noble rank; and what Yang characterizes as "great pastoral lords," whose estates were centers of production (p. 115). As Yang describes them, these local "powerful families" could only ensure their status through contacts at court (pp. 116–19). Utsunomiya Kiyoyoshi, *Kandai shakai keizaishi kenkyū* (Tokyo: Kōbundō, 1955), defines *haozu* as those inclined to appropriate the fields of the poor (p. 445), and those who enjoyed economic and bureaucratic power (p. 446), so this term usually referred to the *waiqi* and sometimes to palace eunuchs (n. 67). Tsuzuki Shōko, "Rokuchō kizoku kenkyū genkyō," *Nagoya Daigaku Tōyōshi kenkyū gakuhō*, vol. 7 (1981), pp. 84–110, defines *haozu* simply as *guizu* ("nobles"). (For complaints against a eunuch who had the temerity to build two stone pillar-gates for himself, see *HHS*, 78.2523.)

82 *HHS*, 49.1637. Wang Fu, *Qianfu lun* (Shanghai: Guji chubanshe, 1978), 3.158, corresponds to this. For further information on the *Qianfu lun*, see Loewe, *ECT*, pp. 12–15; Étienne Balazs, "Political Philosophy and Social Crisis at the end of the Han Dynasty," in *Chinese Civilization and Bureaucracy: Variations on a Theme*, trans. H.M. Wright (New Haven: Yale University Press, 1964), pp. 187–225. That the building of *citang* by the imperial *waiqi* clans was still dangerous in the Tang becomes evident from

Sima Guang, *Zizhi tongjian*, *Siku* edition, 203/18b; 224/41b.

83 Sima Guang, *Chuan jia ji*, 79/1a–b. The term *guiren* can also refer to their wives, presumably, since most held rank at court.

84 "How to Read a Document," in *Sources of the West: Readings in Western Civilization*, ed. Mark A. Kishlansky (New York: Longman, 2003), pp. xi–xix.

85 William G. Baxter (private communication via Email, 16 March 2004), says that unquestionably the terms *ci* and *shi* were sometimes used interchangeably, even if nothing in Bernhard Karlgren, *Grammata Serica Recensa* (reprint, Taipei: Ch'eng-Wen Publishing Company, 1966), nos. 921 and 972, shows a clear connection between them. See Zhu Junsheng, *Shuowen tongshu shun dingsheng* (Taibei: Shijie shuju, 1966), vol. A, *juan* 5, pp. 125–26, 129, 179.

86 Wang Jianzhong, *Handai huaxiang shi tonglun* (Beijing: Zijincheng chubanshe, 2001). Xin Lixiang, *Handai huaxiang shi zonghe yanjiu*, pp. 71–73, proposes that since the *ci* of *citang* means to "offer sacrifice," the terms *miaoci*, *shitang*, *zhaici*, and *zhaishi* must be closely related. Brashier, "Thanatology," p. 153, says that *shitang* is simply a euphemism for the tomb. The precise relations among architectural and ritual terms are not yet fully understood, and transcription errors are not infrequent.

87 Jiang Yingju, "Handai de xiao citang," *Kaogu* 1983.8, p. 749. Chen Zhi, *Han shu xin zheng* (Tianjin: Tianjin remin chubanshe, 1979), p. 333, reports on a roof-tile end (*wadang*)

bearing the legend *shou citang dang*, which Huang Xiaofen, *Hanmu de kaoguxue yanjiu* (Changsha: Yuelu shushe, 2003), p. 272, seems to indicate was found within a tomb.

88 Jiang Yingju, ibid., p. 749, n. 6.

89 For a fairly complete list of inscriptions using the word *shitang*, see Xin Lixiang, *Handai huaxiang shi zonghe yanjiu*, p. 67; see also n. 86 above.

90 For the Xiang Tajun inscription, see Nagata Hidemasa, *Kandai sekkoku shūsei*, vol. 1, p. 84, entry 72; vol. 2, p. 118. Nagata, p. 84, notes the rarity of such a full heading, but then writes that "one can deduce" that a pair of stone pillars faced the front of the shrine. As noted by several stele experts, a cemetery marker would hardly need to stipulate the location of the cemetery in which it stood in such detail. Wang Zhuanghong, *Beitie jianbie changshi* (Shanghai: Shanghai shuhua chubanshe, 1985), p. 28, also notes that stele heads of the early period often omit place names and even family names, presumably because steles were placed in family cemeteries. The perfect rendering of the Ionic column capital suggests a time either (a) third or second century BCE (when Ionic columns were the height of fashion), (b) after Buddhism had come to China from parts of the globe in contact with the Mediterranean; or (c) after the arrival of the Jesuits (since Ionic columns were revived in the Renaissance). Attempts to provide a secure provenance for the Xiang Tajun inscription remain at the level of conjecture, as is clear from Luo Fuyi, "Xiang Tajun shi citang tizi jieshi," *Gugong bowuyuan yuankan*, vol. 2

(1960), pp. 178–80. In any case, if we are to follow the same high standards set by scrupulous archaeologists, we will exclude all unprovenanced or poorly provenanced pieces when formulating our theories about ancient cultures.

91 This statement was made in a July 2002 meeting with members of the Recarving China's Past team. Hu was speaking of sets of stones that are finished on both sides, unlike some of the stones from Wuzhai Shan.

92 See, for example, Doi Yoshiko, *Kodai Chūgoku no gazōseki* (Tokyo: Dōhōsha, 1986), pp. 103–17; Wu Hung, *The Wu Liang Shrine: The Ideology of Early Chinese Political Art* (Stanford: Stanford University Press, 1989), pp. 193–217; and Xin Lixiang, *Handai huaxiang shi zonghe yanjiu*, pp. 83–102, citing Nagahiro Toshio and others.

93 For fashions in joint and conjoint burials, see Han Guohe, "Shilun Han Jin shiqi hezang lisu de yuanyuan ji fazhan," *Kaogu* 1999.10, pp. 933–42.

94 Reports of such families figure largely in the standard histories, our main literary sources to date.

95 Cao Cao's proscription (215 CE) of such steles is well known. For a proscription ordering closure of all *citang* in the provinces except those connected with sacrifices to clouds and rain that "bring benefit to the people," see Fang Xuanling, *Jinshu* (Beijing: Zhonghua shuju, 1974), 105.2748. Li Fang, *Taiping yulan*, *Siku* edition, 589/10a records a Jin-dynasty proscription banning all *citang*, steles, stone markers, and stone animals.

96 "Shandong Jiaxiang Songshan 1980 nian chutu de Han huaxiang shi," *Wenwu* 1982.5, pp. 60–70. Fuller and revised reports can be found in Feng Zhou, "Kaogu zaji (er)," *Kaogu yu wenwu* 1983.3, pp. 98–100, and Hu Shunli, "Shandong Jiaxiang Han An Guo muci tiji taisui nian shibian," *Kaogu yu wenwu* 1984.4, p. 112, which note problems with the inscription. Jiang Yingju's reconstruction of the small shrines, which seems sound to me, has been challenged by Li Falin, "Guanyu 'Jiaxiang Songshan Han An Guo muci tiji taisui nian shidu' de yijian," *Kaogu yu wenwu* 1984.6, pp. 105–106. The Recarving China's Past team examined a great many stones in Shandong and Anhui for comparisons.

97 For Hu Yuanren, see Wang Buyi, "Anhui Su Xian Chulan Han huaxiang shi mu," *Kaogu xuebao* 1993.4, pp. 515–49, esp. p. 515. The above-ground shrine, having three sides but no roof, was reconstructed, based on traces of the stones and walls in the earth. One presumes the reconstruction is correct, but if the stones were found in the entryway, we may remember the conjectures of Hu Xinli.

98 Albert Dien (two personal communications, 11 February 2004) proposes that one very famous "stone house" (once routinely described as a shrine), recorded in Kojiro Tomita, "A Chinese Sacrificial Stone House of the Sixth Century A.D.," *Bulletin of the Museum of Fine Arts, Boston*, vol. 40 (December 1942), pp. 98–110, originated as a "sarcophagus."

99 Wu Hung, "A Case of Cultural Interaction: House-shaped Sarcophagi of the Northern Dynasties," *Orientations* (May 2002), pp. 34–41, written in consultation with Zheng Yan. For further information, see Gao Wen and Gao Chenggang, eds., *Zhongguo huaxiang shiguan yishu* (Taiyuan: Shanxi renmin chubanshe, 1996); Gao Wen, *Sichuan Handai shiguan huaxiang ji* (Beijing: Renmin meishu chubanshe, 1998); Luo Erhu, *Handai huaxiang shiguan* (Chengdu: Ba Shu shushe, 2002); Wang Yingtian and Liu Junxi, "Datong Zhijiabao Bei Wei mu shiguo bihua," *Wenwu* 2001.7, pp. 40–51; Li Zichun and Zhao Liguo, "Hebei Luan Xian chutu Dong Han huaxiang shiguan," *Wenwu* 2002.7, pp. 84–85; "Xi'an shi Bei Zhou Shi jun shiguo mu," *Kaogu* 2004.7, pp. 38–49.

100 Certainly today we have heated debates regarding recently discovered "stone chambers" (*shishi*). See Lin Shimin, "Zhejiang yanhai tudun yicun tansuo," *Nanfang wenwu* 1998.2, pp. 68–71. Opposing theories posit that the Zhejiang finds represent (1) the remains of dwelling places; (2) military installations (but these are not in the areas where Wu and Yue fought a lot); and (3) tightly secured graves (but so far the majority of sites do not contain skeletons or grave goods).

101 See "Shandong Jinxiang Xian faxian Handai huaxiang zhuan mu," *Kaogu* 1989.12, pp. 1103–9, pl. 7. For Han mortuary architecture, see Huang Xiaofen, *Hanmu de kaogu xue yanjiu*, esp. fig. 68 (nos. 4, 5).

102 See nn. 12 or 18 above.

103 Tony Barbieri-Low reports: "When I ran the simulations, I oriented the shrines to the northwest (as the tombs and towers face) and moved the sunlight through a full day, for different times of the year for Northeast China. I found that the sun only entered the shrine at the end of the day, during certain months of the year, and that it would illuminate principally the lower portion of the eastern walls, lower eastern part (left) of the back wall, and just illuminate the back niche (on some days)...." Of course, passersby could have used oil lamps and candles to see the images, as they did with the "tomb of the Han prince" said to be in the same area in early Qing (which went inexplicably missing after Huang Yi's finds), but both oil and beeswax were expensive.

104 The stone complex at Wuzhai Shan is dated to circa 150 CE, some three centuries before the practice of rubbing memorial stones supposedly began (ca. 4th century CE). Of course, wax candles and oil lamps could have been used to illuminate the scenes, but both forms of lighting were expensive. Certainly there exist cases where exquisite designs were produced that, given their locations, could not always have been read by the living. The Shang and Zhou bronzes have inscriptions that could not have been seen when the bronzes contained food or wine offerings. David N. Keightley, among others, therefore believes that the bronze inscriptions were meant to be read during elaborate ceremonies only by the ancestors who were themselves objects of cult. See David N. Keightley, "Marks and Labels: Early Writing in Neolithic and Shang China," in *Archaeology of Asia*, ed. Miriam T. Stark (Oxford: Blackwell, 2006),

pp. 177–201. Cf. the work of Tonio Hölscher on visibility in the classical cultures of Greece and Rome.

105 Zheng Yan, *Muzang bihua: hua gei shei kan* (originally sent as a personal communication from Zheng to Hsing I-tien, via Email, 23 September 2002); Miranda Dympna Brown, "Men in Mourning: Ritual, Human Nature, and Politics in Warring States and Han China, 453 BC–AD 220" (PhD diss, University of California at Berkeley, 2002), esp. pp. 178ff.; Michael Nylan, "Toward an Archaeology of Writing: Text, Ritual, and the Culture of Public Display in the Classical Period (475 BCE–CE 220)," in *Text and Ritual in Early China*, ed. Martin Kern (Seattle: University of Washington Press, 2005), pp. 3–49.

106 For Zhu Wei, see *Dongguan Han ji*, *Siku* edition, 14.1a. For further information on the *Dongguan Han ji*, see Loewe, *ECT*, pp. 471–73.

107 See Yu Weichao and Xin Lixiang, "Xiaotangshan Shici," entry in *Zhongguo da baike quanshu: kaogu xue* (Beijing: Zhongguo da baike quanshu chubanshe, 1986), p. 584; Ruitenbeek, *Chinese Shadows*, pp. 11–14, p. 86 nn. 4, 5, for the identification. For the definitive statement that "Xiaotang Shan is definitely not the shrine of Guo Ju," see Lao Gan, "Lun Luxi huaxiang sanshi: Zhu Wei shishi, Xiaotangshan, Wushi ci," *Lishi yuyan yanjiu suo jikan* 1939.8 (1939), pp. 93–127, esp. p. 100. Zhao Mingcheng in 1117 CE had already noted that the site could not mark the grave of Guo Ju, whom legend put some 450 km southwest of Xiaotang Shan. Note that the figure of Guo

Ju appears first not in the *Shiji* or *Hanshu*, but in the *Shuijing zhu*.

108 Bi Yuan et al., *Shanzuo jinshi zhi*, *Shike shiliao xinbian* edition (Taipei: Xinwenfeng chuban gongsi, 1977), 7/9a–b, "Xiaotang Shan huaxiang"; cf. in Cai Hongru, "Huang Yi 'De bei shi'er tu'," *Wenwu* 1996.3, "Feicheng Xiaotang Shan shishi tu" (Huang Yi colophon), pp. 75, 77, fig. 4. Huang Yi, according to the 1785 gazetteer, was also the expert called in to judge the calligraphic quality of the Zhu Wei inscriptions within a year of the discovery of Zhu Wei's shrine (see below).

109 Shen Gua, *Mengxi bitan*, 19/3b–4a. Zhu Wei, by virtue of his post, was a Han noble. In Song, extreme care was taken with depictions of social models, the appearance of high or low status, and robes and headgear of the different dynasties, as noted in Guo Ruoxu (d. ca. 1098), *Tuhua jianwen zhi*, in *Early Chinese Texts on Painting*, trans. Susan Bush and Hsio-yen Shih (Cambridge, Mass.: Harvard-Yenching Institute, 1985), p. 109.

110 For example Zeng Gong (1019–1083) in his *Yuanfeng tiba*, *Shike shiliao xinbian* edition, 1/10a–11b, tells us that when the typical Eastern Han auspicious subjects, such as "dragons, deer, the person receiving [sweet] dew, auspicious grain, and the trees with intertwining branches (*lianli*), all appear on stone carvings, we can know that they are not fake." The Han decorative program was entirely clear, in other words, to Song antiquarians.

111 For connoisseurs, see Wen-chien Cheng, "Drunken Village Elder or

Scholar-Recluse? The Ox-rider and Its Meanings in Song Paintings of 'Returning Home Drunk'," *Artibus Asiae* 2005.2, pp. 309–57. For philosophers, see Zhu Xi's commentaries to the *Rites* canons.

112 See Cai Hongru, "Huang Yi 'De bei shi'er tu'," "Jinxiang ti shishi zhi tu," p. 78, fig. 7, colophon by Huang Yi; this is reported in *Wenwu* 1996.3, p. 72. *Jining zhili zhouzhi*, facsimile reproduction of 1859 edition (Taipei: Taipei xuesheng shuju, 1968), 5/61a [p. 1059], notes that Marquis Zhu should have been buried in Chenliu. Perhaps the tomb occupant was somehow connected to Zhu Wei, rather than being Zhu Wei himself (?). See *HS*, 99C.4176–9, and *Dongguan Han ji*, 14.1a.

113 For two careful scholars' (Fairbank and Rowley) hesitations about the ascription to Zhu Wei and about possible recarvings, see Wilma Fairbank, *Adventures in Retrieval: Han Murals and Shang Bronze Molds* (Cambridge, Mass.: Harvard University Press, 1972), p. 127, n. 47. On hollow-tile "subterranean house" structures that resemble shrines and were found in Han tombs, see ibid., pp. 93–94.

114 For the first view, see Jessica Rawson, ed., *Mysteries of Ancient China* (New York: George Braziller, 1996), pp. 203–4, cpl. 106; and, for the second, Kenneth Brashier, personal communication, 8 June 2004.

115 After Xin Lixiang, *Handai huaxiang shi zonghe yanjiu*, fig. 43, p. 82; cf. Shin Risshō [Xin Lixiang], *Chūgoku Kandai gazōseki no kenkyū* (Tokyo: Dōseisha, 1966), fig. 41, p. 65. In 2003 Cary Liu (personal

communication by Email, 9 August 2007) examined this same stone and the group among which it was found (now in the Toyokan of the Tokyo National Museum). He is of the opinion that although the individual pictorial stones may date to the second or third centuries, they probably were found as scattered stones and manipulated to fit together into a shrine reconstruction. The architectural joints and parts of the backs are chiseled away to allow the slabs to fit together.

116 See *Shandong Yinan Han mu huaxiang shi*, p. 113; there it is labeled a *miaoyu* ("temple") by the editors. This might be the sort of structure that was built by one Huan Dian for a disgraced minister of Pei, for whom Huan built a mound and a *citang* (*HHS*, 37.1258). We simply cannot know.

117 We have ample evidence that the mourning practices of Han elites were utterly different from those of Ming and Qing. See Wang Xianqian, *Hanshu buzhu* (Changsha: Wangshi, 1900), 11/2b–3b, where two Qing scholars, Zhou Shouchang (act. 1750) and He Zhuo (1661–1722), ask why so few high-ranking officials in Han are recorded to have observed the three year's mourning period. The strict mourning required in late imperial China does not appear to have been in effect in the classical period. See Michael Nylan, "Confucian Piety and Individualism in Han China," *Journal of the American Oriental Society*, vol. 116, no. 1 (1996), pp. 1–27; cf. n. 4 above, for recent work distinguishing the lineage halls of late imperial China

from the worship halls in earlier periods.

118 Gideon Shelach, "Marxist and Post-Marxist Paradigms for the Neolithic," in *Gender and Chinese Archaeology*, ed. Katheryn M. Linduff and Yan Sun (Walnut Creek, Ca.: Alta Mira Press, 2004), p. 21. Shelach is discussing Neolithic archaeology, but the same may be said of much recent scholarship that assumes continuities over millennia.

119 *Songshi*, *Siku* edition, 123/14a.

120 Huang Yi may have had in mind the record by his ancestor Huang Ruheng of Wulin, which told of the stone *citang* erected to Yan Zhong, whose walls were carved with depictions of ancient sovereigns, loyal officials, and filial sons (with images to the right and captions to the left). The *citang* was reportedly made in the old Central States style. See Liu Tong (*jinshi* 1634), *Di jing jingwu lüe*, "Yan gong ci," in *Biji congbian* (Taipei: Guangwen shuju, 1969), vol. *xia*, 6/73b–75b; Sun Chengze, *Chunming mengyu lu*, *Siku* edition, 68/22b.

121 Fan Bangjin, "Guanyu Shandong Jiaxiang Han Wushi muqun jiazu ruogan wenti de tantao," *Shanghai bowuguan jikan* 4 (1987), pp. 377–83.

122 See also the entries on Zhang Yu and Liu Biao, in Zhao Yiqing, *Shuijing zhu shi*, *Siku* edition, 28/11a; Zhao Yiqing, *Shuijing zhu qian kanwu*, *Siku* edition, 4/10b. For Zhang Yu (act. 59–5 BCE), a Noble of the Interior (*Guannei Hou*), see Loewe, *Biographical Dictionary*, pp. 696–98; Liu Biao (d. 208) was a member of the imperial clan who strove to attain a position of preeminence in the last

years of Han. It is in connection with a miracle after his death that we learn of the *citang* built for Liu and his wife. See *Sanguo zhi*, "Weishu," 6.210–13.

123 Later traditions associated with Li's classic briefly mention only two other *citang* (neither known to be decorated).

124 For a translation of Qianlong's order, see Patricia Berger, *Empire of Emptiness: Buddhist Art and Political Authority in Qing China* (Honolulu: University of Hawai'i Press, 2003), pp. 68–69. Berger argues that Qianlong's order was not primarily to show off his connoisseurship, "but rather to memorialize what ha[d] fallen into ruin." Perhaps this explains why Qianlong did not bring the stones or rubbings associated with the Wu Family Shrines into his own collection.

125 For further information, see Han Seunghyun, "Re-inventing Local Tradition: Politics, Culture, and Identity in Early Nineteenth Century Suzhou" (PhD diss., Harvard University, 2005), esp. chap. 2. Steven B. Miles has discussed the events in 1811 leading up to the dedication of a new local shrine to a Han dynasty commentator, Yu Fan (164–233), by a figure whose mentor, as it happens, was Weng Fanggang. See Miles, "Celebrating the Yu Fan Shrine: Literati Networks and Local Identity in Early Nineteenth-Century Guangzhou," *Late Imperial China*, vol. 25, no. 2 (2004), pp. 33–73; in another essay Miles has talked about the "Rewriting" of the past that such events entailed.

126 For the depiction of the Seven Sages in a tomb near Nanjing, see Audrey Spiro, *Contemplating the Ancients: Aesthetic and Social Issues*

in *Early Chinese Portraiture* (Berkeley: University of California Press, 1990). The famous "Painted Basket" from Namjŏng-ri Tomb 116 (old Lelang Commandery, near present-day Pyŏngyang) has now been redated by Korean experts to the post-Han period, on the basis of earthenware found in the same tomb. See Yi

Song-mi et al., "The Archaeology of the Outlying Lands," in the forthcoming supplement to *The Cambridge History of China* (2007). Zhao Qi (d. 201) may have begun a trend among the literate elite, when he had himself portrayed in his tomb entertaining four legendary moral exemplars (*HHS*, 64.2124).

127 For the Mawangdui mourning diagram, see Guolong Lai, "The Diagram of the Mourning System from Mawangdui," *Early China*, 28 (2003), pp. 43–99; for the Zhangjiashan materials, see Michael Nylan, "Notes on an Illicit Sex Case from Zhangjiashan, a Translation and Commentary" (forthcoming in *Early China*, 30).

Composition, Typology, and Iconography of the "Sino-Barbarian Battle Scene" in Han Pictorial Images

(Abstract*)

HSING I-TIEN

The pictorial stone carvings from the Wu Family Shrines have attracted scholarly attention since the beginning of the twentieth century, and one of the most discussed themes in these carvings is the scene of the battle between the Chinese and the barbarians (*Hu Han zhanzheng tu*), hereafter the battle scene.

My study concerns the following questions:
1. What is the battle scene?
2. What is the evidence for interpreting the scene as a battle between the Chinese and the barbarians?
3. Do other types of battle scene exist?
4. What are the major pictorial components of the battle scene?
5. What kind of iconographic relationship exists between the battle scene and the main themes in the pictorial images, and what are the differences between them?
6. What are the purpose and function of the battle scene in Han mortuary architecture (tombs and offering shrines)?

Scholars in the past have given many diverse readings of the battle scene, based on different source materials, interpretative focuses, angles, and methodologies. After a brief summary of past scholarship, I will discuss this theme by analyzing the cartouches, compositions, typologies, and meanings of the battle scene in order to offer a new understanding of the iconography.

The pictorial program of the battle scene is very complicated; it comprises at least two parts, either combined in one setting or as independent units. The first unit is the depiction of the actual combat (*jiaozhan tu*), and the second unit shows the presenting of the prisoners of war (*xianfu tu*). The former describes victory over the barbarians, and it leads to the report of triumph and the

presentation of prisoners. The two themes are complementary, as they convey the same basic meaning. In addition, a hunting scene may sometimes also appear in the same pictorial frame as the battle scene, or nearby. Occasionally, the combat, the presentation of prisoners, and the hunting scene coexist and are mingled in the same picture frame, creating a rather intricate pictorial configuration.

A systematic analysis of the compositional program enables us to sort out the principal components of the pictorial images; these components express the fundamental ideas in the visual presentation of war. In the extant examples of these battle images in Han pictorial carvings, many subordinate or decorative elements unnecessarily complicate the visual contents, contributing to the seemingly variant typological models.

Depending on the degree of complexity, the battle scene can be classified into two modes: the basic mode and the compound mode. The basic mode refers to the compositional arrangement in which the images of the actual combat and presenting the prisoners are separate, and sometimes even respectively merged with other themes. The compound mode denotes a type of composite pictorial form, in which two or all images—the combat scene, the presentation of prisoners, or the hunting scene—are fused into a more elaborate visual program. These two modes can be further classified based on the presence or absence of background settings.

Whether in tombs or in shrines, the battle scene in Han pictorial stone carvings is invariably meant to describe the triumph of the Chinese over the barbarians, and the presentation of the prisoners intends to further glorify this victory. Their purposes are the same: together or separately, the depictions of the actual combat and the final delivery of the captured enemies are schematized images, designed to fulfill the common wishes and expectations of the Han people.

The original meanings of Han pictorial stone carvings were often obscured through layers of iconographies supplemented by different artists and patrons and employed at different locations. Moreover, as the basic schemes became standardized, the meanings of the core images were increasingly overshadowed and skewed by the heavy presence of the accumulating decorative forms. I am inclined to agree with the theory proposed by Professor Hayashi Minao, who argues that the battle scene reflects the prevailing longing of the Han Chinese to return to a peaceful life after warding off the incursions of the northern nomads. The fierce combat and capture of the prisoners not only signal victory over the enemies but symbolize the end of hardship and misery caused by heavy taxation in times of prolonged and constant wars. The theory is plausible, but regrettably it cannot be proved, owing to lack of concrete evidence.

The extant late Western Han to early Eastern Han examples of the battle scene images reveal quite a complex iconographic development, which can be understood as symbolizing the removal of obstacles to the journey into immortality; yet another interpretation may be that the battle scene exalts the "martial" spirit (*wu*), which was considered equal to the quality of "civil and literary" cultivation (*wen*) of an ideal public official. Both can be considered important functions of the battle scene, but we must also consider the possibility that other reasons and meanings may have prompted the inclusion of a battle scene in a mortuary setting. ○

*For the full article see Hsing I-tien, "Handai huaxiang *Hu Han zhanzhengtu* de goucheng, leixing yu yiyi," *Meishu shi yanjiu jikan*, gen. no. 19 (2005), pp. 63–132.

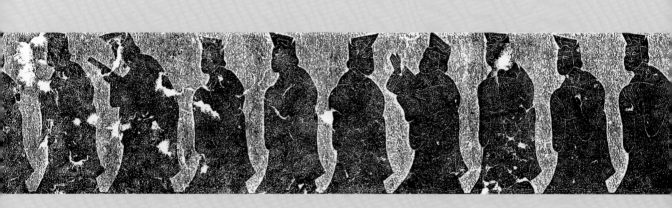

PART FOUR QING DYNASTY RECEPTION OF THE "WU FAMILY SHRINES"

Zeitgeist: The defining spirit of a particular period of history.
— *Oxford English Dictionary*

Huang Yi's *Fangbei* Painting

EILEEN HSIANG-LING HSU

In the fall of 1786 Huang Yi (1744–1802) traveled to Mount Ziyun in Jiaxiang County of Shandong Province to conduct a personal investigation of some stone halls (*shishi*) that were described in the local gazetteer as being "crumbled down," with slabs "scattered about."[1] In the gazetteer the stone halls were recorded to be in the vicinity of a Han prince's tomb, about nine miles (thirty *li*) south of Jiaxiang, and their walls were carved with pictorial images of historical figures and with auspicious signs. Something else that caught Huang Yi's attention was that the gazetteer report also mentioned "an old stele, with a hole [pierced through] it."[2] Prior to the trip he had sent craftsmen to the site to make rubbings of the stele inscription and the engraved images. Checking the rubbings against the epigraphic records, he concluded that the stele was dedicated to Wu Ban (d. 145 CE), a member of the Wu family of the Eastern Han dynasty, and that the pictorial stones were part of the offering shrine dedicated to Wu Liang (d. 151). In his subsequent trip to Mount Ziyun, he was able to further compare the rubbings with more than forty stone slabs that he unearthed and subsequently preserved in a newly-constructed hall on the site.[3]

Chinese archaeologists today often follow up on local records or word-of-mouth information by conducting scientific excavations, but two hundred years ago it was certainly not routine for individuals to organize trips in search of reported ruins. Huang Yi's expedition to Mount Ziyun was just one of many that he planned and carried out with the aim of finding and identifying inscribed stone tablets, and ancient writings engraved on mountain cliffs or temple walls. To achieve this goal, he also had to have the buried artifacts excavated. Known

as *fangbei* ("visiting" or "seeking steles"), a term already seen in travel literature before the Qing, these journeys became routine during Huang Yi's time and they reflected the prevailing cultural practice of acquiring new materials to advance scholarly research in the field of bronze and stone inscriptions (*jinshi xue*). Both *jinshi* scholarship and its concomitant *fangbei* travels had developed in earlier times,[4] but it was not until the Qing dynasty that they received the earnest and widespread support and participation of prominent government officials and members of local social elites. The importance of epigraphic documents was demonstrated by their proposed inclusion in the *Siku quanshu* (*Comprehensive library of the four treasuries*) project, the ambitious undertaking of the Qing imperial government with the goal of collecting and cataloguing all books ever published.[5] This massive program of collectanea was proposed in 1772 by the Hanlin academician and bibliophile Zhu Yun (1729–1781), who stipulated that "a complete catalogue of stone inscriptions" should be compiled along with the catalogue of books.[6]

Steles were the most common physical format in which stone inscriptions were produced in China. As cultural artifacts they were a ubiquitous visual symbol of history, which often evoked a poetic feeling of nostalgia for the past or, among scholars loyal to a lost dynasty, a deep and poignant sense of loss.[7] In keeping with their memorial function, steles were mostly erected as public monuments; as such, they were subject to damage from natural disasters, and the vicissitudes of dynastic change often left them unattended and unnoticed. They were occasionally sighted and rediscovered by accident, sometimes well cared for through isolated preservation efforts,[8] but often only to sink into oblivion again.[9] As unique embodiments of written history, inscribed steles were treasured

for their textual value, as they were believed to "have been written at the time of the events, and therefore can be totally trusted," as the renowned Song epigrapher and collector Zhao Mingcheng (1081–1129) stated.[10] Antiquarians and epigraphers of the Qing dynasty particularly sought to collect legible reproductions of stele inscriptions as primary research materials, which were held indispensable for scholars of "evidential studies" (*kaozheng xue*) who focused on precise etymological and phonological analysis of texts as a way to verify historical facts. The best testimony of this new focus is the assessment of Ouyang Xiu's (1007–1072) *Jigu lu* (*Record of collected antiquities*) by Gu Yanwu (1613–1682), the pioneering figure in this line of scholarly inquiry: "Far from being merely bits of high-flown rhetoric, they [i.e., stele inscriptions] are of actual use in supplementing and correcting the histories."[11]

Benjamin Elman's study of Qing intellectual history illuminates the research methodology crucial to *kaozheng* scholars: the careful gathering of original materials and culling and recording information from them in their notebooks. Gu Yanwu, for example, utilized all sorts of information, from local gazetteers to rubbings of stone inscriptions, to support his research.[12] Their commitment to textual study encouraged *fangbei* travels, and the literati were devoting much of their intellectual energy to obtaining and identifying unpublished stone inscriptions. The celebrated scholar, poet, and bibliophile Zhu Yizun (1629–1709), for example, traveled often and widely to historical sites seeking steles. It was this devotion to *fangbei* that motivated him to borrow a carriage from a visiting official in Taiyuan and take a special trip to Mount Meng, in Shanxi Province, returning with four rubbings of steles dating from the Northern Qi through the Five Dynasties.[13]

Huang Yi, the amateur archaeologist who discovered and identified the Eastern Han mortuary site of the Wu family, was perhaps the most active and successful practitioner of *fangbei*. Following the model established by Gu Yanwu, Huang compiled catalogues in which, for each rubbing, he noted the time and place of its examination, the name of its collector, as well as the year when he searched for and obtained a stele (*fanghuo souti*), or acquired a rubbing.[14] He also created paintings to celebrate some of the most memorable experiences and events associated with his epigraphic study and collecting. The *Debei shi'er tu* (*Twelve paintings of obtaining steles*; hereafter *Obtaining Steles*), an album in the collection of the Tianjin Municipal Museum of Art,[15] preserves for us invaluable visual evidence of his passion for procuring stele inscriptions. Moreover, the twelve exquisite pictures are accompanied by colophons written by Huang Yi and his close associate Weng Fanggang (1733–1818), a Hanlin scholar and competent calligrapher who also served as an editor for the *Siku quanshu* project. In both narrative prose and commemorative poems these colophons give further insight into the complex social structures and networks of connections that were the foundation of *jinshi* scholarship and antiquarian practice in the Qing dynasty. Before proceeding to the detailed examination of this album, let us first look at the life of Huang Yi, a unique eighteenth-century artist, collector, engineer, and amateur archaeologist.

A Literati Artist Obsessed with Antiquities

Born in Qiantang (present-day Hangzhou) as a descendant of a Ming-dynasty ranking official, Huang Yi nevertheless grew up in a family of meager means and moderate social standing. His father Huang Shugu (1701–1751) was an accomplished calligrapher, seal carver, and epigrapher, but he shunned public service and apparently lived most of his life to reflect his style name "Retired gentleman among pines and rocks" (*Songshi chushi*).[16] This humble background may have influenced Huang Yi's later career choice, because after his father passed away the family was struck by poverty and hardship, and he came to realize that teaching (*shegeng*, literally, "ploughing with the tongue"), a profession he might have contemplated at one time, could not afford him a living. He decided to embark on more practical pursuits, including criminal law (*xingming xue*), which won him immediate praise from peers at his initial jobs.[17] He may also have studied hydraulic engineering, and this useful skill later secured him critical positions in charge of waterway navigation and canal transportation in Henan and Shandong. According to a biographical account written by Weng Fanggang, Huang's training and experience in water control brought him "the promotion, in two terms, to the post of co-commissioner of the Canal in Yanzhou Prefecture (in present-day Shandong)."[18] This was not a particularly prestigious job, however, compared with those attained by many of his friends and associates. One reason for his relatively modest advancement in government service may be that he is not known to have passed any civil service examinations,[19] possibly because his family could not afford formal schooling. In any case, Weng Fanggang lamented that Huang's talent "should have brought him even higher offices and greater achievements, but it is a pity that they were not realized!"[20]

Despite economic constraints, Huang received a good education in painting and calligraphy from his father and learned to write poetry from his talented mother.[21] He also inherited his father's excellent skill in seal carving, and began at age nineteen to study with the Hangzhou artist Ding

Jing (1695–1765), both becoming members of the esteemed group later known as the Eight Masters of the Zhejiang School of seal carving. Huang carved with such ease, dexterity, and confidence that he was said to be able to "make several seals and present them as gifts while leisurely chatting with his friends."[22] He also excelled at painting, and perhaps even sold his works to compensate for his small income. In 1786, just one month before his trip to the Wu site, Huang Yi carved a seal and composed a *biankuan* colophon on it, asserting that, although he was adamant about not accepting "improper money" (*nieqian*), that is, money obtained by illegal or corrupt means,[23] he did not regard selling paintings as inappropriate.[24] Perhaps the best autobiographical reflection on his poverty-stricken life is the seal, "*Wo sheng wu tian shi poyan*" (literally, "Since I have no land [to harvest food], I eat my broken ink stone [to sustain myself]),[25] metaphorically implying that his livelihood may have indeed come from the market value of his art works. While working in Shandong, Huang's reputation as an expert in deciphering ancient inscriptions grew, as did the value of his paintings, for which the demand was so great that "even a sketch of a flower or a leaf could be pawned for money."[26]

Huang's traditional training in seal and clerical script calligraphy, standard writing forms in early China through about the third century CE, enhanced his visual acumen and knowledge of ancient scripts. Weng Fanggang recounted that his expertise brought him such a reputation that antiquities lovers would ask him to authenticate and identify the obscure and abstruse inscriptions and old carvings they had found.[27] The passion with which Huang Yi pursued his antiquarian hobby prompted him to carve at least two seals taking ironic pride in being "Addicted to bronze

Fig. 1 Huang Yi (1744–1802). "Addicted to bronze and stone inscriptions" (*Jinshi pi*). Seal impression. From Ding Ren, ed., *Xiling bajia yin xuan* (Shanghai: Shanghai guji chubanshe, 1991, reprint, 1995), p. 151.

and stone inscriptions" (*Jinshi pi*)[28] (fig. 1). His rich collection of antiquities included Han seals, ancient bronzes, and various artifacts, but rubbings of stone inscriptions were among his most cherished; as Weng Fanggang wrote, "Mr. Huang traveled as far north as the borders of Yan and Zhao, and as far south as Mt. Song and the Luo River.... Whenever he obtained a piece of old rubbing, his eyes lit up, and signs of rejoicing filled his cheeks."[29] Qian Daxin (1728–1804), another leading scholar in Qing evidential research, portrayed the *fangbei*-traveler Huang Yi in these lines:

With a pair of straw sandals and a pair of eyes,
 [Huang Yi travels];
Heaven entrusts this man [with the responsibility
 of finding] bronze and stele inscriptions.[30]

Like many eighteenth-century literati artists and antiquarians, Huang Yi also practiced epigraphic calligraphy, a form of aesthetic writing closely connected with the intellectual development of the seventeenth and eighteenth centuries.[31] His early training in clerical script calligraphy gave him an early exposure to old forms of stele inscriptions, and the expertise he had acquired from seal carving also helped him develop a connoisseur's eye in deciphering old-fashioned orthographies and sometimes even obsolete characters. In another

seal colophon he carved in 1786, Huang stated the mutually beneficial practices of epigraphic study and seal carving: "I have always had a passionate interest in epigraphy, and I also enjoy exploring the origins of seal and clerical styles of writing. Entrusting [this interest] to my hands and to the stone, I enjoy carving seals and giving them to friends as gifts, for making seals not only entertains my mind and spirit, it is also a means to test my knowledge and ability."[32] The archaic-style writings engraved on age-old stone surfaces naturally became a nurturing source for Huang Yi's artistic endeavor. The aesthetic and technical influence of epigraphic writing so penetrated his paintings and calligraphy that many later critics have remarked that his brushwork contains "a flavor of bronze and stone inscription" (*jinshi qiwei*). As I show below, the observation made by the eminent scholar-official Ruan Yuan (1764–1849), that Huang Yi's "passionate feelings and fondness for deep antiquity are conveyed through his elegant brush,"[33] is eloquently expressed in the paintings, inscribed calligraphy, and colophons of Tianjin Museum's album of *Obtaining Steles*.

"One Character Is Worth a Hundred Gold Cash"

One of the literati artist's creative hobbies is carving seals to celebrate special events or happy moments in his life, and Huang Yi was blessed with many such memorable occasions. The seal *Xiaosong suode jinshi* ("Bronze and Stone Inscriptions Obtained by Xiaosong [i.e., Huang Yi]") (fig. 2)[34] was made in 1775 to commemorate the installation in the Longhua Temple of an Eastern Han stele, which he had newly identified as being inscribed with a memorial on the sacrifices performed at Mount Sangong. The act of moving the stone stele, about 125 centimeters high and 62 centimeters wide, is the subject of *Moving the*

Fig. 2 Huang Yi (1744–1802). "Bronze and stone inscriptions acquired by Xiaosong" (*Xiaosong suode jinshi*). Seal impression. From *Zhongguo xiyin zhuanke quanji* (Shanghai: Shanghai shuhua chubanshe, 1999), vol. 3, no. 588 (p. 118).

Stele of Mount Sangong (*Sangong Shan yibei tu*) (fig. 3), painting in the album of *Obtaining Steles*. In a mountain valley, four men are seen carrying a large rectangular slab with two posts on their shoulders, walking towards a cluster of buildings nestled amongst hills and boulders. Stylistically the landscape scene is reminiscent of Huang Gongwang's (1269–1354) *Dwelling in the Fuchun Mountains* (fig. 4),[35] but the terrains were portrayed with different techniques. While the Yuan master used soft texture strokes to delineate the mountain village nestled in misty hills, Huang Yi applied them sparingly to suggest the dry northern plain in Yuanshi District, Hebei Province. The title of the painting is written, in clerical script, on the upper right corner, and its six well-proportioned characters demonstrate Huang's masterful brush in calligraphic art.[36]

Besides the title of the painting, Huang Yi also wrote a colophon, in a more naturalistic and informal standard script, giving the background of the event:

The mountains Fenglong, Sangong, Wuji, and Baishi are all in Yuanshi District, but among [the steles erected for sacrifices to these mountains during] the Han dynasty, the *Stele of the Divine Lord of Mount Baishi* is the only one that still remains. When I visited Nangong in 1775, I was received by Yang Hezhou of Wuxing in Yuanshi, so I asked him to look for stele inscriptions for me. He later obtained a rubbing of the *Stele of Sacrifice*

to Mount Sangong, with a date corresponding to the fourth year of the [?]chu reign-period. After [examining the rubbing, I realized that] its calligraphy displays a mixture of the seal and clerical scripts, and the literary style of its text is condensed and archaic; both features are different from [those of the Stele of Mount Sangong, as recorded in] the Lishi. The latter, dated in the fourth year of the Guanghe reign-period [181 CE], was made in the middle of the Eastern Han period. I then asked the magistrate, Mr. Wang Zhiqi, to have the stele moved and installed in the Longhua Temple, so

that it could forever stand together with the Stele of the Divine Lord of Baishi."[37]

The physical action of moving the heavy stone is obviously the visual focus of the painting, which documents the extraordinary effort taken to transport and restore an ancient monument newly uncovered and identified. As I have noted briefly above, Qing antiquarians believed that bronze and stone inscriptions, having been produced at the time of the events being commemorated, were valuable primary sources for their scholarly work.

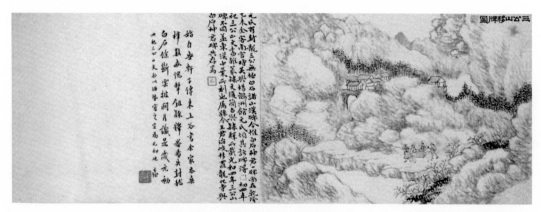

Fig. 3 Huang Yi (1744–1802). *Moving the Stele of Sangong Mountain* (*Sangong Shan yibei tu*). Album leaf; ink and light colors on paper; h. 18 cm, w. 51.8 cm. Tianjin Municipal Museum of Art. From Zhang Shulan, "Qing Huang Yi *Debei tu ce*," *Shoucangjia*, no. 17 (1996), p. 15.

Fig. 4 Huang Gongwang (1269–1354). *Dwelling in the Fuchun Mountains* (*Fuchun Shanju tu*), detail. Handscroll; ink on paper; h. 33 cm, w. 639.9 cm. National Palace Museum. From James Cahill, *Hills Beyond a River: Chinese Painting of the Yüan Dynasty, 1279–1368* (New York: Weatherhill, 1976), pl. 41.

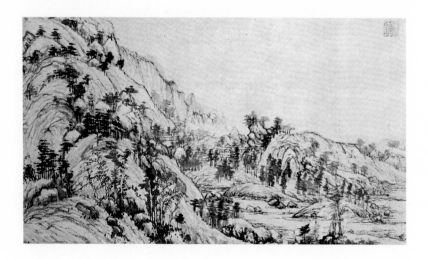

Zhu Yun's proposal in 1774 to include in the *Siku quanshu* a comprehensive catalogue of stone inscriptions essentially laid out detailed plans for the unprecedented imperial undertaking: "Rubbings should be made of all the steles and grave stone inscriptions of each province, sent to the capital, and collated and listed in a complete form."[38] Encouraged by the *Siku* proposal, local officials may have set out enthusiastically looking for stone inscriptions and collecting rubbings. Wang Zhiqi, the magistrate mentioned in Huang Yi's colophon, was in fact the person who first found the Sangong Shan stele, one year before Huang's visit, in 1774, on a deserted slope outside the district.[39] The condition of the stele at the time of discovery was quite poor, according to Huang Yi's report, and although the number of characters could be discerned, their precise compositional details were "almost indistinguishable (*ji bu ke bian*)."[40] Traces of the characters, however, were apparently still visible, because their unusual written form caught the eye of Yang Hezhou, a fellow stele lover mentioned in Huang's colophon, who was so intrigued and curious that he asked Huang Yi to try to decipher them. By his own account,[41] Huang was able to read 190 characters, and to recognize that it was a memorial text associated with the ritual sacrifices to Mount Sangong that took place in the Eastern Han dynasty, a dating based as much on the part of the reign-period name still visible, as on his knowledge of and artistic training in early calligraphy.

A skeptical reader would surely have questioned the credibility of Huang Yi's report. How could anyone possibly identify so many engraved characters carved on a stone almost sixteen hundred years earlier? Even Huang himself admitted that the task was challenging. What colophons and other writings may not have told us about, however, was the necessary and often tedious process of preparation needed before rubbings could be taken, a prerequisite of any attempt at accurate reading of old and damaged stone inscriptions. Without the assistance of modern equipment and technology for the repair and restoration of ancient artifacts, Chinese epigraphers, archaeologists, and collectors relied on the best tools and methods available to them. Epigraphic writings on *fangbei* or on reading inscriptions often mention the word *ti* (literally, "to scrape off," or "to remove") in the context of recovering engraved texts. The "knife" radical in the character indicates that a sharp tool was used to remove dirt and moss that had been accumulating in the incised character lines (most Chinese stele engravings are done in intaglio). Very often this procedure required thorough prior cleaning with water, since many steles had lain underground for centuries.

The painstaking process by which mud-covered characters engraved on old steles are miraculously revealed after cleaning, is vividly described in a poem by Ruan Yuan on Huang Yi's painting *He Menghua Washing a Stele* (*He Menghua dibei tu*):

Washing Han steles with care, as a single character
 carved on them is worth a thousand gold cash.
The traces [of the characters engraved on] the Shi
 Chen stele are completely revealed, and the
 engravings on its obverse, the Lu Xiang stele,
 can also be discerned.[42]
First we poured spring water onto bamboo leaves,
 then we boiled their whisks and tied the pine
 needles [into bunches?].[43]
After I washed the two stone figures,[44] the
 marvelous writings on them are now finally
 retrieved![45]

He Menghua (1766–1829) was an enthusiastic epigrapher and antique collector, and, like his friend

Huang Yi, scoured Shandong looking for stele inscriptions and making rubbings. He also worked as an assistant to Ruan Yuan, a Hanlin academician who was also one of the celebrated *jinshi* scholars and calligraphers of the Qing dynasty, and probably the most active advocate of epigraphic calligraphy.[46] Huang Yi did the painting to commemorate He's admirable effort to clean the Shi Chen stele in order to read the characters on its lower part.[47] The result of the cleaning must have seemed miraculous, for the Shi Chen stele as well as for other newly unearthed steles, transforming the engraved characters from "almost indistinguishable," as Huang Yi wrote of the Sangong Shan stele, to "marvelous writings finally retrieved." Promoted by enthusiastic scholarly engagement in evidential studies, the demand for stone inscriptions increased, as did the value of engraved characters. Ruan Yuan's analogy that "one character is worth a thousand gold cash," echoed in Huang Yi's own seal "One character is worth a hundred gold cash" (*Yi zi zhi baijin*) (fig. 5),[48] may have been hyperbole, but it certainly expresses their heartfelt reverence for ancient epigraphies that was a preponderant feature of Qing antiquarianism.

A similar cleaning process may also have been performed to enable Huang Yi to decipher close to two hundred characters in the fresh rubbings taken from the Sangong Shan stele, the first step in epigraphic work, crucial and indispensable to further scholarly examination. The careful, step-by-step philological and historiographical scrutiny of the inscription by Zhao Wei (*zi* Jinzhai; 1746–1825) and Weng Fanggang added much more information about the religious rituals performed to the sacred mountain Sangong, to what had previously been documented in Ouyang Xiu's *Jigu lu* and Zhao Mingcheng's *Jinshi lu* (*Record of bronze and stone inscriptions*), two paramount epigraphic classics of

Fig. 5 Huang Yi (1744–1802). "One character is worth a hundred gold cash" (*Yi zi zhi baijin*). Seal impression. From *Zhongguo xiyin zhuanke quanji* (Shanghai: Shanghai shuhua chubanshe, 1999), vol. 3, no. 614 (p. 127).

the Song dynasty.[49] Huang Yi's critical judgment, based on the stylistic discrepancy between the calligraphy of the stele found in 1774 and that of a different Sangong Shan stele recorded in the Song texts, as well as his initial reading of the former, guided Zhao Wei and Weng Fanggang in their further analysis of the texts, ultimately helping them to verify that the two steles were in fact erected sixty-four years apart, the former in 117 and the latter in 181.[50]

Huang's ability to discern stylistic subtleties in ancient calligraphic writings led him to make the important observation that "the calligraphy [of the Sangong Shan stele found in 1774] mixes [the stroke techniques of] the seal and clerical scripts," as written in his colophon to the painting. Weng Fanggang, an accomplished calligrapher himself, followed up on Huang's observation and elaborated on the technical aspect of this mixed style: "[It shows] a stylistic transformation from the seal to the clerical, by which the rounded winding turns of the seal script change into the straight lines of the clerical script. This intermediate style can be called the 'archaized clerical' (*guli*)."[51] Weng's visual scrutiny of the *Sangong Shan* inscription was made possible by his receiving a copy of the rubbing from Huang Yi, whom he met only later.[52] Weng expressed his gratitude in a poetic colophon written next to Huang's own (see fig. 3), acknowledging their mutual interests and collegial friendship. The *Moving the Stele of Mount Sangong* is a delicate painting (18 × 51.8 cm.), but it reflects the much

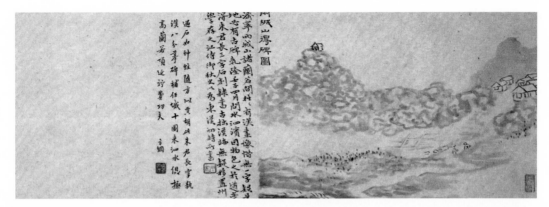

Fig. 6 Huang Yi (1744–1802). *Obtaining a Stele at Liangcheng Mountain* (*Liangcheng Shan debei tu*). Album leaf; ink and light colors on paper; h. 18 cm, w. 51.8 cm. Tianjin Municipal Museum of Art. From Zhang Shulan, "Qing Huang Yi *Debei tu ce*," *Shoucangjia*, no. 17 (1996), p. 17.

larger picture of dynamic intellectual and artistic interactions facilitated by the common interest of the Qing literati in stone inscriptions.

The great reverence of Qing antiquarians for engraved characters is best exemplified by another painting in the *Obtaining Steles* album, entitled *Obtaining a Stele at Liangcheng Mountain* (*Liangcheng Shan debei tu*) (fig. 6). In the serene mountainscape, mirage-like Buddhist temples are seen almost floating on the hills and boulders layered up in abstract formation. The painting's historicist reality is suggested only by the two small bent-over figures, a few slabs lying about, and the rice paddies vaguely visible farther beyond. This was a remote, perhaps even forgotten, world, but as Huang's colophon tells us, it was a world he believed to contain traces of writings engraved on stone. His conviction, search, and subsequent reward are described as follows:

Han pictorial stone carvings are occasionally seen scattered among the Buddhist temples on Liangcheng Mountain, in Jining, but it is a pity no inscriptions have yet been found. I have always suspected that there must be old steles at this mountain site. In 1792, on my trip to the Si River

area to examine the water conditions there, I found [an old stele] beside a road, which was inscribed with three characters: *zhu, jun,* and *chang*. Judging by their archaic and awkward (*guzhuo*) clerical-script calligraphy, there was no doubt that the inscription must be from Han times. The stele was then moved to the Academy....[53]

Unlike the Sangong Shan stele, on which Huang Yi uncovered a lengthy inscription, the slab from Liangcheng Shan contains only three characters (fig. 7), and they designate neither a reign-period nor a personal name. Despite this obvious lack of textual meaning, the slab was given a permanent installation at the Jining Academy, joining a number of monumental Han steles that had already been placed there earlier. The only merit of the characters was their "archaic and awkward-looking" form of clerical-style writing, inscribed on the lower right corner of the stone (approx. 110 × 80 cm.).[54] As the unrestrained and casual quality of these three characters suggests, Huang Yi was impressed by their seemingly effortless brushwork and stylistic simplicity that not only set them apart from the post-Tang schema, but also from the structured and formal writing commonly seen in Han memorial steles.[55]

Just as the scholars of classical learning were reviving the Han textual tradition, epigraphers and calligraphers were also turning to stone inscriptions of the Han as their source of inspiration and artistic models. The desire for genuine new pieces of ancient inscriptions was so strong that, based on aesthetic alone, Huang Yi even assigned a Han date for the *"zhu jun chang"* inscription, and Weng Fanggang agreed with Huang's assessment. The new discovery must have generated quite an exhilarating mood, attracting many admirers who rushed to the Academy to obtain rubbings. According to Wang Zhuanghong, a modern expert on stele inscriptions, rubbings made right after the installation include the colophons by Huang Yi, Weng Fanggang, and others, which were engraved directly on the stone, but many of their characters are already missing in later versions.[56] The classical scholars, however, were more cautious in their judgement of this newfound relic. On his official trip to Jining in 1795, Ruan Yuan carefully examined the *"zhu jun chang"* slab, and based on the chisel marks on the surface and the upper edge of the stone, he believed that the slab was probably broken from a

Fig. 7 Stone fragment with three engraved characters: *zhu, jun, chang*. Ink rubbing. Jining, Shandong Province. From Gong Xingyan, *Jining quan Han bei* (Jinan: Qi-Lu shushe, 1999), pl. 31.

mortuary structure.[57] As I have mentioned above, Ruan Yuan was an avid advocate of epigraphic calligraphy, and an accomplished calligrapher himself, but apart from a cautious speculation on the slab's origin, he offered no personal evaluation of its calligraphy, nor did he attribute a date to the three-character inscription. Huang Yi, in the end, was the single individual responsible for the resuscitation of the stone from its historical anonymity. The Cinderella story of the *"zhu jun chang"* slab took place on the stage of a Qing *zeitgeist*, without which the stone would probably still be lying on the Liangcheng Shan roadside.

Savoring Antiquities

In the Palace Museum in Beijing there is a very rare set of Song rubbings taken from texts of the Confucian Classics engraved during the Eastern Han dynasty; these rubbings have a prestigious provenance involving Huang Yi.[58] Known as the *Xiping shijing* (*Stone Classics of the Xiping reign*), the engravings were the first imperial undertaking in Chinese history to produce a complete and standardized canon for education in Confucian philosophy and thought. The texts were inscribed on both sides of about forty-six stone tablets and erected at the National Academy in Luoyang, capital of the Eastern Han.[59] Imperial efforts in later times continued to repair, revise, and replace parts of this massive library of monolithic books, but the majority of the stones had been lost. Except for fragments scattered in public and private collections, the only parts of the engraved texts to have been preserved are in the form of rubbings. Some of these rubbings are based on recarved stones of various recensions and qualities made in successive dynasties, and the earliest known versions are those from the Song period.[60] The Palace Museum rubbings were purchased by Huang

Yi in 1777 from Dong Yuanjing (*zi* Shizhi, act. 18th century), an official at the Ministry of Revenue, who had told Huang earlier about the prized artifact in his possession. Delighted by his special acquisition, Huang visited Weng Fanggang in the latter's studio to show him the rubbings, and the two men, meeting in person for the first time and in the company of other like-minded friends, shared a happy time together. *Viewing Stele Rubbings in the Pavilion of Poetic Surroundings* (*Shijing Xuan shangbei tu*), painting in *Obtaining Steles*, illustrates this felicitous gathering of literati artists and anti-quarians (fig. 8).

The serene wintry scene is delineated with Huang Yi's dry and delicate brushwork in very light ink, as if any extra touches would spoil the scholar's quiet meditation on the past. A literati artist trained in the southern tradition of painting the misty landscape of the Yangzi delta, Huang Yi had a reputation for being frugal with his ink. The nineteenth-century collector Li Yufen (act. 1865–1897), for example, has remarked that Huang was "so careful with ink that he used it as if it was gold" (*xi mo ru jin*), and that by applying it economically his paintings would display "a unique sense of spirited resonance."[61] This album

leaf is the best example of Huang's dexterity in composing a crystallized, self-contained scene with minimal use of ink and water. Except for a few tree branches framing the ends of the courtyard wall, and the mountain ranges so far and distant that they are hardly visible, there are almost no other depictions of natural elements, as if their presence would have been too intrusive for the occasion. The poetic surroundings of the scholar's retreat are so clear that the guests' envious excitement is almost palpable. Scholarly gatherings are a common theme in Chinese literati painting, but the *Viewing Stele Rubbings* was celebrating a unique moment. Huang's colophon tells the story:

In 1777 I was selected to go to the capital.[62] Dong Shizhi, of the Ministry of Revenue, once said to me that he had in his possession three rubbings of the *Xiping Stone Classics*, containing passages from the *Classic of Documents* and the *Analects*. They were mounted on one sheet and inserted in an album, but he had not been able to locate it for some time. Since I had often inquired about them, he finally searched them out and gave them to me as a gift.[63] I took them to Weng Fanggang's *Studio of Poetic Surroundings* and happily enjoyed them with a few

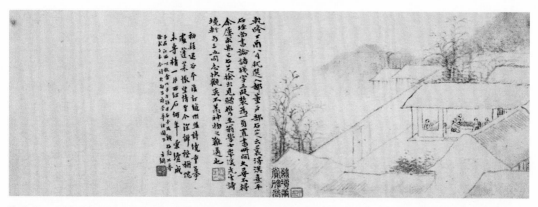

Fig. 8 Huang Yi (1744–1802). *Viewing Stele Rubbings in the Pavilion of Poetic Surroundings* (*Shijing Xuan shangbei* tu). Album leaf; ink and light colors on paper; h. 18 cm, w. 51.8 cm. Tianjin Municipal Museum of Art. From Zhang Shulan, "Qing Huang Yi *Debei tu ce*," *Shoucangjia*, no. 17 (1996), p. 15.

other like-minded friends, who could not conceal their envy, for it is indeed quite difficult to chance upon such a 'divine' treasure as [these rubbings].[64]

So memorable was the opportunity to procure antiquities of this rarity that Huang wrote the title of the painting in seal script (see fig. 8), an archaic form of early Chinese writing predating even the script used to carve the texts of the *Stone Classics*. The choice of the seal script must have not been a casual one, because its orthography is sometimes quite different from that of later forms, requiring not only special training in brush technique but also sufficient knowledge of paleography. Several Qing literati scholars and artists devoted their calligraphic practice to seal-script writing and became experts; one was Qian Dian (1744–1806), a relative of Qian Daxin, whose colophon embellishes the commemorative portrait of Huang Yi (fig. 9), painted by Yu Ji (1738–1823).[65] Holding the album of the *Xiping Stone Classics*, Huang's seemingly calm demeanor cannot conceal the satisfaction and excitement of a zealous collector having just acquired his dream treasure. Qian Dian's handsome seal-script calligraphy, which reads, "Small portrait of Huang Yi, age thirty-six, at the time of obtaining the [engraved] characters from the Han *Stone Classics*," lends a subdued sense of ceremonial elegance to the painting.

Huang Yi's exquisite rendition of the scholar's gathering at the Pavilion of Poetic Surroundings followed the traditional formulas in theme and style of his literati predecessors, but it was not created merely to express some poetic ideas or philosophical thoughts. Rather, like his friend Yu Ji's painting, it documented a triumphant moment of both personal and social significance in Qing intellectual history. Huang's acquisition of rare rubbings of the *Xiping Stone Classics*, more than any other stone inscriptions,

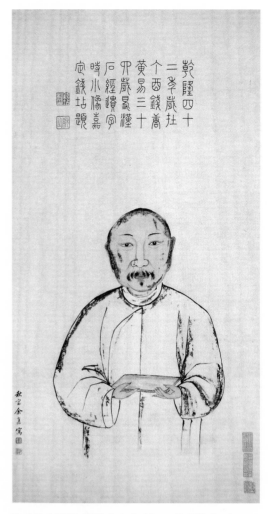

Fig. 9 Yu Ji (1738–1823). *Portrait of Huang Yi*. 1777. Hanging scroll; ink on paper; h. 78 cm, w. 41 cm. From *Chinese Classical Paintings and Calligraphy*, auction catalogue, China Guardian (13 July 2003), lot 118.

was particularly memorable, not only because very few such antiquities were known to have survived, but also because they were the very embodiment of the orthodox Confucian teaching established in the Han dynasty. It was this form of classical learning, or *Hanxue*, that Qing scholars and researchers intended to revive, and the acquisition of Song rubbings of Han imperially sponsored *Stone Classics* was the quintessential objective of their scholarly endeavor.

Huang Yi's passion for and ability to retrieve steles and decipher obscure inscriptions won him the high regard of many giants of Qing officialdom and academia, despite his humble social and economic background. In the fall of 1777 Zhu Yun, chief proponent of the *Siku quanshu* project, and Huang Yi got together in Beijing to visit private collections and shops in search of Han seals; Huang also invited Zhu to view the rubbings of the *Stone Classics* he had just acquired.[66] Presenting seals as gifts was another means by which Huang forged social relationships with the luminaries of his time. In 1776 a rare Song edition of an anthology of poems by Su Shi (1037–1101), one of the most brilliant literati artists and men of letters in Chinese history, entered the collection of Weng Fanggang, who then asked Huang Yi to make a seal to be impressed on the book's title page.[67] As Weng was then working as an editor for the *Siku quanshu* project, and the two had still not met in person, Huang humbly, and with great joy, expressed his gratitude: "[by being attached to the anthologies of Ouyang Xiu[68] and Su Shi], my little seal is to be handed down in history. How exciting that [Mr. Weng and I] came to know each other through our shared interest in savoring antiquities (*wei gu you yuan*)!"[69] For Huang, ancient stone inscriptions preserved in rubbings were the inspiration for his artistic creation,[70] and for classical scholars, they yielded additional and invaluable information to supplement the knowledge they acquired from transmitted texts.

An old means of reproducing multiple copies of engraved texts and images, ink-on-paper rubbings had been made in China as far back as the sixth century CE.[71] During the Song dynasty rubbings were studied, made, and collected mainly for their textual value, contributing to the first flourishing of *jinshi* study in Chinese history. No

scholarly examinations of stone inscriptions in the Qing could begin without making references to the major Song epigraphic classics. Curiously, although the Song masters were studying inscriptions from rubbings, they did not show much concern for the stones themselves, from which their research materials ultimately derived.[72] In the Ming dynasty stele rubbings were collected along with other traditional objects of desire, such as jades, bronzes, and paintings, and their values also resided in their inscriptions. Ming scholars, however, did not much advance in the field of epigraphy, resting content with the achievement made during Song times.[73]

The intellectual milieu of the seventeenth and eighteenth centuries was decisively different from that of the Ming. The new scholarly *kaozheng* methodology and the flourishing of *jinshi xue* offered both the incentive and necessity for retrieving as many ancient writings as possible. The common practice throughout Chinese history of making recarved stones based on rubbings, both potentially many generations removed from the original versions, made connoisseurship of rubbings particularly challenging in this period.[74] Competitive and aggressive collecting of stone inscriptions prompted exchanges and circulation of rubbings, mostly as social tokens among friends, but also through commercial transactions. The value of rubbings, especially those of Han inscriptions, increased because of their higher desirability and scarcity; they also became the subject of intense aesthetic scrutiny.[75] It was not surprising that Huang Yi regarded the delicate small album of the *Xiping Stone Classics* he held in his hand as a "divine object," because, as the great epigrapher Wang Chang (1725–1806) concurred (when Huang Yi showed him the album): "the shining texture of its paper and the sheen of its ink, deepened by age, reflects its quality of enduring antiquity. These

rubbings are truly rare treasures unmatched by anything in the world."[76]

"Mad about Steles"

Huang Yi carved a number of seals to express his devotion to epigraphic collecting. In addition to the "Addicted to bronze and stone" and the "One character is worth a hundred gold cash," already mentioned above, he also made the seal *Bei chi* (literally, "Mad about steles") and impressed it on a hanging scroll of calligraphy which he wrote transcribing the famous Han cliff inscription in Shaanxi Province entitled *Eulogy on the Stone Gate*

(*Shimen song*).[77] Indeed, as implied in the *bing* (illness) radical for both the characters *chi* and *pi*, Huang Yi's impassioned pursuit of antiquities must have been so intense as to be almost pathological. Two paintings in the *Obtaining Steles* album, the *Cleaning the Stone Shrine Hall in Jinxiang* (*Jinxiang ti shishi zhi tu*; hereafter *Stone Shrine Hall in Jinxiang*) (fig. 10) and *Searching for Steles While Praying in a Cemetery* (*Dao mu fangbei tu*; hereafter *Praying in a Cemetery*) (fig. 11), portray his trips to two cemetery sites in Shandong.

The so-called stone shrine hall in Jinxiang is first mentioned in the *Commentary on the*

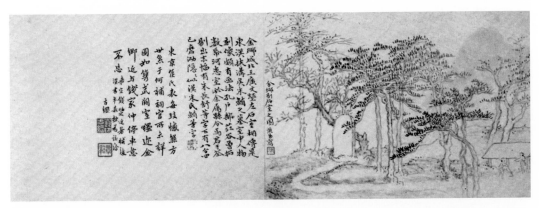

Fig. 10 Huang Yi (1744–1802). *Cleaning the Stone Shrine Hall in Jinxiang* (*Jinxiang ti shishi zhi tu*). Album leaf; ink and light colors on paper; h. 18 cm, w. 51.8 cm. Tianjin Municipal Museum of Art. From Zhang Shulan, "Qing Huang Yi *Debei tu ce*," *Shoucangjia*, no. 17 (1996), p. 16.

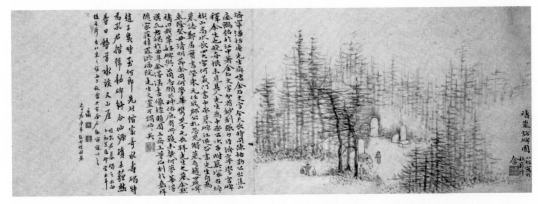

Fig. 11 Huang Yi (1744–1802). *Searching for Steles While Praying in a Cemetery* (*Dao mu fangbei tu*). Album leaf; ink and light colors on paper; h. 18 cm, w. 51.8 cm. Tianjin Municipal Museum of Art. From Zhang Shulan, "Qing Huang Yi *Debei tu ce*," *Shoucangjia*, no. 17 (1996), p. 17.

Classic of Waterways, as a stone temple (*shimiao*) located near the cemetery of Zhu Wei, a Han military official.[78] The Song anthology *Mengxi bitan* (*Miscellaneous jottings in Mengxi*) by the erudite scholar-official Shen Gua (1031–1095) contains a fairly detailed description and commentary on the pictorial images carved on its walls.[79] In his report on the trip to Mount Ziyun, Huang Yi commented on the similarity of architectural style between one of the Wu Family Shrines and the Zhu Wei shrine in Jinxiang. Based on this report, Jiang Yingju and Yang Aiguo, two archaeologists in the Shandong Stone Carvings Museum, believe that Huang had visited the Zhu Wei shrine before 1786, the year he uncovered the Wu Family Shrines.[80] Huang Yi recounted his trip to the Jinxiang site in the colophon to the *Stone Shrine Hall in Jinxiang*:

The stone hall on the left side of the Wang Guangwen tomb, north of Jinxiang District, has been said to [be part of] the cemetery compound of Zhu Wei, Duke of Fugou of the Eastern Han dynasty. The figures carved on its walls are rendered with good skill, of which Kong Honggu [i.e., Kong Jihan, *jinshi* 1771] made a few sheets of rubbings earlier. Since the hall has been flooded, I asked the magistrate, Ma Yuquan, to clean it and remove [the mud and dirt from the walls]. The rubbings taken after the cleaning reveal a few characters, including *zhu, chang, shu,* and others. Below them are characters in *bafen* [i.e., clerical] script, four of which are already eroded and illegible. However, those still visible seem to suggest the characters *zhu, shi*, and *wei*.[81]

Before Huang Yi cleaned the stone hall in Jinxiang, it was a structure on the cemetery site of Zhu Wei that had only been known in literary sources; no epigraphers or other travelers after the Song were known to have done any on-site investigations. With the assistance of local officials, once again, Huang was able to make fresh rubbings, enabling more characters to be deciphered. In another colophon, Huang reported that a "better and clearer" rubbing reveals the characters *Han, wei,* and others, based on which he then speculated that Changshu might have been Zhu Wei's style name.[82] Carvings of pictorial images in the Zhu Wei shrine have also been known through rubbings; regarding these, Ruan Yuan noted that the human figures appeared to be wearing Tang-style garments. He then noted that "perhaps the carvings were added by Zhu Wei's descendants in Fugou as a way to honor and remember him."[83] Weng Fanggang also pointed out that the images "do not quite correspond with what is described in the *Mengxi bitan*."[84] These comments on the anachronism between the pictorial carvings and historical sources demonstrate that Qing scholars were meticulous in their examination of epigraphic materials, and that their efforts may not have been possible had Huang Yi not secured better and newer rubbings. The different purposes of Huang Yi and his Hanlin associates in their approach to steles—the former single-mindedly focusing on inscriptions and the latter regarding the carvings in broader historical contexts, further illustrate the obsessive nature of Huang's pursuit of inscribed antiquities.[85]

Praying in a Cemetery commemorates a special trip taken during the Qingming Festival in 1793 to the tomb in Jinxiang of Pan Zhaolin, a distinguished seventeenth-century scholar-official and epigrapher. While serving as the district magistrate in Tianchang, in present-day Anhui Province, Pan participated in the recovery of the stone fragments of the famed cliff inscription *Eulogy on Burying a Crane* (*Yihe ming*) from the

Yangzi River.[86] Pan Zhaolin was widely respected for his scholarly dedication and lofty personality, and his burial ground on the site of the Pan family cemetery was marked by tomb steles and epitaphs honored with the calligraphies of prominent figures of the time. His epitaph was inscribed by He Zhuo (1661–1722), a distinguished bibliophile, scholar of textual criticism, and book collector in the early Qing period.[87]

After giving a brief biographical account of Mr. Pan, Huang Yi's colophon to the painting states the purpose of his visit to the Pan family cemetery site:

On the Qingming festival in 1793, He Menghua, his son Yuanchang, and I went to pay our respects at the grave of Pan Tian'an [i.e., Pan Zhaolin]. Silently I prayed [to Pan's spirit]: 'We all share the same deep interest in epigraphy, as you once did. May your spirit bless us with more harvests of engraved inscriptions.' Soon after this trip He Menghua found the stele of Kong Jun in Qufu. I also obtained the inscriptions with the characters *zhou wang* ["King of Zhou"] and *qi wang* ["King of Qi"] in Suijia Zhuang, in Jiaxiang, which were later moved to the Hongfu Yuan Buddhist temple. Mr. Pan's spirit is truly luminous![88]

In his succinct and soft brush strokes Huang Yi rendered in shades of ink his trip to "sweep the grave," as the Qingming Festival is commonly known in China. The three large tomb steles are set in a central clearing bordered with leafless trees receding into the distance (see fig. 11). The visual impression is that of a mixture of reality and dream, tangibility and evanescence, present and past. Although "steles" are by and large the prominent feature in many of Huang Yi's *fangbei* paintings, their iconographic significance in those works is in many ways very different from that of the steles in

paintings with the title *Reading a Stele* (*Dubei tu*), a minor genre that first appeared in Song catalogues. For example, two works by the tenth-century master Li Cheng (919–967), entitled *Reading a Stele by Pitted Rocks* (*Dubei keshi tu*), are included in the *Xuanhe huapu* (*Catalogue of the Xuanhe imperial painting collection*).[89] In addition, records in literary anthologies suggest that paintings with such titles as *Reading a Stele*, or *Reading a Stele by the Cao E River* (*Cao E jiang dubei tu*) received considerable attention from Yuan and Ming literati scholars and artists. Their commentaries and poems unquestionably identify the subject of the paintings as that of the Three Kingdoms period general Cao Cao (155–220) reading a commemorative stele of Cao E (d. 108), a filial daughter who drowned in an attempt to retrieve the body of her father. But besides the nominal mention of Cao E's filial virtue, the Yuan and Ming authors spared few words praising the wisdom of Yang Xiu, a quick-witted assistant who accompanied the general.[90] The attraction of the paintings about which the commentaries and poems were written, in fact, resides in the anecdotal tale that it was Yang who outpaced Cao Cao in decoding the eight-character anagram inscribed on the back of the Cao E stele.[91]

As Peter Sturman has pointed out, the story of Cao Cao reading the Cao E stele has for centuries been erroneously identified as the subject of a later version of Li Cheng's *Reading a Stele by Pitted Rocks*,[92] now in the Osaka Municipal Museum of Art (fig. 12). The steles in Huang Yi's *fangbei* paintings, by contrast, are themselves the *true* protagonists of the visual representation, being the very objects materially transformed from partial ruins, barely visible, to reclaimed cultural properties of historical significance. As I have discussed briefly elsewhere, in two other leaves of the *Obtaining Steles* album, *Erecting the Steles in the Jining*

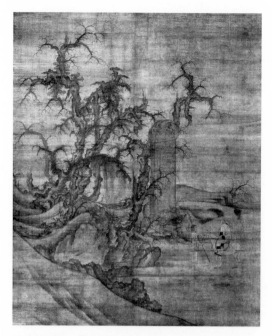

Fig. 12 Li Cheng (919–967), attrib. *Reading the Stele by Pitted Rocks*. 14th century. Hanging scroll; ink and light colors on silk; h. 126 cm, w. 104.9 cm. Osaka Municipal Museum of Fine Art. From *Chinese Paintings in the Osaka Municipal Museum of Fine Art* (Tokyo: Asahi shinbun, 1975), vol. 2, p. 16.

Academy, and *Searching for Steles on Mount Ziyun*, Huang Yi documented his amateur archaeological work with carefully drafted pictorial details and contextual accuracy.[93] From the Zheng Jixuan stele being lifted up by ropes (in the former), to the Wu Ban stele and crumbling slabs scattered in the field (in the latter), there is nothing metaphoric about the imagery: the paintings are realistic illustrations of important events in the life of the artist. These paintings are biographical vignettes of the painter Huang Yi (who is present in almost all of them), and the central theme is concrete and consistent. In his *fangbei* paintings Huang and his friends who contributed to the colophons are active participants in historical moments wherein the past is brought closer in order to define the present, as opposed to the *dubei* paintings, in which both the painter

and his later followers (viewers and painters alike) are traveling back in time to different historical points.[94] Huang Yi's preservationist and therefore forward-looking attitude, reflected in his colophons bearing such hopeful expressions as "so that it can be standing together forever with…", and "so it can be passed down and preserved for a long time," was compatible with the intellectual spirit of his age. His practical action, of having the recovered stones moved to safe locations or installed together with other monuments, realized the profoundly influential slogan, "*shi shi qiu shi*" ("searching for the truth in actual facts"), which set the course for much of late Qing intellectual pursuit.[95] Huang Yi may not have been a degree holder and classical scholar, but he was nonetheless a literatus whose artistic and cultural activities were very much conditioned by the defining spirit of his time.

"Steles Known Through Paintings": Huang Yi's Legacy

In her study of the late Qing scholarly community, Shana Brown describes the social life of the eighteenth-century elite as being "epitomized in the semiofficial circles of patronage and pedagogy which grew up particularly in the latter half of the century. In these circles, contacts were made, personal bonds were cemented, research goals were articulated, research projects formulated, and sources of financial support secured."[96] Indeed, Huang Yi's adventurous and successful career in amateur archaeology fully benefited from the support provided by these social networks. Many more scholars, collectors, and educators in the nineteenth and early twentieth centuries continued to participate in this intense and intensive social networking, as Brown's study has shown, and one of the most active and distinguished among them was Wu Dacheng (1835–1902). In addition to

having had a brilliant career in military affairs and diplomacy, Wu also excelled in antiquarian studies, calligraphy, and seal carving, and has been viewed as "China's most accomplished antiquarian scholar prior to the introduction of modern archaeology as an academic discipline."[97]

Not surprisingly, Wu Dacheng was a great admirer of Huang Yi, whose artistic and *fangbei* achievement must have been a model and goal of intellectual assimilation for the later antiquarian.[98] As a demonstration of his esteem for Huang, Wu copied the entire twenty-four leaves of paintings and colophons of the album *Seeking Steles in the Mount Song and Luo River Areas*, which Huang Yi painted to commemorate his 1796–97 *fangbei* trip to Henan Province.[99] The result of this copy-learning, a traditional training tool for Chinese artists, is not only the creation of a facsimile reproduction of Huang's artistic work, but also a display of Wu Dacheng's incredibly dexterous brush skills and his dedication to learning from original sources.[100] Despite major differences in motivation and format, Huang Yi's effort to remove steles, many already damaged, from their discovery sites, and Wu Dacheng's exercise in copying Huang's visual recollection of his visits to ancient ruins, were no doubt both motivated by the conviction that the past—no matter how fragmentary its remains—needed to be preserved.

The idea of passing along a tradition, whether a moral or philosophical principle, a family name, or an artistic legacy, is quite fluid in China, because the material substance of any recognizable tradition is accepted as and expected to be ever-changing. Many ancient inscriptions that Huang Yi labored to uncover, identify, and restore have since been lost, rendered unintelligible by exposure to natural elements, but his reputation as a pioneering amateur archaeologist endeavoring to retrieve traces of China's remote past endures beyond the lives of the steles he found. The literati artist He Daosheng (1766–1806), born only two decades after Huang Yi, already made the canny prediction, in a colophon to one of Huang's paintings: "[Although] fragments of stone have their limited time span of existence, the steles [depicted] will one day become known to posterity [only] through his paintings."[101] Indeed, as we unfold each leaf of the Tianjin Museum album, we are unveiling generations of effort to retrieve the past, sharing collective memories about the past, and acquiring knowledge of the changing meanings of the past. Layers and accumulations of history—the steles made in the Han, the records written in the Song, and for the stones fortunate enough to have survived, their retrieval in the Qing—are revealed through Huang Yi's legacy as a *fangbei* traveler and a *fangbei* painter. ○

Notes

1 See Huang Yi's colophon to his painting *Ziyun Shan tanbei tu*, in Cai Hongru, "Huang Yi *Debei shi'er tu*," *Wenwu* 1996.3, pp. 77–78.
2 Huang Yi, *Xiu Wushi citang jilüe*, in Wang Chang, *Jinshi cui bian*) (reprint,

Xi'an: Shaanxi renmin meishu chuban-she, 1990), 20/37b. The same record can also be found in the gazetteer of Yanzhou prefecture, of which Jiaxiang was a district; see *Yanzhou fu zhi* (published 1770), 21/6a–7a.

3 These stone slabs recovered and reinstalled by Huang Yi became important archaeological materials for a number of major studies of Han archaeology, art history, and architecture, among which are Wilma

Fairbank, "The Offering Shrines of 'Wu Liang Tz'u'," *Harvard Journal of Asiatic Studies*, vol. 6, no. 1 (1941), pp. 1–36; reprinted in Fairbank, *Adventures in Retrieval: Han Murals and Shang Bronze Molds* (Cambridge, Mass.: Harvard University Press, 1972), pp. 43–86; Wu Hung, *The Wu Liang Shrine: The Ideology of Early Chinese Pictorial Art* (Stanford: Stanford University Press, 1989); Jiang Yingju and Wu Wenqi, *Handai Wushi muqun shike yanjiu* (Jinan: Shandong mei-shu chubanshe, 1995). For a recent examination of the Wu site, see Cary Y. Liu, "The 'Wu Family Shrines' as a Recarving of the Past," in Liu et al., *Recarving China's Past: Art, Archaeology, and Architecture of the "Wu Family Shrines"* (Princeton: Princeton University Art Museum; New Haven and London: Yale University Press, 2005), pp. 23–97.

4 For example, R.C. Rudolph notes that "travels were undertaken to 'seek out' ancient monuments"; see his "Notes on the Sung Dynasty Archaeological Catalogs," *Archives of the Chinese Art Society of America*, vol. 19 (1965), p. 173. For a history of *jinshi* scholarship, see Zhu Jianxin, *Jinshi xue* (Taipei: Shangwu yinshu-guan, 1995), pp. 213 ff.

5 Kent R. Guy, *The Emperor's Four Treasuries* (Cambridge, Mass.: Council on East Asian Studies, Harvard University, 1987), pp. 16 ff.

6 Ibid., pp. 64–65.

7 For Ming loyalists' emotional reac-tions to steles in the seventeenth century, see Qianshen Bai, *Fu Shan's World: The Transformation of Chinese Calligraphy in the Seventeenth Century* (Cambridge, Mass. and

London: Harvard University Asia Center, 2003), pp. 172–78.

8 One example is the "Tianfa shen chen bei," believed to have been sponsored in 276 by Sun Hao (r. 264–280), last king of the Wu kingdom in southern China. The stele was apparently broken into three parts not long after the Wu kingdom was defeated, and for hundreds of years the stones were moved from one open site to another, and eventually to a Buddhist temple. Not until the eleventh century were the fragments properly restored and preserved through the effort of an official. See Toyama Gunji, "Tenhatsu shinshin hi ni tsuite," in *Shōdō zenshū*, vol. 3: *Chūgoku: Sangoku, Seishin, jūrokugoku* (Tokyo: Heibonsha, 1959), pp. 19–23.

9 Gazetteers and epigraphic texts frequently mention the random surfacing of steles and other ancient monuments, demonstrating that the laws of nature, no less than human intervention, also determine the fate of cultural relics. Huang Yi, for example, thought that the stones on Mount Ziyun had been buried in mud by periodic flooding and the changing course of the Yellow River after the Yuan period; see his *Jilüe*, 20/37b.

10 See Zhao Mingcheng's preface in *Song ben Jinshi lu* (reprint, Beijing: Zhonghua shuju, 1991), p. 2.

11 For Qing scholars' use of stone inscriptions as historical documents in their evidential studies, see Ben-jamin A. Elman, *From Philosophy to Philology: Intellectual and Social Aspects of Change in Late Imperial China* (Los Angeles: UCLA Asian

Pacific Monograph Series, 2001), pp. 225–28.

12 Ibid., pp. 213 ff.

13 See Zhu Yizun, *Pushu ting ji*, in *Yingyin Wenyuange Siku quanshu* (Taipei: Shangwu chubanshe, 1983–86), vol. 1318, p. 410. Zhu's collection of rubbings went to Li Guangying, who in 1729 published a catalogue that includes Zhu's commentaries; see Arthur E. Hummel, ed., *Eminent Chinese of the Ch'ing Period (1644–1912)* (reprint, Taipei: Ch'eng Wen Publishing Company, 1975), p. 185.

14 See Feng Rujie's synopsis (*tiyao*) of Huang Yi, "Qin Han Wei Liuchao beike yudi kao," in *Xuxiu Siku quanshu zongmu tiyao gaoben* (Jinan: Qi-Lu shushe, 1996), vol. 2, p. 300.

15 See Cai Hongru, "Huang Yi *Debei tu*"; Zhang Shulan, "Qing Huang Yi *Debei tu ce*," *Shoucangjia*, vol. 17 (1996), pp. 15–17.

16 Liang Shaoren, *Liangban Qiuyu an suibi*, in *Qingdai biji congkan* (Shanghai: Wenyi shuju, 1900), vol. 104, 3/1a.

17 Feng Jinbo, *Moxiang ju huashi* (Taipei: Mingwen shuju, 1985), *juan* 7.

18 See Weng Fanggang, *Fuchuzhai wenji* (Yonghe Zhen, Taipei: Wenhai chubanshe, 1969), 13/6a (p. 535).

19 Huang appears to have won a *jiansheng* (Student by Purchase Fourth Class) title, a "subcategory of Students by Purchase," given to men who were admitted to the *Taixue* national university without a legitimate degree; see Charles O. Hucker, *A Dictionary of Official Titles in Imperial China* (Stanford: Stanford University Press, 1985), p. 150. See

also Li Junzhi, *Qing huajia shi shi* (reprint, China, 1930), vol. *ding/xia*. In Huang's colophon to one of the paintings in the *Obtaining Steles* album, discussed below, he mentions that he "was selected to go to the capital," a trip probably connected to his being granted the *jiansheng* status.

20 Weng Fanggang, *Fuchuzhai*, 13/6a.

21 Huang's mother, Liang Ying, was a published poet, whose anthology was praised by the famous painter Jin Nong (1687–1763) as *zi zi xiang* ("every word exudes fragrance"); see Ruan Yuan, *Xiao canglang bitan* (reprint, Taibei: Guangwen shuju, 1970), p. 53.

22 Weng Fanggang, *Fuchuzhai*, 13/7a (p. 537).

23 Huang Yi's moral integrity and altruistic character are highly praised by Weng Fanggang; see ibid., 13/6a–6b (pp. 535–36). In fact, Huang carved a seal *Bu shi nie qian* ("Do not accept/use improper money") as a reminder to stay upright; see Qin Zuyong, *Qijia yinba*, in *Zhuanke xue* (Taipei: Shijie shuju, 1966), p. 195.

24 This is the colophon to the seal *Shi qing hua yi* ("To lodge/express feelings and ideas in poetry and painting"), which he carved in 1786; see Qin Zuyong, ibid., p. 199.

25 *Zhongguo xiyin zhuanke quanji*, vol. 3: *Zhuanke, shang*, ed. Zhongguo xiyin zhuanke quanji bianji weiyuanhui (Shanghai: Shanghai shuhua chubanshe, 1999), no. 604 (p. 123).

26 See Jiang Baolin, *Molin jinhua* (reprint, Taipei: Xuehai chubanshe, 1975), 5/4a (p. 137).

27 Weng Fanggang, *Fuchuzhai*,

13/6a (p. 537). See also Huang Yi's biography in *Qingshi gao jiaozhu* (Taipei: Guoshi guan, 1986), vol. 14, p. 11208.

28 Ding Ren, ed., *Xiling bajia yin xuan* (reprint, Shanghai: Shanghai guji chubanshe, 1995), p. 151. See also *Xiling sijia yinpu* (Hangzhou: Xiling yin she, 1965), p. 87.

29 Weng Fenggang, *Fuchuzhai*, 13/6a (p. 537).

30 This is the last couplet of a poem that Qian Daxin wrote on one of Huang Yi's paintings; see Jiang Baolin, *Molin*, 5/4b (p. 138).

31 Qianshen Bai, *Fu Shan's World*, pp. 185 ff.

32 See Qin Zuyong, *Qijia yinba*, p. 198. Another example of Huang's diligence in studying epigraphic writing is seen in his *Xiao Penglai Ge jinshi wenzi* (reprint, China: Shimoxuan, 1834). In this study, Huang Yi included reproductions of stele inscriptions in the *shuanggou* (double outline) technique, faithfully tracing the stroke shapes and structures of each character.

33 Ruan Yuan, *Xiao canglang*, p. 53.

34 *Zhongguo xiyin zhuanke*, no. 588 (p. 118).

35 James Cahill, *Hills Beyond a River: Chinese Painting of the Yüan Dynasty, 1279–1368* (New York: Weatherhill, 1976), pl. 41 (pp. 111–13).

36 *Tianjin Shi yishu bowuguan canghua ji* (Beijing: Wenwu chubanshe, 1982), vol. 2, p. 148; see also Cai Hongru, "Huang Yi *Debei tu*," p. 73, and Zhang Shulan, "Qing Huang Yi *Debei tu ce*," p. 15. According to the nineteenth-century critic and collector Qin Zuyong, Huang Yi's clerical-script calligraphy "broke free of the Tang

formula"; see Qin Zuyong, *Tongyin lunhua* (reprint, Taipei: Wenguang tushu gongsi, 1967), p. 61. For Qing calligraphers' seeking their artistic inspirations from pre-Tang models, see Qianshen Bai, *Fu Shan's World*, pp. 192 ff.

37 Cai Hongru, "Huang Yi *Debei tu*," p. 73.

38 Guy, *Emperor's Four Treasuries*, p. 64.

39 See Huang Yi's study of the Sangong Shan stele in his *Xiao Penglai*, vol. 4: *Sangong Shan bei*, 1a–b.

40 Ibid.

41 Ibid.

42 For Shi Chen and Lu Xiang, see n. 47 below.

43 One instrument used to wash and clean the steles seems to have been a bundle of pine needles tied together with bamboo leaves that had been softened by boiling spring water. In his study of rubbings Wu Hung described a "pointed bamboo pick" being used to clean every sunken line; see his "On Rubbings: Their Materiality and Historicity," in *Writing and Materiality in China* (Cambridge, Mass.: Harvard University Asian Center, 2003), p. 34.

44 The two stone figures, each more than two meters high, are in the Confucius Temple in Qufu. Before Ruan Yuan had them moved to the temple in 1794, they had been standing in front of a Han mausoleum south of Qufu District. Ruan carved the colophon, "Moved by Ruan Yuan in the *jiayin* year of the Qianlong reign-period [i.e., 1794]," on the backs of the stone figures. See Gong Xingyan, *Jining quan Han bei* (Jinan: Qi-Lu shushe, 1990), pp. 33–34, and pls. 28–30.

45 Ruan Yuan, *Xiao canglang*, p. 43.

46 Ruan Yuan's critical theory on the stylistic development of Chinese calligraphy is represented by his two important essays, *Nan bei shupai lun* and *Bei bei nan tie lun*. For an annotated study of these works, see Hua Rende, *Nan bei shupai lun*, *Bei bei nan tie lun* (Shanghai: Shanghai shuhua chubanshe, 1987).

47 The full title of the Shi Chen stele is now known as "Lu xiang Shi Chen si Kongzi zou ming" ("Memorial on sacrifice to Confucius, written by the minister of Lu, Shi Chen"), housed in the Confucius Temple in Qufu, Shandong; see Wang Chang, *Jinshi cuibian*, 13/1a. Because its inscription is long, and covers both the front and reverse of the stele, epigraphic records since the Song sometimes recorded it as belonging to two separate steles, Shi Chen and Lu Xiang; this confusion was likely due to the fact that Song scholars usually worked from ink-on-paper rubbings, rather than the stones themselves. Because the bottom of the stele had been covered in earth, the characters on the buried part could not be seen in early rubbings. In 1789 He Menghua excavated the stele and cleaned the dirt from its base, thereby uncovering the full text of the inscription; see Yuan Weichun, *Qin Han bei shu* (Beijing: Gongyi meishu chubanshe, 1990), p. 322. For scholarly comments and notes on this stele inscription, see Wang Chang, *Jinshi cuibian*, 13/1a–3a.

48 *Zhongguo xiyin zhuanke*, no. 614 (p. 127).

49 Ouyang Xiu's *Jigu lu bawei* contains an entry on a "Stele of the Northern Marchmount" of Later Han, which is described as recording the sacrifice to Sangong Shan, but according to Zhao Mingcheng, Ouyang Xiu's rubbing may have been taken from a different stele. For Ouyang's colophon, see his *Ouyang Xiu quanji* (Beijing: Zhongguo shudian, 1986), p. 1102. For Zhao's commentary on the Sangong Shan stele rubbing, see Zhao Mingcheng, *Song ben jinshi lu* (reprint, Beijing: Zhonghua shuju, 1991), pp. 404–5.

50 Huang Yi, *Xiao Penglai*, vol. 4, "Sangong Shan bei," 1a–4a. According to Weng Fanggang's reckoning, they were sixty-five years apart. Huang Yi reported that the 181 stele was no longer extant, but according to Ma Ziyun, a former curator of the Palace Museum, Beijing, specializing in stone inscriptions and rubbings, the Sangong Shan stele recorded in the *Jigu lu* and *Jinshi lu*, was rediscovered in the nineteenth century; see Ma Ziyun and Shi Anchang, *Bei tie jianding* (Guilin: Guangxi shifan daxue chubanshe, 1993), p. 67. The meticulous analysis of the Sangong Shan stele inscription by Zhao Wei and Weng Fanggang is a very typical example of Qing scholars' application of vigorous textual analysis in their effort to verify and validate history, a subject that merits further research but is beyond the scope of this essay.

51 Huang Yi, *Xiao Penglai*, vol. 4, *Sangong Shan bei*, 3a.

52 Ibid., 4a.

53 Cai Hongru, "Huang Yi *Debei shi'er tu*," p. 78.

54 Yuan Weichun, *Qin Han bei shu*, p. 688.

55 For Qing epigraphic calligraphy that favored pre-Tang aesthetics, see Qianshen Bai, *Fu Shan's World*, n. 36.

56 Wang Zhuanghong's study of stone steles, *Zengbu jiaobei suibi*, is cited in Yuan Weichun's *Qin Han bei shu*, p. 688.

57 Ruan Yuan, *Shanzuo jinshi zhi*, cited in Yuan Weichun, *Qin Han bei shu*, and Wang Chang, *Jinshi cuibian*, 19/4b.

58 Ma and Shi, *Beitie jianding*, p. 63.

59 Tsuen-Hsuin Tsien, *Written on Bamboo and Silk*, second edition (Chicago and London: University of Chicago Press, 2004), pp. 78 ff.

60 The *Xiping Stone Classics* is probably among the most studied epigraphic materials in China; see Wang Chang, *Jinshi cuibian*, juan 16; see also Yuan Weichun, *Qin Han bei shu*, pp. 421–51. According to Ma and Shi, *Beitie jianding*, pp. 62–64, stone fragments of the Xiping Stone Classics were excavated in 1922 in Luoyang, and some rubbings also surfaced in Xi'an about that time, suggesting that some tablets had been transferred to Xi'an during the Tang period. For a summary of the twentieth-century discovery of *Stone Classics* fragments, see also Zhao Chao, *Gudai shike* (Beijing: Wenwu chubanshe, 2001), pp. 5–8.

61 Li Yufen, *Ouboluo Shi shu hua guomu kao* (Shanghai: Hongwen Zhai, 1900?), 3/31a.

62 This trip to the capital was probably to receive his *jiansheng* degree; see n. 19 above.

63 Although Huang stated that these rubbings were presented as gifts, other records indicate that Dong sold them to Huang to finance his daughter's wedding; see Weng Fanggang's account in his *Liang Han jinshi*

ji, cited in Wang Chang, *Jinshi cuibian*, 16/10b. Also see Cai Hongru, "Huang Yi *Debei shi'er tu*," p. 73.

64 Cai Hongru, "Huang Yi *Debei shi'er tu*," p. 72.

65 See *Chinese Classical Paintings and Calligraphy*, auction catalogue, China Guardian (13 July 2003), lot 118.

66 See Zhu Yun's colophon in Huang Yi, *Xiao Penglai*, vol. 1, *Shijing canbei*, 4a.

67 *Zhongguo xiyin,* no. 594 (p. 120).

68 In Huang's *biankuan* colophon on the seal, *Tanxi jiancang* ("Collection authenticated by Tanxi [i.e., Weng Fanggang]"), he mentions that he also carved a collector's seal for Wang Xuejiang, a prominent book collector, to be impressed in the latter's edition of an anthology of poems by Ouyang Xiu; see ibid., p. 53.

69 Ibid.

70 Judging by Huang Yi's writings, he did not seem to be engaged in the kind of sophisticated textual analysis of stone inscriptions practiced by his degree-holding peers. For example, in deciphering the Sangong Shan stele inscription, Huang could not read the first character of the reign-period, so he left it undeciphered. He did not try to study the text further in order to extrapolate the possible date from historical events or other internal evidence, a method often applied by Song and Qing scholars. It was Huang's artistic training and experience in calligraphic connoisseurship that enabled him to make the initial conclusion that the stele he identified in 1775 was executed earlier than the one Hong Gua recorded and transcribed in the *Lishi*; see the discussion above.

71 Tsien, *Written on Bamboo*, pp. 92–95.

72 It does not appear that Ouyang Xiu or Zhao Mingcheng took *fangbei* trips. Their records indicate that rubbings were sent to them, either by local officials or government clerks via messenger, or by friends visiting the sites in the course of their official duties. Hong Gua could not visit many of the regions where production of steles was particularly prolific, such as Shandong and Henan, because during his time northern China was largely lost to the Jurchens; see Qian Daxin's preface to Huang's *Xiao Penglai*.

73 For Ming antiquarianism and cultural life, see Craig Clunas, *Superfluous Things: Material Culture and Social Status in Early Modern China* (Urbana and Chicago: University of Illinois Press, 1991), pp. 90ff. Also see Chuang Shen, "Ming Antiquarianism, an Aesthetic Approach to Archaeology," *Journal of Oriental Studies* (Hong Kong), vol. 8, no.1 (1970).

74 For the multi-layered material relationships between rubbings and stones, see Wu Hung, *On Rubbings*.

75 Qianshen Bai, *Fu Shan's World*, p. 202. Bai writes that Zhu Yizun once commented on the rubbings made by Zheng Fu as "superior in the subtlety of their ink tones and in the skill with which they reproduced the texture of the carvings and the effects of damage and wear."

76 Wang Chang, *Jinshi cuibian*, 16/12b.

77 Shanghai bowuguan, ed., *Zhongguo shuhuajia yinjian kuanshi* (Beijing: Wenwu chubanshe, 1987), vol. 2, p. 1138.

78 Li Daoyuan, *Shuijing zhu shu*, comm. Yang Shoujing, ed. Duan Zhongxi (Nanjing: Jiangsu guji chubanshe, 1989), pp. 772–73.

79 Shen Gua, *Mengxi bitan*, in *Yingyin Wenyuange Siku quanshu*, vol. 862, pp. 811–12.

80 See Huang Yi's colophon in Fang Shuo, *Zhenjing Tang jinshi shuhua tiba* cited in Jiang Yingju and Yang Aiguo, *Handai huaxiang shi yu huaxiang zhuan* (Beijing: Wenwu chubanshe, 2001), pp. 92–93.

81 Cai Hongru, "Huang Yi *Debei shi'er tu*," p. 78.

82 Ibid.

83 Ruan Yuan, *Shanzuo jinshi zhi*, cited in Wang Chang, *Jinshi cuibian*, 21/8b–9a.

84 Weng Fanggang, *Liang Han jinshi ji*, cited in Wang Chang, *Jinshi cuibian*, 21/8b.

85 Because of the stylistic problems presented by the pictorial carvings of the Zhu Wei shrine, more research may be needed in order to ascertain their dates. See Jiang and Yang, *Handai*, p. 93.

86 For a study of the *Yihe ming*, see Robert E. Harrist, Jr., "Eulogy on Burying a Crane: A Ruined Inscription and Its Restoration," *Oriental Art*, vol. 44, no. 3 (1998), pp. 2–10.

87 Cai Hongru, "Huang Yi *Debei shi'er tu*," p. 79

88 Ibid.

89 See *Xuanhe huapu*, in *Huashi congshu*, ed. Yu Anlang (reprint, Shanghai: Shanghai renmin meishu chubanshe, 1962), 11/116.

90 See *Yingyin Wenyuange Siku quanshu*, vol. 1221, p. 108; vol. 1372, p. 452; and vol. 1416, p. 453, to name a few.

91 For the story of Cao E, see Peter Charles Sturman, "The Donkey Rider as Cultural Icon: Li Cheng and Early Landscape Painting," *Artibus Asiae*, vol. 15, no. 1/2 (1995), p. 85. A painting entitled *Wei Wu dubei tu* (*Reading a Stele by Wei Wu* [i.e., Cao Cao]), mentioned in Mi Fu's (1052–1107/8) *Hua shi*, may also depict the same theme; see Huang Binhong and Deng Shi, eds., *Meishu congshu* (reprint, Nanjing: Jiangsu guji chubanshe, 1986), vol. 2, p. 1187.

92 Sturman, "Donkey Rider," p. 85.

93 Eileen H. Hsu, "Huang Yi's *Fangbei* Painting: A Legacy of Qing Antiquarianism," *Oriental Art*, vol. 55, no. 1 (2005), pp. 56–63.

94 Sturman's semiotic analysis of the Li Cheng landscapes asserts that "the expression of distance is an affirmation of the person who occupies that point in space and time," and is suggestive of the retrospective nature of the *Reading a Stele by Pitted Rocks*; see Sturman, "Donkey Rider," p. 88.

95 This was a Han-dynasty expression evoked in the eighteenth century by scholars who advocated evidential research; see Elman, *From Philosophy to Philology*, the calligraphic writing of the four characters on verso of the title page.

96 Shana Julia Brown, "Pastimes: Scholars, Art Dealers, and the Making of Modern Chinese Historiography, 1870–1928." (PhD diss., University of California, Berkeley, 2003), pp. 30–31.

97 Qianshen Bai, "From Wu Dacheng to Mao Zedong: The Transformation of Chinese Calligraphy in the Twentieth Century," in *Chinese Art, Modern Expressions*, eds. Maxwell K. Hearn and Judith G. Smith (New York: The Metropolitan Museum of Art, 2001), p. 249. For another study of Wu Dacheng's scholarly and artistic activities, see Brown, "Pastimes," pp. 14–25.

98 Wu's *Shimen fangbei ji* was written in the same fashion as Huang Yi's diaries of two *fangbei* trips in 1796 and 1797, to Henan and Shandong, respectively. For Wu's trip to Shimen, see Wu Dacheng, *Wu Kezhai chidu* (Taipei: Wenhai chubanshe, 1971), pp. 32–36.

99 See the catalogue entry on "Seeking Steles on Mount Tai," by Eileen Hsiang-ling Hsu, in Liu et al., *Recarving China's Past*, pp. 471–81. For an iconographic interpretation of Huang Yi's album, see Lillian Lan-ying Tseng, "Retrieving the Past, Inventing the Memorable: Huang Yi's Visit to the Song-Luo Monuments," in *Monuments and Memory, Made and Unmade*, ed. Robert S. Nelson and Margaret Olin (Chicago and London: University of Chicago Press, 2003), pp. 37–58.

100 This dedication is also demonstrated by Wu's attempt to copy the characters in the *Shuowen jiezi*, China's earliest etymological dictionary, in seal script. See Brown, "Pastimes," pp. 26–27.

101 Li Junzhi, *Qing huajia shi shi*, vol. *ding/xia*.

Mediums and Messages:
The Wu Family Shrines and Cultural
Production in Qing China

LILLIAN LAN-YING TSENG

Ancient objects suddenly emerged from the ground easily arouse intense excitement, which is often channeled into three different approaches to antiquities. The scholarly mind tends to place objects in their original context, and to study them in relation to the historical period when they were produced or interred, even though specialists from different disciplines would emphasize different contextual loci. Contemporary popular attention, however, may be caught by some features that have nothing to do with the origin of the objects. On one hand, antiques can be bestowed an "afterlife" or a "cultural biography" in the wake of their discovery by those who discover and appreciate them; their meanings are invented and accumulated either in the context of exchange or exhibition, or because of their entanglements with current events.[1] On the other hand, antiques may also serve as a vehicle to evoke historical memories that are irrelevant to the objects' production and interment but meaningful to their discoverers and admirers; the significance of antiques lies in their triggering something other than their own existence.[2]

This paper explores a fourth aspect of the excitement generated by unexpected archaeological finds. Instead of focusing on how antiquities are studied and perceived, I ask how newly unearthed objects inspire other types of cultural production that would otherwise have not come into being. I do not aim at any inquiries based on classicism, in which attention is focused on the application of past styles or motifs in current works; this has long been an established topic in art-historical research.[3] Rather, I analyze various cultural products that are derived from or caused by archaeological discoveries.

More specifically, this paper centers upon the "Wu Family Shrines" uncovered in eighteenth-century China. I discuss how the excavation of

the ancient monuments first stimulated the discoverer, who happened to be an eminent literati painter, to produce a group of paintings to depict his discovery. I examine how the preservation of the archaeological site then led to the creation of a brand-new stele to commemorate the collective efforts of the contributors to that endeavor. Finally, I investigate how the need to capture the carvings in the discovered shrines further brought about competition in the market of woodblock prints.

Since this study touches upon mediums ranging from painting to stele to print, I also consider whether the medium is the message, as Marshall McLuhan claimed.[4] Whereas painting is normally distinguished by its representational capacity, the stele genre is noted for its commemorative nature, and the print for its facility in mass reproduction. This paper suggests that, in the case of the Wu Family Shrines, the representational painting in fact conveyed the wish for documentation and remembrance, the commemorative stele signaled the mood of celebration and discrimination, and the mass-reproduced print demonstrated the concern for readability and authenticity.

The Paintings: Documentation and Commemoration

In the eighth month of 1786 Huang Yi (1744–1802) stopped by Jiaxiang on his way back to Jining, both in present-day Shandong. Reviewing the local gazetteer in the county office, Huang noticed the report of a Han stele inscribed with incomprehensible text and three Han shrines incised with exquisite images, half buried at Mount Ziyun, approximately thirty *li* south of the county town of Jiaxiang. Huang immediately had some rubbings made, and was delighted to discover that the stele had been erected for Wu Ban, and that one of the

shrines had been built for Wu Liang, both of whom had been active during the Han dynasty.

To retrieve more Han monuments, Huang Yi soon returned to Jiaxiang and investigated the site in person the following month. He first unearthed and cleaned the carved stones of the Wu Liang Shrine. Then, with the help of local assistants, he fully exposed the twin *que* gate-pillars that had sunk eight to nine *chi* belowground.[5] To the north of the gate-pillars lay the toppled stele in honor of Wu Ban, distinguished by its triangular head and its perforated upper body. Next, Huang discovered two groups of carved stones, one in front of the Wu Liang Shrine and the other behind it. He identified them as the front and the rear chambers of the Wu Family Shrines.

After the excavation, Huang Yi moved the stone engraved with the meeting of Confucius and Laozi back to Jining and had it installed in the Hall of Comprehending Ethics (Minglun Tang) in the prefectural school there. He also conferred with local scholars, mainly Li Dongqi, Li Kezheng, and Gao Zhengyan, on how best to deal with the remaining finds. Together they formulated a plan to preserve all the stones in situ, likely the first archaeological preservation in early modern China. Huang Yi later recounted the entire process of this exciting discovery in his 1787 essay entitled "A Brief Record of Preserving the Wu Family Shrines" ("Xiu Wushi citang jilüe").[6]

In addition to his textual account, Huang Yi also provided a visual record of this event. His painting entitled *Searching for Steles at Mount Ziyun* (*Ziyun Shan tanbei tu*) is one leaf in an album now in the Tianjin Municipal Museum of Fine Arts (hereafter the Tianjin album; fig. 1).[7] In this painting Huang Yi placed himself in the middle ground, between the gate-pillars and the scattered stone slabs. Two persons accompany him, with one of the

little group pointing to the tumbled monuments ahead. Two donkey carts in the foreground indicate how the group traveled to the site, while the upland village in the background signifies that the site was at the foot of a hill.

To load the pictorial form with more precise content, Huang Yi placed a colophon next to the painting:

In the fall of the *bingwu* year of the Qianlong reign [1786], [I] saw the gazetteer of Jiaxiang County. [It mentioned that] at Mount Ziyun were small stone chambers lying apart and an ancient stele with a perforation. [I] had the rubbings made and examined them carefully. [It dawned on me that they were] the stele for Wu Ban — a chief clerk of Dunhuang in the Han dynasty — and the carvings for the Wu Liang Shrine. [I] went with Li Dongqi, Li Kezheng, and Gao Zhengyan to investigate [the site]. One after another, [we] sought and found three stone chambers in the front, rear, and left, [a stone with] the image of omens, the gate-pillars of the Wu family, [a stone] with the image of Confucius meeting Laozi, etc. [I] have never acquired so many steles as this [discovery], which is one of the most joyful events in my life! Together with those who appreciate antiquities, [I] had the Wu Family Shrine rebuilt and had the steles placed inside. [I] moved the stone with the image of Confucius meeting Laozi to the Hall of Comprehending Ethics in the prefectural school in Jining. [These arrangements shall make these stones] remembered forever by posterity.[8]

The colophon is evidently condensed from Huang's lengthy report.[9] However brief, the colophon suffices to help the viewer, who may or may not have read the report beforehand, to identify the mountain afar, the participants in the project,

and the stones lying on the ground. The painting focuses on the investigation and excavation Huang conducted in the ninth month of 1786, but the colophon covers a longer span, which includes what happened before and after the excavation. If the painting highlights a single moment, then the colophon relates the extended duration of a process; image and text thus complement each other to document this significant event.

Far from having an archival purpose, Huang Yi created his visual record to share this magnificent discovery with friends who could understand and appreciate his efforts. Weng Fanggang (1733–1818), for instance, saw the Tianjin album leaf between 1792 and 1793, and on it wrote a colophon expressing his regret that even though he twice traveled to Shandong after the excavation, a heavy load of duties kept him from visiting the site in person.[10] More importantly, Weng recalled that he had received an earlier version of this painting in 1787, when he supervised educational affairs in Jiangxi. Although that earlier painting is no longer extant, Weng's poetical colophon for that painting, also entitled *Searching for Steles at Mount Ziyun*, still exists. In his colophon, Weng first acknowledged the significance of the discovery:

The carved stones of the Wu Family Shrines
 [are where]
The virtuous and sages left their forms and molds.
For centuries [they] were concealed in the wild field,
Yet suddenly [they] offered up the precious signs.[11]
 [Appendix 1a]

He then complimented Huang on his good fortune to serve in the hometown of Confucius and his principal followers. For Weng, the painting inevitably triggered thoughts of the ancient Lu state, the cradle of Confucian culture:

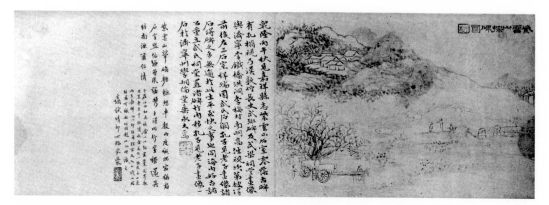

Fig. 1 Huang Yi (1744–1802). *Searching for Steles at Mount Ziyun*. 1792–1793. Album; ink on paper; 51.5 × 17.8 cm. Tianjin Municipal Museum. From *Tianjin shi yishu bowuguan canghua ji* (Beijing: Wenwu chubanshe, 1963), vol. 2, p. 147.

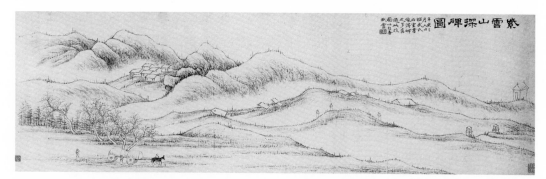

Fig. 2 After Huang Yi. *Searching for Steles at Mount Ziyun*. Handscroll; ink on paper; 31 × 138 cm. From Christie's auction catalogue, (Hong Kong: 31 October 2004), lot 416.

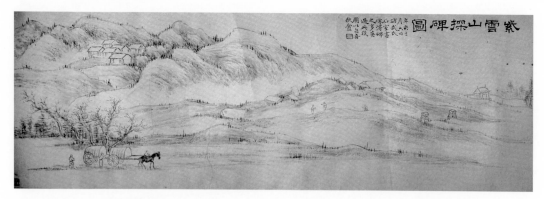

Fig. 3 After Huang Yi. *Searching for Steles at Mount Ziyun*. Handscroll; ink on paper; Private collection, Taipei. Photos by author.

Huang Yi is holding an office in Zou and Lu,
Plowing daily the meaning of the Classics.
While I am laboring in Jiangxi,
Dabbling in Lake Poyang and Mt. Lu.
[I] lift horns and roots,
[Dreaming] of the Rivers Huai, Si, Zhu in sleep.[12]

[Appendix 1b]

At the end of the poem, Weng described what he
saw in the painting, and wished Huang would grant
him a copy to embellish his own studio:

Bleak, bleak, the grass in the chilly wild,
Desolate, lonely, the two chariots.
In between is the brace of the ages,
[And] the green peak in the wake of autumn rain.
If [you] could produce an additional painting for me,
[I shall have it] mounted to privilege [my]
Bao Su Studio.[13]

[Appendix 1c]

Weng received the wished-for painting in the
winter of 1787, after he had been informed of the
discovery and had helped financially in restoring
the Han monuments.[14] Still, Weng's mood was
elated, as he wrote in his colophon: "Huang
sending [the painting] to Weng is a gratification
truly beyond words."[15] Not having had the pleasure
of witnessing the discovery, Weng found that the
painting brought the obscure site and the historical
moment to life. For Weng, a learned scholar who
cherished the past, the painting even served as an
allusion to the Confucian legacy that the retrieved
Han monuments were believed to represent.

Hong Liangji (1746–1809) also received a
painting from Huang, in about the summer of
1788, when he worked for the local government in
Kaifeng, Henan.[16] Before he saw the painting, like
Weng, Hong had been aware of the discovery and

had financially assisted in preserving the Wu shrines.[17]
According to Hong, Huang sent the painting to him
and asked for a poem in return. In his return poem,
Hong offered his reading of the painting:

With the Yellow River moving southward and
changing the land,
Sharpened stones are angular, [surviving] houses
are few.
Not following monstrous waves to the vast sea,
Inside [the stone chambers] are sages and the
virtuous who have firmly grounded their feet.
…
How elegantly the guests who visit steles arrive,
Imprinting the earth to make steles and to erect
a large building.
Mistaking the master of Lu by the side of the road,
Are the restless passersby with a carriage and
two horses.[18]

[Appendix 2]

Hong eulogized the ancients engraved on the
stones, crediting the survival of the monuments
through floods to their miraculous power. It is
obvious that Hong overinterpreted the painting,
viewing the sparseness of the houses in the back-
ground as a consequence of floods, and mistaking
the people with a carriage in the foreground as
mere passersby. Nonetheless, Hong's poem and
preface perfectly manifest how Huang used the
painting as an agent to encourage his friends far
away from Shandong to participate in the event
by exercising their literary imaginations.

Based on the writings of Weng and Hong,
it is evident that Huang Yi produced more than
one painting to represent his discovery of the Wu
shrines. Weng clearly stated that the painting he
saw in 1787 was a different version of the painting
he examined between 1792 and 1793 (i.e., the

A B C

Fig. 4 Gate-pillars in *Searching for Steles at Mount Ziyun*. (a) the Tianjin album, (b) the Christie's handscroll, (c) the Taipei handscroll.

one in the Tianjin album). Judging from Weng's description, however, in both paintings the composition and main motifs—mountains afar, carriages nearby, and monuments in between—were nearly identical. The painting Hong received in 1788 seems to differ from those sent to Weng only in the minute detail of having one carriage, not two.

The abovementioned are by no means the only paintings in circulation depicting Huang's discovery of the Wu shrines. The handscroll recently auctioned by Christie's[19] and the one owned by a private collector in Taipei are two examples (hereafter the Christie's handscroll and the Taipei handscroll; figs. 2, 3). The similarities between the two paintings are obvious: both bear the identical inscription with the title *Searching for Steles at Mount Ziyun*; both are handscrolls but maintain the basic composition and major motifs as seen on the Tianjin album leaf. Their differences are, however, substantial. First, the Christie's handscroll starts, like the Tianjin album, with a simple house behind a slope, whereas the Taipei handscroll

adds walls and trees behind that simple house, giving the impression that the house is part of a larger compound (fig. 4). Secondly, the Christie's handscroll is replete with dry, parallel, repetitive strokes, whereas the Taipei handscroll displays greater dimensionality of brush strokes and more variations in the density of ink tonality, in this respect more closely approaching the quality of the Tianjin album (fig. 5). And thirdly, the stone slabs in the Christie's handscroll are oddly two-dimensional and unrealistically positioned relative to the line of the slope, whereas the illusion of depth in the Taipei handscroll is even more plausible than that in the Tianjin album (fig. 6). The most intriguing aspect of the handscrolls is, however, the date of the inscription they share:

On the sixth day of the third month of the *xinhai* year [1791], [I] visited the carved images of the Wu Family Shrines. [I] have never acquired more steles than by this endeavor. [I] paint [the scene] to please myself. Huang Yi.

Huang discovered the Wu shrines in the fall of 1786, not in the spring of 1791. The erroneous date immediately puts the authenticity of both hand-scrolls into question. And yet the forgeries were not pure inventions without any reliable visual source at the very outset. The incorrect date was somehow made up and crept into the long and treacherous process of (re)production and circulation.

Huang Yi visually documented the Wu shrines not only for friends living afar, but also for friends nearby. Sun Xingyan (1753–1818), for example, was once guided by Huang Yi to the site at Mount Ziyun when he was transferred to an official position in Shandong in 1795, long after he had known of the discovery and had been a sponsor of the preservation project.[20] Apparently pleased with Sun's visit, Huang made a painting to commemorate their tour of the Wu shrines. Moved by Huang's enthusiasm, Sun composed a poem in response:

The stone chambers for centuries are open for you,
On the green [we] visited the ancient and roamed
 around together
…

A pair of stone gate-pillars are half buried by dust,
Who would have asked after myriads of trees
 with peach blossoms [nearby]?
…

To paint is to hand down a legend for the future,
[Which is our] friendship on bronze and stone
 and [our] affinity with brush and ink.[21]
 [Appendix 3]

Unlike the paintings Huang sent earlier to Weng and Hong, the painting Huang made for Sun was not to document his discovery of the Wu shrines, but to commemorate their visit to the site, a token of their friendship deeply rooted in their shared antiquarianism. We do not know if Huang simply

repeated or modified his ready composition *Searching for Steles at Mount Ziyun*, small individual variations notwithstanding, or drew something entirely different for the occasion.

Huang Yi's depictions of the Wu shrines in situ surely seem unique when appreciated singly, whether painted as mementos of discovery or friendship. But when the scene is juxtaposed with others as in the Tianjin album, its uniqueness becomes secondary to a more complicated interplay between documentation and commemoration. The

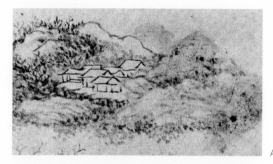

A

B

C

Fig. 5 Upland houses in *Searching for Steles at Mount Ziyun*.
(a) the Tianjin album, (b) the Christie's handscroll, (c) the Taipei handscroll.

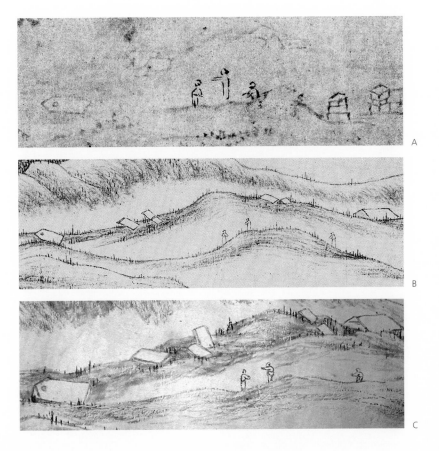

Fig. 6 Scattered steles in *Searching for Steles at Mount Ziyun*. (a) the Tianjin album, (b) the Christie's handscroll, (c) the Taipei handscroll.

A

B

C

Tianjin album is composed of twelve leaves, which exhibit Huang Yi's major acquisitions in Shandong between 1775 and 1793. It depicts him retrieving Han stones inscribed with texts,[22] examining Han stones engraved with images,[23] and obtaining rare and precious rubbings of Han steles.[24] The entire album ends with the leaf entitled *Celebrating Steles at the Little Penglai Pavilion* (*Xiao Penglai Ge hebei tu*), portraying Huang sharing a new acquisition — the rubbings of a broken stele dated to the year 173 from Qufu — with his friends in his studio, the Little Penglai Pavilion (fig. 7).[25] According to Huang's colophon, while his family and relatives raucously honored his fiftieth birthday, he preferred to quietly celebrate the steles he procured with bosom friends. As the album shows,

the collection he was celebrating was not limited to the Qufu rubbings obtained on his birthday, but went back eighteen years to his first advance in the search for ancient steles, and retraced his every major achievement thereafter. No doubt each leaf individually was intended to document a discovery Huang stumbled across at a specific moment in a specific place, but as a whole they were meant to memorialize the lifelong accomplishment of Huang in his dogged and passionate practice of visiting steles. The leaf illustrating the search for steles at Mount Ziyun is therefore retrospectively interwoven into Huang Yi's intellectual biography, while also serving as a visual record of a remarkable discovery and, at the same time, as a commemoration of friendship.

Fig. 7 Huang Yi. *Celebrating Steles at the Little Penglai Pavilion.* 1793. Album leaf; ink and color on paper; 51.5 × 17.8 cm. Tianjin Municipal Museum. From *Shoucangjia*, vol. 3 (1996), p. 17.

The Stele: Celebration and Discrimination

Not long after the excavation, about the winter of 1787, a brand-new stele was produced and installed in situ. The stele was incised with Weng Fanggang's essay entitled "The Record of Re-erecting the Stones of the Wu Family Shrine" ("Chongli Han Wushi citang shi ji"; fig. 8).[26]

Less ambiguous than the paintings, this stele was intended to commemorate the preservation project initiated by Huang Yi. As Weng Fanggang clearly described in his essay, Huang and his local assistants "gathered all the stones, established a building at the site, erected an enclosing wall for fortification, named [the site] as the Wu Family Shrines with an inscribed plaque, and asked natives to guard it."[27] More details were provided by Huang's own aforementioned report. Huang felt obliged to take care of the unearthed stones because he was the one who had had them exposed to the world. Due to the weight and quantity of the stones, Huang decided that it would be more feasible to preserve them on site than to move them elsewhere. The building was thus constructed to shelter the stones, and the wall to define the protective boundary that would enclose

the two gate-pillars. Inside the building the stele for Wu Ban was placed at the center and other carved stones along the four walls. A wooden plaque inscribed with "The Wu Family Shrines" was hung above the door to mark the building. Huang was pleased that the preservation turned archaeological finds into public property. Instead of being monopolized by a handful of collectors for a limited time, the Wu shrines preserved in situ would be appreciated and cherished by the public for many generations to come.[28]

Given that Weng Fanggang had never been to the site, he must have followed Huang's report when he composed his essay for the commemorative stele. Nevertheless, the main focus of Weng's essay was not on details of the preservation project but on the significance of the discovery. Weng began his essay with the revered Song scholar Ouyang Xiu (1007–1072) and his catalogue *The Record of the Search for Antiquities* (*Jigu lu*). Mourning for the loss of the past, Ouyang Xiu was probably the first scholar who consciously took notes on ancient monuments that had been abandoned or neglected for centuries in the wild. Although Ouyang claimed that he had set foot in

all the important ruins, Weng pointed out that his renowned catalogue did not include the Wu shrines.

Weng traced the first documentation of the Wu shrines to Zhao Mingcheng (1081–1129), a Song scholar who was said to have compiled some information on the Wu shrines in five chapters (*juan*), but whose text was no longer available.[29] Only the efforts of a third Song scholar, Hong Gua (1117–1184), who included the inscriptions and images of the Wu shrines in his books *Lishi* and *Li xu*, had, to Weng's great delight, survived to Weng's own time. Even so, as Weng lamented, the original printings of Hong's books, already scarce in the thirteenth century, were almost unobtainable in the eighteenth.

It is in comparison with early documentation of the Wu shrines that Weng Fanggang defined Huang Yi's epochal contribution. Due to Hong Gua's books, many scholars were aware of the existence of the Wu shrines, but few had seen the original monuments. Even Hong himself grounded his study of the Wu shrines on the rubbings owned by the contemporary collector Liang Jiheng.[30] In his essay Weng recalled how he and Huang had always regretted being unable to examine some older rubbings of ancient monuments since they began to study ancient steles together in 1777.[31] Neither had ever imagined that they would get to inspect the stones of the Wu shrines in person. Huang's discovery in 1786 was therefore a groundbreaking event. Henceforth those who cared about ancient texts (and images) would have more reliable, even firsthand, materials at their disposal. Although Weng was in Jiangxi, the hometown of Hong Gua, when Huang retrieved the precious stones in Shandong, Weng's mood was jubilant. He exulted in his essay that "Huang Yi's excavation was arguably a greater achievement than Hong Gua's publication." The newly erected stele was thus not merely to commemorate the restoration, but mostly to celebrate the discovery.

It is worth mentioning that because of his discovery Huang Yi eventually obtained the older rubbings of the Wu shrines that he and Weng Fanggang had craved. More privileged than Weng, Huang was invited to appreciate the allegedly Tang

Fig. 8 List of donors at the end of Weng Fanggang, *Record of Re-erecting the Stones of the Wu Family Shrines*. Ink rubbings; h: 31–31.5 cm, w: 89.5–90 cm. Princeton University Art Museum. From Cary Liu, *Recarving China's Past*, p. 193.

rubbings when Wang Xuejiang procured them in 1775 (fig. 9).[32] To his regret, however, Huang did not make any tracing copies, and was thus unable to double-check details afterward. Huang sent Wang Xuejiang rubbings imprinted from the original stones after he reovered the Wu shrines. To show his gratitude and recognition, Wang went so far as to grant Huang his prized "Tang rubbings."[33] Huang Yi consequently had the good fortune both to discover the Wu shrines and to possess their most valuable rubbings.

In addition to its celebratory function, the 1787 stele also served to distinguish a unique group of scholars who were enthusiastic about the study of ancient steles. To carry out the preservation plan, Huang Yi started a fund-raising campaign shortly after the excavation. He and local scholars took the lead in contributing money, hoping to inspire more donations from patrons all over the country who valued the discovery and understood the importance of the preservation. To honor the contributors, Huang proposed to have their names and donated amounts engraved on the stele.[34] In

the end, eighty donors were recorded on the stone. Their donations ranged from one thousand to fifty thousand *qian*, with Huang Yi's forty thousand plus one hundred thousand the largest donation, and Bi Yuan's (1730–1797) fifty thousand the second largest (fig. 8).

Among the eighty donors Weng Fanggang was probably a pioneer in the practice of visiting steles; he began investigating ancient monuments in the region where he held an official position. Long before Huang Yi's excavation, Weng Fang-gang in 1771 compiled *The Record of Bronzes and Stones in Guangdong* (*Yue dong jinshi ji*), taking full advantage of his post as supervisor of education in Guangdong Province since 1764.[35] Huang Yi's own adventures, including the unearthing of the Wu shrines, also had everything to do with his official appointment as an assistant to canal transportation in Shandong Province.[36] It was Bi Yuan who led the most vigorous search team during his administration of Shaanxi Province from 1767 to 1786.[37] Bi initiated a catalogue project for *The Record of Bronzes and Stones in Shaanxi* (*Guanzhong jinshi ji*),

Fig. 9 *Story of Min Ziqian*, Wu Liang Shrine. Jiaxiang, Shandong. 2nd century. Ink rubbing once collected by Wang Xuejiang and Huang Yi and believed to be a Tang production. Palace Museum Beijing. From *Zhongguo meishu quanji, shufa zhuanke bian*, vol. 1, pl. 72.

which was finished about 1782.[38] The gifted young scholars Bi Yuan recruited for his head office then implemented the practice of investigating steles wherever they were sent, tactfully combining their eager search for steles with their duty to compile county gazetteers. Among them, Zhang Xun created separate chapters to accommodate his notes on the steles he examined when he assembled the gazetteers for Xingping (1777) and Fufeng (1781), both in Shaanxi.[39] Likewise, Qian Dian (1744–1806) included more accounts of steles in the gazetteer he composed for Hancheng (1784).[40] Sun Xingyan, who won Bi Yuan's full support, incorporated his notes of local steles into the gazetteer of Liquan (1784).[41] Hong Liangji, who stayed with Bi Yuan longer than others, also reported on steles in detail in the gazetteer he was responsible for in Chunhua (1784).[42] Sun and Hong even worked together to produce the Chengcheng gazetteer (1784).[43] It is thus not surprising that Bi Yuan and his active staff all contributed to the preservation of the Wu shrines.

Some donors did not have the opportunity to exercise their privilege as scholar-officials to record antiquities until after their preservation of the Wu shrines. Feng Minchang (1747–1806), for instance, surveyed local monuments for the county gazetteer of Meng in 1790, under the supervision of Bi Yuan after he was transferred to administer Henan Province.[44] When Xie Qikun (1737–1802) compiled the provincial gazetteer for Guangxi in 1801, he also finished *The Outline of Bronzes and Stones in Guangxi* (*Yue xi jinshi lüe*), a work comparable to Weng Fanggang's earlier catalogue on Guangdong.[45] Instead of working in far-flung outposts, the senior scholar and high-ranking official Qian Daxin (1728–1804) preferred to investigate the remains in his hometown. Carrying out his project in Yin in Zhejiang Province, Qian published an extensive account of steles in the county gazetteer

in 1788.[46] Wu Yi (1745–1799) also worked assiduously in and around his hometown, itemizing stone steles in the county gazetteers he made for Yanshi (1788) and Anyang (1793) in Henan Province.[47]

Much as the institutional mechanism of compiling gazetteers facilitated the practice of investigating steles in the eighteenth century, the most ambitious among the donors did not confine themselves within a regional framework. They were either frequent travelers or accomplished rubbing collectors, or both. Weng Fanggang, again, took the lead in putting together a comprehensive book entitled *The Record of Bronzes and Stones in the Western and Eastern Han Dynasties* (*Liang Han jinshi ji*) in 1789.[48] More than a simple catalogue, the book consisted of Weng's personal opinions, his discussions with friends, and his disagreements with past scholars about Han relics all over the country. It also included Huang Yi's report and Weng's essay about the preservation of the Wu shrines, making both texts more widely known to the public. Sun Xingyan, who had been given a tour of the foot of Mount Ziyun by Huang and had compiled quite a few gazetteers, also produced *The Record of Visiting Steles around the World* (*Huanyu fangbei lu*) in 1802.[49] The book was no more than an inventory enumerating hundreds of steles Sun had investigated, but it covered a time frame longer than the Han period. The most inclusive work was Wang Chang's (1724–1806) *Assemblage of Bronzes and Stones* (*Jinshi cuibian*), which came out in 1805.[50] Like an encyclopedia, the book not only provided basic information about each stele, such as measurement, location, and transcription, but also collected all the related comments on each stele from Song forerunners to Qing contemporaries.

Moreover, the eighty donors listed on the stele were all connected one way or another. Some

Fig. 10 Huang Yi. *The Likeness of Wu Yi*. Tracing copy of a Han stone carving in Jinxiang, Shandong. From Wu Muchun, ed. *Shoutang yishu* (1843).

were related by blood, such as Qian Daxin and his nephew Qian Dian, and Weng Fanggang and his son Weng Shupei (1765–1809). Some developed a close friendship because of a shared birthplace. Wu Yi and Wang Fu (1738–1788) both came from Yanshi, Henan; Sun Xingyan, Hong Liangji, and Zhao Huaiyu (1756–?) all grew up in northern Jiangsu.[51] Many of the donors were associated in a kind of senior-junior relationship that was established through learning, working, or promotion in civil-service examinations. Huang Yi claimed to be a disciple of Bi Yuan; so did Sun Xingyan, Hong Liangji, Wang Fu, and Gui Fu (1736–1805).[52] He Yuanxi (1766–1829) was Qian Daxin's pupil.[53] Feng Minchang, Song Baochun (1748–1818), and Jiang Deliang (1752–1793) were Weng Fanggang's followers.[54] These donors' common interests in antiquities, history, and literature gave rise to continual communications that formed a network that facilitated the flow of information. The preservation of the Wu shrines was an excellent test of this network.

It is noteworthy that the network of antiquarians who supported the preservation of the Wu shrines overlapped that of the literati who advocated evidential analysis of ancient texts. Established in the seventeenth century, the

so-called evidential study (*kaozheng xue*) reached its peak in the second half of the eighteenth century. Derived from the field of classical learning, evidential scholarship emphasized careful review of the Confucian canons, bringing to bear philology, etymology, and phonology in order to correctly grasp the essence of Confucianism.[55] This critical approach was applied to various branches of knowledge, including historical research. No longer confined to received texts, many evidential scholars turned to inscriptions on excavated bronzes and retrieved steles, and considered them to be primary sources of greater reliability. Epigraphy, along with philology, etymology, and phonology, became an essential tool for reconstructing the past.[56] The fascination with ancient monuments in Huang Yi's generation was therefore an outgrowth of the dominant evidential scholarship.

This distinctive eighteenth-century scholarly community for evidential study through investigating steles, as embodied by the donors of the Wu shrines, inevitably created its own distinctive shared cultural codes. Those who knew Han steles well would have understood the *format* Huang Yi proposed for listing donors, which, as Huang explained in his report, was intended to reproduce

the Han convention.[57] Those who often studied Han steles would also have appreciated the calligraphic *style* Weng Fanggang chose for his commemorative essay, which, as Weng declared in a poem, was meant to match the Han monuments referred to in the essay, the "clerical style of calligraphy" (*lishu*) having developed in the Han period.[58]

The most revealing example of the coded communication was probably a Han image Huang Yi copied for Wu Yi. In examining the rubbings taken from a Han shrine at Jinxiang in Shandong, Huang Yi spotted an incised figure without any identifying inscription that greatly resembled his good friend Wu Yi. Huang made a linear tracing copy of the figure and sent it to Wu (fig. 10).[59] Rather than Wu's own portrait, the Jinxiang image became the sanctioned representation of Wu Yi after his death. It appeared in the opening pages of a posthumous collection that Wu's son assembled in his honor. The image even served as an icon to which Wu's friends expressed their grief at his death. Wang Fu composed a poem in memory of Wu Yi based on this image:

Writing books just in wait to be stored in famous
 mountains,
[Your] ancient appearance was disseminated from
 a stone chamber.
Without the elegant envoy who visited steles,
Who would have wiped off the dust from the
 Han carvings?[60]

 [Appendix 4]

Moving in the same circle as Wu Yi, Wang Fu had no difficulty in decoding the messages underlying Huang Yi's copy of the Han rubbing that bore Wu's likeness. First of all, there was a temporal trick. With his Han-dynasty "likeness," Wu Yi could be simultaneously an ancient in the present

and a contemporary in the past. Wang's poem also contained a double reading. "The elegant envoy who visited steles" may refer to Huang Yi, as he uncovered Wu Yi's likeness in the deserted Han stone chamber, or the envoy may be Wu Yi, inasmuch as Wu himself had a lifelong practice of visiting steles.

The Jinxiang image similarly inspired Weng Fanggang to contribute his memorial poem in 1800.[61] He started the poem with a profile of Wu Yi:

Mr. Wu was a follower of Hong Gua and
 Zhao Mingcheng,
Stones and inks, abundant in compilation
 and writing.
From Hebei [he] set foot in Shandong,
Through wooded graveyards [he] daily scavenged.[62]

 [Appendix 5a]

Weng then shifted his focus to Huang Yi, who traced the image:

Huang Yi is a person of curiosity,
Maintaining the rope [as if] to draw the ancient
 [from the well].
By hand [he] picked the gate-pillars of the
 Wu family,
While making rubbings [to fill] the bamboo cases
 [brought to] Jinxiang.[63]

 [Appendix 5b]

Ending the poem with his own participation, Weng furthered the established juxtaposition of the Jinxiang shrine and the Wu shrines:

I imitated the inscriptions of the Wu Family [Shrines],
[Rendering] the small clerical scripts beside and
 above [the image] like steps.

Someday were [my poem and the image] inscribed
 together,
[Their] genuine breath the mosses would quietly
 inhale.
Honest and frank to the north of the Yellow River,
Image by image the spirits would gather.
Purple clouds in the mountain green,
Old eagles rapidly screaming through the wind.[64]

 [Appendix 5c]

 Weng composed the poem for a solemn
occasion, but his mood was playful. Since the
Jinxiang image came from a Han shrine without
cartouches, he saw it only fit to appropriate the
calligraphic style for the poem from another Han
shrine that was filled with inscriptions. Yet he was
aware that, by the calligraphic appropriation, he
might produce an ambiguity if the image and the
poem were ever combined. Together, would they
represent the upright Wu Yi living to the north of
the Yellow River?[65] Or, would they allude to the
Wu shrines at the foot of Mount Ziyun? To make
sure that the reader would not fail to grasp this cue,
Weng even added a note after the poem, specifying
that the "purple clouds in the mountain green"
referred to Mount Ziyun, where the Wu shrines
were located. Weng's thoughts obviously drifted
from the deceased friend to the cultural legacy they
both appreciated. He encoded the subtle interplay
between the real and the fictional with the kind
of tacit knowledge shared only by those who were
familiar with the practice of investigating steles and
with the approach of evidential study.

 In sum, the 1787 stele served to include
all the donors who had helped preserve the Wu
shrines. Given that the donors were bound by
a specific interest in mapping the past through
ancient monuments, the stele excluded all those
who did not belong to this special community or

did not understand its particular cultural practice.
The stele therefore encompassed all the denotation
and connotation — commemorative, celebrative and
discriminative — derived from the preservation of
the Wu shrines, and emerged as a new cultural
landmark on its own.

The Prints: Readability and Authenticity

After the discovery of the Wu shrines, their carvings
were circulated mainly by means of rubbings.
Huang Yi was without doubt the major supplier. He
quite prolifically sent rubbings to friends here and
there. For many, these direct imprints became the
primary sources for their studies of ancient monu-
ments. Weng Fanggang, for example, received the
rubbings of the Wu shrines successively from Huang
Yi, starting from the ninth month of 1786, the very
month Huang returned to Jiaxiang for excavation.[66]
As the first to share the extraordinary discovery,
Weng was also the first to publicize the content of
these rubbings in his 1789 *Record of Bronzes and
Stones in the Western and Eastern Han Dynasties*.[67]
Even though he composed a long poem to eulogize
the incised images that constituted the main body
of the carvings, Weng was chiefly interested in the
inscribed texts, i.e., the brief titles of the images,
and therefore devoted almost all the pages to
textual transcriptions.[68] It never occurred to him
that it would be worthwhile to reproduce the
images. Many of his contemporaries followed the
same textual approach to the Wu shrines, whether
in a systematic collection like Bi Yuan's *Record of
Extant Bronzes and Stones in Shandong* (*Shanzuo
jinshi zhi*) published in 1797,[69] or in the more
random commentaries of scholars such as Qian
Daxin and Wu Yi.[70]

 These publications may have enhanced the
publicity of the Wu shrines, but they added little
to their visibility. Wang Chang, one of the leading

donors to their preservation, rightly pointed out three difficulties in circulating knowledge of the Wu shrines. First, textual accounts of the engraved images, however explicit, could not create a likeness of the artwork. The viewer had to rely on rubbings for full comprehension. Secondly, to laboriously hang gigantic rubbings on the wall whenever one wished to see the carvings was hardly practicable, let alone pleasurable. And thirdly, many who were interested in antiquities would find it hard to come by the rubbings. Most of them could only imagine the look of the pictorial carvings.[71] For Wang Chang, only print, a medium capable of reduced reproduction and mass-production, could resolve all of these "viewer-unfriendly" problems and make the Wu shrines truly known to people outside the elite community that endorsed the preservation project.

Long before Wang Chang stated the problem, Hong Gua had already tried to convert rubbings into prints in his 1167 book *Li xu*.[72] Hong intended to maintain the visual effect of rubbings in print. Black figures with white linear details stood out from the white background, indicating that the rubbings were imprinted from stones carved in relief with incised lines to delineate details on the figures (fig. 11). The arrangement of the figures in two horizontal registers also reproduced the original format of the rubbings, even though each rubbing was too large to be reduced to book size, and had to be divided into two or three sections. As one of the very few pieces of physical evidence of the Wu shrines, Hong's prints had been greatly admired and cherished among scholars until the rediscovery of the monuments themselves in the eighteenth century.

With the unearthing of the Wu shrines, Qing scholars became discontented with Hong Gua's efforts. As Huang Yi noticed, the sequence of the divided sections published by Hong did not correctly reflect their spatial order on the three walls of the Wu Liang Shrine (fig. 12). The discrepancies certainly confirm that Hong had never examined the shrine in person. In addition, Wang Chang also found Hong's prints aesthetically unsatisfactory because the figures were poorly delineated and inaccurately portrayed.[73] Wang further deplored the abbreviation of the inscriptions

Fig. 11 Carvings from the Wu Liang Shrine. Ink rubbing represented in Hong Gua, *Li xu*, *juan* 6 (Beijing: Zhonghua shuju, 1983), n.p.

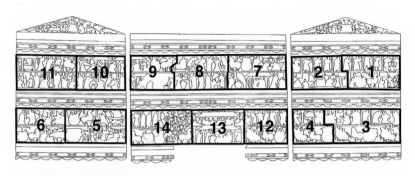

Fig. 12 Diagram showing the sequence of rubbings from the Wu Liang Shrine. In Hong Gua, *Li xu*. Drawing by author.

A B C

Fig. 13 *Yu of the Xia.* Wu Liang Shrine. Jiaxiang, Shandong. 2nd century. (a) From the "Tang rubbing," Palace Museum Beijing. From *Gugong bowuyuan yuankan*, vol. 2 (1960), p. 175, (b) Huang Yi's tracing copy of the "Tang rubbing," from Huang Yi, *Xiao Penglai Ge jinshi wenzi*, n.p. (c) ink rubbing in Wang Chang, *Jinshi cuibian* (Beijing: Zhongguo shudian, 1985), *juan* 20, n.p.

in the overly reduced illustrations, which necessitated consulting the complete transcription of the inscriptions in Hong's other book, *Lishi*, in order to understand the content of the illustrations in *Li xu*. These defects made Hong Gua's reproduction scarcely reader-friendly.[74]

Qing scholars therefore felt the need to remake the prints. Among his peers, Huang Yi was probably the first to replicate images of the Wu shrines in his 1800 catalogue *Bronze and Stone Inscriptions from the Little Penglai Pavilion* (*Xiao Penglai Ge jinshi wenzi*). Unlike Hong Gua, Huang Yi preferred to trace the contours of images and to have his linear tracing copies transferred onto woodblocks for printing (figs. 13A, B).[75] Interestingly, what Huang chose to reproduce was not the images on the rubbings recently imprinted from the stones, but the images on the "Tang rubbings" he

had come to possess.[76] Since the "Tang rubbings" had been cut by scene and mounted as an album, Huang's catalogue also exhibited one scene per page and thus fashioned a scene-by-scene viewing sequence. Whether so intended or not, turning the pages of Huang's catalogue gave the feeling of reading a book.

It was Wang Chang who first tackled the rubbings made directly from Huang Yi's discovery in his ambitious *Assemblage of Bronzes and Stones* of 1805, almost two decades after the excavation. Having noted all the imperfections of Hong Gua's work, Wang Chang formulated a different strategy for his own project. Like Hong Gua, he tried to maintain the visual effect of rubbings, but he adopted Huang Yi's scene-by-scene rendition, including both image and text on each page (fig. 13C). He ordered the images carefully,

specifying the register and stone numbers on each leading scene in order to better anchor the reader (fig. 14A). This presentation made it infinitely easier to more or less envision the stones themselves.

Huang Yi's attempt to transform the "Tang rubbings" and Wang Chang's effort to popularize the contemporary rubbings did not slake the ensuing passion for reproducing the carvings of the Wu shrines. Feng Yunpeng, too young to be part of the elite community sponsoring the preservation of the Wu shrines, embarked on an even more ambitious project in 1820 and finally published the result in *The Index to Bronzes and Stones* (*Jinshi suo*) in about 1824.[77] As a latecomer, Feng naturally made use of all the positive features of his predecessors' works. Like Hong Gua and Wang Chang, he preferred to preserve the look of rubbings. Following the examples of Huang Yi and Wang Chang, he presented one zoomed-in scene on each page, paid heed to the spatial relationship of the images, and informed the reader of the location of each. As a vigorous competitor, however, Feng knew how to distinguish himself. Whereas Hong, Huang, and Wang separated their comments from the illustrations, Feng placed image and annotation on the same page, a design

that greatly facilitated reading (fig. 17). Rather than using the standard movable type for printing, Feng preferred to present the annotations in his own versatile calligraphic style, a consuming and expensive choice that reinforced the distinctiveness of his personal presentation. Moreover, he added outer and inner frames to each page, which distanced the images from their origin as rubbings and brought them closer to book format.

It is evident that readability was both a challenge and a priority for those who wanted to turn rubbings into prints. Making the final product more like an illustrated book to accommodate the general reading experience became a favored solution. In addition, Qing scholars vaunted the authenticity of their prints. As mentioned, Huang Yi in his 1800 catalogue used the "Tang rubbings" rather than the contemporary rubbings he himself produced and distributed, for the reason that the early imprints preserved more details than the later ones, due to wear that inevitably damaged the stones over time (figs. 13A, C).[78] Hence, even with obvious defects, Hong Gua's reproduction was still valuable, as Huang Yi admitted, in preserving some scenes that were seriously damaged by the time he retrieved the stones, particularly the depiction

A

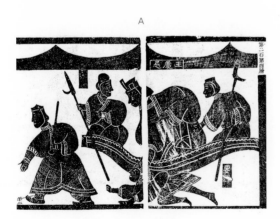

B

Fig. 14 *Yao Li's Assassination of Prince Qing Ji*. Wu Liang Shrine, Jiaxiang, Shandong. 2nd century. Ink rubbings represented in (a) Wang Chang, *Jinshi cuibian*, (b) Hong Gua, *Li xu*.

Fig. 15 Diagram showing the carvings of the Wu Liang Shrines included in the "Tang rubbings." Drawing by author.

A B

Fig. 16 *Story of Jin Midi.* Wu Liang Shrine, Jiaxiang, Shandong. 2nd century. Ink rubbings represented in (a) Hong Gua, *Li xu,* (b) Wang Chang, *Jinshi cuibian.*

of the orphan of the Li family and the portrayal of King Xiu Tu (figs. 11, 16A). Only the "Tang rubbings" could make Huang's work superior to Hong Gua's Song rubbings. Unfortunately, the "Tang rubbings" were incomplete, containing only fourteen scenes from the Wu Liang Shrine, far fewer than the forty-four scenes identified by Weng Fanggang based on the newly made rubbings (fig. 15).[79]

The incompleteness of the "Tang rubbings" gave scope to competing Qing scholars. Wang Chang, for example, gladly embraced the contemporary rubbings provided by Huang Yi in his 1805 collection. He established the authenticity of his prints by being as faithful as possible to the rubbings imprinted from the unearthed stones. He even included the decorative patterns that merely framed each scene and had nothing to do with the content. Wang Chang also left damaged spots or sections daringly blank (figs. 13C, 16B).[80] Even

though Hong Gua's reproductions were believed to represent the carvings when the stones were in better condition, Wang Chang blithely supplemented the scene depicting Yao Li's assassination of Prince Qing Ji (fig. 14A), which was intriguingly incomprehensible in *Li xu* (fig. 14B).[81]

Whatever rubbings they selected to print, Hong Gua, Huang Yi, and Wang Chang reproduced solely the three stones that constitute the three walls of the Wu Liang Shrine. That incompleteness offered Feng Yunpeng scope for amplification. His book incorporated all the stones Huang Yi and his local assistants had uncovered at the site, including fifteen stones from the Front Chamber, ten stones each from the Rear and Left Chambers, the stones with images of omens, and the stone engraved with the meeting of Confucius and Laozi. Moreover, Feng found ways to claim authenticity, even though he had never had the fortune to see the "Tang

rubbings," the best imprints of the Wu Liang Shrine in his own time. Feng was able to guarantee the quality of the rubbings used for printing by supervising, in person, their making at the site. Because of his scrutiny of crucial details on the exquisite rubbings, Feng was confident that his replication would only add to the visual information contained in the carvings.[82] Indeed, Feng exceeded all his predecessors in his meticulous attention to details, and he made sure that his artisans took equal care. Feng's driven perfectionism, however, could not tolerate any blank spots on rubbings. To compensate for the stones' damaged state, he consulted Hong Gua's *Li xu*. And yet, when comparing Hong's illustration (fig. 16A) with Feng's remediation as shown in the scene of King Xiu Tu (fig. 17), it seems clear that Feng's efforts at repair were overtaken by creation *de novo*.[83]

In any case, Huang Yi's, Wang Chang's, and Feng Yunpeng's combinations of readability and authenticity, however different, all appeared to have been well received. Although it is impossible for us to track the distribution of each set of prints, they were all republished by the end of the Qing dynasty. Before the introduction of lithography, republication meant that the images on the original prints had to be copied and that new woodblocks for printing had to be cut based on those copies. In woodblock reproduction, Huang Yi's catalogue was republished in 1834[84] and 1890,[85] Wang Chang's in 1872.[86] After the adoption of lithography, however, it was Wang Chang's and Feng Yunpeng's prints that were most sought after, particularly in the Shanghai area. Three Shanghai publishers reissued Wang's collection in 1893.[87] Two Shanghai publishers reprinted Feng's book, in 1893 and in 1897 respectively.[88]

All things considered, it is fair to conclude that Huang Yi's, Wang Chang's, and Feng Yunpeng's

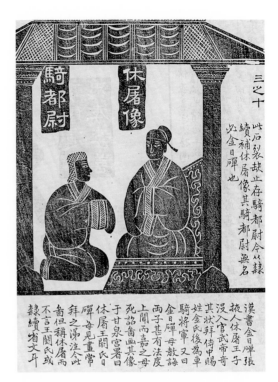

Fig. 17 *Story of Jin Midi.* Wu Liang Shrine, Jiaxiang, Shandong. 2nd century. Ink rubbings represented in Feng Yunpeng and Feng Yunyuan, *Jinshi suo* (1824 edition), n.p.

prints and reprints shaped the general impression of the Wu shrines. Only a handful of zealous devotees and local residents actually viewed the carved stones. And only a limited number of literati and collectors possessed rubbings of the carvings. The vast majority of people had to depend on prints and reprints of the carvings for leisure appreciation or for serious study. The reputation of the Wu shrines was therefore singularly established by the reproductions of reproductions (monument—rubbing—print) and by the transformations of transformations (rubbing—album—book). The firsthand monument may alone be genuine and priceless, but it is the third-hand and even fourth-hand reproductions that truly sustained the legacy of the Wu Family Shrines. ◉

Appendix

1a
武氏祠刻石
賢聖留形模
千年闃原野
一旦貢寶符

1b
黃子官鄒魯
經義日耕鋤
而我西江役
鄱陽涉匡廬
掔提角與根
痡痗淮泗洙

1c
荒荒寒原草
蕭寥兩馬車
中有萬古襄
碧峰秋雨餘
儻應添畫我
裝軸壓寶蘇

2
大河南移川變陸
削石棱棱數間屋
不隨大浪入滄溟
中有聖賢牢置足
…
訪碑客至何瀟灑
拓地為碑營大廈
道旁錯認魯東家
一車兩馬栖栖者

3
石室千年為爾開
翠微訪古共徘徊
…
一雙石闕半埋塵
萬樹桃花孰問津

畫圖他日傳佳話
金石交情翰墨緣

4
著書正待名山貯
古貌先從石室傳
不遇風流訪碑使
誰來拂拭漢時鐫

5a
武君洪趙徒
石墨富編著
河北涉東齊
林冢日衰拾

5b
黃九好奇者
修緪古所汲
手剟武氏闕
搨並金鄉笈

5c
我仿武氏題
小隸旁崖級
他日并鐫勒
真氣苔岑吸
耿耿河朔間
幅幅精靈集
紫雲嵐翠中
老鶻呼風急

Notes

1 Chris Gosden and Yvonne Marshall, "The Cultural Biography of Objects," *World Archaeology*, vol. 31, no. 2 (1999), pp. 169–78; Y. Hamilakis, "Stories from Exile: Fragments from the Cultural Biography of the Parthenon (or 'Elgin') Marbles," *World Archaeology*, vol. 31, no. 2 (1999), pp. 303–20.
2 (Lillian) Lan-ying Tseng, "Myth, History and Memory: The Modern Cult of the *Simuwu* Bronze Vessel," in *Zhonghua wenhua bainian*, ed. Kuang-nan Huang (Taipei: Guoli lishi bowuguan, 1999), pp. 717–67.

3 Such as Christian F. Murck, ed., *Artists and Traditions: Uses of the Past in Chinese Culture* (Princeton: The Art Museum, Princeton University, 1976).
4 Marshall McLuhan and Quentin Fiore, *The Medium is the Message* (New York: Bantam Books, 1967).
5 The total height of the gate-pillars is 4.30 m. Jiang Yingju and Wu Wenqi, *Handai Wushi muqun shike yanjiu* (Jinan: Shandong meishu chubanshe, 1995), p. 7.
6 Huang Yi, "Xiu Wushi citang jilüe," in Weng Fanggang, *Liang Han jinshi ji* (1789; reprint, *Xuxiu Siku quanshu*,

vol. 892 [Shanghai: Shanghai guji, 1995]), 15.44b–47a.
7 Zhang Shulan, "Qing Huang Yi *Debei tu ce*," in *Shoucangjia*, vol. 3 (1996), pp. 15–17.
8 Unless otherwise indicated, translations are my own. It is noteworthy that what Huang Yi helped to erect was a building to house the carved stones of the Wu Family Shrines. He did not restore the original structure of each shrine.
9 There are only two points in the colophon that differ slightly from Huang Yi's earlier report. First, we

learn from the colophon that Li Dongqi, Li Kezheng, and Gao Zhengyan also participated in the excavation, whereas the three local scholars were mentioned as consultants for restoration in the report. Second, the left chamber was discovered by Li Dongqi in 1789. It was therefore unknown when Huang wrote his report in 1787. See Bi Yuan and Ruan Yuan, *Shanzuo jinshi zhi* (preface 1797; reprint, *Shike shiliao xinbian*, ser. I, vol. 18 [Taipei: Xinwenfeng chuban gongsi, 1982]), 7.54a.

10 Weng Fanggang administered educational affairs in Jiangxi Province from the ninth month of 1785 to the ninth month of 1789. See Shen Jin, *Weng Fanggang nianpu* (Taipei: Institute of Chinese Literature and Philosophy, Academia Sinica, 2002), pp. 224–25, 268.

11 Weng Fanggang, "Ti Huang Xiaosong *Ziyun Shan tanbei tu*" in his *Fuchuzhai shiji* (foreword 1793; reprint, *Xuxiu Siku quanshu*, vol. 1454 [Shanghai: Shanghai guji, 1995]), 35.9a–9b.

12 Ibid.

13 Ibid.

14 Ibid. Weng mentioned in the poem that he had composed an essay for the stele commemorating the preservation of the Wu shrines. See the second section of this paper, The Stele: Celebration and Discrimination, for further discussion.

15 Ibid.

16 Lü Pei, ed., *Hong Beijiang xiansheng nianpu* (Shanghai: Dalu shuju, 1933), p. 38.

17 Hong Liangji was one of the donors who financially supported the restoration of the Wu shrines. See The Stele: Celebration and Discrimination in the second section of this paper.

18 Hong Liangji, *Juanshige ji* (1877; reprint, *Xuxiu Siku quanshu*, vol. 1467 [Shanghai: Shanghai guji, 1995]), *Shiji*, 7.15a–b.

19 *Fine Classical Chinese Paintings and Calligraphy*, auction cat., Hong Kong: Christie's (31 October 2004), lot 416.

20 Sun Xingyan, *Sun Yuanru xiansheng quanji* (Shanghai: Shangwu, 1935), p. 436.

21 Ibid.

22 They include the Sangong Shan stele, the Zheng Jixuan stele, the Wu Ban stele, and the Wu shrines. Only one leaf depicts monuments not produced in the Han; they are Buddhist carvings at Mt. Jinyang near Jining.

23 They are the carvings in the Xiaotang Shan and Zhu Wei shrines, and at Liangcheng Shan and Hongfuyuan.

24 They are the rubbings of the Fanshi stele and of the Xiping Stone Classics.

25 Zhang Shulan, "Qing Huang Yi *Debei tu ce*," p. 17.

26 Weng Fanggang, "Chongli Wushi citang shi ji," in his *Liang Han jinshi ji*, 15.47a–48a.

27 Ibid.

28 Huang Yi, "Xiu Wushi citang jilüe," in Weng Fanggang, *Liang Han jinshi ji*, 15.46a–47a.

29 Zhao Mingcheng, *Jinshi lu* (afterword 1117; reprint, *Shike shiliao xinbian*, ser. I, vol. 12 [Taipei: Xinwenfeng, 1982]), 19.7b–8a.

30 Hong Gua, *Li xu* (foreword 1167; reprint, *Shike shiliao xinbian*, ser. I, vol. 10 [Taipei: Xinwenfeng, 1982]), 6.15a.

31 Weng Fanggang and Huang Yi first met in 1777, when Huang obtained rare rubbings of the Han Xiping Stone Classics in Beijing. See Weng Fanggang, "Huang Qiu'an zhuan," in *Fuchuzhai wenji* (n.d.; reprint, *Xuxiu Siku quanshu*, vol. 1455 [Shanghai: Shanghai guji, 1995]), 13.6a. Weng heard about Wang Xuejiang's "Tang rubbings" in 1777, but failed in his attempt to see the rare collection in person. See Weng Fanggang, *Liang Han jinshi ji*, 15.17b.

32 The "Tang rubbings" are currently in the collection of the Palace Museum in Beijing. They had been made before Huang Yi rediscovered the Wu shrines, and are believed to have originated during the Song dynasty. See Ma Ziyun, "Tan Wu Liang ci huaxiang de Song ta yu Huang Yi taben," *Gugong bowuyuan yuankan*, vol. 2 (1960), pp. 170–77.

33 Huang Yi, "Wu Liang ci Tang taben," in *Xiao Penglai Ge jinshi wenzi* (1800), 23b–24a, 25b–26a. In fact, it was Huang Yi who urged Wang Xuejiang to receive the rubbings from a friend in the first place.

34 Huang Yi, "Xiu Wushi citang jilüe," in Weng Fanggang, *Liang Han jinshi ji*, 15.48b.

35 Ye Yanlan and Ye Gongchuo, eds., *Qingdai xuezhe xiang zhuan* (Shanghai: Shanghai shudian, 2001), p. 192; Weng Fanggang, *Yue dong jinshi ji* (1771; reprint, *Shike shiliao xinbian*, ser. I, vol. 17 [Taipei: Xinwenfeng chuban gongsi, 1982]).

36 Weng Fanggang, "Huang Qiu'an zhuan," in *Fuchuzhai wenji*, 13.6a.

37 Wang Chang, "Bi gong shendao bei," in *Chunrongtang ji* (1807; reprint, *Xuxiu Siku quanshu*, vol. 1438

[Shanghai: Shanghai guji, 1995]), 52.11a–12b.

38 Bi Yuan, *Guanzhong jinshi ji* (preface 1782; reprint, *Shike shiliao xinbian*, ser. II, vol. 14 [Taipei: Xinwenfeng chuban gongsi, 1982]).

39 Zhang Xun, *Xingping jinshi zhi* (1777; reprint, *Shike shiliao xinbian*, ser. III, vol. 31 [Taipei: Xinwenfeng chuban gongsi, 1982]); *Fufeng jinshi zhi* (1781; reprint, *Shike shiliao xinbian*, ser. III, vol. 32, both excerpted from original county gazetteers).

40 Qian Dian, *Hancheng jinshi zhi* (1784; reprint, *Shike shiliao xinbian*, ser. III, vol. 32, excerpted from original county gazetteer).

41 Sun Xingyan, *Liquan jinshi zhi* (1784; reprint, *Shike shiliao xinbian*, ser. III, vol. 31, excerpted from original county gazetteer).

42 Hong Liangji, *Chunhua jinshi zhi* (1784; reprint, *Shike shiliao xinbian*, ser. III, vol. 32, excerpted from original county gazetteer).

43 Hong Liangji and Sun Xingyan, *Chengcheng jinshi zhi* (1784; reprint, *Shike shiliao xinbian*, ser. III, vol. 32, excerpted from original county gazetteer).

44 Feng Minchang, *Mengxian jinshi zhi* (1790; reprint, *Shike shiliao xinbian*, ser. III, vol. 29, excerpted from original county gazetteer).

45 Xie Qikun, *Yue xi jinshi lüe* (1801; reprint, *Shike shiliao xinbian*, ser. I, vol. 17).

46 Qian Daxin, *Yinxian jinshi zhi* (1790; reprint, *Shike shiliao xinbian*, ser. III, vol. 8, excerpted from original county gazetteer).

47 Wu Yi and Sun Xingyan, *Yanshi xianzhi* (1788; reprint, *Zhongguo fangzhi congshu*, vol. 442 [Taipei:

Chengwen chubanshe, 1968]). Wu Yi, *Anyang xian jinshi lu* (1793?; reprint, *Shike shiliao xinbian*, ser. I, vol. 18, excerpted from original county gazetteer).

48 Weng Fanggang, *Liang Han jin shi ji*, as n. 6.

49 Sun Xingyan, *Huanyu fangbei lu* (1802; reprint, *Xuxiu Siku quanshu*, vol. 904).

50 Wang Chang, *Jinshi cuibian* (1805; reprint, *Lidai beizhi congshu*, vols. 4–7 [Nanjing: Jiangsu guji, 1998]).

51 Ye Yanlan and Ye Gongchuo, *Qingdai xuezhe xiangzhuan*, pp. 246, 256, 290. Sun Xingyan and Hong Liangji were from Yanghu. Zhao Huaiyu was from Wujin.

52 Identifying themselves as *menren* ("followers"), Huang Yi, Sun Xingyan, Hong Liangji, Wang Fu, and Gui Fu proofread different chapters of Bi Yuan's *Lingyan shanren shiji* (1799; reprint, *Xuxiu Siku quanshu*, vol. 1450).

53 He Yuanxi, ed., *Zhuting xiansheng riji chao* (1805; reprint, *Jiading Qian Daxin quanji*, vol. 8 [Nanjing: Jiangsu guji, 1997]). Identifying himself as *dizi* ("pupil"), He Yuanxi compiled Qian's diary shortly after his death.

54 Weng Fanggang, *Fuchuzhai wenji*, 22.11b.

55 Benjamin Elman, *From Philosophy to Philology: Intellectual and Social Aspects of Change in Late Imperial China* (Los Angeles: University of California, Los Angeles, 2001), pp. 1–122; Qi Yongxiang, *Qian-Jia kaojuxue yanjiu* (Beijing: Zhongguo shehui kexue chubanshe, 1998), pp. 8–110.

56 Elman, *From Philosophy to Philology*, pp. 225–28.

57 Huang Yi, "Xiu Wushi citang jilüe," in Weng Fanggang, *Liang Han jinshi ji*, 45.8b.

58 Weng Fanggang, "Ti Huang Xiaosong *Ziyuanshan tanbei tu*," *Fuchuzhai shiji*, 35.9b.

59 Wu Muchun, ed., *Shoutang yishu* (1843), ii–iii. The stone chamber at Jinxiang is better known as Zhu Wei's shrine, although this attribution is not beyond controversy.

60 Wu Muchun, *Shoutang yishu*, pt. 1, "Huaxiang tici," 4a.

61 Ibid., 1a; Weng Fanggang, *Fuchuzhai shiji*, 54.11a–11b.

62 Ibid.

63 Ibid.

64 Ibid.

65 Wu Yi was famous for his open confrontation with the notorious and venal official He Shen. See Lillian Lan-ying Tseng, "Retrieving the Past, Inventing the Memorable: Huang Yi's Visit to the Song-Luo Monuments," in *Monuments and Memory, Made and Unmade*, eds. Robert Nelson and Margaret Olin (Chicago: University of Chicago Press, 2003), pp. 37–58.

66 Weng Fanggang, *Liang Han jinshi ji*, 15.30a–b.

67 Ibid., 15.17b–44b.

68 Weng Fanggang, "Wushi citang huaxiang shi," in *Liang Han jinshi ji*, 15.48a–49b.

69 Bi Yuan and Ruan Yuan, *Shanzuo jinshi zhi*, 7.17a–54b. This collaborative work came out after the death of Bi. The authors gave a very detailed account of the content of the carvings.

70 Qian Daxin, *Qianyantang jinshi wen wei ba* (foreword 1787; reprint, *Shike shiliao xinbian*, ser. I, vol. 25), 1.29b–30b. Wu Yi, *Jinshi yiba* (1843;

reprint, *Shike shiliao xinbian*, ser. I, vol. 25), 2.8b–9a.

71 Wang Chang, *Jinshi cuibian*, 20.53b.

72 Hong Gua, *Li xu*, 6.1a–15b. The compilers of the *Siku quanshu* believed that *Li xu* contained only ten chapters when it was first published in 1168; the version composed of twenty-one chapters was finalized in 1181. Neither was available when the *Siku* project started in 1772. The version included in *Siku quanshu* was Cao Yin's republication in 1706 (known as the Yangzhou version). Before the *Siku* project was completed in 1782, Wang Rixiu republished another version of *Li xu* in 1778 (known as the Lousong shuwu version). One of the most significant differences between the Yangzhou and the Lousong shuwu versions is that the former represents the carvings of the Wu shrines with line drawings, the latter with ink rubbings. It is not easy to decide which one is more authentic because no example from the twelfth century is extant. The illustrations in an early manuscript believed to have been produced in the Song, today in the Fu Ssu-nien Library in Taipei, are, however, in the mode of ink rubbings. In addition, the drawings seen in the Yangzhou version are very sketchy and far from the quality displayed in other Song antiquarian catalogues such as *Kaogu tu*. Therefore, I am inclined to believe that if Hong Gua had ever published *Li xu* with illustrations, he most likely used the mode of ink rubbings as duplicated in early manuscripts and the Lousong shuwu version. The figures in this paper come

from the modern reproduction of the Lousong shuwu version in the *Shike shiliao xinbian*.

73 It is, however, uncertain whether the poor quality of the illustrations in *Li xu* was inherent in its original printing or developed in later reproductions.

74 Wang Chang, *Jinshi cuibian*, 20.54a.

75 Huang Yi, "Wu Liang ci Tang taben," in *Xiao Penglai Ge jinshi wenzi*, 24a. As explained in n. 72 above, there were two different versions of *Li xu* showing two different modes of representing the carvings of the Wu shrines in Huang Yi's time. We do not know how Huang assessed the two versions. Nevertheless, it can be noted that his careful attention to accurate shaping and incised details was just what was lacking in the line drawings in the Yangzhou version.

76 For the newly made rubbings, Huang Yi only copied the inscriptions and had them printed in the chapter following the "Tang rubbings."

77 Feng Yunpeng and Feng Yunyuan, *Jinshi suo* (preface 1824; Ziyang, Shandong: the County Government, 1821–1824). Since Feng Yunpeng was the one who truly carried out this book project, I consider him the main compiler.

78 Huang Yi, "Wu Liang ci Tang taben," in *Xiao Penglai Ge jinshi wenzi*, 25b.

79 Weng Fanggang, *Liang Han jinshi ji*, 15.1a–30b.

80 Wang Chang, *Jinshi cuibian*, 20.54a–b.

81 Ibid., 20.54b.

82 Feng Yunpeng and Feng Yunyuan, *Jinshi suo*, "Shi suo," 3.35b.

83 Wu Hung points out the inconsistency between the female portrait on the right and its identification as a male in the accompanying cartouche, and speculates that *Jinshi suo* could have been "a reconstruction based on literary sources rather than on the carving itself." See Wu Hung, *The Wu Liang Shrine: The Ideology of Early Chinese Pictorial Art* (Stanford: Stanford University Press, 1989), pp. 296–98.

84 Huang Yi, *Xiao Penglai Ge jinshi wenzi* (republished 1834; reprint, Taipei: Yiwen yinshuguan, 1976).

85 Huang Yi, *Xiao Penglai Ge jinshi wenzi* (reprint, Xuandu: Yang Shoujing, 1890).

86 Wang Chang, *Jinshi cuibian* (republished 1872; reprint, *Shike shiliao xinbian*, ser. I, vols. 1–4). The 1872 edition is believed superior by virtue of more careful proofreading.

87 Wang Chang, *Jinshi cuibian* (republished 1893; Shanghai: Zuiliutang; Shanghai: Baoshan; Shanghai: Hongbaozhai).

88 Feng Yunpeng and Feng Yunyuan, *Jinshi suo* (republished 1893, Shanghai: Jishan shuju; republished 1897, Shanghai: Wenxin shuju and Qianqingtang).

PART FIVE IDEALS, PRACTICES, AND PROBLEMS:
A CRITIQUE OF *RECARVING CHINA'S PAST* AND RESPONSES

The Intellectual Legacy of
Huang Yi and His Friends:
Reflections on Some Issues
Raised by *Recarving China's Past*

QIANSHEN BAI

Huang Yi (1744–1802) was a famous eighteenth-century artist and antiquarian with multiple talents and skills. Though the Wu Family Shrines, recovered in 1786, has long been the subject of western scholarly attention, Huang Yi's intellectual and artistic life is less familiar to Western readers. For this reason, when I first was asked to present a paper at the symposium "Recarving China's Past," my goal was to introduce the audience to the intellectual and artistic activities of Huang Yi, which I did.

At that time I had not had the opportunity to read the newly published catalogue for the symposium's exhibition, *Recarving China's Past* (hereafter, *Recarving*). Symposium finished, and having read some of the essays in *Recarving*, I began to encounter serious problems in this volume. During the summers of 2005 and 2006, I had visited libraries in Beijing and in Cambridge, Massachusetts. Carefully going over my notes from these trips, I researched the accuracy of the evidence and assertions of some of the essays in *Recarving* and confirmed my initial impression of the catalogue: it contains more than a few errors.

Everyone makes mistakes because our knowledge and methods are always limited. We learn from these, tolerate others' honest mistakes, ignore minor errors, and criticize each other's significant mistakes with the hope that constructive criticism will prevent future errors and improve scholarship.

The mistakes in some essays of *Recarving* are too frequent to ignore and too serious to let pass. I reflected for a considerable time on the problems in *Recarving*, and increased reflection only made me feel more obligated to point out its errors. Failing that, its mistakes will be cited as facts by those who do not or cannot verify the evidence and assertions of two of the writers of *Recarving*. Since too often an article's worst errors can become

its most "reliable" points, it is important to clarify significant errors as promptly as possible. Most of the mistakes I will discuss here are not the result of different theoretical approaches. They are errors of fact. Among possible reasons for these errors, a major one appears to be insufficient training in the basic skills and knowledge needed for researching ancient stone inscriptions and the early catalogues of these inscriptions. Despite a lack of familiarity with Han pictorial art, epigraphy, clerical script, Chinese rare books, and related fields, one of *Recarving*'s authors ambitiously claims that their research is "intended to generate new directions for future research."[1]

The exhibition catalogue—*Recarving China's Past: Art, Archaeology, and Architecture of the "Wu Family Shrines"*—includes several essays and a number of catalogue entries for the rubbings of the Wu Family Shrines and Han objects. It should be pointed out that, among these writings, only a few espouse the thesis of "recarving," specifically Cary Liu's "Curator's Preface and Acknowledgements," his introductory essay, "The 'Wu Family Shrine' as a Recarving of the Past," and his second essay "Reconfiguring the 'Wu Family Shrines': A Typological Study," as well as Michael Nylan's "'Addicted to Antiquity' (*nigu*): A Brief History of the 'Wu Family Shrines,' 150–1961 CE."[2] Other essays, such as Anthony Barbieri-Low's on stone carving artisans of the Eastern Han dynasty, have little to do with the question of whether the monuments of the Wu Family Shrines have been "recarved." For this reason, in this article I shall analyze issues raised only in the essays of Cary Liu and Michael Nylan.

A major thesis closely tied to the "recarving" theme is that the Wu Family Shrines may not date from the Han, that they may not belong to the so-called Wu family, and that they may not be shrines.[3] In proposing their thesis, Nylan and Liu

challenge a longstanding scholarly consensus that the pictorial and written engravings on the shrines' stones are products of Han culture.

This argument has two major targets: Hong Gua (Hong Kuo, 1117–1184) and Huang Yi. Why have these two authors been singled out? First, Hong Gua was the author of a famous epigraphical work, the *Lishi* (*Explications of clerical-script inscriptions*). In this catalogue of ancient inscriptions carved in stone, for the first time Hong linked five inscribed stones together and proposed that they should be grouped into a single entity, the Wu Family Shrines. Hong Gua's work was thus critical for the concept of the shrines as a unitary site. Second, Huang Yi, having discovered a group of stones in 1786, used Hong Gua's *Lishi* to identify them as belonging to the Wu Family Shrines, thereby restoring the location and identity of this collection of monuments. Hence, the work of these two scholars constitutes a historical continuum of research and information on the Wu Family Shrines central to our knowledge of them, including their status as Han monuments.

Although they contest a Han date for the Wu Family Shrines, the major writers of *Recarving* do not supply an alternative date. Or rather, they provide a plethora of dates, each of which tends to undermine the plausibility of the others. To the authors, the Wu Family Shrines may have been built for Wu Mao of the Western Jin period (third century), or they may be monuments of the Tang, or their inscriptions may have been recarved in the Song or later. In the end, the shrines could have been created almost any time after the Han. Usually, a monument dates from only one period. The multiplicity of the authors' data and dates results in many inconsistencies, even contradictions, among them.[4] But such lapses in logic and reasoning do not seem to concern the authors, who have but

one limited aim: to sow doubt about a Han date for these monuments and, as a measure integral to achieving this goal, to cast suspicion on Hong Gua's scholarship and Huang Yi's integrity, on whose epigraphical work rests much of the evidence for a Han date for the shrines. To achieve this, they apparently think it unnecessary to produce a single, internally consistent set of arguments to support their thesis of "recarving," but instead use a disparate collection of tactical devices to throw as much doubt as possible on any piece of evidence that may be inconsistent with it. Prima facie, it might be argued that, since the Shrines are a collection of monuments, its components may be of different dates. But not only is there a significant degree of interrelatedness among many of its elements in terms of textual references, pictorial carving designs, and physical location, but the unsystematic and opportunistic criticisms put forward by Nylan and Liu seem to function primarily as a sweeping yet inconsistent, scatter-shot defense of the recarving thesis, undisciplined by an integrated alternative history for this site. Generating "new directions for future research" needs a better foundation than indiscriminate nay-saying.

In addition to undermining ancient studies of the shrines that do not support their major argument, the authors also cast indirect doubt on modern archaeological discoveries that support the shrines as Han monuments. They do so, however, not by assessing the reliability of newly excavated stone carvings but by omitting them as relevant materials for discussion. They seem to imply that, if the older discoveries of the Wu Family Shrines are post-Han recarvings or forgeries, any recent discoveries in the Jiaxiang area that share stylistic similarities with the shrines will also be of suspect authenticity. Cary Liu states: "Many Han stones besides those of the 'Wu family shrines' may have

been physically recarved or their cultural histories restoried, and that possibility has implications for how almost all Han-dynasty carvings and inscriptions are to be studied. The credibility of all such carvings and inscriptions must be reevaluated, and the results of such reevaluation may substantially alter our understanding of Han art, history, and culture."[5]

But long before the publication of *Recarving*, many scholars, ancient and modern, such as Huang Yi, Jiang Yingju, Xin Lixiang, and Zheng Yan, to list only a few, have already carefully and critically examined and reexamined Han dynasty stone carvings, whether handed down from the past or newly excavated. Such scholars always paid great attention to the problem of authenticity, and connoisseurship has always been an important part of their scholarship and a prerequisite of their historical narratives and interpretations. Similarly, many important catalogues of ancient stone carvings have also been carefully examined and reexamined by scholars since the mid Qing, research that, from its inception up to the present, has been held in high regard for its careful discrimination and detailed precision. Thus, the skepticism of Cary Liu's statement quoted above can be misleading unless seen against the historically high opinion of the efforts and accomplishments of these scholars. In all, Nylan and Liu's persistent challenge to the authenticity of the Wu Family Shrines is at once flawed and too serious to ignore.

May authorities and canons be challenged? Certainly. But they should be challenged in a commonly accepted scholarly manner. In making their major argument, Nylan and Liu do not acknowledge the extensive research and evidence that is not supportive of, even contradictory to, their arguments. They neither cite nor dispute this material; they act as if it does not exist. But more

serious than such omissions are the many mistakes, including mistranslations and misrepresentations of primary materials, that serve to support their argument. Yet, rather than support their argument, the problematic aspects of their research techniques do much to leave it open to serious question.

My article is therefore intended to achieve two goals. On the one hand, I introduce readers to various aspects of the intellectual life of Huang Yi and his friends, who were not only the core group of scholars of eighteenth-century China but who were particularly meticulous and talented in their research. On the other hand, I wish to show that some writings in *Recarving* contain serious faults, both methodological and factual, in passages in which their authors challenge the integrity of Hong Gua's *Lishi*. These two goals are not as disparate as they might seem, for much of the intellectual legacy of eighteenth-century Chinese is not only extremely rich, accomplished, and generally reliable, but it directly underpins much of the discussion of the two principal authors of *Recarving*. While introducing the achievements of Huang Yi and his friends, I have adopted their research methods to analyze problems in *Recarving*.

I. The Intellectual Circle of Huang Yi

Huang Yi was born in 1744 into a Hangzhou family with a substantial literary and artistic tradition. His seventh-generation ancestor was Huang Ruheng (1558–1626), a *jinshi* of 1598, government official, and calligrapher who worked in the styles of Su Shi (1037–1101) and Mi Fu (1051–1107). Huang Yi's father, Huang Shugu (1701–1751), was a scholar and calligrapher who excelled in the clerical and lesser seal scripts. Huang Yi's mother, also well educated, wrote poetry and painted. His family background not only helped insure that Huang Yi became a well-educated literati artist but also that

he was socially at ease with leading scholar-officials despite his lack of a high degree.

Huang Yi was a renowned painter, calligrapher, and seal carver. As a painter, his works most famous among modern art historians belong to the genre "Visiting a Stele" (*Fangbei tu*, also translated as "Searching for Steles" in *Recarving*).[6] Because Huang Yi was famous for his discoveries of ancient steles, these paintings, along with their inscriptions by Huang and colophons by distinguished scholars and artists, have become invaluable documents for studying eighteenth-century intellectual pursuits. As to calligraphy, Huang Yi was unquestionably one of the most accomplished calligraphers of his time. In contemporary calligraphy circles, he was famous for his clerical script, which was modeled after the inscriptions on Han-dynasty steles. As a seal carver, Huang Yi was in later times classified both popularly and by art historians as one of the Eight Masters of Seal Carving of Xiling (Hangzhou). He was a student of Ding Jing (1695–1765), the most senior among the eight masters of Xiling; often, Ding and Huang were referred to by the rubric Ding–Huang. This classification reflects that Huang Yi's highest artistic achievement is usually considered to have been his seal carving. Ruan Yuan (1764–1849), a leading scholar of Huang Yi's time, once commented that Huang Yi surpassed his master Ding Jing as the greatest seal carver of his time.[7]

Huang Yi was appointed to several government posts. His positions were never high, but the regions in which he worked were important to his scholarly and artistic activities. For example, his employment in a government office in Jining, Shandong Province, an area rich in ancient steles, enabled him to locate and make rubbings of these monuments. Eventually, he gained a major reputation for his work on steles, including a huge collection of fine rubbings.

Huang Yi lived at a time when the study of the humanities was entering its historic peak. Many of his friends were important members of so-called Qian-Jia school of scholarship (*Qian-Jia xuepai*), namely, the school of evidential research that flourished in the Qianlong (1736–1795) and Jiaqing (1796–1820) eras. Among them were Bi Yuan (1730–1797), Weng Fanggang (1733–1818), Gui Fu (1736–1805), Qian Daxin (1744–1806), Hong Liangji (1746–1809), Zhao Wei (1746–1825), Sun Xingyan (1753–1818), and Ruan Yuan, to list only a few.[8]

Bi Yuan, a native of Zhenyang, Jiangsu, performed brilliantly in the civil service examination (he was a *zhuangyuan*, that is, he achieved first place in the Palace Examination held by the Qianlong emperor in 1760). He soon became a senior official. He was both a distinguished scholar who published several works on epigraphical studies and an important academic sponsor, supporting many young scholars later eminent in their fields.[9]

Weng Fanggang was probably Huang Yi's closest friend among government officials. Unlike most of Huang Yi's friends, Weng was a northerner (Daxing [Beijing], Zhili) during a period in which China's intellectual life was dominated by southern scholars from the lower Yangzi delta.[10] A senior government official, Weng was one of the foremost experts of *jinshi xue* ("studies of ancient metal and stone objects").

Gui Fu, another northerner (a native of Qufu, Shandong), became a *jinshi* degree-holder fairly late in life (1790). Besides epigraphical studies, his specialties were paleography and etymology, especially the study of Xu Shen's classic work on paleography, the *Shuowen jiezi* (*Analysis of Characters as an Explanation of Writing*).

Qian Daxin, a native of Jiading, Jiangsu, was regarded by his contemporaries and later authorities as the best scholar in many fields, including history, epigraphy, paleography, phonology, ancient geography, bibliography, mathematics, etc. Despite a successful political career, Qian retired early to devote himself to scholarly investigation, and this allowed him to be productive in many fields.

Hong Liangji was a native of Yanghu, Jiangsu. After repeatedly failing the civil service examination, he became *jinshi* in 1790, but even before that he had been an accomplished scholar for many years under the sponsorship of Bi Yuan. His research fields included phonology, local history, and historical geography.

Among Huang Yi's friends, Zhao Wei, like Huang, was one of the few without a high degree. A native of Renhe (present-day Hangzhou), Zhejiang, Zhao's specialty was epigraphy. Also like Huang, Zhao avidly visited steles and took rubbings of them. He worked for Bi Yuan for a time and compiled several catalogues of ancient metal and stone objects.

Sun Xingyan was a native of Yanghu, Jiangsu. In 1787 he passed the *jinshi* examination and became a government official. An erudite scholar, Sun was accomplished in several fields, including the Confucian Classics, bibliography, and epigraphy.

Ruan Yuan, another pivotal figure in the late eighteen-century intellectual community, was native to Yizheng, Jiangsu. A distinguished scholar of epigraphy and biographer of mathematicians and astronomers, Ruan Yuan was also an active and important organizer of academic research projects, due partly to his senior position in government. Under his leadership, several important projects were accomplished.

Although the research fields and scholarly interests of the members of Huang Yi's circle differed, all of them adopted the evidential

approach (*kaozheng*) to research that became increasingly influential in eighteenth-century intellectual life. The fundamental principle of evidential research, as its name suggests, is that conclusions must be based on carefully gathered evidence. Elman writes: "Relying on systematic gathering of materials that they would then critically scrutinize and in certain cases even quantify, Jiangnan scholars combined evidential research methods with data collection and organization. Liang Qichao has estimated that Qian Daxin recorded over one hundred items in his notebooks before he could shed new light on the linguistic phenomenon of dental labials (*qingchun yin*) recorded in ancient Chinese texts. Qian presented his data within a systematic discussion of ancient pronunciation."[11] Qian Daxin exemplified this scholarly approach among Huang Yi's friends.

After more than two hundred years, although later generations of scholars have found occasional errors in the writings of the Qian-Jia scholars, in general, time has proved the solidity of their scholarship, and many of the research skills utilized by the Qian-Jia scholars remain useful for scholarly investigations today. Not only do many of the studies pursued by these eighteenth-century scholars continue to have relevance today, but two areas of their research have particular application to the discussion of some problems in *Recarving China's Past*.

Let us start with Qian Daxin. One of his many research projects was to compile lists of historical figures who shared the same name.[12] In one project he made lists of Han figures whose names are written with identical characters, then did the same for those with identically written names from the Han to Yuan dynasties. Thus, he pointed out that there was a Kong Anguo in the Han dynasty and another in the Jin dynasty, and he lists three people

named Zhang Heng, one each in the Han, Jin, and Sui dynasties.[13]

Although this kind of study may seem slightly esoteric from a modern perspective, it has proven useful in helping to sort out who was who in ancient times, especially in light of otherwise inadequate information. In particular, Qian's studies of ancient individuals with identical names were of great assistance to me in illuminating some aspects of the Wu Family Shrines.[14] For example, while the pictorial carvings in the Wu Liang Shrine include a portrait of someone named Zhu Ming, Hong Gua, a Southern Song expert on ancient steles, recorded a broken Han stele from the area of Shu in his classic work *Lishi*, whose text mentions a low-ranking government staffer named Zhu Ming.[15] The distance between these two sites suggests that there may have been at least two individuals named Zhu Ming in the Han.

But other Zhu Mings lived about this time, too. A general of that name lived in the late Three Kingdoms to early Western Jin period,[16] and the Tang writer Lu Guangwei's *Wudi ji* records a temple named Zhumingsi (Zhu Ming Temple) built in the Eastern Jin to commemorate the high moral conduct of a native son.[17] In addition to the two Zhu Mings of Han times, this adds two Zhu Mings during the Jin. Hence, my research demonstrates that there may have been at least four Zhu Mings in the Han and Jin periods. This becomes relevant when considering Cary Liu's comment in *Recarving*:

Textual records indicate that Zhu Ming lived after the Han dynasty during the Eastern Jin. Acceptance of the "Wu family shrines" as a Han-dynasty monument required that the texts should be corrected and history recarved. On the other hand, if the textual records are presumed correct, then the carved inscriptions need to be explained.[18]

The problem with this passage is the assumption that the Zhu Ming of the Wu Liang Shrine and the Zhu Ming of the Eastern Jin recorded by Lu Guangwei were the same person. This becomes questionable in light of my research demonstrating the possible presence of up to four Zhu Mings during the Han-Jin era.

Other subjects of study by some members of Huang Yi's circle were the personnel system of the government bureaucracy and China's ancient administrative districts. Again, the greatest authority in both fields was Qian Daxin. He and his friends compiled many writings on ancient geography, titles of government officials, and changes in the units of territorial administration. In their writings they also corrected many mistakes made by past scholars. They then applied their knowledge of this field to the study of ancient metal and stone objects, including stele inscriptions.

The rich body of scholarly work left by the Qian-Jia scholars in these fields is an invaluable resource in our study of the Wu Family Shrines. For instance, the text of the Wu Kaiming stele as recorded in Zhao Mingcheng's (1081–1129) *Jinshi lu* and transcribed in Hong Gua's *Lishi* mentions that one member of the Wu family, Kaiming, had served as the *fucheng* of Wujun. The early Qing scholar Ye Yibao reflected on the use of this term in his entry for the Wu Ban stele, which notes that one of the stele donors was a former colleague of Wu Ban who served as a *fucheng* in Chenliu Commandery. Ye believed that *fu* was not used to designate a unit of territorial administration until the Tang dynasty, so *juncheng* ("commandery aide"), rather than *fucheng*, might be the proper title for the assistant to the governor of a commandery (*jun*) in the Han dynasty. But Ye also cautiously listed the term *fucheng* as a form of address used in three Han stone inscriptions

of whose authenticity he had no doubt, implying that the terms *fucheng* and *juncheng* may be equivalent titles.[19] Citing Ye's reflections, Michael Nylan writes: "Ye Yibao's (act. 1697) classic work, *Jinshi lu xuba* (*Further notes on [Zhao's] 'Records of metal and stone'*) states that the donor list includes a reference to the post of *fucheng* ("associate in the *fu*"), that almost certainly indicates a Tang date for the Wu Ban stele inscription."[20] The implication here is that the Wu Ban stele, a key monument in the Wu Family Shrines, is either a Tang recarving or a forgery.

But Nylan's "almost certainly" implies that she is less than certain. With good reason: the term *fucheng* appears in many Han stone monuments recorded in Ouyang Xiu's (1007–1072) *Jigu lu* (*Records of Collected Antiquities*), Zhao Mingcheng's *Jinshi lu* (*Records of Metal and Stone*), and Hong Gua's *Lishi*.[21] Moreover, the *History of the Former Han* (*Han shu*) and the *History of Latter Han* (*Hou Han shu*), foundation works in the study of any subject related to Han history, frequently apply this title to local officials.[22] Finally, a commonly accepted Han monument, the famous Gao Yi *Pillar-Gate* in Sichuan (ancient Shu), uses this term in its inscription. These numerous Han uses of *fucheng* prove it a title held by certain local officials in the Han dynasty.[23]

Study of the uses of *fucheng* in Han texts makes it clear that the use of *fu* in these cases does not relate to an administrative district but to an office, that of *junshou* ("commandery governor").[24] But since a *junshou* was often called a *fuyin* or *fujun*, a *juncheng* ("commandery aide") was commonly referred to as a *fucheng*.[25] In addition to the primary Han sources listed above, modern scholarship also shows that *fucheng* was a term used for addressing the chief of staff to the *junshou* in the Han dynasty. In an article

on the *jun* administrative system in the Han, the renowned historian Lao Gan drew materials both from historical texts like the *History of the Western Han* and the *History of the Eastern Han* as well as archaeological evidence such as the writing on Han bamboo slips and wooden tablets unearthed in the early twentieth century to analyze the administrative duties and staff titles of *junshou*. He particularly points out that the office of a *junshou* was called *fu*, that the chief of staff was a *fucheng*, and that *fucheng* and *juncheng* were interchangeable terms, with the latter more formal.[26] Hence, for Nylan to cite Ye's discussion of the term *fu* in dating the Wu Ban stele to the Tang is certainly incorrect.[27]

As a member of an active intellectual community in the eighteenth century, Huang Yi wrote such scholarly works as his diaries recording his stele-hunting visits to Mt. Song, Luoyang, and to Mt. Tai and its surrounding areas, his scholarly catalogue of the Han stele rubbings in his own collection, and his research notes (including colophons) on many ancient steles. But Huang Yi's most important contributions to metal and stone scholarship were his activities as a discoverer of ancient steles, and a collector of fine rubbings.

That Huang Yi's rubbings were celebrated by his contemporaries should be viewed in a broad context. In the eighteenth century, the evidential method triumphed as a dominant intellectual approach, in which the Confucian Classics, the canons of historiography, and other ancient books were subject to empirical scrutiny. Contributing to the evidential evaluation of knowledge during this period, the study of ancient metal and stone objects (*jinshixue*) reached its zenith. Scholars paid particular attention to metal and stone inscriptions as primary sources for the study of the Confucian classics and other historical texts. The search for ancient inscriptions promoted the practice of

visiting steles (*fangbei*) in the mid-Qing period,[28] and Huang Yi was deemed the foremost stele visitor and rubbing collector.

When Huang Yi acquired a good rubbing, he would ask his friends to inscribe research notes (colophons) on it. As mentioned, most of Huang Yi's friends followed the evidential approach to research. The fundamental principle of evidential research is that research must base its conclusions on reliable, verifiable evidence. Knowing the complex history of the transmission of stele inscriptions and the practice of recarving or even forging old stele inscriptions, scholars of the Qian-Jia period would not have accepted Huang Yi's rubbings uncritically even though he was famous for the quality of his collection in this field. The authenticity of the sources of his rubbings would be the first issue to undergo scrutiny by his friends. Existing documents demonstrate that Weng Fanggang's colophons comment frankly on the authenticity of Huang's rubbings, and Weng opined that several rubbings in Huang Yi's collection were not rubbings of original stele inscriptions but of recut steles. In his *Liang Han jinshi ji* (*Records of metal and stone carvings of the Former and Latter Han*), Weng writes:

Qiu'an [Huang Yi] obtaining [rubbings of] three Han steles at once, then sent them to me to examine and write colophons…. All three rubbings were made from recarved steles.[29]

What is most impressive here is that not only did Weng Fanggang publish his opinions but also that, when Huang Yi published his rubbing catalogue *Xiao Penglai Ge jinshi wenzi* (*Metal and stone inscriptions from the Xiao Penglai Ge*), Weng's colophons, even those unfavorable to Huang's rubbings, were included.[30] In doing so, Huang

notified his readers of conflicting scholarly opinions on his rubbings. Furthermore, the inclusion of such comments enabled his catalogues to perform the valuable function of circulating scholarly opinion, amplifying the explosion of scholarly knowledge in the eighteenth century.

In a short research note on the rubbing of *The Stele of the Spiritual Terrace of Chengyang* (Han, erected the fifth year of the Jianning reign, i.e. 172), Qian Yong (1759–1844), writes:

This stele rubbing resides in the collection of Sima Huang Xiaosong [Huang Yi]. Mr. Weng Tanxi [Weng Fanggang] judged that it is a rubbing of a later recarving of this stele. But recently, even rubbings of the recarved stele are hardly to be found.[31]

Doubtless, Qian Yong acquired this information from the catalogues of Weng Fanggang and Huang Yi. This is but one of many examples of the high scholarly integrity and rectitude of the Qian-Jia period, when scholars, even as they inscribed colophons on works belonging to good friends, held to high academic standards.

Thus, the publications of Qian-Jia scholars frequently and openly pointed out the mistakes of scholars past and present. On several occasions, for instance, Qian Daxin straightforwardly discussed the errors of such past scholars as Hong Gua and Gu Yanwu (1613–1682). He did this despite his admiration for them and for their work. He also expressed disagreement with Weng Fanggang on certain scholarly issues.[32] Many similar examples might be cited.

China, like other cultures, was not without its share of forgeries of ancient texts and monuments. But in the Qing dynasty, much effort was devoted to the detection of forgeries (*bianwei*), a process that became inextricably linked to, even

identified with, the evidential research movement.[33] Qian-Jia scholars did not accept ancient works uncritically, not even canonical writings or works written by canonical figures. Zhao Wei, a close friend of Huang Yi and a connoisseur of ancient rubbings and calligraphy, once commented that many engravings of Wang Xizhi's calligraphic works were likely based on Tang copies. Eventually, his comment led to a twentieth-century debate over the authenticity of Wang Xizhi's *Lanting xu*, the most revered work in the history of calligraphy.[34] If canonical works associated with Wang Xizhi could be doubted, what could not be challenged? The importance of such a critical attitude for this discussion is that, had Qian-Jia scholars thought the Wu Family Shrines doubtful in any respect, they would have been sure to express their reservations; yet, no doubts as to the authenticity of its monuments are on record.

Discussing ancient scholarship, modern scholars have sometimes held that the scholars of imperial China, including those of the Song and Qing, worked under the sway of the doctrines of *fu gu* ("recovering and revitalizing the past")[35] and *ni gu* ("addiction to antiquity").[36] While by themselves these descriptions may not be wrong, also by themselves they present an unbalanced picture of ancient research. One must consider that many antiquarian scholars, especially those of the Qing, were not only equipped with great technical skills for studying antiquity but exercised wide powers of critical thinking. The latter drove them to check their evidence, and the conclusions they drew from it, with great care and to exercise particular vigilance with respect to forged and recut steles. Much of their work was so excellent that, even today, it is difficult to find serious fault with it.[37]

In conclusion, not only were scholars of Huang Yi's time keenly aware of the problem of

recarvings and forgeries of ancient steles, but they were quite frank in expressing their opinions on authenticity. No scholarly work is free of error, but mistakes made by the Qian-Jia scholars were seldom the result of attempts to advance personal interests or to please a client or audience. Furthermore, the work of later scholars has proven the quality of Qian-Jia scholarship as generally solid and reliable. For this reason, these scholars and their works continue to enjoy a high reputation today.

II. Huang Yi's Rubbings

The friends and colleagues of Huang Yi firmly believed that he was the best collector and connoisseur of ancient rubbings of their day, even though Weng Fanggang, for example, considered some of the rubbings in Huang's collection to be products of later recarving. Qian Daxin shared this widespread high opinion of Huang Yi, writing in his preface to Huang Yi's *Xiao Penglai Ge jinshi wenzi*:

Among contemporary scholars who carefully study inscriptions on metal and stone objects, there are about twenty or so with whom I have made friends over time. Among them, not only is Mr. Huang Qiu'an from Qiantang the most obsessed with the subject, but also he is the best connoisseur of this field.

In a letter to Huang Yi now in the collection of the Shanghai Museum, Hong Liangji writes: "Have you searched for metal and stone objects recently and found any new items? Should you have extra rubbings or double-line tracing copies, would you please send me one or two?" This letter is evidence that Huang was chiefly esteemed among his fellow scholars as a major researcher of ancient steles. In a letter to Zhao Wei, then visiting

Guangdong, Huang Yi wrote that he was about to send rubbings to Zhao and hoped that, if Zhao obtained rubbings of steles in Guangdong, Zhao would send him some of these in return. In another letter to Zhao, Huang Yi wrote that he had made several "fine rubbings" (*jingta*) of the Heng Fang stele and would send one to Zhao.[38]

Huang Yi was highly successful in acquiring rubbings of ancient steles, because he lived in convenient proximity to many of the locations of ancient objects. Weng Fanggang once commented that Jining, to which Huang had been posted, was the site of most steles surviving from the Han and Wei periods.[39] Overall, the history of the production of rubbings during the Ming and Qing dynasties shows a positive relationship between geographical concentrations of ancient objects and the rubbings of those objects made by scholars who worked or lived near these concentrations.

For instance, Zhao Han (act. 1573–1620) and Guo Zongchang (d. 1652) were both natives of Shaanxi, a province rich in ancient steles, and were both also major late Ming collectors of ancient stele rubbings. Similarly, Chen Jieqi (1813–1884) was the greatest nineteenth-century collector of pre-Qin seals and inscriptions on pre-Qin ceramics. Helpful to him in amassing his huge collection of pre-Qin materials was his residence in Weixian, Shandong Province, which is proximate to the ancient political and cultural centers of the state of Qi of the Warring States period. Because of this advantage in geography, not only was no one in the late Qing able to compete with the volume of his collecting, but his collection was heavily oriented toward collectibles common in his region.[40]

That what Huang Yi terms "fine rubbings" played such an important role in the intellectual and artistic life of the mid-Qing and yet remain relatively obscure to western readers makes

it necessary to expand on their importance at this time. In an article on rubbings, I wrote, "People today are used to modern printing technology, which can create countless identical reproductions of art works. Chinese calligraphy rubbings, however — even those made from the same block — are never identical, their manual production making each an original work of art."[41] In the making of rubbings, their singular production, which entails variations in ink (wet or dry) and paper (degree of absorbency), degree of pressure when tapping the paper, and weather during their production (clear or inclement) can cause significant differences between two rubbings made on the same day by the same person from the same stone. This degree of variation was multiplied in rubbings made by workers with varied goals: attractiveness, accuracy, productivity.

To illustrate, consider two rubbings of a Western Han stone inscription. The *Wufeng Stone Inscription* (*Wufeng keshi*, or *Lu Xiaowang keshi*) is housed in the Confucian Temple in Qufu, Confucius' hometown. It was carved in the second year of the Wufeng reign-period (56 BCE) of the Western Han, and is famous because of the rarity of stone inscriptions from the Western Han. Many scholars and calligraphers visited this stone during the early Qing, including the Shanxi scholar Fu Shan (1607–1684/85) and his grandson (1657–after 1725), who saw it in 1671.[42] About four years later, in 1675, the famous early Qing calligrapher Zheng Fu (1622–1693) visited this stone and made several rubbings of its inscription.[43] He sent one of these rubbings to his friend, the distinguished scholar Zhu Yizun (1629–1709), which survives today in the collection of the Palace Museum, Beijing (fig. 1).

This rubbing by Zheng Fu is an interesting example of the art of rubbing. Because he used a

Fig. 1 *Wufeng Stone Inscription*. Dated to 56 BCE. Rubbing mounted in an album; ink on paper; measurements unavailable. Palace Museum, Beijing. After Qi Gong, *Zhongguo meishu quanji, Shufa zhuanke bian, Shang-Zhou zhi Qin-Han shufa* (Beijing: Renmin meishu chubanshe, 1987), vol. 1, pl. 45a (p. 64).

Fig. 2 *Wufeng Stone Inscription*. Dated to 56 BCE. Rubbing mounted in an album; ink on paper; measurements unavailable. National Library of China, Beijing. After Qi Gong, *Zhongguo meishu quanji, Shufa zhuanke bian, Shang-Zhou zhi Qin-Han shufa* (Beijing: Renmin meishu chubanshe, 1987), vol. 1, pl. 45b (p. 66).

wet ink method when making this work, its paper, except where pushed into the engraved characters, is covered by rich ink. Viewed in color, its elegant tonalities of ink are immediately impressive. However, although the wet ink used in this method created a rubbing of great beauty, this technique made a few characters illegible (especially the character *cheng* in the bottom left corner). Zheng, foremost an artist, emphasized beauty at the expense of legibility in this rubbing.

Another rubbing of the *Wufeng Stone Inscription*, in the collection of the National Library of China, provides a significant contrast with Zheng's (fig. 2). The National Library rubbing was once in the collection of Gu Guangqi (1766–1835), famous collator of ancient books. It is recorded as having been made in the early Qing (1644–1722),[44] roughly contemporary with the rubbing made by Zheng Fu. The ink pad with which this rubbing was made must have been much drier than the one used by Zheng Fu. The inscription's characters had already been severely damaged at the time of this rubbing, and, to make them legible, the rubber touched the paper surface quite lightly, which made the ink tone light to pale. Scholars believe that both rubbings were made from the same original. These two rubbings, published together in the *Complete Works of Chinese Fine Arts* (*Zhongguo meishu quanji*), demonstrate that two rubbings, even though made in the same period and from the same stone, may differ dramatically in legibility and appearance.

Why did Zheng Fu, supposedly an excellent rubbing maker, make a blurred rubbing?[45] As noted, Zheng Fu created this rubbing as an aesthetic object at the expense of its legibility. This artistic quality has been revered by many calligraphers ever since. In the late Ming, seal carving became popular among literati. Calligraphers in that period,

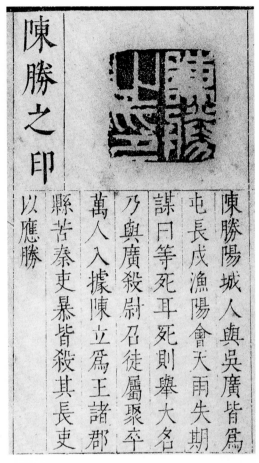

Fig. 3 *A seal impression reading* "Chen Sheng zhi yin." From He Tong's *Yin Shi, juan* 1, p. 5. Dated to 1623. Harvard-Yenching Library.

attracted by antique seals marked by the wear and damage of time, attempted to impart an antique flavor to their calligraphy by emulating a ravaged appearance. Marks of decay also became a desirable aesthetic quality that seal carvers attempted to reproduce in their works. Take, for example, a seal impression reading "Chen Sheng" in He Tong's (act. 1625) *History Carved on Seals* (fig. 3). In this work the carver deliberately severed strokes and marred areas between the strokes, damage that contributes an aura of antiquity to the impression of this seal.

Fig. 4 Wang Duo (1593–1652), *Calligraphy for Shan Danian*. Dated to 1647. Hanging scroll; ink on satin; 237 × 56 cm. Ho Ch'uang-shih Calligraphy Foundation, Taipei.

Fig. 5 Detail of fig. 4.

In calligraphy, as noted, a similar goal became popular. In a hanging scroll written in running script in 1647 by Wang Duo (1593–1652) (fig. 4), the brush is so saturated that the ink in a number of characters bled, and the irregular edges of their strokes resemble the unexpected and random marks in stone seals that result from speedy carving. The ink in the character *wu* (without), eighth character in the leftmost column (fig. 5), is so wet as to make the central strokes in the character indistinguishable. Zheng Fu's richly inked rubbing

pursues a visual ambiguity common in the second half of the seventeenth century in both seal carving and calligraphy.

In addition to intended effects, chance may cause a rubbing's illegibility. Moss covering a stele, dirt filling its engraved characters, unskillful or sloppy rubbing, and other phenomena can introduce a variety of aleatoric effects into a rubbing. For this reason, scholars and connoisseurs of rubbings have long noted that the characters in earlier rubbings may be less legible than those in more recent rubbings, despite increased wear and damage to the subject stone. Ye Changchi (1847?–1917), a leading scholar and connoisseur of stone objects and their rubbings, writes in his famous *Discussion of Stone Objects* (*Yu shi*):

Although people distinguish early rubbings from later rubbings [made from the same stones], some later fine rubbings (*jingta*) are even better than older rubbings (*jiuta*). [For instance, among] the rubbings of *Inscription on the Stone Pillar-Gate to the Grand Chamber at Marchmount Song* (*Song Shan Taishi shique ming*), a new rubbing seen by Wang Xuzhou [Wang Shu, 1666–1739] contains more characters than an older rubbing (*jiutaben*) once owned by Cheng Mengyang [Cheng Jiasui, 1565–1643]. All rubbings of steles from Zhaoling obtained by me were made in the reign of Daoguang [1821–1850].[46] Comparing the rubbings of the *Stele of Former Imperial Concubine Lu* (Lu Xianfei) and the *Stele of Princess Qinghe* (Qinghe gongzhu) in my collection with those recorded in the *Compilation of Metal and Stone Inscriptions* (*Jinshi cuibian*), my rubbings are longer by several dozens of characters.[47] The rubbings of the Zhang Yun stele and the Du Junchuo stele [in my collection] have up two to three hundred more characters than those [recorded in *Jinshi cuibian*, published

1805]. This is because in the northwest highlands earth piled up, forming small mounds, burying the lower parts of steles in the earth. Rubbing workers rubbed only the exposed upper portions of steles, while recording no characters on their lower portions. They were unaware that the engraved texts on the lower portions remained intact, texts that were unearthed by people of a hundred years later. Other reasons [for poor earlier rubbings] are that steles were entangled in vines, partly covered by mosses, or obscured by accumulated layers of dust and dirt, and hurried rubbing workers sometimes did not wash and clean their steles. How can good rubbings be made? If one scrapes off dirt and grease, cleans the surface, and then makes rubbings, the rubbings' spirit will suddenly appear. Take rubbings of the *Stone Drum Inscriptions* as an example. Recent rubbings made after the stones were washed and cleaned have a number of additional characters compared with rubbings made at the beginning of our dynasty.[48] The evidence of this last example is especially convincing.[49]

Thus, Ye describes some of the practices that yield good rubbings. On relatively recent steles the edges of engraved characters are fairly sharp and clear. Here legibility is not much affected by rubbing quality: texts are readable even in bad rubbings. When a stone inscription is severely damaged, however, how a rubbing is produced becomes critical to whether or not it can be read. With rubbing quality decisive to clarity, a small difference in technique can make large difference in legibility. Characters barely readable in a good rubbing may become illegible in a rubbing of only slightly less quality.

With these considerations in mind, it becomes easier to understand why reputable scholars, connoisseurs, and collectors in the late Ming and

the Qing paid great attention to cleaning steles and thus often created rubbings of higher quality than those made in the distant past. The following passages by late Ming and early Qing writers are illuminating:

[Mr. Zhao Han, act. 1573–1620] loves antiquities from the depths of his heart.... He often rides a donkey from which hangs a *pianti* [a flask-like container] full of strong wine. Followed by attendants carrying brocade bags and rubbing makers armed with paper and ink, he travels the regions around the Zhou and Han capitals. When he finds a stele, he cleans it himself. Then, he directs exquisite rubbings to be made, which he puts into his travel bag.[50]

Describing Zhu Yizun's stele-visiting activities, the early Qing scholar Ye Yibao writes:

Zhu Yizun and Cao Rong [1613–1685] lived in the areas of Yan [roughly, the northern part of modern Hebei Province] and Jin [roughly, modern Shanxi Province], and, once they found ancient steles, they did not mind taking the trouble to dig down several feet to get them out of the earth. All their assistants excelled in making and mounting rubbings.[51]

These two passages confirm that digging steles out of the earth, washing and cleaning steles, and employing excellent rubbing makers are critical to making fine rubbings. Huang Yi's *fangbei* paintings, which record the process of making fine rubbings, depict such activities as "erecting steles" and "cleaning steles." These preparatory efforts were rewarding to Huang Yi and his friends. When Huang visited the Kaimu Pillar-Gate on Mount Song, he made a rubbing of its inscription and brushed a

painting that recorded this event. In the colophon to this painting, he said that he made the rubbing with great care, using highly refined paper, with the result that more than twenty characters not captured by older rubbings could be seen on his rubbing.[52]

If it is accepted that often a carefully made later rubbing is of better quality and contains more readable characters than an older rubbing of the same inscription, then it may be assumed that some rubbings in the collection of the Northern Song literatus Ouyang Xiu, from which he compiled his *Colophons to the Collected Records of Antiquity* (*Jigu lu bawei*), need not have been better than rubbings in the collections of later scholars like Zhao Mingcheng and Hong Gua. Take a rubbing of the Wu Ban stele as an example. Ouyang Xiu states in his *Colophons to the Collected Records of Antiquity* that this stele was so ruined that eighty to ninety percent of the characters on this stele are illegible. But in Zhao Mingcheng's *Jinshi lu*, there is an entry on the Wu Ban stele that reads:

On the right is the [rubbing of] the *Stele of Dunhuang Chief of Staff Wu Ban*. Mr. Ouyang writes in his *Jigu lu*: "This is the [Wu] Ban stele *of the Han Dynasty*. Because its characters are ruined, it does not have a readable text. The clan, official title, and dates of death and burial [of Wu Ban] cannot be found. What can be read are "The deceased person's name is Ban." Now, when I compare it to the rubbing [of the Wu Ban stele] in my family collection, [I find that] although the characters are damaged, they yet remain legible.[53]

This passage tells us that Zhao Mingcheng had read Ouyang Xiu's *Jigu lu* and was aware that about eighty to ninety percent of the characters in Ouyang's rubbing were illegible. While admitting that the stele from which his rubbing was made was damaged to some degree, Zhao also points out that the text of the Wu Ban stele rubbing in his collection is readable. He did not challenge the integrity of Ouyang Xiu's record because he believed in the honesty of Ouyang Xiu. But the implication of "the rubbing in my family collection" is clear: Zhao believed that he had a better, and authentic, rubbing.[54]

It should be kept in mind that the study of metal and stone objects experienced major progress in the late Northern Song, and it is likely that increasingly better rubbings were made and available to scholars in the decades after the time of Ouyang Xiu. The circulation of fakes cannot be excluded, but Zhao Mingcheng was a connoisseur of rubbings, and it would appear that forgeries would not easily have escaped his notice.[55] If it is reasonable to think that Zhao, a scholar living only several decades after Ouyang Xiu, was likely to have owned a better rubbing than Ouyang's, then it will not be surprising that Hong Gua, a scholar thirty or more years later yet than Zhao Mingcheng, recorded the full text of the Wu Ban stele.[56]

To depict Ouyang Xiu as a trustworthy scholar among Song epigraphers, Cary Liu and Michael Nylan describe in *Recarving* his role in the history of rubbings. Liu claims that Ouyang Xiu wrote his entry for the Wu Ban stele in 1064 when in exile at Rencheng (present-day Jining, Shandong), the area in which the Wu Family Shrines is located, without giving textual sources for his statement.[57] Michael Nylan, in her essay in the same volume, comments: "Of those three Song experts, only Ouyang Xiu knew the town of Rencheng well, for he had spent years in exile there. (See Cary Liu's "Recarving the Past" in this catalogue.) By contrast, Zhao Mingcheng and Hong Gua, as Hong's remarks reveal, knew the vicinity of Rencheng from hearsay

about the rubbings in their possession, all of which were soon lost."[58]

But is it true that Ouyang Xiu wrote his colophon to the Wu Ban stele in Rencheng, lived there for years, and knew the town well? This version of the history of Ouyang's rubbings needs closer examination, for the claim that Ouyang Xiu was exiled to Rencheng has become important evidence in challenging the reliability of the Wu Family Shrines, the rubbings made from its monuments, and the reliability of the catalogues that record these monuments. For example, in questioning the authenticity of the pillar-gate inscription of the Wu Family Shrines, Nylan writes: "No reference to a pillar-gate inscription can be found in the works of Ouyang Xiu, though it is hardly likely that Ouyang Xiu would have failed to notice such an imposing monument during his period of exile in Rencheng."[59] That is, accepting Ouyang's work as definitive, Nylan implies that the pillar-gate, its inscription, and rubbings of its inscription may not be original.

But doubt may be thrown on the history of Ouyang Xiu's exile in Rencheng as recounted by Cary Liu and Michael Nylan. Ouyang Xiu's commentary on the Wu Ban stele in his *Jigu lu* is dated to 1064. But Ouyang was not present there that year, as Liu claims. Instead, in 1064 he served as a senior official at the imperial court in the capital city, far from Rencheng.[60] More damaging to a Rencheng exile are conclusions based on my review of Ouyang Xiu's writings and a few of his biographies (including biographical chronologies).[61] There is no evidence in these documents that Ouyang Xiu was exiled to Rencheng at any time; nor is there mention of his having resided there for "years."

The accounts of Nylan and Liu regarding Ouyang Xiu's exile at Rencheng present an unusual picture. In his essay, Liu provides his readers with

no textual sources that support the idea that Ouyang Xiu was exiled to Rencheng. While a note to his discussion of the Rencheng exile refers readers to his source, the source has no information on a Rencheng exile. Nylan also provides no independent source for an exile. Throughout her paper, she appends an impressive quantity of notes that lend her work an authoritative appearance. Still, none of these reveal a source for her account of Ouyang's stay in Rencheng except for her reference to Cary Liu's essay.

Moreover, Liu's account states merely that Ouyang Xiu was in exile at Rencheng in 1064; there are no further details, such as the length of his residence there. And yet, without other citations than to Liu, Nylan expands Liu's account of Ouyang's stay in Rencheng by saying he spent years there. Liu's source for the Rencheng exile refers the reader to the entry for the Wu Ban stele in Ouyang Xiu's *Jigu lu*. This entry, however, makes no reference to an exile of Ouyang to Rencheng. Moreover, both Liu and Nylan cite or mention the *Jigu lu* entry for the Wu Ban stele several times. Thus, it may be expected that they are entirely familiar with its short entry and understand that it contains no information on an Ouyang Xiu exile. That these authors mention the Rencheng exile thrice in their essays makes it a critical support for their contention that the monuments of the Wu Family Shrines may have been altered or are post-Han (even post-Song). In the end, however, this key evidence for Nylan and Liu's recarving theme has no source except mutual textual support between the two writers.

The story of Ouyang Xiu's exile may not have been an intentional fabrication. If they are mistaken in claiming that Ouyang Xiu was exiled to Rencheng, it is understandable that, during an enthusiastic search for evidence for their recarving argument, hearsay or wishful thinking may have

slipped unintentionally into the authors' presentations. But the chief reason it is troubling is that it is only one example of how research materials were mishandled in Liu and Nylan's essays in *Recarving*. For example, there are numerous misreadings of their cited texts, all highly misleading. (It is advisable that interested readers with a command of Chinese compare the original sources to Michael Nylan's translations and interpretations.)

Here, as examples, I shall cite three serious mistranslations or misrepresentations of primary textual materials by Nylan in *Recarving*. First, she writes: "Explicit discussions of the best methods for the successful forging of antiquities appear at least as early as the Song, and are discussed at least as often with approbation as with moral indignation. See, e.g., the techniques of forging Han clerical script in Lu You (1125–1209), *Lao Xue an biji*."[62] But what Lu You writes in his *Lao Xue an biji* is that the calligrapher Du Zhongwei used a worn brush to write clerical script calligraphy to catch the flavor of the ruinous appearance of the characters in Han stele inscriptions, and that Du further claimed his method inherited the legacy of the Han method. Yet, not only did Lu You think Du Zhongwei inaccurate as to the latter point, but, more generally, what Lu's note outlines is a contemporary method of practicing calligraphy that has nothing to do with "the techniques of forging Han clerical script."[63]

A second example is a discussion by the rubbing connoisseur Fang Ruo of the rubbings of the pillar-gate inscription of the Wu Family Shrines. Nylan writes: "We do know that Fang Ruo's (1869–1954) *Jiaobei suibi* (*Notes comparing steles*) records that existing rubbings of the pillar-gate inscription present markedly different carving styles and formats, 'with not a single stroke in a similar place.'"[64] But this version of Fang's text is quite misleading. His note reads: "Rubbings [of the Wu Family Shrines pillar-gate] are not difficult to acquire, but those made after the Daoguang reign are less clear than older rubbings. Recently, there are rubbings of a recarved version that do not have a single stroke similar to [the strokes in the old rubbings]."[65] Here Fang Ruo distinguishes rubbings of the original stone from fakes. Nylan only mentions that rubbings of the pillar-gate looked quite different from one another, omitting to mention that Fang regarded the earlier of these as genuine.

The third example is Nylan's discussion of the history of the Wu clan. In a note, she refers to "Zhan Ruoshui (1466–1560), *Gewu tong* (*Siku* edition), *juan* 31/6b, which says that there were in Jin times two consort families, the Wu and Bian (the latter character often confused with the Ban of Wu Ban), whose histories seem to have vanished from the records." The passage in Zhan Ruoshui's text which Nylan cites reads "Jinwu bian ershi zhinü shenming." Nylan seriously misunderstands this passage. It is part of Zhan Ruoshui's commentary on a text that discusses the politics of selecting a spouse for the crown prince during the time of Emperor Wudi of the Western Jin (r. 265–290). The text tells us that the emperor preferred a daughter of the Wei family, arguing that the children of the Wei family were beautiful and virtuous, whereas the daughter of Jia Chong (not a Bian family) had weaknesses. Some of his courtiers, however, persuaded him to allow the crown prince to marry the daughter of Jia Chong. Following this text, Zhan Ruoshui's commentary reads, "Although Emperor Wudi of the Jin clearly analyzed the distinctions between the daughters of the two families, in the end, he did not realize his own intention." Nylan mistakenly treats Jinwu, a short form of address for Emperor Wudi of the Western Jin, as a reference to the Wu family of Jin

and then takes *bian* ("analyze"), as a family name. After misreading and mistranslating this passage from Zhan's *Gewu tong*, Nylan continues: "We know that the Wus had a cemetery in Rencheng in Song; we know also that as late as the Song, many persons who had won fame as warriors were awarded the family name of Wu ("martial"). In late imperial times, exemplary women of the Wu clan were honored in the Rencheng/Jiaxiang area. See *Yuanhe xingzuan* (*Siku* edition), *juan* 6/29b)."[66] But if we check Nylan's citation of the *Yuanhe xingzuan*, it contains none of the information that Nylan supplies. Furthermore, since *Yuanhe xingzuan* was completed in the Tang dynasty (618–907), how could it refer to matters that pertained either to the Song dynasty (960–1279) or "late imperial times"? Such empty citations occur quite a few times elsewhere in Nylan's essay. It is also notable that every misleading translation in Nylan's *Recarving* essay well serves the theme of recarving.

In contrast to her empty citations, Nylan, when framing criticisms, not infrequently leaves them devoid of notes or citations, which makes them closer to opinions than facts. As one example, she writes: "A modern epigraphical expert believes that some 80 percent of the material authenticated by Weng [Fanggang] was forged."[67] This is a serious criticism of Weng Fanggang, yet Nylan offers this important statement without identifying either the expert or a source for his/her claim, making it difficult to verify the expert, the source, or the claim.[68] Indeed, although Nylan's criticism of Weng Fanggang (1733–1818) is potentially devastating to his professional reputation, it is also one contrary to established scholarly opinion of Weng, whose work has been highly regarded for two centuries. In light of this generally favorable opinion, it becomes critical that Nylan support her contrarian position for it to attain any measure of credibility.

Yet there was a scholar who resided at Rencheng for years — Huang Yi, eyewitness to the Wu Ban stele and the Wu Family Shrines in the second half of the eighteenth century. But Huang had no digital camera and wrote no detailed excavation reports comparable to those of contemporary archaeologists. He only brushed sketches of the sites he visited as an aid to memory and wrote lucid colophons or notes in classical Chinese, which left so much room for interpretation that his scholarly integrity is now under challenge.

But Huang is not the only scholar whose academic integrity is questioned. Hong Gua's catalogue *Lishi* is the object of similar academic doubt because it records longer texts for the Wu steles than those in Ouyang Xiu's *Jigu lu*. Therefore, after telling us that Hong Gua knew Rencheng only from hearsay, Nylan challenges the authenticity of his rubbings, writing:

Hong Gua, collecting half a century after Zhao Mingcheng, once again dramatically increased the number of rubbings for which he composed entries, though by Hong's time the northern half of the Central States territory had fallen into the hands of nomadic Jurchens. That more inscriptional material might be gathered in a later work like Hong Gua's *Lishi* (compiled 1167) is hardly surprising, but that such significantly better rubbings of the very same materials from Rencheng and elsewhere would turn up in later collections is harder to explain, especially in Hong's case.[69]

Three points need clarification before further discussion of this issue. First, Hong Gua did not "dramatically increase" the total number of rubbings in his collection. As a collector who focused on collecting rubbings of inscriptions in clerical script, Hong, compared with Ouyang Xiu

and Zhao Mingcheng, had a greater number only of rubbings in clerical script. Second, some of Hong's rubbings had likely been made before the fall of the Northern Song. Third, judging from Zhao Mingcheng's *Jinshi lu*, Hong Gua's rubbings may not have been "significantly better" than those in Zhao's collection. Zhao did not transcribe the full texts of the rubbings in his collection; if he had done so, his *Jinshi lu* would have been several times larger than in its current form. But this does not mean that his rubbings were of poor quality. Instead, it would appear that good rubbings were already increasingly available to scholars and collectors by the late Northern Song.

With these points in mind, we can further discuss why Hong Gua was able to obtain rubbings even though, living in the south, he never traveled north to the primary concentrations of Han steles. Although Hong grew up in the Southern Song and never visited Shandong in northern China, the places in which he grew up and worked had long been within the territory of the Northern Song before the imperial court fled south in 1127. We can assume that many rubbings of Han steles, including fine rubbings, were already in southern collections before the Northern Song's collapse. Indeed, although the capital remained in the north during the Northern Song, important concentrations of literati, in a pattern that was to continue in dynastic China, had already substantially shifted to the more agreeable climate and scenery of the south, bringing with them their collections and culture. Thus, many Northern Song connoisseurs were southerners, including even Ouyang Xiu, who was a southerner and worked in the south for years. Likewise his friend Liu Chang (1019–1068), the calligrapher and collector Mi Fu (1051–1107), and the famous antiquarian Li Gonglin (1049–1106), whose collections may have

been returned after their deaths to their family homelands in the south.

In addition, not only did southern collections of rubbings exist before the demise of the Northern Song, but northerners, fleeing south before the invaders, often added to the concentrations of art in the south by bringing their collections with them. Furthermore, trading between south and north during the Southern Song continued despite their political division, as itinerant merchants bought rubbings in the north and sold them in the south.[70] It is clear that fine rubbings of the Wu Ban stele and many other steles were available to Southern Song scholars. Without major collections of fine antiques in the south, for instance, the Southern Song scholar Xue Shanggong (act. ca. 1131–1162) could not have written his classic on ancient bronze inscriptions, *Lidai zhongding kuanzhi fatie* (*Inscriptions on bronze ritual vessels from successive dynasties*).

A few modern parallels may also illuminate the transmission of artworks across political divisions. Even without official diplomatic relationships between the United States and the People's Republic of China, between 1949 and the normalization of the two countries' relations in the 1970s, the American collectors John Crawford (1913–1988) and John Elliott (1928–1997) were able to build large private collections of Chinese calligraphy more important than any private collections of calligraphy assembled after 1949 in China. Also, the Metropolitan Museum was able to build its important collection of early Chinese paintings during the 1960s because a significant number of these works had come to the United States before the establishment of the People's Republic of China. In the Southern Song, Hong Gua could have acquired fine rubbings of ancient steles much more easily than Crawford or Elliott acquired

Chinese calligraphy: Hong lived within the Song empire, and, whereas paintings and calligraphies are unique, multiple rubbings may be made from the same stele.

In sum, both Zhao Mingcheng and Hong Gua were renowned connoisseurs and scholars of rubbings and inscriptions. Without sufficient evidence—that is to say, without direct knowledge of the quality of either Ouyang Xiu's rubbings or those in the collections of Zhao Mingcheng and Hong Gua—we cannot assume or even imply that any textual records of the Wu Ban stele longer than the one recorded in Ouyang Xiu's *Jigu lu* resulted from recarving, let alone forgery. Especially, the integrity of Zhao and Hong's records and scholarship cannot be challenged in this way if we take into consideration the complex processes of rubbing production and the variable effects these processes could have had on the resulting rubbings. The assumption that prior sources are the more reliable is, in the context of the variable results of rubbing processes, unreliable. Thus, to assume that because Ouyang's rubbings are earlier they are more reliable—and that therefore rubbings that differ from Ouyang's are suspicious—is highly problematic. In the context of rubbing production, conclusions or strong suggestions based on this assumption have serious methodological flaws.

Furthermore, the terms *huanman* or *manmie*, used to describe ruined stele inscriptions, do not necessarily mean that these inscriptions were undecipherable in every respect. Sometimes, even when every stroke is damaged, the basic shape of a character allows an educated and experienced scholar to read it with high degree of certainty. Moreover, even if unable to read the entire inscription of his rediscovered stele, Huang Yi would have been able to count the number of its characters to see if they closely matched the number in Hong Gua's *Lishi*.[71]

Finally, if some of the semi-legible characters or phrases matched in number and general character configuration the characters in the same locations in Hong's record, Huang would have had yet another reason to believe he had found the Wu Ban stele.[72] For example, when Huang found what he thought was the Wu Ban stele, he made a fine rubbing of its inscription and sent it to Weng Fanggang. Though the stele was severely damaged, 121 of its characters remained legible in Huang's rubbing. Although this was a significant reduction from the 489 legible characters recorded in the *Lishi*, these 121 characters were sufficient to make Huang, Weng, and their friends confident that Huang had rediscovered the Wu Ban stele.[73]

Qian Daxin also provides evidence that parts of the Wu Ban stele inscription remained legible in the eighteenth century. After he was shown a rubbing of the stele by a friend just returned from Shandong, where the Wu Ban stele is located, he stated in a research note that, although the rubbing showed that stele to be seriously decayed (*manmie*), legible characters remained. In addition, he also pointed out that the verso of the stele bore three characters reading "Mr. Wu's Stele" in calligraphy close to the style of the Six Dynasties, characters not recorded by Ouyang Xiu, Zhao Mingcheng, or other early scholars. In the same note Qian Daxin compared the Wu Ban stele inscription to the study of the Han writer Ying Shao analyzing the origin of the Wu clan.[74] The implication of Qian Daxin's note is clear: he had no doubt that the rubbing was made from an original Han stele and that the three characters on the verso were added later to identify the now ruined stele. Had Qian believed the stele was a later recarving, why would he have failed to point this out?[75]

With this discussion of rubbings in mind, it is easier to understand why Huang Yi's rubbings were

Fig. 6 *Wu Ban Stele* and *Wu Liang Stele* inscriptions and Hong Gua's commentaries. In the 1588 edition of the *Lishi*, with Fu Shan's collation and notes. (Shanghai: Hanfenlou, 1935).

highly praised and treasured by scholars, collectors, and connoisseurs: quite a number of the rubbed stele inscriptions were newly discovered by Huang and his friends, and rubbings made by Huang Yi or assistants under his supervision were "fine rubbings" (*jingta*), some of which included more characters than many older rubbings. It is ironic that the subtle skill and accuracy of Huang's rubbings that caused his contemporaries to regard him as the most important rubbing collector of his time should generate contemporary criticism of his work as suspiciously over-accomplished. But good academic research was by no means limited to Huang Yi. As we have seen, scholars of the mid-Qing generally reached then-historic heights of quality in their work, and they accomplished this partly by building on the excellence of their forebears' efforts. Among the latter, especially fine were the research and publications of the Song-dynasty literati, not the least of which were the outstanding accomplishments of Hong Gua in his *Lishi* and other works.

III. Catalogues of Ancient Metal and Stone Objects

Huang Yi and his friends did more than collect rubbings of ancient metal and stone objects:

frequently, they also compiled extensive catalogues of such items. Among these works are Huang Yi's *Xiao Penglai Ge jinshi wenzi*, Weng Fanggang's *Liang Han jinshi ji*, Zhao Wei's *Zhuyan an jinshi mulu* (*Bibliography of metal and stone objects compiled at the Zhuyan Studio*), Qian Daxin's *Qianyan tang jinshi bawei* (*Qianyan Studio's colophons to metal and stone objects*), Bi Yuan's *Shanzuo jinshi zhi* (*Records of metal and stone objects in Shandong*), Sun Xingyan's *Huanyu fangbei ji* (*Records of visiting steles around the world*), Ruan Yuan's *Liang Zhe jinshi zhi* (*Records of metal and stone objects in Zhejiang*), and Wang Chang's *Jinshi cuibian*. There are many others. This wave of cataloguing was a hallmark of the greatest peak in the study of ancient metal and stone objects since the Song.

Studying ancient steles, the Qian-Jia scholars routinely consulted older catalogues compiled by scholars of the past, including those of Ouyang Xiu, Zhao Mingcheng, and especially Hong Gua's *Lishi*. Thus, the *Lishi* has long been a central reference work on the content of Han stele inscriptions.

The *Lishi*, published in 1167, contains 180 or so entries for stone inscriptions of the Han dynasty and Three Kingdoms, most of them on steles. In the table of contents, Hong Gua indicates

which of his items had previously been listed in Li Daoyuan's *Shuijing zhu*, Ouyang Xiu's *Jigu lu*, and Zhao Mingcheng's *Jinshi lu*. By doing so, he not only recognizes the contributions of past scholars to this field but provides his readers with a convenient guide when comparing his transcriptions and commentaries with entries on the same monuments in the older works.

It is not clear how many copies were printed of Hong's *Lishi*, but it is known that a new edition was issued in 1325 in the Taiding reign of the Yuan dynasty, which is now commonly referred to as the Yuan Taiding edition. By the Ming, however, even the Yuan edition had become rare. In 1588 the governor of Guangling, Wang Yunlu, acquired a manuscript version of the Yuan Taiding edition of the *Lishi*. Based on this, Wang Yunlu in 1588 printed a new edition (fig. 6), and in the mid-Qing that edition served as the basis for the *Siku quanshu* edition of the *Lishi* (the edition used by Nylan and Liu in *Recarving*).

Not long after its publication, the errors of the 1588 edition caught the attention of two scholars, Mei Dingzuo (1553–1619) and Fu Shan. The most serious problems they found in it are: (1) part of Hong Gua's commentary on the Wu Ban stele and (2) most of the stele inscription in the entry for the Wu Liang stele were missing. That these two passages were missing from the 1588 edition was obvious from the interrupted logic of what remained of their respective passages, and this enabled Mei Dingzuo and Fu Shan to detect these omissions despite their lack of access to rare early editions of the *Lishi* (which could have clarified the omissions by way of comparison).

Regarding the first of these two omissions in the *Lishi*'s 1588 edition, Hong Gua's commentary on the Wu Ban stele inscription ends so abruptly that it is clear that his discourse is incomplete. In the second omission the inscription of the Wu Liang stele is clearly incomplete because it is too short. This inscription of only a few columns lacks much of the biographical information on the dedicatee that a memorial stele of this type would normally have recorded. Could this deficiency have been caused by an illegible inscription on the original or by a bad rubbing with illegible characters? Or is the stone the remains of a broken stele? These possibilities may be ruled out because, if there had been illegible characters within the text, Hong Gua would have substituted small characters indicating how many characters are missing.

There is other evidence that the Wu Liang text in the *Lishi* of 1588 is incomplete: Hong's commentary on the Wu Liang stele in this edition survives intact and provides evidence on the missing passage in two respects. First, his commentary makes no mention of the stele being broken or damaged (he was judging, of course, from the rubbing on hand), and this indicates that the missing text was not the result of damage to the stele. Second, his commentary includes a long passage from the Wu Liang stele inscription, a passage missing from the 1588 edition's textual entry for this stele.[76] The absence of this passage in the stele text signaled to late Ming and early Qing scholars (including Mei Dingzuo and Fu Shan) that, when Hong Gua prepared the *Lishi*, he was working with a substantially longer Wu Liang stele inscription than is found in the *Lishi* of 1588. Since he quoted a passage from the missing portion of the stele text, this passage, at least, should have been included in his transcription of the stele's inscription. Apparently the missing text was lost from either the manuscript on which Wang Yunlu based the 1588 edition or from its source manuscript.

The most conclusive point about the history of these two passages omitted from the 1588 edition, however, is that they are adjacent in the *Lishi*. In other words, since, in the *Lishi*, the missing middle-to-end of Hong's commentary on the Wu Ban stele is contiguous with the missing beginning-to-middle of the text of the Wu Liang stele, these two adjacent passages both appear to have been lost when a leaf was dropped from the source manuscript of the 1588 edition.

External evidence that Hong Gua had a more complete Wu Liang stele text than that in the edition of 1588 is supplied by one of his contemporaries. In 1167, the year Hong had the plates for his book engraved, Wei Bo, a Southern

Song scholar, wrote a colophon on rubbings of the Wu Family Shrines' pictorial carvings. In this long colophon, Wei cites Zhao Mingcheng's *Jinshi lu*, yet omits mention of Hong's book. This is evidence that Hong's work was not yet available, but more important is that Wei Bo's colophon quotes several sentences totaling 28 characters from the Wu Liang stele inscription, of which 18 characters are absent from the 1588 edition.[77] Prior to Wei Bo, Zhao Mingcheng's *Jinshi lu* also mentions the general completeness and legibility of the Wu Liang stele inscription, but Zhao does not transcribe it (*qita ke hua jie wan*, *ke du*, *wen duo bu jin lu*).[78] Because the 28 characters Wei Bo quotes in his colophon do not appear in Zhao Mingcheng's *Jinshi lu*, we can conclude that Wei Bo transcribed these 28 characters directly from a rubbing, not from the *Jinshi lu*. This tells us that Southern Song scholars knew, from previous sources, of a Wu Liang stele inscription longer than that recorded in the 1588 edition.

When Mei Dingzuo (see above) compiled his *Dong Han wenji* (*Collected writings of the Eastern Han*), he included the inscription of the Wu Liang stele. Very likely he took the 1588 edition as his source for the inscription of the Wu Liang stele, because, in a lengthy note on the Wu Liang inscription, he describes his bibliographic source as *jinben* ("today's edition"). "Today's edition" probably refers to the 1588 edition for three reasons. First, his version of the Wu Liang stele inscription is identical to that of 1588, including its errors. Second, the edition prior to 1588 was issued in the Yuan, too far in the past to be considered "today's edition." Third, evidence associated with his *Donghan wenji* argues that Mei wrote it after the publication of the 1588 edition.[79]

To understand fully the errors in the 1588 Wu Liang inscription, it is important to know that the first column of this inscription is not from the Wu

Liang stele but is an interpolation from Hong Gua's commentary on the Wu Ban stele. Perhaps because the Wu Liang inscription was so abbreviated in the source manuscript, either the scribe of the source manuscript or the editor of the 1588 edition mistakenly moved a line from the preceding entry on the Wu Ban stele into the Wu Liang entry. Since this line speaks of a death, that is, consists of a phrase typical of any memorial stele, it was easy to assume it part of the Wu Liang instead of the Wu Ban to which it belongs.

Mei states that the inscription recorded in his copy of the 1588 edition has two missing passages: (1) the beginning of the Wu Liang stele inscription had been lost sometime after Hong printed the complete text in 1167; (2) a second passage is missing from the Wu Liang stele inscription, following the first column's last two characters, *keqi* ("engrave it"). In other words, a passage is missing between the first and the second columns, a conclusion that Mei could easily have reached because the first and second columns cannot be joined into a plausible text: something is missing between them.

Aware of the incompleteness of the Wu Liang stele inscription, Mei Dingzuo, in his note attached to the Wu Liang text, quotes Hong Gua's commentary, including its long quotation from the Wu Liang inscription that is absent from the stele inscription in the 1588 edition. Moreover, Mei goes on to establish where in the Wu Liang stele inscription Hong's excerpt should have been located. He does so by making a crucial observation: that the last two characters of the Wu Liang excerpt in Hong's commentary, *chenghang*, are identical to the first two characters in column two of the 1588 *Wu Liang* inscription. This suggests that these two passages should be conjoined, and therefore Mei states that the excerpt in Hong's commentary, from

xiaozi xiaosun ("filial son[s] and grandson") to *luolie* ("lay out"), should be inserted into the Wu Liang inscription between the last two characters of column one, *keqi* ("engrave it"), and the first two characters of column two, *chenghang* ("as rows"), that is, between the first and second columns of the Wu Liang stele inscription in the 1588 *Lishi*. (Mei remained unaware that column one was not part of the Wu Liang inscription.) That he was correct in this assertion is verified by yet another manuscript version (of 1576) based on the *Lishi*'s Yuan-dynasty edition, in which the Wu Liang text is complete (see below).

Another literatus, the Shanxi scholar Fu Shan, an expert on ancient metal and stone objects, acquired a copy of the 1588 edition of the *Lishi* circa 1630s. Thirty years later, circa 1660s, he carefully studied it. In his resulting notes, he, too, points out several missing passages, including the adjacent lacunae in the entries for the Wu Ban and Wu Liang steles in *juan* 6. He further observes what we have noted above, that the last column of the commentary on the Wu Ban stele may have been transposed into the Wu Liang stele inscription to become the latter's first column.[80]

We are uncertain which versions of the *Lishi* Huang Yi consulted as he pursued his studies of Han steles and their rubbings, but that sources other than that of 1588 were extant becomes evident from the work of Weng Fanggang. In an analysis of the Wu Ban stele Weng quotes the line in Hong Gua's commentary on the Wu Ban stele[81] that, in the 1588 edition, had became interpolated into the text of the Wu Liang stele, as noted above. But Weng did not treat this sentence as part of the *Wu Liang* inscription but as part of Hong Gua's commentary to the Wu Ban inscription, so it is clear that he must have been made aware this problem in the 1588 *Lishi* by the presence of a complete

pages 32a and 32b

Fig. 7B *Wu Ban Stele* and *Wu Liang Stele* inscriptions and Hong Gua's commentaries. In the 1576 manuscript version of the *Lishi*. Former collection of the Qu family of Changshu, current collection of National Library of China.

version. It also is likely that Qian Daxin may have owned a manuscript version of the *Lishi* that derived from a Song edition.[82]

In a related matter, among the colophons collected in Huang Yi's *Xiao Penglai Ge jinshi wanzi*, one by Jiang Deliang (1752–1793) refers to a Wanli (1573–1620) edition of the *Lishi*, while another by Li Dongqi mentions owning a Ming version of the *Lishi*.[83] Probably Jiang's edition was that of 1588; which version Li Dongqi owned is uncertain. More generally, however, that scholars of Huang Yi's time made references to specific versions of the *Lishi* implies that they were distinguishing among a variety of available sources.

Indeed, in addition to the edition of 1588, many manuscripts of the *Lishi* circulated in the eighteenth century even as knowledge and scholarship of the work grew. We know that at least the following versions of the *Lishi* were copied out before the eighteenth century. In Beijing the National Library of China houses a manuscript completed in 1576 (the fourth year of the Wanli-reign period in the Ming),[84] twelve years prior to the 1588 edition. In this manuscript both Hong

Gua's commentary on the Wu Ban stele and the inscription on the Wu Liang stele are complete (fig. 7). Thus, the passages missing from the 1588 edition were extant in the 1576 manuscript. When Zhou Ju collated the 1576 manuscript in 1764, in his Table of Contents he made a note above the titles of the Wu Ban stele and Wu Liang stele inscriptions (*juan* 6) that reads: "There are a number of missing and displaced passages in the texts of the two steles for Wu Ban and Wu Liang in the edition printed in the Wanli reign. The present manuscript should be used to supply its missing passages and correct its errors."[85]

The second manuscript extant by the eighteenth century belonged to the early Qing scholar and bibliophile Xu Qianxue (1631–1694) and was commonly called the Chuanshilou manuscript. It was on this version that Wang Rixiu based his printed edition of the *Lishi* of 1777–78.

Twenty years later, in 1797, two distinguished scholars of ancient books, Gu Guangqi (1766–1835, a native of Yuanhe, Jiangsu Province) and Huang Pilie (1763–1825, a native of Suzhou), used three different versions of the *Lishi*, all based

Fig. 7A *Wu Ban Stele* and *Wu Liang Stele* inscriptions and Hong Gua's commentaries. In the 1576 manuscript version of the *Lishi*. Former collection of the Qu family of Changshu, current collection of National Library of China.

on the Song edition (including tracing copies of it [*ying Song chaoben*]), to collate the Wang Rixiu edition of 1777–78, a collation that was later published by Huang Pilie (1816).[86] Although Huang and Gu found quite a few errors in the Wang Rixiu edition, neither collator questioned the complete-ness of its entries for the Wu Ban and Wu Liang steles. This confirms the accuracy of the claim by Mei Dingzuo and Fu Shan over a hundred years earlier that something was missing from *juan* 6 of the 1588 *Lishi*.

In addition to the editions discussed above, Kuroda Akira has investigated manuscript versions of the *Lishi* that survive in such major Chinese libraries as the National Library of China, Peking University Library, and Shanghai Library. He found five Ming-dynasty manuscript versions (including the Qu family version of 1576) and six Qing manuscript versions, including one from the early Qing, and another based on the Yuan-dynasty Taiding edition of the *Lishi*. In addition to these versions, Kuroda noted another Ming manuscript version of the *Lishi*, in the Hubei Provincial Library. He meticulously analyzed the relations between

known versions of the *Lishi* and concluded that the 1576 version once owned by the Qu family of Changshu is the best extant version of the *Lishi*. By comparison, the version on which Wang Yunlu based his 1588 edition was by no means a good one.[87] It should be pointed out that, during the Taiping Rebellion of the 1850s and 1860s, numerous private libraries were destroyed in the Jiangnan area.[88] Moreover, China also experienced extensive warfare in the twentieth century. These turbulent periods certainly caused the loss of additional manuscript versions of the *Lishi* such that, before the nineteenth century, the corpus of early, high-quality versions of the *Lishi* available to scholars was significantly larger than it is today.

It becomes evident that scholars of ancient books in the Qianlong and Jiaqing period were widely aware of problems in the 1588 edition and its descendent *Siku quanshu* edition. But even though internal evidence indicates that passages are missing from the 1588 edition, this seems not to have been thought a major problem because other versions were available for consultation. Whenever textual differences were found between

inscriptions in the *Lishi* and those on extant stones, scholars routinely took the stones as definitive. This is a major reason why newly made rubbings from original stones were popular at this time: they were a primary source for collating the *Lishi*.

Although internal evidence convinced scholars that passages were missing from *juan* 6 of the 1588 edition, the cause of this error apparently remained a mystery until 1935. In that year Zhang Yuanji (1867–1959), a leading expert on rare books, planned to publish a facsimile edition of the 1588 *Lishi* once owned by Fu Shan, discussed above. In the process of publishing Fu Shan's copy, textual collations noted by Fu in his copy caught Zhang's attention. Zhang knew that the Qu family of Changshu owned a Ming manuscript copy of the Yuan Taiding edition (the 1576 version discussed above), so he borrowed it to collate with the 1588 edition. After carefully comparing the Qu manuscript with the edition of 1588, Zhang concluded that one leaf (two pages), or a total of twenty columns, was missing from the 1588 edition's source manuscript, an error subsequently replicated in the 1588 edition. In other words, when Zhang compared the content of pages 32a and 32b (which contained parts of the entries for the Wu Ban and Wu Liang steles, see fig. 7B) from the Qu manuscript of 1576 with the gap in the entries for the Wu Ban and Wu Liang steles in the *Lishi* of 1588, he found that the content of pages 32ab of the Qu manuscript fit the gap in the 1588 edition.

Zhang also concluded that this error was the result of a problem in the source manuscript or one of its ancestor manuscripts. A number of manuscript versions of the *Lishi* that derived from the Song edition, including the Yuan Taiding edition, were formatted in 20 columns per leaf (10 columns per page), whereas the editor of the 1588 *Lishi* (perhaps following the format of his source

manuscript) cast it in 18 columns per leaf.[89] This led to two conclusions. First, Zhang used a word-by-word comparison of the Qu manuscript and the edition of 1588 to locate the omission in the latter's *juan* 6. That this omission consisted of 20 columns (that is, one leaf) of the Qu manuscript of 1576 suggests an explanation of how these 20 columns were lost: an ancestor manuscript of the 1588 edition with 20 columns per leaf (it could have been an ancestor manuscript to the source manuscript, or even a copy of the Yuan Taiding edition) lost a leaf. It is relatively easy to drop a leaf from a manuscript or printed edition, which explains the probable origin of this error. Second, the new edition's change from 20 to 18 columns per leaf made this one-leaf omission hard to detect by a comparison of leaf formats, for the change in columniation meant the leaves no longer matched one to one. Only Zhang's word-by-word comparison of the Qu manuscript of 1576 with the 1588 edition revealed the location of the omission in the latter. Since the new columniation of the 1588 edition made its omission hard to identify, Zhang further concluded that the omission from the 1588 edition was most likely unintentional and undetected by its editor.

Zhang's discovery is convincing and conclusive.[90] His solution is also supported by Huang Pilie. In his preface to *Wang ben Lishi kanwu*, Huang notes that all three versions of the *Lishi* he used in collating the Wang Rixiu edition had ten columns per page and twenty characters per column. So does the Yuan dynasty Taiding edition of the *Li xu* (*Supplement to "Explications of Clerical Script"*), which was published together with the Taiding *Lishi* and therefore shared the same bibliographic layout.[91] Although no printed copies of the Yuan Taiding *Lishi* are extant, it may be inferred from the 20-column format of the *Li xu* that the *Lishi* also used this format.

As Zhang Yuanji noted, the omission of pages from the 1588 edition may be taken as unintentional. We have seen that such omissions are common in printed books of the late Ming period. Historians of Chinese books frequently comment that late Ming books often contain careless errors. Qian Daxin said that some late Ming books, even the important editions of the Confucian classics published by Jiguge (studio name of the famous late Ming publisher Mao Jin, 1599–1659), have a variety of flaws, including missing parts, notes misinterpreted as text, etc. He listed several books in which at least one leaf (two pages) is missing. Therefore he suggested that readers should practice care in selecting a version. It is likely that the 1588 edition, as noted above, was taken from a source that was missing a leaf.[92]

Apparently unaware or unwilling to accept that the Wu Liang stele inscription recorded in the 1588 edition is incomplete, Nylan writes: "The *Lishi*, in commenting on the Wu Liang pictorial carvings, relates in addition the careful manner in which unidentified family members selected stones for the Wu memorial, set up an altar (*tanshan*) in back, and a worship hall (*citang*) (aboveground hall for worship, thus a "shrine") in front, which were decorated by the artist Wei Gai—though the main entry for the Wu Liang does not name the artist. Modern readers have assumed that this passage represents part of the text of the Wu Liang stele inscription, but that assumption flatly contradicts Hong's own assessment:

When speaking about funerary and burial matters, one should not be as verbose as this. The stone [attributed to Wu Liang] is not very long or wide, and since it has neither skillfully carved inscriptions or images, not to mention nicely arranged rows, the phrases quite definitely were not composed

for a stele. In mulling it over carefully, it seems that this [the aforementioned passage] refers only to the pictorial stones in the stone chamber (*shishi*) [of Wu Liang].

If not part of the stele inscription, what is the identity of this appended passage? Certainly if the Song epigraphical masters could not answer this question, modern scholarship will be unable to do so. Mei Dingzuo's *Donghan wenji* (*Collected Writings of the Eastern Han*) seems to know two versions of the stele inscription, and to believe the shorter version that does not mention Wei Gai to be the 'original text' (*yuan wen*)."[93]

Nylan's argument quoted here contains several serious mistakes in presenting Hong Gua's discussion of the Wu Liang stele in his *Lishi*. As source for her research and argument, Nylan used the *Siku* edition of the *Lishi*, which is based on the 1588 edition, but seems unaware of, or unwilling to acknowledge, this edition's problems, as discussed above. However, two other participants in the *Recarving* project, Cary Liu and Eileen Hsu, mention the problems of the 1588 edition in an unusual note attached to Nylan's note, writing:

The *Siku* and 1588 editions of the *Lishi* conflate parts of the Wu Liang stele inscription and Hong Gua's commentary on the Wu Ban stele. This probably was the result of scribal omission in the Ming dynasty. A manuscript copy of two leaves from a Yuan-dynasty Taiding edition is appended to the end of *juan* 6 in the *Sibu congkan sanbian* edition, and apparently represents the entire missing section. Based on another Ming manuscript, Wang Rixiu reinserted the text in his 1777–78 edition. This lacuna was also noted by Mei Dingzuo (1553–1619), Fu Shan (1607–1684), and other scholars before the eighteenth century."[94]

Allow me a minor correction to this note before I discuss Nylan's problems: Wang Rixiu did not "reinsert" the missing text in his 1777–78 edition but faithfully based it on the Chuanshilou manuscript, which contained complete entries for the Wu Ban and Wu Liang steles.

Nylan treats the edition of 1588 (and its replication in the *Siku* edition) as the most reliable and fundamentally bases her arguments on it. Even so, Nylan's understanding, translation, presentation, and interpretation of the material of the Wu monuments in the 1588 edition remain problematic.

First, Hong Gua did not say that the passage in his commentary on the Wu Liang stele regarding an elaborately carved stone chamber (*shishi*) was not part of the stele inscription. Just the opposite: his commentary clearly indicates that he is quoting this passage from the Wu Liang inscription. In the commentary, after summarizing Wu Liang's life (apparently, he got this information from a complete Wu Liang stele inscription), Hong Gua writes "After that, the stele inscription reads" (*qi hou yun*) and then quotes a passage from the inscription that is missing from the 1588 edition.[95] Apparently because, in classical Chinese, quoted passages are not marked off by punctuation, Nylan conflates this quotation with Hong's commentary.

In addition to the Wu Liang quotation in his commentary to the Wu Liang stele, Hong Gua again quotes the same passage from the Wu Liang stele in his commentary on the Wu Liang Shrine's pictorial stones. He clearly writes that "In Rencheng there is a Wu Liang stele…. Its inscription reads (*qi ci yue*)…," and then he quotes a passage regarding an elaborately carved stone chamber for Wu Liang, which is missing from the 1588 edition.[96]

Second, Mei Dingzuo, in his note attached to the text of the Wu Liang stele included in his *Donghan wenji* and discussed above, shows that

he believed (1) that there was only one inscription for the Wu Liang stele; (2) that the one recorded in the 1588 edition is incomplete; (3) that part of the passage absent from the Wu Liang inscription of 1588 was preserved in Hong Gua's commentary (even in the edition of 1588); and (4) that textual evidence allows this passage to be reinserted into the truncated text. Therefore, Nylan's claim that Mei Dingzuo "seems to know two versions of the stele inscription, and to believe the shorter version that does not mention Wei Gai to be the 'original text' (*yuan wen*)" is wrong. Instead, Mei believed that both "versions" of the text were different parts of a single text, and hence that neither portion was more "original" than the other.

Third, Nylan is not entirely correct when she states that "the main entry for the Wu Liang does not name the artist [Wei Gai]" and that "The *Lishi*, in commenting on the Wu Liang pictorial carvings, relates in addition the careful manner in which unidentified family members selected stones for the Wu memorial."[97] In the incomplete edition of 1588 it is true that Wei Gai's name is missing from the Wu Liang stele inscription; it disappeared along with the portion of the inscription missing from the main entry for the stele's text. Yet Wei Gai's name is retained in the Wu Liang inscription excerpt quoted by Hong Gua in his commentary, and in that manner, remained present in the 1588 Wu Liang entry. Unfortunately, Nylan does not acknowledge that this quoted excerpt is part of the original Wu Liang inscription, so, for her, the Wu Liang inscription does not name Wei Gai.

Nylan's statement that the *Lishi*'s commentary refers to "unidentified family members" selecting stones for the shrine is also inaccurate. When Hong Gua's commentary refers to the family members who commissioned Wu Liang's shrine, it names Wu Liang's "filial son Zhongzhang and other [sons]."[98]

So Wu Liang's family members are not entirely "unidentified." In conclusion, the three points just enumerated show that Nylan does not have a good understanding of the interrelationships of the three texts discussed above (the Wu Liang stele inscription, Hong's commentary on the Wu Liang stele, and Mei Dingzuo's note in his *Donghan Wenji* on the presence of an excerpt from the Wu Liang inscription in Hong's commentary), and therefore her interpretations of these texts go astray in several respects.

A fundamental error in judgment by Liu and Nylan is their rejection of the Wang Rixiu edition as unreliable.[99] This prevented them from rectifying the 1588 edition, which would have prevented some of the mistakes into which they were led by their reliance on the 1588 edition. While omitting scholarly arguments as to why the Wang Rixiu edition should be disregarded, Nylan and Liu do not hesitate to express dubiety about it. Cary Liu writes: "The Wang Rixiu edition is now commonly cited as the authoritative version, but needs to be used with circumspection. It should be noted that Wang Rixiu was from Huang Yi's hometown. Later versions of his edition include an 1871 reprint by the Hong family of Hangzhou, known as the *Huimuzhai congshu* edition."[100] The import of this passage lies in Wang Rixiu's being native to Hangzhou. Michael Nylan adds: "The Wang Rixiu edition of *Lishi, juan* 6/13a supplies the 'full text' of the Wu Liang inscription, which is not surprising, given its provenance and dating."[101]

Neither Liu nor Nylan state explicitly that Wang's edition falsifies the Wu Liang stele inscription by including the passages missing in the 1588 edition, but the implication is clear that it should be used with circumspection; that is, they imply that it is preferable to use the edition of 1588. Why? Because the publisher of the edition of 1588 was

not from Huang Yi's hometown and its publication occurred almost two hundred years before Huang Yi rediscovered the Wu Family Shrines, and hence there could have been no question of influence from Huang Yi and his friends. By comparison, Wang Rixiu published his edition of the *Lishi* in what Nylan and Liu consider a suspicious place and time. Hence, the efforts by the two leading Qing scholars Huang Pilie and Gu Guangqi (who were not native to Hangzhou) to collate and verify the Wang Rixiu edition are dismissed simply because Wang Rixiu was native to Hangzhou and published his fellow-townsman Huang Yi's edition of the *Lishi* close to the time when Huang rediscovered the Wu Family Shrines.[102] At bottom, Wang's edition seems to have been rejected as an important source because it contains the full Wu Liang stele inscription, something that does not serve, and even contradicts, the purpose of *Recarving*: recarving the Wu Family Shrines into post-Han monuments.

While the "additional note" by Liu and Hsu may be designed to temper the role played by the 1588 *Lishi* in *Recarving*, many of the arguments, assertions, speculations, and interpretations in the articles of Nylan and Liu were already heavily reliant on it, including the presumption that any edition containing a Wu Liang stele text longer than that of 1588 is doubtful. Because these writers did not consult the Wang Rixiu edition, the incomplete text of the Wu Liang stele leads them to confused or erroneous statements regarding the Wu Family Shrines. Nylan writes, with regard to the Wu Family pillar-gate inscription:

[The *Lishi* entry for Wu Liang] says that Wu Kaiming erected the pillar-gates for his elder brother, Wu Liang—a statement flatly contradicting the pillar-gate inscription transcribed in *Jinshi lu*, which has Wu Kaiming and his three brothers, as "filial sons,"

erecting the gates…. According to the standard genealogy devised for members of the family, Wu Kaiming died three years before his elder brother Wu Liang, in which case we must either credit Kaiming with astounding prescience in building the pair of pillar-gates or presume that they were not erected in a funerary context.[103]

Hence, Nylan professes to spot a contradiction between the pillar-gate being constructed by Kaiming for his elder brother Wu Liang (*Lishi*) versus the pillar-gate being constructed by Kaiming with his three elder brothers (*Jinshi lu*). But this "contradiction" arises from her being unaware that, in the 1588 edition, the first column of the *Wu Liang* inscription (including the phrase "Wu Kaiming built a pillar-gate for his brother") is a misplaced interpolation that strayed from Hong Gua's commentary on the Wu Ban stele. This interpolation becomes apparent if the Wang Rixiu edition and the *Sibu congkan* edition are compared with that of 1588. By rejecting the Wang Rixiu edition as unreliable, Nylan and Liu lost an opportunity to detect this interpolation.

Nylan is correct in asserting that Wu Kaiming died before his elder brother Wu Liang and therefore that the pillar-gate could not have been built to memorialize Wu Liang. But since Kaiming had three elder brothers, even after removing the errant column of text from the Wu Liang inscription and returning it to Hong's commentary on the Wu Ban inscription, it cannot be determined for which other elder brother (*xiong*) Kaiming built the pillar-gate.

Hong Gua introduces the inscription on the Wu pillar-gate into his commentary on the Wu Ban stele inscription because it associates the names of Wu Kaiming and Wu Ban; specifically, it refers to Ban as Kaiming's son. This establishes the father-son relationship between Kaiming and Ban, a relationship not mentioned on the Wu Ban stele. As to the source of Hong's information on the pillar-gate inscription in his Wu Ban commentary, a careful analysis of the commentary reveals that its passage on Wu Kaiming variously paraphrases and quotes the pillar-gate inscription as recorded in Zhao Mingcheng's *Jinshi lu*. Nylan points out that Hong Gua's *Lishi* lacks an entry for the pillar-gate inscription. This means that Hong did not have a rubbing of it, which is why he paraphrased the *Jinshi lu*. Although the *Lishi* commentary on the construction of the Wu pillar-gate was derived from the *Jinshi lu*, they contradict each other on whether Kaiming built the Wu pillar-gate for or with his brother(s). But since the *Jinshi lu* is the source of Hong's commentary on this point, the difference between the two texts on the pillar-gate probably results from a mistranscription or an error of fact in Hong's work.

What might explain the contradiction between Zhao Mingcheng's *Jinshi lu* and Hong's commentary regarding the Wu brothers and the construction of the pillar-gate? The *Jinshi lu* contains a complete pillar-gate inscription that lists all four brothers as commissioning the pillar-gate for their parent(s),[104] which Hong reproduces in full in *juan* 24 of his *Lishi*. Yet Hong Gua's commentary in extant printed editions and manuscript copies states that Wu Kaiming had the gate built *for* his elder brother(s). But this is erroneous. It should read that the pillar-gate was commissioned by Kaiming *and* his elder brothers. This error seems to rest on either a mistranscription by Hong Gua or by a confused reading of a character in the commentary by a copyist. In the latter case, since the character "for" (*wei*) and the character "and" (*ji*) have similar configurations in the casual style of running script (fig. 8), when a later copyist transcribed Hong's commentary, he apparently mistook the

Fig. 8 The characters *wei* and *ji* in running and cursive scripts. Lin Hongyuan et al., eds., *Zhongguo shufa dazidian* (Guanghua chubanshe, 1980), pp. 920, 216–217.

character "for" for the character "and." Abetting this confusion, the passage remains grammatically correct because the word "brother" (*xiong*, elder brother) may be read as either singular or plural: its number can be determined only by background knowledge.[105]

Regardless of the details of this transformation, that Hong based his commentary on the *Jinshi lu* is, by itself, sufficient evidence that Hong's commentary should have stated that Kaiming *and* his elder brothers built the pillar-gate (for one or both of their parents). Hence, it is clear that Kaiming commissioned the pillar-gate with his brothers, and not for his brother Liang. This error corrected, the apparent contradiction between the Wu Liang stele and pillar-gate inscriptions disappears.

It seems to me that Michael Nylan and Cary Liu have not thoroughly and carefully studied the *Lishi*, although this source is widely used in their articles. Let me support my argument with the following evidence. Michael Nylan writes:

The Wu Ban of *Lishi*, *juan* 6, is a native of Rencheng serving as Senior Officer in Dunhuang, while a second Wu Ban, mentioned in another chapter

included in present editions of the *Lishi*, is said to be a native of Dunhuang, thousands of miles from Rencheng. At first glance, the problem seems easy to resolve: the Wu Ban entry in *Lishi*, *juan* 23, is simply corrupt and/or less reliably old. Extant versions of the *Lishi* derive ultimately from a 1588 edition of Wang Yunlu — in other words, from a time that is (a) centuries after Hong Gua; and (b) known for sloppy popular editions of famous reference works. *Juan* 20–27, consisting of selections from the epigraphical classics compiled by Ouyang Xiu and Zhao Mingcheng, represent Ming or even early Qing versions of those classics. The record may well point to a conflation of two or even three different Wu Ban steles, just as the sources list multiple Wu Kaimings, with their own biographical similarities.[106]

Nylan's description of the *Lishi* quoted above demonstrates unfamiliarity with the *Lishi*, its various editions, and its internal structure. First, as to its internal structure, when Hong Gua first published his *Lishi* in 1167, it totaled 27 *juan*. In another of his works, *Panzhou wenji* (*Collected writings of Panzhou*), Hong Gua noted that he included in his *Lishi* a *juan* that lists the Han steles recorded in Li Daoyuan's *Shuijing zhu*, another six *juan* that list the Han and Three Kingdoms-period steles recorded in the catalogues of Ouyang Xiu, Ouyang Fei (son of Ouyang Xiu), and Zhao Mingcheng, and finally a *juan* with a listing of steles by an anonymous writer.[107] This means that in effect Hong compiled *juan* 20–27 from earlier sources as an appendix to the *Lishi*. This contrasts with Nylan's comments about this part of the *Lishi*. When she hints that a second Wu Ban is mentioned in another chapter of "present" editions of the *Lishi*, and when she states that the *Wu Ban* entry in *juan* 23 is "less reliably old," she seems, in effect, to be telling us that

she is unaware that these *juan* have always been part of the original text. To claim that *juan* 20–27 "represents Ming or even early Qing versions of those classics" is to misunderstand the role of these *juan* as a kind of appendix to the *Lishi* that consists of earlier catalogues of stele inscriptions.

Second, and again in reference to the *Lishi*'s internal structure, Nylan's apparent misunderstanding of the appendix role of the *Lishi*'s *juan* 20–27 causes her to state that the *Lishi* refers to two Wu Bans. But this confuses people with entries. As an entry, the Wu Ban stele appears twice in the *Lishi*, yet, both entries refer to the same stele and the same Wu Ban. The first entry is in *juan* 6, where the Wu Ban stele inscription is transcribed by Hong Gua and accompanied by his commentary. Its second appearance is in *juan* 23 among the Han inscriptions recorded in Ouyang Fei's *Jigu lu mu* (*List of the Inscriptions recorded in "Jigu lu"*). In *juan* 23, Wu Ban is recorded as a native of Dunhuang. Since this entry was not written by Hong Gua but Ouyang Fei, Hong kept Ouyang Fei's original entry without alteration.

But while Hong's treatment of Ouyang's text is proper and scholarly, this does not mean that he agrees with everything Ouyang Fei wrote.[108] Hong Gua knew that Wu Ban had only a political connection to Dunhuang and was not born there. But even Ouyang Fei's error in deeming Wu Ban a native of Dunhuang may be explained in a broader context. The Wu Ban stele listed in Ouyang Fei's work is the same as that recorded in his father's *Jigu lu*. In the first year of the Zhiping reign (1064), when Ouyang Xiu recorded this stele based on his rubbing of it, he claimed that Wu Ban's birthplace was not present on the stele. Later, in the second year of the Xining reign (1069), he obtained another and better rubbing, and, although it also showed the stele as severely damaged, it had more

legible characters than had the previous rubbing.[109] Apparently, Ouyang Fei based his list on the second rubbing. But because the rubbing was partly illegible, he thought two newly legible characters, *Dunhuang*, were Wu Ban's birthplace instead of his official title. Thus, there was but one Wu Ban stele, and it memorialized only one Wu Ban.[110]

To say, on Nylan's grounds, that there were two Wu Ban is equivalent to concluding that, because historical documents show that Ouyang Xiu had never been to Rencheng, whereas Liu and Nylan tell us that he was in exile there for years, there were two Ouyang Xiu. In an analogous case, Nylan's problematic and misleading claim that "the sources list multiple Wu Kaimings, with their own biographical similarities" is based on a similar misunderstanding of the *Lishi*'s multiple entries for the same stele. Analysis of all sources that mention the name Wu Kaiming points to one conclusion: there was only one Wu Kaiming, who was the younger brother of Wu Liang and the father of Wu Ban and Wu Rong.

Third, Nylan's claim that "extant versions of the *Lishi* derived ultimately from a 1588 edition of Wang Yunlu" is erroneous. In the Qing dynasty many versions of the *Lishi* did not derive from the 1588 edition, as discussed above. In a note regarding editions of the *Lishi* and *Li xu* (*Supplement to "Explications of Clerical Script"*), Nylan writes:

All citations for Hong Gua's *Lishi* and *Li xu* use the *Yingyin Wenyuange Siku quanshu* version of 1983, which is based on the Ming Wanli edition of 1588.… This essay assumes that the *Lishi* is generally reliable, though the *Siku* editors comment that the Yangzhou edition on which it is principally based "had comparatively few mistakes but a very considerable number of lacunae."[111]

This description of the *Lishi* and the *Li xu* has several problems. One is that the *Siku quanshu* edition of the *Li xu* is not based on an edition of 1588. There was none; only the *Lishi* was published that year. The other is that, although the 1588 *Lishi* was likely to have been printed by Wang Yunlu in Yangzhou when he served the governor of Guanling (present-day Yangzhou), the Yangzhou edition mentioned by the *Siku quanshu* editors refers to the *Li xu* (not the *Lishi*) printed by Cao Yin (1659–1712) in Yangzhou in 1706, which remains available in many major libraries. Moreover, the *Siku* editors' reference to a "considerable number of lacunae" quoted by Nylan does not refer to the *Lishi*, it refers to the *Li xu*. Finally, the *Siku* edition *Lishi* was not "principally based" on the Yangzhou edition mentioned by the *Siku* editors. This is because not only is it undetermined where Wang Yunlu published the 1588 *Lishi* but, as already noted, the *Siku* editors were referring in this passage only to the 1706 Yangzhou edition of the *Li xu*. Is Nylan's confusion of the *Lishi* and *Li xu* only a typographical error; did she mean *"Li xu"* when she wrote "This essay assumes that the *Lishi* is generally reliable…."? Even if so, her description of the *Li xu* remains problematic because, although the *Siku quanshu* editors mention the *Li xu*'s 1706 Yangzhou edition at one point, their reference to an edition that "had comparatively few mistakes but a very considerable number of lacunae" refers not to the 1706 Yangzhou edition of the *Li xu* but to its Yuan Taiding edition.

Fourth, Nylan's unfamiliarity with the *Lishi* is also evident in her discussion of the Wu Rong stele. Discussing an apparent oddity in the inscription of this stele, she writes:

To the total of 74 characters that had been legible to Ouyang, *Lishi* added 148, 11 of which give the names and titles of Wu Kaiming and Wu Ban, all of which is very odd for a stele text dedicated to Wu Rong. No other Han stele, to my knowledge, uses the formula "The Lord is then X's relative" (*Jun ji*....). These eleven characters most probably represent commentary that has been interpolated into the main text.[112]

In a note on this part of her text, Nylan explicates why she thinks the inscription of the Wu Rong stele is odd:

This information is based on an electronic stele database which has been compiled on the basis of Zhang Yansheng's *Shanben beitie lu* (Beijing: Zhonghua shuju, 1984). Only one other Han stele in that compendium, the Chunyu zhang Xiacheng stele, mentions by name the brothers of the stele dedicatee, and since the stele has long been lost, we cannot be certain that the transcription in the compendium is accurate.[113]

It is clear that Nylan is implying that the Wu Rong stele inscription is either a later recarving or a forgery because its text is corrupted by an interpolated phrase "The Lord is then X's relative" foreign to the original. But to determine whether this phrase is unusual in Han monumental inscriptions, we shall examine whether Han steles other than the Wu Rong stele and the Chunyu zhang Xia Cheng stele use the formula "The Lord is then X's relative." Consulting the three Song dynasty catalogues of Ouyang Xiu, Zhao Mingcheng, and Hong Gua as well as modern catalogues of Han steles, it becomes evident that many Han steles adopt the formula "The Lord is then X's relative." Most often, these mention the dedicatee's ancestors, especially grandfather and father. But brothers are also mentioned, especially those who held official

posts (they are usually mentioned with their official titles). So it would appear that the appearance of this relationship formula in the Wu Rong stele is by no means "very odd."

There are too many steles whose inscriptions mention the dedicatees' brothers to enumerate them here, but I will provide a partial list. Among this type of stele are: the Eastern Han Jinxiang shouzhang Lord Hou stele (*Jigu lu*, *juan* 3, p. 9b), the Jinxiang zhang Hou Cheng Stele (*Lishi*, *juan* 8, p. 6a), the Second Stele for Fei Feng (*Lishi*, *juan* 9, p. 21a), the Anping xiang Sun Gen Stele (*Lishi*, *juan* 10, p. 10b–11a), the Xiaohuangmen Jiaomin Stele (*Lishi*, *juan* 11, p. 6b), the Duyou Ban Stele (*Lishi*, *juan* 12, p. 9a),[114] the Zhaoxiangyong Quan Que Stele (*Lishi*, *juan* 12, p. 12b), and the Fuchun Cheng Lord Zhang Stele (*Lishi*, *juan* 17, p. 3b). It would appear that the electronic database consulted by Nylan is, with respect to this formula, less reliable than more traditional sources. However, if Nylan doubts the reliability of Song catalogues, many extant steles, including newly excavated examples, might be cited instead.

Nylan makes other problematic arguments with regard to Han steles. For instance, because the full text of the Wu Rong stele inscription occupies only one half of the surface of the stele, Nylan cites in a note: "Wang Zhuanghong, *Beitie*, p. 8, says that the sort of stele on which only half is inscribed is 'typically associated with the Sanguo-Cao Wei period' [i.e., post-Han]."[115] But the stele that Wang Zhuanghong discusses on the page to which Nylan refers is the Broken Stele of Wang Ji. This stele is of the Three Kingdoms period, but what Wang Zhuanghong writes is that only half of its inscription has been carved while the other half is filled with a brush-written inscription that remains uncarved. Therefore, it is not a half-inscribed stele but a half-carved stele.[116] This case of a fully inscribed

but half-carved stele is not comparable to the Wu Rong stele, whose inscription covers only half of the stele but is fully carved. Furthermore, not only does Wang Zhuanghong nowhere say that the inscription layout of the Wu Rong stele in particular is "typically associated with the Sanguo-Cao Wei period," but instead lists, in another of his works, *Zengbu Jiaobei suibi*, the Wu Rong stele as a genuine Han monument.[117] In concert with this, Huang Yi, in discussing the format of the Wu Rong stele, mentions that another Han-dynasty work, the Han Ren inscription (Han Ren ming), has a similar inscription layout.[118]

Fifth, Nylan's unfamiliarity with the *Lishi* is further illustrated by the "evidence" she uses to accuse Hong Gua of attributing later recarved steles to earlier dates. She writes: "Modern scholarship has shown that Hong Gua sometimes attributed early dates to steles that had been recut in the Tang era. For one example, see Yuan Weichun, *Sanguo beishu* (Beijing: Beijing gongyi meishu chubanshe, 1992), p. 81. Yuan bases his opinion on Hong's remark that the inscription was complete and without omissions."[119]

Here are two serious errors. First, Yuan Weichun is not of the opinion that Hong Gua attributes an early date to the carved inscription of the Daxiang stele inscription (the stele Yuan discusses at Nylan's citation). Scholars agree that this stele was recut in the Tang dynasty after being erected during the Wei of the Three Kingdoms period. So does Hong Gua. (1) Yuan, on page 82, quotes Hong's statement in the *Lishi* that this stele was recut by Li Ji in the Tang dynasty. Moreover, on page 81, Yuan praises Hong Gua for preserving the text even of the recut stele because it no long exists in any state. (2) In the *Lishi*, Hong Gua, at the beginning of his commentary appended to the transcribed text of the Daxiang stele, is quite

plain-spoken that his text for this stele's inscription is based on a Tang recutting.[120] It should be pointed out that, when Nylan accuses Hong Gua of attributing later recarved steles to earlier dates, as discussed above, she writes that he does this "sometimes," implying he did this on a number of occasions. As demonstrated above, in the one example that Nylan cites as evidence of this practice, her source is entirely misread. Thus, Nylan needs other "evidence" to support her accusation against Hong Gua, without which it is groundless and misleading.

Nylan finds the 1588 edition to be the most reliable version of the *Lishi*, an attitude reinforced by her apparent unawareness that its two entries for the Wu Ban and Wu Liang steles are incomplete. Despite her faith, she seems confused and disappointed by the *Lishi*. She writes the following description:

The careful editors of the *Siku quanshu* would condemn Hong's quite tentative talk about Wu Liang; in their view, Hong had "not avoided stretching the wording" (*weimian qianhe qi ci*). See their preface to the *Lishi* (*Siku* edition), vol. 681, p. 444 (3a–3b).[121]

I suggest reading the entire preface by the *Siku quanshu* editors to Hong Gua's *Lishi*. This preface, like the prefaces to all the works compiled in the *Siku quanshu*, is a short and general review of Hong Gua's *Lishi*. It starts with a short introduction that includes biographical information about Hong Gua and discusses the structure and contents of the *Lishi*, the dates of the *Lishi*'s early printings, the edition on which the *Siku quanshu* edition is based, etc.

After this introduction to the *Lishi*, the editors give a general evaluation of the book, which they praise highly: "Since inscriptions were first engraved on steles, this book is the most refined and erudite [book on stele inscriptions]" (*zi you bei ke yi lai, tui shi shu wei zui jingbo*). In other words, in the editors' collective opinion, this book exemplifies the best scholarship on stele inscriptions in recorded history. Of the three important Song compilations of stone and metal inscriptions, this is the only one they praise.[122]

Following this assessment, the *Siku* editors point out that "occasionally, mistakes may be found in this work" (*qi zhong ou you yi lou*). They then list a few errors in Hong Gua's transcriptions of characters.[123] They also point out that "Moreover, there are minor mistakes [in interpreting some monuments]" (*you qi xiao you pi miu*). Among the four minor mistakes listed by the *Siku* editors, one is Hong Gua's identification of the Wu Family Shrines as the "Wu Liang Shrine." The *Siku* editors hold that the monument is better dubbed the Wu Family Shrine(s). After listing the three other "minor mistakes," the *Siku* editors comment again: "But such errors are analogous to the single impure hair among a hundred pure ones. They do not compromise the great significance [of this work]" (*ran bai chun yi bo, jiu bu hai qi hong zhi*).[124] When the *Siku quanshu* editors' evaluation of the *Lishi* is studied carefully, it becomes more than evident that they did not condemn Hong Gua, as Nylan describes. Rather, they admired him as a great scholar.[125]

The *Siku* editors' criticism of Hong Gua for identifying the stone chamber as the Wu Liang Shrine was based on Gu Aiji's argument that a cartouche on the shrine incorporates the character *zhuang*, which at that time was banned as a taboo character because it was the given name of the Emperor Mingdi of the Eastern Han (r. 58–74). Gu argued that, since the character on the cartouche was not altered, the stone engravings Hong Gua

identified as the Wu Liang Shrine should be dated earlier than the death of Wu Liang in 151. The modern scholar Yu Jiaxi, having examined the evidence used by the *Siku quanshu* editors, convincingly argues that the *Siku* editors were wrong to follow Gu's argument, because the practice of character taboo was not strictly followed in the Han.[126] Kuroda Akira's review of Nylan's essay also points out the error of the *Siku* editors in criticizing Hong Gua, citing other scholars' (e.g., Chen Yuan) research that shows that taboo characters, despite their banned status, were not infrequently used in the Han.[127] Modern archaeological discoveries confirm the positions of Yu Jiaxi and Chen Yuan. For instance, the excavated Han-dynasty inscribed bamboo slips do not avoid the character *bang* even though it was the given name of the first Han emperor Liu Bang (r. 206–195 BCE).[128]

Nylan's effort to challenge the credibility of texts associated with the Wu Family Shrines goes beyond the *Lishi*. She writes: "Obviously, the problems surrounding the stele inscriptions associated with the Wu family make them less-than-ideal historical sources. The scholar He Zhuo (1661–1722), after a careful review of all the written records then available for the site, commented, rather sadly, that he could make no sense of the materials before him—the more materials he gathered, the more they scattered, 'like leaves falling'."[129] Was He Zhuo's comment made "after a careful review of all the written records then available for the site"? No, his comment did not concern "all" the written records about the Wu site but only the *Li xu*, another volume written by Hong Gua. Does He Zhuo's comment mean "he could make no sense of the materials before him"? No, the cited comment does not seem to imply this. Does He Zhuo's comment, even if he is speaking of the *Li xu* rather than the *Lishi*, mean "the more

materials he gathered, the more they scattered, 'like leaves falling'"? Again, no. The "leaves" used by He is part of the phrase "sweeping leaves" (*sao baiye*), and this does not refer to scattered textual materials generally but is a term used by collators of ancient books to refer only to textual errors.

The errors He Zhuo mentions in his comment are errors in transcribing characters (*e zi*). The term *e zi*, in the context of collation, includes characters with but slight formal differences from the characters they were copied from (see the discussion of Huang and Gu's collation of the *Lishi* below). Hence, not only are many *e zi* not errors in meaning, they do not even constitute major differences in character formation, and hence this type of "error" is usually not fatal to the meaning of its passage. An altered text usually reads the same as its original, and hence He Zhuo could not have meant that such passages in the *Li xu* make no sense to him. An experienced reader, even when presented with numerous errors of this type, may find that, in general, the essential integrity of a text is preserved.

Another consideration is that, even were there generally many mistranscribed characters in the copy of the *Li xu* collated by He Zhuo, for our purposes it is necessary to look only at its entries for the Wu Family Shrines. The *Li xu*, not generally about the Wu Shrines, contains only one entry concerning them, one that addresses only the Shrines' pictorial stones; it does not discuss even the four stele inscriptions and the pillar-gate inscription. Thus, when evaluating the accuracy of the *Li xu*'s discussion of the Wu Family Shrines, it should be determined whether the specific passages pertaining to the shrines include altered characters and to what extent, if any, these changes distort the meanings of their passages. In the end, Nylan provides no evidence for her claims regarding this passage in He Zhuo's work. Her discussion here is

another example of how she mishandles sources to discredit both the Wu Family Shrines and its textual records.

In another case involving minor errors in transcription after Wang Rixiu's edition of the *Lishi* was published in 1778–79, the famous bibliographers Huang Pilie and Gu Guangqi collated it and found numerous errors. Yet many of these errors were caused by Wang Rixiu's mistranscribing characters with clerical script structures into regular script, and, again, such errors are no barrier to readers in comprehending the correct meanings of words. Collators are typically quite exacting in scrutinizing a text for its correspondence with the original, conscientiously noting the slightest differences in content or form. But often the differences between texts they catalogue are not sufficient to impede our understanding of these texts.

Furthermore, since criticism of a text with respect to its discussion of specific subjects (such as the Wu Family Shrines) must be based only on errors in the entries for those subjects, Huang and Gu's collation of Wang Rixiu's *Lishi* must be analyzed in this manner as well. In Wang's *Lishi*, Huang and Gu found only three mistakes in the entry for the Wu Ban stele, all minor. The first error is that Wang used the ordinary form of the character *ning* to replace its Han clerical version. The second is that, at one point, Wang Rixiu, instead of initiating a new column in conformance to his source text, continued the text in the previous column. His final error was to write "second month" for "third month," an apparent mistranscription (p. 26a).

As for other entries concerning the Wu Family Shrines in the Wang Rixiu edition, Huang and Gu found but one error in the entry for the Wu Liang stele (p. 26b), and none for the Wu Rong stele. They uncovered sixteen errors in the entry for Wu

Family Shrines pictorial stones (pp. 66b–67b), but again, most of them were associated with Wang's replacement of clerical characters with their regular script equivalents, which changed their forms but not their meanings. As to the entry for the Wu Kaiming stele, which Hong Gua copied from Zhao Mingcheng's *Jinshi lu*, no errors were found; likewise for the pillar-gate inscription, which Hong copied from the same source. Overall, errors in entries pertaining to the Wu Family Shrines were few and almost universally inconsequential, leaving the content of these entries essentially intact. To conclude our review of these texts and He Zhuo's colophon, we find nothing to support Nylan and Liu's claim that, the more He Zhuo gathered materials regarding the Wu Family Shrines, the more they became scattered. Not only are "gather" and "scatter" in Nylan's version of He Zhuo's text contradictory actions, but He made no such a statement; instead, it comes, groundless and misleading, from Nylan and Liu.

Cary Liu acknowledges, in the "additional note" to Nylan's article discussed above, that the 1588 edition is missing two pages and that the Wang Rixiu edition was based on a Ming manuscript copy of an early edition, whether Song or Yuan. But apparently he was reluctant, in his own essay, to alter arguments related to this matter. Thus, his article still refers readers to Nylan's examination (which I hope to have shown is seriously flawed) of "the confused and complex collation history of each of the reconstructed texts."[130] Liu writes:

Substantial new sections of the Wu Ban stele inscription appeared in later received editions of Hong Gua's *Lishi*, making the stele text now eighty to ninety percent comprehensible (contrast Ouyang Xiu). The stele text is relatively the same in many of the *Lishi* editions, but starting with Wang Rixiu's

(eighteenth century) Lousong shuwu collated edition in 1777, Hong Gua's appended commentary was expanded to include part of his comments on the Wu Liang stele and the gate-pillar inscription, as well as other materials.[131]

He further claims: "Additionally, in the textual transmission of the stele, gate-pillar, and cartouche inscriptions [for the Wu Family Shrines], it was often scholarly practice to interpolate missing or ambiguous characters to supply intelligibility. This may explain why only ten to twenty percent of the Wu Ban stele was legible to Ouyang Xiu in the eleventh century, whereas in late eighteenth-century editions of Hong Gua's Lishi, some eight to ninety percent could suddenly be read." He continues: "Until the differences and relationships between earlier and later editions of commonly accepted texts, such as Ouyang Xiu's Jigu lu, Zhao Mingcheng's Jinshi lu, and Hong Gua's Lishi and Li xu, are fully understood, they should not be accepted as authoritative sources upon which to build a study of the 'Wu Family Shrines' or of Han-dynasty art history and material culture."[132]

But Liu knows that, as early as the late Northern Song, Zhao Mingcheng stated he had a rubbing of the Wu Ban stele and that its text could be read. Similarly, judging from his note attached to Nylan's note, Liu knows that the full text of the Wu Ban stele was recorded in various editions long before the eighteenth century. He should also have known that the text of the Wu Ban stele that Weng Fanggang recorded in his Liang Han jinshi ji, which was based on a newly made rubbing sent to him by Huang Yi after Huang rediscovered the Wu Family Shrines, contained not more but significantly fewer readable characters than in earlier rubbings.[133] Yet, Liu claims that "in late eighteenth century editions of Hong Gua's Lishi, some eighty to ninety percent

could suddenly be read." We have seen examples in which improvements in rubbing technology increased the legibility of old inscriptions, but this is not the case here.

Liu's argument that, in the Wu Ban entry in the Wang Rixiu Lishi, "Hong Gua's appended commentary was expanded to include part of his comments on the Wu Liang stele and the gate-pillar inscription, as well as other materials" shows he does not understand that Hong Gua's commentary on the Wu Ban stele is incomplete in the 1588 and Siku quanshu editions.[134]

The second part of this argument by Liu for his and Nylan's recarving thesis is that available research on Song catalogues (and their later editions) is inadequate and insubstantial. Yet, by the eighteenth century, a number of scholars had made carefully detailed analyses and collations of the editions of these texts. By contrast, although the Lishi remains central to much of their discussion, Nylan and Liu do not seem to have studied it thoroughly and carefully. As a result, many of their confusions were caused by their unfamiliarity with its text, by their excessive attachment to its flawed 1588 and Siku editions, and by their rejection without substantive cause of alternative and more adequate editions made by earlier scholars, whom Liu here criticizes. Under these circumstances, Liu's criticism that the Song catalogues and their later editions have not received serious analysis would seem not only incorrect but inappropriate.

Nylan and Liu's criticisms of the Lishi are frequently inaccurate or unfounded. They seem not to have understood the history of the transmission of the Lishi and the scholarship pertaining to this great work. Even up to the point when they completed their essays for Recarving, they seem not to have comprehended the structure of the Lishi, the terms used by Hong Gua, the relations

among the five inscriptions associated with the Wu Family Shrines, or Hong's commentaries on these inscriptions. Despite this, they have proceeded to challenge the *Lishi* and much of the scholarship associated with it. It is difficult to explain these mistakes by Nylan and Liu as mere carelessness.

As discussed above, in the study of ancient metal and stone objects, Huang Yi and his friends routinely consulted catalogues written by epigraphical experts from the Song to early Qing. In their writings we can hear an ongoing dialogue among generations of scholars over many centuries. From this dialogue we can trace the development of the field of metal and stone studies over more than seven hundred years. Wang Mingsheng (1722–1797), an accomplished historian of Huang Yi's time, writes in his preface to Qian Daxin's *Qianyan tang jinshi bawei*: "The study of metal and stone objects (*jinshi zhi xue*) has been valued since the Zhou, Han, and Northern and Southern dynasties. But books that specialize in this field began with Ouyang Xiu. Since then, many have compiled catalogues to record [metal and stone objects]. Some catalogues focused only on inscriptions written in a single script, such as Hong Gua's *Lishi* and Lou Ji's [1133–1211] *Hanli ziyuan* (*Sources of clerical-script calligraphy*); others only recorded metal objects but not stone objects, such as the *Xuanhe bogu tu* and Xue Shanggong's [*Lidai*] *Zhongding* [*yiqi*] *kuanzhi* [*fatie*] (*Inscriptions on bronze ritual vessels from successive dynasties*); some specialized in recording metal and stone objects from particular areas, such as Huang Shujing's *Zhongzhou Jinshi kao* (*Studies of metal and stone objects in Zhongzhou*) and Bi Yuan's *Guanzhong jinshi ji* (*Records of metal and stone objects in Guanzhong*)."[135] Wang Mingsheng's outline of this field of study correctly points out that since the Song, studies of metal and stone

objects became not only more frequent but increasingly specialized, not to say more exacting and detailed.

Ouyang Xiu was no doubt the most influential pioneer in the field. Although Ouyang virtually established the genre of research notes (*bawei*) on ancient metal and stone objects, nevertheless his scholarship, compared with that of later generations, lacked detail and method. For this reason, his *Jigu lu* was often criticized by later scholars from the Southern Song to the Qing.[136] In the early Qing, the young scholar Yan Ruoqu (1636–1704) commented:

In literary accomplishment, I have said that Mr. Ouyang was a literatus unmatched for generations whom no one could surpass; but in scholarship, no one was so poor. Mr. Fu Shan heard this comment of mine and asked, "Did you criticize Ouyang because Liu Yuanfu [Liu Chang] belittled him? You simply followed Liu's criticism, did you not?" "Certainly not," I said, "I examined his notes in the *Collected Records of Antiquities*."[137]

Similar criticism comes from Huang Yi's friend, Qian Daxin: "Liu Yuanfu once criticized Ouyang Xiu for not reading books. After reading [Ouyang Xiu] *Jigu lu bawei*, one can believe Liu's criticism."[138]

There may be several reasons for criticizing Ouyang Xiu's scholarship. First, the limits of Ouyang's knowledge: many have held that Liu Chang was the better scholar. Second, during the early days of metal and stone studies, rubbings were likely of lesser quality than those made after the field entered its maturity. Third, Ouyang Xiu's skill in reading rubbings in clerical script was inadequate. In an entry for a Han stele, Ouyang Xiu admitted he was not at his best in reading clerical script.[139]

Several decades later, by the end of the Northern Song, epigraphical scholarship seems to

have advanced significantly, and better rubbings became available to scholars. By Hong Gua's time, metal and stone scholarship had become significantly more sophisticated as it became subdivided into more specialties. As Wang Mingsheng observed, a number of specialized books were published in the period from the late Northern Song to the early Southern Song, including catalogues of inscriptions in specific script types or of inscriptions in particular mediums. Hong Gua, for example, focused only on collecting, recording, and studying stele inscriptions in clerical script, and this relatively narrow focus and the increased responsibility it laid on him helped drive him to collect better rubbings, to record inscriptions more carefully, and to write more detailed research commentaries.

In contrast to Ouyang Xiu's unfamiliarity with clerical script, Hong Gua was expert at it, and his research notes on clerical inscriptions are much more scholarly. These improvements in scholarship resulted from decades of technical refinements, an expanding knowledge base among scholars, and the division of scholarly expertise into academic specialties. It was these developments, not the practice of recarving old artifacts, that were the source of the great improvements in the legibility and completeness of stele texts in the Song. The new refinements in scholarly research in Hong Gua's work, for instance, stimulated the editors of the *Siku quanshu* to praise his *Lishi* as the most refined and erudite book on stele inscriptions since inscriptions were first engraved in stone.

A similar evolution may be found in catalogues of Chinese paintings compiled in the United States. Some painting catalogs published several decades ago did not include the colophons attached to those paintings. Some later catalogues of the same paintings provide readers with

transcriptions of their colophons. But we cannot cast doubt on the authenticity of these paintings by saying that their colophons [seem to] have increased in number. As in the development of the study of metal and stone objects, the later catalogues were an improvement over earlier examples; if not, they would hardly have been worth writing. So, just as earlier catalogues cannot incautiously be used as a standard by which to judge the authenticity and reliability of later examples, earlier rubbings are not necessarily superior to later ones in quality or completeness.

Although most of the stone inscriptions and original monuments recorded in the *Lishi* and *Li xu* no longer exist, fortunately, some of the stones from which Hong Gua's rubbings were made survive. These are: the Yi Ying stele (*juan* 1, pp. 15a–16b; Hong Gua's title is *Kongmiao zhi shoumiao baishi Kong He bei*); the Liqi stele (*juan* 1, pp. 17b–19a);[140] Verso of the Liqi stele (*juan* 1, pp. 20a–21b); the Former Shi Chen stele (*juan* 1, pp. 25a–26b); the Latter Shi Chen stele (*juan* 1, pp. 27b–28b); the Huashan stele (*juan* 2, pp. 1a–3a); the Sangong shan stele (*juan* 3, pp. 15a–17b); Baishi shenjun stele (*juan* 3, 22b–24a); Ode of the Stone Gate (*juan* 4, pp. 3b–5a); Ode of the Western Gorge (*juan* 4, pp. 8b–10b; here, the principal text is correct, but the staff names attached to it are excluded);[141] Ode of Fuge (*juan* 4, pp. 11a–12b); the Xiaoguan stele (*juan* 5, pp. 3a–4b); the Beihaixiang Jingjun stele (*juan* 6, pp. 9a–10b); the Zheng Gu stele (*juan* 6, 16b–18a); the Kong Zhou stele (*juan* 7, pp. 4a–5a); the Heng Fang stele (*juan* 8, pp. 1a–3b); the Kong Biao stele (*juan* 8, pp. 14b–17b); the Lu Jun stele (*juan* 9, pp. 4b–6a); the Fan Min stele (*juan* 11, pp. 9a–11a); and the Wu Rong stele (*juan* 12, pp. 7b–9b).

Even this list might be incomplete, but in any case approximately twenty extant stones are

available for study. Comparing the inscriptions of rubbings made from the original stones listed above and the inscriptions recorded in the *Lishi*, I found the inscriptions of all these monuments to be accurate in the *Lishi* without exception. By "accurate," I mean that the length of any recorded inscription matches that on its original stone within a few characters and variant readings of its characters are only found occasionally, with such variations being caused by transcription errors, printing errors, or differences in character interpretation. Overall, the *Lishi* consistently preserves the integrity of its inscriptions. These extant steles prove the *Lishi* a reliable reference for studying the steles of the Han and Three Kingdoms periods.

Those who disagree with my assessment have two options. (1) They may compare the inscriptions of the original stones with their inscriptions in the *Lishi* to see whether my verification is reliable. (2) They may challenge the authenticity of the stones that I and many other epigraphical scholars believe to be original. But to challenge the authenticity of the stele stones listed above, and the accuracy of Hong's *Lishi* regarding them, puts the enormous burden of proof on the challenger: since many stele stones and their inscriptions exist, it would be necessary to find a pattern of evidence proving these stones suspicious in origin; to prove the textual formats and literary and calligraphic styles of the steles are inconsistent with the Han; to prove that someone took the monumental trouble to carve heavy rocks with elaborate inscriptions and decorations and arrange them on a site, even though stele rubbings may be forged without such labor; to prove that historians of calligraphy have built an unsound chronological framework for early calligraphy (and in turn to demonstrate how scholars created this framework and why it is so widely accepted); and so forth. Considerations like

these should have been evaluated by the principal authors of *Recarving* before they put forward the thesis of recarving.

Since its principal stele inscriptions remain substantially identical among different editions of the *Lishi*, how do we explain the numerous small differences among them? The sources of error listed immediately above provide many of the explanations. For example, scribes hand-copying a book are error-prone. A peculiarity in the *Lishi*'s text should also be taken into consideration. The steles discussed in the *Lishi* were written in Han clerical script, whose character structures often differ from those of regular script, which superseded clerical. As Hong Gua transcribed stele texts into his *Lishi*, he preserved many clerical character structures no longer used in regular script. These clerical structures, later being transcribed into regular script, became regular-script variants of their originals. Some of these peculiar variants of regular-script character forms in the *Lishi* are difficult to read without special training. Thus, when collating the *Lishi*, Fu Shan spent much of his time correlating its regular-script variants with characters in current use to make its text intelligible.[142] Scribes with more ordinary skills than Fu Shan were more prone to make mistakes. Even today, many readers unfamiliar with both clerical script and Hong's clerical variants of regular script have difficulty reading the *Lishi*'s transcriptions of Han stele texts.

As one example of the complications induced by different script types, Nylan writes: "Why does the *Lishi* transcription of the Wu Liang stele delete the poetic *xi* (repeated four times in *Jinshi lu* transcription) in its encomium? (The particles missing from the 1588 *Lishi* reappear in the *Siku quanshu* version.)"[143] But the particle *xi* is not missing from the 1588 edition. Nylan is perplexed here because she is unfamiliar with the clerical

structure of the character *xi*. It was difficult for her to discern its occurrences in the *Lishi* because the clerically-derived structure of *xi* in the 1588 edition resembles the regular-script character for "son" (*zi*); which is to say, it differs considerably from its regular-script character form in, for example, Zhao Mingcheng's *Jinshi lu*, in which Nylan had no difficulty recognizing *xi*. This case exemplifies how Nylan, when confused about the meanings of the texts and sources she is using, attributes problems created by her inexperience to Hong Gua's *Lishi*.

Scholars in the early Qing revived the study of ancient metal and stone objects that once flourished in the Song. Influenced by this intellectual trend, the art of calligraphy revived the use of clerical script. Fu Shan, Zhu Yizun, and Zheng Fu were famous for their work in clerical, and it continued as calligraphy's favored script into the mid-Qing.[144] Huang Yi, also an excellent clerical calligrapher, wrote numerous works in this script; many of his friends were similarly skilled. As learning models for clerical script, they adopted the styles of Han stele inscriptions. In turn, this training improved their skills in deciphering stele inscriptions. In their writings, they frequently discussed the inscriptions of Han steles and corrected misreadings of characters recorded in early catalogues of steles. The study of Han stele texts for artistic and intellectual purposes encouraged the production of intelligible rubbings and increased familiarity with the terminology of stele inscriptions and a broad knowledge of Han culture, including its history, government, geography, and clerical script. These intellectual strengths made many scholars of Huang Yi's generation experts in the epigraphy, etymology, and phonology of written Han sources, allowing them to write the discerning and carefully researched works that laid the foundation for modern research into these subjects.

Concluding Thoughts

Even in Huang Yi's time relatively large-scale scholarly projects could not be managed financially by a single individual — they needed the support of a larger community. A case in point: Huang's restoration of the Wu Family Shrines. But rather than write elaborate research proposals on standard forms, Huang merely wrote notes to a few friends asking for their assistance, and his friends gave him money because they knew the quality of his work. In those days, patrons, like the applicants for their resources, were refined scholars, experts in the fields in which they sponsored research, and could make accurate judgments as to what they would support. These factors were part of the institutional background of eighteenth-century Chinese scholarship and created an environment in which research was based on careful review of all available evidence. In such an institutional environment, research errors were likely to be quickly arrested.

Huang Yi died in 1802 at the age 59 *sui*, and so he is no longer available to talk to us about his times. I wonder, were he to rise from the ground and observe today's evaluations of the academic achievements of his era, what his reactions would be. One guess is that he would be happy to see that the rubbings he made and the scholarship of his friends continue to be received with great pleasure and respect. However, with regard to the Wu Family Shrines, he might be amused or dumbfounded by the present debate over whether these monuments are genuine and over whether the research of his time or ours is the more reliable as to their authenticity. He thus might invite us to ponder with him the question, "Who is recarving China's past?" ◉

Acknowledgements

I would like to thank my friend Matthew Flannery for helping me prepare this article. Many scholars who read the draft of this article have offered their scholarly opinions; some of them have been incorporated into my writing. I deeply appreciate their advice.

After my article was completed, I discovered that the Japanese scholar Kuroda Akira had published a long review of Michael Nylan's essay. In his review Kuroda Akira criticizes Nylan's serious mistreatment of texts concerning the Wu Family Shrines. See Kuroda Akira, "Bushishi Gazōseki no Kisoteki Kenkyū—Michael Nylan 'Addicted to Antiquity' Dokugo"—Michael Nylan "Addicted to Antiquity" ("Fundamental Research on the Wu Family Carved Pictorial Stones—In Response to Michael Nylan's 'Addicted to Antiquity'"), *Kyōto Gobun* no.12 (November 2005), pp. 155–204. Kuroda Akira and I share many opinions we reached independently. For instance, both of us believe that the Wang Rixiu edition of *Lishi* published in 1778–79 is a credible text for studying the Wu Family Shrines. Since publishing his first article, Professor Kuroda has finished two more articles that contest Nylan's work, "Bushishi Gazōseki no Kisoteki Kenkyū—Michael Nylan 'Addicted to Antiquity' Dokugo (2)"—Michael Nylan "Addicted to Antiquity" ("Fundamental Research on the Wu Family Carved Pictorial Stones—In Response to Michael Nylan's 'Addicted to Antiquity' (2)"), which will be published in *Sōgō Ningengaku Sōsho*, vol. 3 (June 2007); and "Bushishi Gazōseki wa Gikokuka—Michael Nylan 'Addicted to Antiquity' eno Hanron" ("Are Pictorial Stones from the Wu Family Shrines Forgeries?"), which will be published in *Setsuwa Bungaku Kenkyū*, no. 42 (June 2007). I am grateful to Professor Kuroda for generously sharing his insights and materials with me.

Furthermore, I am deeply grateful to the Princeton University Art Museum for generously publishing my article criticizing *Recarving*, which was published by this museum.

I would also like to point to the existence of an album of rubbings of the Wu Family Shrines by Huang Yi in the collection of the Shanghai Library. It contains six long colophons by Huang in which he provides detailed discussions of his discovery and restoration of the Wu Family Shrines. This album was recently published by the Shanghai guji chubanshe (2005). Huang Yi's colophons in this album help us clarify some problems and mistakes in *Recarving*. For instance, in *Recarving*, Cary Liu speculates that Mount Wuzhai, or Mount Wu-Zhai, may not have anything to do with the Wu family but with a Zhai family with military connections. That is, Liu reads the "Wu" in "Wu-Zhai" as "military" or "martial" rather than as a family name (see Cary Liu, *Recarving*, pp. 41–42.) This is a very awkward reading of the text. Huang Yi's colophon on the album under discussion, however, states that the mountain (or hill) is called Wu-Zhai because the residents of a village at its foothills belonged mainly to two clans: those of Wu and Zhai. (See Shanghai tushuguan, ed., *Shanghai tushuguan cang shanben beitie* [Shanghai: Shanghai guji chubanshe, 2005], vol. 1, p. 23). This clarification is but one demonstration of the importance of the information in Huang's album. I thank Eileen Hsu for informing me of the publication of this album.

Notes

1 See Cary Liu, "Curator's Preface and Acknowledgements," in Cary Y. Liu, Michael Nylan, Anthony Barbieri-Low, et al., *Recarving China's Past: Art, Archaeology, and Architecture of the "Wu Family Shrines"* (Princeton: Princeton University Art Museum; New Haven and London: Yale University Press, 2005), p. 9. Hereafter, this catalogue will be cited as "*Recarving*."

2 Although the authors of the catalog use the term "recarving" rather vaguely and appear to include historical reinterpretation as "recarving," they unmistakably argue or imply that at least some components of the Wu Family Shrines' monuments were recarved physically.

3 Cary Liu, "Curator's Preface," *Recarving*, p. 8.

4 Some argue that only some of the

many pictorial stone carvings and five inscriptions constituting the Wu Family Shrines may have been recarved or forged in later periods. But regardless, the net effect is to challenge the integrity of Wu Family Shrines as unitary monument of the Han. Other arguments, for instance, that the shrines may have been made for a senior official of the Western Jin dynasty, Wu Mao, appear to be groundless speculations.

5 See Cary Liu, "Curator's Preface," *Recarving*, p. 9.

6 Since this volume includes Eileen Hsu's in-depth discussion of Huang Yi's paintings related to stele-visiting activities, I will not go into detail here. Paintings depicting or recording activities associated with ancient steles were not the invention of Huang Yi. Works on the subject of visiting or reading steles had appeared by at least the Song and continued without cease into the Qing. One example, about a century before Huang Yi in the early Qing, is a work by the Nanjing painter Zhang Feng titled "Reading a Stele." See Qianshen Bai, *Fu Shan's World: The Transformation of Chinese Calligraphy in the Seventeenth Century* (Cambridge, Mass.: Harvard University Asia Center, 2003), pp. 181–82.

7 Ruan Yuan, *Xiao Canglang bitan* (*Notes from the Small Canglang*) (Taipei: Guangwen shuju, 1970), *juan* 2, p. 30ab.

8 Biographies of most Huang Yi's friends discussed here can be found in Arthur W. Hummel, ed. *Eminent Chinese of the Ch'ing Period* (1644–1912) (Washington, D.C.: United States Government Printing Office, 1944). Most of them have also been discussed by Benjamin A. Elman in his classic

study of the intellectual life of this period, *From Philosophy to Philology: Intellectual and Social Aspects of Changes in late Imperial China* (Cambridge, Mass.: Harvard University, Council on East Asian Studies, 1984).

9 For the patron roles played by Bi Yuan and Ruan Yuan (which will be discussed below), see Elman, *From Philosophy to Philology*, pp. 104–11.

10 For the role played by southern scholars, see Elman, *From Philosophy to Philology*.

11 Elman, *From Philosophy to Philology*, p. 177. All Wade-Giles spellings have been changed to *pinyin*.

12 Studying historical figures with the same name commenced in the Liang dynasty of the Six Dynasties period. See Peng Zuozhen, ed., *Gujin tong xingming dacidian* (*Dictionary of people with identical names, ancient and present*) (Shanghai: Shanghai shudian, 1983), p. 3.

13 Qian Daxin, *Jiading Qian Daxin quanji*, vol. 7, pp. 319–22.

14 Another example of identical names: in addition to the Huang Yi of the eighteenth century, two others were recorded in Ming-Qing texts. One lived in the mid-Ming period (*jinshi* 1517), the other in the early Qing (*jinshi* 1658, d. after 1673), just several decades before the eighteenth-century Huang Yi.

15 Hong Gua, *Lishi* (the 1588 Wang Yunlu edition collated by Fu Shan (1607–1684/85) and Zhang Yuanji (1867–1959), photographically reproduced in the *Sibu congkan* series (Shanghai: Shangwu yinshuguan, 1935), *juan* 18, p. 9a.

16 See "Biography of Wang Hun," in *Jin shu* (*Jin history*) (Beijing: Zhonghua shuju, 1974), vol. 4, *juan* 42, p. 1202.

17 Lu Guangwei, *Wudi ji* (*Siku quanshu* edition), p. 19a. For modern scholarship on *Biographies of Filial Sons*, see Kuroda Akira, *Kōshiden no Kenkyū* (*Studies of "Biographies of Filial* Sons*"*), (Kyōto: Shibunkaku Shuppan, 2001); Yōgaku no Kai, *Kōshiden Chūkai* (*Annotations to "Biographies of Filial Sons"*) (Tōkyō: Kyūko Shoin, 2003); and Kuroda Akira, *Kōshidenzu no Kenkyū* (*Studies of the Illustrations of Biographies of Filial Sons"*) (Tōkyō: Kyūko Shoin, 2007).

18 Cary Liu, "The 'Wu Family Shrines' as a Recarving of the Past," in *Recarving*, p. 29.

19 Ye Yibao, *Jinshi lu bu xuba* (*Additional notes to Supplement to the Jinshi lu*) in *Shike shiliao xinbian* (Taipei: Xinwenfeng chuban gongsi, 1982), vol. 12, *juan* 2, p. 4ab (new page number 9147).

20 See Michael Nylan, "Addicted to Antiquity" (*nigu*): A Brief History of the Wu Family Shrines, 150–1961 CE," in *Recarving*, p. 522. Hereafter, referring to Nylan's essay, I will give only the catalogue title (as *Recarving*) and page number.

21 For instance, the term *fucheng* is found in Ouyang Xiu's *Jigu lu* in the inscriptions of *Peixiang Lord Yang's Stele of the Latter Han* (*Siku quanshu* edition) (*juan* 2, p. 18a). It also appears in Zhao Mingcheng's *Jinshi lu* (facsimile reproduction of Song edition, Beijing: Zhonghua shuju, 1991) not only in the inscription of the Wu Kaiming stele (*juan* 14, new page number 338) but in the inscription of the *Chenggao Magistrate Ren Bosi stele* (*juan* 15, new page number 359). Furthermore, in Hong Gua's *Lishi*, it appears in the Stele of Mt. Hua Pavilion (*juan* 2, 5a),

the Stele of Bajun Governor Zhang Na (*juan* 5, p.12a), the Filial and Incorrupt Liu Min Stele (*juan* 8, p. 8b), the Kong Biao stele (*juan* 8, p. 15a), the Stele of Yizhou Governor Gao Yi (*juan* 11, p. 13a), the Two Pillar-Gates of Yizhou Governor Gao Yi (*juan* 13, p. 2b), and the Stele of Nanyang Governor Qin Jie (*juan* 17, p. 7a). Finally, in Hong Gua's *Li xu* (*Siku quanshu* edition), it appears in the Stele of Wudu Governor Geng Xun (*juan* 11, 2b) and the Broken Stele of the Temple Gate of Jiaodong Magistrate Mr. Wang (*juan* 11, p. 14a).

22 Uses of the term *fucheng* as a title for local officials are found in the following biographies in the *History of the Former Han* (Beijing: Zhonghua shuju, 1962): *Wang Zun* (*juan* 76, p. 3228), *Zhu Bo* (*juan* 83, p. 3401), and *Yan Yannian* (*juan* 90, p. 3670). In the *History of the Latter Han* (Beijing: Zhonghua shuju, 1965), it occurs in *Kong Fen* (*juan* 31, p. 1099), *Yang Xu* (*juan* 31, p. 1110), *Yuan An* (*juan* 45, p. 1518), *Ban Chao* (*juan* 47, p. 1579), *Xie Bi* (*juan* 57, p. 1860), and *Shi Bi* (*juan* 64, p. 2111). Other examples occur in the following Han and pre-Tang texts: Xun Yue, *Han ji* (*Records of the Western Han*); Ban Gu and Liu Zhen, et al., *Dongguan Han ji* (*Records of the Western Han from the Dongguan*), Chen Shou, *Sanguo zhi* (*Records of Three Kingdoms*); and Yuan Hong, *Hou Han ji* (*Records of the Eastern Han*). The frequent uses of *fucheng* in these sources are too numerous to cite here.

23 The *Gao Yi Pillar-Gate* is recorded in Hong Gua's *Lishi, juan* 13, p. 2a. Modern photographic reproductions of this monument may be found in archaeological texts.

24 When discussing the multiple meanings of *fu* associated with official titles in imperial China, Hucker correctly points out the meaning of *fu* as "Court or Office, throughout history commonly appended as suffix to official titles, usually of dignitaries, to designate their work places or official headquarters and in addition the staff of personnel that served them." *Fu* also meant, from the Tang to Yuan dynasties, "Superior Prefecture, a unit of territorial administration comparable to an ordinary Prefecture (*chou*) but in a specially honored or strategic location such as the environs of a capital city." See Charles O. Hucker, *A Dictionary of Official Titles in Imperial China* (Stanford: Stanford University Press, 1985), p. 216.

25 That the term *fucheng* meant *juncheng* in the Han dynasty can be seen in the "Biography of Kong Fen" in Fan Ye, *Hou Han shu* (*History of the Eastern Han*), *juan* 31, p. 1099.

26 Lao Gan, "Handai junzhi jiqi duiyu jiandu de canzheng" ("The 'jun' system in the Han and the mutual verification of this system with bamboo slip documents"), in *Lao Gan xueshu lunwenji* (*Collected scholarly essays by Lao Gan*) (Taipei: Yiwen yinshuguan, 1976), vol. 2, pp. 1049–68. In Huang Yi's time there was also a scholar who had discussed the term *fucheng* as used in the Han dynasty. See Qian Daxin, *Jiading Qian Daxin quanji*, vol. 6, p. 8.

27 In his review of Nylan's essay, Japanese scholar Kuroda Akira also discusses the use of *fucheng*, arguing that *fucheng* was interchangeable with *juncheng* during the Han. He also mentions that Ye Yibao does not state that the Wu Ban stele was almost certainly a Tang monument. See Kuroda

Akira, "Bushishi Gazōseki no Kisoteki Kenkyū—Michael Nylan 'Addicted to Antiquity' Dokugo" ("Fundamental Research on the Wu Family Carved Pictorial Stones—In Response to Michael Nylan's 'Addicted to Antiquity'"), *Kyōto Gobun* no.12 (Nov. 2005): 168–69.

28 For a discussion of the revival of *jinshi xue* and the activity of stele visiting in the early Qing period, see Qianshen Bai, *Fu Shan's World*, pp. 161–64, 172–84. For an excellent discussion of the study of ancient metal and stone objects in the eighteenth century, see Elman, *From Philosophy to Philology*, pp. 188–97.

29 Weng Fanggang, *Liang Han jinshi ji* (*Records of metal and stone objects from the Western and Eastern Han*) (1789 edition), *juan* 16, p. 6b.

30 See Huang Yi, *Xiao Penglai Ge jinshi wenzi*, reprint, *Shike shiliao xinbian* (Taipei: Xinwenfeng chuban gongsi, 1986), vol. 3, pp. 560, 573, 574, 588.

31 Qian Yong, *Lüyuan conghua* (Beijing: Zhonghua shuju, 1979), p. 237.

32 See Qian Daxin, *Jiading Qian Daxin quanji*, vol. 6, pp. 9, 10, 11, 24, 34. The writings of Weng Fanggang, Qian Daxin, and others show that, explicitly or implicitly, they often debated one another.

33 On the subject of forgery detection in the early Qing, see Lin Ch'ing-chang, *Qingchu de qunjing bianweixue* (*Detecting forgeries of Confucian Classics in the early Qing*) (Taipei: Wenjin chubanshe, 1990); and Elman, *From Philosophy to Philology*, pp. 68–70.

34 See Guo Moruo, "You Wang Xie muzhi de chutu lundao Lanting xu de zhenwei" ("On the authenticity of the *Lanting xu*: evidence drawn from the newly excavated epitaph

stones of Wang [Xingzhi] and his wife and Xie [Kun]"), in *Lanting lunbian* (*Controversies over the "Lanting xu"*) (Beijing: Wenwu chubanshe, 1973), p. 12.

35 Liu, *Recarving*, p. 23.

36 Nylan, *Recarving*, p. 513.

37 The academic phenomenon of detecting forgeries (*bianwei*) in Huang Yi's time has been discussed by Elman. For Elman's discussion of the criticism and skepticism in evidential research of the Qing, see *From Philosophy to Philology*, pp. 29–36. It is unusual that Nylan and Liu, with their deep interest in forged antiquities and the epigraphical studies of the eighteenth century, do not refer to Elman's discussions of these subjects. However, since the content of Elman's book does not generally provide positive support for the "recarving" argument, one might ask if this is the reason this important book was not included even in the bibliography of *Recarving*. Elman's book is recommended to interested readers as an overview of the intellectual landscape of the eighteenth century.

38 This letter is now in the collection of Tokyo National Museum.

39 Weng Fanggang, "Huang Qiu'an Debei shiertu xu" ("Preface to Huang Yi's twelve paintings on acquiring steles"), in *Fuchu zhai wenji*, *juan* 2, p. 7b.

40 See Lu Mingjun, *Fuzhi yanjiu* (*Studies of Chen Jieqi*) (Beijing: Rongbaozhai chubanshe, 2004).

41 Qianshen Bai, "The Artistic and Intellectual Dimensions of Chinese Calligraphy Rubbings: Some Examples from the Collection of Robert Hatfield Ellsworth," *Orientations* (March 1999), p. 83. Interested readers may also read Wu Hung's article "On Rubbings: Their

Materiality and Historicity," in *Writing and Materiality in China: Essays in Honor of Patrick Hanan*, ed. Judith T. Zeitlin and Lydia H. Liu (Cambridge, Mass.: Harvard University Asia Center, 2003), pp. 29–72.

42 Fu Shan wrote a poem for his grandson Fu Liansu commemorating their visit to Mt. Tai and Qufu. Two lines read: "You, too, loved the calligraphy of the *Wufeng Stone Inscription* (*Wufeng keshi*): how marvelous is the radical *ge* in the character *cheng*." This tells us that when Fu Shan visited this monument this character was legible. See *Fu Shan quanshu* (Taiyuan: Shanxi renmin chubanshe, 1991), vol. 1, p. 49. Note that the character '*cheng*' is in the lower left corner of the Wufeng Stone and its rubbing.

43 Zhu Yizun, *Pushu ting ji* (Shanghai: Zhonghua shuju, 1936), *juan* 47, p. 10a.

44 See *Beijing tushuguan cang Zhongguo lidai shike taben huibian: Zhanguo, Qin-Han* (Zhengzhou: Zhongzhou guji chubanshe, 1989), p. 12.

45 Zhu Yizun in *Pushuting ji* (Shanghai: Zhonghua shuju, 1936), *juan* 47, p. 10a

46 Zhaoling is the imperial mausoleum of Emperor Taizong of the Tang. Therefore, the steles Ye Changchi mentioned in this passage are probably Tang steles.

47 *Jinshi cuibian* is a catalogue of metal and stone objects compiled by Wang Chang (1725–1806). Hence, rubbings seen by Wang Chang were earlier than those compiled by Ye.

48 Namely, the early Qing, or the second half of the seventeenth century, two hundred or so years before Ye's time.

49 Ye Changchi (commentary by Ke Changsi), *Yu shi* (Beijing: Zhonghua shuju, 1994), *juan* 9, p. 529. In his essay in *Recarving*, Cary Liu discusses the

processes of making rubbings and fine rubbings (*jingta*) (pp. 71–72). However, he focuses attention on the recarved parts of rubbings.

50 This is Kang Wanmin's (act. 1573–1620) preface to Zhao's catalogue *Excellent Rubbings of Stone Carvings* (*Shimo juanhua*). See Zhao Han, *Shimo juanhua*, in SKSLXB, vol. 25, p. 18583.

51 Ye Yibao, *Jinshi lu bu*, p. 9133a.

52 This painting is a leaf in Huang Yi's album "Visiting Steles in the Song-Luo Area," now in the collection of the Palace Museum, Beijing.

53 Zhao Mingcheng (collated by Jin Wenming), *Jinshi lu jiaozheng* (*Collation of 'Jinshi lu'*) (Shanghai: Shanghai shuhua chubanshe, 1985), p. 256.

54 Although scholars in Shandong have already raised the question of the quality of Ouyang Xiu's rubbings (see Zhu Xilu, *Wushi ci Han huaxiang shi* [*The pictorial stones of the Wu Family Shrines*] [Jinan: Shandong meishu chubanshe, 1986], p. 1), the two principal authors of *Recarving* have not responded to this issue and simply assume Ouyang's rubbings are more reliable than Zhao Mingcheng's and Hong Gua's.

55 It becomes apparent that, in the study of the history of the Wu Family Shrines, even as some scholars have been harshly critical of the reliability of the rubbings of Zhao Mingcheng and Hong Gua, they have shown unquestioning acceptance of the high quality of Ouyang Xiu's. Neither position seems entirely objective.

56 For Kuroda Akira's detailed discussion of recorded rubbings of the Wu Ban stele, see Kuroda Akira, "Bushishi gazōseki no kisoteki kenkyū," pp. 159–64.

57 See Liu, *Recarving*, pp. 37. Cary Liu appends a note to his statement, but it contains no information on exile. See ibid., p. 84, n. 65.

58 Nylan, *Recarving*, p. 520.

59 Nylan, *Recarving*, p. 526.

60 Liu Deqing, *Ouyang Xiu nianpu* (*Chronological biography of Ouyang Xiu*), in *Songren nianpu congkan* (*Series of chronological biographies of Song figures*), ed. Wu Hongze and Yin Bo (Chengdu: Sichuan daxue chubanshe, 2003), vol. 2, pp. 1161–64.

61 Besides the chronological biography by Liu Deqing cited above, the other two biographies of Ouyang Xiu I have consulted are the Song writer Hu Ke's *Luling Ouyang Wenzhonggong nianpu* (*Chronological biography of Ouyang Xiu from Luling*), which is included in the same volume as Liu Deqing's work; and Chen Ming, *Ouyang Xiu zhuan* (*Biography of Ouyang Xiu*) (Guangzhou: Guangdong gaodeng jiaoyu chubanshe, 1998). During Ouyang Xiu's political career, he was sent to Shandong just once, in the first year of Xining (1068). Far from being an exile, however, he was sent there as the appointed governor of Qingzhou, which is at a considerable distance from Rencheng. Ouyang Xiu remained at Qingzhou for about a year and a half, then was transferred to Taiyuan. See Liu Deqing, *Ouyang Xiu nianpu*, pp. 1188–93. There are no records during his tenure in Qingzhou that suggest he ever visited Rencheng.

62 Nylan, *Recarving*, p. 545. n. 32.

63 See Lu You, *Lao Xue an biji* (Beijing: Zhonghua shuju, 1979), p. 53.

64 See Nylan, *Recarving*, p. 526.

65 Fang Ruo and Wang Zhuanghong, *Zeng bu Jiaobei suibi*, p. 59.

66 Nylan, *Recarving*, p. 550, n. 45.

67 Nylan, *Recarving*, p. 538.

68 Elsewhere, Nylan's essay omits notes where verification is needed; limited by space, I cannot discuss every such instance.

69 Nylan, *Recarving*, p. 521.

70 See Wu Hung, "On Rubbings," p. 36.

71 A small difference between two inscriptions in number of characters may be acceptable because characters may be omitted or added when inscriptions are transcribed and engraved on printing plates.

72 To be sure, the Wu Family Shrines, including the Wu Ban stele, were not treated as important monuments until the mid-Qing. That was why they were abandoned for centuries until Huang Yi noticed them. Numerous Han and pre-Han objects did not receive serious attention until the rise of antiquarianism in the Northern Song. Any absence of prior records for these objects can easily be understood in this historical context. Such neglect also tends to preserve objects from human alteration.

73 See Weng Fanggang's entry for the Wu Ban stele in his *Liang Han jinshi ji*, *juan* 15, p. 49b–51b.

74 Qian Daxin, *Jiading Qian Daxin quanji*, vol. 6, p. 11.

75 Citing Qing scholars' records of the three characters on the back of the Wu Ban stele, Michael Nylan writes: "Some of the finest Qing epigraphical scholars pointed out contradictions in the records." (See *Recarving China's Past*, p. 527). The finest Qing epigraphical scholars to whom Nylan refers were Bi Yuan and Qian Daxin. After reviewing the writings of these two scholars, I have found no mention of contradictions regarding the Wu Ban stele. Both Bi and Qian believed the Wu Ban stele

to be a Han monument. Also, it would appear entirely unreasonable that the three characters on the verso and the severely ruined text on the recto were engraved during the same period. If the entire stele had been reengraved during the Six Dynasties period, not only would its text have been as clear as the note on its verso, but a legible text alone would have made it evident that this was Mr. Wu's stele, making it unnecessary to add the three characters on the reverse. In addition, the three characters' casual carving and unusual location (not on the stele-head) further indicate that they were an explanatory note, not a formal title. I believe that these characters were intended to identify what had become a relatively illegible text. Thus, to identify the three-character identification on the verso of the Wu Ban stele as a post-Han work does not contradict my belief that the Wu Ban stele is a Han monument. Quite the reverse: this explanation of these characters requires that they be post-Han, and the monument, not. To help confirm this, I consulted Weng Fanggang's entry on the Wu Ban stele in his *Liang Han jinshi ji*, in which he notes that there are three large characters in standard script on the reverse of the stele reading "Mr. Wu's stele." He writes: "[These characters] were carved by later individuals to identify the stele because the front had become seriously damaged. In comparison [to these three characters, the text's] style is relatively archaic and clumsy" (1789 edition, *juan* 15, p. 50b). Finally, when Huang Yi sent a rubbing of the Wu Ban stele to Weng, he attached a separate rubbing of the three characters. It should also be pointed out that both Qian Daxin and

Bi Yuan donated significant amounts of money to help Huang Yi restore the Wu Family Shrines. Among donors, Bi Yuan, who contributed 50,000 *qian*, was one of the most generous. Both Qian and Bi were senior officials and distinguished scholars; had they any thought that the Wu Ban stele was a post-Han recarving, they would have been unlikely to have donated so liberally to Huang Yi's project. Overall, it should be clear from this note that "the finest Qing epigraphical scholars" pointed out none of the "contradictions" attributed to them by Nylan.

76 In his commentary appended to the entry for the pictorial stones of the Wu Liang Shrine, Hong Gua repeats the quotation from the Wu Liang stele inscription (see *Lishi, juan* 16, p. 4b) that he quotes in his commentary on the Wu Liang stele inscription in *juan* 6.

77 Wei Bo, *Ding an leigao* (*Siku quanshu* edition), *juan* 4, p. 19b–20b. See Zhao Mingcheng, *Song ben Jinshi lu, juan* 14.

78 Zhao Mingcheng, *Jinshi lu, juan* 14.

79 There are several reasons why it is plausible that Mei compiled his *Donghan wenji* after the publication of the 1588 edition of the *Lishi*. First, his book includes the text of the Cao Quan stele, which was excavated in the early years of the Wanli reign, circa 1580. Rubbings were available to southern scholars by the end of the sixteenth century. Second, the earliest edition of Mei's *Donghan wenji* was not printed until the Chongzhen reign (1628–1644). Had it been completed relatively early in Mei's life, it is more likely that it would have been published before his death in 1619. Hence, it is probable that Mei did not finish his

compilation until his late years in the early seventeenth century.

80 Fu Shan's study of the *Lishi* is discussed in my book *Fu Shan's World*, pp. 163–64. It is now clear that what Fu Shan saw as a textual confusion in *juan* 6 (as opposed to the omitted passage he also detected there) is the interpolation of a line from the Wu Ban stele commentary into the Wu Liang stele inscription.

81 Weng Fanggang, *Liang Han jinshi ji, juan* 15, p. 51.

82 Qian Daxin, *Jiading Qian Daxin quanji*, vol. 6, p. 24. Note that the stele inscription Qian discusses when mentioning his manuscript copy of the *Lishi* is not from the *Lishi* but the *Li xu*. We are not sure if this is a mistake on Qian's part (or on the part of the engraver) or if Qian owned a manuscript copy that included both works. In another note, on the *Stele of Boling Commandery Chief Kong Biao*, Qian points to an error "presently in the common printed editions [*su keben*] [of the *Lishi*]." This at least means that Qian was aware of the problems in the common printed editions of the *Lishi*, or he had a manuscript version of the *Lishi*, or both.

83 Huang Yi, *Xiao Penglai Ge jinshi wenzi*, pp. 561, 650.

84 Owner and scholar colophons and seals in the 1576 manuscript allow us to trace its provenance. The 1576 manuscript was created from a copy (or a manuscript) of the Yuan Taiding edition *Lishi* borrowed from Qian Gu (1508–after 1578), a Suzhou artist and book collector. The manuscript went into the Jiguge collection of the Mao family in Changshu near the end of the late Ming. Slightly later (no later than the early Qing), it went into the

collection of the Sun family. It was borrowed by Gui Dingchen from the Sun family in 1708 and not returned. Fifty years later, in 1758, Sun Congzhan restored it to his family's collection by purchasing it from an unknown party. Then, in 1764, Sun invited the epigraphical scholar Zhou Ju to collate it. Later it entered the Tieqin tongjian lou collection of the Qu family in Changshu. The Qu family donated it to the Beijing Library (now the National Library of China) in the 1950s.

85 The note is not signed, but judging from the context, it was likely made by Zhou Ju.

86 These three versions are: a tracing copy of the Song edition in the former collection of Ye Yibao in Kunshan, a copy Huang Pilie borrowed from a Mr. Yuan, and a copy Huang borrowed from Zhou Xiangyan. Zhou's version was copied out by a Mr. Qian in 1570, and may be the manuscript copied by Qian Gu mentioned above. If so, then this copy was the basis of the manuscript of 1576. This alone accounts for at least five manuscript copies of the *Lishi* in the Ming-Qing period. See Huang Pilie's preface to *Wang ben Lishi kan wu* (*Correcting errors in the Wang edition Lishi*), in *Shike shiliao congshu, jiabian* (Taipei: Yiwen yinshuguan, 1967), p. 1a-b. Also see Li Qing, *Gu Qianli nianpu* (*Chronological biography of Gu Qianli* [*Guangqi*]) (Shanghai: Shanghai guji chubanshe, 1989), pp. 58–59, 61, 170, 363–64. Tan Xian believes that the first copy listed above (collection of Ye Yibao) was a tracing copy of the Yuan edition, not the Song.

87 See Kuroda Akira, "Bushishi Gazōseki no Kisoteki Kenkyū — Michael Nylan 'Addicted to Antiquity' Dokugo

(2)" ("Fundamental Research on the Wu Family Carved Pictorial Stones—In Response to Michael Nylan's 'Addicted to Antiquity' (2)"), published in *Sōgō Ningengaku Sōsho*, vol. 3 (June 2007).

88 See Elman, *From Philosophy to Philology*, p. 249.

89 See Zhang's collation remarks at the end of the *Sibu congkan sanbian* edition *Lishi*, a facsimile edition of the 1588 *Lishi* once owned by Fu Shan, discussed above. This edition also includes Zhang's collation remarks and a handcopied insertion of the 20 columns missing from the 1588 edition.

90 In the summer of 2005 I visited the National Library of China (formerly the Beijing Library), where I made a detailed comparison of a Ming manuscript of the Yuan Taiding edition of the *Lishi* in their collection with the 1588 edition of the *Lishi*. Since this manuscript preserved the material missing from the 1588 edition, I came to the conclusion that Zhang Yuanji was correct: there is one leaf (20 columns in the original format of the Yuan Taiding edition) missing in the 1588 edition. I also examined the calligraphy and colophons of the library's manuscript and I feel that there is no problem with regard to its authenticity.

91 Huang Pilie, *Wangben Lishi kanwu*, p. 1a.

92 Qian Daxin, *Jiading Qian Daxin quanji*, vol. 7, p. 76.

93 Nylan, *Recarving*, p. 525. Nylan's understanding of *yuanwen* is incorrect. Mei Dingzuo's commentary does not state that there were two versions of the Wu Liang stele inscriptions. On the contrary, he thought that the two "versions" were both genuine excerpts from this stele's inscription, excerpts that could be conjoined because their texts overlapped by two characters, as previously discussed. Nylan, by believing that only one of the two excerpts from the Wu Liang stele inscription (the short one in the Wu Liang entry) is genuine, excludes the possibility that the other excerpt (the long one quoted in Hong's commentary) is also genuine.

94 *Recarving China's Past*, p. 549, additional note attached to Nylan's note 36. While Cary Liu coauthored the additional note with Hsu and was aware that Zhang Yuanji had detected the scribal omission and supplied the missing leaves in his *Sibu congkan sanbian* edition, he did not change the problematic arguments in his essay that derive from his incorrect reading of the *Siku* edition. It is even more troubling that Nylan and Liu continued to use the problematic texts in the *Siku* after they had been informed there was a complete Ming transcription of the Wu Liang stele inscription that showed Wang Rixiu's edition reliable. Central to this is that, if the Wang Rixiu edition were to have been accepted by Nylan and Liu, it would have become difficult to sustain a number of arguments supporting their "recarving" theme.

95 Hong Gua, *Lishi* (1588 edition with Fu Shan's collations), *juan* 4, p. 13b. Note that Hong Gua, when quoting this passage from the Wu Liang stele, also omits the names of Wu's three sons and grandson from the first four characters of the quotation, *xiaozi xiaosun* (filial son[s] [three names omitted] and grandson [name omitted]). Hence, strictly speaking, this passage is paraphrased by Hong, not quoted. The unaltered quotation starts with the phrase *gongxiu zidao* ("personally followed the path of filial duty"), which follows *xiaozi xiaosun*.

96 Hong Gua, *Lishi*, *juan* 16, p. 4b. In this quotation, Hong Gua includes the names of Wu Liang's three sons and grandson.

97 Nylan, *Recarving*, p. 525.

98 Hong Gua, *Lishi*, *juan* 6, p. 13b. Zhongzhang's name is mentioned at the beginning of the commentary. Wu Hung lists the names of Wu Liang's children in *The Wu Liang Shrine*, p. 27.

99 For a detailed comparison of three editions of the *Lishi* (the 1588 Wang Yunlu edition, the *Siku* edition, and the Wang Rixiu edition) and for a discussion of Nylan's mistakes caused by her misunderstanding and misrepresentation of these editions, see Kuroda Akira, "Bushishi Gazōseki no Kisoteki Kenkyū," pp. 169–90.

100 Liu, *Recarving*, p. 84, n. 69.

101 Nylan, *Recarving*, p. 549, n. 36.

102 Even then, Nylan's and Liu's innuendo-laden comments ignore that Wang published his edition of the *Lishi* a few years prior to Huang Yi's rediscovery of the Wu Shrines, meaning that nothing about Huang's rediscovery could have influenced the Wang edition. Also, since eighteenth-century Hangzhou was the center for printing and publication, it is not at all exceptional that Wang Rixiu published his edition of the *Lishi* there. In a discussion of the eighteenth-century intellectual landscape, Elman particularly stresses the importance of the book collectors in Hangzhou. He writes: "In the eighteenth century, Hangzhou in particular was a mecca for book collectors and scholar-printers. The bibliophiles there serve as an excellent sample of the kinds of literary groups that were

formed and the close friendships that promoted the exchange of information.... The activities of the libraries in the Hangzhou area were at their height in the period between 1740–1790. Swann points out that of the nine private donors whose presentations to the *Siku quanshu* commission were accepted and numbered more than one hundred items, five came from the Hangzhou library group." (See Elman, *From Philosophy to Philology*, pp. 147–48. Wade-Giles spellings have been changed to pinyin.).

103 Nylan, *Recarving*, p. 526.

104 Wu Hung thinks the Wu brothers built the pillar-gate for their mother, who died in 145. See Wu Hung, *The Wu Liang Shrine: The Ideology of Early Chinese Pictorial Art* (Stanford: Stanford University Press, 1989), pp. 26–27. Wu Hung's argument seems based on the Wu Kaiming stele inscription, in which the death date of Kaiming's mother is mentioned. See Zhao Mingcheng, *Song ben Jinshi lu*, juan 14, new page number 338.

105 For Kuroda Akira's discussion of this issue, see Kuroda Akira, "Bushi-shi gazōseki no kisoteki kenkyū," pp. 190–97.

106 Nylan, *Recarving*, p. 522.

107 See Hong Gua, *Panzhou wenji* (*Siku quanshu* edition), juan 63, p. 15b. Also see Qian Daxin, "Hong Wenhuigong nianpu" ("Chronological biography of Hong Gua"), p. 9, in *Jiading Qian Daxin quanji*, vol. 4.

108 Weng Fanggang is in agreement with him and points out Ouyang Fei's mistake in his *Liang Han jinshi ji*, juan 15, p. 51b.

109 As asserted by Ouyang Xiu in a note attached to his entry of 1064,

in Ouyang Xiu, *Jigu lu*, juan 3, p. 2a. Michael Nylan thinks this note an interpolation (see Nylan, p. 546, n. 9). But this is unlikely. Ouyang Fei's entry appears to have been based on the second rubbing because the information he gives in the *Jigu lu mu* could not be found in his father's discussion of the first rubbing.

110 For Kuroda Akira's discussion of this issue, see Kuroda Akira, "Bushi-shi Gazōseki no Kisoteki kenkyū," pp. 163–66.

111 Nylan, *Recarving*, p. 546, n. 2.

112 Nylan, *Recarving*, p. 523.

113 Ibid., p. 548, n. 21.

114 Nylan mentions this stele in her essay (p. 546, n. 46) but does not note its use of this relationship formula.

115 Nylan, *Recarving*, p. 548, n. 27.

116 Wang Zhuanghong, *Beitie jianbie changshi* (Shanghai: Shanghai shuhua chubanshe, 1985), p. 8.

117 Fang Ruo and Wang, *Zhuanghong, Zengbu Jiaobei suibi* (Shanghai: Shanghai shuhua chubanshe, 1981), p. 85.

118 Huang Yi, *Qiu'an yigao* (Shanghai: Juzhen fang Song yinshuju, 1918), *tiba*, p. 11a.

119 Nylan, *Recarving*, p. 547, n. 5.

120 Hong Gua, *Lishi*, juan 19, pp. 2b–3a.

121 Nylan, *Recarving*, p. 551, note 53.

122 Qing scholars also admired Hong Gua. For example, Qian Daxin took the trouble to compile Hong Gua's chronological biography. See Qian Daxin, *Jiading Qian Daxin quanji*, vol. 4. Note that this volume does not have consecutive page numbers; each of its sections is paginated individually. Hong Gua's chronological biography is located toward the end of the volume.

123 From the examples presented, the phrase *yilou* here refers to mistakes in transcribing characters, not to missing characters.

124 Hong Gua, *Lishi* (*Siku quanshu* edition), pp. 1a–3b.

125 Nylan also writes: "If all the passages attributed to Hong were indeed composed by him, which seems doubtful, he may have hoped to increase the value of his rubbings by attributing them to a single Han family engaged in ancestor worship.... Or Hong may simply have been exhibiting the sort of careless scholarship that some say distinguishes the Southern Song literati from those of Northern Song." Nylan, *Recarving*, p. 528. Two points should be clarified here: (1) Hong Gua's grouping several monuments together as a single Han family cemetery was based on his careful study of these monuments. There is no evidence he was driven by the hope of increasing the value of his rubbings, not least because the evidence of the monuments alone is sufficient to sustain Hong's conclusion. (2) There are several careful studies of epigraphy dating from the Southern Song, one of which was Hong Gua's *Lishi*. And though there are careless scholars in any period, past or present, there is no ground for arguing that Hong Gua should be included among them.

126 See Yu Jiaxi, *Siku tiyao bianzheng* (*Analysis of the Annotated bibliography of "Siku quanshu"*) (Beijing: Zhonghua shuju, 1980), vol. 1, pp. 504–6. Also, see *Siku quanshu yanjiusuo* ed., *Qinding Siku quanshu zongmu (zhengliben)* (*Annotated bibliography of Siku quanshu* [collated edition]) (Beijing: Zhonghua shuju, 1997), vol. 1, pp. 1138–39. See Chen Yuan, *Bihui juli* (Beijing:

Zhonghua shuju, 1962), esp. pp. 101, 103, and 129–32 for practices governing the use of taboos in the Qin and Han dynasties.

127 See Kuroda Akira, "Bushishi gazōseki no kisoteki kenkyū," pp. 200–2. See also Chen Yuan, as cited immediately above.

128 See Chen Jiangong and Xu Min, eds., *Jiandu boshu zidian* (*Dictionary of characters written on bamboo slips and silks*) (Shanghai: Shanghai shuhua chubanshe, 1991), pp. 827–28.

129 Nylan, *Recarving*, p. 527. Rather than give He Zhuo's colophon a careful reading, Cary Liu, in his "Curator's Preface and Acknowledgements," accepts and repeats Nylan's misinterpretation of He's words. See *Recarving*, p. 9.

130 Liu, *Recarving*, p. 26.

131 Liu, *Recarving*, p. 37.

132 Liu, *Recarving*, p. 74.

133 Weng Fanggang writes: "[Because the stele is] so severely damaged, only ten to twenty percent of the characters survive compared to the text Hong Gua recorded [in the *Lishi*]." *Liang Han jinshi ji*, *juan* 15, p. 51a.

134 Cary Liu's essay shows that he understands the *Lishi* no better than Nylan. Space does not permit a discussion of many other errors in their essays in *Recarving*. Space also does not allow discussion of the many mistakes in Nylan's essay in addition to those mentioned here.

135 See Qian Daxin, *Jiading Qian Daxin quanji* (*Complete works of Qin Daxin of Jiading*) (Nanjing: Jiangsu guji chubanshe, 1997), vol. 6, p. 1.

136 A common story is that Ouyang Xiu was criticized by his close friend Liu Chang as someone without wide reading. See Mou Yan (1227–1311), *Moushi Lingyang ji* (or *Lingyang ji*) (*Collected writings of Lingyang* [*Mou Yan*]), (*Siku quanshu* edition), *juan* 10, p. 14b. Mou Yan does not criticize Ouyang Xiu; he quotes another critic. See also Yang Shen (1488–1559), *Sheng'an ji* (*Collected writings of Sheng'an* [*Yang Shen*]) (*Siku quanshu* edition), *juan* 3, p. 27b; and Wang Shizhen (1526–1590), *Yanzhou xugao* (*Sequel to the Collected writings of Yanzhou* [*Wang Shizhen*]) (*Siku quanshu* edition), *juan* 167, p. 17a.

137 Yan Ruoqu, *Qianqiu zhaji* (1745 edition), *juan* 1, pp. 39b–40a.

138 Qian Daxin, *Jiading Qian Daxin quanji*, vol. 9, p. 519. In another note, Qian also mentions this story, protesting that, while Liu Chang was more knowledgeable than Ouyang Xiu, Liu's criticism of Ouyang was too harsh (see ibid., p. 577). Ouyang Xiu and Liu Chang were good friends. Ouyang often consulted Liu and asked him to review the manuscript of *Jigu lu bawei*. See *Ouyang Xiu quanji* (*Complete works of Ouyang Xiu*) (Beijing: Zhonghua shuju, 1986), vol. 2, p. 1266.

139 See Ouyang Xiu's entry for the Stele of Gaozhang Lord Cai of the Eastern Han dynasty, *Jigu lu* (*Siku quanshu* edition), *juan* 3, pp. 18b–19a.

140 Some steles listed here have long titles. For them, I have adopted commonly accepted short titles.

141 See He Yinghui and Zhou Chi, ed., Liu Zhengcheng, gen. ed., *Zhongguo Shufa quanji (8): Qian-Han keshi II* (Complete works of Chinese calligraphy [8]: Stone inscriptions of the Qin and Han [II]), pp. 500–501.

142 See facsimile reproduction of Fu Shan's collated 1588 edition.

143 Nylan, *Recarving*, p. 551, n. 55. Another error in this note regarding the *Lishi* is Nylan's assertion that "the earliest extant edition of the *Lishi* (the Ming Wanli edition of 1588) inserts an additional two pages of text (labeled as *bu*, 'supplement'), right in the middle of *juan* 6, on pages 13a-b." Yet the 1588 edition lacks these pages. They were inserted by Zhang Yuanji in 1935 in his facsimile of the 1588 edition collated by Fu Shan, and Zhang inserted them precisely because they were missing from the 1588 edition, as discussed above. Ironically, the two pages missing from *juan* 6 of the 1588 edition are those that caused the gaps in the Wu Ban and Wu Liang stele inscriptions; that Nylan is unaware of these gaps is the source of a number of errors in her essay.

144 For a discussion of this revival, see Qianshen Bai, *Fu Shan's World*, pp. 185–208, 260–61.

Response to Qianshen Bai

MICHAEL NYLAN

Qianshen Bai was originally invited by the Princeton editors to submit a paper about calligraphy pertaining to the Wu Family Shrines (either the calligraphy of Huang Yi or the Wuzhai Shan inscriptions themselves). He chose instead, for his contribution to this volume, to write an impassioned essay about the perceived failings of the Princeton catalogue, in which he charges the editors with multiple failures to understand basic matters relating to his own discipline of art history. More outrageous, in Bai's view, the editors are guilty of the crime of "gross irreverence" (*dani wudao*, in the Han lingo) toward those whom Bai terms Chinese "academics" and I would call antiquarians and collectors.[1] Bai seriously misreads both the tone and the specific arguments of the essays by Cary Liu and myself, which he says "target" two respected figures: Hong Gua (1117–1184), author of the *Lishi* catalogue, and Huang Yi (1744–1802).[2] Bai seems determined to put the worst possible construction on every aspect of the catalogue, accusing us, for instance, of bad faith in the insertion of a note about the 1588 *Lishi* edition, rather than simply seeing it as a late editorial decision to provide as much information as possible when the catalogue was going to press.[3] More than a few of Bai's charges are silly, as when he misconstrues the rhetorical intent behind my citation of He Zhuo (1661–1722), or compares the steady accrual of characters in stele inscriptions (with the price of a stele inscription partly dependent upon the number of characters) to changing fashions in catalogue entries.[4] Others exhibit circular logic, as when he

"proves" the reliability of the *Lishi* by checking its entries against twenty extant stones said to be based on it. What Bai refuses to admit is this: some steles routinely assigned to Han are problematic.[5]

Professor Bai's piece has conceded (more often in his footnotes than in his main text) seven major points advanced with great trepidation in the exhibition catalogue: (1) that scholars have long understood that good forgeries of stone inscriptions and stone carvings, as well as recut steles, were in circulation; (2) that since the Song there have been many stormy debates about the authenticity of particular pieces; (3) that just because something is written in stone doesn't mean that its rubbings are easy to decipher; (4) that multiple mistakes were made by even the best scholars, including Hong Gua, in the decipherings of stele inscriptions;[6] (5) that multiple mistakes needing explanation exist in many of the editions produced by antiquarians whom Bai praises, including Hong Gua and Wang Rixiu; (6) that a measure of skepticism is necessary if a field is to move forward; and (7) that only a few artifacts from Han have survived aboveground. By my calculation, ninety-three percent of the several hundred stele inscriptions we now associate with Han times are known only from transcriptions or from what are widely agreed to be recarvings. (By comparison, the corpus known to Roman historians numbers some 396,000 inscriptions (about one in fourteen of which are identified as forgeries) and fifty percent or more of which have survived in stone).[7] For transcriptions, we must repudiate nearly all the recent work on memory,

reception, and the social practices of the text, if we insist on clinging to the antiquated assumption that a millennium ago people held essentially modern ideas about the need for faithful transcription.[8]

Bai chastises the editors for not supplying a date for the Wuzhai Shan stones. The Wuzhai Shan stones, if an intentional forgery, were based on considerable knowledge of Eastern Han materials from the area. That forgers had access to such knowledge in the Qing is indisputable; if forgers had neither the knowledge nor the means to make excellent copies and pastiches that would deceive, antiquarians would hardly have engaged in spirited debates about authenticity. The historical records mention instances of recarving where there was no intention to deceive, and I provided one archaeological instance: the faithful reproduction of Han styles under Northern Wei. Therefore my essay tried to sidestep the moralistic language of "forged" and "authentic," believing this language to be both anachronistic and simplistic when applied to cultural reproduction in earlier eras, especially to mass-produced stone carvings rather than to paintings and calligraphies.[9] I tried to suggest that complex reasons may propel the profoundly human impulse to "fill in the blanks" when gaps occur.[10] I continue to believe that neither "interrelatedness" nor coherence constitute sufficient proof of the authenticity of a piece. Such is the stuff of historians' fallacies.[11]

Bai focuses nearly all his attention—as does a Japanese article by Kuroda Akira, whose tone is less bellicose—on the *Lishi*, which was only one of many texts whose statements we tried to weigh. Bai therefore never mentions much of the evidence presented in the exhibition catalogue, including: (1) a Song report that a set of inscriptions identical to those attributed to the Wu Family Shrines were in Sichuan, not in Shandong; (2) a different Song report attributing—in no fewer than six separate passages—a set of inscriptions now associated with the Wu Liang Shrine to a site dedicated to Liang Wudi; (3) the uniqueness, among Han pictorial carvings, of the lengthy Wu Liang inscriptions identifying subjects of the carved scenes; (4) modern epigraphical experts' assessments of Weng Fanggang's rubbing collection;[12] (5) the skepticism of some epigraphical experts, including Rong Geng, working in Bai's approved *kaozheng* manner;[13] (6) the avowedly political agenda of the *kaozheng* movement formed to defend Chinese culture against research casting doubt upon the historicity of the Five Classics; and (7) the curious disappearance of a major site, the "tomb of a Han prince," from the local gazetteers after Huang Yi's discovery. It is the weight of accumulated evidence, rather than any single fact, that gave rise to my own skepticism.

According to Bai, the editors also wished to cast "indirect doubt on modern archaeological discoveries." The closest carving parallels are undoubtedly with the Songshan stones, but the archaeological reports date the Songshan finds on the basis of the Wu Liang shrines, so they cannot help.[14] Moreover, the Songshan finds differ significantly from those of Wu Liang, insofar as no Songshan stone includes carved inscriptions explicating moral scenes—surely the most troubling feature of the Wuzhai Shan stones. Bai rushes to the defense of a modern archaeological establishment, that has not been without blemish[15]—in this, being unlike Jiang Yingju, the senior archaeologist at Wuzhai Shan, who cheerfully scoffed, during the symposium, at an "altar" recently "discovered" at the Wuzhai Shan site and likely designed for tourists.

One error of fact I readily acknowledge: Ouyang Xiu was not in exile *in* Rencheng, but in the

vicinity of Rencheng; we know that he traveled in the area, but we cannot know more.[16] Otherwise, Bai and I disagree more about the *implications* of statements made by previous scholars than about *translations* (as when discussing Lu You's *Laoxue an biji* or Fang Ruo's account). Meanwhile, Bai introduces irrelevancies into the debate, via assertions that he knows the beliefs held by such men as Zhao Mingcheng and Hong Gua. No evidence that I know of allows us to ascertain the beliefs of Song-dynasty figures. Professor Bai may be forgiven for his lack of skepticism. He, unlike this author, does not make his base in the great state of California, where Drake's Plate was fabricated as an affectionate joke by graduate students, then prematurely authenticated by numerous experts, after which it was exhibited for decades as the centerpiece of the Bancroft Library collection, before all was revealed about the prank. I still fail to see how carved stones exposed to weather and subjected to pounding during rubbing so often yielded not less but more information as long centuries passed. (Ouyang Xiu was only one of those who mentioned the damage done to stones by repeated rubbings).

During the symposium, Cary Liu in his presentation showed indisputable evidence of recarving in the pillar-gates.

It is the fashion these days to trash skeptics, saying that modern scientific archaeology has shown them all to be wrong. Some of this dispute is about style and individual predilections, rather than about rectitude (as Bai puts it), though some part of the larger "doubting antiquity" (*yi gu*)—"believing antiquity" (*xin gu*) controversy represents real differences over (a) what constitutes evidence; and (b) whether China has been, throughout its entire history, a true exception in world history. "Believing antiquity" is a slogan and a rallying cry, not a methodology or a program for future research projects. My study of the history of history and of archaeology leaves me with the distinct feeling that "the past is a foreign country" and that the work of disentagling past presumptions from present knowledge has no foreseeable end. If I have failed in my language to convey the urgency of that task or my fervent wish that academic questions be less politicized—now that would be a regrettable lapse indeed. ◉

Notes

1 For the crucial difference between antiquarians and historians, see Arnaldo Momigliano, "Ancient History and the Antiquarian," *Journal of the Warburg and Courtauld Institutes* 13: 3–4 (1950), pp. 285–315. Momigliano writes there, "An element of play and pastime was inherent in erudition from its inception," and "erudite pleasure is always ambiguous."
2 Wu Hung, *The Wu Family Shrines*, and Bai both conflate Huang Yi's

discovery with scientific excavation, which creates confusion. Regarding Hong Gua, my essay states unequivocally, "This essay assumes that the *Lishi* is generally reliable." Nietszche, quite characteristically, prefers to see erudition in a darker light: "In all desire to know there is already a drop of cruelty."
3 Note the continual slippage in Bai's text, whereby his entirely *plausible* "suggestions" about how to resolve

"problems in the source manuscript or one of its ancestor manuscripts" quickly become established historical facts.
4 Equally illogical is Bai's insistence that many men may have had the same name as a cultural icon, such as Zhu Ming, since it would only be the cultural icon that would have been depicted on stone as an exemplar.
5 The "Yingling zhi she bei," about which Rafe de Crespigny writes in his

forthcoming *Biographical Dictionary of Eastern Han* (Leiden: Brill, 2007), p. 304 (manuscript version), says that the dedicatee's county is given as Shanyang and the commandery Hedong (when it must be Henei); and the Sun Gen stele, of which a Cambridge University dissertation by Kenneth E. Brashier (1997), p. 181, says: "The reverse of the stele appears to date from the Six Dynasties, as the official titles of the donors postdate the fall of the Eastern Han." As we now know from the careful work of Stanley Abe, parts of stele inscriptions could be added later to the stones.

6 As when, in Bai's account (p. 309, this volume), Mei Dingzuo "remained unaware that column one was not part of the *Wu Liang* inscription."

7 These figures are derived from the Clauss-Slaby site (www.manfredclauss.de), and from Arthur E. Gordon, *Illustrated Introduction to Latin Epigraphy* (Berkeley: University of California Press, 1983); M.P. Billanovich, "Falsi epigrafici," *Italia Medioevale e Umanistica*, vol. 10 (1967), pp. 25–110. Gordon writes that there is no reliable way to tell whether an inscription known only from the received tradition is genuine or not. The percentage of forgeries is thought to be higher in Italy than elsewhere, since inscriptions were forged for patriotic reasons.

8 Beginning with Mary J. Carruthers, *The Book of Memory: A Study of Memory in Medieval Culture* (Cambridge: Cambridge University Press, 1990).

9 Bruce Rusk, "Artifacts of Authentication: People Making Texts Making Things in Late Imperial China," in *Antiquarian Life and Learning in Late Renaissance Europe and Late Imperial China*, ed. François Louis and Peter Miller (New Haven: Yale University Press, forthcoming 2007).

10 Neuroscience suggests reasons for the human urge to fill in the blanks. I recommend David J. Linden, *The Accidental Mind: How Brain Evolution Has Given Us Love, Memory, Dreams, and God* (Cambridge, Mass.: Belknap/Harvard Press, 2007); and Zenon W. Pylyshyn, *Seeing and Visualizing: It's Not What You Think* (Cambridge, Mass.: MIT Press, 2006).

11 See David Hackett Fischer, *Historian's Fallacies: Toward a Logic of Historical Thought* (New York: Harper Perennial, 1970).

12 Bai insists that every modern epigraphical expert believes Weng Fanggang to have been a good judge of authentic rubbings. Wang Zhuanghong, *Beitie jianbie changshi* (Shanghai: Shanghai shuhua chubanshe, 1985), pp. 61–62, says that Weng made "mistake after mistake" and that his collection was full of forgeries.

13 Rong Geng, for example, certainly noted potential conflicts of interest when collectors acted as their own authenticators. See his withering account of Zhu Yizun, for example, as cited in "Addicted to Antiquity" in *Recarving China's Past*; Zhu was, by the way, regarded as somewhat less than a paragon in his own time, since he took the Qing examinations, rather than remaining a Ming loyalist.

14 *Wenwu* 1979.9, pp. 1–6; *Wenwu* 1982:5, pp. 60–70, which elicited several follow-up reports, and corrections, including *Kaogu yu wenwu* 1983:3; *Kaogu yu wenwu* 1984:4, p. 112; Rusk, "Artifacts of Authentication."

15 Xia Nai, *Kaogu* 4.121 (1972), pp. 34–39; for one scientifically excavated stele that may be a forgery, see Wang Jiakui, "Han Fei Zhi bei kaoyi", *Daojiao yanjiu* 2001.2, pp. 47–51. On the political aims of the young discipline of archaeology in China, see James Leibold, "Competing Narratives of Racial Unity in Republican China: From the Yellow Emperor to Peking Man," in *Modern China* 12:2 (April 2006), pp. 181–220; and Ian C. Glover, "Some National, Regional, and Political Uses of Archaeology in East and Southeast Asia," in *Archaeology of Asia*, ed. Miritam T. Stark (Oxford: Blackwell, 2006), pp. 17–36.

16 Ouyang Xiu held office just south of Jinxiang in Shangqiu (the "southern capital") in 1050. In the late 1060s, he held office a bit farther south, in Haozhou, then might well have passed through the area of Rencheng on his way east to assume his post at Qingzhou (Shandong) after that. Neither Cary Liu nor I can reconstruct at this point when, how, or why a reference to Cary Liu's paper was inserted in my essay.

Response to Qianshen Bai

CARY Y. LIU

For Cary Liu's response to Qianshen Bai, please refer to his essay "Perspectives on the 'Wu Family Shrines': Recarving the Past" in this volume (Part One, page 20).

Tables of Numbering Systems for Rubbings: "Wu Family Shrines"

Stone Chamber 1 (Front Group)

Huang Number	Fairbank Number	Chavannes[1] Number	Quanji[2] Number	Princeton Accession	Liu-Nylan Number	Catalogue[3] Number
F.2	F2	105 (pediment missing)	1:57	2002-307.1 (pediment missing)	1-E.1	1.11
F.7	F7	104	1:58	2002-307.2	1-E.2	1.12
F.1	F1	103	1:60	2002-307.3	1-S.1	1.3
Confucius/Laozi	Confucius/Laozi	137	1:59	unaccessioned	1-S.2	1.4
F.4	F4	108	1:61	2002-307.4	1-S.3	1.5
F.10	F11	113	1:62	2002-307.5	1-S.4.a (south wall)	1.6
F.10	F12	114	1:64	2002-307.6	1-S.4.b (west wall)	1.8
F.11	F14	117	1:63	2002-307.7	1-S.5.a (south wall)	1.7
F.11	F13	116	1:65	2002-307.8	1-S.5.b (east wall)	1.10
F.3	F3	107	1:66	2002-307.9	1-S.6	1.9
			1:67		1-S.7 (altar stone)	
F.5	F5	106 (pediment missing)	1:55	2002-307.10 (pediment missing)	1-W.1	1.1
F.6	F6	109	1:56	2002-307.11	1-W.2	1.2
F.12	F15	115	1:68	2002-307.12	1-N.1	1.14
F.9	F10	120	1:69	2002-307.13	1-N.2	1.13
F.8	F8	112	1:71	2002-307.14	1-CG.a (east face)	1.16
F.8	F9	111	1:70	2002-307.15	1-CG.b (west face)	1.15
R.4	R4	133	1:73	2002-307.16	1-R.1	1.17
R.5	R5	134	1:72	2002-307.17	1-R.2	1.18

1. Édouard Chavannes, *Mission archéologique dans la Chine septentrionale* (*Archaeological Mission to Northern China*). 2 vols. of text, 4 vols. of plates. Paris: Imprimerie Nationale, 1913 and 1915. 2. *Zhongguo huaxiang shi quanji* (*Compendium of Chinese pictorial stone carvings*). Vols. 1–3: *Shandong Han huaxiang shi* (*Han pictorial stone carvings from Shandong*). Jinan: Shandong meishu chubanshe, 2000. 3. Cary Y. Liu, Michael Nylan, Anthony Barbieri-Low et al., *Recarving China's Past: Art, Archaeology, and Architecture of the "Wu Family Shrines"* (Princeton: Princeton University Art Museum; New Haven and London: Yale University Press, 2005).

Stone Chamber 2 (Left Group)

Huang Number	Fairbank Number	Chavannes[1] Number	Quanji[2] Number	Princeton Accession	Liu-Nylan Number	Catalogue[3] Number
L.2	L2	121 (pediment missing)	1:76	2002-307.18	2-E.1	1.28
L.3	L3	122	1:77	2002-307.19	2-E.2	1.29
L.10						
L.6	L6	125	1:78	2002-307.20	2-S.2	1.21
R.6	R6	135	1:79	2002-307.21	2-S.3	1.22
L.4	L4	123	1:80	2002-307.22	2-S.4	1.23
L.5	L5	124	1:81	2002-307.23	2-S.5	1.24
L.9	L9	129	1:84	2002-307.24	2-S.6	1.26
L.8	L8	128	1:82	2002-307.25	2-S.7.a–b	1.25
L.7	L7	127	1:83	2002-307.26	2-S.8.a–b	1.27
					2-S.9 (decorative fragment)	
R.9	R9	141	1:74	2002-307.27 (pediment missing)	2-W.1	1.19
R.7	R7	136	1:75	2002-307.28	2-W.2	1.20
R.8	R8	139	1:85	2002-307.29	2-CG.a (east face)	1.31
R.8	R10	140	1:86	2002-307.30	2-CG.b (west face)	1.30
R.3	R3	132	1:88	2002-307.31	2-R.1	1.32
R.2	R2	131	1:87	2002-307.32	2-R.2	1.33
R.1	R1	130	1:89	2002-307.33	2-R.3	1.34
					2-Ridge (fragment)	

Stone Chamber 3 (Wu Liang Shrine)

Huang Number	Fairbank Number	Chavannes[1] Number	Quanji[2] Number	Princeton Accession	Liu-Nylan Number	Catalogue[3] Number
WLC.2	WLC2	76	1:50	2002-307.34	3-E.1	1.37
WLC.1	WLC3	77	1:51	2002-307.35	3-S.1	1.36
WLC.3	WLC1	75	1:49	2002-307.36	3-W.1	1.35
Good Omen.1	Good Omen 1	78		2002-307.37a–c	3-R.1	1.39–41
Good Omen.2	Good Omen 2	79		2002-307.38	3-R.2	1.38
Wu jia lin stone	*Wu jia lin* stone		1:52–54	2002-307.47	3-E.2	1.42

Column stones

Huang Number	Fairbank Number	Chavannes[1] Number	Quanji[2] Number	Collection	Liu-Nylan Number	Catalogue[3] Number
		92		Ethnological Museum, Berlin	Pictorial column	Part One supplement
				Tianjin Municipal Museum of Art	Column capital	

Miscellaneous slabs

Huang Number	Princeton Accession	Catalogue[3] Number
Left Group Stone 1 (L.1)	2002-307.42	1.48
Wang Ling mu		
He kui	2002-307.43	1.49
You niao ru he	2002-307.44	1.50

Gate-Pillars, Statues, Steles, and Inscriptions

Stone Number	Princeton Accession	Catalogue[3] Number
West gate-pillar	2002-307.48	1.44
a) East main face —"Wu shi ci"	2002-307.39	1.43
b) North main face — with inscription		
c) South main face		
d) North secondary face		
e) South secondary face		
f) West secondary face		
g) Capping stone over secondary column		
h) Base slabs		
Eastern gate-pillar	2002-307.40	1.45
a) East main face		
b) North main face		
c) South main face		
d) North secondary face		
e) South secondary face		
f) West secondary face		
g) Capping stone over secondary column		
West stone lion		
East stone lion		
Wu Kaiming stele (not found)		
Wu Liang stele (not found)		
Wu Ban stele	2002-307.41	1.46
Wu shi bei inscription (on reverse)	2002-307.46	1.47
Wu Rong stele		
Blank stele		
Weng Fanggang inscription	2002-307.45a–g	1.51
Li Dongqi inscription	2002-307.49	1.52
Qian Yong inscription	2002-307.50	1.53

Glossary

An Guo 安國
Andi 安帝
Anhui 安徽
Anping xiang Sun Gen bei 安平相孫根碑
Anqiu, Shandong 安丘, 山東
Anyang 安陽

bafen 八分
bai xing 百姓
Baihu tong 白虎通
Baishi 白石 (mountain)
Baishi shenjun bei 白石神君碑
Baizi Cun 百子村
Ban 班
Ban Gu 班固
bang 邦
bangti 榜題
bawei 跋尾
bei 碑
Bei bei nan tie lun 北碑南帖論
Bei chi 碑癡
Bei Qi 北齊
Beihaixiang Jingjun ming 北海相景君銘
Beijing 北京
Beijing tushuguan cang Zhongguo lidai shike tuoben
 huibian 北京圖書館藏中國歷代石刻拓本匯編
Beijing tushuguan jinshizu 北京圖書館金石組
Beilin 碑林
Beiping 北平
beitie 碑帖
Beitie jianbie changshi 碑帖鑑別常識
beiyin 碑陰
bi 璧
Bi Feng 費鳳
Bi Feng bie bei 費鳳別碑
Bi gong shendao bei 畢公神道碑

bi shi Dongzhou qian long dangshi jing you ci zhi
 必是東州仟壟當時競有此製
Bi Yuan 畢沅
Bian 辨
biankuan 邊款
bianti 變體
bianwei 辨僞
bimu yu 比目魚
Bin 邠/豳
bing 丙 (illness)
bing 病
bingfeng 并封
bingwu 丙午
bini 俾倪
Bin wang lishi 邠王力士
bo 伯
bo can 白餐
Bo Xing qi mu bei 伯興妻墓碑
Bo Yi 伯義
bu 不
bu jing 不敬
Bu shi nie qian 不使孽錢
buque 補缺
"Bushishi Gazōseki wa Gikokuka — Michael Nylan
 'Addicted to Antiquity' eno Hanron" 武氏祠画象石
 は偽刻か — Michael Nylan "Addicted to Antiquity"
 への反論
"Bushishi Gazōseki no Kisoteki Kenkyū" — Michael Nylan
 'Addicted to Antiquity' Dokugo" 武氏祠画象石の基礎
 的研究 — Michael Nylan "Addicted to Antiquity" 読後
Bushu canbei 簿書殘碑

Cai Hongru 蔡鴻如
Cai Yong 蔡邕
Cai Zhonglang ji 蔡中郎集
Cai Zhonglang wenji 蔡中郎文集
Cang Jie 倉頡

Cangshan 蒼山

Cao 曹

Cao Cao 曹操

Cao E Jiang dubei tu 曹娥江讀碑圖

Cao E 曹娥

Cao Pi 曹丕

Cao Rong 曹溶

Cao Yin 曹寅

Caoshi mu can bei 曹氏墓殘碑

Caoyi 操義

Chang Qu 常璩

chang 長

Chang'an 長安

Changbai 長白

Changli shuiku, Jiangsu 昌黎水庫, 江蘇

Changqing 長清

Changshu 常熟

Chao Cuo 鼂錯

che hou 徹侯

Chen Can 陳參

Chen Fan 陳蕃

Chen Jieqi 陳介祺

Chen Jin 陳錦

Chen Sheng 陳勝

Chen Tang 陳湯

Chen Xian 陳咸

Chen Yuan 陳垣

Cheng 程 (surname)

cheng 成

cheng dan 城旦

Cheng Jiasui 程嘉燧

Cheng Mengyang 程孟陽

Cheng Sheng 程繩

Cheng Wang 成王

Chengcheng 澄城

Chengdi 成帝

Chengdu 成都

chenghang 成行

Chengyang 城陽

Chenliu Jun 陳留郡

chi 癡

chong 舂

chongke 重刻

Chongli Wushi citang shi ji 重立武氏祠堂石記

Chongqing 重慶

Chongxiu Wushi citang ji 重修武氏祠堂記

Chu Song guiren zhong shang wu citang
　初宋貴人冢上無祠堂

[]*chu* []初

Chu Wang 楚王

chuan 剶 (on bronze seal)

chuan 掾 (assistant official)

chuan/chan 剶／產

Chuanjia ji 傳家集

Chuanshilou 傳是樓

Chuci zhangju 楚辭章句

Chuci 楚辭

Chulan 褚蘭

Chulan Zhen 褚蘭鎮

Chunhua 淳化

Chunming mengyu lu 春明夢餘錄

Chunqiu fanlu 春秋繁露

Chunrongtang ji 春融堂集

Chunyu 淳于

Chunyu zhang Xia Cheng bei 淳于長夏承碑

chushi 處士

ci 祠

ci gong 祠功

Ci jin can shi 此金殘石

ci muzhu 祠木主

ci Qi Wang ye 此齊王也

cimiao 祠廟

cishi 祠室

citang 祠堂

ciwu 祠屋

ciyu 祠宇

cizhu shouji tu 祠主收祭圖

Congshi Wu Liang bei 從事武梁碑

Congshu jicheng 叢書集成

Cui Shi 崔寔

da chen 大臣

da nan, nü 大男, 女

Dabaodang 大保當

Daisheng 代盛

Danggu 黨錮

Dangjiagou 黨家溝

dani wudao 大逆無道

Danyang 丹陽

Dao mu fangbei tu 禱墓訪碑圖

Daoguang 道光

dasitu 大司徒

dawang 大王

Dawenkou, Shandong 大汶口, 山東

Daxiang bei 大饗碑

Daxing 大興

Debei shi'er tu 得碑十二圖

Deng 鄧

Derang 德讓

Di jing yanwu lüe 帝京晏物略

diaogu 弔古

ding 鼎

Ding Jing 丁敬

Ding Lan 丁蘭

"Dinggui" 訂鬼

dinghai 丁亥

dizi 弟子

Dong Han 東漢

Dong Han wenji 東漢文紀

Dong Jin 東晉

Dong Louping 董樓平

Dong Yuanjing 董元鏡

Dong Zhongshu 董仲舒

Dong'e 東阿

Dongguan [Han] ji 東觀[漢]記

Dongwanggong 東王公

Dou 竇

dougong 斗栱

Du duan 獨斷

Du Junchuo 杜君綽

Du Qin 杜欽

du xing 獨行

Du Zhongwei 杜仲微

Duanfang 端方

Duanjiawan 段家灣

Dubei keshi tu 讀碑窠石圖

Dubei tu 讀碑圖

Dunhuang 敦煌

Duyou Ban bei 督郵班碑

e zi 訛字

Eisei Bunko 永青文庫

erchu que 二出闕

Fan Min bei 樊敏碑

Fan Shi 范式

Fan Sui 范睢

Fan Ye 范曄

Fang Ruo 方若

Fangbei tu 訪碑圖

fangbei 訪碑

fanghuo souti 訪獲搜剔

fangshi 方士

fangxiangshi 方相士

Fangyu shenglan 方輿勝覽

Fanshi 范氏

Fanyang 繁陽

Fayan 法言

Feicheng 肥城

Feicheng Xiaotang Shan tu 肥城孝堂山圖

feiyi 非衣

Feng Erkang 馮爾康

Feng Gun 馮緄

Feng Minchang 馮敏昌

Feng Yi 馮異

Feng Yunpeng 馮雲鵬

Feng Yunyuan 馮雲鵷

Feng zhen shi 封診式

fenghuang 鳳凰

Fenglong 封龍 (mountain)

Fengsu tongyi 風俗通義

fu 府 (government bureau)

fu 賦 (rhapsody)

Fu [] 伏[]

fu chi 浮侈

Fu Shan 傅山

fucheng 府丞

Fuchun Cheng Zhang jun bei 富春丞張君碑

Fuchuzhai shiji 復初齋詩集

Fuchuzhai wenji 復初齋文集

Fufeng 扶風

Fuge song 郵閣頌

Fugou 扶溝

fugu 復古

fujun 府君

fusang 扶桑

Fushi 膚施

Fusu 扶蘇

Fuxi 伏羲

fuyin 府尹

Gan Yanshou 甘延壽

Ganquan Gong 甘泉宮

Gansu Mozuizi 甘肅磨嘴子

Ganyu 坩輿

Gao Mei 高禖

Gao Wen 高文

Gao Yi 高邑

Gao Zhengyan 高正炎

Gaoping 高平

Gaowen 高文

Gaoyang 高陽

Gaozu 高祖

ge 戈

"Getao, bangti, wenxian yu huaxiang jieshi: yi yige
 Shichuan de 'Qinü wei fu baochou' Hanhua gushi
 wei li" 格套, 榜題, 文獻與畫像解釋: 以一個失傳的
 "七女為父報仇" 漢畫故事為例

Ge Zhaoguang 葛兆光

gengshen 庚申

Gewu tong 格物通

gong 公 (Duke)

gong 宮 (palace)

gong shi 公士

Gongcao Que 功曹闕

Gongliu 公劉

gongshu 公署

Gongsun Shu 公孫述

gongxiu zidao 躬修子道

Gongyang 公羊

gongzu 公卒

Gu Aiji 顧藹吉

Gu Guangqi 顧廣圻

Gu Kaizhi 顧愷之

gu taishou 故太守

Gu Yanwu 顧炎武

Gu Yong 谷永

Guan neihou 關內侯

guan 觀

Guanling 關岭

Guannei hou 關內侯

guanzhe 觀者

Guanzhong jinshi ji 關中金石記

Guang Li 光里

Guangdong 廣東

Guanghe 光和

Guangling 廣陵

Guangwudi 光武帝

Gui Fu 桂馥

gui xin 鬼薪

gui 桂 (cassia tree)

gui 貴

guiren 貴人

guizu 貴族

guli 古隸

Guo Ju 郭巨

Guo Moruo 郭沫若

Guo Zongchang 郭宗昌

guwen 古文

Guwenci leizhuan 古文辭類纂

guzhuo 古拙

Han 漢

Han bei jishi 漢碑集釋

Han bei yanjiu 漢碑研究

Han dai Wushi muqun shike yanjiu
 漢代武氏墓群石刻研究

Han Fei Zhi bei kaoyi 漢肥致碑考疑

Han gu Xihe Huanyang shouling Pingzhou Niu gong
 Chan wansui zhi zhaizhao
 漢故西河圜陽守令平周牛公產萬歲之宅兆

Han Guohe 韓國河

Han Ren ming 韓仁銘

Han Tongting Hongnong Yangshi zhongying kaolüe
 漢潼亭弘農楊氏冢塋考略

Han Yongyuan canshi 漢永元殘石

Hancheng 韓城

"Handai huaxiang Hu Han zhanzhengtu de goucheng,
 leixing yu yiyi" 漢代畫象胡漢戰爭圖的構成、
 類型與意義

Handan 邯鄲

Hangzhou 杭州

Hanli ziyuan 漢隸字源

Hanlin 翰林

Hanshantang jinshilin shidi kao 寒山堂金石林時地考

Hanshu 漢書

Hanshu buzhu 漢書補注

Hanxue 漢學

haojia 豪家

haozhe 豪者

Haozhou 浩州

Hayashi Minao 林巳奈夫

He Daosheng 何道生

He kui 何饋

He Menghua dibei tu 何夢華滌碑圖

He Tong 何通

He Yuanxi 何元錫

He Zhuo 何焯

Hebei 河北

Hedong 河東

Helingor 和林格爾

Henan 河南

Henan sheng Yanshixian wenwu guanli weiyuanhui 河南省偃師縣文物管理委員會

Henei 河內

Heng Fang 衡方

Heng Fang bei 衡方碑

Heng Shan 衡山 (Hunan)

Heng Shan 恆山 (Shanxi)

Heping 和平

Heping yuannian Xihe Zhongyang Guangli Zuo Yuanyi zaozuo wannian lushe 和平元年西河中陽光里左元異造作萬年盧舍

He Shan ji 鶴山集

hong 薨

Hong Beijiang xiansheng nianpu 洪北江先生年譜

Hong Gong 弘恭

Hong Gua (/Kuo) 洪适

Hong Liangji 洪亮吉

Hongfu Yuan 洪福院

Hou Han ji 後漢記

Hou Han Kong jun bei 後漢孔君碑

Hou Hanshu 後漢書

hou 侯 (noble; marquis)

hou 猴 (monkey)

Houtu 后土

Houyi 后羿

Hsing I-tien 邢義田

hu 戶 (household)

hu 胡 ("barbarian")

Hu Changren 胡長仁

Hu Han zhanzheng tu 胡漢戰爭圖

Hu Shan 虎山

Hu Shi 胡適

Hu Xinli 胡新立

Hu Yuanren 胡元任

Hua Shan bei 華山碑

huabing chongji 畫餅充飢

Huainanzi 淮南子

Huan Kuan 桓寬

Huandi 桓帝

Huang Baichuan 黃白川

Huang Gongwang 黃公望

Huang Pilie 黃丕烈

Huang Qiu'an zhuan 黃秋盦傳

Huang Ruheng 黃汝亨

Huang Shengqing 皇聖卿

Huang Shugu 黃樹穀

Huang Shujing 黃叔璥

Huang Yi 黃易

Huang Yi de bei shi'er tu 黃易得碑十二圖

huanman 澷漫

Huanyang 圜陽

Huanyu fangbei lu 寰宇訪碑錄

Hua Shan 華山

Huayang guozhi 華陽國志

Hubei 湖北

hui 諱

Huimuzhai 晦木齋

Huimuzhai congshu 晦木齋叢書

Hun Dian 圂典

Huoshan 霍山

ji 及 (and)

ji 禨 (prosperity)

ji 雞 (fowl)

ji bu ke bian 幾不可辨

Ji Zha 季札

jia 家

Jia Chong 賈充

Jin Midi 金日磾

Jia li 家禮

Jin Nong 金農

Jia Yi 賈誼

jinben 今本

jia zhang 家長

Jing Ke 荊軻

Jiabao quanji 家寶全集

Jinglaoyuan 敬老院

Jiading, Jiangsu 嘉定, 江蘇

jingshen 精神

Jiading Qian Daxin quanji 嘉定錢大昕全集

jingshi guiqi junxian haojia 京師貴戚郡縣豪家

jiajie 假借

jingta 精拓

jiamiao 家廟

Jining 濟寧

jian 建

Jining zhili zhouzhi 濟寧直隸州志

Jian[] *yuan nian taisui zai dinghai* 建[]元年太歲在丁亥

Jinling 金陵

Jianchu 建初

Jinque Shan 金雀山

Jiang Deliang 江德量

jinshi 進士

Jiang Yingju 蔣英炬

Jinshi cuibian 金石萃編

Jiangdu 江都

Jinshi cun 金石存

Jiangnan 江南

Jinshi lu 金石錄

Jiangsu 江蘇

Jinshi lu xuba 金石錄續跋

Jianhe 建和

Jinshi lu bu xuba 金石錄補續跋

Jianhe yuan nian wu yue gengchen [] [] [] *ri zao*
建和元年五月庚辰[][][]日造

jinshi pi 金石癖

jinshi qiwei 金石氣味

jianmu 建木

Jinshi suo 金石索

Jianning 建寧

Jinshi wen bawei 金石文跋尾

"*Jianning sannian Cai Bojie shu*" 建寧三年蔡伯喈書

Jinshi wen kaolüe 金石文考略

jiansheng 監生

Jinshi yiba 金石一跋

Jiaobei suibi 校碑隨筆

jinshixue 金石學

jiaohu 鐎壺

jinshi zhi xue 金石之學

Jiaozhan tu 交戰圖

Jinshu 晉書

Jiaozhou 交州

Jinwu bian ershi zhinü shenming 晉武辨二氏之女甚明

Jiaqing 嘉慶

Jinxiang Xian 金鄉縣

Jiaxiang 嘉祥

Jinxiang shouzhang bei 金鄉首長碑

Jiaxiang xian zhi 嘉祥縣志

Jinxiang ti shishi zhi tu 金鄉剔石室之圖

jiayin 甲寅

Jinxiang zhang Hou Cheng bei 金鄉長侯成碑

Jicheng 集城

Jinzhai 晉齋

jie 節

jisi rufa 祭祀如法

"*Jifa*" 祭法

jiu zu 九族

Jigu lu 集古錄

jiuta 舊拓

Jigu lu bawei 集古錄跋尾

jiutaben 舊拓本

Jigu lu mu 集古綠目

jiuwen 舊文

Jigu qiuzhen 集古求真

Jiuzhen 九真

Jiguge 汲古閣

Jiyin 濟陰

jimao 己卯

Jizhou 濟州

jin 斤

juan 卷

Jin 晉

Juanshige ji 卷詩閣集

Jin guan ling 津關令

jue 爵 (mark of social status)

jun 郡

Jun ji 君即

jun wei shiyuan shi 君為市掾時

juncheng 郡丞

junshou 郡守

kaiming 開明

Kaimu 開母 (pillar-gate)

Kandai sekkoku shūsei 漢代石刻集成

kaozheng 考證

kaozheng xue 考證學

keqi 刻其

Kong Anguo 孔安國

Kong Bao 孔褒

Kong Biao 孔彪

Kong Biao bei 孔彪碑

Kong Honggu 孔荭谷

Kong Jihan 孔繼涵

Kong Jun bei 孔君碑

Kongmiao zhi shoumiao baishi li Kong He bei
　　孔廟置守廟百石吏孔龢碑

Kong Qian 孔謙

Kong Rong 孔融

Kong Zhou 孔宙

Kong Zhou bei 孔宙碑

Kongzi 孔子

Kunlun 崑崙

Kuroda Akira 黑田彰

Kyōto Daigaku Jinbun Kagaku Kenkyūjo shozō takuhon
　　京都大學人文科學研究所所藏拓本

Kyōto Gobun 京都語文

Lai Fei 賴非

lan 覽

Lanling 蘭陵

Lanting xu 蘭亭序

Lao Gan 勞幹

Laoxue an biji 老學庵筆記

Laozi 老子

Lelang 樂浪

Leshan 樂山

li 禮 (rites)

li 立 (establish)

li 里 (village)

Libian 隸辨

Li Cheng 李成

li ci 立祠

Li Daoyuan 酈道元

Li Dimao 李第卯

Li Dongqi 李東琪

Li Gang 李剛

Li Gonglin 李公麟

Li Gu 李固

li guan guishu 立官桂樹

Li Guangying 李光暎

Li Hong 李弘

Li Hongzhang 李鴻章

Li Ji 李曁

Li Kezheng 李克正

Li lun 禮論

limin 吏民

Li Qing 李卿

Li Shan 李善

Li Si 李斯

Li xu 隸續

Li Yuan 李淵

Li Yufen 李玉棻

Li Zhongxian 李重先

lian 連

Liang 梁

Liang Han jinshi ji 兩漢金石記

Liang Jiheng 梁季珩

liang ke guai ye 良可怪也

Liang Qichao 梁啟超

Liang Wudi 梁武帝

Liang Ying 梁瑛

Liang Zhe jinshi zhi 兩浙金石志

Liang Zonghe 梁宗和

Liangcheng Shan debei tu 兩城山得碑圖

Liangcheng Shan 兩城山

Liangzhu 良渚

lianli 連理

Liaodong 遼東

Lidai beizhi congshu 歷代碑志叢書

Lidai zhongding yiqi kuanshi fatie
　　歷代鐘鼎彝器款識法帖

liehou 列侯

Liji 禮記

ming 銘 (epitaph)
Ming 明 (dynasty)
mingchen 名臣
mingci 名刺
Mingdi 明帝
Minglun Tang 明倫堂
mingqi 明器
*ming*qi* 冥器
mingtang 明堂
Mizhi 米脂
Mozi 墨子
mu 墓 (grave)
mu 木 (tree)
mu qian 墓前
mu shang citang 墓上祠堂
mu zang bihua: hua gei shei kan 墓葬壁畫: 畫給誰看
mu zhong 墓中
mushou 牧守
musi 墓祀
Mu Tianzi 穆天子

Nagahiro Toshio 長廣敏雄
Nagata Hidemasa 永田英正
Namjŏng-ri 南井里
Nan Bei shupai lun 南北書派論
Nangong 南宮
Nanjing 南京
Nanzheng 南鄭
Neixiang 內鄉
Nie Zheng 聶政
nieqian 孽錢
nigu 泥古; 溺古
ning 寍 (Han clerical script form)
ning 寧 (ordinary form)
Ning Mao (B-MFA carved stones)
Niu Chan 牛產
Niu Chuan 牛剶
Niu Chuan yinxin 牛剶印信
Northern Qi 北齊
Northern Wei 北魏
Nüwa 女媧

Ouyang Fei 歐陽棐
Ouyang Fu 歐陽輔

Ouyang Xiu 歐陽修
Ouyang Xiu quanji 歐陽修全集

Pan Tian'an 潘恬庵
Pan Zhaolin 潘兆遴
Panzhou wenji 盤洲文集
Pei 沛
pianti 偏提
Pingding 平定 (capital of Xihe)
Pingyi 平邑
Pingyuan 平原
Pingzhou 平周
pi 癖
pushou 鋪首
Pushu ting ji 曝書亭集

qi 起 (constructing)
qi 氣
Qi 齊
qi ci yue 其辭曰
qi hou yun 其後云
Qinü wei fu baochou 七女為父報仇
Qi Wang 齊王
qi zhong li ci, sui shi ci ji 起塚立祠, 歲時祠祭
qi zhong ou you yi lou 其中偶有遺漏
Qian Baofu 錢寶甫
Qian Daxin 錢大昕
Qian Dian 錢坫
Qian Yong 錢泳
qian 錢
Qianfu lun 潛夫論
Qiang 羌
Qian–Jia kaojuxue yanjiu 乾嘉考據學研究
Qian–Jia xuepai 乾-嘉學派
Qianlong 乾隆
Qiantang 錢塘
Qianyan tang jinshi wen bawei 潛研堂金石文跋尾
qiao 巧
Qiao Cai 橋裁
Qiao Ren 橋仁
qie kong ru Hongshi suo cheng bu jie Wushici zhi wu 且恐如洪氏所稱不皆武氏祠堂之物
Qijia Hou Hanshu 七家後漢書
Qikou 磧口

qin 寢

Qin 秦

Qin Han beishu 秦漢碑述

Qin Jun que 秦君闕

Qin Mi 秦宓

Qing 卿 (given name)

Qing 清

Qing Gaozong Qianlong yuzhi shi wen quanji
　　清高宗乾隆御制詩文全集

Qing Huang Yi Debei tu ce 清黃易得碑圖冊

Qing Ji 慶忌

qingchun yin 輕唇音

Qingdai xuezhe xiang zhuan 清代學者象傳

Qinghe gongzhu bei 清河公主碑

Qingming 清明

Qingzhou 青州

qita ke hua jie wan, ke du, wen duo bu jin lu
　　其他刻畫皆完, 可讀, 文多不盡綠

qiu fu 求福

Qiu'an 秋盦

Qu family 瞿氏 (1576 version of Lishi)

Qu Yuan 屈原

que 闕 (watchtower)

que 雀 (birds)

Qufu 曲阜

ran bai chun yi bo, jiu bu hai qi hong zhi
　　然百醇一駁, 究不害其宏旨

Rencheng 任城

Renhe 仁和

renyi 仁義

ri 日

ri yue yi ming 日月以明

Rinan 日南

Rizhi lu 日知錄

Rong 榮

Rong Geng 容庚

Rongbao 榮保

Ruan Yuan 阮元

"San buzu" 散不足

sanchu que 三出闕

Sanchuan He 三川河

Sang Hongyang 桑弘羊

Sangong Shan 三公山

Sangong Shan bei 三公山碑

Sangong Shan yibei tu 三公山移碑圖

Sangong Shan 三公山

Sanguo beishu 三國碑述

Sanguo huiyao 三國會要

Sanguo zhi 三國志

Sanguo–Cao Wei 三國–曹魏

santang 三堂

sao baiye 掃敗葉

Sekino Tadashi 關野貞

Setsuwa Bungaku Kenkyū 説話文学研究

Shaanxi 陝西

Shanben beitie lu 善本碑帖錄

Shandong 山東

"Shandong faxian Dong Han mu zhi yi fang"
　　山東發現東漢墓志一方

"Shandong Liang Han beike zhenwei kao sanli"
　　山東兩漢碑刻真偽考三例

Shang 商

shang 商

Shanghai 上海

Shang Jun 上郡

Shangqiu 商丘

shangzhong 上冢

Shanhaijing 山海經

Shanxi 山西

Shanyang 山陽

shanyu 單于

Shanzuo jinshi zhi 山左金石志

Shao Gong 召公

Shao Mingsheng 邵茗生

Shao Qiangsheng 邵強生

Shao Shanjun 邵善君

she hou 射猴

she que 射雀

shegeng 舌耕

Shen Gua 沈括

Shen Shanglong 申上龍

Shen Shu 神荼

sheng 勝 (hair ornament)

sheng bu ji yang, si nai chong sang 生不極養, 死乃崇喪

sheng ci 生祠

shenming 神明

Shenmu 神木

shi 士 (official)

shi 石 (stone)

shi 氏 (family)

Shi Chen hou bei 史晨後碑

Shi Chen qian bei 史辰前碑

shi gong qing gui ren 世公卿貴人

Shi lü 史律

shi nan, nü 使男, 女

Shi qing hua yi 詩情畫意

shi shi qiu shi 實事求是

shi si ru shi sheng 事死如事生

shi wu 士五

Shi Xian 石顯

Shi Xiongnu zhonglangjiang 使匈奴中郎將

Shi Xueyan (Shih Hsio-yen) 時學顏

Shi Zhecun 施蟄存

shi'er yue nianqi ri gengshen ancuo yu si
　　十二月廿七日庚申安錯於斯

shigu 嗜古

Shiji 史記

shijia 世家

Shijing Xuan shangbei tu 詩境軒賞碑圖

Shike shiliao xinbian 石刻史料新編

Shike tiba suoyin 石刻題跋索引

Shilin yanyu 石林燕語

Shimen song 石門頌

shimiao 石廟

Shiming 釋名

Shimo juanhua 石墨鐫華

shipan 式盤

Shipan 石盤

Shiqiao 石橋

shishi 石室

shitang 食堂

shiwu 實物

Shiyin 濕陰

shizhaici 食齋祠

Shizhe chijie zhonglangjiang mufu zoucao shi Xihe Zuo
　　Biao zi Yuanyi zhi mu 使者持節中郎將莫府奏曹史西
　　河左表字元異之墓

Shizhi 石芝

shou 守 (governor)

shou 收 (take over, confiscate)

shou ci tang dang 守祠堂當

shou ru jin shi 壽 如金石

shoucang 壽藏

Shoutang yishu 授堂遺書

shu 樹 (tree)

shu 舒 (part of Zhu Wei's style name?)

Shu 蜀 (ancient Sichuan)

shu ren 庶人

Shu Xiang 叔向

shuanggou 雙鈎

Shuihudi 睡虎地

Shuijing zhu 水經注

Shuijing zhu beilu 水經注碑錄

Shuijing zhu jian kanwu 水經注箋刊誤

Shuijing zhu shi 水經注釋

shumu sheniao tu 樹木射鳥圖

Shuowen jiezi 說文解字

Shuowen tongxun dingsheng 說文通訓定聲

Si 泗 (river)

Si hao 四皓

si shi wei ci hua ye, gu yu yi Wu Liang citang huaxiang
　　ming zhi 似是謂此畫也故予以武梁祠堂畫像名之

Sibu beiyao 四部備要

Sibu congkan 四部叢刊

Sichuan 四川

Sichuan sheng Wenwu kaogu yanjiusuo deng
　　四川省文物攷古研究所等

si kou 司寇

Siku 四庫

Siku quanshu 四庫全書

Siku quanshu zhenben wuji 四庫全書珍本五集

Siku quanshu zongmu tiyao 四庫全書總目提要

Siku tiyao bianzheng 四庫提要辨證

Sima Guang 司馬光

Sima Huang Xiaosong 司馬黃小松

Sima Qian 司馬遷

Sima Xiangru 司馬相如

Simin yueling 四民月令

Sishipu 四十鋪

Sishilipu 四十里鋪

Sōgō Ningengaku Sōsho 総合人間学叢書

Song 宋

Song Baochun 宋葆淳

Song huiyao jigao 宋會要輯稿

Song Renzong 宋仁宗
Song Shan 宋山 (Shandong)
Song Shan 嵩山 (Henan)
Song Shan Taishi shique ming 嵩山太室石闕銘
Songshi 宋史
Songshi chushi 松石處士
su keben 俗刻本
Su Shi 蘇軾
Su Xian 宿縣
Sui 隋
Suide 綏德
Suijiazhuang 隨家莊
Suiyang 睢陽
Suizong 綏宗
Sun Chengze 孫承澤
Sun Gen 孫根
Sun Xingyan 孫星衍
Sun Yuanru xiansheng quanji 孫淵如先生全集
Sunzong 孫宗
Suxian 宿縣
Suzhou 蘇州

taben 拓本
Tai Shan 泰山
Taiding 泰定
Taiping 太平
Taiping yulan 太平御覽
taishi ling 太史令
taishou 太守
Taisui 太歲
Taixue 太學
Taiyi 太一
Taiyuan 太原
taizi 太子
Tan Wu Liang ci huaxiang de Song ta yu Huang Yi taben
 談武梁祠畫像的宋拓與黃易拓本
Tanbei tu 探碑圖
Tancun 灘村
Tanxi jiancang 覃谿鑑藏
Tang 唐
tang 堂
Tang Gongfang 唐公房
"Tangong" 檀弓
Tangyi ling Bi Feng bei 堂邑令費鳳碑

Tao Yuanming 陶淵明
Tengxian 滕縣
Ti Huang Xiaosong Ziyun shan tanbei tu
 題黃小松紫雲山探碑圖
ti 剔
Tian Fang 田魴
Tianchang 天長
Tianjin 天津
Tianshen 天神
Tianwen 天問
Tianwu 天吳
Tianxia jinshi zhi 天下金石志
Tianyi Ge 天一閣
tiyao 提要
tizan 題贊
tong hou 通侯
tongtianshu 通天樹
Tsio Ho (Qiu He) 湫河

wadang 瓦當
waiqi 外戚
Wan 宛
Wan Guoding 萬國鼎
wan xing 萬姓
Wang ben Lishi kanwu 汪本隸釋刊誤
Wang Chang 王常 (Han dynasty)
Wang Chang 王昶 (Qing dynasty)
Wang Chong 王充
Wang Ci 王次
Wang Duo 王鐸
Wang Fu 王符 (Han dynasty)
Wang Fu 王復 (Qing dynasty)
Wang gong, gui qi, gong chen 王公, 貴戚, 功臣
Wang Guangwen 王廣文
Wang Ji canbei 王基殘碑
Wang Jiakui 王家葵
Wang Jinyuan 王金元
Wang Liqi 王利器
Wang Ling mu 王陵母
Wang Mang 王莽
Wang Mingsheng 王名生
Wang Rixiu 汪日秀
Wang Shang 王商
Wang Sheren canbei 王舍人殘碑

Wang Shu 王恕

Wang Sili 王思禮

Wang Wentai 汪文臺

Wang Xianqian 王先謙

Wang Xiaoyuan bei 王孝淵碑

Wang Xizhi 王羲之

Wang Xuejiang 汪雪礓

Wang Xuzhou 王虛舟

Wang Yanshou 王延壽

Wang Yi 王逸

Wang Yong 王㭕

Wang Yunlu 王雲鷺

Wang Zhiqi 王治歧

Wang Zhongshu 王仲殊

Wang Zhuanghong 王壯弘

Wangjiapo 王家坡

Wangzhi 王制

Wanli 萬曆

wei 為 (on behalf of; for)

Wei 魏 (state of)

wei 鮪 (from Zhu Wei stele)

Wei Bo 衛博

wei duyou [shi] 為督郵[時]

Wei Gai 衛改

wei gu you yuan 味古有緣

Wei Juxian 衛聚賢

wei li zhi dao 為吏之道

Wei Liaoweng 魏了翁

wei shi nan, nü 未使男, 女

Wei Wendi 魏文帝

Wei Wu 魏武

Weichuan 洧川

weimian qianhe qi ci 未免牽合其詞

Weishan 微山

Wei Xian 濰縣

wen 文

Wenguo Wenzheng Sima gong ji 溫國文正司馬公集

Wen Weng 文翁

Wen Xiang 閿鄉

Wen Yanbo 文彥博

Weng Fanggang 翁方綱

Weng Fanggang nianpu 翁方綱年譜

Weng Shupei 翁樹培

Weng Tanxi 翁覃溪

Wenlu Gong jiamiao bei 文潞公家廟碑

Wenmiao 文廟

Wenshan 汶山

wenxian 文獻

Wenxuan 文選

Wo sheng wu tian shi poyan 我生無田食破硯

wu 伍 (responsibility group)

wu 午 (midday)

wu 巫 (shaman)

wu 武 (martial)

wu 無 (without)

Wu Ban 武班

Wu Dacheng 吳大澂

Wu Dafu 五大夫

Wu Han 吳漢

Wu Jingxing 武景興

Wu Kaiming 武開明

Wu Liang 武梁

Wu Liang ci 武梁祠

Wu Liang ci Tang taben 武梁祠唐拓本

Wu Liang citang huaxiang 武梁祠堂畫像

Wu Liang dian 武梁殿

Wu Mao 武茂

wu miao 無廟

Wu Muchun 武穆淳

Wu Rong 武榮

Wu Rong bei 武榮碑

Wu shi 武氏

Wu shi ci 武氏祠

Wu shi citang 武氏祠堂

Wu shi shishi 武氏石室

Wu Shigong 武始公

Wu Suizong 武綏宗

Wu Wang 吳王

Wu Wenqi 吳文棋

Wu Xian 巫咸

Wu Yi 武億

Wu Yujin 吳玉搢

Wudi 武帝

Wudi ji 吳地記

Wudinghe 無定河 (river near Suide)

Wufeng keshi 吳鳳刻石

Wuhu, fei ai li cai, po yu zhidu 嗚呼, 飛愛力財, 迫於制度

Wuji 無極 (mountain)

Wujiazhuang 吳家莊
Wujin 武進
Wujun 吳郡
Wulaowa 五老洼
Wulin 武林
Wushi citang huaxiang shi 武氏祠堂畫像詩
wuxing 五行
Wuxing 吳興
Wuyang 武陽 (Pingyi County, Shandong)
Wuyang 舞陽 (Henan)
Wuzhai Shan 武宅山/武翟山

xi 兮
xi mo ru jin 惜墨如金
Xi'an 西安
Xia Cheng 夏承
Xia Nai 夏鼐
xian 縣
xian gongcao 縣功曹
xianfu tu 獻俘圖
xianling 先令
xiang 鄉
Xiang Fengzong 鄉奉宗
Xiang Tajun 鄉他君
Xiang Tuo 項橐
Xiang Wuhuan 鄉無患
"Xiangfeng xing" 相逢行
Xiangshe lun 像設論
xiangtang 享堂
Xianyu Huang 鮮于璜
xiao citang 小祠堂
Xiao He 蕭何
Xiao Penglai Ge hebei tu 小蓬萊閣賀碑圖
Xiao Penglai Ge jinshi wenzi 小蓬萊閣金石文字
Xiao Wangzhi 蕭望之
xiao 孝
Xiaoguan bei 校官碑
Xiaohuangmen Qiao Min bei 小黃門譙敏碑
xiaolian 孝廉
Xiaosong suode jinshi 小松所得金石
xiao tang 孝堂
xiaotang 小堂
Xiaotang Shan 孝堂山
xiaozi tang 孝子堂

xiaozi xiaosun 孝子孝孫
Xiaqiu 瑕丘
Xiayang 夏陽
Xie Cheng Hou Han Shu 謝承後漢書
Xie Guozhen 謝國楨
Xie Qikun 謝啟昆
Xihe 西河 (commandery)
Xihe 羲和 (sun god)
Xihe taishou 西河太守
Xiling 西泠
xin 新
Xin Lixiang 信立祥
Xin Wudai shi 新五代史
Xin yu 新語
xing 省
xingming xue 刑名學
Xingping 興平
Xining 熙寧
xiong 兄
Xiongnu 匈奴
Xiping 熹平
Xiping shijing 熹平石經
xiu jiu 修舊
Xiu Tu 休屠
Xiu Wushi citang jilüe 修武氏祠堂記略
"Xiu zao citang ru fa" 修造祠堂如法
Xiwangmu 西王母
Xiyue Hua Shan 西嶽華山
Xu Qianxue 徐乾學
Xu Shen 許慎
Xu Song 徐松
Xu You 許由
xuanche 懸車
Xuandi 宣帝
Xuanhe bogu tu 宣和博古圖
Xuanhe huapu 宣和畫譜
Xuanwu 玄武
Xuanzhang 宣張
Xue Guangde 薛廣德
Xue Shanggong 薛尚功
Xunyi Xian 旬邑縣
Xunzi 荀子
Xuxiu Siku quanshu 續修四庫全書
Xuzhou 徐州

Ya'an xin chutu Hanbei erzhong 雅安新出土漢碑二種

Yan 燕 (area of northern Hebei)

Yan 閻 (surname)

Yan Junping 嚴君平

Yan Ruoqu 閻若璩

Yan Shigu 顏師古

Yan Ying 晏嬰

Yan Zhong 宴忠

yang 陽

Yang Aiguo 楊愛國

Yang Dianxun 楊殿珣

Yang Hezhou 楊鶴洲

Yang Shugong 楊叔恭

Yang Tong 楊統

Yang Xiong 揚雄

Yang Xiu 楊修

Yang Zhen 楊震

Yang Zhu 楊著

Yanghu 陽湖

Yangong ci 宴公祠

Yangzhou 揚州

Yangzi Jiang 楊子江

Yanjiacha 延家岔

Yanshi 偃師

Yantie lun 鹽鐵論

Yantie lun duben 鹽鐵論讀本

Yantie lun jiaozhu 鹽鐵論校注

Yanyi yimou lu 燕翼貽謀錄

Yanzhou fu zhi 兗州府志

Yanzhou 兗州

Yao Li 要離

Yao Nai 姚鼐

Ye Changchi 葉昌熾

Ye Yibao 葉奕苞

Yi 夷

yi gu—xin gu 疑古—信古

yi jin huan xiang 衣錦還鄉

Yi ying bei 乙瑛碑

Yi zi zhi baijin 一字值百金

Yihe ming 瘞鶴銘

Yijing 易經

Yili 儀禮

yilou 遺漏

yin guan 隱官

"Yin jiu" 飲酒

yin si 淫祀

Yin Zhou 尹宙

Yin 鄞

Yinan 沂南

Ying Shao 應邵

ying Song chaoben 影宋鈔本

yingtang 影堂

Yingyin Wenyuange Siku quanshu 影印文淵閣四庫全書

yinyang 陰陽

Yizheng 儀徵

Yongcheng, Henan 永城, 河南

yongdao 甬道

Yonghe 永和

Yongjian 永建

Yongkang 永康

Yongle dadian 永樂大典

Yongshou 永壽

Yongxing 永興

Yongyuan can shi 永元殘石

You keneng yuanshi cimiao 有可能原是祠廟

You niao ru he 有鳥如鶴

you qi xiao you pi miu 又其小有紕繆

you shumin er ji gu xianren zhi mu zhe
 有庶民而祭古賢人之墓者

Youzhou 幽州

yu 餘 (abundance)

yu 魚 (fish)

Yu Fan 虞翻

Yu Ji 余集

Yu Jiaxi 余嘉錫

Yu Lu 鬱壘

Yu Rang 豫讓

Yu shi 語石

Yu Yizheng 于奕正

Yuan 元

Yuan An 袁安

Yuan Ang 爰盎

Yuan Chang 袁敞

Yuan Liang 袁良

Yuan Mei 袁枚

Yuan Weichun 袁維春

yuan wen 原文

Yuandi 元帝

Yuanfeng tiba 元豐題跋
Yuanhe 元和
Yuanhe xingzuan 元和姓纂
Yuanshang 元上
Yuanshi 元氏
Yudi jisheng 輿帝記勝
yue 月
Yue dong jinshi ji 粵東金石記
Yue xi jinshi lüe 粵西金石略
Yulin 榆林
Yung Ning Chow (Yongning Zhou) 永寧州

Zaowang ye 竈王爺
Zeng Gong 曾鞏
Zengbu jiaobei suibi 增補校碑隨筆
zhaici 齋祠
zhaigong 齋宮
zhaishi 齋室
Zhan Ruoshui 湛若水
zhang 長
Zhang Fan 張翻
Zhang Feng 張風
Zhang Heng 張衡
Zhang Jing bei 張景碑
Zhang Lu 張魯
Zhang Pingzi 張平子
Zhang Pu 張醋
Zhang Shaolun 張少崑
Zhang Tang 張湯
Zhang Wensi 張文思
Zhang Xuan 張玄
Zhang Xun 張塤
Zhang Yansheng 張彥生
Zhang Yu 張禹
Zhang Yuanji 張元濟
Zhang Yun 張允
Zhangdi 章帝
Zhanghe 章和
Zhangjia Shan 張家山
Zhao Bing 趙炳
Zhaodi 昭帝
Zhao Han 趙崡
Zhao Huaiyu 趙懷玉
Zhao Jun 趙俊

Zhao Mingcheng 趙明誠
Zhao Pei 趙沛
Zhao Qi 趙歧
Zhao sheng 詔聖
zhaoshu si baibi qing shi youyi yu min zhe
　　詔書祀百辟卿士有益於民者
Zhao Wei 趙魏
zhao wei qi citang, junren li miao si zhi
　　詔為起祠堂, 君人立廟祀之
Zhao Xuan 趙宣
Zhao Yi bei 趙儀碑
Zhao Yiqing 趙一清
"Zhaohun" 招魂
Zhaoling 昭陵
Zhaoxiang Yong Quan Que bei 趙相雍勸闕碑
zhen 箴
Zheng Fu 鄭簠
Zheng Gu bei 鄭固碑
Zheng Ji 鄭吉
Zheng Jixuan bei 鄭季宣碑
Zheng Jixuan 鄭季宣
Zheng Xuan 鄭玄
Zheng Yan 鄭岩
zhengge shehui zhong zongzu guannian bu nonghou
　　整個社會中宗族觀念不濃厚
wei jian 未見
zhenmuwen 鎮墓文
zhenmushou 鎮墓獸
Zhenyang 鎮洋
Zhi Du 之都
Zhida Jinling xin zhi 至大金陵新志
zhidu 制度
Zhifang Zhen 紙坊鎮
Zhili 直隸
Zhiping 治平
zhishi xuanche 致仕懸車
zhishi 致仕
zhong qian 冢前
zhong zhe citang ping ge, yuan que fu si
　　中者祠堂屏閣, 垣闕罘罳
Zhongguo meishu quanji 中國美術全集
Zhongguo shufajia xiehui Shandong fenhui
　　中國書法家協會山東分會
Zhonghua shuju 中華書局

Zhonghua wenhua bainian 中華文化百年

Zhongli Chun 鍾離春

Zhongyang Xian 中陽縣

Zhongzhang 仲章

Zhongzhou 忠州

Zhongzhou jinshi kao 中州金石考

Zhou 周

Zhou Bao 州苞

Zhou Fu 州輔

Zhou Gong 周公

Zhou Ju 周榘

Zhou Qin 周秦

Zhou Shouchang 周壽昌

Zhou Wang 周王

Zhou yi 周易

Zhouli 周禮

Zhu Changshu 朱長舒

Zhu Jianxin 朱劍心

zhu jun chang 朱君長

Zhu Ming 朱明

Zhu Mu 朱穆

Zhu Wei 朱鮪

Zhu Xi 朱熹

Zhu Ye 朱野

Zhu Yizun 朱彝尊

Zhu Yun 朱筠

zhuang 莊

zhuangyuan 狀元

Zhulong 燭龍

Zhumingsi 朱明寺

[zhuoli mozhi] guiju shizhang [琢礪磨治] 規矩施張

Zhuque 朱雀

Zhuting xiansheng riji chao 竹汀先生日記鈔

Zhuyan an jinshi mulu 竹厓庵金石目錄

zhu 朱

zi 子 (son)

zi 字(style)

Zi Chan 子產

zi you beike yilai, tui shishu wei zui jingbo
自有碑刻以來, 推是書為最精博

zi zi xiang 字字香

Zibo 淄博

Ziyun Shan tanbei tu 紫雲山探碑圖

Ziyun Shan 紫雲山

Ziyun 紫雲

Zizhi tongjian 資治通鑑

zong 宗 (ancestral)

zongci 宗祠

Zongjiaoxue yanjiu 宗教學研究

Zou yan shu 奏讞書

Zoucheng 鄒城

Zunguzhai 尊古齋

Zuo Biao 左表

Zuo Yuanyi 左元異

Contributors

QIANSHEN BAI
Associate Professor of Art History
Boston University

MIRANDA BROWN
Associate Professor
Asian Languages and Cultures
University of Michigan

SUSAN N. ERICKSON
Associate Professor of Art History
University of Michigan-Dearborn

HSING I-TIEN
Research Fellow
Institute of History and Philology
Academia Sinica, Taiwan

EILEEN HSIANG-LING HSU
Independent Scholar

JIANG YINGJU
Professor Emeritus
Shandong Stone Inscriptions Art Museum,
Jinan, Shandong

CARY Y. LIU
Curator of Asian Art
Princeton University Art Museum

MICHAEL LOEWE
Lecturer Emeritus of Chinese Studies
Cambridge University

MICHAEL NYLAN
Professor of History
University of California at Berkeley

KLAAS RUITENBEEK
Louise Hawley Stone Chair of Far Eastern Art
Royal Ontario Museum, Canada

LYDIA THOMPSON
Independent Scholar

LILLIAN LAN-YING TSENG
Assistant Professor of Art History
Yale University

ZHENG YAN
Professor of Art History
Central Academy of Fine Arts, Beijing

Index

Index compiled by Robert J. Palmer
References to illustrations are in **boldface**.

Papers prepared for an international symposium (April 30–May 1, 2005) organized by the Princeton University Art Museum, in conjunction with the exhibition *Recarving China's Past: Art, Archaeology, and Architecture of the "Wu Family Shrines"* (March 5–June 26, 2005).

Rethinking Recarving: Ideals, Practices, and Problems of the "Wu Family Shrines" and Han China is cosponsored by the P. Y. and Kinmay W. Tang Center for East Asian Art at Princeton University, the Princeton University Art Museum, The Andrew W. Mellon Foundation, and the B. Y. Lam Foundation. The symposium was organized by the Princeton University Art Museum in memory of Frederick W. Mote. Cosponsors included the Chiang Ching-kuo Foundation for International Scholarly Exchange, the East Asian Studies Program, and the P. Y. and Kinmay W. Tang Center for East Asian Art; with the support of the Asian Studies Center at the University of Pittsburgh, the History Department and the East Asian Library at the University of California at Berkeley.

The *Recarving China's Past* exhibition and publication were made possible by grants from the Getty, the E. Rhodes and Leona B. Carpenter Foundation, the Blakemore Foundation, The Andrew W. Mellon Foundation, the National Endowment for the Arts, the Princeton University Art Museum and Apparatus Fund, the Friends and the Partners of the Princeton University Art Museum, and the Department of Art and Archaeology, Princeton University. The project also was supported by gifts from Lillian Schloss and several anonymous donors.

Published by the Princeton University Art Museum
Princeton, New Jersey 08544-1018

Distributed by
Yale University Press, New Haven and London
www.yalebooks.com

ISBN 978-0-300-13704-0
Library of Congress Control Number: 2007943412

Managing Editor: Jill Guthrie
Project Editor: Kim Wishart
Indexer: Robert J. Palmer

Design, composition, production: Binocular, New York
Chinese typesetting: Birdtrack Press, New Haven
Printed and bound in Japan by Nissha, Kyoto

Cover illustration: Stone Chamber 1: Niche, south wall, Stone 1-S.6. Rubbing: h. 68.5 cm, w. 143.3 cm. PUAM acc. no. 2002.307.9

Frontispiece illustration: *Recarved stone on north side of northeast gate-pillar* (detail). Ink-on-paper rubbing. From Sekino Tadashi, *Shina Santōshō ni okeru Kandai Funbo no Hyōshoku* (Tokyo: Imperial University of Tokyo, 1916), pl. 26, fig. 41.

Divider page illustration: Stone Chamber 1: East wall, Stone 1-E.1. Rubbing; h. 87.5 cm, w. 199.3 cm. PUAM, acc. no. 2002.307.1.